STUDY GUID

for

Jim Lee Texas A&M University-Corpus Christi

PEARSON

Boston Columbus Indianapolis New York San Francisco Upper Saddle River Amsterdam Cape Town Dubai London Madrid Milan Munich Paris Montreal Toronto Delhi Mexico City São Paulo Sydney Hong Kong Seoul Singapore Taipei Tokyo

AVP/Executive Editor: David Alexander

Executive Developmental Editor: Lena Buonanno

Editorial Project Manager: Lindsey Sloan Production Project Manager: Andra Skaalrud Senior Manufacturing Buyer: Carol Melville

Copyright © 2015, 2013, 2010 Pearson Education, Inc. All rights reserved. Manufactured in the United States of America. This publication is protected by Copyright, and permission should be obtained from the publisher prior to any prohibited reproduction, storage in a retrieval system, or transmission in any form or by any means, electronic, mechanical, photocopying, recording, or likewise. To obtain permission(s) to use material from this work, please submit a written request to Pearson Education, Inc., Permissions Department, One Lake Street, Upper Saddle River, New Jersey 07458, or you may fax your request to 201-236-3290.

3 4 5 6 7 8 9 10 V036 16 15 14

ISBN-10:

0-13-345552-1

ISBN-13: 978-0-13-345552-6

CONTENTS

	Preface	
Part 1:	Introduction	
Chapter 1:	Economics: Foundations and Models	1
	Appendix: Using Graphs and Formulas	8
Chapter 2:	Trade-offs, Comparative Advantage, and the Market System	27
Chapter 3:	Where Prices Come From: The Interaction of Demand and Supply	55
Chapter 4:	Economic Efficiency, Government Price Setting, and Taxes	85
	Appendix: Quantitative Demand and Supply Analysis	92
Chapter 5	The Economics of Health Care	121
Part 2:	Firms in the Domestic and International Economies	
Chapter 6	Firms, the Stock Market, and Corporate Governance	141
	Appendix: Tools to Analyze Firms' Financial Information	149
Chapter 7	Comparative Advantage and the Gains from International Trade	165
Part 3:	Macroeconomic Foundations and Long-Run Growth	
Chapter 8	GDP: Measuring Total Production and Income	191
Chapter 9	Unemployment and Inflation	213
Chapter 10	Economic Growth, the Financial System, and Business Cycles	241
Chapter 11	Long-Run Economic Growth: Sources and Policies	265
Part 4:	Short-Run Fluctuations	
Chapter 12	Aggregate Expenditure and Output in the Short Run	289
	Appendix: The Algebra of Macroeconomic Equilibrium	304
Chapter 13	Aggregate Demand and Aggregate Supply Analysis	323
	Appendix: Macroeconomic Schools of Thought	333
Part 5:	Monetary and Fiscal Policy	
Chapter 14	Money, Banks, and the Federal Reserve System	351
Chapter 15	Monetary Policy	381
Chapter 16	Fiscal Policy	409
	Appendix: A Closer Look at the Multiplier	424
Chapter 17	Inflation, Unemployment, and Federal Reserve Policy	443
Part 6:	The International Economy	
Chapter 18	Macroeconomics in an Open Economy	469
Chapter 19	The International Financial System	497
	Appendix: The Gold Standard and the Bretton Woods System	505

PREFACE

Why Should You Use the Study Guide?

This Study Guide has been written for use with *Macroeconomics*, Fifth Edition, by R. Glenn Hubbard and Anthony Patrick O'Brien. The textbook and Study Guide both apply economic principles to real-world business and policy examples. The Study Guide summarizes the material covered in the main text and provides you with additional exercises to help you practice interpreting graphs, analyzing problems, and applying the economic concepts you learn to real-life situations. The Study Guide will be especially helpful to you if this is your first course in economics. You can use many of the key concepts you will learn here in other economics and business courses you take.

Study Guide Contents

Each of the 19 chapters of the Study Guide contains the following components:

1. Chapter Summary and Learning Objectives

Each chapter begins with a list of the learning objectives that appear at the beginning of each textbook chapter. Each learning objective is accompanied by a brief summary of the material in the textbook that covers that learning objective.

2. Chapter Review

This offers you a synopsis of each of the sections in each chapter. Reading the Chapter Reviews is a great way to reinforce your understanding of the material in the textbook and prepare for examinations.

3. Study Hints

Study Hints, located in the Chapter Review, will help you understand economic principles and their application through the use of examples that are different from those in the textbook. Select Study Hints also refer you to features in the textbook—for example, *Solved Problems*, *Making the Connection*, and end-of-chapter *Problems and Applications*—that relate to the topics covered in the Chapter Review.

4. Solved Problems

The textbook includes worked-out problems, usually two or three per chapter, each of which is tied to one of the learning objectives. Each of the Study Guide chapters includes one or more additional Solved Problems.

5. Key Terms

Each of the corresponding textbook chapter's bold key terms is defined.

6. Self-Test

This section of the Guide will help you prepare for quizzes and exams. There are approximately 40 multiple-choice questions, 5 short answer questions, and 15 true/false questions for each chapter. The answers to all questions appear at the end of the Self-Test, along with comments that help explain each answer.

Study Tips

- 1. Read the textbook chapter—but don't just read the chapter. To do well in your economics course, you must be able to apply what you learn and not just memorize definitions and read graphs. Both the textbook and the Study Guide have a number of features that allow you to apply and understand what you learn. Take advantage of these learning aids. Economics is a participant sport, not a spectator sport. Use your pencil. Draw graphs, don't just look at them. Try the calculations. Use your calculator.
- 2. Attend class and ask questions. Take this course as seriously as your instructor does. Taking days off will not help you do well in any course and is poor preparation for your life after graduation. Many students are hesitant to ask questions during or outside of classroom meetings because they feel they are the only ones who do not understand a topic (this is almost never true) or that their instructors feel they have better things to do (this is almost never true as well). Your instructor will appreciate the effort you make to learn what can be a challenging subject.
- 3. **Don't leave the subject in the classroom.** The key to doing well in your course is to understand how to apply economic concepts in real-world situations. Learning economics is similar to learning a new language. You will become fluent in the economic way of thinking only after you learn to recognize and apply concepts found in newspaper articles, magazines, and everyday conversation.
- 4. *Organize a study group*. If possible, study with other students in your class. Participating in a study group can help you learn economics—students will bring different insights to the group—and make learning more enjoyable. Explaining a topic to a friend will help you discover areas where you need to spend more study time.

CHAPTER 1 | Economics: Foundations and Models

Chapter Summary and Learning Objectives

1.1 Three Key Economic Ideas (pages 4–8)

Explain these three key economic ideas: People are rational; people respond to economic incentives; and optimal decisions are made at the margin. Economics is the study of the choices consumers, business managers, and government officials make to attain their goals, given their scarce resources. We must make choices because of scarcity, which means that although our wants are unlimited, the resources available to fulfill those wants are limited. Economists assume that people are rational in the sense that consumers and firms use all available information as they take actions intended to achieve their goals. Rational individuals weigh the benefits and costs of each action and choose an action only if the benefits outweigh the costs. Although people act from a variety of motives, ample evidence indicates that they respond to economic incentives. Economists use the word marginal to mean extra or additional. The optimal decision is to continue any activity up to the point where the marginal benefit equals the marginal cost.

1.2 The Economic Problem That Every Society Must Solve (pages 8–11)

Discuss how an economy answers these questions: What goods and services will be produced? How will the goods and services be produced? Who will receive the goods and services produced? Society faces trade-offs: Producing more of one good or service means producing less of another good or service. The opportunity cost of any activity—such as producing a good or service—is the highest-valued alternative that must be given up to engage in that activity. The choices of consumers, firms, and governments determine what goods and services will be produced. Firms choose how to produce the goods and services they sell. In the United States, who receives the goods and services produced depends largely on how income is distributed in the marketplace. In a centrally planned economy, most economic decisions are made by the government. In a market economy, most economic decisions are made by consumers and firms. Most economies, including that of the United States, are **mixed economies** in which most economic decisions are made by consumers and firms but in which the government also plays a significant role. There are two types of efficiency: Productive efficiency occurs when a good or service is produced at the lowest possible cost. Allocative efficiency occurs when production is in accordance with consumer preferences. Voluntary exchange is a situation that occurs in markets when both the buyer and seller of a product are made better off by the transaction. Equity is more difficult to define than efficiency, but it usually involves a fair distribution of economic benefits. Government policymakers often face a trade-off between equity and efficiency.

1.3 Economic Models (pages 11–15)

Understand the role of models in economic analysis. Economists rely on economic models, which are simplified versions of reality used to analyze real-world economic situations. Economists accept and use an economic model if it leads to hypotheses that are confirmed by statistical analysis. In many cases, the acceptance is tentative, however, pending the gathering of new data or further statistical analysis. Economics is a social science because it applies the scientific method to the study of the interactions among individuals. Economics is concerned with positive analysis—what is—rather than normative analysis—what ought to be. As a social science, economics considers human behavior in every context of decision making, not just in business.

1.4 Microeconomics and Macroeconomics (pages 15–16)

Distinguish between microeconomics and macroeconomics. Microeconomics is the study of how households and firms make choices, how they interact in markets, and how the government attempts to influence their choices. Macroeconomics is the study of the economy as a whole, including topics such as inflation, unemployment, and economic growth.

1.5 A Preview of Important Economic Terms (pages 16–17)

Define important economic terms. A necessary step in learning economics is to become familiar with important economic terms, including entrepreneur, innovation, technology, firm, goods, services, revenue, profit, household, factors of production, capital, and human capital.

Appendix: Using Graphs and Formulas (pages 24-34)

Review the use of graphs and formulas.

Chapter Review

2

Chapter Opener: Is the Private Doctor's Office Going to Disappear? (page 3)

Doctors operate their own offices much the same way as other businesspeople. However, an increasing number of doctors have given up their practices and become salaried employees of hospitals. Rising health care costs have led health care insurers and the government to reduce their payments to doctors for treating patients. The president's health care reform package, as passed by Congress in 2010, has also raised doctors' operating costs by increasing their amount of paperwork. The lower revenues and higher costs mean smaller profits for doctors practicing privately with their own offices.

The textbook describes how economics is used to answer many important questions, including the economic effect of the immigration of skilled workers. All of these questions represent a basic economic fact of life: people must make choices as they try to attain their goals. These choices occur because of scarcity, which is the most fundamental economic concept. The resources available to any society—for example, land and labor—to produce the goods and services its citizens want are limited. Society must choose which goods and services will be produced and who will receive them.

1.1

Three Key Economic Ideas (pages 4–8)

Learning Objective: Explain these three key economic ideas: People are rational; people respond to incentives; and optimal decisions are made at the margin.

Economics examines how people interact in markets. A **market** refers to a group of buyers and sellers of a good or service and the institution or arrangement by which they come together to trade. Economists make three important assumptions about the way people interact in markets. First, people are rational. This means that buyers and sellers use all available information to achieve their goals. Second, people act in response to economic incentives. Third, optimal decisions are made at the margin. The terms *marginal benefit* and *marginal cost* refer to the additional benefits and costs of a decision. Economists reason that the best, or optimal, decision is to continue any activity up to the point where the marginal benefit (or MB) equals the marginal cost (MC). In symbols, we can write MB = MC.

Study Hint

You should not assume that the phrase "people respond to economic incentives" means that people are greedy. This phrase is an objective statement or a statement shown to be true rather than a belief or an opinion. Economists do not believe people are motivated solely by monetary incentives. Many people voluntarily devote their time and financial resources to friends, family members, and charities.

The first *Solved Problem* is at the end of this section in the chapter. Each *Solved Problem* helps you understand one of the chapter's learning objectives. The authors use a step-by-step process to show how you can solve the problem. Additional Solved Problems, different from those that appear in the textbook, are included in each chapter of this Study Guide. Work through each of these to improve your understanding of the material presented in each chapter.

1.2

The Economic Problem That Every Society Must Solve (pages 8–11)

Learning Objective: Discuss how an economy answers these questions: What goods and services will be produced? How will the goods and services be produced? Who will receive the goods and services produced?

The basic economic problem any society faces is that it has only a limited amount of economic resources and so can produce only a limited amount of goods and services. Societies face **trade-offs** when answering the three fundamental economic questions:

- 1. What goods and services will be produced?
- 2. How will the goods and services be produced?
- 3. Who will receive the goods and services produced?

The **opportunity cost** of any activity is the highest-valued alternative that must be given up to engage in that activity.

Societies organize their economies in two main ways. A **centrally planned economy** is an economy in which the government decides how economic resources will be allocated. From 1917 to 1991, the Soviet Union was the most important centrally planned economy. Today Cuba and North Korea are among the few remaining centrally planned economies. A **market economy** is an economy in which the decisions of households and firms interacting in markets allocate economic resources. The United States, Canada, Western Europe, and Japan all have market economies. Privately owned firms must produce and sell goods and services that consumers want to stay in business. An individual's income is determined by the payments he receives for what he has to sell.

Study Hint

In a centrally planned economy, government officials or "planners" are responsible for determining how much of each good to produce, who should produce it, and where it should be produced. In contrast, in a market economy no government official determines how much corn, wheat, or potatoes should be produced. Individual producers and consumers interact in markets for these goods to determine the answers to *What? How?* and *Who?* The role of government in a market economy is similar to that of an umpire in a baseball game. Government officials can pass and enforce laws that allow people to act in certain ways, but they do not participate directly in markets as consumers or producers.

The high rates of unemployment and business bankruptcies of the Great Depression caused a dramatic increase in government intervention in the economy in the United States and other market economies. Some government intervention is designed to raise the incomes of the elderly, the sick, and people with

limited skills. In recent years, government intervention has expanded to meet social goals such as the protection of the environment and the promotion of civil rights. The expanded role of government in market economies has led most economists to argue that the United States and other nations have **mixed** economies rather than market economies.

Market economies tend to be more efficient than planned economies because market economies promote competition and **voluntary exchange.** There are two types of efficiency. **Productive efficiency** occurs when a good or service is produced at the lowest possible cost. **Allocative efficiency** is a state of the economy in which production represents consumer preferences. Specifically, every good or service is produced up to the point where the marginal benefit that the last unit produced provides to consumers is equal to the marginal cost of producing it. Inefficiencies do occur in markets for three main reasons. First, it may take time for firms to achieve productive efficiency. Second, governments may reduce efficiency by interfering with voluntary exchanges in markets. Third, production of some goods may harm the environment when firms ignore the costs of environmental damage.

Society may not find efficient economic outcomes to be the most desirable outcomes. Many people prefer economic outcomes that they consider fair or equitable even if these outcomes are less efficient. **Equity** is the fair distribution of economic benefits.

Extra Solved Problem 1.2

Advising New Government Leaders

Supports Learning Objective 1.2: Discuss how an economy answers these questions: What goods and services will be produced? How will the goods and services be produced? Who will receive the goods and services?

Suppose that a poor nation experienced a change in government leadership. Prior to this change, the nation employed a centrally planned economy to allocate its resources. The new leaders are willing to try a different system if someone can convince them that it will yield better results. They hire an economist from a nation with a market economy to advise them and will order their citizens to follow the advisor's recommendations for change. The economist suggests that a market economy replace central planning to answer the nation's economic questions (what, how, and who?).

- a. What will the economist suggest the leaders order their citizens to do?
- b. Do you believe the leaders and citizens will accept the economist's suggestions?

Solving the Problem

Step 1: Review the chapter material.

The problem concerns which economic system a nation must select, so you may wish to review the section "Centrally Planned Economies versus Market Economies" on page 9 of the textbook.

- Step 2: What will the economist suggest the leaders order their citizens to do?

 Market economies allow members of households to select occupations and purchase goods and services based on self-interest and allow privately owned firms to produce goods and services based on their self-interests. Therefore, the economist would advise the leaders of the poor country to not issue any orders.
- Step 3: Do you believe the leaders and citizens will accept the economist's suggestions?

 Even democratically elected leaders, especially those with significant government involvement in the nation's resource allocation, will find it difficult to accept the new system. They may wonder how self-interested individuals will produce and distribute goods and services to

promote the welfare of the entire nation. This new system requires a significant reduction in government influence in people's lives; history has shown that government officials are often reluctant to give up this influence. Acceptance is most likely when the leaders have some knowledge and experience with the successful operation of a market economy in other countries. Ordinary citizens are more likely to accept the economist's suggestions because they will have more freedom to pursue their own economic goals.

1.3

Economic Models (pages 11-15)

Learning Objective: Understand the role of models in economic analysis.

Models are simplified versions of reality used to analyze real-world situations. To develop a model, economists generally follow five steps.

- 1. Decide on the assumptions to use in developing the model.
- 2. Formulate a testable hypothesis.
- 3. Use economic data to test the hypothesis.
- 4. Revise the model if it fails to explain well the economic data.
- 5. Retain the revised model to help answer similar economic questions in the future.

Models rely on assumptions because models must be simplified to be useful. For example, models make behavioral assumptions about the motives of consumers and firms. Economists assume that consumers will buy the goods and services that will maximize their satisfaction and also assume that firms will produce the goods and services that will maximize their profits.

An **economic variable** is something measurable that can have different values, such as the wages of software programmers. A *hypothesis* is a statement that may be correct or incorrect about an economic variable. An economic hypothesis usually states a causal relationship where a change in one variable causes a change in another variable. For example, "outsourcing leads to lower wages for software programmers" means that an increase in the amount of outsourcing will reduce the wages of software programmers. **Positive analysis** is analysis concerned with what is and involves questions that can be estimated. **Normative analysis** is analysis concerned with what ought to be and involves questions of values and basic assumptions.

Study Hint

The feature *Don't Let This Happen to You* appears in each chapter to alert you to mistakes often made by economics students. To reinforce the difference between positive and normative statements, review *Don't Let This Happen To You* "Don't Confuse Positive Analysis with Normative Analysis," in which the minimum-wage law is discussed. Positive analysis can show us the effects of the minimum-wage law on the economy, but it cannot tell us whether the policy is good or bad. Nor can positive analysis tell us whether we should increase or decrease the minimum wage. The discussion of whether a policy is good or bad will depend on an individual's values and experiences and falls under the realm of normative analysis.

Positive economic analysis deals with statements that can be proven correct or incorrect by examining facts. If your instructor stated, "It is snowing outside," it would be easy to determine whether this statement is true or false by looking out a window. Normative analysis concerns statements of belief or opinion. If your instructor wants to go skiing that evening and states, "It *should* be snowing outside today," you could not prove the statement wrong because it is a statement of *opinion*. It is important to recognize the difference between these two types of statements.

Extra Solved Problem 1.3

Sunspot Activity and Economic Growth

Supports Learning Objective 1.3: Understand the role of models in economic analysis.

Sunspots are sites of strong magnetic fields that appear as dark regions on the surface of the sun. The number of sunspots varies over an 11-year cycle. British economist William Stanley Jevons (1835–1882) advanced a theory, or model, of economic growth based on the occurrence of sunspots. Changes in the number of sunspots cause variations in the earth's temperature and, according to this theory, changes in agricultural output. Agriculture accounted for a much greater share of total output of the economies of Great Britain and other nations in Jevons' time than in modern times.

Source: History of Economic Theory and Thought. Jevons Sunspot and Commercial Activity http://www.economictheories.org/2008/08/jevons-sunspots-and-commercial-activity.html

How can we develop and test a sunspot model of economic growth?

Solving the Problem

Step 1: Review the chapter material.

The problem concerns how models are used to analyze economic issues, so you may wish to review the section "Economic Models," which begins on page 11 of the textbook.

Step 2: To develop and test a sunspot model of economic growth, we follow these steps:

- 1. Decide on the assumptions to use in developing the model. Two assumptions of Jevons' model are: (a) Changes in the earth's temperature are related to the amount of sunspot activity. (b) Changes in the earth's temperature cause variations in the value of a nation's output of goods and services.
- 2. Formulate a testable hypothesis. The value of a nation's output of goods and services is greater in years of greater than average sunspot activity than in years of lower than average sunspot activity.
- 3. Use economic data to test the hypothesis. Compare changes in sunspot activity with changes in a standard measure of the value of a nation's output of goods and services; the most common measure is Gross Domestic Product or GDP. Because sunspot activity varies in 11-year cycles, data should cover at least one of these cycles. If data for the United States are used, years of greater than average sunspot activity should be associated with years of above-average economic growth, while years of lower than average sunspot activity should be associated with years of below-average economic growth.
- 4. Revise the model if it fails to explain well the economic data. The model could fail if factors other than sunspot activity have a significant impact on economic growth. These factors include variations in the price of energy, investments in new technologies, and changes in tax rates and other government policies. A revised model would examine the separate influence of sunspots and these other factors.
- 5. Retain the revised model to help answer similar economic questions in the future. Although the sunspot model is based on a plausible relationship between climate changes and changes in agricultural production, agriculture accounts for a much smaller percentage of the output produced in the United States, Great Britain, and other western nations in the twenty-first century than it did in the nineteenth century. In turn, other factors have been shown to be important in affecting economic growth.

1.4

Microeconomics and Macroeconomics (pages 15-16)

Learning Objective: Distinguish between microeconomics and macroeconomics.

Microeconomics is the study of how households and firms make choices, how they interact in markets, and how the government attempts to influence their choices. **Macroeconomics** is the study of the economy as a whole, including topics such as inflation, unemployment, and economic growth.

Extra Solved Problem 1.4

Watching from on High—and Low

Supports Learning Objective 1.4: Distinguish between microeconomics and macroeconomics.

Sports fans are accustomed to seeing game action on television from different camera angles. For popular events such as the Olympics, World Series, and Super Bowl, network coverage captures action from ground level as well as from higher locations. At many events a camera is located in a blimp that circles above the venue where the event is held. The aerial view of the blimp's camera is often visually appealing but is never broadcast for very long; the athletes can be seen only from a great distance, if they can be seen at all. Coverage of the events often includes a view from a mobile or "sideline" camera that can zoom in on individual players or fans sitting in the stands, a degree of detail in stark contrast to that provided by the aerial view. How do the different camera angles help to explain the difference between microeconomics and macroeconomics?

Solving the Problem:

Step 1: Review the chapter material.

The problem concerns the differences between microeconomics and macroeconomics, so you may want to review the section "Microeconomics and Macroeconomics" on pages 15–16 in the textbook.

- Step 2: Compare the focus of microeconomics with the television coverage of a sports event.

 Microeconomics focuses on how individual households and firms make choices, how they interact in markets, and how the government attempts to influence their choices. This focus is similar to that of a sideline camera at a football game. The camera can focus in on an individual player or fan.
- Step 3: Compare the focus of macroeconomics with the television coverage of a sports event.

 Macroeconomics is the study of the economy as a whole, including topics such as inflation, unemployment, and economic growth. Macroeconomics does not study the decisions made by individuals but the consequences of the actions of all decision makers in an economy. This is similar to the blimp's aerial view of the venue where a sports event occurs. You can see the entire venue, but the blimp's point of view is too far away to see any individual player or fan.

1.5

A Preview of Important Economic Terms (pages 16–17)

Learning Objective: Define important economic terms.

This chapter introduces twelve economic terms that will each be covered in depth in future chapters. Those terms are: *entrepreneur*, *innovation*, *technology*, *firm*, *goods*, *services*, *revenue*, *profit*, *household*, *factors of production*, *capital*, and *human capital*.

Appendix

Using Graphs and Formulas (pages 24–34)

Learning Objective: Review the use of graphs and formulas.

Graphs of One Variable

Bar charts, pie charts, and time-series graphs are alternative ways to display data visually. Figures 1A.1 and 1A.2 illustrate how relationships are often easier to understand with graphs than with words or tables alone.

Graphs of Two Variables

Both microeconomics and macroeconomics use two-variable graphs extensively to show the relationship between two variables.

You need to understand how to measure the slope of a straight line drawn in a graph. The slope of a straight line can be measured between any two points on a line because the slope of a straight line has a constant value, so we don't need to worry about the value of the slope changing as we move up and down the line. Slope can be measured as the change in the value measured on the vertical axis divided by the change in the value measured on the horizontal axis. In symbols, the slope formula is written as $\Delta y/\Delta x$. The formula is also described as "rise over run." The usual custom is to place the variable y on the graph's vertical axis and the variable x the horizontal axis. If the slope is negative, then the two variables are inversely (or negatively) related. If the slope is positive, then the two variables are directly (or positively) related. Keep in mind that a relationship between any two variables does not necessarily imply a cause and effect relationship between those two variables.

We can show the effect of more than two variables in a graph by shifting the line representing the relationship between the first two variables. For example, we can draw a graph showing the effect of a change in the price of pizza on the quantity of pizza demanded during a given week. We can then shift this line to show the effect of a change in the price of hamburgers on the quantity of pizza demanded.

If the relationship between two variables is nonlinear, you can still calculate the slope. The slope of a nonlinear curve at a given point is measured by the slope of the line that is tangent to that point.

Formulas

The formula for a percentage change of a variable over time (or growth rate) is:

 $\frac{\text{Value in the second period} - \text{Value in the first period}}{\text{Value in the first period}} \times 100$

The formula for the area of a rectangle is Base \times Height. The formula for the area of a triangle is $\frac{1}{2} \times \text{Base} \times \text{Height}$.

Key Terms

Allocative efficiency A state of the economy in which production is in accordance with consumer preferences; in particular, every good or service is produced up to the point where the last unit provides a marginal benefit to society equal to the marginal cost of producing it.

Centrally planned economy An economy in which the government decides how economic resources will be allocated.

Economic model A simplified version of reality used to analyze real-world economic situations.

Economic variable Something measurable that can have different values, such as the incomes of doctors.

Economics The study of the choices people make to attain their goals, given their scarce resources.

Equity The fair distribution of economic benefits.

Macroeconomics The study of the economy as a whole, including topics such as inflation, unemployment, and economic growth.

Marginal analysis Analysis that involves comparing marginal benefits and marginal costs.

Market A group of buyers and sellers of a good or service and the institution or arrangement by which they come together to trade.

Market economy An economy in which the decisions of households and firms interacting in markets allocate economic resources.

Microeconomics The study of how households and firms make choices, how they interact in markets, and how the government attempts to influence their choices.

Mixed economy An economy in which most economic decisions result from the interaction of buyers and sellers in markets but in which the government plays a significant role in the allocation of resources.

Normative analysis Analysis concerned with what ought to be.

Opportunity cost The highest-valued alternative that must be given up to engage in an activity.

Positive analysis Analysis concerned with what is.

Productive efficiency A situation in which a good or service is produced at the lowest possible cost.

Scarcity A situation in which unlimited wants exceed the limited resources available to fulfill those wants.

Trade-off The idea that because of scarcity, producing more of one good or service means producing less of another good or service.

Voluntary exchange A situation that occurs in markets when both the buyer and seller of a product are made better off by the transaction.

Self-Test

(Answers are provided at the end of the Self-Test.)

Multiple-Choice Questions

- 1. Economics is the study of all of the following except
 - a. how the prices of goods and services are determined.
 - b. how people make decisions, given scarce resources.
 - c. how to eliminate scarcity with new ideas and inventions.
 - d. how buyers and sellers interact in a market.
- 2. Which of the following statements best defines scarcity?
 - a. Scarcity occurs whenever we cannot afford something because it is too expensive.
 - b. Scarcity is an imbalance between buyers and sellers in a specific market.
 - c. Scarcity refers to a lack of trade-offs.
 - d. Scarcity is a situation in which unlimited wants exceed the limited resources available to fulfill those wants.
- 3. When you think of an arrangement or institution that brings buyers and sellers of a good or service together, what are you thinking of?
 - a. marginal analysis
 - b. a market
 - c. scarcity
 - d. rational behavior
- 4. In economics, how do rational people behave?
 - a. They always make the "best" decision.
 - b. They decide on an action only if its benefits outweigh its costs.
 - c. They know everything and never make mistakes.
 - d. They use only the information they believe to be helpful in making a decision.
- Fill in the blank. In economics, optimal decisions are made ______.
 a. once all costs have been considered
 - b. only when all benefits have been considered
 - c. in their totality
 - d. at the margin
- 6. Which of the following is *not* among the fundamental economic questions that every society must solve?
 - a. What goods and services will be produced?
 - b. How will the goods and services be produced?
 - c. What goods and services will be exchanged?
 - d. Who will receive the goods and services produced?

- 7. What types of economies require that answers be given to the following questions: what goods and services will be produced, how will the goods and services be produced, and who will receive the goods and services produced?
 - a. market economies
 - b. centrally planned economies
 - c. mixed economies
 - d. all of the above
- 8. In what type of economy does the government decide how economic resources will be allocated?
 - a. a market economy
 - b. a mixed economy
 - c. a centrally planned economy
 - d. none of the above
- 9. Which of the following is the best classification for the economies of the United States, Canada, Japan, and Western Europe?
 - a. market economies
 - b. mixed economies
 - c. centrally planned economies
 - d. none of the above
- 10. Which of the following terms best refers to a fair distribution of economic benefits?
 - a. productive efficiency
 - b. allocative efficiency
 - c. voluntary exchange
 - d. equity
- 11. Which of the following is achieved when a good or service is produced up to the point where the marginal benefit to consumers is equal to the marginal cost of producing it?
 - a. productive efficiency
 - b. allocative efficiency
 - c. equality
 - d. equity
- 12. Which of the following terms summarizes the situation in which a buyer and a seller exchange a product in a market and, as a result, both are made better off by the transaction?
 - a. productive efficiency
 - b. allocative efficiency
 - c. voluntary exchange
 - d. equity
- 13. What does an economy achieve by producing a good or service at the least possible cost?
 - a. productive efficiency
 - b. allocative efficiency
 - c. voluntary exchange
 - d. equity

- 14. Which of the following best describes the characteristics of models used in economics?
 - a. Models are approximations to reality that capture as many details as possible.
 - b. Models are usually complex abstractions of reality that simulate practical problems.
 - c. Models are concerned with what economic policies ought to be.
 - d. Models are simplifications of reality that include only essential elements and exclude less relevant details.
- 15. Which of the following is *not* an essential component of an economic model?
 - a. assumptions
 - b. hypotheses
 - c. variables
 - d. normative statements
- 16. What is the purpose of an economic hypothesis?
 - a. to establish a behavioral assumption
 - b. to establish a causal relationship
 - c. to make a statement based on fact
 - d. to determine the validity of statistical analyses used in testing a model
- 17. What type of economic analysis is concerned with the way things ought to be?
 - a. positive analysis
 - b. marginal analysis
 - c. normative analysis
 - d. rational behavior
- 18. The statement "A minimum wage actually reduces employment" would be considered what type of statement?
 - a. a positive statement
 - b. a marginal statement
 - c. a normative statement
 - d. an irrational conclusion
- 19. Which of the following is an example of a positive question?
 - a. Should the university offer free parking to students?
 - b. Should the university provide more financial aid assistance to students?
 - c. If the college increased tuition, would class sizes decline?
 - d. Should the college cut tuition to increase enrollments?
- 20. Which of the following questions can be answered using normative economic reasoning?
 - a. If a college offers free parking, will more students drive to campus?
 - b. If a college provided more financial aid, would more students go to college?
 - c. If a college hires better qualified instructors, will more students attend?
 - d. Should a college cut tuition to stimulate enrollments?
- 21. Which of the following involves an estimation of the benefits and costs of a particular action?
 - a. positive analysis
 - b. normative analysis
 - c. the market mechanism
 - d. an irrational conclusion

22	2. What type of assessment is one in which a person's values and political views form part of t assessment?	hat
	a. a positive assessment	
	b. a normative assessment	
	c. a microeconomic assessment	
	d. a macroeconomic assessment	
23	is the study of how households and businesses make choices, he they interact in markets, and how the government influences their choices. a. Microeconomics	ow
	b. Macroeconomicsc. A market mechanismd. Marginal analysis	
24.	Which of the following covers the study of topics such as inflation and unemployment? a. microeconomics b. macroeconomics	
	c. Both microeconomics and macroeconomics give equal emphasis to these problems.d. none of the above	
25.	What is the name given to the development of a new good or a new process for making a good? a. an invention	
	b. an innovation	
	c. entrepreneurship	
	d. capital	
26.	. A firm's processes to produce goods and services are called	
	a. entrepreneurship.	
	b. technology.c. innovation.	
	d. capital.	
27.	. The stock of computers, factory buildings, and machine tools used to produce goods better are known as	wn
	a. physical capital.	
	b. technology.	
	c. innovation.	
	d. goods and services.	
28.	. Human capital is	
	a. physical capital produced by human resources.	
	b. stocks and bonds that are owned by humans rather than corporations.	
	c. the accumulated training and skills that workers possess.	
	d. physical capital owned by humans rather than corporations.	
29.	by the change in the value on the other axis between any two points on the line.	xis
	a. horizontal; multiplied	
	b. horizontal; divided	
	c. vertical; multiplied	t

- 30. Which of the following graphs shown below is the graph of a single variable?
 - Sales 7.3 A. 7.2 (millions of SUVs) 7.1 7.0 6.9 6.8 6.7 6.6 6.5 0.0 2009 2010 2011 2012 2013

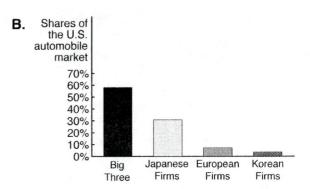

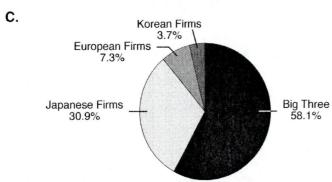

- a. A
- b. B
- c. C
- d. all of the above
- 31. Which of the following is a graph of the relationship between two variables?

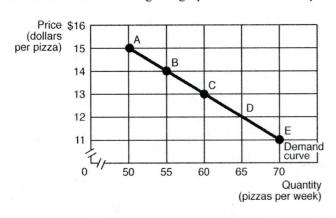

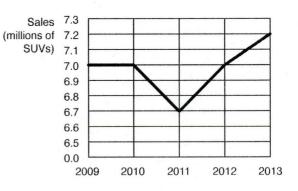

- a. the graph on the left
- b. the graph on the right
- c. both graphs
- d. neither graph

32. Refer to the graph below. What is the value of the slope of this line?

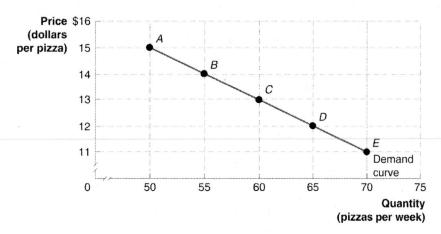

- a. -5
- b. -1/5
- c. -1
- d. There is insufficient information to compute the slope of this line.
- 33. Refer to the graph below. Which of the following explains why the line shifts to the right?

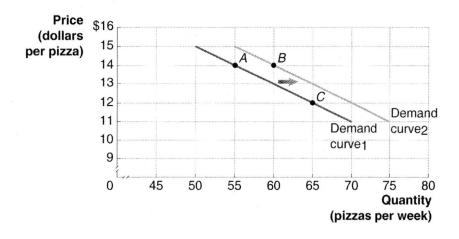

- a. There was a change in the price of pizza.
- b. There was a change in the quantity of pizza demanded.
- c. There was a change in a third variable other than the price or quantity of pizza demanded.
- d. all of the above

34. Refer to the graph below. How many variables are involved in explaining the move from point A to point C on this graph?

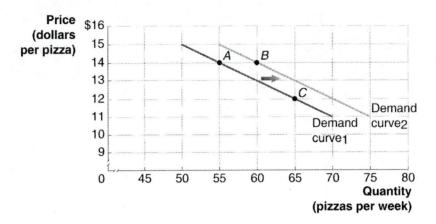

- a. one
- b. two
- c. three
- d. more than three, at least four
- 35. Suppose that there are three variables involved in the graph below: (1) quantity, (2) price, and (3) a third variable. Which of those variables causes the move from point *C* to point *D* in the graph?

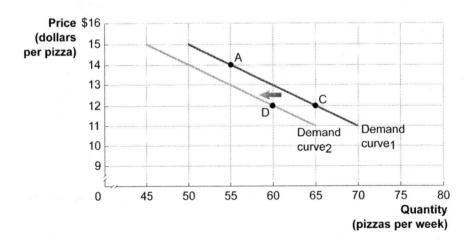

- a. the first variable, quantity
- b. the second variable, price
- c. the third variable
- d. either (a) or (b)

36. Refer to the graph below. What is the best descriptor of the relationship between disposable personal income and consumption spending?

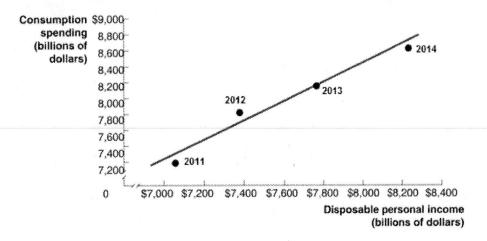

- a. a positive relationship
- b. a negative relationship
- c. a relationship that is sometimes positive and sometimes negative
- d. a relationship that may be positive and negative, but sometimes neither positive nor negative

37. Refer to the graph below. What can be said about the value of the slope of this curve?

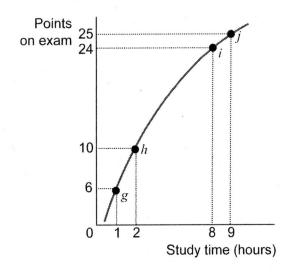

- a. The value of the slope is greater between points i and j than between points g and h.
- b. The value of the slope is greater between points g and h than between points i and j.
- c. The value of the slope is the same between any two points along the curve.
- d. We cannot determine whether the slope is greater between g and h or i and j because the relationship between "Points on exam' and "Study time" is not linear.

- 38. Let V_1 equal the value of a variable in period 1 and V_2 equal the value of the same variable in period
 - 2. What is the rate of growth between periods 1 and 2?
 - a. $[(V_1 + V_2)/2] \times 100$
 - b. $[(V_2 V_1)/V_1] \times 100$
 - c. $(V_2 V_1)/(V_1 + V_2)$
 - d. $V_2 V_1$
- 39. Refer to the graph below. Which of the formulas below must you apply to compute the shaded area shown on the graph?

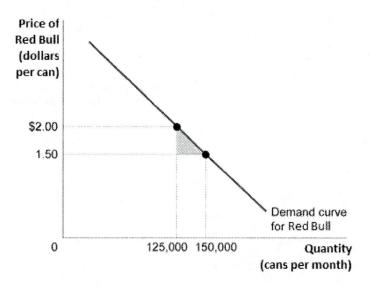

- a. Base × Height
- b. ½ × Base × Height
- c. $2 \times \text{Base} \times \text{Height}$
- d. none of the above

40. Refer to the graph below. What is the name of the area contained in rectangle A?

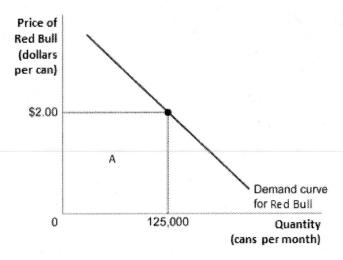

- a. total cost
- b. total revenue
- c. price
- d. average cost

41. Refer to the graph below. What is the value of the shaded area shown on the graph?

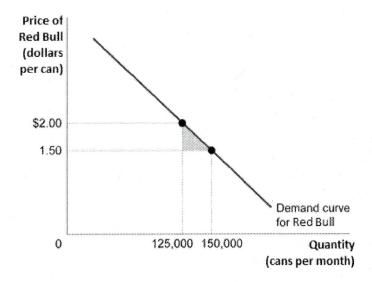

- a. \$300,000
- b. \$225,000
- c. \$62,500
- d. \$6,250

42. Refer to the graph below. What is the value of the area contained in rectangle A?

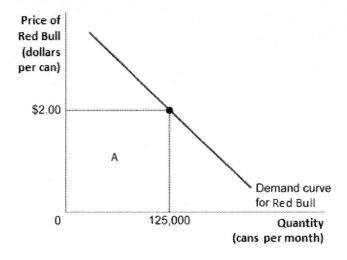

- a. \$2.00
- b. \$125,000
- c. \$250,000
- d. There is not enough information to determine the area.

Short Answer Questions

				* * * * * * * * * * * * * * * * * * *	
Explain the d	ifference betwe	en productive e	fficiency and a	llocative efficiency.	
use of mode	ls and hypothes	sis testing is co	ommon in the	eses to analyze real-w natural sciences such ot a natural science. W	as physics and

					(2)				2 2	
				1 %		-	8			
Mia h	as a full-t	ime iob.	but als	o she s	spends se	everal ho	ours a v	week wo	rking as	a volunteer
organi		at serves	free n	neals t	to the ho	meless	and lo	w-incom		a volunteer e. She also
organi	ization tha	at serves	free n	neals t	to the ho	meless	and lo	w-incom		

True/False Questions

- T F 1. Stating a hypothesis in an economic model is an example of normative analysis.
- T F 2. Only poor people face problems related to scarcity.
- T F 3. Economists assume that human beings respond only to monetary incentives.
- T F 4. In a centrally planned economy, the goods and services produced are always distributed equally to all citizens.
- T F 5. Equity is achieved when economic benefits are equally distributed.
- T F 6. A mixed economy is an economy in which the three fundamental questions (*What? How? Who?*) are answered by a mixture of consumers and producers.
- T F 7. Only centrally planned economies face trade-offs when producing goods and services.
- T F 8. People are rational when they only take actions that benefit society as a whole.
- T F 9. Government intervention in the U.S. economy increased dramatically as a result of the Great Depression.
- T F 10. Economists use normative analysis to show that the minimum-wage law leads to higher unemployment.
- T F 11. Microeconomics is the study of how households and firms make choices, how they interact in markets, and how the government attempts to influence their choices.
- T F 12. The slope of a straight line is the same at any point.
- T F 13. To measure the slope of a nonlinear curve at a particular point, one must draw a straight line from the origin to the point. The slope of this line is equal to the slope of the curve at that point.
- T F 14. All societies face the economic problem of having a limited amount of economic resources.
- T F 15. Economic models can help analyze simple real-world economic situations but are of little value in analyzing complicated economic situations.

Answers to the Self-Test

Multiple-Choice Questions

Question	Answer	Comment
1.	c	"How to eliminate scarcity" is not a typical question to be answered by economics. In economics, scarcity is a basic fact of life that cannot be eliminated.
2.	d	This is the textbook definition of scarcity.
3.	b	This is the definition of a market.
4.	b	In economics, rational people weigh the benefits and costs of each action, and choose an action only if the benefits outweigh the costs.
5.	d	The textbook presents three important ideas: People are rational; people respond to economic incentives; optimal decisions are made at the margin.
6.	С	The three questions are: What goods and services will be produced? How will the goods and services be produced? Who will receive the goods and services produced?
7.	d	These questions refer to the economic problem every society must solve.
8.	c	A centrally planned economy is an economy in which the government decides how economic resources will be allocated.
9.	b	A mixed economy is an economy in which most economic decisions result from the interaction of buyers and sellers in markets, but where the government plays a significant role in the allocation of resources.
10.	d	Equity, or fairness, refers to the fair distribution of economic benefits.
11.	b	This is a state of the economy in which production reflects consumer preferences; in particular, every good or service is produced up to the point where the last unit produced provides a marginal benefit to consumers equal to the marginal cost of producing it.
12.	c	This occurs in markets when both the buyer and the seller of a product are made better off by the transaction.
13.	a	Productive efficiency occurs when a good or service is produced at the lowest possible cost.
14.	d	Economic models are simplified versions of some aspects of economic life used to analyze economic issues.
15.	d	Normative statements, statements concerned with what ought to be, are not components of an economic model.
16.	b	An economic hypothesis is usually about a causal relationship, or how one thing affects another.
17.	c	Normative analysis is analysis concerned with "what ought to be."
18.	a	Positive statements describe "what is." A positive analysis of the minimum-wage law would use a model to estimate how many workers lost their jobs because of the law, its impact on firms, and the gains to workers who received the minimum wage.
19.	c	This question objectively examines a relationship between tuition and class sizes, or "what is."
20.	d	This is a question of "what ought to be."

Question	Answer	Comment
21.	a	Positive analysis uses economic models to estimate the benefit and cost of a particular action. Positive questions are questions that can be tested.
22.	b	A normative assessment would concern what a person believed "ought to be," not "what is." The assessment would be influenced by the person's values and political beliefs.
23.	a	This is the definition of microeconomics.
24.	b	Macroeconomics is the study of the economy as a whole, including topics such as inflation, unemployment, and economic growth.
25.	a	An invention is the development of a new good or a new process for making a good.
26.	b	Technology is the processes that a firm uses to produce goods and services.
27.	a	In economics, capital refers to physical capital, which includes manufactured goods that are used to produce other goods and services.
28.	С	This is the definition of human capital. For example, college-educated workers generally have more skills and are more productive than workers who have only high school diplomas.
29.	d	The slope of a line equals the change in the value on the vertical axis divided by the change in the value on the horizontal axis. The slope is sometimes referred to as "rise over run."
30.	d	The bar chart, pie chart, and time series graph are all graphs of a single variable.
31.	a	The graph on the left shows the relationship between two variables: price and quantity demanded.
32.	b	Along this line, the value of the slope is the same between any two points. As an example, as we move from B (55, 14) to C (60, 13), the value of rise is $(14 - 13) = 1$ and the value of the run is $(55 - 60) = -5$. Therefore, the value of the slope is $-1/5$.
33.	С	Shifting a line involves taking into account more than two variables on a graph. In this case, something other than the price of pizza has changed, causing the demand curve to shift to the right. As a result, the quantity of pizza demanded is greater for each of the prices shown.
34.	a	The movement from A to C is explained by one and only one thing: a change in price. The (quantity demanded, price) combination at A is different from that at C, but the movement from A to C is explained by a change in only one variable: price.
35.	С	A shift of the demand curve is caused by a change in something other than price, such as a change in income. For each price, the quantity of pizza demanded is less than it was before.
36.	a	An upward-sloping line shows that the relationship between two variables is positive, that is, the variables change in the same direction.
37.	b	As you move upward along the curve, the value of the slope decreases. The slope between g and h is greater than the slope between i and j .
38.	b	This is the formula for computing a percentage change or a growth rate.
39.	b	You are computing the area of a triangle, which is $\frac{1}{2} \times \text{Base} \times \text{Height}$.
40.	b	Total revenue equals price \times quantity, which is the area of the rectangle (Base \times Height).
41.	d	The area of the triangle is $\frac{1}{2} \times (150,000 - 125,000) \times (\$2.00 - \$1.50) = \$6,250$.

Question Answer Comment

42. The area of the rectangle is equal to $2.00/can \times 125,000 cans = 250,000$, which is 250,000 in total revenue.

Short Answer Responses

- 1. Economists distinguish financial capital and physical capital because only physical capital (for example, machinery, tools, and buildings) is a productive resource. Financial capital includes stocks, bonds, and holdings of money. Financial capital is not part of a country's capital stock, because financial capital does not produce output.
- 2. Productive efficiency is the situation in which a good or service is produced at the lowest possible cost. Allocative efficiency is a state of the economy in which production reflects consumer preferences: every good or service is produced to the point at which the last unit provides a marginal benefit to consumers equal to the marginal cost of producing it.
- 3. Economics, unlike physics and chemistry, is a social science because it applies the use of models and hypothesis testing to the study of the interactions of people.
- 4. Positive statements are statements of facts, or statements that can be proven to be correct or incorrect. For example: "Abraham Lincoln was the fifteenth president of the United States." (This is a false statement—Lincoln was the sixteenth president—but it is still a positive statement.) A normative statement is an opinion or a statement of what should or ought to be. For example: "The United States should elect a female as president of the United States."
- 5. In economics, people are rational when they weigh the benefits and costs of each action, and they choose an action only if its benefits outweigh its costs. The benefits do not necessarily have monetary values. Even though Mia could earn more income by working instead of serving as a volunteer, she probably enjoys volunteering more. Also, the enjoyment that Mia probably receives from donating money and helping others probably exceeds the monetary values of her donations.

True/False Answers

Question	Answer	Comment
1.	F	A hypothesis is a testable statement about how the world is.
2.	T	In economics, scarcity is a basic fact of life for all people.
3.	F	Economists believe people respond to incentives, but incentives may be monetary or nonmonetary.
4.	F	The distribution of goods and services is determined by the government, so goods and services may or may not be distributed equally.
5.	F	People differ on what they believe is equitable or fair.
6.	F	A mixed economy is one in which the government's influence on the choices of buyers and sellers is greater than in a market economy.
7.	F	All economies, including market economies and centrally planned economies, face trade-offs due to scarce resources.
8.	F	People are rational when they use all available information to achieve their goals and compare benefits and costs of each action. They do not necessarily consider the benefits to society as a whole.

Question	Answer	Comment
9.	T	The high number of business bankruptcies and high level of unemployment
		during the Great Depression resulted in greater government intervention.
		See the section titled "The Modern 'Mixed' Economy" on page 10 in the textbook.
10.	F	Economists would use positive economic analysis to address this issue.
11.	T	This is the definition of microeconomics.
12.	T	A straight line has a constant slope.
13.	F	The slope of a point on a nonlinear curve is measured by the slope of a
		tangent to the curve at that point.
14.	T	That all societies must make choices about how to use their scarce resources is a fundamental assumption of economics.
15.	F	Economic models provide a foundation to analyze both simplistic and complicated economic situations.

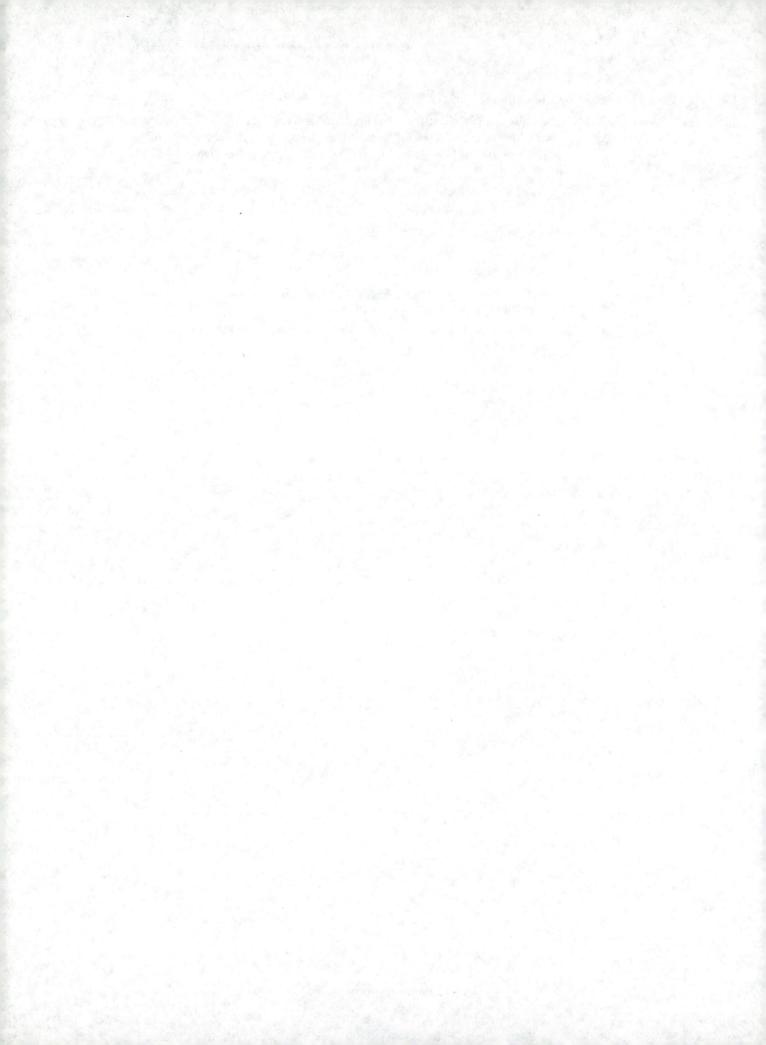

CHAPTER 2 | Trade-offs, Comparative Advantage, and the Market System

Chapter Summary and Learning Objectives

2.1 Production Possibilities Frontiers and Opportunity Costs (pages 38–43)

Use a production possibilities frontier to analyze opportunity costs and trade-offs. The production possibilities frontier (PPF) is a curve that shows the maximum attainable combinations of two products that may be produced with available resources. The PPF is used to illustrate the trade-offs that arise from scarcity. Points on the frontier are technically efficient. Points inside the frontier are inefficient, and points outside the frontier are unattainable. The opportunity cost of any activity is the highest-valued alternative that must be given up to engage in that activity. Because of increasing marginal opportunity costs, PPFs are usually bowed out rather than straight lines. This illustrates the important economic concept that the more resources that are already devoted to any activity, the smaller the payoff from devoting additional resources to that activity is likely to be. Economic growth is illustrated by shifting a PPF outward.

2.2 **Comparative Advantage and Trade (pages 43–49)**

Understand comparative advantage and explain how it is the basis for trade. Fundamentally, markets are about trade, which is the act of buying or selling. People trade on the basis of comparative advantage. An individual, a firm, or a country has a comparative advantage in producing a good or service if it can produce the good or service at the lowest opportunity cost. People are usually better off specializing in the activity for which they have a comparative advantage and trading for the other goods and services they need. It is important not to confuse comparative advantage with absolute advantage. An individual, a firm, or a country has an absolute advantage in producing a good or service if it can produce more of that good or service from the same amount of resources. It is possible to have an absolute advantage in producing a good or service without having a comparative advantage.

The Market System (pages 50–58) 2.3

Explain the basic idea of how a market system works. A market is a group of buyers and sellers of a good or service and the institution or arrangement by which they come together to trade. Product markets are markets for goods and services, such as computers and medical treatment. Factor markets are markets for the factors of production, such as labor, capital, natural resources, and entrepreneurial ability. A circular-flow diagram shows how participants in product markets and factor markets are linked. Adam Smith argued in his 1776 book The Wealth of Nations that in a free market, where the government does not control the production of goods and services, changes in prices lead firms to produce the goods and services most desired by consumers. If consumers demand more of a good, its price will rise. Firms respond to rising prices by increasing production. If consumers demand less of a good, its price will fall. Firms respond to falling prices by producing less of a good. An entrepreneur is someone who operates a business. In the market system, entrepreneurs are responsible for organizing the production of goods and services. The market system will work well only if there is protection for property rights, which are the rights of individuals and firms to use their property.

Chapter Review

Chapter Opener: Managers at Tesla Motors Face Trade-Offs (page 37)

Tesla Motors is an electric car manufacturer. The company's mangers must make decisions regarding the production and marketing of their vehicles. One of those decisions is the introduction of new car models. After receiving an award for World Green Car in 2013, Tesla introduced the model X, a cross between a sports utility vehicle (SUV) and a minivan, to attract families who would otherwise buy traditional gasoline powered SUVs or minivans. Another company decision is how to sell and service its cars. Rather than selling their vehicles through dealerships, which also provide service for the cars they sell, Tesla has decided to sell all of its cars online and relied on company-owned service centers to provide services for its customers.

2.1

Production Possibilities Frontiers and Opportunity Costs (pages 38–43) Learning Objective: Use a production possibilities frontier to analyze opportunity costs and trade-offs.

Scarcity exists because we have unlimited wants but only limited resources available to fulfill those wants. This scarcity requires that we make decisions about how to use our resources. In other words, we face trade-offs. A **production possibilities frontier** (*PPF*) is a curve showing the maximum alternative combinations of two products that may be produced with available resources. A *PPF* is a graphical representation of the trade-offs and opportunity costs a producer faces. As shown in Figure 2.1, points on a *PPF* are efficient, while points under the *PPF* are inefficient. Points beyond the *PPF* are unattainable with current resources. A *PPF* will always have a negative slope because increasing production requires shifting resources away from one activity toward the second activity.

The slope of a PPF is used to measure the opportunity cost of increasing the production of one good along the frontier relative to the other good. The slope of a linear frontier and the opportunity cost of moving along the frontier are constant, but convex or "bowed out" production possibilities frontiers represent a more likely outcome. A convex PPF means marginal opportunity costs rise as more and more of one good is produced. For example, starting from point A in Figure 2.2 and moving downward to points B and C, the slope of the frontier becomes steeper and steeper. This means that the cost of producing one more automobile (the number of tanks that must be given up as resources are transferred to automobile production) is greater at each point.

Along a production possibilities frontier, resources and technology are fixed. If there is an increase in the available resources or an improvement in the technology used to produce goods and services, then the *PPF* will shift outward. The economy will be able to produce more goods and services, which means the economy has experienced economic growth. **Economic growth** is the ability of the economy to increase the production of goods and services. Growth may lead to greater increases in production of one good than another.

Study Hint

Solved Problem 2.1 will help you draw a *PPF* and understand how a linear *PPF* illustrates opportunity costs incurred in production. Be sure you understand how slope is measured along the frontier and that the magnitude of this slope represents the opportunity cost of substituting the production of one good for the production of another.

2.2

Comparative Advantage and Trade (pages 43-49)

Learning Objective: Understand comparative advantage and explain how it is the basis for trade.

By specializing in production and engaging in trade, individuals can enjoy a higher standard of living than would be possible if these individuals produced everything they consumed. Specialization in production is so common that most people take for granted that they must trade income earned from their own labor to buy the services of plumbers, carpenters, medical doctors, and stock brokers. Specialization makes trade necessary. **Trade** is the act of buying or selling.

Absolute advantage is the ability of an individual, firm, or country to produce more of a good or service than competitors using the same amount of resources. Comparative advantage is the ability of an individual, firm, or country to produce a good or service at a lower opportunity cost than other producers. An individual country should specialize in the production of the good or services in which it has a comparative advantage, and then trade this good to other countries for goods in which it does not have a comparative advantage. *Making the Connection* "Comparative Advantage, Opportunity Cost, and Housework" describes the choice married couples make in dividing up their time for housework. Today, married women spend about half the time doing housework as in the 1960s, while married men spend more than twice the time. The decline in the number of hours women devote to housework reflects the greater job opportunities available to women and the raising wages for women relative to men. As a reason, the opportunity cost for women to spend time on housework has increased.

Study Hint

Don't Let This Happen to You clarifies the differences between absolute and comparative advantage. An individual, firm, or a country has the absolute advantage in the production of a good if that individual, firm, or country can produce more of the good. Comparative advantage in the production of a good goes to the individual, firm, or country that can produce the good at a lower opportunity cost. It is possible for an individual, firm, or country to have absolute advantage in the production of both goods, but the country will have a comparative advantage in the production of only one of the two goods.

Solved Problem 2.2 describes the benefits realized when a nation specializes in the production of a good for which it has a comparative advantage. In the problem, the United States has a comparative advantage in producing honey, while Canada has a comparative advantage in producing maple syrup. Each country should specialize in producing the good for which it has a comparative advantage and trade some of that good for the other good. With trade, the United States and Canada can consume outside of their *PPFs*.

Most examples of absolute and comparative advantage are similar to the hypothetical examples in section 2.2 of the textbook. This is due, in part, to the difficulty of identifying people who have an absolute advantage in two different areas. But the career of Babe Ruth offers a good example of someone with an absolute advantage in two activities who was still ultimately better off specializing in the activity in which he had a comparative advantage. Before he achieved his greatest fame as a home run hitter and outfielder with the New York Yankees, Ruth was a star pitcher with the Boston Red Sox. Ruth may have been the best left-handed pitcher in the American League during his years with Boston (1914–1919), but he was used more and more as a fielder in his last two years with the team. In fact, he established a record for home runs in a season (29) in 1919 when he was still pitching. The Yankees acquired Ruth in 1920

and made him a full-time outfielder. The opportunity cost of this decision for the Yankees was the wins Ruth could have earned as a pitcher. But because New York already had skilled pitchers, the opportunity cost of replacing Ruth as a pitcher was lower than the cost of replacing him as a hitter. No one else on the Yankees could have hit 54 home runs, Ruth's total in 1920; the next highest Yankee total was 11. It can be argued that Ruth had an absolute advantage as both a hitter and pitcher in 1920 but a comparative advantage only as a hitter.

2.3

The Market System (pages 50-58)

Learning Objective: Explain the basic idea of how a market system works.

A market is a group of buyers and sellers of a good or service and the institution or arrangement by which they come together to trade. **Product markets** are markets for goods, such as computers, and services, such as medical treatment. **Factor markets** are markets for the factors of production, such as labor, capital, natural resources, and entrepreneurial ability. A **circular-flow diagram** is a model that illustrates how participants in markets are linked. The diagram demonstrates the interaction between firms and households in both product and factor markets. Households buy goods and services in the product market and provide resources for sale in the factor market, while firms provide goods and services in the product market and buy resources in the factor market. A **free market** is a market with few government restrictions on how a good or service can be produced or sold, or on how a factor of production can be employed.

Entrepreneurs are an essential part of a market economy. An **entrepreneur** is someone who operates a business, bringing together the factors of production—labor, capital, and natural resources—to produce goods and services. Entrepreneurs often risk their own funds to start businesses and organize factors of production to produce those goods and services consumers want.

The role of government in a market system is limited but essential. Although government in a market economy imposes few restrictions on the choices made by consumers, resource owners, and firms, government protection of private property rights is necessary for markets to operate efficiently.

Property rights are the rights individuals or firms have to the exclusive use of their physical and intellectual property, including the right to buy or sell it. New technology has created challenges to the protection of property rights. Unauthorized copying of music and other intellectual property in cyberspace reduces the rewards of creativity and may reduce the amount of such activity in the future.

Study Hint

Consumers seldom know the identity of the people who produce the products they buy. The impersonal and decentralized character of markets is illustrated very well by the discussion of the production of Apple's iPad found in *Making the Connection* "A Story of the Market System in Action: How Do You Make an iPad?" The iPad contains many components. Many of the manufacturers of the components of the iPad do not know what the final product will be. No one person at Apple knows how to produce all of these components, so Apple relies heavily on its suppliers.

The role of government in a free market economy can be compared to that of an umpire or referee in a sporting event. The most vocal critics of these officials would argue they are needed. It would not take long for a professional football or baseball game to turn into a shouting match (or worse!) if players were allowed to enforce the rules of their own games. However, the quality of sporting events suffers when officials bar players, coaches, or managers from participating in contests for frivolous reasons.

The stories of successful businesses such as Microsoft and Google can give a misleading impression about the risks of business ownership. Many businesses fail. The National Restaurant Association

estimates an 80 percent failure rate for independently owned restaurants within their first two years of operation. The average work week for many small business owners is much longer than that of the average employee—80 hours is not uncommon—and owners often borrow heavily to start and maintain their businesses.

Patents and copyrights provide entrepreneurs economic incentives to introduce new products. However, *Making the Connection* "Who Owns *The Wizard of Oz*" points out that the roadblocks created by Warner Brothers, which now owns the copyright of the film *The Wizard of Oz*, can deter other companies from producing new films that might infringe on a copyrighted work.

Extra Solved Problem 2.3

Adam Smith's "Invisible Hand"

Supports Learning Objective 2.3: Explain the basic idea of how a market system works.

Alan Krueger, an economist at Princeton University, has argued that Adam Smith was concerned that the invisible hand would not function properly if merchants and manufacturers sought the government to issue regulations to help them.

Source: Alan B. Krueger, "Rediscovering the Wealth of Nations," New York Times, August 16, 2001.

- a. What types of regulation might merchants and manufacturers seek from the government?
- b. How might these regulations keep the invisible hand from working?

Solving the Problem

Step 1: Review the chapter material.

This problem concerns how goods and services are produced and sold and how factors of production are employed in a free market economic system as described by Adam Smith in *An Inquiry into the Nature and Causes of the Wealth of Nations*. You may want to review the section "The Gains from Free Markets," which begins on page 52.

- Answer question (a) by noting the economic system in place in Europe in 1776.

 At the time, governments gave guilds—associations of producers—the authority to control production. The production controls limited the amount of output of goods such as shoes and clothing, as well as the number of producers of these items. Limiting production and competition led to higher prices and fewer choices for consumers. Instead of catering to the wants of consumers, producers sought the favor of government officials.
- Step 3: Answer question (b) by contrasting the behavior of merchants and manufacturers under a guild system and under a market system.

Because governments gave producers the power to control production, producers did not have to respond to consumers' demands for better quality, variety, and lower prices. Under a market system, producers who sell poor quality goods at high prices suffer economic losses; producers who provide better quality goods at low prices are rewarded with profits. Therefore, it is in the self-interest of producers to address consumer wants. This is how the invisible hand works in a free market economy but not in Europe in the eighteenth century.

Key Terms

Absolute advantage The ability of an individual, a firm, or a country to produce more of a good or service than competitors, using the same amount of resources.

Circular-flow diagram A model that illustrates how participants in markets are linked.

Comparative advantage The ability of an individual, a firm, or a country to produce a good or service at a lower opportunity cost than competitors.

Economic growth The ability of the economy to increase the production of goods and services.

Entrepreneur Someone who operates a business, bringing together the factors of production—labor, capital, and natural resources—to produce goods and services.

Factor markets A market for the factors of production, such as labor, capital, natural resources, and entrepreneurial ability.

Factors of production The inputs used to make goods and services.

Free market A market with few government restrictions on how a good or service can be produced or sold or on how a factor of production can be employed.

Market A group of buyers and sellers of a good or service and the institution or arrangement by which they come together to trade.

Opportunity cost The highest-valued alternative that must be given up to engage in an activity.

Product markets A market for goods—such as computers—and services—such as medical treatment.

Production possibilities frontier (PPF)

A curve showing the maximum attainable combinations of two products that may be produced with available resources and current technology.

Property rights The rights individuals or firms have to the exclusive use of their property, including the right to buy or sell it.

Scarcity A situation in which unlimited wants exceed the limited resources available to fulfill those wants.

Trade The act of buying and selling.

Self-Test

(Answers are provided at the end of the Self-Test.)

Multiple-Choice Questions

- 1. What is the term for the highest-valued alternative that must be given up to engage in any activity?
 - a. scarcity
 - b. the production possibilities frontier
 - c. opportunity cost
 - d. a trade-off
- 2. What happens if a country produces a combination of goods that uses all of the resources available in the economy?
 - a. The country is operating on its production possibilities frontier.
 - b. The country is maximizing its opportunity cost.
 - c. The country has eliminated scarcity.
 - d. All of the above occur if a country uses all available resources.
- 3. Refer to the graph below. Which of the following combinations is unattainable with the current resources available in this economy?

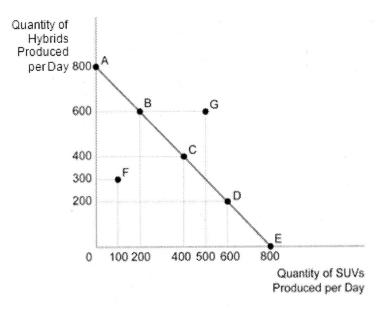

- a. combination G
- b. combination F
- c. combinations A or E
- d. None of the combinations above can be attained with current resources.

4. Refer to the graph below. Which of the following combinations is inefficient?

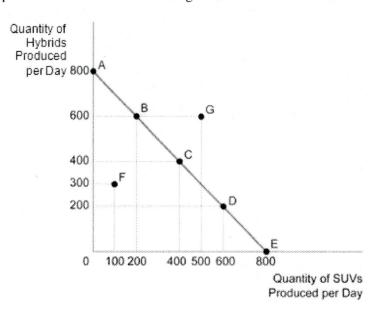

- a. combination G
- b. combination F
- c. combinations A or E
- d. both F and G
- 5. Refer to the graph below. Which of the following best represents the situation in which BMW *must* face a trade-off between producing SUVs and producing hybrids?

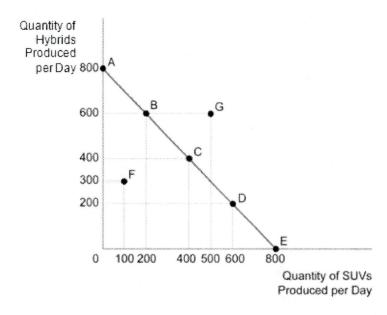

- a. any point on the graph represents that trade-off
- b. moving from B to C
- c. moving from F to B
- d. moving from C to G

6. Refer to the graph below. How many hybrids are produced at the point where BMW produces 800 SUVs?

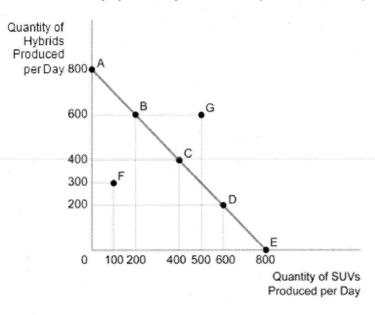

- a. 0
- b. any amount up to 800
- c. exactly 800
- d. 400
- 7. Refer to the graph below. What is the opportunity cost of moving from point B to point C?

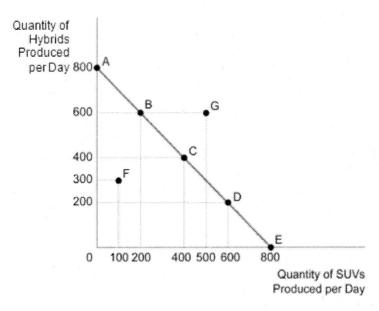

- a. 200 SUVs
- b. 400 SUVs
- c. 200 hybrids
- d. 400 hybrids

8. Refer to the graph below. What is the opportunity cost of switching from Choice D to Choice E?

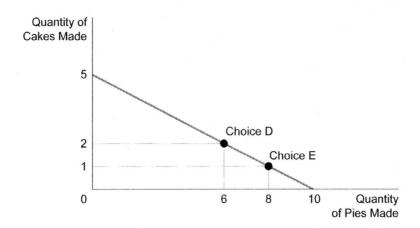

- a. two pies
- b. eight pies
- c. two cakes
- d. one cake
- 9. Refer to the graph below. In this problem, what is the opportunity cost of producing five cakes?

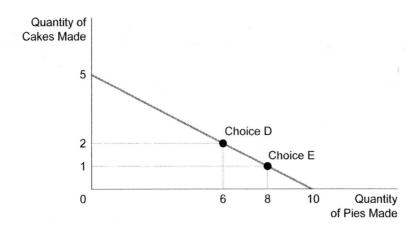

- a. zero cakes
- b. zero pies
- c. ten pies
- d. There is insufficient information to answer the question.

10. Refer to the graph below. Which of the following combinations of pies and cakes is unattainable given existing resources?

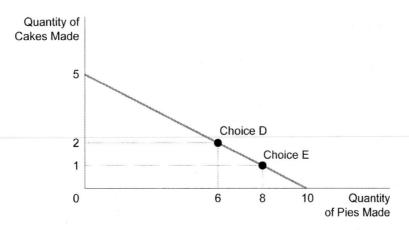

- a. two cakes and six pies
- b. one cake and seven pies
- c. zero cakes and ten pies
- d. four cakes and seven pies
- 11. Refer to the graph below. As you move from point A to point B and then to point C on this graph, what happens to the marginal opportunity cost?

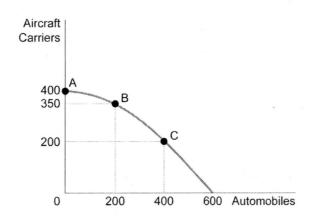

- a. It increases.
- b. It decreases.
- c. It remains constant.
- d. It equals zero.

12. Refer to the graph below. What is the opportunity cost of producing 400 aircraft carriers?

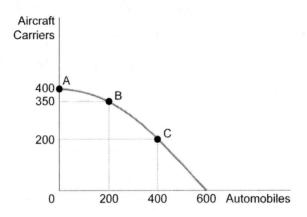

- a. 200 automobiles
- b. 50 aircraft carriers
- c. 200 automobiles
- d. 600 automobiles
- 13. Refer to the graph below. What is the opportunity cost of moving from point B to point C?

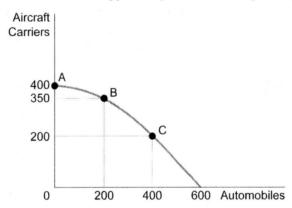

- a. 200 automobiles
- b. 400 automobiles
- c. 50 aircraft carriers
- d. 150 aircraft carriers

14. Refer to the graph below. What does the term "increasing marginal opportunity cost" mean in this graph?

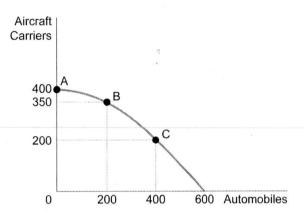

- a. There is a higher opportunity cost of producing either aircraft carriers or automobiles, so long as the quantity produced of that good is decreasing.
- b. There is a higher opportunity cost of producing either aircraft carriers or automobiles, so long as the quantity produced of that good is increasing.
- c. Increasing the production of aircraft carriers results in higher automobile production costs, such as the costs of labor and capital to build automobiles.
- d. Increasing the production of either aircraft carriers or automobiles creates more opportunities in the economy.
- 15. If the opportunity cost of producing one good increases as more of that good is produced, then
 - a. the production possibility frontier is linear.
 - b. the production possibility frontier is bowed out.
 - c. the production possibility frontier does not exist.
 - d. the production possibility frontier has a positive slope.
- 16. The principle of increasing marginal opportunity cost states that the more resources devoted to any activity, the the payoff to devoting additional resources to that activity.
 - a. smaller
 - b. greater
 - c. proportional
 - d. more instant

17. Refer to the graphs below. Which graph better represents an improvement only in the technology used to make automobiles?

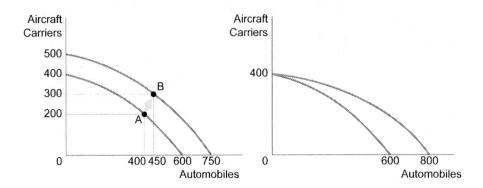

- a. the graph on the left
- b. the graph on the right
- c. both graphs
- d. neither graph
- 18. Refer to the graphs below. Which graph best represents the concept of economic growth?

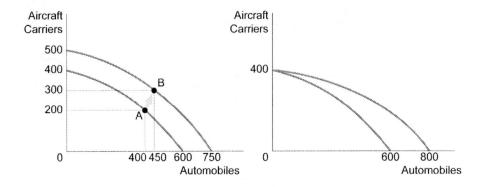

- a. the graph on the left
- b. the graph on the right
- c. both graphs
- d. neither graph

19. Refer to the graphs below. Which of the following could have caused the outward shift of the curve in the graph on the left side?

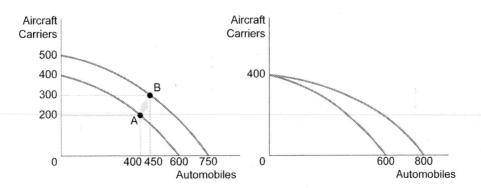

- a. an increase in technology that affects the production of both aircraft carriers and automobiles
- b. technological change that affects only the aircraft carrier industry
- c. unemployment in the economy
- d. a change in the cost of producing automobiles
- 20. Which of the following would create economic growth, that is, shift the production possibilities frontier outward?
 - a. an increase in the available labor
 - b. an increase in technology that affects the production of both goods
 - c. an increase in the available natural resources
 - d. all of the above
- 21. Which of the following statements is most consistent with the principle about the basis for international trade?
 - a. The United States would be better off being self-sufficient because it has an absolute advantage in producing most goods.
 - b. The United States would be better off if it specialized in the production of some goods, and then traded some of them to other countries.
 - c. The United States would be better off by producing at home the goods that it now imports—that way the nation can generate additional jobs here at home.
 - d. The United States can never have an absolute advantage in producing every good it consumes, so it would be better off if it imported goods that it does not have an absolute advantage.
- 22. Absolute advantage is the ability of an individual, firm, or country to
 - a. produce more of a good or service than competitors using the same amount of resources.
 - b. produce a good or service at a lower opportunity cost than other producers.
 - c. consume more goods or services than others at lower costs.
 - d. reach a higher production possibilities frontier by lowering opportunity costs.
- 23. If a country has a comparative advantage in the production of a good, then that country
 - a. also has an absolute advantage in producing that good.
 - b. should allow another country to specialize in the production of that good.
 - c. has a lower opportunity cost in the production of that good.
 - d. All of the above are true.

24. Refer to the graphs below. Each graph represents one country. Which country has a comparative advantage in the production of shirts?

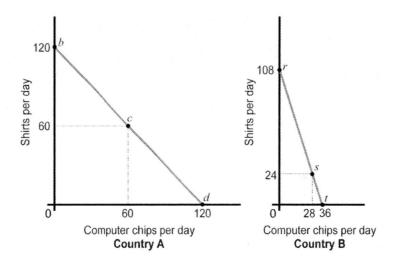

- a. Country A
- b. Country B
- c. neither country
- d. both countries
- 25. Refer to the graphs below. Each graph represents one country. Which country should specialize in the production of computer chips?

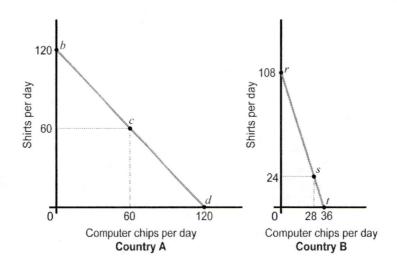

- a. Country A
- b. Country B
- c. Neither country; they both should produce some computer chips and some shirts.
- d. Both countries should specialize in the production of computer chips.

26. The table below shows the quantity of two goods that a worker in Country A and a worker in Country B can produce per day. Which country has an absolute advantage in the production of each good?

	Output per day of work	
	Food	Clothing
Country A	6	3
Country B	1	2

- a. Country A has an absolute advantage in the production of each good.
- b. Country B has an absolute advantage in the production of each good.
- c. Both countries have an absolute advantage in the production of each good.
- d. Neither country has an absolute advantage in the production of each good.
- 27. Consider the table below. Which country has a comparative advantage in the production of each good?

	Output per day of work	
	Food	Clothing
Country A	6	3
Country B	1	2

- a. Country A has a comparative advantage in the production of both goods.
- b. Country B has a comparative advantage in the production of both goods.
- c. Country A has a comparative advantage in the production of food; Country B has a comparative advantage in the production of clothing.
- d. Country B has a comparative advantage in the production of food; Country A has a comparative advantage in the production of clothing.
- 28. Consider the table below. What is country A's opportunity cost of producing 1 unit of clothing?

	Output per day of work		
	Food	Clothing	
Country A	6	3	
Country B	1	2	

- a. 2 units of food
- b. 1/2 a unit of food
- c. 6 units of food
- d. 2 units of clothing

29. Refer to the graphs below. If you have a comparative advantage in the production of apples, what point would best represent your production with trade?

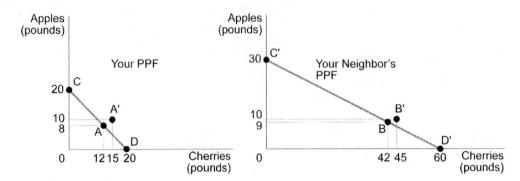

- a. A
- b. A'
- c. C
- d. D
- 30. Refer to the graphs below. What is point B' on your neighbor's PPF curve?

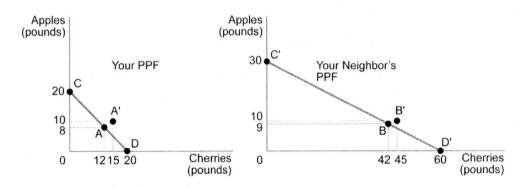

- a. Point B' is your neighbor's production before trade.
- b. Point B' is your neighbor's consumption before trade.
- c. Point B' is your neighbor's production after trade.
- d. Point B' is your neighbor's consumption after trade.
- 31. Which of the following refers to markets where goods such as computers or services such as medical treatment are offered?
 - a. product markets
 - b. essential markets
 - c. factor markets
 - d. competitive markets
- 32. In which markets are factors of production, such as labor, capital, natural resources, and entrepreneurial ability traded?
 - a. product markets
 - b. essential markets
 - c. factor markets
 - d. competitive markets

- 33. Which of the following comprises the two key groups of participants in the circular flow of income?
 - a. domestic residents and foreign residents
 - b. government and financial institutions
 - c. households and firms
 - d. savers and borrowers
- 34. Fill in the blanks. In a simple circular-flow model, there are flows of _____ and flows of
 - a. factors of production; goods and services
 - b. funds received from the sale of factors of production; spending on final goods and services
 - c. Both (a) and (b) are correct.
 - d. None of the above. Actually, there are no flows in the circular flow of income.

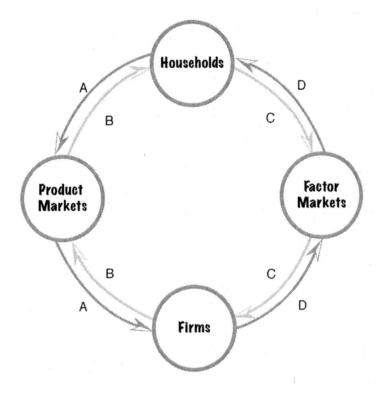

- 35. In the circular-flow diagram above, which arrow shows the flow of goods and services?
 - a. A
 - b. B
 - c. C
 - d. D
- 36. In the circular-flow diagram above, which arrow shows the flow of spending by households?
 - a. A
 - b. B
 - c. C
 - d. D

- 37. In the circular-flow diagram on the previous page, which arrow shows the flow of factors of production?
 - a. A
 - b. B
 - c. C
 - d. D
- 38. In the circular-flow diagram above, which two arrows show the flow of funds?
 - a. A and B
 - b. B and C
 - c. B and D
 - d. A and D
- 39. According to Adam Smith, which of the following is true?
 - Markets work because producers, aided by government, ensure that neither too many nor too few goods are produced.
 - b. Market prices can come to reflect the prices desired by all consumers.
 - c. Individuals usually act in a rational, self-interested way.
 - d. A guild system is the best way for coordinating the activities of buyers and sellers.
- 40. According to Adam Smith, which of the following is the instrument the invisible hand uses to direct economic activity?
 - a. price
 - b. government regulation
 - c. financial markets
 - d. cost
- 41. According to Adam Smith, which of the following is necessary for the proper functioning of the market system?
 - a. For markets to work, people should take into account how their decisions affect society as a whole.
 - b. For markets to work, government should help citizens make the right decisions.
 - c. For markets to work, people must be free to pursue their self-interest.
 - d. For markets to work, people and government need to coordinate their decisions.
- 42. What is the role of an entrepreneur?
 - a. to operate a business that produces a good or service
 - b. to bring together the factors of production—labor, capital, and natural resources
 - c. to take risks
 - d. all of the above
- 43. In a free market system, which of the following groups brings together the factors of production—labor, capital, and natural resources—in order to produce goods and services?
 - a. the government
 - b. entrepreneurs
 - c. lobbyists
 - d. politicians

- 44. Which of the following is critical to the success of a market system?
 - a. to allow individuals or firms to have exclusive use of their property
 - b. to prevent individuals from buying or selling their property depending on the circumstances
 - c. Both a. and b. are critical to the success of a market system.
 - d. to allow the government to determine the optimal use of private property
- 45. Generally speaking, for a market system to work, individuals must
 - a. be very cautious in their approach to saving and investment.
 - b. take risks and act in rational, self-interested ways.
 - c. be able to evaluate and understand all available options.
 - d. consult people who have experience.
- 46. What are copyrights designed to do?
 - a. prevent entrepreneurs from earning excessive profits
 - b. eliminate unnecessary duplication whenever it arises
 - c. protect intellectual property rights
 - d. all of the above
- 47. What is the outcome of enforcing contracts and property rights in a market system?
 - a. increased economic activity
 - b. decreased economic activity
 - c. no effect on economic activity
 - d. an unpredictable but definite effect on economic activity
- 48. In the United States, property rights
 - a. are guaranteed by two amendments to the U.S. Constitution.
 - b. are guaranteed by some state governments but not other state governments.
 - c. are prohibited by the federal government.
 - d. exist in markets but are not enforced by the government.
- 49. If a market system functions well, which of the following is necessary for the enforcement of contracts and property rights?
 - a. powerful political connections
 - b. an independent court system
 - c. action by government to prevent the exercise of certain property rights
 - d. all of the above

Short Answer Questions

Does the story about Apple's production of the iPad on page 53 in the textbook imply that people must cooperate with one another in order for specialization in production and trade to occur? Explain.
Comment briefly on the following statement: "The circular-flow diagram implies that households' spending on goods and services in product markets equals the income they earn from providing factors of production in factor markets."
Could a production possibilities frontier ever slope upward?
Provide an example showing that absolute advantage in an activity does not necessarily imply comparative advantage in an activity.
In the explanation of Adam Smith's argument in favor of replacing the guild system with a market system, the textbook states that "a key to understanding Smith's argument is the assumption that individuals usually act in a rational, self-interested way." Did Smith believe that the success of a market system requires that people act selfishly?

True/False Questions

- T F 1. In his book *An Inquiry into the Nature and Causes of the Wealth of Nations*, Adam Smith argued that a guild system was the most efficient way for a nation to coordinate the decisions of buyers and sellers.
- T F 2. The story about Apple's production of the iPad shows how production requires the coordinated activities of many people, spread around the world.
- T F 3. A nation with an absolute advantage in the production of two goods will usually have a comparative advantage in only one of the goods.
- T F 4. A production possibilities frontier that is bowed outward illustrates increasing marginal opportunity costs.
- T F 5. Technological advances always increase the production of all goods and services equally.
- T F 6. It is possible to have an absolute advantage in producing a good without having a comparative advantage.
- T F 7. Households are suppliers of the factors of production that are used by firms to produce goods and services.
- T F 8. The circular-flow diagram is used to explain why the opportunity cost of increasing the production of one good is the decrease in production of another good.
- T F 9. If property rights are not enforced by the government, then more goods and services will be produced in free markets.
- T F 10. Opportunity cost refers to the all of the alternatives that must be given up to engage in an activity.
- T F 11. An individual who has comparative advantage in producing a good must also have absolute advantage in producing that good.
- T F 12. Without regulations to protect property rights, there will be more incentives for entrepreneurs to introduce new products.
- T F 13. Because the governments of the United States, Canada, and Western European countries impose few restrictions on economic activity, the economies of these countries approximate free market economies.
- T F 14. People can increase their production and consumption by specializing in producing goods and services in which they have an absolute advantage.
- T F 15. The marginal opportunity cost along a linear (straight-line) production possibilities frontier is constant.

Answers to the Self-Test

Multiple-Choice Questions

Question Answer Comment 1. c Opportunity cost is the highest-valued alternative that must be given up to engage in an activity. Refer to page 39 in the textbook. 2. a The production possibilities frontier is a curve showing all the attainable combinations of two products that may be produced with available resources.

Question	Answer	Comment
3.	a	To produce the combination G, the economy needs more machines, more workers, or more of both. If the economy were to produce 600 hybrids with existing resources, then it could produce, at most, 200 SUVs.
4.	b	This combination is attainable but inefficient because not all resources are being used.
5.	b	A move along the curve shows the sacrifice associated with increasing the quantity of SUVs produced, which is the amount by which production of roadsters will have to be reduced.
6.	a	Point E describes this choice. Point E shows that 800 SUVs are produced when zero hybrids are produced.
7.	c a	As you move from point B to point C, the production of SUVs increases by 200. The opportunity cost of the increased production of SUVs is a decrease in the quantity of hybrids produced.
8.	d	As you move from D to E, the production of pies increases by 2 and the production of cakes decreases by 1.
9.	c	Opportunity cost is what you sacrifice. If Rosie produced 0 cakes, then Rosie could make 10 pies.
10.	d	Four cakes could be produced, but only with fewer than 6 pies. Choice D on the graph shows that a maximum of 2 cakes can be made with 6 pies.
11.	a	The opportunity cost associated with producing automobiles increases as more are produced. Refer to Figure 2.2 on page 42 in the textbook.
12.	d	Either the economy produces 400 aircraft carriers or it produces 600 automobiles with the same amount of resources.
13.	d	The economy now produces 400 automobiles instead of 200. To produce the additional 200 automobiles, the economy must decrease production of aircraft carriers by 150 (an opportunity cost $350 - 200 = 150$ aircraft carriers).
14.	b	As the economy moves along the production possibilities frontier, it experiences increasing marginal opportunity costs because increasing the production of one good by a given amount requires larger and larger decreases in the production of the other good.
15.	b	If the opportunity cost of producing one good increases as more of that good is produced, then the production possibilities frontier is bowed outward.
16.	a	This is the principle of increasing marginal opportunity cost.
17.	b	An improvement in the technology used to make automobiles causes a shift of the production possibilities frontier only along the horizontal axis.
18.	С	These graphs show an increase in the production of one or both goods. This increase in the productive capacity of the economy is referred to as economic growth.
19.	a	Economic growth is the ability of the economy to increase the production of goods and services.
20.	d	All of these factors create economic growth.
21.	b	Countries are better off if they specialize in the production of goods that they have a comparative advantage and trade some of them to other countries. Refer to the section entitled "Comparative Advantage and Trade" on page 43 in the textbook.

Question	Answer	Comment
22.	a	Absolute advantage is the ability of an individual, firm, or country to produce more of a good or service than competitors using the same amount of resources.
23.	c	The country with a lower opportunity cost of production has a comparative advantage in the production of that good.
24.	b	The opportunity costs are as follows: The opportunity cost of shirts is: 1 computer chip for Country A and 1/3 computer chip for Country B. The opportunity cost of computer chips is: 1 shirt for Country A and 3 shirts for Country B. Country B has a comparative advantage in the production of shirts because it sacrifices fewer computer chips to produce one shirt.
25.	a	The opportunity costs are as follows: The opportunity cost of shirts is: 1 computer chip for Country A and 1/3 computer chip for Country B. The opportunity cost of computer chips is: 1 shirt for Country A and 3 shirts for Country B. Therefore, Country A has a comparative advantage (or lower opportunity cost) in the production of computer chips because it sacrifices fewer shirts to produce one computer chip. Country A should produce computer chips.
26.	a	A worker in Country A can produce more food and more clothing in one day than a worker in Country B can.
27.	C :	A worker in Country A can produce 6 times as many units of food in one day as a worker in Country B, but only 1.5 as many units of clothing. Country A has a lower opportunity cost than Country B in the production of food, and Country B has a lower opportunity cost than Country A in the production of clothing.
28.	a	For Country A, the production of 3 units of clothing requires a sacrifice of 6 units of food. Therefore, each unit of clothing has an opportunity cost of 2 units of food.
29.	С	If you have a comparative advantage in the production of apples, then you would specialize entirely in the production of apples.
30.	d	After trade, you and your neighbor can consume more than you can produce.
31.	a	Goods and services are exchanged in product markets.
32.	С	Labor, capital, natural resources, and entrepreneurial ability are factors of production that are traded in factor markets.
33.	С	A household includes all the individuals in a home. Firms are suppliers of goods and services.
34.	c	In the circular flow of income, there are flows of funds and spending and also flows of factors of production and goods and services.
35.	b	Goods and services flow from firms to the households through the product market.
36.	a	Spending on goods and services flows from households to firms through the product market.
37.	c	Factors of production flow from households to the firms through the factor market.
38.	d	Arrow A shows the funds that households use to purchase goods and services from firms in product markets. Arrow D shows the funds that firms use to pay households for wages and other payments for factors of production in factor markets.
39.	С	Individuals usually act in a rational, self-interested way. Adam Smith understood that people's motives can be complex.
40.	a	Price represents both the value of the good to consumers and the cost (to producers) of making those goods.

Question	Answer	Comment
41.	c	Individuals usually act in a rational, self-interested way. When people act in their own self-interest, the right quantity of goods will be produced.
42.	d	The role of an entrepreneur is to operate a business and take risks in bringing together the factors of production—labor, capital, and natural resources—to produce goods and services.
43.	b	In a market system, entrepreneurs bring together the factors of production—labor, capital, and natural resources—to produce goods and services.
44.	a	The legal basis for a successful market is property rights. Property rights are the rights individuals or firms have to the exclusive use of their property, including the right to buy or sell it.
45.	b	Risk taking is an essential ingredient of entrepreneurship, and this risk taking is essential for the market system to function well.
46.	c	Property rights are very important in any modern economy. See page 56 in the textbook.
47.	a	Much business activity involves someone agreeing to carry out some action in the future. For a market to work, there must be property rights and enforceable contracts.
48.	a	Property rights in the United States are guaranteed by the Fifth and Fourteenth amendments to the U.S. Constitution.
49.	b	Independence and impartiality on the part of judges are very important.

Short Answer Responses

- Cooperation is essential for specialization and trade, but it is an impersonal cooperation. It is not
 necessary for business owners, workers, suppliers and consumers to know or see one another. In fact,
 many of these individuals can be located thousands of miles away from each other, live in different
 countries, and speak different languages. Their cooperation is due to their self-interest, not their
 regard for one another's welfare.
- 2. This is true. In the circular-flow diagram, households' spending for the goods and services they purchase is linked to the income they earn from providing factors of production. For household members to earn income to buy the goods and services they want, they must first sell their resource services to firms who purchase these services in factor markets. The market value of factor services determines the income resource owners receive.
- 3. No, production possibilities frontiers will always slope downward. Resources used in production are scarce, and increasing production of one good will always require a decrease in the production of another good along a production possibilities frontier. This means that the production possibilities frontiers always have a negative slope, or they are downward sloping.
- 4. Consider the following example: Student One can read 10 pages of psychology per day or 8 pages of economics per day, while Student Two can read 5 pages of psychology per day or 5 pages of economics per day. Student One has an absolute advantage in reading both psychology and economics; however, Student One's cost of reading 1 page of economics is 1.25 pages of psychology, and Student Two's cost of reading 1 page of economics is only 1 page of psychology.

5. Smith did not believe that self-interest was the sole motive, nor did he believe that self-interest was synonymous with selfishness. People are motivated by a broad range of factors, but when they buy and sell in markets, monetary rewards usually provide the most important motivation.

True/False Answers

Question	Answer	Comment
1.	F	Adam Smith explained the inefficiencies of the guild system and how markets were more efficient.
2.	T	See Making the Connection "A Story of the Market System in Action: How Do You Make an iPad?" on page 53 in the textbook.
3.	T	A nation can have the comparative advantage in the production of only one of the two goods.
4.	T	As the slope of the frontier becomes steeper, the opportunity cost of obtaining one more unit of one good increases.
5.	F	Technological advances often affect the production of some goods (those that use the advances most) more than others.
6.	T	Absolute advantage is about who produces more, while comparative advantage is about who produces the good at a lower opportunity cost.
7.	T	See the section titled "The Circular Flow of Income" starting on page 50 in the textbook.
8.	F	A production possibilities frontier, not the circular flow diagram, illustrates opportunity cost in production.
9.	F	For the market system to work properly, property rights must be enforced. Refer to page 56 in the textbook for a discussion of the importance of property rights.
10.	F	See the definition of opportunity cost on page 39 of the textbook.
11.	F	Comparative advantage involves production at the lowest cost, not necessarily the highest level of production overall.
12.	F	Property rights give entrepreneurs incentives to introduce new products.
13.	T	See page 52 in the textbook.
14.	F	Gains from specialization and trade occur when people specialize in producing what they have a comparative advantage, not an absolute advantage.
15.	T	The change in the opportunity cost per each additional unit of the good being produced—the marginal opportunity cost—is constant along a linear <i>PPF</i> .

CHAPTER 3

3 | Where Prices Come From: The Interaction of Demand and Supply

Chapter Summary and Learning Objectives

3.1 The Demand Side of the Market (pages 70–78)

Discuss the variables that influence demand. The model of demand and supply is the most powerful in economics. The model applies exactly only to perfectly competitive markets, where there are many buyers and sellers, all the products sold are identical, and there are no barriers to new sellers entering the market. But the model can also be useful in analyzing markets that don't meet all these requirements. The quantity demanded is the amount of a good or service that a consumer is willing and able to purchase at a given price. A demand schedule is a table that shows the relationship between the price of a product and the quantity of the product demanded. A demand curve is a graph that shows the relationship between the price of a good and the quantity of the good consumers are willing and able to buy over a period of time. Market demand is the demand by all consumers of a given good or service. The law of demand states that ceteris paribus—holding everything else constant—the quantity of a product demanded increases when the price falls and decreases when the price rises. Demand curves slope downward because of the substitution effect, which is the change in quantity demanded that results from a price change making one good more or less expensive relative to another good, and the income effect, which is the change in quantity demanded of a good that results from the effect of a change in the good's price on consumer purchasing power. Changes in income, the prices of related goods, tastes, population and demographics, and expected future prices all cause the demand curve to shift. Substitutes are goods that can be used for the same purpose. Complements are goods that are used together. A normal good is a good for which demand increases as income increases. An inferior good is a good for which demand decreases as income increases. Demographics are the characteristics of a population with respect to age, race, and gender. A change in demand refers to a shift of the demand curve. A change in quantity demanded refers to a movement along the demand curve as a result of a change in the product's price.

3.2 The Supply Side of the Market (pages 78–82)

Discuss the variables that influence supply. The quantity supplied is the amount of a good that a firm is willing and able to supply at a given price. A supply schedule is a table that shows the relationship between the price of a product and the quantity of the product supplied. A supply curve shows on a graph the relationship between the price of a product and the quantity of the product supplied. When the price of a product rises, producing the product is more profitable, and a greater amount will be supplied. The law of supply states that, holding everything else constant, the quantity of a product supplied increases when the price rises and decreases when the price falls. Changes in the prices of inputs, technology, the prices of substitutes in production, expected future prices, and the number of firms in a market all cause the supply curve to shift. Technological change is a positive or negative change in the ability of a firm to produce a given level of output with a given quantity of inputs. A change in supply refers to a shift of the supply curve. A change in quantity supplied refers to a movement along the supply curve as a result of a change in the product's price.

56

3.3 Market Equilibrium: Putting Demand and Supply Together (pages 82–85)

Use a graph to illustrate market equilibrium. Market equilibrium occurs where the demand curve intersects the supply curve. A competitive market equilibrium has a market equilibrium with many buyers and many sellers. Only at this point is the quantity demanded equal to the quantity supplied. Prices above equilibrium result in surpluses, with the quantity supplied being greater than the quantity demanded. Surpluses cause the market price to fall. Prices below equilibrium result in shortages, with the quantity demanded being greater than the quantity supplied. Shortages cause the market price to rise.

3.4 The Effect of Demand and Supply Shifts on Equilibrium (pages 85–91)

Use demand and supply graphs to predict changes in prices and quantities. In most markets, demand and supply curves shift frequently, causing changes in equilibrium prices and quantities. Over time, if demand increases more than supply, equilibrium price will rise. If supply increases more than demand, equilibrium price will fall.

Chapter Review

Chapter Opener: Smartphones: The Indispensable Product? (page 69)

About 10 years ago, the BlackBerry was the only widely used smartphone. Apple introduced the iPhone in 2007. Today, although Apple still has a commanding share of the smartphone market, competition from other manufacturers, such as Samsung, Nokia, HTC, LG, and Huawei, has become very intene. Market competition leads to increases in product choices and decreases in prices for consumers.

3.1

The Demand Side of the Market (pages 70–78)

Learning Objective: Discuss the variables that influence demand.

Although many factors influence the willingness and ability of consumers to buy a particular product, the main influence on consumer decisions is the product's price. The **quantity demanded** of a good or service is the amount that a consumer is willing and able to purchase at a given price. A **demand schedule** is a table showing the relationship between the price of a product and the quantity of the product demanded. A **demand curve** shows this same relationship in a graph. Because quantity demanded always increases in response to a decrease in price, this relationship is called the **law of demand**. The law of demand is explained by the substitution and income effects. The **substitution effect** is the change in the quantity demanded of a good that results from a change in price, making the good more or less expensive relative to other goods that are substitutes. The **income effect** is the change in the quantity demanded of a good that results from the effect of a change in the good's price on consumer purchasing power.

Ceteris paribus ("all else equal") is the requirement that when analyzing the relationship between two variables—such as price and quantity demanded—other variables must be held constant. When one of the nonprice factors that influence demand changes, the result is a shift in the demand curve—an increase or decrease in demand. The most important nonprice factors that influence demand are prices of related goods (substitutes and complements), income, tastes, population and demographics, and expected future prices.

The income that consumers have available to spend affects their willingness to buy a good. A **normal good** is a good for which demand increases as income rises and decreases as income falls. An **inferior good** is a good for which demand increases as income falls and decreases as income rises. When consumers' tastes for a product increase, the demand curve for the product will shift to the right, and when consumers' tastes for a product decrease, the demand curve for the product will shift to the left.

Making the Connection "Are Tablet Computers Substitutes for E-Readers?" points out that we can use a smartphone computer to read e-books, but tablet computers and not perfect substitutes for e-readers. Tablet computers have higher prices, are typically heavier and display text less sharply than e-readers. However, consumers consider the two products close substitutes, and the sales of e-readers have fallen substantially.

Substitutes are goods and services that can be used for the same purpose, while complements are goods that are used together. A decrease in the price of a substitute for a good, such as a tablet computer, causes the quantity demanded of the substitute, such as a laptop computer, to increase (a move along the demand curve for laptop computers), which causes the demand for tablet computers to fall. A fall in demand means that the demand curve for tablet computers will shift to the left. An increase in the price of laptop computers causes the quantity of laptop computers demanded to decrease, shifting the demand curve for tablet computers to the right. Changes in prices of complements have the opposite effect. A decrease in the price of a complement for smartphones causes the quantity demanded of the complement, say an "app," to increase, shifting the demand curve for smartphones to the right. An increase in the price of "apps" causes the quantity of "apps" demanded to decrease, shifting the demand curve for smartphones to the left.

As population increases, the demand for most products increases. **Demographics** are the characteristics of a population with respect to age, race, and gender. As demographics change, the demand for particular goods will increase or decrease because as different demographic groups become more prevalent in the population their unique preferences will become more prevalent in the market. If enough consumers become convinced that a good will be selling for a lower price in the near future, then the demand for the good will decrease in the present. If enough consumers become convinced that the price of a good will be higher in the near future, then the demand for the good will increase in the present. *Making the Connection* "Coke and Pepsi Are Hit by U.S. Demographics" explains the reasons for the declining sales of soft drinks in the United States. One reason is that the average age of the U.S. population is increasing. Yet even younger consumers are now more likely to buy energy drinks, water, or coffee than past generations partly because of increased publicity about the potential health problems with drinking soda.

Study Hint

People often confuse a change in quantity demanded with a change in demand. When the price of a good or service changes, it can cause changes in the quantity demanded of that good or service. This change is described as a movement along a demand curve. Notice that the price of the good or service is on the vertical axis. Changes in demand result in shifts of the demand curve and are caused by changes in factors other than the price of the good itself. Be careful about how these terms are used. When demand increases (shifts to the right), we do not say that there has been an increase in the quantity demanded. Rather, we say there has been an increase in demand. If there is an increase in the quantity demanded, the cause of that would be a decrease in the price, and the increase in quantity demanded would be shown as a movement along the demand curve, not a shift.

Take time to study Figure 3.3, which shows the difference between a change in demand and a change in quantity demanded. Also take time to study Table 3.1, which lists all the variables that shift market demand curves.

Extra Solved Problem 3.1

Supports Learning Objective 3.1: Discuss the variables that influence demand.

Suppose that Justin needs to buy an automobile. Justin has decided to purchase a new Toyota Prius. Justin's neighbor tells him that Toyota will be offering a \$3,500 rebate on all its automobiles starting next month.

- a. Assuming that Justin can wait until next month to buy an automobile, what effect will the rebate have on Justin's demand for a Prius?
- b. Which of the variables that influence demand would explain Justin's change in demand?

Solving the Problem

- Step 1: Review the chapter material.
 - This problem is about variables that shift market demand, so you may want to review the section "Variables That Shift Market Demand," which begins on page 72 in the textbook.
- Step 2: Answer question (a) by considering how a rebate that begins next month will affect Justin's current demand for the Toyota Prius.

 Justin's demand for the Toyota Prius will decrease now and increase next month as he will
 - wait to make his purchase in order to take advantage of the rebate.
- Step 3: Answer question (b) by determining which variable has affected Justin's demand for the Prius.
 - Other things being equal, as the expected future price of the Prius falls, the demand for Priuses will fall in the present time period.

3.2 Th

The Supply Side of the Market (pages 78–82)

Learning Objective: Discuss the variables that influence supply.

Many variables influence the willingness and ability of firms to sell a good or service. The most important of these variables is the price of the good or service. **Quantity supplied** is the amount of a good or service that a firm is willing to sell at a given price. A **supply schedule** is a table that shows the relationship between the price of a product and the quantity of the product supplied. A **supply curve** shows this same relationship in a graph. The **law of supply** states that, holding everything else constant, increases in the price of the good or service cause increases in the quantity supplied, and decreases in the price of the good or service cause decreases in the quantity supplied.

Variables other than the price of the product affect supply. When any of these variables change, a shift in supply—an increase or a decrease in supply—results. The following are the most important variables that shift supply: prices of inputs used in production, technological change, prices of substitutes in production, expected future prices, and the number of firms in the market.

If the price of an input (for example, labor or energy) used to produce a good rises, the supply of the good will decrease, and the supply curve will shift to the left. If the price of an input decreases, the supply of the good will increase, and the supply curve will shift to the right. **Technological change** is a positive or negative change in the ability of a firm to produce a given level of output with a given amount of inputs. A positive technological change will shift a firm's supply curve to the right, while a negative technological change will shift a firm's supply curve to the left.

An increase in the price of an alternative good (B) that a firm could produce instead of producing good A will shift the firm's supply curve for good A to the left. If a firm expects the price of its product will rise in the future, then the firm has an incentive to decrease supply in the present and increase supply in the future. When firms enter a market, the market supply curve shifts to the right. When firms exit a market, the market supply curve shifts to the left.

W Study Hint

The law of supply may seem logical because producers earn more profit when the price they sell their product for rises. But consider Figure 3.4 and the following question: If Apple can earn a profit from selling 10 million smartphones per week at a price of \$200, why not increase quantity supplied to 11 million and make even more profit? The upward slope of the supply curve is due not only to the profit motive but to the increasing marginal cost of producing smartphones. (Increasing marginal costs were discussed in Chapter 2.) Apple will increase its quantity supplied from 10 million to 11 million in Figure 3.4 only if the price it will receive is \$250 because the cost of producing 1 million more smartphones is greater than the cost of the previous 1 million smartphones.

As with demand and quantity demanded, be careful not to confuse a change in quantity supplied (due only to a change in the price of a product) and a change in supply (a shift of the supply curve in response to one of the nonprice factors). Constant reinforcement of this is necessary. Be careful not to refer to an increase in supply as "a downward shift" or a decrease in supply as "an upward shift." Because demand curves are downward sloping, an increase in demand appears in a graph as an "upward shift." But because supply curves are upward sloping, a decrease in supply appears in a graph as an "upward shift." You should always refer to both changes in demand and supply as being "shifts to the right" for an increase and "shifts to the left" for a decrease to avoid confusion.

Take time to study Figure 3.6, which shows the difference between a change in supply and a change in quantity supplied. Also take time to study Table 3.2, which lists all the variables that shift market supply curves. Making the Connection "Forecasting the Demand for iPhones" discusses the importance of forecasting the demand for smartphones by Apple on the sales of iPhones.

Extra Solved Problem 3.2

To (Soy)bean or not to (Soy)bean?

Supports Learning Objective 3.2: Discuss the variables that influence supply.

Iowa, Illinois, Nebraska, Minnesota, and Indiana are the top five producers of corn in the United States. Although climate and soil conditions in these states make them well-suited for growing corn, these five states are also the top soybean producers in the United States. Each year, farmers in these states must decide how many acres of land to plant with corn and how many acres to plant with soybeans.

- a. If both crops can be grown on the same land, why would a farmer choose to produce corn rather than soybeans?
- b. Which of the variables that influence supply would explain a farmer's choice to produce soybeans or corn?

Solving the Problem

Step 1: Review the chapter material.

This problem is about variables that shift supply, so you may want to refer to the section "Variables That Shift Market Supply," which begins on page 80 of the textbook.

Step 2: Answer question (a) by discussing the factors that would influence a farmer's choice.

Among the factors that would influence a farmer's choice is the expected profitability of the two crops. A farmer will grow corn rather than soybeans if he expects the profits from growing corn will be greater than those earned from growing soybeans.

Step 3: Answer question (b) by evaluating which variables are most likely to affect supply in the markets for corn and soybeans.

Other things being equal, as the price of soybeans falls relative to the price of corn, the supply of corn would rise. Because corn and soybeans are alternate products a farmer could use in production, the variable "prices of substitutes in production" would most likely explain the farmer's choice.

3.3

Market Equilibrium: Putting Demand and Supply Together (pages 82–85)

Learning Objective: Use a graph to illustrate market equilibrium.

The purpose of markets is to bring buyers and sellers together. The interaction of buyers and sellers in markets results in firms producing goods and services consumers both want and can afford. At market equilibrium, the price of the product makes quantity demanded equal quantity supplied. A competitive market equilibrium is a market equilibrium with many buyers and many sellers. The market price (the actual price you would pay for the product) will not always be the equilibrium price. A surplus is a situation in which the quantity supplied is greater than the quantity demanded, which occurs when the market price is above the equilibrium price. Firms have an incentive to increase sales by lowering price. As the market price is lowered, quantity demanded will rise, and quantity supplied will fall until the market reaches equilibrium.

A **shortage** is a situation in which quantity demanded is greater than the quantity supplied, which occurs when the market price is below the equilibrium price. Some consumers will want to buy the product at a higher price to make sure they get what they want. As the market price rises, the quantity demanded will fall—not everyone will want to buy at a higher price—and quantity supplied will rise until the market reaches equilibrium. At the competitive market equilibrium, there is no reason for the price to change unless either the demand curve or the supply curve shifts.

Study Hint

It's very important to understand how demand and supply interact to reach equilibrium. Remember that adjustments to a shortage or a surplus represent changes in quantity demanded (not demand) and quantity supplied (not supply). *Solved Problem 3.3* and problems 3.5, 3.6 and 3.7 in the Problems and Applications at the end of the chapter address this topic. In *Solved Problem 3.3*, we see how the demand and supply for the letters written by Lincoln and Booth determine the price for the letters written by each author. Because the supply is low relative to the demand for Booth's letters, his letters sell for a high equilibrium price. Similarly, because the supply of Lincoln's letters is large relative to their demand, his letters sell for a lower equilibrium price. Market or actual prices are easy to understand because these are the prices consumers are charged. You know the price you paid for a CD because it is printed on the receipt, but no receipt has "equilibrium price" written on it.

3.4

The Effect of Demand and Supply Shifts on Equilibrium (pages 85–91)

Learning Objective: Use demand and supply graphs to predict changes in prices and auantities.

Increases in supply result from: a decrease in an input price, positive technological change, a decrease in the price of a substitute in production, a lower expected future product price, and an increase in the number of firms in the market. A decrease in supply results in a higher equilibrium price and a lower equilibrium quantity. Decreases in supply result from the following nonprice factor changes: an increase in an input price, negative technological change, an increase in the price of a substitute in production, a higher expected future product price, and a decrease in the number of firms in the market.

Increases in demand can be caused by any change in a variable that affects demand except price. For example, demand will increase if the price of a substitute increases, the price of a complement decreases, income increases (for a normal good), income decreases (for an inferior good), population increases, or the expected future price of the product increases. A decrease in demand results in a lower equilibrium price and lower equilibrium quantity. Decreases in demand can be caused by any change in a variable that affects demand except the price of the product itself. For example, demand will decrease if the price of a substitute decreases, the price of a complement increases, income decreases (for a normal good), income increases (for an inferior good), population decreases, or the expected future price of the product decreases.

Study Hint

When demand shifts, the equilibrium price and quantity both change in the same direction as the shift. For example, an increase in demand (graphed as a shift to the right of demand) results in an increase in both the price and the equilibrium quantity. However, when supply changes, the equilibrium quantity changes in the same direction as the shift of the supply curve, but the equilibrium price changes in the opposite direction. For example, an increase in supply (graphed as a shift to the right of supply) results in an increase in the equilibrium quantity but a decrease in the equilibrium price. Making the Connection "The Falling Price of Blu-ray Players" discusses how the falling prices of VCR, DVD, and Blu-ray players can be explained by changes in the supply curve. For additional practice, be sure to review Solved Problem 3.4 and problem 4.6 on beef consumption and problems 4.7 and 4.8 in the Problems and Applications section.

Key Terms

Ceteris paribus ("all else equal") condition

The requirement that when analyzing the relationship between two variables—such as price and quantity demanded—other variables must be held constant.

Competitive market equilibrium A market equilibrium with many buyers and many sellers.

Complements Goods and services that are used together.

Demand curve A curve that shows the relationship between the price of a product and the quantity of the product demanded.

Demand schedule A table that shows the relationship between the price of a product and the quantity of the product demanded.

Demographics The characteristics of a population with respect to age, race, and gender.

Income effect The change in the quantity demanded of a good that results from the effect of a change in the good's price on consumers' purchasing power.

Inferior good A good for which the demand increases as income falls and decreases as income rises.

Law of demand The rule that, holding everything else constant, when the price of a product falls, the quantity demanded of the product will increase, and when the price of a product rises, the quantity demanded of the product will decrease.

Law of supply The rule that, holding everything else constant, increases in price cause increases in the quantity supplied, and decreases in price cause decreases in the quantity supplied.

Market demand The demand by all the consumers of a given good or service.

Market equilibrium A situation in which quantity demanded equals quantity supplied.

Normal good A good for which the demand increases as income rises and decreases as income falls.

Perfectly competitive market A market that meets the conditions of (1) many buyers and sellers, (2) all firms selling identical products, and (3) no barriers to new firms entering the market.

Quantity demanded The amount of a good or service that a consumer is willing and able to purchase at a given price.

Quantity supplied The amount of a good or service that a firm is willing and able to supply at a given price.

Shortage A situation in which the quantity demanded is greater than the quantity supplied.

Substitutes Goods and services that can be used for the same purpose.

Substitution effect The change in the quantity demanded of a good that results from a change in price, making the good more or less expensive relative to other goods that are substitutes.

Supply curve A curve that shows the relationship between the price of a product and the quantity of the product supplied.

Supply schedule A table that shows the relationship between the price of a product and the quantity of the product supplied.

Surplus A situation in which the quantity supplied is greater than the quantity demanded.

Technological change A positive or negative change in the ability of a firm to produce a given level of output with a given quantity of inputs.

Self-Test

(Answers are provided at the end of the Self-Test.)

Multiple-Choice Questions

- 1. What does the term "quantity demanded" refer to?
 - a. the total amount of a good or service that a consumer is willing to buy in a given period
 - b. the quantity of a good or service demanded that corresponds to the quantity supplied
 - c. the quantity of a good or service that a consumer is willing and able to purchase at a given price
 - d. none of the above

- 2. Which of the following is the correct definition of demand schedule?
 - a. the quantity of a good or service that a consumer is willing to purchase at a given price
 - b. a table showing the relationship between the price of a product and the quantity of the product demanded
 - c. a curve that shows the relationship between the price of a product and the quantity of the product demanded
 - d. the demand for a product by all the consumers in a given geographical area
- 3. Refer to the graph below. In the market for smartphones, price is \$300, and quantity demanded is 6 million units per year. Which of the following interpretations of this point on the graph is correct?

- a. This point shows that consumers spend a total of \$300 on 6 million smartphones each year.
- b. When the price of one smartphone is \$300, suppliers sell 6 million of them per year.
- c. When the price of one smartphone is \$300, consumers buy 6 million of them per year.
- d. At \$300, the quantity demanded equals the quantity supplied.
- 4. Which of the following is the correct definition of demand curve?
 - a. the quantity of a good or service that a consumer is willing to purchase at a given price
 - b. a table showing the relationship between the price of a product and the quantity of the product demanded
 - c. a curve that shows the relationship between the price of a product and the quantity of the product demanded
 - d. the demand for a product by all the consumers in a given geographical area
- 5. Which of the following is the correct definition of market demand?
 - a. the quantity of a good or service that a consumer is willing to purchase at a given price
 - b. a table showing the relationship between the price of a product and the quantity of the product demanded
 - c. a curve that shows the relationship between the price of a product and the quantity of the product demanded
 - d. the demand by all the consumers for a given good or service

- 6. When the price of a smartphone rises, the quantity of smartphones demanded by consumers falls. Therefore, the demand curve for smartphones is
 - a. unpredictable.
 - b. upward sloping.
 - c. downward sloping.
 - d. an exception to the law of demand.
- 7. Refer to the graph below. What happens to quantity demanded along this demand curve?

- a. Quantity demanded increases as the price increases.
- b. Quantity demanded increases as the price decreases.
- c. Quantity demanded may increase or decrease as the price increases.
- d. Quantity demanded is not related to price.
- 8. Refer to the graph below. Along the demand curve, what happens to the quantity demanded as the price rises from \$300 to \$400 per smartphone?

- a. The quantity demanded increases from 6 million to 7 million smartphones per year.
- b. The quantity demanded decreases from 6 million to 5 million smartphones per year.
- c. We cannot predict the change in the quantity demanded without the supply curve.
- d. The change in the quantity demanded is not related to a change in price.

- 9. Which of the following explains why there is an inverse relationship between the price of a product and the quantity of the product demanded?
 - a. the principle of comparative advantage
 - b. the complementary effect
 - c. the ceteris paribus condition
 - d. the substitution effect
- 10. What is the *law of demand?*
 - a. The law of demand states that a change in the quantity demanded, caused by changes in price, makes the good more or less expensive relative to other goods.
 - b. The law of demand states that a change in the quantity demanded, caused by changes in price, affects a consumer's purchasing power.
 - c. The law of demand is the rule that, holding everything else constant, when the price of a good falls, the quantity demanded will increase, and when the price of a good rises, the quantity demanded will decrease.
 - d. The law of demand is the requirement that when analyzing the relationship between price and quantity demanded, other variables must be held constant.
- 11. Which of the following is used to describe how changes in price affect a consumer's purchasing power?
 - a. the law of demand
 - b. the substitution effect
 - c. the income effect
 - d. the ceteris paribus condition
- 12. Which of the following is used to explain why consumers buy other goods when the price of a good rises?
 - a. the law of demand
 - b. the substitution effect
 - c. the income effect
 - d. the ceteris paribus condition
- 13. Economists refer to the necessity of holding all variables other than price constant in constructing a demand curve as the
 - a. law of demand.
 - b. substitution effect.
 - c. income effect.
 - d. ceteris paribus condition.

14. Refer to the graphs below. Each graph refers to the demand for smartphones. Which of the graphs illustrates the impact of an increase in the price of a substitute good?

- a. the graph on the left
- b. the graph on the right
- c. both graphs
- d. neither graph
- 15. Refer to the graphs below. Each graph refers to the demand for smartphones. Which of the graphs illustrates the impact of an increase in the price of a complementary good?

- a. the graph on the left
- b. the graph on the right
- c. both graphs
- d. neither graph

16. Refer to the graphs below. Each graph refers to the demand for smartphones. Which of the graphs illustrates the impact of an increase in income, assuming that smartphones are a normal good?

- a. the graph on the left
- b. the graph on the right
- c. both graphs
- d. neither graph

17. Refer to the graphs below. Each graph refers to the demand for smartphones. Which of the graphs illustrates the impact of an increase in consumers' preferences for smartphones?

- a. the graph on the left
- b. the graph on the right
- c. both graphs
- d. neither graph

18. Refer to the graphs below. Each graph refers to the demand for smartphones. Which of the graphs illustrates the impact of an increase in the number of young consumers?

- a. the graph on the left
- b. the graph on the right
- c. both graphs
- d. neither graph
- 19. Refer to the graphs below. Each graph refers to the demand for smartphones. Which of the graphs illustrates the impact of an increase in the expected price of smartphones in the future?

- a. the graph on the left
- b. the graph on the right
- c. both graphs
- d. neither graph
- 20. When two goods are complements, which of the following is true?
 - a. The two goods can be used for the same purpose.
 - b. The two goods are used together.
 - c. The demand for each of these goods increases when income rises.
 - d. The demand for each of these goods increases when income falls.

- 21. Which of the following describes two goods that are substitutes?
 - a. As the price of one of the goods increases, the demand for the other good increases.
 - b. The more consumers buy of one good, the more they will buy of the other good.
 - c. The demand for each of these goods increases when income increases.
 - d. The demand for each of these goods increases when income decreases.
- 22. When the price of one good increases, the demand for another good decreases as a result. The two goods can be regarded as
 - a. substitutes.
 - b. complements.
 - c. normal goods.
 - d. inferior goods.
- 23. Which of the following would result in an increase in the demand for Apple's iPhone 5?
 - a. an increase in the price of iPhone 5
 - b. an increase in the price of Samsung's Galaxy, a substitute for Apple's iPhone 5
 - c. a decrease in consumers' income, assuming iPhone 5 is a normal good
 - d. an increase in the price of "apps" for iPhones, a complement of the iPhones
- 24. What is an inferior good?
 - a. a good for which demand increases as income rises
 - b. a good for which demand decreases as income rises
 - c. a good that cannot be used together with another good
 - d. a good that does not serve any real purpose
- 25. What is a normal good?
 - a. a good for which demand increases as income rises
 - b. a good for which demand decreases as income rises
 - c. a good that can be used together with another good
 - d. a good that serves more than one purpose

26. Refer to the graph below. Which of the following moves illustrates a change in demand?

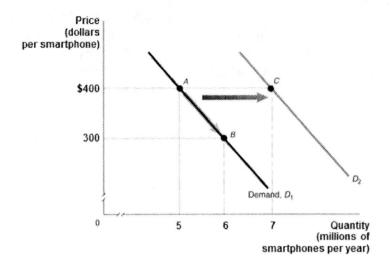

- a. the move from A to B
- b. the move from A to C
- c. either the move from A to B or from A to C
- d. the move from B to A
- 27. Refer to the graph below. Which of the following moves illustrates a change in quantity demanded?

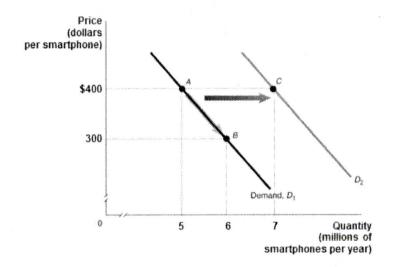

- a. the move from A to B
- b. the move from A to C
- c. either the move from A to B or from A to C
- d. the move from B to C

28. Refer to the graph below. Which of the following moves illustrates what happens when there is a change in a determinant of the demand for smartphones other than the price of smartphones?

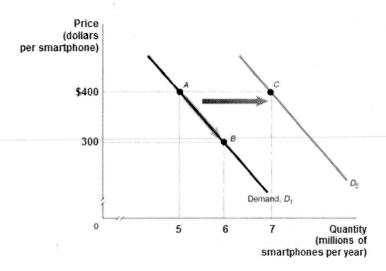

- a. the move from A to B
- b. the move from A to C
- c. either the move from A to B or from A to C
- d. none of the above
- 29. Refer to the graph below. Which of the following moves illustrates what happens when a change in the price of smartphones affects the market demand for smartphones?

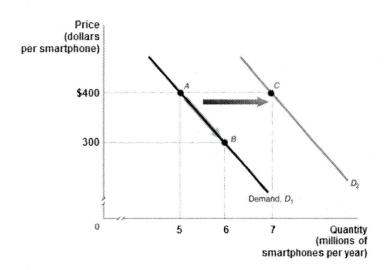

- a. the move from A to B
- b. the move from A to C
- c. either the move from A to B or from A to C
- d. none of the above

- 30. Which of the following would not shift the demand curve for a good or service?
 - a. a change in the price of a related good
 - b. a change in the price of the good or service
 - c. a change in expectations about the price of the good or service
 - d. a change in income
- 31. The term "quantity supplied" refers to
 - a. the quantity of a good or service that a firm is willing and able to supply at a given price.
 - b. a table that shows the relationship between the price of a product and the quantity of the product supplied.
 - c. a curve that shows the relationship between the price of a product and the quantity of the product demanded.
 - d. none of the above.
- 32. Which of the following is the textbook's definition of a supply schedule?
 - a. the quantity of a good or service that a firm is willing to supply at a given price
 - b. a table that shows the relationship between the price of a product and the quantity of the product supplied
 - c. a curve that shows the relationship between the price of a product and the quantity of the product demanded
 - d. none of the above
- 33. Which of the following is the textbook's definition of a supply curve?
 - a. the quantity of a good or service that a firm is willing to supply at a given price
 - b. a table that shows the relationship between the price of a product and the quantity of the product supplied
 - c. a curve that shows the relationship between the price of a product and the quantity of the product supplied
 - d. none of the above
- 34. Which of the following is consistent with the law of supply?
 - a. An increase in price causes an increase in the quantity supplied, and a decrease in price causes a decrease in the quantity supplied.
 - b. A change in price causes a shift of the supply curve.
 - c. Supply shifts are caused not by a single variable but most likely by a number of different variables.
 - d. All of the above are consistent with the law of supply.

35. Refer to the graphs below. Each graph refers to the supply of smartphones. Which of the graphs illustrates the impact of an increase in the price of an input?

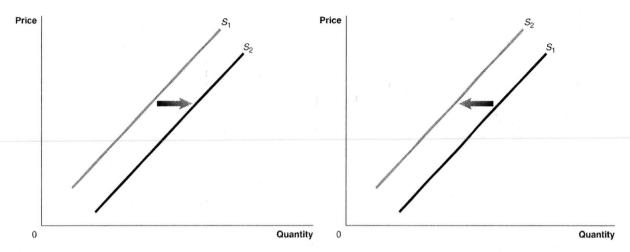

- a. the graph on the left
- b. the graph on the right
- c. both graphs
- d. neither graph
- 36. Refer to the graphs below. Each graph refers to the supply of smartphones. Which of the graphs illustrates the impact of an increase in productivity?

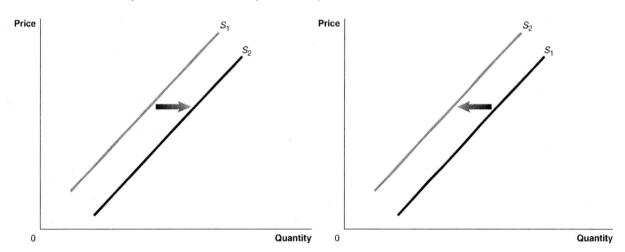

- a. the graph on the left
- b. the graph on the right
- c. both graphs
- d. neither graph

37. Refer to the graphs below. Each graph refers to the supply of smartphones. Which of the graphs illustrates the impact of an increase in the price of a substitute in production?

- a. the graph on the left
- b. the graph on the right
- c. both graphs
- d. neither graph
- 38. Refer to the graphs below. Each graph refers to the supply of smartphones. Which of the graphs illustrates the impact of an increase in the expected future price of the product?

- a. the graph on the left
- b. the graph on the right
- c. both graphs
- d. neither graph

39. Refer to the graphs below. Each graph refers to the supply of smartphones. Which of the graphs illustrates the impact of an increase in the number of firms in the smartphone market?

- a. the graph on the left
- b. the graph on the right
- c. both graphs
- d. neither graph
- 40. Refer to the graph below. Which of the following moves illustrates what happens when there is a change in a determinant of the supply of smartphones other than the price of smartphones?

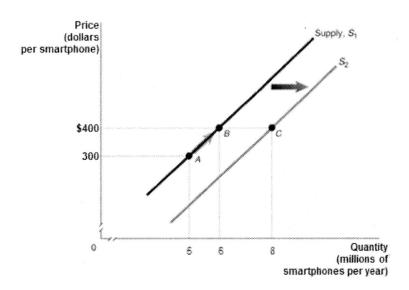

- a. the move from A to B
- b. the move from B to C
- c. either the move from A to B or from A to C
- d. none of the above

41. Refer to the graph below. Which of the following moves illustrates what happens when a change in the price of smartphones affects the market supply of smartphones?

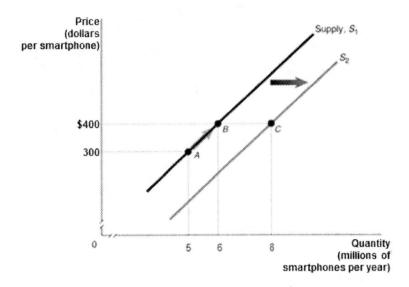

- a. the move from A to B
- b. the move from A to C
- c. either the move from A to B or from A to C
- d. none of the above
- 42. Which of the following would shift the supply of iPhones to the left?
 - a. an increase in the price of iPhones
 - b. an increase in the price of inputs used to produce iPhones
 - c. a decrease in the expected future price of iPhones
 - d. all of the above
- 43. A surplus exists in a market if the actual price is
 - a. equal to the equilibrium price.
 - b. below the equilibrium price.
 - c. above the equilibrium price.
 - d. either above or below the equilibrium price.
- 44. If a shortage exists in a market, we know that the actual price is
 - a. below equilibrium price, and quantity demanded is greater than quantity supplied.
 - b. above equilibrium price, and quantity demanded is greater than quantity supplied.
 - c. above equilibrium price, and quantity supplied is greater than quantity demanded.
 - d. below equilibrium price, and quantity supplied is greater than quantity demanded.
- 45. An early frost in the apple orchards of Washington state would cause
 - a. an increase in the demand for apple juice, increasing equilibrium price.
 - b. an increase in the supply of apple juice, decreasing equilibrium price.
 - c. a decrease in the demand for apple juice, decreasing equilibrium price.
 - d. a decrease in the supply of apple juice, increasing equilibrium price.

- 46. Which of the following would definitely result in a higher price in the market for tennis shoes?
 - a. demand increases and supply decreases
 - b. demand and supply both decrease
 - c. demand decreases and supply increases
 - d. demand and supply both increase
- 47. Suppose that the income of buyers in a market increases and a technological advancement also occurs. What would we expect to happen in the market for a normal good?
 - a. The equilibrium price would increase, but the impact on the amount sold in the market would be ambiguous.
 - b. The equilibrium price would decrease, but the impact on the amount sold in the market would be ambiguous.
 - c. Equilibrium quantity would increase, but the impact on equilibrium price would be ambiguous.
 - d. Both equilibrium price and equilibrium quantity would increase.
- 48. If both demand and supply decrease in the market for smartphones, how will equilibrium be affected?
 - a. Equilibrium price and equilibrium quantity will rise.
 - b. Equilibrium price and equilibrium quantity will fall.
 - c. Equilibrium price will rise, but the impact on equilibrium quantity is ambiguous.
 - d. The impact on equilibrium price will be ambiguous, but the equilibrium quantity will fall.
- 49. How will a decrease in the expected future price of smartphones affect the demand and supply of smartphones?
 - a. Demand will rise, and supply will fall.
 - b. Demand will rise, and supply will rise.
 - c. Demand will fall, and supply will rise.
 - d. Demand will fall, and supply will fall.
- 50. How will a decrease in the expected future price of smartphones affect the equilibrium price and quantity of smartphones?
 - a. Equilibrium price and equilibrium quantity will rise.
 - b. Equilibrium price will fall, and equilibrium quantity will rise.
 - c. Equilibrium price will rise; the impact on equilibrium quantity is ambiguous.
 - d. Equilibrium price will fall; the impact on equilibrium quantity is ambiguous.

Short Answer Questions

7.55		

78 CHAPTER 3 Where Prices Come From: The Interaction of Demand and Supply

Explain t	ne difference between a shortage and scarcity.
organ tra	old there were more than 100,000 people on waiting lists for kidney, lung, and ot asplant operations. By law, organ donors and their families in the United States may or the donated organs. If payments for organ donations were made legal in the United States and their families in the United States are supported by the contract of the United States and the United States are supported by the Contract of the United States are supported by the United States and the United States are supported by the United States and the United States are supported by the United States and the United States are supported by
organ tra be paid	isplant operations. By law, organ donors and their families in the United States may
organ tra be paid	isplant operations. By law, organ donors and their families in the United States may or the donated organs. If payments for organ donations were made legal in the Uni
organ tra be paid	isplant operations. By law, organ donors and their families in the United States may or the donated organs. If payments for organ donations were made legal in the United States or the donated organs.
organ tra be paid	asplant operations. By law, organ donors and their families in the United States may or the donated organs. If payments for organ donations were made legal in the United States or the donated organs.

in supply."		
	*	A

True/False Questions

- T F 1. A market demand curve demonstrates the quantity that each consumer is willing to buy at each possible price.
- T F 2. The law of demand states that, holding everything else constant, increases in price cause decreases in demand.
- T F 3. The price of lobsters is higher in the spring than in the summer, even though demand is greater in the summer. The lower summer price results from increases in the supply of lobsters in the summer.
- T F 4. As a result of a surplus, the price in a market will fall; quantity supplied falls, and quantity demanded rises until equilibrium is reached.
- T F 5. An increase in income causes demand for a normal good to increase.
- T F 6. Tablet computers and e-readers are substitutes because the demand for e-readers rises when the prices of tablet computers decrease.
- T F 7. Inferior goods are goods that are of lesser quality than other similar goods.
- T F 8. Substitution and income effects are used to explain the law of supply.
- T F 9. A negative technological change will shift the supply curve for a product to the left.
- T F 10. Increases in the supply of flat-screen televisions led to lower prices and increased quantity demanded for these televisions.
- T F 11. An increase in the price of a complement for good A will decrease the demand for good A.
- T F 12. The effect of an increase of the actual price of a good on the demand curve for that good is the same as the effect of an increase of the expected future price of that good.
- T F 13. If both demand and supply increase over time, equilibrium price and equilibrium quantity will also rise.
- T F 14. A change in price will not cause a change in demand or supply.
- T F 15. In perfectly competitive markets, many sellers sell similar products that buyers can easily tell the firms that produce them.

Answers to the Self-Test

Multiple-Choice Questions

Question	Answer	Comment
1.	c	Quantity demanded is the amount of a good or service that a consumer is willing and able to buy at a given price. See page 70 in the textbook.
2.	b	The demand schedule is a table, not a curve or a single quantity demanded at a given price. See page 70 in the textbook.
3.	c	In this example, the quantity of smartphones demanded per month is 6 million when the price per smartphone is \$400.
4.	c	This is the definition of demand curve. See page 70 in the textbook.
5.	d	This is the definition of market demand. See page 70 in the textbook.
6.	c	The consumers' demand curve is downward sloping. There is an inverse relationship between price and quantity demanded. Price and quantity demanded move in opposite directions.
7.	b	The demand curve is downward sloping. There is an inverse relationship between price and quantity demanded, meaning that price and quantity demanded move in opposite directions.
8.	b	The demand curve is downward sloping, so as the price rises, the quantity demanded falls.
9.	d	The law of demand states that there is an inverse relationship between the price of a product and the quantity of the product demanded, and the substitution and income effects explain the law of demand.
10.	c	According to the law of demand, there is an inverse relationship between the price of a product and the quantity of the product demanded.
11.	c	Along with the substitution effect, the income effect helps to explain why a demand curve is downward sloping. (Note that the income effect only works in this direction for normal goods.)
12.	b	The substitution effect helps to explain why a demand curve is downward sloping. See page 71 in the textbook.
13.	d	The term ceteris paribus is Latin for "all else equal."
14.	a	This graph shows an increase in demand. When the price of a substitute good rises, the demand for the good in question also rises.
15.	b	Demand decreases when the price of a complementary good increases.
16.	a	This graph shows an increase in demand. When income increases, the demand for any normal good also increases.
17.	a	This graph shows an increase in demand. When tastes for a product increase, the demand for the good in question also increases.
18.	a	This graph shows an increase in demand. When the number of young consumers increases, the demand for smartphones also increases.
19.	a	This graph shows an increase in demand. When the expected future price of a product increases, the demand for the good in question today also increases.
20.	b	When two goods are complements, the more consumers buy of one good, the more they will buy of the other good as well.

Qı	estion	Answer	Comment
	21.	a	Substitutes are goods and services that can be used for the same purpose.
	22.	b	When the price of one good increases, then the demand for its complements decreases.
	23.	b	An increase in the price of a good's substitute will increase the demand for that good.
	24.	b	The term inferior good means consumers will buy less of a good as income rises.
	25.	a	The term normal good means consumers will buy more of a good as their income increases.
	26.	b	Anything that causes a demand curve to shift also causes a change in demand.
	27.	a	Anything that causes movement along a single demand curve also causes a change in quantity demanded. The only factor that can change quantity demanded is a change in the price of the product.
	28.	b	When any variable that affects demand changes, demand shifts. (The sole exception to this rule is changes in the price of the product.)
	29.	a	Anything that causes a movement along a single demand curve also causes a change in quantity demanded. The only factor that can change quantity demanded is a change in the price of the product.
	30.	b	A change in the price of a good or service does not cause a shift in the demand curve. It would cause a movement along the demand curve.
	31.	a	Quantity supplied is the quantity of a good or service that a firm is willing to supply at a given price. See page 78 in the textbook.
	32.	b	A table that shows the relationship between the price of a product and the quantity of the product supplied is called the supply schedule. See page 78 in the textbook.
	33.	c	A curve that shows the relationship between the price of a product and the quantity of the product supplied is called a supply curve. Quantity supplied is the quantity of a good or service that a firm is willing to supply at a given price. See page 78 in the textbook.
	34.	a	This is the law of supply. See page 79 in the textbook.
	35.	b	This graph shows a decrease in supply. When the price of an input increases, supply decreases.
	36.	a	This graph shows an increase in supply. When productivity increases, supply increases.
	37.	b	This graph shows a decrease in supply. When the price of a substitute in production increases, supply of the good in question decreases because more of the substitute is produced and less of the good in question is produced.
	38.	b	This graph shows a decrease in supply. When the expected future price of a product increases, supply of the good in question decreases today because less of the good will be produced today and more will be produced in the future to take advantage of the higher future price.
	39.	a	This graph shows an increase in supply. When the number of firms in the market increases, market supply increases.
	40.	b	A determinant of supply other than price will cause a shift in the supply curve. In this case, the supply increases or the supply curve shifts to the right.
	41.	a	If the price of a good changes that will cause a movement along the supply curve.

Question	Answer	Comment
42.	b	This movement from A to B is an increase in the quantity supplied. An increase in the price of inputs will decrease supply (shifting supply curve to the left).
43.	c	If the actual price is above the equilibrium price, the quantity supplied is greater than the quantity demanded, so there is a surplus.
44.	a	If the actual price is below the equilibrium price, the quantity demanded is greater than the quantity supplied, so there is a shortage.
45.	d	If there is a frost, it will destroy some of the apples, which will cause the price of apples to rise. Because apples are an input in the production of apple juice, the supply of apple juice will decrease, resulting in an increase in the equilibrium price of apple juice.
46.	a	The price will rise when the demand increases and the supply decreases, though the effect on the equilibrium quantity will be ambiguous.
47.	c	Both the demand and supply shift to the right, which will cause an increase in the equilibrium quantity and an ambiguous effect on the price.
48.	d	The decrease in demand and decrease in supply both reduce the equilibrium quantity, but the decrease in demand reduces the equilibrium price while the decrease in supply increases the equilibrium price. As a result, the equilibrium price may rise or fall.
49.	c	A decrease in the expected future price discourages consumers from making purchases in the current period but encourages sellers to increase supply in the current period.
50.	d	The lower demand for smartphones reduces price and quantity, while the increase in supply reduces price but increases quantity.

Short Answer Responses

- 1. Tickets for these events typically sell out soon after they are offered to the public. Many of these tickets are later resold at prices higher than the original prices buyers paid for them. This implies that the quantity demanded for the tickets is greater than the quantity supplied at the original prices. The prices at which the tickets are first sold are below their equilibrium levels.
- 2. The law of demand applies to the inverse relationship between the price of a product and the quantity of the product demanded of that product, holding everything else constant. Some people prefer to buy brand-name products from department stores instead of similar products from discount stores because they perceive those brand-name products to be better in quality or they simply serve as status symbols. The law of demand is not violated as buyers are willing to pay more for a different product.
- 3. A shortage exists when the price for a product is less than the equilibrium price. If the price is allowed to rise to its equilibrium level, the shortage will be eliminated. But the product will be scarce whether the market price is above, below, or equal to its equilibrium value. Every economic product is scarce because unlimited human wants exceed society's limited productive resources.
- 4. Because the price of organs and transplant operations would rise, this would affect quantity demanded rather than demand. An increase in the price of organs and transplant operations would typically decrease the quantity demanded. But it is unlikely that the quantity demanded would change very much, if at all, because there are no good substitutes for the operations.

- 5. Demographics are most responsible for this change. As more members of the so-called baby boom generation reach retirement age, their demand for health care will increase. (Most health care spending is for care of those over age 60.)
- 6. An increase in demand results in an increase in the equilibrium price and equilibrium quantity. As the equilibrium price rises, the quantity supplied also increases. However, supply itself does not shift, so there is no increase in supply. An increase in supply will be caused only by one of the determinants of supply, not an increase in demand.

True/False Answers

uestion	Answer	Comment
1.	F	The demand curve shows the quantity that all consumers would collectively demand at each possible price.
2.	F	Increases in price cause decreases in quantity demanded, not demand.
3.	T	Even though demand increases in the summer, the supply increases even more.
4.	T	A surplus would cause firms to want to decrease their supply to reduce their inventories. As the price falls, the quantity demanded increases and the quantity supplied decreases.
5.	T	A normal good is one for which demand increases as income rises.
6.	F	Two goods are substitutes if the demand for one good's substitute falls when the price of that good decreases.
7.	F	Inferior goods are ones that you buy less of as your income rises.
8.	F	Substitution and income effects explain the law of demand, not supply.
9.	T	If something causes technology to decrease, the supply will decrease.
10.	T	As the supply increased, the market price fell, which caused a downward movement along the demand curve for flat-screen televisions; that is, there was an increase in quantity demanded.
11.	T	Complements, such as coffee and creamer, are consumed together. If the price of one increases, consumers will buy less of the related good.
12.	F	An increase in the actual price of a good causes an upward movement along that good's demand curve, while an increase in the expected future price of that good causes an increase in demand for that good or a shift of its demand curve to the right.
13.	F	An increase in both demand and supply will increase equilibrium quantity, but the equilibrium price will be ambiguous.
14.	T	A change in price causes a change in the quantity demanded or quantity supplied, not demand or supply.
15.	F	In a competitive market, firms sell identical products or products that buyers cannot tell their producers.

하는 경우 보통에 보는 사용하는 것이 되었다. 그는 사용을 하는 것이 되었다. 그는 사용을 하는 것이 되었다. 그는 것이 되었다. 그는 것이 되었다. 그는 것이 없는 것이 없는 것이 없는 것이 없는 한 경우는 사용하는 것이 있는 것이 없는 것이 되었다. 그는 사용을 하는 것이 되었다. 그는 것이 되었다. 그는 것이 없는 것이 없는

CHAPTER 4 | Economic Efficiency, Government Price Setting, and Taxes

Chapter Summary and Learning Objectives

4.1 Consumer Surplus and Producer Surplus (pages 102–106)

Distinguish between the concepts of consumer surplus and producer surplus. Although most prices are determined by demand and supply in markets, the government sometimes imposes price ceilings and price floors. A price ceiling is a legally determined maximum price that sellers may charge. A price floor is a legally determined minimum price that sellers may receive. Economists analyze the effects of price ceilings and price floors using consumer surplus and producer surplus. Marginal benefit is the additional benefit to a consumer from consuming one more unit of a good or service. The demand curve is also a marginal benefit curve. Consumer surplus is the difference between the highest price a consumer is willing to pay for a good or service and the price the consumer actually pays. The total amount of consumer surplus in a market is equal to the area below the demand curve and above the market price. Marginal cost is the additional cost to a firm of producing one more unit of a good or service. The supply curve is also a marginal cost curve. Producer surplus is the difference between the lowest price a firm is willing to accept for a good or service and the price it actually receives. The total amount of producer surplus in a market is equal to the area above the supply curve and below the market price.

4.2 The Efficiency of Competitive Markets (pages 106–109)

Understand the concept of economic efficiency. Equilibrium in a competitive market is economically efficient. Economic surplus is the sum of consumer surplus and producer surplus. Economic efficiency is a market outcome in which the marginal benefit to consumers from the last unit produced is equal to the marginal cost of production and where the sum of consumer surplus and producer surplus is at a maximum. When the market price is above or below the equilibrium price, there is a reduction in economic surplus. The reduction in economic surplus resulting from a market not being in competitive equilibrium is called the deadweight loss.

4.3 Government Intervention in the Market: Price Floors and Price Ceilings (pages 109–116)

Explain the economic effect of government-imposed price floors and price ceilings. Producers or consumers who are dissatisfied with the market outcome can attempt to convince the government to impose price floors or price ceilings. Price floors usually increase producer surplus, decrease consumer surplus, and cause a deadweight loss. Price ceilings usually increase consumer surplus, reduce producer surplus, and cause a deadweight loss. The results of the government imposing price ceilings and price floors are that some people win, some people lose, and a loss of economic efficiency occurs. Price ceilings and price floors can lead to a black market, where buying and selling take place at prices that violate government price regulations. Positive analysis is concerned with what is, and normative analysis is concerned with what should be. Positive analysis shows that price ceilings and price floors cause deadweight losses. Whether these policies are desirable or undesirable, though, is a normative question.

4.4 The Economic Impact of Taxes (pages 116–121)

Analyze the economic impact of taxes. Most taxes result in a loss of consumer surplus, a loss of producer surplus, and a deadweight loss. The true burden of a tax is not just the amount paid to government by consumers and producers but also includes the deadweight loss. The deadweight loss from a tax is the excess burden of the tax. Tax incidence is the actual division of the burden of a tax. In most cases, consumers and firms share the burden of a tax levied on a good or service.

Appendix: Quantitative Demand and Supply Analysis (pages 131–134) *Use quantitative demand and supply analysis.*

Chapter Review

Chapter Opener: The Sharing Economy, Phone Apps, and Rent Control (page 101)

It has become increasingly popular for people to use phone apps, like Airbnb, to facilitate peer-to-peer room or apartment rentals. Some users of Airbnb and other online rental sites have violated rental control regulations in cities like New York, San Francisco, and Los Angeles. Rent control is an example of a price ceiling. Rent controls exist in about 200 cities in the United States. Like any price control, rent control results in a shortage of apartments and the existence of black markets, like those illegal transactions at Airbnb.

Study Hint

Read Solved Problem 4.3 and An Inside Look at Policy from this chapter to reinforce your understanding of the impact of rent control on the markets of apartments.

4.1

Consumer Surplus and Producer Surplus (pages 102–106)

Learning Objective: Distinguish between the concepts of consumer surplus and producer surplus.

Consumer surplus is the difference between the highest price a consumer is willing to pay and the price the consumer actually pays. **Producer surplus** is the difference between the lowest price a firm would be willing to accept and the price it actually receives.

Marginal benefit is the additional benefit to a consumer from consuming one more unit of a good or service. The height of a market demand curve at a given quantity measures the marginal benefit to someone from consuming that quantity. Consumer surplus refers to the difference between this marginal benefit and the market price the consumer pays. Total consumer surplus is the difference between marginal benefit and price for all quantities bought by consumers. Total consumer surplus is equal to the area below the demand curve and above the market price for the number of units consumed.

Marginal cost is the additional cost to a firm of producing one more unit of a good or service. The height of a market supply curve at a given quantity measures the marginal cost of this quantity. Producer surplus refers to the difference between this marginal cost and the market price the producer receives. Total producer surplus equals the area above the supply curve and below price for all quantities sold.

Study Hint

You probably have bought something you thought was a bargain. If you did, the difference between what you would have been willing to pay and what you did pay was your consumer surplus. Consumers differ in the value they place on the same item but typically pay the same price for the item. Those who value an item the most receive the most consumer surplus. For producers, the marginal cost of producing a good rises as more is produced, but the price producers receive remains constant. As a result, the difference between the price producers receive and their marginal cost of production—their producer surplus—falls as more is produced. Be sure you understand Figures 4.3 and 4.4 and the explanation of these figures in the textbook.

Extra Solved Problem 4.1

Consumer and Producer Surplus for the NFL Sunday Ticket

Supports Learning Objective 4.1: Distinguish between the concepts of consumer surplus and producer surplus.

DirecTV and the DISH Network are both providers of satellite television service, but only DirecTV offers its customers the option of subscribing to the NFL Sunday Ticket. In 2008, subscribers to this service paid \$299 for the right to watch every regular season NFL Sunday game broadcast, except for those games played on Sunday evenings. This option is especially attractive to fans who live in cities that do not offer regular broadcasts of the games of their favorite teams. Television stations typically offer games played by teams with the most local interest. A long-time fan of the New York Giants or Denver Broncos who moved to Illinois would have to settle for watching the Chicago Bears most Sunday afternoons—unless the fan had signed up for the DirecTV NFL Sunday Ticket.

Team Marketing Report estimated that the 2008 average ticket price for NFL games for all teams was \$72.20 and the per-game average Fan Cost was about \$396.36 (this includes four average price tickets, four small soft drinks, two small beers, four hot dogs, two game programs, parking, and two adult-size caps).

Use this information to estimate consumer and producer surplus for the NFL Sunday Ticket.

Source: www.teammarketing.com

Solving the Problem

Step 1: Review the chapter material.

This problem is about consumer and producer surplus, so you may want to review the section "Consumer Surplus and Producer Surplus," which begins on page 102 in the textbook.

Step 2: Identify the maximum price a consumer would pay for the NFL Sunday Ticket.

The consumers who benefit most from the NFL Sunday Ticket are those who have the strongest demand to watch their favorite team play on Sundays. Assume that an average season ticket holder found out prior to fall 2008 that he was being transferred by his employer to a location that required him to forgo season tickets for himself and three family members. Using the Team Marketing estimate, he would save \$396.36 for each home game that he and his family would no longer attend. If there are eight home games, then his total savings would be $$396.36 \times 8 = $3,170.80$. This is an estimate of the maximum price he would pay for the NFL Sunday Ticket. (Note that he would also be able to watch his team's away games but would probably be able to view these games from his home at no additional cost if he had not moved.)

4.2

Step 3: Estimate the value of consumer surplus.

For the average season ticket holder and his family, an estimate of the consumer surplus is: \$3,170.80 - \$299 = \$2,871.80. Each family member who no longer attended home games can watch these games at home.

Step 4: Identify the minimum price DirecTV would accept for the NFL Sunday Ticket.

The NFL Package is offered to existing DirecTV customers as an additional viewing option. Therefore, only trivial additional costs are incurred by DirecTV: the customer's billing must be adjusted to reflect this option and the service must be "switched on" for this customer. Assume that this cost is zero.

Step 5: Estimate the value of producer surplus.

Because DirecTV receives \$299 for the NFL Sunday Ticket, its producer surplus for this customer is: \$299 - \$0 = \$299.

The Efficiency of Competitive Markets (pages 106–109)

Learning Objective: Understand the concept of economic efficiency.

Economic surplus is the sum of consumer and producer surplus. **Economic efficiency** is a market outcome in which the marginal benefit to consumers of the last unit produced is equal to its marginal cost of production and where the sum of consumer and producer surplus is at a maximum. When equilibrium is reached in a competitive market, the marginal benefit equals the marginal cost of the last unit sold. This means that equilibrium is an economically efficient outcome.

If less than the equilibrium output were produced, the marginal benefit of the last unit bought would exceed its marginal cost. If more than the equilibrium quantity were produced, the marginal benefit of this last unit would be less than its marginal cost. We can also think of the concept of economic efficiency in terms of economic surplus. When in equilibrium, the willingness of the consumer to pay for the last unit is equal to the lowest price a firm will be willing to accept. If less than the equilibrium output were produced, the willingness to pay for the last unit bought would exceed the minimum price that firms would be willing to accept. If more than equilibrium quantity were produced, the willingness to pay for this last unit would be less than the minimum price that producers would accept. A **deadweight loss** is the reduction in economic surplus resulting from a market not being in competitive equilibrium.

Study Hint

Figure 4.7 illustrates the deadweight loss from producing at a point away from the equilibrium point in a competitive market. Keep in mind the idea that when the quantity of chai tea sold is 14,000 instead of 15,000, there is a loss of both producer surplus and consumer surplus. Consumers are hurt because there are 1,000 cups of tea they can't purchase even though the marginal benefit of those cups exceeds the equilibrium price. And producers are worse off because there are 1,000 cups of tea they aren't producing even though the price producers would receive for those cups at equilibrium exceeds the marginal cost of production.

Extra Solved Problem 4.2

Supports Learning Objective 4.2: Understand the concept of economic efficiency.

Suppose that the tickets for a Christina Aguilera concert just went on sale in your local area. The tickets are selling for \$35 each, the equilibrium price. Suppose that the willingness to pay of the last consumer to buy a ticket was \$50 and the minimum that the producer was willing to accept was \$20.

- a. Is this market outcome economically efficient?
- b. If not, what would need to occur for this market to become economically efficient?

Solving the Problem

Step 1: Review the chapter material.

This problem is about economic efficiency, so you may want to review the section "The Efficiency of Competitive Markets," which begins on page 106 in the textbook.

Step 2: Compare the minimum price that the concert producer is willing to accept to the price the consumer is willing to pay.

Because the value to the consumer of the last ticket sold is higher than the minimum price that the producer is willing to accept, the market is not efficient. The willingness to pay by the consumer must be equal to the minimum price that the producer is willing to accept in order for efficiency to be achieved.

Step 3: Determine what needs to occur in the market for the market to become efficient.

Because the willingness to pay is greater than the minimum the firm is willing to accept, there is additional consumer and producer surplus that could be gained by increasing the number of tickets sold. The number of tickets sold should increase until the willingness to pay of the last consumer is equal to the minimum that the producer is willing to accept.

4.3

Government Intervention in the Market: Price Floors and Price Ceilings (pages 109–116)

Learning Objective: Explain the economic effect of government-imposed price floors and price ceilings.

Though the sum of consumer and producer surplus is maximized at a competitive market equilibrium, individual consumers would be better off if they could pay a lower than equilibrium price, and individual producers would be better off if they could sell at a higher than equilibrium price. Consumers and producers sometimes lobby government to legally require a market price different from the equilibrium price. These lobbying efforts are sometimes successful. During the Great Depression of the 1930s, farm prices fell to very low levels. Farmers were able to convince the federal government to raise prices by setting price floors for many agricultural prices.

A **price floor** is a legally determined minimum price that sellers may receive. A price floor encourages producers to produce more output than consumers want to buy at the floor price. The government often buys the surplus, which is equal to the quantity supplied minus the quantity demanded, at the floor price. The government may also pay farmers to take some land out of cultivation, which would decrease supply. The marginal cost of production exceeds the marginal benefit, and there is a deadweight loss, which represents a decline in efficiency due to the price floor.

Study Hint

In this chapter's *Making the Connection* "Price Floors in Labor Markets: The Debate over Minimum Wage Policy," the minimum wage is identified as an example of a price floor. While there is some debate about the extent of employment losses from the minimum wage, the minimum wage—like any price floor set above equilibrium—will result in inefficiency. This inefficiency comes from two sources. Some of the labor surplus (unemployment) resulting from higher minimum wages comes from reductions in firm willingness to hire workers at higher wages (a decrease in the quantity of labor the firm demands), but some of the unemployment also comes from a higher number of workers entering the labor market (an increase in the quantity of labor supplied). Higher wages increase the incentive for people who may not have been looking for work before the wage increase to start searching for a job. The entire difference between the new quantity of labor supplied by households and the new quantity of labor demanded by firms is the measure of unemployment.

Also, keep in mind that the focus here is not on evaluating whether the minimum wage is "good" or "bad." Those are questions for normative analysis, as defined in Chapter 1. The focus here is on the positive analysis of the impact, if any, the minimum wage will have on employment and efficiency.

A **price ceiling** is a legally determined maximum price that sellers may charge. Price ceilings are meant to help consumers who lobby for lower prices. Consumers typically lobby for price ceilings after a sharp increase in the price of an item on which they spend a significant amount of their budgets (for example, rent or gasoline). At the ceiling price, the quantity demanded is greater than the quantity supplied so that the marginal benefit of the last item sold (the quantity supplied) exceeds the marginal cost of producing it. Price ceilings result in a deadweight loss and a reduction of economic efficiency. Price ceilings create incentives for **black markets**, in which buying and selling take place at prices that violate government price regulations.

With any price floor or price ceiling, there are winners and losers from the policy. The deadweight loss associated with a given policy tells us that the gains to the winners are outweighed by the losses to the losers.

Study Hint

An interesting question to consider is why politicians maintain agricultural price supports despite the significant costs their constituents pay for these programs. Part of the explanation is that because each individual incurs a small fraction of the total cost, it is hardly worth the trouble to register a complaint to lawmakers. But the benefits of price floors are concentrated among a few producers who have a strong incentive to lobby for the continuation of the price supports. Politicians act quite rationally by ignoring the interests of those who pay for these programs.

However, you may be swayed by the argument that a price ceiling is justified because its intent is to help low-income consumers afford a specific product. Though some low-income consumers may be among those who buy the product, there is no guarantee of this. For example, as mentioned in the text, a black market may arise, resulting in consumers paying at least as much as they would in the absence of the price ceiling. Or, given a shortage of apartments, a landlord can choose tenants based on their physical characteristics or their lifestyles. Suppose you were a landlord who owned an apartment subject to rent control. As a result, there are five potential tenants for one apartment you have to rent. The potential tenants include a male college student, a single female school teacher with a pet dog, a low-income retail worker with a spouse and two children, a medical doctor, and a lawyer. Assume that you can select any one of these as your tenant. Would you select the retail worker? What about the college student?

4.4

The Economic Impact of Taxes (pages 116-121)

Learning Objective: Analyze the economic impact of taxes.

Government taxes on goods and services reduce the quantity produced. A tax imposed on producers of a product will shift the supply curve up by the amount of the tax. Consumers pay a higher price for the product, and there will be a loss of consumer surplus. Because the price producers receive after paying the tax falls, there is also a loss of producer surplus. The imposition of a tax will also cause a deadweight loss. **Tax incidence** is the actual division of the burden of the tax between buyers and sellers. The incidence of a tax is not dependent on who is legally required to collect and pay the tax. Tax incidence is determined by the degree to which the market price rises as a result of a tax. This rise, in turn, is determined by the willingness of suppliers to change the quantity of the good or service they offer and the willingness of consumers to change their quantity demanded as a result of the tax. If more than half of the tax is paid for by consumers in the form of higher prices, then the burden of the tax falls on the consumers. If less than half of the tax is paid for by consumers in the form of higher prices, then the burden of the tax falls on suppliers.

Study Hint

Estimating the impact of cigarette taxes is more complicated than it appears from Figure 4.10. This is because state excise taxes on cigarettes vary widely. In 2013, the tax per pack ranged from 30 cents in Virginia to \$4.35 in New York. In addition, some counties and cities impose their own taxes. The variation in taxes creates a black market that reduces legal sales of cigarettes and tax revenue in states with the highest tax rates. Bootleggers can earn illegal profits by buying cigarettes in states with low tax rates and selling them to retail stores in states with the highest taxes.

Appendix

Quantitative Demand and Supply Analysis (pages 131–134)

Learning Objective: Use quantitative demand and supply analysis.

Quantitative analysis supplements the use of demand and supply curves with equations. An example of the demand and supply for apartments in New York City is:

$$Q^{S} = -450,000 + 1,300P$$

$$Q^{\rm D} = 3,000,000 - 1,000P.$$

 $Q^{\rm D}$ and $Q^{\rm S}$ are the quantity demanded and quantity supplied of apartments per month, respectively. The coefficient of P in the first equation equals the change in quantity supplied for a one dollar per month change in price.

$$\frac{\Delta Q^{\rm S}}{\Delta P}$$
 = 1,300

The coefficient of the price term in the second equation equals the change in quantity demanded for a one dollar per month change in price.

$$\frac{\Delta Q^{\rm S}}{\Delta P} = -1,000$$

At the competitive market equilibrium, quantity demanded equals quantity supplied.

$$Q^{D} = Q^{S}$$
 or $3,000,000 - 1,000P = -450,000 + 1,300P$

Rearranging terms and solving for P yields the price at which quantity demanded equals the quantity supplied. This is the equilibrium price.

$$3,000,000 + 450,000 = 1,300P + 1,000P$$

 $3,450,000 = 2,300P$
 $P = $1,500$

Substituting the equilibrium price into the equation for either demand or supply yields the equilibrium quantity.

$$Q^{D} = 3,000,000 - 1,000(1,500)$$

$$Q^{D} = 3,000,000 - 1,500,000$$

$$Q^{D} = 1,500,000$$

$$Q^{S} = -450,000 + 1,300P$$

$$Q^{S} = -450,000 + 1,300 (1,500)$$

$$Q^{S} = 1,500,000$$

The demand equation can be used to determine the price at which the quantity demanded is zero.

$$Q^{\rm D} = 3,000,000 - 1,000P$$

$$0 = 3,000,000 - 1,000P$$
$$-3,000,000 = -1,000P$$
$$P = (-3,000,000)/(-1,000)$$
$$P = \$3,000$$

The supply equation can be used to determine the price at which the quantity supplied equals zero.

$$Q^{S} = -450,000 + 1,300P$$
$$0 = -450,000 + 1,300P$$
$$450,000 = 1,300P$$
$$P = $346.15$$

Study Hint

The equations highlight an oddity of demand and supply analysis. The dependent variable in most graphs is the y variable—the variable measured along the vertical axis—while the independent, or x variable, is measured along the horizontal axis. Economists assume that price changes cause changes in quantity, so the price is the independent variable. However, for historical reasons, our demand and supply graphs have it backwards, with price on the vertical axis and quantity on the horizontal axis. Make sure you recognize that even though the equations for demand and supply may be written to solve for the dependent variable O^D or O^S , those values are actually graphed on the x axis, not the y axis.

Calculating Consumer Surplus and Producer Surplus

Demand and supply equations can be used to measure consumer and producer surplus. Figure 4A.1 uses a graph to illustrate demand and supply. Because the demand curve is linear, consumer surplus is equal to the area of the blue triangle in Figure 4A.1. The area of a triangle is $\frac{1}{2}$ multiplied by the base of the triangle multiplied by the height of the triangle, or:

$$\frac{1}{2} \times (1,500,000) \times (3000 - 1,500) = \$1,125,000,000.$$

Producer surplus is calculated in a similar way. Producer surplus is equal to the area above the supply curve and below the line representing market price. The supply curve is a straight line, so producer surplus equals the area of the right triangle:

$$\frac{1}{2}$$
 × (1,500,000) × (1,500 – 346) = \$865,500,000.

Producer surplus in the market for rental apartments in New York City is about \$865 million.

Economic surplus is the sum of the consumer surplus and the producer surplus, so economic surplus is as follows:

$$1,125,000,000 + 865,500,000 = 1,990,500,000.$$

Key Terms

Black market A market in which buying and selling take place at prices that violate government price regulations.

Consumer surplus The difference between the highest price a consumer is willing to pay for a good or service and the price the consumer actually pays.

Deadweight loss The reduction in economic surplus resulting from a market not being in competitive equilibrium.

Economic efficiency A market outcome in which the marginal benefit to consumers of the last unit produced is equal to its marginal cost of production and in which the sum of consumer surplus and producer surplus is at a maximum.

Economic surplus The sum of consumer surplus and producer surplus.

Marginal benefit The additional benefit to a consumer from consuming one more unit of a good or service.

Marginal cost The additional cost to a firm of producing one more unit of a good or service.

Price ceiling A legally determined maximum price that sellers may charge.

Price floor A legally determined minimum price that sellers may receive.

Producer surplus The difference between the lowest price a firm would be willing to accept for a good or service and the price it actually receives.

Tax incidence The actual division of the burden of a tax between buyers and sellers in a market.

Self-Test

(Answers are provided at the end of the Self-Test.)

Multiple-Choice Questions

- 1. What is the name of a legally determined minimum price that sellers may receive?
 - a. a price ceiling
 - b. a price floor
 - c. marginal benefit
 - d. consumer surplus
- 2. What is the name of a legally determined maximum price that sellers may charge?
 - a. a price ceiling
 - b. a price floor
 - c. marginal benefit
 - d. consumer surplus

- 3. Some people believe there should be legally determined minimum prices for farm products such as milk. A limit on the price of milk would be an example of
 - a. a price floor.
 - b. a price ceiling.
 - c. an equilibrium price.
 - d. a black market.
- 4. In response to information regarding the salaries of executives at firms receiving bailout funds in the United States, some people called for a limit on the salaries paid to executives. Such a limit on the compensation executives can receive is an example of
 - a. a price floor.
 - b. a price ceiling.
 - c. an equilibrium price.
 - d. a black market.
- 5. Which of the following is the definition of consumer surplus?
 - a. the additional benefit to a consumer from consuming one more unit of a good or service
 - b. the additional cost to a firm of producing one more unit of a good or service
 - c. the difference between the highest price a consumer is willing to pay and the price the consumer actually pays
 - d. the difference between the lowest price a firm would have been willing to accept and the price it actually receives
- 6. Which of the following is the definition of producer surplus?
 - a. the additional benefit to a consumer from consuming one more unit of a good or service
 - b. the additional cost to a firm of producing one more unit of a good or service
 - c. the difference between the highest price a consumer is willing to pay and the price the consumer actually pays
 - d. the difference between the lowest price a firm would have been willing to accept and the price it actually receives
- 7. Which of the following is the definition of marginal benefit?
 - a. the additional benefit to a consumer from consuming one more unit of a good or service
 - b. the additional cost to a firm of producing one more unit of a good or service
 - c. the difference between the highest price a consumer is willing to pay and the price the consumer actually pays
 - d. the difference between the lowest price a firm would have been willing to accept and the price it actually receives
- 8. Which of the following is the definition of marginal cost?
 - a. the additional benefit to a consumer from consuming one more unit of a good or service
 - b. the difference between the highest price a consumer is willing to pay and the price the consumer actually pays
 - c. the additional cost to a firm of producing one more unit of a good or service
 - d. the difference between the lowest price a firm would have been willing to accept and the price it actually receives

9. Refer to the graph below. What name other than demand curve can you give this curve?

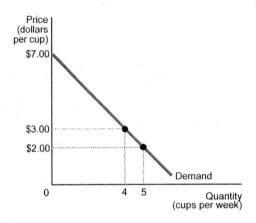

- a. the marginal cost curve
- b. the marginal benefit curve
- c. consumer surplus
- d. the deadweight loss curve
- 10. Refer to the graph below. The graph shows an individual's demand curve for coffee. At a price of \$3.00, the consumer is willing to buy four cups of coffee per week. More precisely, what does this mean?

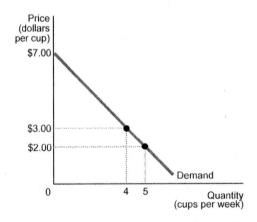

- a. Marginal benefit equals marginal cost when four cups are consumed.
- b. The total cost of consuming four cups is \$3.00.
- c. The marginal cost of producing the fourth cup is \$3.00.
- d. The marginal benefit of consuming the fourth cup is \$3.00.

11. Refer to the graph below. The graph shows an individual's demand curve for coffee. If the price is \$2.00, what is consumer surplus for the fourth cup of coffee?

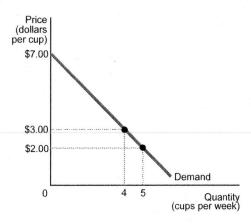

- a. \$3.00
- b. \$2.00
- c. \$1.00
- d. \$0
- 12. Refer to the graph below. The graph shows an individual's demand curve for coffee. If the price is \$3.00, what is consumer surplus for the fourth cup of coffee?

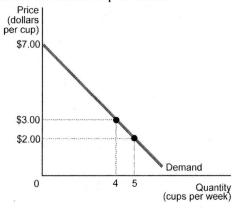

- a. \$3.00
- b. \$2.00
- c. \$1.00
- d. \$0
- 13. If the average price that cable subscribers are willing to pay for satellite TV service is \$200, but the actual price they pay is \$80, how much is consumer surplus per subscriber?
 - a. \$200 + \$80 = \$280
 - b. \$200 \$80 = \$120 c. \$200
 - d. \$80

14. Refer to the graph below. The graph shows the market demand for satellite TV service. If the market price is \$81, which consumers receive consumer surplus in this market?

- a. those willing to pay something less than \$81
- b. those willing to pay exactly \$81
- c. those willing to pay more than \$81
- d. all of the above
- 15. Refer to the graph below. When market price is \$2.00, what is *producer surplus* from selling the fortieth cup?

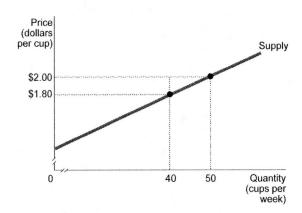

- a. \$72.00
- b. \$1.80
- c. \$0.20
- d. \$36.00

16. Refer to the graph below. How much is the marginal cost of producing the fiftieth cup?

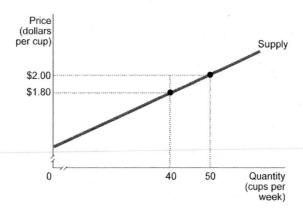

- a. \$100.00
- b. \$0.20
- c. \$2.00
- d. None of the above; there is insufficient information to answer the question.

17. Refer to the graph below. To achieve economic efficiency, which output level should be produced?

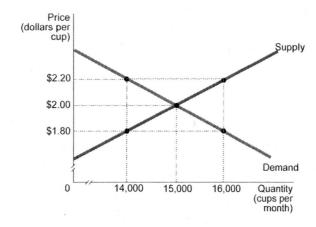

- a. 14,000 cups should be produced per month because, at this level of output, marginal benefit is greater than marginal cost.
- b. 15,000 cups should be produced per month because, at this level of output, marginal benefit is equal to marginal cost.
- c. 16,000 cups should be produced per month because, at this level of output, marginal benefit is less than marginal cost
- d. All of the output levels above are efficient.

18. Refer to the graph below. To achieve economic efficiency, the level of output should be reduced when the quantity of cups produced equals

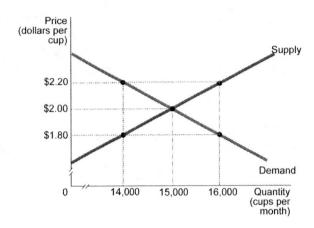

- a. 14,000.
- b. 15,000.
- c. 16,000.
- d. the quantity of cups demanded.
- 19. Refer to the graph below and fill in the blanks. When 14,000 cups of coffee are produced per month, the marginal benefit of the 14,000th cup of coffee is ______, the marginal cost of the 14,000th cup of coffee is ______.

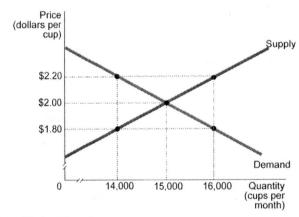

- a. \$1.80; \$1.80; at the efficient level
- b. \$2.20; \$2.20; above the efficient level
- c. \$2.20; \$1.80; below the efficient level
- d. \$1.80; \$2.20; above the efficient level

20. Refer to the graph below. When 15,000 cups of coffee are produced and consumed per month, which of the following is true?

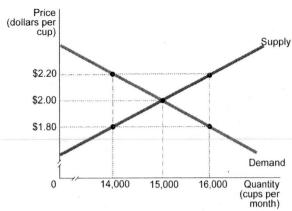

- a. The sum of consumer and producer surplus is maximized.
- b. The level of output is economically efficient.
- c. The marginal benefit to buyers of the last cup of tea is equal to the marginal cost of producing the last cup of tea.
- d. All of the above are true.
- 21. When is output lower than the efficient level?
 - a. when marginal benefit is greater than marginal cost
 - b. when marginal cost is greater than marginal benefit
 - c. when marginal cost is equal to marginal benefit
 - d. All of the above; any output level can be lower than the efficient level.
- 22. When a competitive market is in equilibrium, what is the economically efficient level of output?
 - a. any output level where marginal benefit is greater than marginal cost
 - b. any output level where marginal cost is greater than marginal benefit
 - c. the output level where marginal cost is equal to marginal benefit
 - d. all of the above
- 23. What does the sum of consumer surplus and producer surplus equal?
 - a. economic efficiency
 - b. economic surplus
 - c. deadweight loss
 - d. competitive equilibrium

24. Refer to the graph below. Assume this is a competitive market. Which of the following *does not* exist when the price is \$2.00?

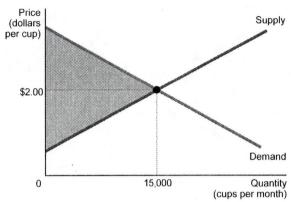

- a. economic efficiency
- b. economic surplus
- c. deadweight loss
- d. competitive equilibrium
- 25. Refer to the graph below. Compared to the competitive equilibrium, how much producer surplus is lost when the price is \$2.20?

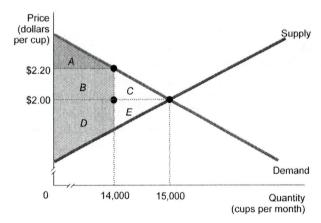

- a. area E
- b. area C + E
- c. area D
- d. area B + D

26. Refer to the graph below. Which area equals producer surplus when price is \$2.20?

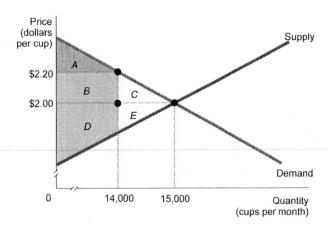

- a. area E
- b. area C + E
- c. area D + E
- d. area B + D
- 27. Refer to the graph below. Which area equals consumer surplus when price is \$2.00?

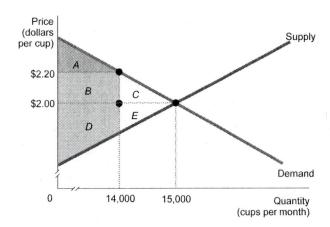

- a. area A
- b. area B + C
- c. area A + B + C
- d. area B + C + D

28. Refer to the graph below. Which area equals consumer surplus when price is \$2.20?

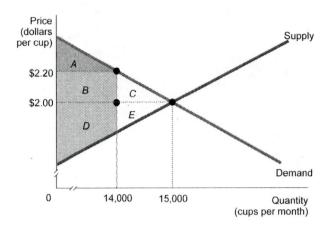

- a. area A
- b. area B
- c. area C
- d. area D
- 29. Refer to the graph below. If 14,000 cups of coffee are produced, what area corresponds to deadweight loss?

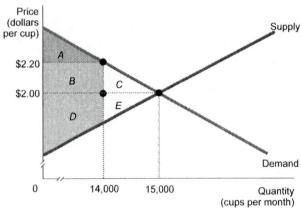

- a. A+B+C
- b. B + C
- c. C
- d. C + E

30. Refer to the graph below. After a price of \$3.50 is imposed by the government in this market, what meaning do we give to area A?

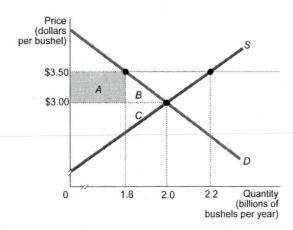

- a. Area A is consumer surplus transferred to producers.
- b. Area A is additional consumer surplus that goes to existing consumers in the market.
- c. Area A is a deadweight loss.
- d. Area A is a surplus of wheat.
- 31. Refer to the graph below. After a price of \$3.50 is imposed by the government in this market, what meaning do we give to area B + C?

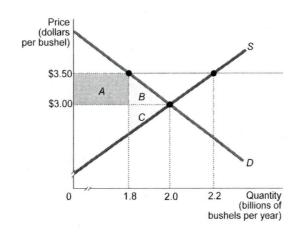

- a. producer surplus transferred to consumers
- b. additional consumer surplus to existing consumers in the market
- c. deadweight loss
- d. a surplus of wheat

32. Refer to the graph below. According to this graph, the existence of a minimum wage in the market for low-skilled workers results in

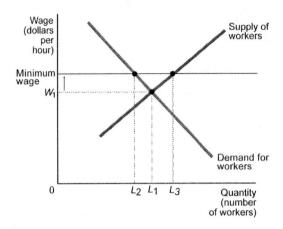

- a. an increase in wages and employment.
- b. an increase in wages but lower employment.
- c. a decrease in wages but higher employment.
- d. a decrease in wages and employment.
- 33. Refer to the graph below. According to this graph, the existence of a minimum wage in the market for low-skilled workers results in

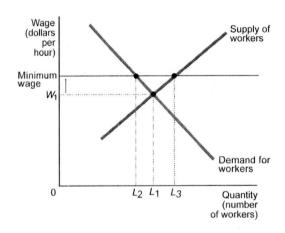

- a. a shortage of workers.
- b. a surplus of workers.
- c. neither a shortage nor a surplus of workers.
- d. a scarcity of workers.

34. Refer to the graph below. After rent control is imposed, area A represents:

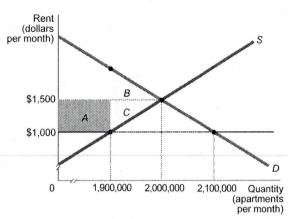

- a. consumer surplus transferred from renters to landlords.
- b. producer surplus transferred from landlords to renters.
- c. a deadweight loss.
- d. a shortage of apartments.
- 35. Refer to the graph below. After rent control is imposed, which area represents a deadweight loss?

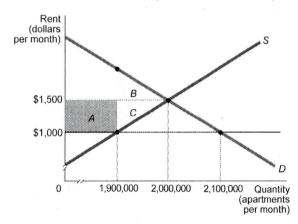

- a. A
- b. A+B+C
- c. B+C
- d. an area other than A, B, or C
- 36. Which of the following statements is correct about a shortage?
 - a. There is a shortage of every good that is scarce.
 - b. There is no shortage of most scarce goods.
 - c. Scarcity and shortage mean the same thing to economists.
 - d. None of the above statements is correct.
- 37. Which of the following terms corresponds to a market in which buying and selling take place at prices that violate government price regulations?
 - a. price conspiracy
 - b. equilibrium
 - c. competitive market
 - d. black market

38. Refer to the graph below. Suppose that this market is operating under the established rent control of \$1,000 per month. Then a black market for rent-controlled apartments develops, and the apartments rent for \$2,000 per month. What meaning does the sum of areas A + E have in this situation?

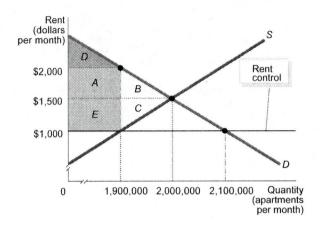

- a. consumer surplus transferred from renters to landlords
- b. producer surplus transferred from renters to landlords
- c. deadweight loss
- d. a surplus of apartments
- 39. Refer to the graph below. When a black market for rent-controlled apartments develops, what is the area of deadweight loss?

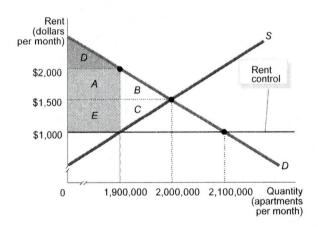

- a. none; the deadweight loss disappears.
- b. B + C
- c. A + E
- d. D
- 40. When the government imposes price floors or price ceilings, which of the following occurs?
 - a. Some people win.
 - b. Some people lose.
 - c. There is a loss of economic efficiency.
 - d. All of the above occur.

- 41. The term tax incidence refers to
 - a. the type of product the tax is levied on.
 - b. the amount of revenue collected by the government from a tax.
 - c. the actual division of the burden of a tax between buyers and sellers in a market.
 - d. the actual versus the desired impact of a tax burden.
- 42. Refer to the graph below. A tax is imposed in this market that shifts the supply curve from S_1 to S_2 . What price do producers receive after this tax is imposed?

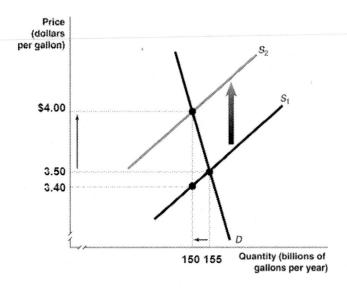

- a. \$4.00
- b. \$3.50
- c. \$3.40
- d. \$0.10
- 43. Refer to the graph below. A tax is imposed in this market that shifts the supply curve from S_1 to S_2 . What area corresponds to the reduction in economic surplus as a result of the tax?

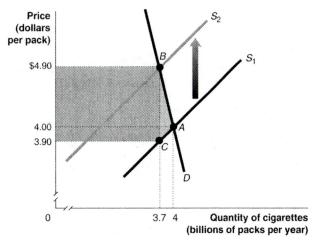

- a. the dark gray area
- b. the light gray area
- c. the sum of the dark gray and light gray areas
- d. an area not shown on this graph

44. Refer to the graph below. A tax is imposed in this market that shifts the supply curve from S_1 to S_2 . What area corresponds to the revenue collected by the government from the tax?

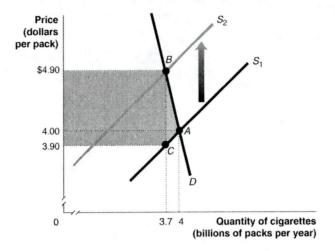

- a. the dark gray area
- b. the light gray area
- c. the sum of the dark gray and light gray areas
- d. an area not shown on this graph
- 45. Refer to the graph below. A tax is imposed in this market that shifts the supply curve from S_1 to S_2 . In this graph, how much of the gas tax do consumers pay?

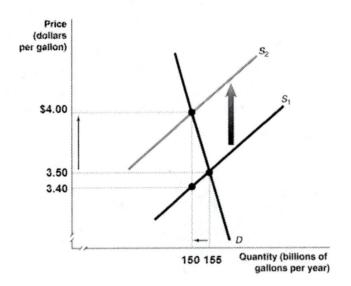

- a. 60 cents per gallon
- b. 50 cents per gallon
- c. 10 cents per gallon
- d. \$3.40 per gallon

46. Refer to the graphs below. In each of the graphs, a curve has shifted as a result of a new social security tax. In which graph does the employer pay the entire social security tax?

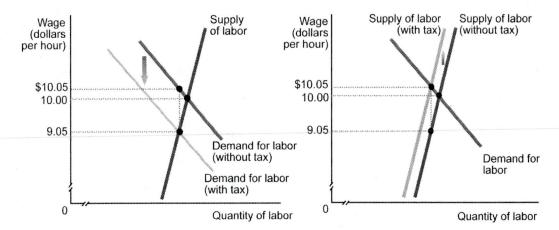

- a. in the graph on the left
- b. in the graph on the right
- c. in both cases
- d. in neither case
- 47. Refer to the graphs below. In each of the graphs, a curve has shifted as a result of a new social security tax. In which graph do the workers pay the entire social security tax?

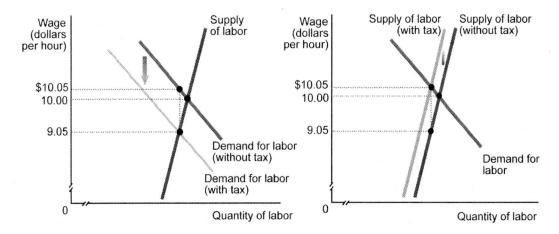

- a. in the graph on the left
- b. in the graph on the right
- c. in both cases
- d. in neither case

48. Refer to the graphs below. In each of the graphs, a curve has shifted as a result of a new social security tax. In which graph is the tax incidence on workers larger?

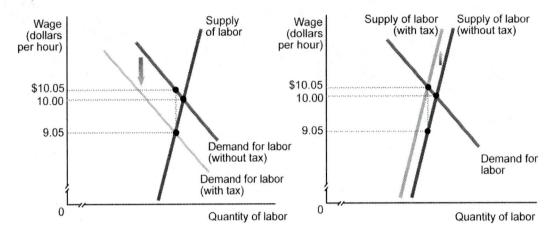

- a. in the graph on the left
- b. in the graph on the right
- c. The workers are not affected by the tax in either case.
- d. In both cases the tax incidence is the same.
- 49. Refer to the graph below. What is the deadweight loss associated with the 60-cent tax on gasoline?

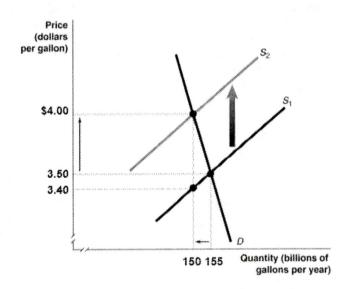

- a. \$2 billion
- b. \$1 billion
- c. \$1.2 billion
- d. \$500 million

50. Refer to the graph below. A tax imposed in the market for cigarettes shifts supply from S_1 to S_2 . What is the excess burden of the cigarette tax?

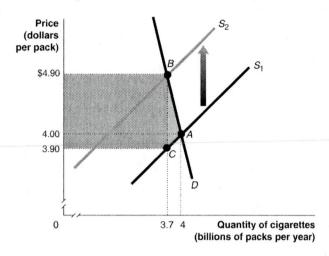

- a. \$300 million
- b. \$150 million
- c. \$270 million
- d. \$30 million

Short Answer Questions

1.	Some economists oppose raising the minimum wage because they believe this would lead to a significant increase in unemployment among low-skilled workers. Is there an alternative to a higher minimum wage to raise the incomes of the working poor? Why do some economists favor raising the minimum wage?					
2.	Federal and state governments periodically raise excise taxes on cigarettes. Politicians often argue that these tax increases discourage smoking. What other motive is there for raising taxes on cigarettes?					
3.	One effect of rent control in San Francisco is a reduction in the number of apartment buildings. In rent control were eliminated, would this result in an increase in the number of apartment buildings and, therefore, lower rents for apartment dwellers?					

						-	
		igs igs		l sarp.	V 4	1	
Section of the sectio	AND THE PROPERTY OF THE PARTY O						
The federal go from price flo they devoted	ors. One sutto planting of	ch attempt v crops subjec	was a progret to price f	ram that pa loors. Wha	id farmers t was the i	to reduce to reason for the	ses that result he amount of he failure of the er this question

True False Questions

- T F 1. The total amount of consumer surplus in a market is equal to the area under the demand curve.
- T F 2. The U.S. government's farm program has increased economic efficiency by raising the quantity supplied of agricultural products above the market equilibrium without the program.
- T F 3. The minimum wage causes an increase in employment of low-skilled workers.
- T F 4. A price control results in a deadweight loss in society because everyone in the market loses as a result of the government policy.
- T F 5. The incidence of a tax depends on whether the government collects the tax for a good from the buyers or from the sellers.
- T F 6. The deadweight loss from a tax is equal to the revenue collected by government from the tax.
- T F 7. Consumers will pay all of an increase in a sales tax only if the demand curve is a horizontal line at the market price.
- T F 8. Economists who have studied the incidence of the social security tax have found that the tax burden is shared equally by employers and their employees.
- T F 9. A tax is efficient if it imposes a small excess burden relative to the tax revenue it raises.
- T F 10. One effect of rent control in New York City and London has been a large reduction in the number of apartment buildings.
- T F 11. The Freedom to Farm Act was passed in Congress in 1996 to phase out price floors and government purchases of agricultural surpluses.
- T F 12. Producer surplus refers to the surplus goods that result from price floors.
- T F 13. Positive economic analysis is used to determine the economic results of price ceilings and price floors. Whether these price controls are desirable is a normative question.

- T F 14. If a black market occurs as a result of a price floor imposed by the government, then prices in the black market will be lower than the regulated price.
- T F 15. Economic efficiency results when the total benefit to consumers is equal to the total cost of production.

Answers to the Self-Test

Multiple-Choice Questions

Question	Answer	Comment
1.	b	This is the definition of a price floor. See page 102 in the textbook.
2.	a	This is the definition of a price ceiling. See page 102 in the textbook.
3.	a	See page 102 in the textbook for the meaning of a price floor.
4.	b	See page 102 in the textbook for the meaning of a price ceiling.
5.	c	See page 102 in the textbook for the definition of consumer surplus.
6.	d	See page 105 in the textbook for the definition of producer surplus.
7.	a	See the definition of marginal benefit on page 102 in the textbook.
8.	c	See the definition of marginal cost on page 105 in the textbook.
9.	b	Marginal benefit is the additional benefit to a consumer from consuming one more unit of a good or service, and price is a measure of that additional benefit, so the demand curve is also the marginal benefit curve.
10.	d	The willingness of a consumer to pay \$2 for five cups of coffee per week means that the fifth cup consumed is worth exactly \$2.00 to the consumer.
11.	c	The fourth cup of coffee has a marginal benefit of \$3, and the consumer pays \$2 for that cup, so consumer surplus is the difference of \$1.
12.	d	The fourth cup of coffee has a marginal benefit of \$3, and the consumer pays \$3 for that cup, so consumer surplus is the difference of \$0.
13.	b	Consumer surplus is the difference between the price a consumer is willing to pay (\$200) and the price actually paid (\$80).
14.	С	These consumers participate in the market and receive consumer surplus equal to the difference between the highest price the consumers are willing to pay and the price they actually paid.
15.	c	Producer surplus is the difference between the lowest price a firm would have been willing to accept (\$1.80) and the price it actually receives (\$2.00).
16.	c	Price equals marginal cost, or the additional cost to a firm of producing one more unit of a good or service.
17.	b	To achieve efficiency, output should be produced up until the marginal benefit to consumers is equal to the marginal cost to producers.
18.	С	In this case, decreasing the level of output would increase efficiency. As output decreases, the gap between marginal cost and marginal benefit decreases, until the two are equal at 15,000 units of output.

Question	Answer	Comment
19.	С	Marginal benefit comes from the demand curve; marginal cost comes from the supply curve. When marginal benefit is greater than marginal cost, output is less than the efficient level.
20.	d	At equilibrium, marginal benefit equals marginal cost, and efficiency is achieved, which also implies that the sum of consumer and producer surplus is maximized.
21.	a	Marginal benefit is greater than marginal cost when the quantity of output produced is less than the equilibrium level of output.
22.	c	When competitive markets are in equilibrium, marginal benefit equals marginal cost, and the quantity of output produced and sold is economically efficient.
23.	b	Economic surplus equals the sum of consumer surplus and producer surplus. See page 107 in the textbook.
24.	С	The equilibrium output level yields maximum economic efficiency; the market is in equilibrium, and the sum of consumer surplus and producer surplus yields the largest possible value. There is no deadweight loss.
25.	a	Area E is the producer portion of the deadweight loss.
26.	d	At a price of \$2.20, only 14,000 cups will be produced per month. Producer surplus is the area below the \$2.20 price and above the supply curve up to the 14,000 cups. This area is the trapezoid that includes areas B and D .
27.	c	Consumer surplus is the area below the demand curve and above the price out to the number of units sold.
28.	a	Consumer surplus is the area below the demand curve and above the market price.
29.	d	Deadweight loss is the combination of lost consumer surplus (area C) and lost producer surplus (area E).
30.	a	Producers capture some of the consumer surplus after market price increases to \$3.50.
31.	С	After the price of \$3.50 is imposed by government, some producers and consumers no longer participate in the market, so a deadweight loss is created.
32.	b	The minimum wage causes an excess of quantity supplied over quantity demanded, which corresponds to additional unemployment.
33.	b	The minimum wage causes an excess of quantity supplied over quantity demanded, or a surplus of workers.
34.	b	The lower price at which the first 1,900,000 apartments are rented benefits consumers who would have paid more in the absence of the rent control. So producer surplus is transferred from landlords to renters.
35.	C	In the absence of the rent control, more landlords and renters would have participated in the market. This area shows that loss.
36.	b	Scarcity and shortage are not the same thing. A shortage is the difference between quantity demanded and quantity supplied of a good when the market price is below the equilibrium price. Scarcity exists as long as the resources used to produce one thing could be used to produce another. There is no shortage of most scarce goods.
37.	d	A market where buying and selling take place at prices that violate government price regulations is a black market. See page 113 in the textbook.
38.	a	Renters would have paid \$1,000 but now pay more. When price rises, consumer surplus decreases and producer surplus increases.
39.	b	The black market does not change the deadweight loss.

Question	Answer	Comment
40.	d	Price controls have the consequences mentioned in all of these answers.
41.	c	Tax incidence is the actual division of the burden of a tax between buyers and sellers in a market. See page 117 in the textbook.
42.	c	Producers charge a price of \$4.00 and give the government \$0.60, leaving them effectively with \$3.40 per gallon sold.
43.	Ь	The excess burden from the tax is equivalent to the deadweight loss created by the tax.
44.	a	That amount of revenue equals $(\$4.90 - \$3.90) \times 3.7 = \$3.7$ billion.
45.	b	Consumers pay a price of \$4.00, which is a \$0.50 increase in price from the \$3.50 equilibrium price. Producers receive \$4.00 from consumers, pay \$0.60 to the government, and keep \$3.40 per pack.
46.	d	Although the graph on the left shows that the firms are legally required to pay the tax, the legal requirement to pay a tax does not determine tax incidence. In both cases, workers see a \$0.95 decrease in their wage after the tax, and employers see a \$0.05 increase in the wage they pay their workers after the tax.
47.	d	Although the graph on the right shows that the workers are legally required to pay the tax, the legal requirement to pay a tax does not determine tax incidence. In both cases, workers see a \$0.95 decrease in their wage after the tax, and employers see a \$0.05 increase in the wage they pay their workers after the tax.
48.	d	It does not matter who pays the tax to the government, the tax incidence will remain the same. In both cases, workers see a \$0.95 decrease in their wage after the tax, and employers see a \$0.05 increase in the wage they pay their workers after the tax.
49.	c	Deadweight loss is the area of two triangles. The first triangle has a height from \$3.50 to \$4.00 (height = \$0.50) and a base from 150 billion to 155 billion (base = 5 billion). Using the formula for the area of a triangle: $\frac{1}{2}$ base × height = $\frac{1}{2}$ × \$0.50 × 4 billion = \$1 billion. The second triangle has a height from \$3.40 to \$3.50 (height = \$0.10) and a base from 150 billion to 155 billion (base = 5 billion).
		Using the formula for the area of a triangle: $\frac{1}{2}$ base \times height = $\frac{1}{2}$ \times \$0.10 \times 4 billion = \$0.2 billion. The sum of the two areas is \$1 billion + \$0.2 billion = \$1.2 billion.
50.	b	The area of the triangle that equals the deadweight loss (excess burden) of the tax is equal to $\frac{1}{2} \times 0.3$ billion \times \$1 = \$150 million

Short Answer Responses

1. Opponents of the minimum wage argue that raising the minimum wage will reduce employment, especially among workers with the least skills. An alternative policy is the earned income tax credit. Workers who do not owe any federal taxes receive payments from the federal government. This program increases the incomes of low-skilled workers without the risk of increasing unemployment. Despite these arguments against the minimum wage and the evidence from positive economic analysis that a higher minimum wage reduces employment, some economists still favor raising the minimum wage. They base their argument on normative economics. First, they believe the benefits of higher wages to those still employed outweigh the costs to those thrown into unemployment. This is a value judgment; you are free to agree or disagree. Second, they argue that many low-income workers miss the earned income tax credit because they don't file tax returns.

- 2. Because cigarettes are addictive, many smokers will pay higher prices for cigarettes rather than reduce the quantity they purchase. This results in greater government revenue from the cigarette taxes. Taxes on cigarettes and alcohol (often called "sin taxes") do not affect as many people as a sales tax or income tax. Therefore, politicians do not face as much public opposition to tax increases on these products.
- 3. Although this result is likely to occur eventually, it will take time for the elimination of rent controls to affect the quantity of apartments in San Francisco. The immediate effect would likely be an increase in rents on existing apartments. This is one reason why many San Francisco residents oppose the elimination of rent control.
- 4. A tax does not reduce economic efficiency if it imposes a small excess burden relative to the tax revenue it generates. The example in *Solved Problem 4.4* shows this case: When the demand curve is a vertical line, consumers bear the entire tax burden by paying all of the tax increase. The loss in consumer surplus is identical to the gain in tax revenue that the government collects. As the equilibrium quantity after the tax increase remains the same as the equilibrium quantity before the tax increase, there is no loss in economic efficiency.
- 5. The "important idea" that can be used to answer this question is: people respond to economic incentives. Given the opportunity to reduce the amount of land they used to grow crops, many farmers removed their least productive land from production and planted more on the land they did use. This program resulted in greater money payments to farmers—for the land they did not cultivate—and a smaller than expected reduction in crops harvested and sold.

True/False Answers

Question	Answer	Comment
1.	F	The total amount of consumer surplus in a market is equal to the area under the demand curve above the market price.
2.	F	The U.S. farm program creates price floors on agricultural goods. The price floors, or supported prices, benefit farmers but hurt consumers. Because the loss in consumer surplus exceeds the gain in producer surplus, the program reduces the amount of economic surplus in the markets.
3.	F	The minimum wage is a price floor, which reduces the quantity of labor demanded particularly in the market for low-skilled labor.
4.	F	While price controls result in a loss of economic efficiency in society, or deadweight loss, some people do gain in the market. For instance, price floors in agricultural markets benefit those farmers who are able to sell their products at prices higher than the market equilibrium prices without the price floors.
5.	F	The actual division of a tax between buyers and sellers of a good in a market does not depend on whether the government collects the tax from the buyers or the sellers. See page 117 in the textbook.
6.	F	Government revenue is not a deadweight loss. This revenue will be used to provide goods and services to the economy.
7.	F	Consumers will pay all of an increase in a sales tax if the demand curve is a vertical line.
8.	F	Economists have found that the burden falls almost entirely on workers.
9.	T	See page 116 in the textbook.

Question	Answer	Comment
10.	T	Landlords often sell or convert their buildings to other uses to avoid rent control regulations.
11.	T	See page 110 in the textbook.
12.	F	Producer surplus is the net benefit producers receive from participating in the market.
13.	T	Positive analysis tells us the cost and benefits associated with particular policy measures.
14.	T	If the government imposes a price floor in a market, then buying and selling may occur illegally in a black market in which actual prices are below the regulated price.
15.	F	Economic efficiency results when the marginal benefit to consumers of the last unit produced equals the marginal cost of production.

CHAPTER 5 | The Economics of Health Care

Chapter Summary and Learning Objectives

5.1 The Improving Health of People in the United States (pages 138–140)

Discuss trends in U.S. health over time. Health care refers to goods and services, such as prescription drugs and consultations with a doctor, that are intended to maintain or improve health. Over time, the health of people in most countries has improved. In the United States, as a result of improving health, life expectancy has increased, death rates have decreased, infant mortality has decreased, and the average person has become taller.

5.2 Health Care around the World (pages 140–145)

Compare the health care systems and health care outcomes in the United States and other countries.

Health insurance is a contract under which a buyer agrees to make payments, or premiums, in exchange for the provider's agreeing to pay some or all of the buyer's medical bills. A majority of people in the United States have private health insurance, which they typically obtain through their employer. Other people have health insurance through the government's Medicare and Medicaid programs. In 2009, about 17 percent of people in the United States lacked health insurance. Many health insurance plans operate on a fee-for-service basis under which doctors and hospitals receive a payment for each service they provide. Most countries outside of the United States have greater government involvement in their health care systems. Canada has a single-payer health care system, in which the government provides national health insurance to all Canadian residents. In the United Kingdom, the government owns most hospitals and employs most doctors, and the health care system is referred to as socialized medicine. The United States spends more per person on health care than do other high-income countries. The United States has lower life expectancy, higher infant mortality, and a greater incidence of obesity than do other high-income countries. The United States has more medical technology per person and has lower mortality rates for people diagnosed with cancer than do other high-income countries. Various problems make it difficult to compare health care outcomes across countries.

5.3 Information Problems and Externalities in the Market for Health Care (pages 145–152)

Discuss how information problems and externalities affect the market for health care. The market for health care is affected by the problem of asymmetric information, which occurs when one party to an economic transaction has less information than the other party. Adverse selection, the situation in which one party to a transaction takes advantage of knowing more than the other party to the transaction, is a problem for firms selling health insurance policies because it results in less healthy people being more likely to buy insurance than are healthier people. Moral hazard, actions people take after they have entered into a transaction that make the other party to the transaction worse off, is also a problem for insurance companies because once people have health insurance, they are likely to make more visits to their doctors and in other ways increase their use of medical services. Moral hazard can also involve a principal—agent problem in which doctors may order more lab tests, MRI scans, and other procedures than they would if their patients lacked health insurance. Insurance companies use deductibles, copayments, and restrictions on coverage of patients with preexisting conditions to reduce the problems of adverse selection and moral hazard. There may be externalities involved with medicine and health care because, for example, people who are vaccinated against influenza or other diseases may not receive all of

the benefits from having been vaccinated and people who become obese may not bear all of the costs from their obesity.

5.4 The Debate over Health Care Policy in the United States (pages 152–161)

Explain the major issues involved in the debate over health care policy in the United States. In March 2010, Congress passed the Patient Protection and Affordable Care Act (PPACA), which significantly reorganized the U.S. health care system. Spending on health care in the United States has been growing rapidly as a percentage of GDP, and spending per person on health care has been growing more rapidly than in other high-income countries. Third-party payers, such as employer-provided health insurance and the Medicare and Medicaid programs, have financed an increasing fraction of health care spending, while out-of-pocket payments have sharply declined as a fraction of total health care spending. Several explanations have been offered for the rapid increase in health care spending in the United States: Slow rates of growth of labor productivity in health care may be driving up costs, the U.S. population is becoming older, medical technology and new prescription drugs have higher costs, and the tax system and the reliance on third-party payers have distorted the economic incentives of consumers and suppliers of health care. The PPACA has several important provisions: (1) an individual mandate that requires every resident of the United States to obtain health insurance or be fined; (2) the establishment of health exchanges that will be run by the state governments and provide a means for individuals and small businesses to purchase health insurance; (3) an employer mandate that requires every firm with more than 200 employees to offer health insurance to them; (4) increased regulation of health insurance companies; (5) expansion of eligibility for Medicare and the establishment of the Independent Payment Advisory Board, which has the power to reduce Medicare payments for prescription drugs and for the use of diagnostic equipment and other technology if Medicare spending exceeds certain levels; and (6) increased taxes on workers with incomes above \$200,000. Some critics of the PPACA argue that it does not go far enough in increasing government involvement in the health care system, while other critics argue that health care reform should rely more heavily on market-based reforms, which involve changing the market for health care so that it becomes more like the markets for other goods and services.

Chapter Review

5.1

Chapter Opener: How Much Will You Pay for Health Insurance? (page 137)

Many employees are not aware of how much health care costs they actually pay. In addition to the health insurance they pay, their employers often pay for their health insurance that might otherwise have been paid to them in salary. Also, both employees and employers pay taxes to support healthcare-related Medicare and Medicaid programs. In the United States, health care spending increased from 5.2 percent of GDP in 1960 to 17.9 percent in 2013. In 2010, President Obama and Congress enacted the Patient Protection and Affordable Care Act that made major changes to the U.S. health care system, including a provision for each state to set up health insurance exchanges that aim at making health insurance for small businesses and individuals less expensive.

The Improving Health of People in the United States (pages 138–140) Learning Objective: Discuss trends in the U.S. health over time.

Health care refers to goods and services, such as prescription drugs and consultations with a doctor, that are intended to maintain or improve health. Health care is provided through markets, just as other goods and services such as hamburgers and haircuts. In the United States, the doctors and hospitals that supply

most health care are primarily private firms. The government provides some health care services directly through the Veterans Health Administration, and indirectly through the Medicare and Medicaid programs.

Over time, the health of people in most countries has improved. In the United States, as a result of improving health, life expectancy has increased, death rates have decreased, infant mortality has decreased, and the average person has become taller. Health improvement is seen in the decline of deaths from cancers and cardiovascular disease, such as heart attacks, strokes, and liver diseases. During the late nineteenth and early twentieth centuries, improvements in sanitation and in the distribution of food lead to better health, which in turn made it possible for people to work harder. In effect, the long-run improvement in health shifts out a country's production possibilities frontier. Higher incomes also allow the country to devote more resources to medical research.

Study Hint

Because health care is provided through markets, we can understand health care related issues by applying the tools of economic analysis we learned in previous chapters, particular the supply and demand model in Chapter 3. For instance, long-term trends of rising health care spending and health improvement in the United States can be a result of increases in income over time. Health care is a normal good. As we learned in Chapter 3, demand for normal goods increases as household income increases. In addition to the quantity of health care goods and services, higher income makes it possible for people to afford better quality and thus more expensive health care.

Extra Solved Problem 5.1

Obesity of Immigrants to the United States

Supports Learning Objective 5.1: Discuss trends in U.S. health over time.

Italian migration to the United States occurred in two large waves. The first wave occurred between 1880 and 1920, when Italy experienced increased poverty and major socio-economic and political changes. The second wave occurred between 1946 and 1970, when Italy experienced high unemployment after World War II. The immigrants from Italy were mostly young males between the ages of 20 and 39. They were largely motivated by a desire to improve their living conditions. Economists Maria Danubio, Elisa Amicone, and Rita Vargiu examined how both height and weight changed among those Italian immigrants to the United States. Height and weight are indicators of individual living standards and economic development in society. The economists found no major change in the average height of Italian immigrants by the end of the 1990s, but they found that the Body Mass Index (BMI) of those immigrants were within the range of overweight. Obesity was more prevalent among Italian immigrants than among native-born Americans or people in several European countries.

- a. What do the results of the study about Italian immigrants' health data indicate about changes in the living conditions of those immigrants?
- b. Given the observations on changes in the physical conditions of Italian immigrants, what would you expect about the physical conditions of the children of immigrants as compared to their parents?

Solving the Problem

Step 1: Review the chapter material.

This problem is about trends in U.S. health over time, so you may want to review the section "The Improving Health of People in the United States," which begins on page 138 in the textbook.

Step 2: Answer question (a) by explaining the relationship between the Italian immigrants' health data and changes in their living conditions.

The study shows that the average BMI of Italian immigrants was higher than the native-born Americans or people in several European countries. The finding of a higher obesity rate among Italian immigrants may reflect a change in the lifestyle and an improvement in the biological standard of living for those immigrants in the United States.

Step 3: Answer question (b) by discussing how the physical conditions of the children of Italy immigrants would change.

The quality of life for immigrants' children will likely be higher than that for their parents. Better nutrition, health care and living conditions will likely result in an increase in height and an improvement in other health indicators for second-generation Americans.

Source: Maria Enrica Danubio, Elisa Amicone, and Rita Vargiu, "Height and BMI of Italian Immigrants to the USA, 1908-1970," *Economics & Human Biology*, 2005, Vol. 3, No. 1, pp. 33–44.

5.2

Health Care Around the World (pages 140–145)

Learning Objective: Compare the health care systems and health care outcomes in the United States and other countries.

One important difference among health care systems in different countries is how people pay for the health care they receive. Most people in the United States have health insurance that helps them to pay for their medical bills. **Health insurance** is a contract under which a buyer agrees to make payments, or premiums, in exchange for the provider agreeing to pay some or all of the buyer's medical bills. A majority of people in the United States have private health insurance, which they typically obtain through their employer. Other people have health insurance through the government's Medicare and Medicaid programs. In 2012, about 16 percent of people in the United States lacked health insurance. Many health insurance plans operate on a **fee-for-service** basis under which doctors and hospitals receive a payment for each service they provide.

Most countries outside of the United States have greater government involvement in their health care systems. Canada has a **single-payer health care system**, in which the government provides national health insurance to all Canadian residents. Japan has a system of universal health insurance under which every resident is required to either enroll in one of the many nonprofit health insurance societies that are organized by industry or profession, or enroll in the government's health insurance program. In the United Kingdom, the government owns most hospitals and employs most doctors, and the health care system is referred to as **socialized medicine**.

The United States spends more per person on health care than do other high-income countries. The United States has lower life expectancy, higher infant mortality, and a greater incidence of obesity than do other high-income countries. The United States has more medical technology per person and has lower mortality rates for people diagnosed with cancer than do other high-income countries. Various problems make it difficult to compare health care outcomes across countries. Those problems include data consistency, problems with measuring health care delivery, problems with distinguishing health care effectiveness from lifestyle choices, and problems with determining consumer preferences.

Study Hint

The United States appears to be facing a health care crisis, prompting some commentators and policymakers to propose the adoption of a health care system like that in Canada. It is important to understand that every health care system in the world has its strengths and weaknesses. For example, under the national health insurance system of Canada, individuals pay nothing for doctor's visits or hospital stays, but they have pay for medical care indirectly through taxes. Unlike the United States, doctors and hospitals in Canada are required to accept the fees that are set by the government. Rather than allowing the fees to reflect the balance between supply and demand, this restriction reduces the incentive to provide the sufficient amount of health care, leading to long waiting lists.

Extra Solved Problem 5.2

Physicians for a Single-Payer Health Care System

Supports Learning Objective 5.2: Compare the health care systems and health care outcomes in the United States and other countries.

The Physicians for a National Health Program (PNHP) is an organization of over 18,000 physicians and health professionals who support single-payer national health insurance. This organization argues that private health insurance companies are responsible for rising health care costs. It also claims that health insurance companies' administration and paperwork have little to do with health care, but together they account for 31 percent of health care costs. The organization argues that a single-payer financing system would reduce this waste. By eliminating private health insurance companies, a single payer like the U.S. government would save more than \$400 billion a year. Under this system, delivery of health would remain largely private as before and physicians would still be paid on a negotiable fee-for-service basis.

- a. To what extent is the single-payer national health insurance program that the PHNP proposes similar to the national health care system in Canada? To what extent are they different?
- b. Why would you suppose that physicians have little incentive to propose a single-payer system organized by the government?

Solving the Problem

Step 1: Review the chapter material.

> This problem is about comparing the health care systems in the United States and other countries, so you may want to review the section "Health Care around the World," which begins on page 140 in the textbook.

Step 2: Answer question (a) by explaining the major similarity and difference between the proposed single-payer national health insurance program and the Canadian health care system.

> The single-payer national health insurance program that PNHP calls for is similar to the Canadian health care system in that health care will be financed through the government's health insurance program. The physicians and hospitals will still be private businesses. However, the fees for physicians' services are negotiable in the proposed single-payer health care program, whereas physicians in Canada are required to accept the fees that are set by the government,

Answer question (b) by explaining why physicians have little incentive to propose Step 3: a single-payer system organized by the government.

> The organization emphasizes the drawback of dealing with multiple private health insurance companies. However, a single national health insurance agency that replaces the existing

private health insurance companies is likely to have more power in reducing payments to physicians for their services, even though excessive paperwork and other overhead costs will likely reduce. In Canada, physicians and hospitals are required to accept the fees set by the government.

Source: http://www.pnhp.org

Information Problems and Externalities in the Market for Health Care (pages 145–152)

Learning Objective: Discuss how information problems and externalities affect the market for health care.

The market for health care is affected by the problem of **asymmetric information**, which occurs when one party to an economic transaction has less information than the other party.

Adverse selection is the situation in which one party to a transaction takes advantage of knowing more than the other party to the transaction. In the market for health insurance, policyholders always know more about the state of their health than do the insurance companies. This situation creates a problem for firms selling health insurance policies because it results in less healthy people being more likely to buy insurance than are healthier people. One controversial way to deal with this problem is impose the individual mandate, which became law in the United States through the passage through the Patient Protection and Affordable Care Act in 2010.

Moral hazard refers to actions people take after they have entered into a transaction that makes the other party to the transaction worse off. Moral hazard is also a problem for insurance companies because once people have health insurance, they are likely to make more visits to their doctors and in other ways increase their use of medical services. The third-party payer system, in which the insurance company is the third party to the purchase of medical services, also leads consumers to buy more health care than they otherwise would. Moral hazard can also involve a **principal–agent problem** in which doctors may order more lab tests, MRI scans, and other procedures than they would if their patients lacked health insurance. Insurance companies use deductibles, copayments, and restrictions on coverage of patients with preexisting conditions to reduce the problems of adverse selection and moral hazard.

There may be externalities involved with medicine and health care because, for example, people who are vaccinated against influenza or other diseases may not receive all of the benefits from having been vaccinated and people who become obese may not bear all of the costs from their obesity.

Study Hint

The problems of asymmetric information apply to many industries other than insurance, including banking and other financial services. Read *Solved Problem 5.3* in the textbook to strengthen your understanding of the adverse selection problem. This Solved Problem explains how the adverse selection problem is easily extended to a firm outside health insurance and how the firm can deal with this problem. Read the *Don't Let This Happen to You* feature in this section of the textbook to understand the difference between adverse selection and moral hazard.

Making the Connection "Should the Government Run the Health Care System?" provides a thorough discussion on the role of the federal government in health care. Government intervention is justified in the case of a public good, which is both nonrival and nonexcludable. A good is nonrival if one person's consumption does not interfere with another person's consuming it. A good is nonexcludable if one can consume it without paying for it. Because health care is neither nonrival nor nonexcludable, it does not

qualify as a public good under the usual definition. However, the asymmetric information problems and externalities of health care do provide justifications for government intervention.

5.4

The Debate over Health Care Policy in the United States (pages 152-161)

Learning Objective: Explain the major issues involved in the debate over health care policy in the United States.

Spending on health care in the United States has been growing rapidly as a percentage of GDP, and spending per person on health care has been growing more rapidly than in other high-income countries. Third-party payers, such as employer-provided health insurance and the Medicare and Medicaid programs, have financed an increasing fraction of health care spending, while out-of-pocket payments have sharply declined as a fraction of total health care spending. Several explanations have been offered for the rapid increase in health care spending in the United States: Slow rates of growth of labor productivity in health care may be driving up costs, the U.S. population is becoming older, medical technology and new prescription drugs have higher costs, and the tax system and the reliance on thirdparty payers have distorted the economic incentives of consumers and suppliers of health care.

In March 2010, Congress passed the Patient Protection and Affordable Care Act (PPACA), which significantly reorganized the U.S. health care system. The PPACA has several important provisions: (1) an individual mandate that requires every resident of the United States to obtain health insurance or be fined; (2) the establishment of health exchanges that will be run by the state governments and provide a means for individuals and small businesses to purchase health insurance; (3) an employer mandate that requires every firm with more than 200 employees to offer health insurance to them; (4) increased regulation of health insurance companies; (5) expansion of eligibility for Medicare and the establishment of the Independent Payment Advisory Board, which has the power to reduce Medicare payments for prescription drugs and for the use of diagnostic equipment and other technology if Medicare spending exceeds certain levels; and (6) increased taxes on workers with incomes above \$200,000. Some critics of the PPACA argue that it does not go far enough in increasing government involvement in the health care system, while other critics argue that health care reform should rely more heavily on market-based reforms, which involve changing the market for health care so that it becomes more like the markets for other goods and services

Study Hint

It is important to understand that whether spending on health care has risen faster in the United States than in other countries is an outcome of changing consumers' preferences for health care (changes in market demand) or an outcome of the rising cost of providing health care services (changes in market supply). Figure 5.6 shows that out-of-pocket spending on health care as a percentage of all spending on health care has steadily declined from 45 percent in 1965 to only 11 percent today. This observation means that consumers of health care have been directly paying for a smaller portion of the true cost of health care services, while the remainder has been picked up by third-party payers, such as health insurance providers and the government-provided Medicare or Medicaid program. As a result of the thirdparty payment system, consumers demand a larger quantity of health care services than they would if they had to pay the full price. Doctors and other health care providers also have a reduced incentive to control costs because insurance companies will pick up most of the bill.

Making the Connection "Are U.S. Firms Handicapped by Paying for Their Employees' Health Insurance?" uses demand and supply analysis to explain that having firms rather than the government provide health insurance to workers does not change the level of compensation the firms pay their workers but its composition.

Extra Solved Problem 5.4

Health Savings Accounts

128

Supports Learning Objective 5.4: Explain the major issues involved in the debate over health care policy in the United States.

In 2003, Congress authorized health savings accounts that allow individuals to put aside funds that can be used for medical care. Individuals with a relatively high health insurance deductible of \$1,000 or more can open a deposit account at a financial institution that issues those accounts and use the deposited funds to cover any out-of-pocket health care bills. Individuals 55 years old or younger can make annual deposits up to \$2,600, and families can deposit up to \$5,150 a year. The funds are tax exempt. If they become unemployed, they can draw on the accounts to pay for health insurance premiums. There is a 10 percent penalty for withdrawals used for nonmedical purposes before retirement. Any unused amount of the deposit becomes a type of retirement account.

- a. The health savings accounts were created to reduce the moral hazard problem of health care. How?
- b. What would be the drawbacks for this health savings account program?

Solving the Problem

Step 1: Review the chapter material.

This problem is about U.S. health care policy, so you may want to review the section "The Debate over Health Care Policy in the United States," which begins on page 152 in the textbook.

Step 2: Answer question (a) by explaining how the health savings account can reduce the moral hazard problem of health care.

The health savings accounts do not affect the existing relationship between physicians and patients and health insurance companies and the government is not involved in paying medical expenses. Because patients can keep any funds saved in their accounts, they will have no incentive to allow physicians to order expensive tests or drugs.

Step 3: Answer question (b) by explaining the drawbacks for this health savings account program.

Because participants can keep whatever they do not spend from their health savings accounts, they may forgo necessary doctor visits and develop more serious medical problem later. Some critics also argue that this program will sabotage managed care programs, in which deductibles are low or eliminated but physician choice is limited. On the contrary, the health savings accounts allow for high deductibles but unrestricted physician choice.

Key Terms

Adverse selection The situation in which one party to a transaction takes advantage of knowing more than the other party to the transaction.

Asymmetric information A situation in which one party to an economic transaction has less information than the other party.

Fee-for-service A system under which doctors and hospitals receive a separate payment for each service they provide.

Health care The goods and services, such as prescription drugs and consultations with a doctor, that are intended to maintain or improve a person's health.

Health insurance A contract under which a buyer agrees to make payments, or premiums, in exchange for the provider's agreeing to pay some or all of the buver's medical bills.

Market-based reforms Changes in the market for health care that would make it more like the markets for other goods and services.

Moral hazard The actions people take after they have entered into a transaction that make the other party to the transaction worse off.

Patient Protection and Affordable Care Act (PPACA) Health care reform legislation passed by Congress and signed by President Barack Obama in 2010.

Principal-agent problem A problem caused by agents pursuing their own interests rather than the interests of the principals who hired them.

Single-payer health care system A system, such as the one in Canada, in which the government provides health insurance to all of the country's residents.

Socialized medicine A health care system under which the government owns most of the hospitals and employs most of the doctors.

Self-Test

(Answers are provided at the end of the Self-Test.)

Multiple-Choice Questions

- 1. Which of the following statements is true about the health of people in the United States during the past 150 years?
 - a. Life expectancy has more than doubled.
 - b. Infant mortality has decreased.
 - c. The average person has become taller.
 - d. All of the above are true.
- 2. Which of the following is true about the mortality rate, or the death rate, of the United States over the period between 1981 and 2013?
 - a. The overall mortality rate increased.
 - b. The mortality rate for people suffering from cancer increased.
 - c. The mortality rate for people suffering from diabetes increased.
 - d. The mortality rate for people suffering from heart attacks and strokes increased.
- 3. Which of the following is one of the major reasons for the improvement in U.S. health in the last two centuries?
 - a. improvements in the distribution of food
 - b. better sanitation
 - c. advances in medical equipment and prescription drugs
 - d. all of the above

- 4. What is the term for the payment that a buyer agrees to make in a health insurance contract in exchange for the provider agreeing to pay some or all of the buyer's medical bills?
 - a. commission
 - b. premium
 - c. down payment
 - d. load
- 5. Which of the following is the largest source of finance for health insurance in the United States?
 - a. employer-provided insurance plans
 - b. Medicare
 - c. Medicaid
 - d. individual insurance plans
- 6. When a health insurance plan reimburses doctors and hospitals on a fee-for-service basis, how do health care providers receive their payments?
 - a. They receive a flat fee per patient they serve.
 - b. They receive a payment for each good or service they provide.
 - c. They receive payments for only services but not goods that they provide.
 - d. They receive payments only when the patients do not pay them directly.
- 7. Which of the following countries operates under a single-payer health insurance system?
 - a. United States
 - b. Japan
 - c. Canada
 - d. United Kingdom
- 8. Which of the following best describes the system of socialized medicine?
 - a. a health care system under which the prices of medical services are determined by free markets
 - b. a health care system under which hospitals and physicians operate as private businesses
 - c. a health care system under which the government owns most of the hospitals and employs most of the physicians
 - d. a health care system under which unions provide all medical services to union members and nonmembers
- 9. In which is the country does the government deliver most health care services to its residents through a single agency?
 - a. Japan
 - b. United Kingdom
 - c. United States
 - d. Canada
- 10. According to the textbook, the data on the relationship between health care spending per person and income per person shows that health care is a
 - a. normal good.
 - b. inferior good.
 - c. substitute to wealth.
 - d. complement to education.

- 11. Fill in the blanks. According to Table 5.2 of the textbook, the death rate among people diagnosed with cancer is for the United States than for the OECD average, and the number of MRI units and CT scanners per person is for the United States than for the OECD average.
 - a. lower: lower
 - b. higher; higher
 - c. higher; lower
 - d. lower; higher
- 12. Which of the following countries has the highest male life expectancy at age 65?
 - a Japan
 - b. United States
 - c. Canada
 - d. United Kingdom
- 13. Which of the following is one of the difficulties in making cross-country comparisons in health care outcomes?
 - a. Countries do not always collect health care related data in the same way.
 - b. Countries do not deliver health care services in the same way.
 - c. Countries may have different lifestyle choices that affect health care outcomes beyond the effectiveness of the countries' health care system.
 - d. All of the above make cross-country comparisons difficult.
- 14. In the market for health care, the price that consumers with health care insurance pay is
 - a. the same as the cost of providing the health care service.
 - b. higher than the full cost of providing the health care service.
 - c. lower than the full cost of providing the health care service.
 - d. none because health care insurance companies cover all health care expenses.
- 15. What will happen to the quantity of health care services demanded if the co-payment for the patients of health insurance increases?
 - a. The quantity demanded will increase.
 - b. The quantity demanded will decrease.
 - c. The quantity demanded will not change.
 - d. None of the above: The quantity demanded will increase or decrease, depending on consumer preferences.
- 16. Which country currently has the highest health care spending per person?
 - a. United States
 - b. Austria
 - c. Norway
 - d. Canada
- 17. Which of the following refers to the situation in which one party to an economic transaction has more information than the other party?
 - a. symmetric information
 - b. asymmetric information
 - c. positive selection
 - d. adverse selection

- 18. Which of the following refers to the situation in which one party to an economic transaction takes advantage of knowing more than the other party to the transaction?
 - a. immoral hazard
 - b. moral hazard
 - c. positive selection
 - d. adverse selection
- 19. Which of the following refers to the actions people take after they have entered into a transaction that makes the other party to the transaction worse off?
 - a. immoral hazard
 - b. moral hazard
 - c. positive selection
 - d. adverse selection
- 20. Which of the following refers to the problem in which one person with no deductible on her health insurance policy tends to engage in a less healthy lifestyle than another person with a high insurance deductible?
 - a. immoral hazard
 - b. adverse selection
 - c. moral hazard
 - d. biased selection
- 21. In the market for used cars, which of the following is true of information about the true condition of a car?
 - a. The potential buyer and seller have the same information about the true condition of the car.
 - b. The potential buyer knows more about the true condition of the car than does the seller.
 - c. The seller knows more about the true condition of the car than does the potential buyer.
 - d. Neither the potential buyer nor the seller knows the true condition of the car.
- 22. Which of the following is referred to as a "third party" in the health care market?
 - a. health insurance company
 - b. physician
 - c. hospital
 - d. patient
- 23. Which of the following is an outcome of the moral hazard problem in the market for health insurance?
 - a. Consumers of health care have to worry about the expense of all medical services.
 - b. Consumers of health care will buy more health care services than they otherwise would without health insurance.
 - c. Physicians and hospitals have an incentive to keep the costs of health care down.
 - d. Only sick people, but not healthy people, will buy health care services.
- 24. Which of the following refers to the "individual mandate" in the Patient Protection and Affordable Care Act (PPACA) passed in 2010?
 - a. All hospitals must admit every patient, including illegal immigrants.
 - b. All physicians must treat any patient without charging a fee.
 - c. All U.S. residents are required to carry insurance or pay a fine.
 - d. All of the above are true.

- 25. Which of the following is an example of the third-party financing of health care services?
 - a. a patient paying for her visit to the doctor's office
 - b. a patient looking for a second or third opinion from another doctor
 - c. a patient not going to see a doctor in order to save money
 - d. a patient paying her medical bill through Medicare
- 26. Fill in the blanks. In the health care market, are principals, and are agents.
 - a. doctors; patients
 - b. patients; doctors
 - c. doctors; health insurance companies
 - d. health insurance companies; doctors
- 27. Which of the following refers to the principal-agent problem in the market for health care?
 - a. doctors pursuing the interests of health insurance providers rather than the interests of the patients
 - b. doctors pursuing their own interests rather than the interests of the patients
 - c. a conflict of interests between doctors and health insurance companies
 - d. doctors pursuing only the interests of the patients rather than the interest of society
- 28. How does the fee-for-service aspect of third-party payer health insurance affect the extent of the principal-agent problem in the health care market?
 - a. an increase in the number of medical procedures performed by doctors
 - b. an improvement in the effectiveness of diagnosing illness and treatments
 - c. an increase in the number of malpractice lawsuits
 - d. all of the above
- 29. Which of the following is an example of how health insurance companies deal with the problem of adverse selection?
 - a. requiring a deductible
 - b. eliminating coinsurance
 - c. limiting insurance coverage on pre-existing conditions
 - d. reducing reimbursements to doctors and hospitals
- 30. What is the main reason for health insurance companies to require deductibles and coinsurance?
 - a. to subsidize doctors and hospitals
 - b. to deal with the moral hazard problem
 - c. to deal with the adverse selection problem
 - d. to deal with the two-party payment problem
- 31. Which of the following refers to the effect of a vaccination that a person takes against a disease on reducing the chances that other people will contract that disease?
 - a. negative internality
 - b. positive internality
 - c. negative externality
 - d. positive externality
- 32. When no more than one person can be simultaneously treated in the same surgical operation, the consumption of surgical operation is
 - a. rivalrous.
 - b. nonrivalrous.
 - c. symmetric.
 - d. asymmetric.

- 33. Which of the following statements is consistent with the belief of economists who propose market-based solutions to the health care system?
 - a. Government bureaucracy is the main cause for the rising cost of health care.
 - b. The price that consumers pay for health care is far below the true cost of providing the service.
 - c. Moral hazard does not exist in the health care market.
 - d. Adverse selection does not exist in the health care market.
- 34. Which of the following is true of the health care spending in the United States?
 - a. Spending on health care as a percentage of GDP reduced by half between 1965 and 2013.
 - b. Spending on health care as a percentage of GDP more than doubled between 1965 and 2013.
 - c. Spending on health care as a percentage of GDP was roughly constant between 1965 and 2013.
 - d. None of the above is true.
- 35. Which of the following is one of the major reasons for rapid increases in health care spending in the United States?
 - a. high rates of labor productivity growth in health care
 - b. an increase in the number of malpractices among doctors
 - c. reductions in Medicare, Medicaid, and other government programs that help defray health care costs
 - d. advances in medical technology and new prescription drugs that have higher costs
- 36. According to economist William Baumol, what is the main reason for the rising cost of health care?
 - a. the aging population
 - b. moral hazard in health care
 - c. slow growth in labor productivity in the health care sector
 - d. the third-party health insurance payment system
- 37. Which of the following is the health care reform legislation passed by Congress and signed by President Obama in March 2010?
 - a. The Social Security Act
 - b. The Health Savings Accounts Act
 - c. The Patient Protection and Affordable Care Act
 - d. The National Health Insurance Act
- 38. Which of the following will become effective in 2014?
 - a. Medicare and Medicaid will be eliminated.
 - b. The health insurance industry will be deregulated.
 - c. Every firm with more than 200 employees is required to offer health insurance to its employees.
 - d. No U.S. resident will need health insurance.
- 39. The U.S. health care reforms beginning in 2009 would help lead to
 - a. greater government involvement in the health care system.
 - b. market-based solutions to the rising health care spending.
 - c. increased economic efficiency in delivering health care services.
 - d. a socialized medicine system like that in the United Kingdom.

- 40. Why would supporters of market-based reforms to health care propose to make the tax treatment of employer-provided health insurance the same as the tax treatment of individually purchased health insurance?
 - a. This would result in a reduction in health insurance premiums.
 - b. This would result in a reduction in employers' spending on health insurance policies for employees.
 - c. This would result in an increase in employees' out-of-pocket spending on health care.
 - d. All of the above are true.

Short Answer Questions

liv abl	cording to the textbook, people in high-income countries tend to have a higher standarding than do people in low-income countries, and so they are healthier because they are me to pay for health care. Nobel Laureate Robert Fogel, however, argued instead that ationship between health and income is a vicious cycle, meaning that they affect each other.
	nat is his rationale?
the	e outcomes of different consumer preferences?
-	
	sed on the convention wisdom, buyers in a used car market will most likely end up wismon." What is the reason behind this problem?

A second second	400	*	
	100		
0			
0			
sing such solutions as o ypes of insurance, leading			*

True/False Questions

- T F 1. The decline in the average height of adult males in the United States from 1830 to 1890 was a result of falling income.
- T F 2. The overall mortality rate of the United States decreased by more than 25 percent between 1981 and 2011.
- T F 3. In the United States, most physicians and hospitals operate as private businesses.
- T F 4. In 2013, about 99 percent of firms employing more than 200 workers offered health insurance to their employees as a fringe benefit.
- T F 5. Health maintenance organizations (HMOs) typically reimburse health care providers on a fee-for-service basis.
- T F 6. In 2012, more than 65 percent of U.S. population did not have health insurance coverage.
- T F 7. The largest government-run health care provider in the world is the National Health Service.
- T F 8. The U.S. population has higher rates of obesity than the OECD averages.
- T F 9. In the market for health insurance, adverse selection occurs when healthy people are more likely to purchase healthy insurance than are sick people.
- T F 10. Adverse selection refers to the potential problem that occurs before the buyer and seller in a market enter into a transaction, whereas moral hazard refers to the potential problem that occurs after the buyer and seller enter into the transaction.
- T F 11. As a result of a negative externality in consumption, the market produces less than the efficient quantity.
- T F 12. Health care is a public good because it is both nonrival and nonexcludable.
- T F 13. Consumers in the United States have chosen to purchase less health care since 1965 because their total out-of-pocket spending has decreased.

- 14. Between 1970 and 2013, health care spending per person grew at a faster rate in the United States than in the majority of European countries.
- According to the U.S. government, increases in the cost of providing health care will have a larger effect on future government spending on the Medicare and Medicaid programs than will the effect of the aging population.

Answers to the Self-Test

Multiple-Choice Questions

Question	Answer	Comment
1.	d	Health in the United States has generally improved with higher life expectancy, lower death rates, lower infant mortality, and a higher average height for adult males.
2.	С	The overall mortality rate decreased over the period. The increased mortality rate for people suffering diabetes was largely due to the effects of increasing obesity. See page 140 in the textbook.
3.	d	Improvements in sanitation and in the distribution of food led to better health during the late nineteenth and early twentieth centuries, and advances in medical equipment and new prescription drugs resulted in the overall decline in death rates since the 1980s. See page 140 in the textbook.
4.	b	A health insurance premium is a payment a buyer makes in a health insurance policy contract.
5.	a	As shown in textbook Figure 5.2, about half of people in the United States pay for health care through employer-provided insurance plans.
6.	b	A fee-for-service system is one under which consumers of health care pay separately for each good or service they receive from physicians and hospitals.
7.	c	In Canada, the government provides health insurance to all of the country's residents.
8.	c	See page 142 in the textbook for the definition of socialized medicine.
9.	b	In the United Kingdom, the government delivers most health care services to its residents.
10.	a	For a normal good, health care spending per person increases as income per person increases, as indicated by textbook Figure 5.3.
11.	d	The death ratio for cancer is 39.5 percent for the United States, as compared to the OECD average of 48.1 percent. The United States has 60.2 MRI units and CT scanners per 1,000,000 population, as compared to the OECD average of 27.2 units.
12.	a	Japan has the highest life expectancy of 18.2 years for males at age 65.
13.	d	The difficulties in making cross-country comparisons in health care outcomes include data problems, problems with measuring health care delivery, problems with distinguishing health care effectiveness from lifestyle choices, and problems with determining consumer preferences.
14.	c	The price that consumers with health care insurance pay for health care is the co- payment, which is less than the full cost of providing the health care service.

Question	Answer	Comment
15.	b	The co-payment for the patients of health insurance is the price for patients receiving health care services, so that a higher co-payment reduces the quantity of health care services demanded.
16.	a	According to Figure 5.3, the United States has the highest health care spending per person.
17.	b	See page 145 in the textbook for the definition of asymmetric information.
18.	d	See page 145 in the textbook for the definition of adverse selection.
19.	b	See page 146 in the textbook for the definition of moral hazard.
20.	С	The problem of moral hazard occurs when a person engages in less healthy activities after purchasing a health insurance policy.
21.	c	In the market for used cars, the seller has more information about the true condition of a car.
22.	a	A health insurance company is a "third party" to the health care market because the insurance company, not the patient, pays for some or all of the health care service.
23.	b	With health insurance companies as the third-party payers, consumers of health care do not pay prices that reflect the full costs of providing the services, leading consumers to buy more health care than they otherwise would.
24.	c	The "individual mandate" in the Patient Protection and Affordable Care Act (PPACA) requires that all residents of the United States carry health insurance by 2014 or pay a fee.
25.	d	Paying medical bills through Medicare or other health insurance plans is an example of third-party financing.
26.	b	Patients are principals and doctors are agents. See page 147 in the textbook.
27.	b	The principal-agent problem occurs when doctors as agents pursue their own interests rather than the interests of patients as the principals.
28.	a	When doctors are paid for each service they perform, they have an incentive to perform more medical procedures.
29.	c	Health insurance companies deal with the problem of adverse selection by limiting coverage on pre-existing conditions.
30.	b	Insurance companies use deductibles and coinsurance to deal with the moral hazard problem.
31.	d	A positive externality occurs when the person getting vaccinated also reduces the chances that people who have not been vaccinated will contract the disease.
32.	a	The consumption of surgical operation is rivalrous because no two patients can consume it at the same time.
33.	b	Those economists believe that health care markets are delivering inaccurate signals to consumers because consumers pay a price far below the true cost of providing the service.
34.	b	Spending on health care as a percentage of GDP increased from less than 6 percent to about 17.9 percent between 1965 and 2013. See textbook Figure 5.5.
35.	d	The high costs of medical technology and new prescription help explain increases in health care spending.

Question	Answer	Comment
36.	c °	William Baumol argues that service industries such as health care suffer from slow productivity growth, which helps explain the rising cost of health care.
37.	c	The Patient Protection and Affordable Care Act was passed by Congress in 2010.
38.	c	See pages 158–159 in the textbook for the provisions of the PPACA.
39.	a	The PPACA would lead to greater government involvement in the health care system, but it stopped short of the degree of government involvement that exists in Canada, Japan, or the United Kingdom.
40.	b	Employers' spending on health insurance would be reduced if their health insurance policies for employees are taxed.
		insurance poncies for employees are taxed.

Short Answer Responses

- 1. Robert Fogel and his coauthors explained that better health makes it possible for people to work harder, raising a country's labor productivity and total income, which in turn make it possible for the country to afford better sanitation, more food, and better distribution of food. Higher incomes also allow the country to devote more resources to medical research.
- 2. In most markets, the quantities and prices observed reflect the interactions between the preferences of consumers and the costs to suppliers. This is not the case for the health care market. If the government plays the dominant role in supplying the service, as in many countries other than the United States, then the costs are not fully reflected in its price. If consumers pay through health insurance, as in the United States, then the price they pay for the service is typically smaller than the full cost of the service.
- 3. In a used car market, the seller of a used car typically knows more about the true condition of the car than do potential buyers. Because the buyers cannot tell reliable cars from lemons, they will generally offer a price somewhere between the price they would be willing to pay for a good car and the price they would be willing to pay for a lemon. However, the seller of a good car will be reluctant to sell the car whose true value is thought to be higher than the offering price. But the seller of a lemon will be happy to sell the car whose true value is thought to be lower than the offering price. In the end, most used cars offered for sale will be lemons.
- 4. Agree. First, health care spending is not the same as its cost. A system like the United Kingdom has less health care spending per person than the United States, but that system does not necessarily have a lower cost because patients spend more time waiting for services. Spending on health care in the past might be lower than now partly because people suffered and died from illnesses that can now be treated and cured. In addition, improvements in health care services allow people to live longer and health care spending increases as a result.
- The basic idea of insurance is that the risk of an unpredictable event, such as a house fire or a car accident, is pooled among the consumers who buy insurance. Health insurance, however, also typically covers many planned expenses, such as routine checkups and vaccinations. Health insurance encourages the overuse of these routine expenses when the true cost of such expenses can be easily disguised.

True/False Answers

Question	Answer	Comment	
1.	F	The decline in the average height of adult males in the United States can be explained by deterioration in the conditions of sanitation in cities and food distribution.	
2.	T	See page 140 of the textbook for the reduction in the overall mortality rate since 1980.	
3.	T	See page 141 in the textbook.	
4.	T	See page 141 in the textbook.	
5.	F	Health maintenance organizations (HMOs) typically reimburse health care providers by paying a flat fee per patient, instead of paying each service provided.	
6.	F	In 2012, 16 percent of U.S. population does not have health insurance coverage because people either cannot afford to buy health insurance or choose not to buy it.	
7.	T	The National Health Service (NHS) of the United Kingdom has 1.7 million employees, and it is the largest government-run health care system in the world.	
8.	T	The obesity rate is 35.7 percent for the United States and 13.1 percent for the OECD countries.	
9.	F	Adverse selection occurs in the health insurance market when sick people are more likely to purchase healthy insurance than are healthy people.	
10.	T	Adverse selection occurs before entering a transaction and moral hazard occurs after entering a transaction. See the <i>Don't Let This Happen to You</i> feature on page 147 in the textbook.	
11.	F	As a result of a negative externality in consumption, the market produces more than the efficient quantity.	
12.	F	A public good is both nonrival and nonexcludable, but health care is neither nonrival nor nonexcludable. See the <i>Making the Connection</i> feature beginning on page 151 in the textbook.	
13.	T	According to textbook Figure 5.6, out-of-pocket spending on health care as a percentage of all health care spending decreased from 45 percent in 1965 to 11 percent today. This change means that consumers now choose to devote relatively less of their incomes to spending on health care.	
14.	T	Textbook Figure 5.5 shows that health care spending per person in the United States grew at the fastest rate between 1970 and 2013.	
15.	T	See textbook Figure 5.7 for a comparison between the effects of aging and the health care cost on future federal spending on Medicare and Medicaid.	

CHAPTER 6 Firms, the Stock Market, and **Corporate Governance**

Chapter Summary and Learning Objectives

Types of Firms (pages 170–173) 6.1

Categorize the major types of firms in the United States. There are three types of firms: A sole proprietorship is a firm owned by a single individual and not organized as a corporation. A partnership is a firm owned jointly by two or more persons and not organized as a corporation. A corporation is a legal form of business that provides the owners with limited liability. An asset is anything of value owned by a person or a firm. The owners of sole proprietorships and partnerships have unlimited liability, which means there is no legal distinction between the personal assets of the owners of the business and the assets of the business. The owners of corporations have **limited liability**, which means they can never lose more than their investment in the firm. Although only 18 percent of firms are corporations, they account for the majority of revenue and profit earned by all firms.

6.2 The Structure of Corporations and the Principal-Agent Problem (pages 173-174)

Describe the typical management structure of corporations and understand the concepts of separation of ownership from control and the principal-agent problem. Corporate governance refers to the way in which a corporation is structured and the impact a corporation's structure has on the firm's behavior. Most corporations have a similar management structure: The shareholders elect a board of directors who appoint the corporation's top managers, such as the chief executive officer (CEO). Because the top management often does not own a large fraction of the stock in the corporation, large corporations have a separation of ownership from control. Because top managers have less incentive to increase the corporation's profits than to increase their own salaries and their own enjoyment, corporations can suffer from the principal-agent problem. The principal-agent problem exists when the principals—in this case, the shareholders of the corporation—have difficulty getting the agent—the corporation's top management—to carry out their wishes.

6.3 How Firms Raise Funds (pages 174–181)

Explain how firms raise the funds they need to operate and expand. Firms rely on retained earnings which are profits retained by the firm and not paid out to the firm's owners—or on using the savings of households for the funds they need to operate and expand. With direct finance, the savings of households flow directly to businesses when investors buy stocks and bonds in financial markets. With indirect finance, savings flow indirectly to businesses when households deposit money in saving and checking accounts in banks and the banks lend these funds to businesses. Federal, state, and local governments also sell bonds in financial markets, and households also borrow funds from banks. When a firm sells a bond, it is borrowing money from the buyer of the bond. The firm makes a **coupon payment** to the buyer of the bond. The interest rate is the cost of borrowing funds, usually expressed as a percentage of the amount borrowed. When a firm sells stock, it is selling part ownership of the firm to the buyer of the stock. **Dividends** are payments by a corporation to its shareholders. The original purchasers of stocks and bonds may resell them in stock and bond markets, such as the New York Stock Exchange. The performance of the U.S. stock market is often measured using stock market indexes. The three most widely followed stock indexes are the Dow Jones Industrial Average, the S&P 500, and the NASDAQ composite index.

6.4 Using Financial Statements to Evaluate a Corporation (pages 181–183)

Understand the information provided in corporations' financial statements. A firm's income statement sums up its revenues, costs, and profit over a period of time. A firm's balance sheet sums up its financial position on a particular day, usually the end of a quarter or year. A balance sheet records a firm's assets and liabilities. A liability is anything owed by a person or a firm. Firms report their accounting profit on their income statements. Accounting profit does not always include all of a firm's opportunity cost. Explicit cost is a cost that involves spending money. Implicit cost is a nonmonetary opportunity cost. Because accounting profit excludes some implicit costs, it is larger than economic profit.

6.5 Corporate Governance Policy and the Financial Crisis of 2007–2009 (pages 183–187)

Discuss the role that corporate governance problems may have played in the financial crisis of 2007–2009. Because their compensation often rises with the profitability of the corporation, top managers have an incentive to overstate the profits reported on their firm's income statements. During the early 2000s, it became clear that the top managers of several large corporations had done this, even though intentionally falsifying financial statements is illegal. The Sarbanes-Oxley Act of 2002 took several steps intended to increase the accuracy of financial statements and increase the penalties for falsifying them. The financial crisis of 2007–2009 revealed that many financial firms held assets that were far riskier than investors had realized. Congress passed the Wall Street Reform and Consumer Protection Act (Dodd-Frank Act) in July 2010 to address some of the issues raised by the financial crisis of 2007–2009.

Appendix: Tools to Analyze Firms' Financial Information (pages 193–199)

Understand the concept of present value and the information contained on a firm's income statement and balance sheet.

Chapter Review

6.1

Chapter Opener: Facebook Learns the Benefits and Costs of Becoming a Publicly Owned Firm (page 169)

In 2004, Mark Zuckerberg, a college sophomore at the time, started Facebook. As Facebook's popularity expanded, the costs of running the business grew as well, and the company looked for sources of funding to continue operating the business. In May 2012, Facebook became a *public firm* by selling shares to the general public. During the following year, the company had difficulty selling advertisements as more people began using Facebook on smartphones than on computers, and so its revenue grew more slowly than expected. Facebook's stock price dropped substantially, causing investors who had bought its shares to suffer large losses.

Types of Firms (pages 170–173)

Learning Objective: Categorize the major types of firms in the United States.

In the United States, a firm can assume one of three basic legal structures. A **sole proprietorship** is a firm owned by a single individual and not organized as a corporation. A **partnership** is a firm owned by two or more persons and not organized as a corporation. Owners of sole proprietorships and partnerships have control of their day-to-day operations, but they are subject to unlimited liability. There is no legal distinction between the owners' personal assets and those of the firms they own. As a result, employees or

suppliers have a legal right to sue if they are owed money by these firms, even if this requires the owners to sell their personal assets.

A **corporation** is a legal form of business that provides owners with limited liability. **Limited liability** is the legal provision that shields owners of a corporation from losing more than they have invested in the firm. The profits of corporations are taxed twice in the United States, and corporations are more difficult to organize and run than sole proprietorships and partnerships. Despite these disadvantages, limited liability and the possibility of raising funds by issuing stock make corporations an attractive form of business.

Study Hint

You may hear a corporation described as a "publicly owned company." This phrase means that corporations are owned by members of the general public, not that they are owned by the government. *Making the Connection* "How Important Are Small Businesses to the U.S. Economy?" explains that while sole proprietorships and other small businesses together employ a small fraction of the nation's workforce, they are by no means unimportant to the U.S. economy. In a typical year, 40 percent of all new jobs are created by small firms with fewer than 20 workers. More than 85 percent of all jobs created by new firms are created by small firms instead of large corporations.

Extra Solved Problem 6.1

The Risks of Private Enterprise: The "Names" of Lloyd's of London Supports Learning Objective 6.1: Categorize the major types of firms in the United States.

The world-famous insurance company, Lloyd's of London, got its start in London in the 1600s. Ship owners would come to Edward Lloyd's coffeehouse to find someone to insure (or "underwrite") their ships and cargo for a fee. Coffeehouse customers—merchants and ship owners themselves—who agreed to insure ships would make payment from their personal funds if a ship was lost at sea. By the late 1700s, each underwriter would recruit investors known as "Names" and use the funds raised to back insurance policies sold to a wide variety of clients.

By the 1980s, 34,000 people around the world had invested in Lloyd's as Names. A series of disasters in the 1980s and 1990s—earthquakes, oil spills, etc.—resulted in huge payments made on Lloyd's insurance policies. It had become clear that Lloyd's was not a corporation, and the Names did not have the limited liability that a corporation's stockholders have. Many Names lost far more than they had invested. Some of those who invested in Lloyd's had the financial resources to absorb their losses, but others did not. Tragically, as many as 30 Names may have committed suicide as a result of their losses. By 2008, only 1,100 Names remained invested in Lloyd's. New rules allow insurance companies to underwrite Lloyd's policies for the first time, and Names now provide only about 20 percent of Lloyd's funds.

- a. What characteristic of Lloyd's of London's business organization was responsible for the financial losses suffered by the Names who had invested in Lloyd's?
- b. In the early 2000s, firms such as Enron and WorldCom suffered severe losses after it was discovered that executives of the firms had falsified financial statements to deceive investors. How were the losses suffered by Enron and WorldCom stockholders different from the losses suffered by Lloyd's of London's Names?

Solving the Problem:

Step 1: Review the chapter material.

This problem is about firms and corporate governance, so you may want to review the section "Types of Firms," which begins on page 170 in the textbook.

Step 2: Determine what characteristic of Lloyd's of London's business organization was responsible for the financial losses suffered by the Names who had invested in Lloyd's.

Lloyd's of London was a partnership. A disadvantage of partnerships, as well as sole proprietorships, is the unlimited personal liability of the owners of the firm. The liability Lloyd's partners, or Names, incurred went beyond the amount of funds they invested in the company. Therefore, when the insurance company was hit with a series of financial losses, some of the Names suffered severe financial losses.

Step 3: Explain how the losses suffered by Enron and WorldCom stockholders were different from the losses suffered by Lloyd's of London's Names.

Enron and WorldCom were corporations, so their stockholders had limited liability. Their losses were limited to the amount they had invested in these firms.

6.2

The Structure of Corporations and the Principal—Agent Problem (pages 173–174)

Learning Objective: Describe the typical management structure of corporations and understand the concepts of separation of ownership from control and the principal–agent problem.

Corporate governance is the way corporations are structured and the effect that structure has on the firm's behavior. Shareholders in a corporation elect a board of directors to represent their interests. The board of directors appoints a chief executive officer (CEO) to run day-to-day operations and may appoint other top managers. Managers may serve on the board of directors (they are referred to as inside directors). Outside directors are directors who do not have a management role in the firm. In corporations, there is a separation of ownership from control. In most large corporations the top management, rather than the shareholders, control day-to-day operations. The separation of ownership from control is an example of a principal—agent problem—a problem caused by an agent pursuing his own interests rather than the interests of the principal who hired him.

6.3

How Firms Raise Funds (pages 174–181)

Learning Objective: Explain how firms raise the funds they need to operate and expand.

To finance expansion, firms can use some of their profits, called retained earnings, rather than pay the profits to owners as dividends. Firms may obtain external funds in two ways. **Indirect finance** is the flow of funds from savers to borrowers through financial intermediaries such as banks. Intermediaries raise funds from savers to lend to firms and other borrowers. **Direct finance** is the flow of funds from savers to firms through financial markets. Direct finance usually takes the form of the borrower selling a financial security to a lender.

A financial security is a document that states the terms under which the funds have passed from the buyer of the security to the borrower. There are two main types of financial securities. A **bond** is a financial security that represents a promise to repay a fixed amount of funds. When a firm sells a bond to raise

145

funds, it promises to pay the purchaser of the bond an interest payment each year for the term of the loan as well as the final payment (or principal) of the loan. The interest payments on a bond are referred to as **coupon payments**. The **interest rate** is the cost of borrowing funds, usually expressed as a percentage of the amount borrowed. If the coupon is expressed as a percentage of the face value of the bond, then we have the coupon rate of the bond.

If the face value of a bond is \$1,000 and the annual interest payment on the bond is \$60, then the coupon rate is

$$\frac{$60}{$1,000} = 0.06$$
 or 6 percent.

A **stock** is a financial security that represents partial ownership of a firm. As an owner of the firm, a shareholder is entitled to a share of the corporation's profits. Management decides how much profit to reinvest in the firm (retained earnings). The remaining profits are paid to stockholders as **dividends**.

There is a broad market for previously owned stocks and bonds. Changes in the prices of these financial instruments represent future expectations of the profits likely to be earned by the firms that issued them. Changes in the prices of bonds issued by a corporation reflect investors' perceptions of the firm's ability to make interest payments as well as the prices of newly issued bonds. A previously issued bond with a coupon payment of \$80 and a principal of \$1,000 is less attractive than a newly issued bond with a coupon payment of \$100 and a principal of \$1,000. The price of the previously issued bond must fall, and its interest rate must rise, to induce investors to buy it.

■ Study Hint

The double taxation of corporate profits—once via the corporate profits tax and again via the income tax on shareholders' dividends—gives corporations an incentive to raise funds more through debt (bonds) than equity (stocks). Some economists have criticized the corporate profits tax because it gives corporations an incentive to incur debt solely to reduce taxes. *Making the Connection* "The Rating Game: Is the U.S. Treasury Likely to Default on Its Bonds?" provides a discussion of the major credit rating agencies' bond ratings and the meaning of degrading U.S. Treasury bonds by Standard & Poor's in August 2011. *Making the Connection* "Following Abercrombie & Fitch's Stock Price in the Financial Pages" provides a thorough explanation of how to read the stock pages in the newspaper using Abercrombie & Fitch as an example.

Extra Solved Problem 6.3

Facebook's Stocks

Supports Learning Objective 6.3: Explain how firms raise the funds they need to operate and expand.

On September 6, 2013, Facebook's stock closed at a price of \$43.95 per share, and the trading volume for the day was 117 million. The trading volume is the number of shares traded on the secondary market for that day.

- a. How much financial capital did the trading of these stocks raise for Facebook to use for expansion?
- b. How could Facebook raise additional funds for growth?

Solving the Problem

Step 1: Review the chapter material.

This problem is about how firms raise funds, so you may want to review the section "How Firms Raise Funds," which begins on page 174 in the textbook.

Step 2: Discuss the secondary market for stocks and the impact on funds available for Facebook to expand.

In the feature *Don't Let This Happen to You* "When Facebook Shares Are Sold, Facebook Doesn't Get the Money," you will find a description of secondary markets. The majority of stocks that are bought and sold on a daily basis are being traded in the secondary market. Trading in the secondary market does not raise additional funds for Facebook.

Step 3: Consider the options that Facebook has to raise funds for growth.

There are three main options for a firm to obtain funds for growth. A firm can save some of its profits, called retained earnings. It can borrow money from a bank. Or it can issue more stocks or bonds and sell them directly to the public. All of these options are available to Facebook.

Source: http://finance.yahoo.com/q?s=fb

6.4

Using Financial Statements to Evaluate a Corporation (pages 181–183) Learning Objective: Understand the information provided in corporations' financial statements.

A firm must accurately disclose its financial condition to enable potential investors to make informed decisions about the firm's stock and bond offerings. The Securities and Exchange Commission (SEC) requires publicly owned firms to report their performance according to generally accepted accounting principles.

There are two main types of financial statements. An **income statement** is a financial statement that sums up a firm's revenues, costs, and profit over a period of time. The income statement is used to compute the firm's **accounting profit**, which is the firm's net income measured by revenue minus operating expenses and taxes paid. Economic profit—measured by a firm's revenue minus all of its implicit and explicit costs—provides a better indication than accounting profit of how successful a firm is. **Opportunity cost** is the highest-valued alternative that must be given up to engage in an activity. Opportunity costs can include both **explicit costs** that involve spending money and **implicit costs** that are nonmonetary costs. One significant implicit cost is the cost of investor's funds, measured as the value of those funds in their

highest-alternative use. If a firm fails to provide investors with at least a normal rate of return, it will not be able to retain investors and will not be able to remain in business over the long run.

A balance sheet is a financial statement that sums up a firm's financial position on a particular day, usually the end of a quarter or year. The balance sheet summarizes a firm's assets and liabilities. An asset is anything of value owned by a person or a firm. A liability is anything owed by a person or a firm. The difference between the value of assets and liabilities is the firm's net worth.

■ Study Hint

Keep in mind that, while accounting profit is useful in measuring whether a company is earning enough revenue to pay its bills, economic profit is a more accurate measure of how successful a firm is. Firms that are earning accounting profits may not be earning economic profits. Even though such a firm may look healthy financially, if the opportunity costs of producing are greater than revenues, then there are alternative uses of the company's resources that would be more profitable. Firms that do not earn economic profits will not remain in business over the long run.

Extra Solved Problem 6.4

Accounting Profit versus Economic Profit

Supports Learning Objective 6.4: Understand the information provided in corporations' financial statements.

Suppose that Sally decides to open a business. Opening Sally's Sassy Salon will cost \$130,000 for the necessary capital equipment. Sally is considering two options for financing her new beauty salon. The first option she is considering is to borrow \$100,000 and take \$100,000 from her savings. The second option is to take \$130,000 from her savings to start the business. Suppose that her savings account is earning 5 percent interest and the loan that her bank offered her also has a 5 percent interest rate.

- a. What is the explicit cost of opening Sally's Sassy Salon if she chooses the first option? If she chooses the second option? What is the implicit cost of opening Sally's Sassy Salon using the first option? The second option?
- b. Which option will give Sally the higher economic profit? The higher accounting profit?

Solving the Problem

Step 1: Review the chapter material.

This problem is about financial statements, so you may want to review the section "Using Financial Statements to Evaluate a Corporation," which begins on page 181 in the textbook.

Determine the implicit and explicit costs of each option. Step 2:

The explicit costs would be costs that require an outlay of money, for example, the interest on the loan, and the implicit costs would be the forgone interest on her savings. The first option has an explicit cost of $0.05 \times \$100,000 = \$5,000$ and an implicit cost of $0.05 \times \$100,000 = \$5,000$. The second option has no explicit cost and has $0.05 \times \$130,000 = \$10,000$ in implicit costs.

Step 3: Evaluate the economic and accounting profit for Sally's Sassy Salon.

Assuming that her revenue will be unaffected by her choice of how she finances her new firm, we can see that the explicit cost of the second option is lower than the first option. This means that the second option would have a higher accounting profit. If we consider all of the costs, both explicit and implicit, then we are calculating the economic profit. In this case, the explicit cost plus implicit cost is the same for both options, so the economic profit would be the same for either option.

6.5

Corporate Governance Policy and the Financial Crisis of 2007—2009 (pages 183—187)

Learning Objective: Discuss the role that corporate governance problems may have played in the financial crisis of 2007–2009.

During 2001 and 2002, the importance of providing accurate financial information through financial statements was illustrated by several major financial scandals. The *Sarbanes-Oxley Act of 2002* was passed in response to these scandals. The act requires corporate directors and chief executive officers to have greater accountability for the accuracy of their firms' financial statements. Beginning in 2007, the U.S. economy suffered its worst financial crisis since the Great Depression, stemming from problems in the subprime mortgage industry. Borrowers who were unable to afford their mortgages began to default, and as housing prices fell, banks and other private financial firms who had securitized these mortgages began to fail. New regulations were considered to increase oversight over banks and other financial firms that securitize mortgages. In July 2010, Congress passed the Wall Street Reform and Consumer Protection Act (Dodd-Frank Act) in an attempt to overhaul regulation of the financial system. The act's provisions include the creation of the Consumer Financial Protection Bureau that determines rules intended to protect consumers in their borrowing and investing activities, and the creation of the Financial Stability Oversight Council that identifies and acts on risks to the financial system. However, some economists have argued that the principal-agent problem was the cause for those large investment banks to take on so much risk and so they eventually failed during the financial crisis.

Study Hint

One result, likely an unintended one, of the Sarbanes-Oxley Act was to increase the demand for newly hired accountants. For example, the accounting firm Ernst and Young hired 4,500 undergraduate accounting students in 2005, an increase of 30 percent from the previous year.

Source: "Jobs: Accountants are kings among grads," *CNNMoney*, June 5, 2005. http://money.cnn.com/2005/06/pf/accountant.jobs.reut/index.htm?ccc=yes

149

Appendix

Tools to Analyze Firms' Financial Information (pages 193–199)

Learning Objective: Understand the concept of present value and the information contained on a firm's income statement and balance sheet.

Using Present Value to Make Investment Decisions

Most people value funds they have today more highly than funds they will receive in the future. **Present value** is the value in today's dollars of funds to be paid or received in the future. Someone who lends money expects to be paid back the amount of the loan and some additional interest. If someone lends \$1,000 for one year at 10 percent interest, the value of money received in the future is:

$$1,000 \times (1+0.10) = 1,100.$$

Dividing this expression by (1 + 0.10) and adjusting terms:

$$$1,000 = \frac{$1,000}{(1.10)}$$

Writing this more generally:

Present Value =
$$\frac{\text{Future Value}}{(1+i)}$$

The present value formula for funds received any number of years in the future (*n* represents the number of years) is:

Present Value =
$$\frac{\text{Future Value}_n}{(1+i)^n}$$

The present value formula can be used to calculate the price of a financial asset. The price of a financial asset should be equal to the present value of the payments to be received from owning that asset. The general formula for the price of a bond is:

Bond Price =
$$\frac{\text{Coupon}_1}{(1+i)} + \frac{\text{Coupon}_2}{(1+i)^{2}} + \dots + \frac{\text{Coupon}_n}{(1+i)^n} + \frac{\text{Face Value}}{(1+i)^n}$$

In this formula,

Coupon is the coupon payment, or interest payment, to be received after one year.

Coupon₂ is the coupon payment after two years.

Coupon_n is the coupon payment in the year the bond matures.

Face Value is the face value of the bond to be received when the bond matures.

The interest rate on comparable newly issued bonds is i.

The price of a share of stock should be equal to the present value of the dividends, or the profits paid to shareholders, that investors expect to receive as a result of owning the stock. The general formula for the price of a stock is:

Stock Price =
$$\frac{\text{Dividend}_1}{(1+i)} + \frac{\text{Dividend}_2}{(1+i)^2} + \dots$$

Unlike a bond, a stock has no maturity date, so the stock price is the present value of an infinite number of dividend payments. Unlike coupon payments, which are written on the bond and can't be changed, dividend payments are uncertain. If dividends grow at a constant rate, the formula for determining the price of a stock is:

Stock Price =
$$\frac{\text{Dividend}}{(i - \text{Growth Rate})}$$
.

Dividend refers to the dividend currently received, and Growth Rate is the rate at which dividends are expected to grow.

Going Deeper into Financial Statements

Corporations disclose substantial information about their business operations and financial position to investors. This information is provided for two reasons. First, participants in financial markets demand the information. Second, some of this information meets the requirements of the U.S. Securities and Exchange Commission. The key sources of information about a corporation's profitability and financial position are its income statement and balance sheet. Income statements summarize a firm's revenues, costs, and profit over a time period (for example, one year). These statements list the firm's revenues and its cost of revenue (also called its costs of sales or cost of goods sold). The difference between a firm's revenues and costs is its profit. Operating income is the difference between revenue and operating expenses. Investment income is income earned on holdings of investments such as government and corporate bonds. The net income that firms report on income statements is referred to as after-tax accounting profit.

A balance sheet summarizes a firm's financial position on a particular day. An asset is anything of value owned by the firm. A liability is a debt or obligation owed by the firm. **Stockholders' equity** is the difference between the value of a corporation's assets and the value of its liabilities, also known as net worth. Balance sheets list assets on the left side and liabilities and net worth or stockholders' equity on the right side. The value on the left side of the balance sheet must equal the value on the right side. Current assets are assets the firm could convert into cash quickly. Goodwill represents the difference between the purchase price of a company and the market value of its assets. Current liabilities are short-term debts. Long-term liabilities include long-term bank loans and outstanding corporate bonds.

Key Terms

Accounting profit A firm's net income, measured by revenue minus operating expenses and taxes paid.

Asset Anything of value owned by a person or a firm.

Balance sheet A financial statement that sums up a firm's financial position on a particular day, usually the end of a quarter or year.

Bond A financial security that represents a promise to repay a fixed amount of funds.

Corporate governance The way in which a corporation is structured and the effect that structure has on the corporation's behavior.

Corporation A legal form of business that provides owners with protection from losing more than their investment should the business fail.

Coupon payment An interest payment on a bond.

Direct finance A flow of funds from savers to firms through financial markets, such as the New York Stock Exchange.

Dividends Payments by a corporation to its shareholders.

Economic profit A firm's revenues minus all of its implicit and explicit costs.

Explicit cost A cost that involves spending money.

Implicit cost A nonmonetary opportunity cost.

Income statement A financial statement that sums up a firm's revenues, costs, and profit over a period of time.

Indirect finance A flow of funds from savers to borrowers through financial intermediaries such as banks. Intermediaries raise funds from savers to lend to firms (and other borrowers).

Interest rate The cost of borrowing funds, usually expressed as a percentage of the amount borrowed.

Liability Anything owed by a person or a firm.

Limited liability The legal provision that shields owners of a corporation from losing more than they have invested in the firm.

Opportunity cost The highest-valued alternative that must be given up to engage in an activity.

Partnership A firm owned jointly by two or more persons and not organized as a corporation.

Principal—agent problem A problem caused by an agent pursuing his own interests rather than the interests of the principal who hired him.

Separation of ownership from control A situation in a corporation in which the top management, rather than the shareholders, control day-to-day operations.

Sole proprietorship A firm owned by a single individual and not organized as a corporation.

Stock A financial security that represents partial ownership of a firm.

Wall Street Reform and Consumer Protection Act (Dodd-Frank Act) Legislation passed during 2010 that was intended to reform regulation of the financial system.

Key Terms—Appendix

Present value The value in today's dollars of funds to be paid or received in the future.

Stockholders' equity The difference between the value of a corporation's assets and the value of its liabilities; also known as *net worth*.

Self-Test

(Answers are provided at the end of the Self-Test.)

Multiple-Choice Questions

- 1. Which of the following statements is true about firms in the United States?
 - a. In the United States, most firms are organized as corporations.
 - b. In the United States, there are more partnerships than sole proprietorships.
 - c. In the United States, corporations account for the majority of profits earned by all firms.
 - d. all of the above
- 2. Which of the following types of firms have limited liability?
 - a. a corporation
 - b. a sole proprietorship
 - c. a partnership
 - d. all of the above
- 3. Your friend asks you to join him in the new smartphone app business he is setting up as a partnership. If you invest \$10,000 in the business, what is the limit to your liability?
 - a. \$10,000
 - b. \$100,000
 - c. \$1,000
 - d. There is no limit to your liability.
- 4. Which of the following is true about liability for a corporation?
 - a. The owners of a corporation have limited liability.
 - b. The owners of a corporation have unlimited liability.
 - c. The owners of a corporation may or may not be subject to unlimited liability.
 - d. The owners of a corporation do not face any constraints with regard to liability issues.
- 5. In which of the following cases is there a legal distinction between the personal assets of the owners of the firm and the assets of the firm?
 - a. sole proprietorships
 - b. partnerships
 - c. corporations
 - d. in both the case of sole proprietorships and the case of partnerships
- 6. When a corporation fails, which of the following is true?
 - a. The owners can always lose more than the amount they have invested in the firm.
 - b. The owners can never lose more than the amount they have invested in the firm.
 - c. The owners will always lose less than the amount they have invested in the firm.
 - d. What the owners lose is unrelated to liability laws.

- a. \$10,000
- b. \$100,000
- c. \$1,000
- d. There is no limit to your liability.
- 8. In the United States, how are corporate profits taxed?
 - a. Corporate profits are taxed only when investors of the corporations receive a share of the profits.
 - b. Corporate profits are taxed only once at the corporate level.
 - c. Corporate profits are taxed both at the corporate level and at the time when investors of the corporations receive a share of the profits.
 - d. Corporate profits are exempt from taxation.
- 9. Which of the following is one of the advantages of a sole proprietorship as a business organization?
 - a. The firm can protect itself against debts.
 - b. Its owner has unlimited personal liability.
 - c. Profits are taxed only once.
 - d. Its owner has great ability to raise funds.
- 10. Which type of firms account for the majority of revenue earned in the United States in 2012?
 - a. sole proprietorships
 - b. corporations
 - c. partnerships
 - d. none of the above
- 11. Which type of firms accounts for the majority of business organizations in the United States in 2012?
 - a. sole proprietorships
 - b. partnerships
 - c. corporations
 - d. none of the above
- 12. What is corporate governance?
 - a. Corporate governance is a structure imposed on all corporations by the Securities and Exchange Commission.
 - b. Corporate governance is the way in which corporations are structured and the impact a corporation's structure has on the firm's behavior.
 - c. Corporate governance is the division of business firms among proprietorships, partnerships, and corporations.
 - d. Corporate governance is the relationship between corporations and the government officials in the states in which firms operate.
- 13. What term do economists use to refer to the conflict between the interests of shareholders and the interests of top management?
 - a. corporate governance
 - b. a principal-agent problem
 - c. gold plating
 - d. capture theory

154 CHAPTER 6 Firms, the Stock Market, and Corporate Governance

- 14. How can a firm obtain funds for an expansion of its operation?
 - a. by reinvesting profits
 - b. by recruiting additional owners to invest in the firm
 - c. by borrowing funds from relatives, friends, or a bank
 - d. all of the above
- 15. Which of the following refers to a flow of funds from savers to firms through financial markets?
 - a. indirect finance
 - b. direct finance
 - c. business finance
 - d. financial borrowing
- 16. What is the name given to the interest payments on a bond?
 - a. coupon payments
 - b. the cost of borrowing funds
 - c. the face value of the bond
 - d. capital gains
- 17. What are the payments by a corporation to its shareholders?
 - a. stocks
 - b. dividends
 - c. retained earnings
 - d. interest
- 18. If Facebook sells a bond with a face value of \$10,000 and agrees to pay \$300 of interest per year to bond purchasers, what is the interest rate paid on the bond?
 - a. 1%
 - b. 3%
 - c. 8%
 - d. 30%
- 19. If Facebook sells a bond with a face value of \$5,000 and an interest rate of 1 percent, what is the coupon payment on the bond?
 - a. \$50
 - b. \$500
 - c. \$250
 - d. \$1,500
- 20. An increase in a firm's stock price most likely reflects which of the following?
 - a. concern that the firm will soon go out of business
 - b. optimism about the firm's profit prospects
 - c. a higher cost of new external funds
 - d. All of the above would increase the price of a firm's stock.
- 21. What are markets called in which an issuer sells new claims to buyers?
 - a. primary markets
 - b. secondary markets
 - c. tertiary markets
 - d. initial public offerings

- 22. Investors resell existing stocks to each other in what type of market?
 - a. a primary market
 - b. a secondary market
 - c. a bond market
 - d. a dividend market
- 23. When Mark Zuckerberg, the owner and founder of Facebook, opened up ownership of his company to the public, the initial public offering of stock in Facebook would take place in what type of market?
 - a. a primary market
 - b. a secondary market
 - c. a bond market
 - d. a coupon market
- 24. Which of the following is the most important of the over-the-counter markets?
 - a. the New York Stock Exchange
 - b. the American Stock Exchange
 - c. the NASDAO
 - d. the S&P 500
- 25. In the United States, the Securities and Exchange Commission requires publicly owned firms to report their performance in financial statements using standard methods. What are these methods called?
 - a. Standard and Poor's Accounting Standards
 - b. generally accepted accounting principles
 - c. Moody's Investors Service Standards
 - d. U.S. Standard Financial Practices
- 26. If investors become more optimistic about a firm's profit prospects, and the firm's managers want to expand the firm's operations as a result, what will happen to the price of the company's stock?
 - a. It will rise.
 - b. It will fall.
 - c. It will remain constant.
 - d. It may rise for a while but then fall.
- 27. To answer the three basic questions: what to produce, how to produce it, and what price to charge, what does a firm's management need to know?
 - a. the firm's revenues and costs
 - b. the value of the property and other assets the firm owns
 - c. the firm's debts, or other liabilities, that it owes to another person or business
 - d. all of the above
- 28. Which of the following sums up a firm's revenues, costs, and profit over a period of time?
 - a. the balance sheet
 - b. the income statement
 - c. the firm's accounting profit
 - d. the firm's economic profit

- 29. An income statement starts with the firm's revenue and subtracts its operating expenses and taxes paid. What is the remainder called?
 - a. net income
 - b. gross income
 - c. economic profit
 - d. explicit cost
- 30. Which of the following is considered an explicit cost?
 - a. the cost of labor
 - b. the cost of materials
 - c. the cost of electricity
 - d. All of the above are explicit costs.
- 31. What term do economists use to refer to the minimum amount that investors must earn on the funds they invest in a firm, expressed as a percentage of the amount invested?
 - a. opportunity cost
 - b. the normal rate of return
 - c. explicit cost
 - d. economic profit
- 32. Accounting profit is equal to which of the following?
 - (i) Total revenue explicit costs
 - (ii) Total revenue opportunity costs
 - (iii) Economic profit + implicit costs
 - a. (i) only
 - b. (ii) only
 - c. (iii) only
 - d. (i) and (iii) only
- 33. In which of the following industries do investors require a higher rate of return?
 - a. in more risky industries
 - b. in less risky industries
 - c. in more established industries, such as electric utilities
 - d. in any industry (Investors always need to receive high rates of return regardless of the type of investment or the risk involved.)
- 34. Which of the following statements is correct?
 - a. Economic profit equals the firm's revenues minus its explicit costs.
 - b. Accounting profit equals the firm's revenues minus all of its costs, implicit and explicit.
 - c. Accounting profit is larger than economic profit.
 - d. all of the above
- 35. What is a balance sheet?
 - a. a summary of a firm's financial position on a particular day
 - b. a summary of revenues, costs, and profit over a particular period of time
 - c. a firm's net income measured by revenue less operating expenses and taxes paid
 - d. a list of anything owed by a person or business

- 36. What do you obtain by subtracting the value of a firm's liabilities from the value of its assets?
 - a. income
 - b. net worth
 - c. economic profit
 - d. accounting profit
- 37. Which set of incentives does the top management of a corporation have?
 - a. an incentive to attract investors and to keep the firm's stock price high
 - b. an incentive to attract investors and to keep the firm's stock price low
 - c. an incentive to discourage investors and to keep the firm's stock price high
 - d. an incentive to discourage investors and to keep the firm's stock price low
- 38. Which of the following is true? Top managers who are determined to cheat and hide the true financial condition of their firms can
 - a. deceive investors but never outside auditors.
 - b. deceive outside auditors but never investors.
 - c. deceive investors and sometimes also deceive outside auditors.
 - d. deceive other managers but never the company's investors or its outside auditors.
- 39. The landmark Sarbanes-Oxley Act of 2002 mandated that
 - a. chief executive officers personally certify the accuracy of financial statements.
 - b. financial analysts and auditors shall disclose whether any conflicts of interest might exist that could limit their independence in evaluating a firm's financial condition.
 - c. managers shall be held accountable and face stiff penalties (including long jail sentences) for not meeting their responsibilities.
 - d. all of the above be satisfied.
- 40. What does the term "insiders" refer to in the realm of corporate management?
 - a. Insiders are auditors who have access to the corporation's financial statements.
 - b. Insiders are members of top management who also serve on a firm's board of directors.
 - c. Insiders are managers who have connections with people on independent auditing boards.
 - d. An insider is anyone who is not part of a public corporation but who knows something that the public at large does not know.
- 41. In 2010, Congress attempted to overhaul regulation of the U.S. financial system with the passage of
 - a. the Dodd-Frank Act.
 - b. the Gramm-Leach-Bliley Act.
 - c. the Glass-Steagall Act.
 - d. the Sarbanes-Oxley Act.
- 42. One of the causes of the 2007–2009 financial crisis was a dramatic decrease in the value of mortgagebacked securities when housing prices began to fall. What does it mean to securitize a mortgage?
 - a. To securitize a mortgage is to bundle mortgages together and sell them to investors.
 - b. To securitize a mortgage is to buy insurance that guarantees your mortgage will be paid even if you lose your job.
 - c. To securitize a mortgage is to offer a mortgage to a borrower whose credit is below average.
 - d. To securitize a mortgage is to purchase a mortgage from Fannie Mae or Freddie Mac.

Short Answer Questions

	principal-agent	problem. W		vner's liab sole propr				
problem?								
				***************************************	·			
		77			E (a)			
	ions, the owner ovision importan							hy
	//							

	o salary and be							atio
								atic
								atio
								atio
								atic
includes share		stock or optio	ns to buy	the stock a	t a favoral	ble price.	Why?	
Explain why	res of company	stock or optio	ns to buy	the stock a	t a favoral	ble price.	Why?	
Explain why	res of company	stock or optio	ns to buy	the stock a	t a favoral	ble price.	Why?	

5.	Publicly owned firm statements using gene by private firms and WorldCom fail to presulted in billions of	erally accepted accour investors. Why did rovide investors with	nting principle the public dis advance war	s. These starsclosure of	tements are exan the statements o	nined closely of Enron and
					· · · · · · · · · · · · · · · · · · ·	
				-		

True/False Questions

- F 1. In the United States, Standard and Poor's requires publicly owned firms to report their performance in financial statements.
- T F 2. If investors expect a firm to earn economic profits, the firm's share price will rise, providing a dividend for shareholders.
- 3. Indirect finance refers to raising funds through financial intermediaries such as banks.
- T F 4. A disadvantage of organizing a firm as a sole proprietorship or a partnership is that owners have limited liability.
- F A disadvantage of organizing a firm as a corporation is that the firm is subject to the T 5. principal-agent problem.
- T F 6. Economic profit is equal to a firm's revenue minus its operating expenses and taxes paid for a given time period.
- F 7. When a firm incurs an opportunity cost without spending money, its accounting profit is larger than its economic profit.
- The larger a firm's profits are, the higher its stock price. F 8.
- 9. The price of a bond is equal to the present value of dividends, or the profits paid out by the T F firm that issues the bond.
- The unexpected rise in the price of Google stock in 2004 led to the passage of the Sarbanes-F 10. Oxley Act.
- More thanw 70 percent of firms in the United States are sole proprietorships. T 11.
- F 12. The day-to-day operations of a corporation are run by the firm's board of directors.
- T F 13. An advantage of organizing a firm as a partnership is that the partners share the risks of owning the firm.
- T The accounting scandals that occurred in Enron and WorldCom helped bring on the financial crisis of 2007-2009.
- T 15. The Glass-Steagall Act of 1933 that reduced competition between investment banks and commercial banks was a major cause for the financial crisis of 2007–2009.

Answers to the Self-Test

Multiple-Choice Questions

Question	Answer	Comment
1.	c	Corporations currently account for 60 percent of the profits earned by all firms in the United States. See Figure 6.1 on page 171 in the textbook.
2.	a	The owners of corporations have limited liability, while sole proprietorships and partnerships have unlimited liability.
3.	d	Partnerships are firms owned jointly by two or more people, and there is no limit to liability.
4.	a	Most large firms are organized as corporations. A corporation is a legal form of business that provides the owners with limited liability.
5.	С	Unlimited liability means there is no legal distinction between the personal assets of the owners of the firm and the assets of the firm. In sole proprietorships and partnerships, the owners are not legally distinct from the firms they own.
6.	b	Limited liability is the legal provision that shields owners of a corporation from losing more than they have invested in the firm.
7.	a	Liability for owners of a corporation is limited to the amount invested in the firm.
8.	c	Corporate profits are taxed twice—once at the corporate level and again when investors receive a share of corporate profits (revenues less expenses).
9.	c	The profit of a sole proprietorship is taxed only once, without possible double taxation of income as for corporations.
10.	b	Although only 18 percent of all firms are corporations, corporations account for the majority of revenue and profits earned by all firms. See textbook Figure 6.1 for the distribution of revenues and profits by business type.
11.	a	Sole proprietorships account for 72 percent of all firms in the United States. See Figure 6.1 for the distribution of firms by business type.
12.	b	The way in which corporations are structured and the impact a corporation's structure has on the firm's behavior is referred to as corporate governance.
13.	ь	The fact that top managers do not own the entire firm means they may have an incentive to decrease the firm's profits by spending money to purchase private jets or schedule management meetings at luxurious resorts. This problem occurs when agents—in this case, a firm's top management—pursue their own interests rather than the interests of the principal who hired them—in this case, the shareholders of the corporation.
14.	d	All of these are ways in which firms raise the funds they need to expand their operations.
15.	b	A flow of funds from savers to firms through financial markets is known as direct finance. Direct finance usually takes the form of firms selling savers financial securities.
16.	a	A coupon payment is the interest payment on a bond, usually expressed as a percentage of the amount borrowed.
17.	b	Dividends are payments by a corporation to its shareholders.

Questio	n Answer	Comment	
18.	b	The interest rate on a bond is calculated as the ratio of the coupon payment to the face value of the bond.	
19.	a	The annual coupon payment will be the face value of the bond multiplied by the interest rate.	
20.	b	Higher stock prices mean that investors are more optimistic about the firm's profit prospects.	
21.	a	Primary markets are those in which newly issued claims are sold to initial buyers by the issuer.	
22.	b	When stocks and bonds are resold, they are traded in secondary markets.	
23.	a	New issues of stocks and bonds are sold in primary markets.	
24.	С	The stocks of many computer and other high-technology firms—including Microsoft and Apple—are traded on the NASDAQ.	
25.	b	In most high-income countries, government agencies establish standard requirements for information that is disclosed in order for publicly owned firms to sell stocks and bonds. In the United States, this government agency is the	
		Securities and Exchange Commission. To maintain consistency, all firms are required to use generally accepted accounting principles.	
26.	a	Changes in the value of a firm's stocks and bonds offer important information for a firm's managers, as well as for investors. An increase in the stock price means that investors are more optimistic about the firm's profit prospects, and the firm's managers may wish to expand the firm's operations as a result.	
27.	d	To answer these questions, a firm's management needs the following information: The firm's revenues and costs, the value of the property and other assets the firm owns, and the firm's liabilities.	
28.	b	A firm's income statement sums up the firm's revenues, costs, and profits over a period of time.	
29.	a	A firm's net income is revenue less expenses and taxes paid in a given time period.	
30.	d	Firms pay explicit labor costs to employees. They have many other explicit costs as well, such as the cost of the electricity used to light their office buildings.	
31.	b	Economists refer to the minimum amount that investors must earn on the funds they invest in a firm, expressed as a percentage of the amount invested, as a normal rate of return.	
32.	d	Accounting profit equals a firm's revenue minus its explicit costs. This is equivalent to adding a firm's economic profit and implicit costs.	
33.	a	The necessary rate of return that investors must receive to continue investing in a firm varies from firm to firm. If the investment is risky, then investors will require a high rate of return to compensate them for the risk.	
34.	c	Because accounting profit excludes some implicit costs, it will be larger than economic profit.	
35.	a	A firm's balance sheet sums up its financial position on a particular day, usually the end of a quarter or a year.	
36.	b	We can think of the net worth as what the firm's owners would be left with if the firm closed, its assets sold, and its liabilities paid off. Investors can determine a firm's net worth by inspecting its balance sheet.	

Question	Answer	Comment
37.	a	The top management of a firm has at least two reasons to attract investors and keep the firm's stock price high. First, a higher stock price increases the funds the firm can raise when it sells a given amount of stock. Second, to reduce the principal—agent problem, boards of directors will often tie the salaries of top managers to the firm's stock price or to the profitability of the firm.
38.	С	This is what the textbook argues in "Corporate Governance Policy and the Financial Crisis of 2007–2009," beginning on page 183 in the textbook.
39.	d	Each of the responses is a provision of the Sarbanes-Oxley Act.
40.	b	"Insiders" are members of top management of a firm who also serve on the firm's board of directors.
41.	a	In 2010, Congress passed the <i>Wall Street Reform and Consumer Protect Act</i> , also referred to as the <i>Dodd-Frank Act</i> .
42.	a	When groups of mortgages are bundled together and sold to investors, they are securitized.

Short Answer Responses

- 1. The principal-agent problem is used to describe the consequence of separating ownership and management. There is no such division with a sole proprietorship and no principal-agent problem because the principal is also the agent.
- 2. The legal provision of limited liability is important for corporations that try to raise large amounts of funds because the incentive for investors to buy stocks will be greater if they know that their total liability is limited to the investment they make in buying the shares of stock.
- 3. Tying the compensation of managers to the stock price of the firms they manage provides a greater incentive to pursue strategies that enhance profitability. Members of corporate boards of directors choose this form of compensation, in part, in response to the principal—agent problem.
- 4. An income statement reports a firm's accounting profit, which is net income measured by revenue minus explicit costs—operating expenses and taxes paid—over a period of time. Because the income statement does not account for the implicit costs incurred by the firm, accounting profit will be greater than economic profit. Economic profit is computed by subtracting both explicit and implicit costs from total revenue.
- 5. Ultimately the accuracy of a firm's statements depends on the integrity of corporate officials and the accountants who audit these statements. If some corporate officials deliberately choose to provide incomplete and misleading information in their financial statements, then analysts may be persuaded that their firms are more profitable than they actually are.

True/False Answers

Question	Answer	Comment
1.	F	This is the responsibility of the Securities and Exchange Commission.
2.	F	An increase in the share price results in a capital gain.
3.	T	This is the definition of indirect finance.
4.	F	These firms have unlimited liability.
5.	T	The managers of a corporation are typically not the owners, so the principalagent problem may arise.
6.	F	This is the definition of accounting profit.
7.	T	Because the opportunity cost is included its calculation, economic profit is smaller than accounting profit.
8.	T	Stock ownership represents a claim on the firm's profits, so the larger the firm's profits are, the higher will be its stock price.
9.	F	This statement confuses stocks with bonds. The price of stock is equal to the present value of dividends.
10.	F	The Sarbanes-Oxley Act came about to prevent future accounting scandals like those of Enron and WorldCom in 2001.
11.	T	See Figure 6.1 in the textbook for the distribution of firms.
12.	F	The chief executive officer of a corporation is appointed by the board of directors to conduct the firm's day-to-day operations.
13.	T	A partnership allows owners to share risk.
14.	F	The accounting scandals in Enron and WorldCom occurred in the early 2000s. The financial crisis of 2007–2009 was due in part to the process of securitizing mortgages among financial firms.
15.	F	The Glass-Steagall Act of 1933 was repealed by Congress in 1999, after which some commercial banks engaged in investment banking while investment banks took on too much risk.

CHAPTER 7 | Comparative Advantage and the Gains from International Trade

Chapter Summary and Learning Objectives

7.1 The United States in the International Economy (pages 204–207)

Discuss the role of international trade in the U.S. economy. International trade has been increasing in recent decades, in part because of reductions in *tariffs* and other barriers to trade. A **tariff** is a tax imposed by a government on imports. The quantity of goods and services the United States imports and exports has been continually increasing. **Imports** are goods and services bought domestically but produced in other countries. **Exports** are goods and services produced domestically but sold to other countries. Today, the United States is the leading exporting country in the world, and about 20 percent of U.S. manufacturing jobs depend on exports.

7.2 Comparative Advantage in International Trade (pages 207–209)

Understand the difference between comparative advantage and absolute advantage in international trade. Comparative advantage is the ability of an individual, a business, or a country to produce a good or service at the lowest opportunity cost. Absolute advantage is the ability to produce more of a good or service than competitors when using the same amount of resources. Countries trade on the basis of comparative advantage, not on the basis of absolute advantage.

7.3 How Countries Gain from International Trade (pages 209–215)

Explain how countries gain from international trade. Autarky is a situation in which a country does not trade with other countries. The terms of trade is the ratio at which a country can trade its exports for imports from other countries. When a country specializes in producing goods where it has a comparative advantage and trades for the other goods it needs, the country will have a higher level of income and consumption. We do not see complete specialization in production for three reasons: Not all goods and services are traded internationally, production of most goods involves increasing opportunity costs, and tastes for products differ across countries. Although the population of a country as a whole benefits from trade, companies—and their workers—that are unable to compete with lower-cost foreign producers lose. Among the main sources of comparative advantage are climate and natural resources, relative abundance of labor and capital, technology, and external economies. External economies are reductions in a firm's cost that result from an increase in the size of an industry. A country may develop a comparative advantage in the production of a good, and then as time passes and circumstances change, the country may lose its comparative advantage in producing that good and develop a comparative advantage in producing other goods.

7.4 Government Policies That Restrict International Trade (pages 215–222)

Analyze the economic effects of government policies that restrict international trade. Free trade is trade between countries without government restrictions. Government policies that interfere with trade

usually take the form of *tariffs*, *quotas*, or *voluntary export restraints* (VERs). A **tariff** is a tax imposed by a government on imports. A **quota** is a numerical limit imposed by a government on the quantity of a good that can be imported into the country. A **voluntary export restraint (VER)** is an agreement negotiated between two countries that places a numerical limit on the quantity of a good that can be imported by one country from the other country. The federal government's sugar quota costs U.S. consumers \$3.44 billion per year, or about \$1,150,000 per year for each job saved in the sugar industry. Saving jobs by using tariffs and quotas is often very expensive.

7.5 The Arguments over Trade Policies and Globalization (pages 222–227)

Evaluate the arguments over trade policies and globalization. The World Trade Organization (WTO) is an international organization that enforces international trade agreements. The WTO has promoted globalization, the process of countries becoming more open to foreign trade and investment. Some critics of the WTO argue that globalization has damaged local cultures around the world. Other critics oppose the WTO because they believe in protectionism, which is the use of trade barriers to shield domestic firms from foreign competition. The WTO allows countries to use tariffs in cases of dumping, when an imported product is sold for a price below its cost of production. Economists can point out the burden imposed on the economy by tariffs, quotas, and other government interferences with free trade, but whether these policies should be used is a normative decision.

Chapter Review

Chapter Opener: Saving Jobs in the U.S. Tire Industry? (page 203)

In 2009, the U.S. government imposed a tariff on Chinese tires equal to 35 percent of the tires' value. According to President Barack Obama, the purpose of the tariff was to protect jobs in the U.S. tire industry. Like other attempts to protect U.S. firms from foreign competition, the tariff on Chinese tires created winners—the firms and workers in the U.S. domestic tire industry—but it also created losers—U.S. firms that sell imported Chinese tires, and U.S. consumers who must pay higher prices for the Chinese tires.

7.1 The United States in the International Economy (pages 204–207) Learning Objective: Discuss the role of international trade in the U.S. economy.

Imports are goods and services bought domestically but produced in other countries. A **tariff** is a tax imposed by a government on imports. **Exports** are goods and services produced domestically but sold to other countries. Tariff rates in the United States have fallen, and international trade has increased significantly since 1930. The United States is the world's largest exporter, although exports and imports are a smaller fraction of GDP in the United States than in most other countries.

Study Hint

International trade is a controversial topic among politicians and the general public. You may have formed opinions about trade based on comments made through newspaper and magazine articles and conversations with family and friends. In every country there are winners and losers from international trade. Remember that the analysis presented here is positive analysis, not normative. *Making the Connection* "Goodyear and the Tire Tariff" explains the reasons that a tariff does not necessarily help domestic firms and their workers.

Extra Solved Problem 7.1

Chinese Tire Tariff

Supports Learning Objective 7.1: Discuss the role of international trade in the U.S. economy.

In 2009, President Barack Obama announced that he would impose a three-year tariff on tires imported from China. Shortly after the tire tariff policy expired in 2012, a major U.S. tire manufacturer, Goodyear, reported a more than 50 percent increase in its profits in early 2013 compared with the previous year, despite increases in imports of Chinese tires.

Source: Jeff Bennett, "Goodyear Posts First-Quarter Profit," Wall Street Journal, April 26, 2013; and John Bussey, "Get-Tough Policy on Chinese Tires Falls Flat," Wall Street Journal, January 20, 2012.

Explain the impact of the tariff on manufacturers and sellers of tires in the United States.

Solving the Problem

Step 1: Review the chapter material.

This problem asks you to interpret the effect of trade on the United States, so you may want to review section "The United States in the International Economy," which begins on page 204 in the textbook.

Explain the impact of the tariff on manufacturers and sellers of tires in the United Step 2: States.

A tariff will cause Chinese tires to become more expensive in the United States. This makes it more difficult for Chinese tire manufacturers to compete with U.S. tire manufacturers. The tariff would cause imported tires to fall, and U.S. tire manufacturers like Goodyear would be able to sell more tires at a higher price. However, U.S. retailers that sell tires have to deal the effect of the tariff on their profits, as explained in Chapter 4 of this textbook. Also, if a U.S. tire firm like Goodyear operates factories in China and export its tires to the United States, then its tires will also be subject to the tariff.

7.2

Comparative Advantage in International Trade (pages 207–209)

Learning Objective: Understand the difference between comparative advantage and absolute advantage in international trade.

Comparative advantage is the ability of an individual, a firm, or a country to produce a good or service at a lower opportunity cost than another individual, firm, or country. Mutually beneficial trade between two parties is possible when they specialize in the production of the goods and services for which they have a comparative advantage and trade for the goods and services for which they have comparative disadvantage in production. Comparative advantage is the basic argument in favor of free domestic trade as well as free international trade.

Study Hint

Absolute advantage and comparative advantage were explained in Chapter 2 on pages 45–48. Review Solved **Problem 2.2** on page 47 from that chapter to ensure you understand these two concepts.

Extra Solved Problem 7.2

Supports Learning Objective 7.2: Understand the difference between comparative advantage and absolute advantage in international trade.

Suppose that the United States and China each produce only two goods, rice and smartphones. Further assume that these two countries use only labor to produce the two goods. Use the productivity information in this table to answer the questions below.

	Output per hour of work		
	Rice	Smartphones	
United States	2 bushels	10 units	
China	1 bushel	8 units	

- a. Who has the absolute advantage in the production of rice? Who has absolute advantage in the production of smartphones?
- b. Who has the comparative advantage in the production of rice? Who has comparative advantage in the production of smartphones? What good should the United States specialize in? What good should China specialize in?

Solving the Problem:

Step 1: Review the chapter material.

This problem is about comparative advantage, so you may want to review the section "Comparative Advantage in International Trade," which begins on page 207 in the textbook.

Step 2: Determine who has the absolute advantage in the production of each good.

To determine absolute advantage, you should begin by looking at each good individually and ask yourself the question "Who can produce more of the good?" The United States can produce more rice than China, so the United States has the absolute advantage in the production of rice. The United States can also produce more smartphones, so the United States also has the absolute advantage in the production of smartphones.

Step 3: Determine who has the comparative advantage in the production of each good by calculating opportunity costs.

For the United States to produce one bushel of rice, it must give up five smartphones, while China must give up eight smart phones for the same bushel of rice. The United States gives up less to produce rice, so it has the comparative advantage in the production of rice. To produce 1 smartphone, the United States must give up 1/5 of a bushel of rice, while China gives up only 1/8 bushel of rice. Therefore, China has the comparative advantage in the production of smartphones.

Step 4: Determine specialization by looking at the comparative advantage.

To receive gains from trade, countries should specialize in the good in which they have a comparative advantage and then trade that good for goods from other countries. In this case, the United States should specialize in the production of rice, and China should specialize in the production of smartphones.

7.3

How Countries Gain from International Trade (pages 209–215)

Learning Objective: Explain how countries gain from international trade.

The gains from trade can be illustrated with an example of two countries that produce the same two goods under conditions of autarky. Autarky is a situation in which a country does not trade with other countries. When each country specializes in the production of the good for which it has a comparative advantage and trades some of this good for some of the good produced by the other country, (a) total production of both goods can be greater than it would be under conditions of autarky, and (b) total consumption of both goods in both countries can be greater with trade than under conditions of autarky.

The terms of trade is the ratio at which a country can trade its exports for imports from other countries. Although countries as a whole are made better off from trade, trade can harm firms and workers in industries that produce goods at a higher cost than foreign competitors.

Study Hint

Read Solved Problem 7.3 "The Gains from Trade," which describes the gains from trade in David Ricardo's famous cloth and wine example. In this example, Portugal and England each gains from trade. Portugal can specialize in wine, while England specializes in the production of cloth. The two countries can make themselves better off through trade. Be sure you understand the example in the textbook where Japan and the United States are both able to consume more cellphones and tablets after trade than under autarky. The Don't Let This Happen to You feature clarifies that international trade creates not only winners, but also losers who lose their jobs at companies that are less efficient than foreign companies.

In reality, countries do not specialize completely in the goods in which they have the comparative advantage. This lack of complete specialization is because some goods are not traded internationally, opportunity costs increase as production increases, and consumers in different countries have different preferences for products. There are several reasons why a country may have a comparative advantage in producing a particular good. A firm in one country may have a relatively low opportunity cost in the production of a good because of favorable climate, abundant supplies of certain natural resources, or relatively abundant supplies of labor or capital. Another source of comparative advantage is superior technology in one country. Comparative advantage may also result from external economies. External **economies** are reductions in a firm's costs that result from an expansion in the size of an industry.

Study Hint

Raymond Vernon provided the following classic example of the importance of external economies. Anyone who lives in or has visited New York City, Manhattan in particular, knows that prices for most goods and services are higher there than in most other cities. Real estate and transportation are expensive, streets are crowded, and firms must pay employees a premium to compensate for the high cost of living. Yet, the garment and financial industries located in Manhattan continue to thrive despite these disadvantages. For both of these industries, ready access to suppliers, customers, and competitors are important assets. Personal contacts and face-to-face meetings are critical to the success of doing business. The large market size and concentration of related businesses offered by New York City are more important assets than the lower cost of real estate and transportation offered by locations outside of Manhattan.

Making the Connection "Leaving New York City Is Risky for Financial Firms" explains the benefit of external economies for financial firms to be located in New York City. Firms in New York City can benefit from a high concentration of productive workforce and support services in the area.

Government Policies That Restrict International Trade (pages 215–222)

Learning Objective: Analyze the economic effects of government policies that restrict international trade.

Free trade refers to trade between countries that is without government restrictions. Free-trade policies offer benefits to consumers of imported goods and allow for a more efficient allocation of resources than is possible when international trade is restricted by tariffs or other trade barriers. But free trade also harms domestic firms that are less efficient than their foreign competitors.

While a tariff is a tax on imports imposed by the government, a quota is a numerical limit imposed by the government on the quantity of a good that can be imported into the country. A voluntary export restraint (VER) is an agreement negotiated between two countries that places a numerical limit on the quantity of a good that can be imported by one country from the other country. The imposition of these barriers to free trade creates a deadweight loss for the domestic economy.

Study Hint

Figures 7.6 and 7.7 illustrate the deadweight losses that result from the imposition of a tariff or quota. Tables 7.5 and 7.6 describe the costs of trade restrictions in a different but compelling manner. The tables list estimates of the per-job cost to consumers of saving jobs in industries protected by trade restrictions. Those who favor restrictions on international trade must be willing to argue that these high costs of preserving jobs in domestic industries are justified.

See Solved Problem 7.4, "Measuring the Economic Effect of a Quota," for additional practice with analyzing the deadweight losses associated with a quota. If the United States imposes a quota on the number of apples that can be imported into the country, then the price of apples will increase and the quantity of apples that can be purchased will decrease. This causes a decrease in consumer surplus and a deadweight loss to the economy.

Making the Connection "The Effect on the U.S. Economy of the Tariff on Chinese Tires" explains the net effect of the tire tariff on U.S. employment when both winners and losers are taken into consideration. The effect was a net decline of jobs as the decrease in the number of jobs in the U.S. retailing industry due to the tariff more than offset the increase in the number of jobs that the tariff saved in the U.S. tire industry.

7.5

The Arguments over Trade Policies and Globalization (pages 222–227)

Learning Objective: Evaluate the arguments over trade policies and globalization.

Debates over the merits of free trade and policies to restrict trade date back to the beginning of the United States. After World War II, government officials from the United States and Europe negotiated an international agreement to reduce trade barriers and promote free trade. Some interest groups began to oppose free trade policies in the 1990s. You have probably heard the term globalization. Globalization refers to the process of countries becoming more open to foreign trade and investment. Opposition to globalization is based on the fear that low-income countries are at risk of losing their cultural identity as multinational countries sell Western goods in their markets and relocate factories in their countries to take advantage of low-cost labor.

Protectionism is the use of trade barriers to shield domestic firms from foreign competition and is demanded by those who wish to preserve domestic jobs in certain industries or who believe that certain domestic industries should be protected from foreign competition for reasons of national security. Dumping refers to selling a product for a price below the cost of production. If a country is able to establish that foreign firms have dumped products on the domestic market, then they are allowed under

international agreements to impose tariffs on these products. The World Trade Organization (WTO) is an international organization that oversees international trade agreements.

Study Hint

Arguments for and against free trade and globalization offer you an opportunity to analyze important policy issues in an objective manner using positive analysis. You may have formed opinions about these issues after reading or seeing reports of low wages and poor working conditions offered by multinational corporations in developing countries.

Making the Connection "The Unintended Consequences of Banning Goods Made with Child Labor" explains how in some developing countries the alternative to working in a multinational firm is begging or illegal activity. Positive analysis predicts that, as incomes rise in countries, families rely less on child labor. Whether this result is enough to justify child labor involves normative analysis.

Extra Solved Problem 7.5

Sunlight—Bah, Humbug!

Supports Learning Objective 7.5: Evaluate the arguments over trade policies and globalization.

Arguments over international trade are nothing new. Alexander Hamilton called for the protection of socalled "infant industries" in the United States, and farming interests have long espoused trade restrictions to prevent consumers from buying cheaper food products from abroad. Although the countries and industries have changed over time, the arguments over trade restrictions have not. The nineteenth century French economist, Frédèric Bastiat, satirized French opponents of free trade in writing a petition to the French government supposedly from the manufacturers of "candles, waxlights, lamps, candlesticks, street lamps . . . generally of everything connected with lighting." Bastiat's "petition" has been reprinted many times and often appears in textbooks because of its clever theme as well as its applicability to the arguments of twenty-first century "petitioners." Here is a brief excerpt from the "petition:"

We are suffering from the intolerable competition of a foreign rival, placed, it would seem, in a condition so superior to ours for the production of light that he absolutely inundates our national market with it at a price fabulously reduced. The moment he shows himself, our trade leaves us—all consumers apply to him; and a branch of native industry, having countless ramifications, is all at once rendered completely stagnant. This rival . . . is no other than the sun

What we pray for is, that it may please you to pass a law ordering the shutting up of all windows, skylights, dormer-windows, outside and inside shutters, curtains, blinds . . . all openings, holes, chinks, clefts, and fissures by or through which the light of the sun has been in use to enter houses, to the prejudice of the meritorious manufacturers with which we flatter ourselves we have accommodated our country—a country which, in gratitude, ought not to abandon us now to strife so unequal.

Source: Frédèric Bastiat, Social Fallacies, translated by Patrick James Stirling, Santa Anna, CA: Register Publishing, 1944, pp. 60-61.

Cite arguments from Chapter 7 that are similar to those raised in Bastiat's petition.

Solving the Problem

Step 1: Review the chapter material.

This problem is about arguments over trade policies, so you may want to review the section "The Arguments over Trade Policies and Globalization," which begins on page 222 in the textbook.

Step 2: Cite arguments from Chapter 7 that are similar to those raised in Bastiat's petition.
In describing protectionism, Hubbard and O'Brien write:

For as long as international trade has existed, governments have attempted to restrict it to protect domestic firms . . . protectionism causes losses to consumers and eliminates jobs in domestic industries that use the protected product Supporters of protectionism argue that free trade reduces employment by driving domestic firms out of business . . . jobs are lost, but jobs are also lost when more-efficient domestic firms drive less-efficient domestic firms out of business No economic study has ever found a long-term connection between the total number of jobs available and the level of tariff protection for domestic industries.

Source: Hubbard/O'Brien, Macroeconomics, 5th ed., Boston: Prentice Hall, 2012, page 225.

As Bastiat might have said: "plus ça change, plus c'est la même chose." ("The more things change, the more they stay the same.")

Key Terms

Absolute advantage The ability to produce more of a good or service than competitors when using the same amount of resources.

Autarky A situation in which a country does not trade with other countries.

Comparative advantage The ability of an individual, a firm, or a country to produce a good or service at a lower opportunity cost than competitors.

Dumping Selling a product for a price below its cost of production.

Exports Goods and services produced domestically but sold in other countries.

External economies Reductions in a firm's costs that result from an increase in the size of an industry.

Free trade Trade between countries that is without government restrictions.

Globalization The process of countries becoming more open to foreign trade and investment.

Imports Goods and services bought domestically but produced in other countries.

Opportunity cost The highest-valued alternative that must be given up to engage in an activity.

Protectionism The use of trade barriers to shield domestic firms from foreign competition.

Quota A numerical limit imposed by a government on the quantity of a good that can be imported into the country.

Tariff A tax imposed by a government on imports.

Terms of trade The ratio at which a country can trade its exports for imports from other countries.

Voluntary export restraint (VER) An

agreement negotiated between two countries that places a numerical limit on the quantity of a good that can be imported by one country from the other country.

World Trade Organization (WTO) An international organization that oversees international trade agreements.

Self-Test

(Answers are provided at the end of the Self-Test.)

Multiple-Choice Questions

- 1. Fill in the blanks. The sugar quota in the United States creates winners and losers. The winners are , and the losers are
 - a. U.S. sugar consumers; U.S. sugar producers
 - b. U.S. sugar producers; U.S. sugar consumers
 - c. foreign sugar consumers; foreign sugar producers
 - d. foreign sugar producers; foreign sugar consumers
- 2. Since 1930, what has generally happened to tariff rates?
 - a. Tariff rates have risen.
 - b. Tariff rates have fallen.
 - c. Tariff rates have remained the same.
 - d. Tariffs rates have fluctuated up and down.
- 3. Goods and services produced domestically but sold to other countries are called
 - a. imports.
 - b. exports.
 - c. tariffs.
 - d. net exports.
- 4. Which of the following is true about the importance of trade in the U.S. economy?
 - a. Exports and imports have steadily declined as a fraction of U.S. GDP.
 - b. While exports and imports have been steadily rising as a fraction of GDP, not all sectors of the U.S. economy have been affected equally by international trade.
 - c. Only a few U.S. manufacturing industries depend on trade.
 - d. none of the above

5. Refer to the graph below. The figure is a representation of the pattern of U.S. international trade. Which trend line shows exports?

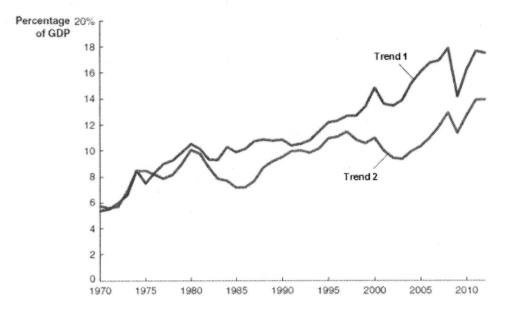

- a. Trend 1
- b. Trend 2
- c. Both lines show exports.
- d. Both lines show imports.
- 6. Refer to the bar graph below. The graph shows the eight leading exporting countries. The values are the shares of total world exports of merchandise and commercial services. In which of the first four positions does the United States come in?

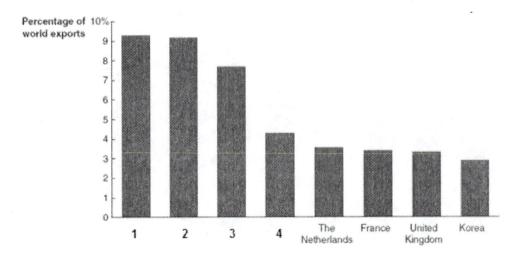

- a. 1
- b. 2
- c. 3
- d. 4

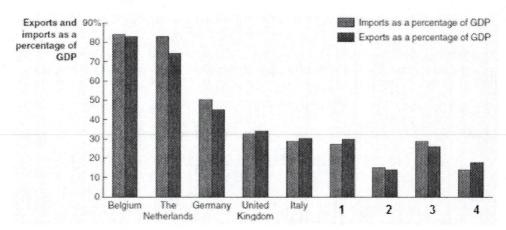

- a. 1
- b. 2
- c. 3
- d. 4
- 8. If a country has a comparative advantage in the production of a good, then that country
 - a. also has an absolute advantage in producing that good.
 - b. should allow another country to specialize in the production of that good.
 - c. has a lower opportunity cost in the production of that good.
 - d. All of the above are true.
- 9. You and your neighbor pick apples and cherries. If you can pick apples at a lower opportunity cost than your neighbor can, which of the following is true?
 - a. You have a comparative advantage in picking apples.
 - b. Your neighbor is better off specializing in picking cherries.
 - c. You can trade some of your apples for some of your neighbor's cherries, and both of you will end up with more of both fruit.
 - d. All of the above are true.
- 10. What is absolute advantage?
 - a. the ability of an individual, firm, or country to produce more of a good or service than competitors using the same amount of resources
 - b. the ability of an individual, firm, or country to produce a good or service at a lower opportunity cost than other producers
 - c. the ability of an individual, firm, or country to consume more goods or services than others at lower costs
 - d. the ability of an individual, firm, or country to reach a higher production possibilities frontier by lowering opportunity costs

- 11. Fill in the blanks. Countries gain from specializing in producing goods in which they have a(n) _____ advantage and trading for goods in which other countries have a(n) _____ advantage.
 - a. absolute; absolute
 - b. absolute; comparative
 - c. comparative; absolute
 - d. comparative; comparative
- 12. Consider the table below. The table shows the quantity of two goods that a worker can produce per day in a given country. Which of the following statements is true?

Output per hour of work				
	Computers	Smartphones		
Country A	12	6		
Country B	2	4		

- a. Country A has an absolute advantage in the production of both goods.
- b. Country B has an absolute advantage in the production of both goods.
- c. Both countries have an absolute advantage in the production of both goods.
- d. Neither country has an absolute advantage in the production of either good.
- 13. Consider the table below. The table shows the quantity of two goods that a worker can produce per hour in a given country. Which of the following statements is true?

Output per hour of work				
	Computers	Smartphones		
Country A	12	6		
Country B	2	4		

- a. Country A has a comparative advantage in the production of both goods.
- b. Country B has a comparative advantage in the production of both goods.
- c. Country A has a comparative advantage in the production of smartphones.
- d. Country B has a comparative advantage in the production of smartphones.
- 14. In the real world, specialization is not complete. Why do countries not completely specialize?
 - a. because not all goods are traded internationally
 - b. because production of most goods involves increasing opportunity costs
 - c. because tastes for products differ
 - d. all of the above
- 15. Which of the following is a source of comparative advantage?
 - a. autarky
 - b. absolute advantage
 - c. the relative abundance of capital and labor
 - d. all of the above
- 16. The term external economies refers to
 - a. the process of turning inputs into goods and services.
 - b. the reduction of production costs due to increased capacity utilization.
 - c. the reduction of costs resulting from increases in the size of an industry in a given area.
 - d. the benefits an industry derives from other industries located nearby.

17. Refer to the graph below of the market for lumber in the United States. Under autarky, what is the equilibrium price of lumber?

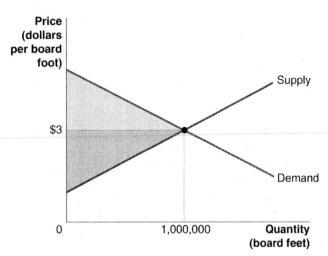

- a. \$3 per board foot
- b. less than \$3 per board foot
- c. \$333,333 per board foot
- d. \$1,000,000 per board foot
- 18. Refer to the graph below of the market for lumber in the United States. Under autarky, which area represents consumer surplus?

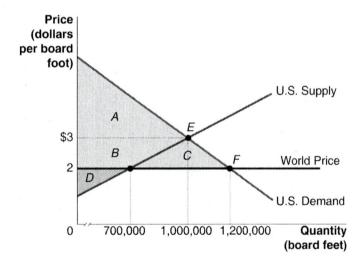

- a. A
- b. A + B
- c. A+B+C
- d. C only

19. Refer to the graph below of the market for lumber in the United States. Under autarky, which area represents the total economic surplus?

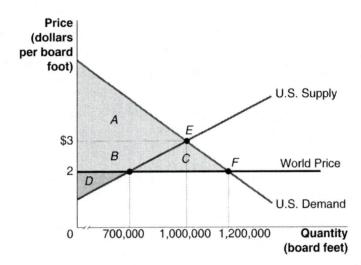

- a. A
- b. A + B
- c. A+B+C
- d. A+B+D
- 20. Refer to the graph below of the market for lumber in the United States. How many board feet of lumber are imported when imports are allowed into the United States?

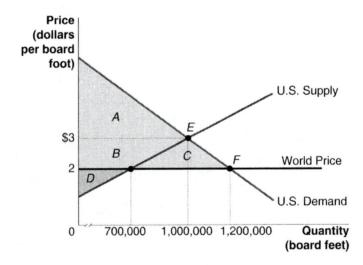

- a. 1,000,000
- b. 500,000
- c. 700,000
- d. 1,200,000

21. Refer to the graph below of the market for lumber in the United States. Which area represents domestic producer surplus with free trade?

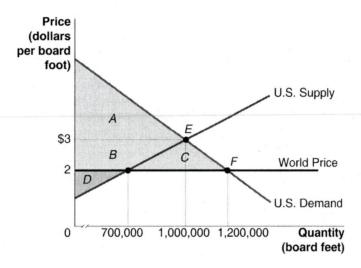

- a. A
- b. A+B
- c. A+B+D
- d. D
- 22. Refer to the graph below of the market for lumber in the United States. If the world price is \$2 and the United States imports lumber with no trade restrictions, what area represents consumer surplus?

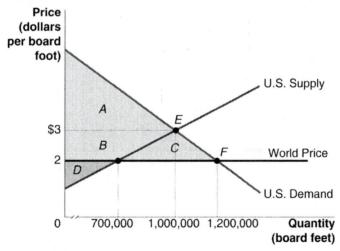

- a. A
- b. A + B
- c. A+B+C
- d. D

23. Refer to the graph below of the market for lumber in the United States. Which area represents the increase in economic surplus from opening the economy to imports?

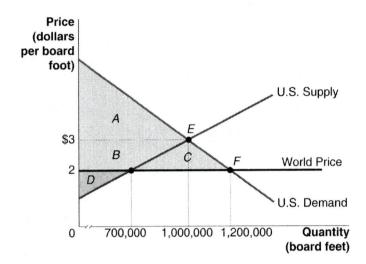

- a. Area A
- b. Area B + C
- c. Area C
- d. Area D
- 24. Refer to the graph below of the market for lumber in the United States. The figure shows the effect of a \$0.50 per board foot tariff on lumber. Which area represents the deadweight loss from this tariff?

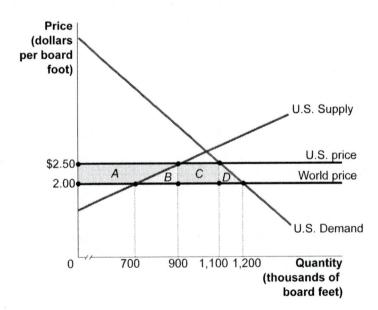

- a. A
- b. *C*
- c. B+D
- d. B+C+D

25. Refer to the graph below of the market for lumber in the United States. The graph shows the effect of a \$0.50 per board foot tariff on lumber. What is the quantity of lumber supplied (in thousands of board feet) by domestic producers after the tariff?

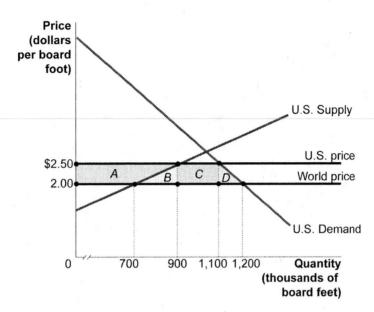

- a. 700
- b. 900
- c. 1,100
- d. 1,200
- 26. Refer to the graph below of the market for lumber in the United States. The graph shows the effect of a \$0.50 per board foot tariff on lumber. What is the reduction in U.S. lumber consumption (in thousands of board feet) as a result of the tariff?

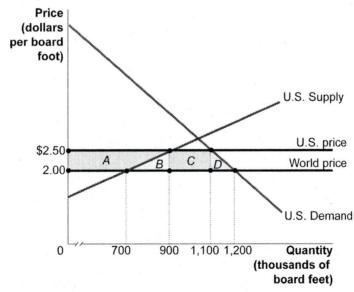

- a. 100
- b. 200
- c. 300
- d. 500

27. Refer to the graph below of the market for lumber in the United States. The graph shows the effect of a \$0.50 per board foot tariff on lumber. Which area represents the revenue collected by government from the tariff?

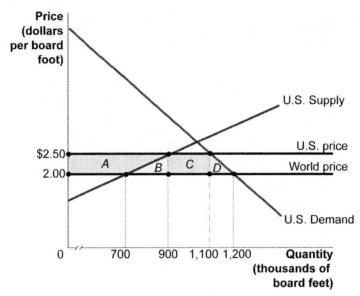

a.
$$A + B + C + D$$

b.
$$B + D$$

28. Refer to the graph below of the market for lumber in the United States. The graph shows the effect of a \$0.50 per board foot tariff on lumber. How much revenue is collected by the government from the tariff?

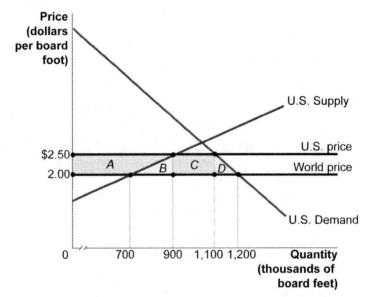

- a. \$100,000
- b. \$300,000
- c. \$400,000
- d. \$500,000

29. Refer to the graph below of the market for lumber in the United States. The graph shows the effect of a \$0.50 per board foot tariff on lumber. What is the deadweight loss associated with the tariff?

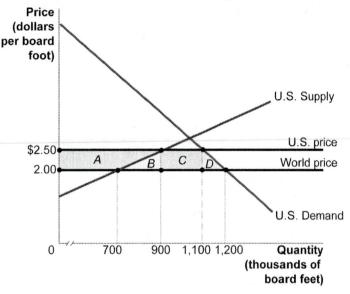

- \$100,000
- b. \$75,000
- c. \$50,000
- d. \$25,000
- 30. What is a quota?
 - a. A quota is a numerical limit on the quantity of a good that can be imported.
 - b. A quota is an agreement negotiated between two countries that places a numerical limit on the quantity of a good that can be imported by one country from the other country.
 - c. A quota is the same thing as a voluntary export restraint.
 - d. All of the above are true.
- 31. What is a voluntary export restraint?
 - a. a numerical limit on the quantity of a good that can be imported
 - b. an agreement negotiated between two countries that places a numerical limit on the quantity of a good that can be imported by one country from the other country
 - c. a quota imposed by the WTO
 - d. the same as a tariff
- 32. In the United States and Japan, the cost of saving jobs through trade barriers like tariffs and quotas is
 - a. relatively low in both countries.
 - b. relatively high in both countries.
 - c. relatively high in the United States but relatively low in Japan.
 - d. relatively low in the United States but relatively high in Japan.
- 33. Which of the following groups of people are significant sources of opposition to the World Trade Organization (WTO)?
 - a. people who want to protect domestic firms
 - b. people who believe that low-income countries gain at the expense of high-income countries
 - c. people who favor globalization
 - d. All of the above oppose the WTO.

- 34. The opponents of globalization contend that
 - a. globalization destroys cultures.
 - b. globalization causes factories to relocate from low-income to high-income countries.
 - c. globalization means that workers in poor countries lose jobs.
 - d. all of the above occur as a result of globalization.
- 35. The use of trade barriers to shield domestic companies from foreign competition is called
 - a. protectionism.
 - b. dumping.
 - c. globalization.
 - d. patriotism.
- 36. Which of the following arguments is used to justify protectionism?
 - a. Tariffs and quotas save jobs.
 - b. Tariffs and quotas protect national security.
 - c. Tariffs and quotas protect infant industries.
 - d. All of the above are used to justify protectionism.
- 37. Which of the following is a drawback of the "infant industry" as a justification for protectionism?
 - a. The industry under protection will never become efficient enough to compete with foreign firms.
 - b. It is inefficient and unfair to protect some domestic industries but not other domestic industries.
 - c. Learning by doing among firms in infant industries can occur only through interacting with foreign firms.
 - d. Most infant industries do not have a comparative advantage in production.
- 38. What is the name given to the sale of a product for a price below its cost of production?
 - a. bargain pricing
 - b. cut-throat pricing
 - c. grim-trigger pricing
 - d. dumping
- 39. How does the World Trade Organization allow countries to determine whether dumping has occurred?
 - a. The WTO determines that dumping has occurred if a product is imported for a lower price than it sells for in the home market.
 - b. The WTO determines that dumping has occurred if a product is exported for a lower price than it sells for in the home market.
 - c. The WTO determines that dumping has occurred if firms are selling products for a price that exceeds the cost of production.
 - d. The WTO determines that dumping has occurred if some brands in the country sell for lower prices than other brands in the same country.
- 40. Which of the following is an example of positive economic analysis?
 - a. measuring the impact of the sugar quota on the U.S. economy
 - b. asserting that the sugar quota is bad public policy and should be eliminated
 - c. justifying the profits of U.S. sugar companies based on the number of workers they employ
 - d. All of the above are examples of positive economic analysis.

Short Answer Questions

		· · · · · · · · · · · · · · · · · · ·		,			1
United Sta jobs saved	and 7.6 in t tes and Japar is much smal do the govern	for each jol ler than the n	saved in sumber of co	everal produ onsumers wh	o must pay	Because thigh prices	he numb to save
			· · · · · · · · · · · · · · · · · · ·				
							A ACTION OF THE STATE OF THE ST
	pt of compara						
producing		it can produ	ce at a lowe	er opportunit	y cost than o	other count	ries. Bu
producing	one good that	it can produ	ce at a lowe	er opportunit	y cost than o	other count	ries. Bu
producing	one good that	it can produ	ce at a lowe	er opportunit	y cost than o	other count	ries. Bu
producing why, in the	ardo's explar	t it can produre many good	ce at a lower dis like autor	er opportunity nobiles produ	y cost than ouced in man	to be one	of the
producing why, in the	ardo's explar	t it can produre many good	ce at a lower dis like autor	er opportunity nobiles produ	y cost than ouced in man	to be one	of the

186 CHAPTER 7 | Comparative Advantage and the Gains from International Trade

PB	be demonstrate	 	Pro	
			1 1 1 1 1	

True/False Questions

- T F 1. As a percentage of GDP, U.S. imports and exports have both decreased during the past 20 years.
- T F 2. In the Netherlands, imports and exports represent a larger fraction of GDP than in any other country.
- T F 3. In 2012, the United States was the leading exporting country in the world.
- T F 4. One reason why countries do not specialize completely in production is that not all goods and services are traded internationally.
- T F 5. Most governments in the world erect barriers to foreign competition because the costs of trade barriers on consumers are very small in total as compared to the jobs saved as result of those trade barriers.
- T F 6. Financial firms in New York City developed a comparative advantage in financial services because of external economies.
- T F 7. Over the past 50 years, most governments have increasingly practiced protectionism by imposing tariffs and quotas.
- T F 8. Barriers to international trade include health and safety requirements that are more strictly imposed on imported goods than goods produced by domestic firms.
- T F 9. The Smoot-Hawley Tariff of 1930 lowered average tariff rates in the United States by about 50 percent.
- T F 10. One reason why countries do not specialize completely in production is that complete specialization requires countries to have an absolute advantage in the products they produce.
- T F 11. Although countries gain overall from international trade, some individuals are harmed, including some workers who lose their jobs.
- T F 12. The terms of trade refers to the length of trade agreements signed by officials from countries that are parties to these agreements.
- T F 13. In 2012, exports were about 14 percent of U.S. GDP and imports were about 18 percent of U.S. GDP.
- T F 14. Economic surplus in a country that does not engage in international trade is always greater than economic surplus in a country that does engage in international trade.
- T F 15. A tariff imposed on imports of textiles will raise the price of textiles in the importing country and create a deadweight loss in the domestic textile market.

Answers to the Self-Test

Multiple-Choice Questions

Question	Answer	Comment
1.	b	The sugar quota creates winners—U.S. sugar producers and their employees—and losers—U.S. companies that use sugar, their employees, and U.S. consumers who must pay higher prices for goods that contain sugar.
2.	b	Tariff rates have fallen. In the 1930s, the United States charged an average tariff rate above 50 percent. Today, the average rate is less than 2 percent.
3.	b	Imports are goods and services bought domestically but produced in other countries. Exports are goods and services produced domestically but sold to other countries.
4.	b	Not all sectors of the U.S. economy have been affected equally by international trade.
5.	Ь	Exports have been less than imports since 1982.
6.	a	The United States is the leading exporting country, accounting for about 10 percent of total world exports.
7.	d	International trade is less important to the United States than to most other countries.
8.	C	The country with a lower opportunity cost of production has a comparative advantage in the production of that good.
9.	d	If you can pick apples at a lower opportunity cost than your neighbor can, you have a comparative advantage in picking apples. Your neighbor is better off specializing in picking cherries, and you are better off specializing in picking apples. You can then trade some of your apples for some of your neighbor's cherries, and both of you will end up with more of both fruit.
10.	a	Absolute advantage is the ability of an individual, firm, or country to produce more of a good or service than competitors using the same amount of resources.
11.	d	Countries gain from specializing in producing goods in which they have a comparative advantage and trading for goods in which other countries have a comparative advantage.
12.	a	Country A can produce more computers and more smartphones in one hour than Country B.
13.	С	Country A can produce 6 times as many computers as a worker in Country B but only 1.5 times as many smartphones. Country A is more efficient in producing computers than smartphones relative to Country B.
14.	d	These are the three reasons given in the textbook. See page 212.
15.	c	The main sources are: climate and natural resources, the relative abundance of labor and capital, technology, and external economies.
16.	c	The advantages include the availability of skilled workers, the opportunity to interact with other companies in the same industry, and being close to suppliers. These advantages result in lower costs to firms located in the area. Because these lower costs result from increases in the size of the industry in an area, economists refer to them as external economies.
17.	a	When the U.S. does not trade with other nations, the domestic price is also the equilibrium price.

Question	Answer	Comment
18.	a	Autarky refers to equilibrium without international trade. Area A is consumer surplus when price equals the domestic price, or \$3 per board foot.
19.	d	The total economic surplus is the area between the demand and supply curves out to the domestic equilibrium.
20.	b	Imports will equal 500,000 board feet, which is the difference between U.S. consumption and U.S. production at the world price.
21.	d	With free trade and a price of \$2, only 700,000 board feet of lumber will be produced domestically, so producer surplus is area D .
22.	С	With free trade, consumer surplus is the area below demand but above the price of \$2.
23.	c	Area C is additional consumer surplus that did not exist under autarky.
24.	c	The areas B and D represent deadweight loss.
25.	b	After the tariff is imposed, the quantity supplied domestically is 900 board feet, at a price of \$2.50.
26.	a	At a price (before the tariff) of \$2.00, U.S. consumption is 1,200 thousand. After the tariff is imposed, U.S. consumption falls to 1,100 thousand, so the decrease is 100 thousand.
27.	c	Government revenue equals the tariff multiplied by the number of board feet imported, or area A .
28.	a	Government revenue equals the tariff multiplied by the number of board feet imported, or $\$0.50 \times (1,100,000-900,000) = \$0.50 \times 200,000 = \$100,000$.
29.	b	The deadweight loss is equal to area B plus area D . Both are triangles. The value of area B is $\frac{1}{2} \times 200,000 \times \$0.50 = \$50,000$ and the value of area D is $\frac{1}{2} \times 100,000 \times \$0.50 = \$25,000$, so the sum of the two areas is \$75,000.
30.	a	A quota is a numerical limit on the quantity of a good that can be imported, and it has an effect similar to a tariff.
31.	b	This is the definition of a voluntary export restraint.
32.	b	Tables 7.5 and 7.6 show how expensive it is to save jobs in each country.
33.	a	The WTO favors the opening of trade and opposes most trade restrictions.
34.	a	Some believe that free trade and foreign investment destroy the distinctive cultures of many countries.
35.	a	Protectionism is the use of trade barriers to shield domestic companies from foreign competition.
36.	d	According to the textbook, all of these reasons, in addition to protecting high wages, are used to justify protectionism.
37.	a	Trade barriers that protect an infant industry may eliminate the need for firms in the industry to become efficient enough to compete with foreign firms, so that the infant industry will never "grow up."
38.	d	Dumping is selling a product for a price below its cost of production.
39.	b	Although there are problems with this method for determining whether dumping has occurred, the WTO determines that dumping has occurred if a country exports a product at a lower price than it sells the product for domestically.
40.	a	Positive analysis concerns "what is." Measuring the impact of the sugar quota on the U.S. economy is an example of positive analysis.

Short Answer Responses

- 1. Quotas may be used to restrict trade when there are legal and political obstacles to raising tariffs. Quotas may also be used when there is a desire to limit imports by a specified amount. It is difficult to know the impact of a tariff rate on the amount of imports before the tariff is imposed.
- 2. Because the benefits are concentrated among relatively few workers and producers, these workers and their employers have strong incentives to lobby for trade restrictions. Although many consumers are negatively affected, the impact is spread widely so that no individual has a strong incentive to lobby for the removal of the trade restrictions.
- 3. In the real world, complete specialization does not occur because (1) not all goods and services can be traded freely because of high transportation costs or other reasons; (2) the production of most goods involves increasing opportunity costs that may cause a country to stop short of complete specialization in producing one particular good; and (3) tastes for products differ across countries and most products are differentiated, so that each country may have a comparative advantage in producing different models or styles of the same product like an automobile.
- 4. Comparative advantage explains why domestic and international trade is mutually beneficial under very general conditions, even when one of the parties to a trade has an absolute advantage in both traded goods. Specialization can improve the opportunities for consumption for all countries involved in trade, not just the countries that can produce the largest quantities of goods.
- 5. Dumping (selling a good below its cost of production) is difficult to prove for two main reasons. First, it can be difficult to measure the true cost of production for firms from countries different from the country where the dumping allegedly occurred. Second, what is dumping to a firm harmed by the practice may be normal business practice to the firm that does the selling.

True/False Answers

Question	Answer	Comment
1.	F	U.S. imports and exports have both increased as a fraction of GDP.
2.	T	See textbook Figure 7.3.
3.	F	In 2012, China became a larger exporter than the United States. See page 206 in the textbook.
4.	T	Because not all goods are traded internationally, countries will have to produce some goods domestically to satisfy the demands of domestic consumers.
5.	F	The costs to consumers for each job saved as a result of trade barriers are large in total, but they are spread across many consumers so that the costs are relatively small per person.
6.	T	See <i>Making the Connection</i> "Leaving New York City Is Risky for Financial Firms" on page 214 in the textbook.
7.	F	Over the past 50 years, increasingly more governments have reduced trade barriers and facilitated international trade. See page 204 in the textbook.
8.	T	These are examples of non-tariff barriers to trade.
9.	F	The Smoot-Hawley Tariff raised average tariffs rates to more than 50 percent.
10.	F	A country need not have an absolute advantage in producing any good in order to specialize and gain from trade.

190 CHAPTER 7 | Comparative Advantage and the Gains from International Trade

Question	Answer	Comment
11.	T	There are winners and losers in international trade, and the workers in the industry that competes with the imported goods may lose their jobs.
12.	F	The terms of trade refers to the ratio at which goods trade between two countries.
13.	T	It is true that exports were about 14 percent of GDP and imports were about 18 percent. See page 205 in the textbook.
14.	F	Free trade increases economic surplus.
15.	T	Tariffs are similar to taxes and result in an increase in the price of the good. The resulting decrease in consumption and production creates a deadweight loss.

CHAPTER 8 | GDP: Measuring Total **Production and Income**

Chapter Summary and Learning Objectives

8.1 **Gross Domestic Product Measures Total Production (pages 239–246)**

Explain how total production is measured. Economics is divided into the subfields of microeconomics—which studies how households and firms make choices—and macroeconomics which studies the economy as a whole. An important macroeconomic issue is the **business cycle**, which refers to alternating periods of economic expansion and economic recession. An expansion is a period during which production and employment are increasing. A recession is a period during which production and employment are decreasing. Another important macroeconomic topic is economic growth, which refers to the ability of the economy to produce increasing quantities of goods and services. Macroeconomics also studies the inflation rate, or the percentage increase in the price level from one year to the next. Economists measure total production by gross domestic product (GDP), which is the value of all final goods and services produced in an economy during a period of time. A final good or service is purchased by a final user. An intermediate good or service is an input into another good or service and is not included in GDP. When we measure the value of total production in the economy by calculating GDP, we are simultaneously measuring the value of total income. GDP is divided into four major categories of expenditures: consumption, investment, government purchases, and net exports. Government transfer payments are not included in GDP because they are payments to individuals for which the government does not receive a good or service in return. We can also calculate GDP by adding up the value added of every firm involved in producing final goods and services.

8.2 Does GDP Measure What We Want It to Measure? (pages 246–249)

Discuss whether GDP is a good measure of well-being. GDP does not include household production, which refers to goods and services people produce for themselves, nor does it include production in the underground economy, which consists of concealed buying and selling. The underground economy in some developing countries may be more than half of measured GDP. GDP is not a perfect measure of well-being because it does not include the value of leisure, it is not adjusted for pollution or other negative effects of production, and it is not adjusted for changes in crime and other social problems.

8.3 Real GDP versus Nominal GDP (pages 249–252)

Discuss the difference between real GDP and nominal GDP. Nominal GDP is the value of final goods and services evaluated at current-year prices. Real GDP is the value of final goods and services evaluated at base-year prices. By keeping prices constant, we know that changes in real GDP represent changes in the quantity of goods and services produced in the economy. When the **price level**, the average prices of goods and services in the economy, is increasing, real GDP is greater than nominal GDP in years before the base year and less than nominal GDP for years after the base year. The GDP deflator is a measure of the price level and is calculated by dividing nominal GDP by real GDP and multiplying by 100.

8.4 Other Measures of Total Production and Total Income (pages 253-255)

Understand other measures of total production and total income. The most important measure of total production and total income is gross domestic product (GDP). As we will see in later chapters, for some purposes, the other measures of total production and total income shown in Figure 8.4 are actually more 8.1

useful than GDP. These measures are gross national product (GNP), national income, personal income, and disposable personal income.

Chapter Review

Chapter Opener: Ford Motor Company Rides the Business Cycle (page 237)

Why is GDP important to you? Economic expansions and contractions have a dramatic impact on business outcomes. Ford Motor Company is the oldest automaker in the United States. In early 2009, the U.S. economy was suffering its worse downturn since the 1930s. Meanwhile, Ford suffered heavy losses as the demand for of its cars and trucks dropped 20 percent from a year earlier. By 2013, as the economy's recovery from the downturn was underway, Ford's sales were rising again. Ford and the automobile industry as a whole were experiencing the effects of the business cycle. A business cycle refers the periodic expansion and contraction in the level of production in the nation.

Gross Domestic Product Measures Total Production (pages 239–246) Learning Objective: Explain how total production is measured.

An economy that produces a large quantity of goods and services creates an interesting measurement problem. How do we add together the production of different goods and services to arrive at an aggregate measure of total production?

Economists have developed a method of aggregating the wide variety of production by calculating a measure called gross domestic product or GDP. GDP is defined as the market value of all final goods and services produced in a country during a period of time. We aggregate goods by adding their value, and we determine their value by their price. We count only newly produced goods and services, not all transactions, and we count only transactions that have a market price. Transfer payments, such as Social Security and unemployment insurance, are not counted in GDP because they are payments by the government for which the government does not receive a new good or service in return. Intermediate goods are not counted because they are an input into a final good. For example, General Motors produces cars, but it does not produce the tires that go on the cars. General Motors buys tires from Goodyear and Michelin. The tires are an intermediate good. In calculating GDP, we include the value of the General Motors car but not the value of the tire. If we included the value of the tire, we would be double counting: The value of the tire would be counted once when the tire company sold it to General Motors, and a second time when General Motors sold the car, with the tire installed, to a consumer. GDP is the sum of price multiplied by quantity for all final goods and services produced.

When we calculate GDP as the value of production in a country, we are also measuring the value of income in that country. This is because \$100 spent on a good will ultimately result in \$100 worth of income for the various factors of production that produced that good. The measurement of GDP is often referred to as national income accounting. GDP measures both production and income.

We can also look at GDP from the point of view of expenditures. From the expenditure point of view, we divide GDP into four components:

- 1. Consumption expenditures are expenditures made by households (excluding the purchase of new houses, which we count in investment expenditures).
- 2. Investment expenditures are final goods and services purchased by business firms (equipment for production and new buildings), changes in inventories (which is the difference between production

and sales), and residential construction purchased by households. Read the *Don't Let This Happen to You* feature in this chapter in the textbook for more discussion of the definition of investment.

- 3. Government purchases are spending by the federal, state, and local governments.
- 4. Net exports are exports minus imports.

Study Hint

The feature *Don't Let This Happen to You* appears in this and other chapters to show you how to avoid mistakes often made by economics students. A primary component of investment is the purchase of final goods by business firms. These purchases include equipment used in production and buildings used for production, such as factories and office buildings. Investment in this chapter does not include buying stocks, bonds, and other types of financial assets. *Making the Connection* "Adding More of Lady Gaga to GDP" discusses how the measurement of GDP is affected by the BEA's counting research and development spending as investment instead of as in intermediate good as before.

The components of GDP can be expressed in an equation as:

$$Y = C + I + G + NX$$
.

The equation tells us that GDP (Y) equals consumption (C) plus investment (I) plus government purchases (G) plus net exports (NX).

Value added refers to the additional market value a firm gives to a product and is equal to the difference between the price the firm sells a good for and the price it paid other firms for intermediate goods. The value-added method is an alternative way of calculating GDP that also avoids the problem of double counting intermediate goods.

8.2

Does GDP Measure What We Want It to Measure? (pages 246–249)

Learning Objective: Discuss whether GDP is a good measure of well-being.

Economists use GDP to measure the total production in the economy. As a measure of production, GDP calculations exclude two types of production: production in the home and production in the underground economy. Household production refers to goods and services that people produce for themselves, such as the services that a homemaker provides for his or her family. The **underground economy** refers to the buying and selling of goods and services that are concealed from the government to avoid taxes or regulations because the goods or services are illegal, such as drugs or prostitution. For the United States, these omissions do not cause a serious distortion in the measurement of total production because the underground economy is relatively small and does not change in size very much from year to year. For some lesser developed countries, these values may be very large.

In addition to measuring a country's total production, GDP is also frequently used as a measure of well-being. Although increases in GDP lead to increases in the well-being of a population, it is not a perfect measure for several reasons. GDP does not measure leisure, unless leisure results in a market transaction, such as spending on vacations. GDP also does not subtract the costs of negative nonmarket effects of production, such as pollution and crime. On the other hand, GDP will increase as households make expenditures to offset the impact of these negative nonmarket effects of production. Examples of these expenditures include health care costs due to poor air quality or spending on burglar alarms.

GDP also does not say anything about the distribution of income. Is income distributed equally among the people in the economy, or is the income distribution very unequal, so that a few get a lot of the income?

Study Hint

The feature *Making the Connection* "Why Do Many Developing Countries Have Such Large Underground Economies?" explains the effect of high taxes in many developing countries on the size of their underground economies, or informal sectors. Another *Making the Connection* "Did World War II Bring Prosperity" explains that although GDP rose and unemployment fell during World War II due to increased production of military goods, the amount of consumption goods available to the typical person in fact fell.

Extra Solved Problem 8.2

The Relationship between Real GDP Growth and Per-capita Real GDP Growth Supports Learning Objective 8.2: Discuss whether GDP is a good measure of well-being.

The table below gives real GDP (in billions of 2000 dollars) and U.S. population (in thousands) for the years 1992–2012. For each year, calculate the growth rate in real GDP and the growth rate in per-capita real GDP. Are the growth rates the same?

Year	Real GDP (billions of 2000 dollars)	Population (thousands)
1992	7,336.6	256,514
1993	7,532.7	259,919
1994	7,835.5	263,126
1995	8,031.7	266,278
1996	8,328.9	269,394
1997	8,703.5	272,647
1998	9,066.9	275,854
1999	9,470.4	279,040
2000	9,817.0	282,172
2001	9,890.7	285,040
2002	10,048.9	287,727
2003	10,301.1	290,211
2004	10,675.7	292,892
2005	10,989.5	295,561
2006	11,294.9	298,363
2007	11,523.9	301,290
2008	11,652.0	304,060
2009	11,245.8	306,656
2010	11,586.5	309,051
2011	11,800.5	311,588
2012	12,128.5	313,914

Solving the Problem

Review the chapter material. Step 1:

This problem is about calculating per capita real GDP, so you may want to review the section "Shortcomings of GDP as a Measure of Well-Being," which begins on page 247 in the textbook.

Step 2: Calculate per-capita real GDP and the growth rates.

Per-capita real GDP is the amount of real GDP per person. This is calculated as real GDP/Population. Because real GDP is measured in billions and population is measured in thousands, you need to multiply the value of real GDP/Population by 1,000,000. Then calculate the growth rates. Remember, the growth rate between two years is calculated by subtracting the second year from the first year, dividing by the first year, and multiplying by 100. For example, the growth in real GDP for 2012 equals [(\$12,128.5 - \$11,800.5)/ $11,800.5 \times 100 = 2.8$ percent. (Question: Why can't we calculate growth rates for 1992? Answer: We would need the real GDP and per capita real GDP values for 1991.)

Results:

Year	Real GDP (billions of 2000 dollars)	Real GDP growth rate	Population (thousands)	Per capita real GDP	Per capita real GDP growth rate
1992	7,336.6	-	256,514	28,601	_
1993	7,532.7	2.7%	259,919	28,981	1.3%
1994	7,835.5	4.0%	263,126	29,779	2.8%
1995	8,031. <i>7</i>	2.5%	266,278	30,163	1.3%
1996	8,328.9	3.7%	269,394	30,917	2.5%
1997	8,703.5	4.5%	272,647	31,922	3.3%
1998	9,066.9	4.2%	275,854	32,868	3.0%
1999	9,470.4	4.5%	279,040	33,939	3.3%
2000	9 , 81 <i>7</i> .0	3.7%	282,172	34,791	2.5%
2001	9,890.7	0.8%	285,040	34,699	-0.3%
2002	10,048.9	1.6%	287,727	34,925	0.7%
2003	10,301.1	2.5%	290,211	35,495	1.6%
2004	10,675.7	3.6%	292,892	36,449	2.7%
2005	10,989.5	2.9%	295,561	37,182	2.0%
2006	11,294.9	2.8%	298,363	37,856	1.8%
2007	11,523.9	2.0%	301,290	38,249	1.0%
2008	11,652.0	1.1%	304,060	38,321	0.2%
2009	11,245.8	-3.5%	306,656	36,672	-4.3%
2010	11,586.5	3.0%	309,051	37,491	2.2%
2011	11,800.5	1.8%	311,588	37,873	1.0%
2012	12,128.5	2.8%	313,914	38,636	2.0%

Real GDP versus Nominal GDP (pages 249–252)

Learning Objective: Discuss the difference between real GDP and nominal GDP.

Because GDP is calculated using the quantities of final goods and services produced at current market prices, GDP can change because (1) production changes or (2) the prices of goods and services change. If the price of a product increases from one year to the next and we produce the same quantity of the product in both years, GDP will be higher in the year with the higher price even though production has not increased.

To remedy this problem, economists have developed an alternative measure called real GDP. **Real GDP** is calculated by designating a particular year as the *base year*. The prices of goods and services in the base year are used to calculate the value of goods and services in all other years. GDP is often referred to as either **nominal GDP** or current dollar GDP, and real GDP is often called constant dollar GDP.

In an economy with rising prices, nominal GDP will be smaller than real GDP in years before the base year, and nominal GDP will be larger than real GDP in years after the base year. In the base year, nominal GDP and real GDP will have the same value.

We can use the values of nominal and real GDP to calculate a measure of **prices levels** in the economy. The **GDP deflator** is a measure of the average prices of goods and services compared to the base year. The GDP deflator is calculated as:

GDP deflator =
$$\frac{\text{Nominal GDP}}{\text{Real GDP}} \times 100$$

Study Hint

A value of the GDP deflator of 110 tells us that the average price of goods and services is 10 percent higher than the average price in the base year. This is not the inflation rate.

Other Measures of Total Production and Total Income (pages 253–255) Learning Objective: Understand other measures of total production and total income.

The Bureau of Economic Analysis (BEA) calculates several other measures of production and income in addition to GDP. These are Gross National Product (GNP), Net National Product (NNP), National Income, Personal Income, and Disposable Personal Income. Each of these gives a slightly different measure of production and income in a country. No one measure is better than another—they just measure things in a different way.

Extra Solved Problem 8.4

GDP and GNP

Supports Learning Objective 8.4: Understand other measures of total production and total income.

In 2010, nominal Gross Domestic Product (GDP) was \$16,245 billion and nominal Gross National Product (GNP) was \$16,497 billion. Explain the differences between these two measures of total production.

Solving the Problem

Step 1: Review the chapter material.

This problem is about two different measures of production, gross domestic product and gross national product, so you may want to review the definitions of these terms on pages 253 and 254 in the textbook.

Step 2: Explain the differences.

GDP measures final goods and services produced within the United States, and GNP is the value of final goods and services produced by the residents of the United States, even if that production takes place outside the United States.

Because GNP was larger than GDP in 2012, income earned from the rest of the world (by U.S. firms and individuals outside the United States) must have been larger than income payments for production in the United States made to the foreign firms and foreign households. In this case, the difference was \$252 billion—an amount that is about 1.5 percent of GDP.

Key Terms

Business cycle Alternating periods of economic expansion and economic recession.

Consumption Spending by households on goods and services, not including spending on new houses.

Economic growth The ability of an economy to produce increasing quantities of goods and services.

Expansion The period of a business cycle during which total production and total employment are increasing.

Final good or service A good or service purchased by a final user.

GDP deflator A measure of the price level, calculated by dividing nominal GDP by real GDP and multiplying by 100.

Government purchases Spending by federal, state, and local governments on goods and services.

Gross domestic product (GDP) The market value of all final goods and services produced in a country during a period of time, typically one year.

Inflation rate The percentage increase in the price level from one year to the next.

Intermediate good or service A good or service that is an input into another good or service, such as a tire on a truck.

Investment Spending by firms on new factories, office buildings, machinery, and additions to inventories, plus spending by households and firms on new houses.

Macroeconomics The study of the economy as a whole, including topics such as inflation, unemployment, and economic growth.

Microeconomics The study of how households and firms make choices, how they interact in markets, and how the government attempts to influence their choices.

Net exports Exports minus imports.

Nominal GDP The value of final goods and services evaluated at current-year prices.

Price level A measure of the average prices of goods and services in the economy.

Real GDP The value of final goods and services evaluated at base-year prices.

Recession The period of a business cycle during which total production and total employment are decreasing.

Transfer payments Payments by the government to households for which the government does not receive a new good or service in return.

Underground economy Buying and selling of goods and services that is concealed from the government to avoid taxes or regulations or because the goods and services are illegal.

Value added The market value a firm adds to a product.

Self-Test

(Answers are provided at the end of the Self-Test.)

Multiple-Choice Questions

- 1. Which of the following is a macroeconomic study?
 - the study of how households and businesses make choices
 - the study of how households and businesses interact in markets
 - the study of how the government attempts to influence the choices of households and businesses

the study of how fast prices in general are increasing

- 2. Gross domestic product is best defined as
 - a. the total quantity of goods and services produced in a country during a period of time.
 - the total value of all goods that can be found in a country.
 - the market value of all final goods and services produced in a country during a period of time.
 - the amount of all incomes earned by all citizens of a country, including those living overseas.
- 3. How does the Bureau of Economic Analysis of the U.S. Department of Commerce measure GDP?
 - by adding the quantities produced of every good and service in the economy
 - by adding the value in dollar terms of all of the final goods and services produced domestically
 - by ascribing a historic *value* to all of the quantities produced in the economy
 - in some cases, by adding quantities, and in others by adding the *value* of goods and services produced
- 4. Which is the largest component of GDP?
 - (a) consumption
 - b. investment
 - & government purchases
 - & exports
- 5. Which of the following are not considered as final goods, as used in the definition of GDP?
 - à: consumption goods
 - b. investment goods
 - e. exports
 - intermediate goods

- 6. Which of the following is *not* true of GDP?
 - a. GDP is measured by adding up the market values of goods produced, not the quantities of goods produced.
 - Us. GDP includes both intermediate and final goods.
 - c. GDP includes only current production.
 - d. GDP is calculated by the Bureau of Economic Analysis (BEA).
- 7. When a consumer purchases a new computer, how is that purchase counted in GDP?
 - a. by adding the value of the various components of the computer to the final price paid for the computer by the consumer
 - b. by subtracting the value of the components from the price paid by the consumer
 - by counting only the value of the computer and ignoring the value of the components
 - d. None of the above. The production and sale of the computer would not be counted in GDP.
- 8. Which of the following is counted in this year's GDP?
 - (a) only this year's production of goods and services
 - b. only goods that are both produced and sold within the United States
 - c. new goods produced and sold this year plus the value of used goods resold this year
 - d. this year's production of goods and services added to the value of GDP last year
- 9. What happens if we measure GDP by adding up the value of every good and service produced in the economy?
 - a. This is the accurate measure of nominal GDP but not real GDP.
 - b. This is the accurate measure of real GDP but not nominal GDP.
 - © GDP is overestimated because of double counting.
 - d. GDP is underestimated because of double counting.
- 10. If we add up the value of every final good and service produced in the economy, we must get a total that is exactly equal to the value of
 - a. investment.
 - b. net national product.
 - disposable personal income.
 - all of the income in the economy.
- 11. Which of the following would be considered a factor of production?
 - a. capital
 - b. natural resources
 - c. entrepreneurship
 - all of the above
- 12. In the circular-flow diagram, who supplies factors of production in exchange for income?
 - a. households
 - (I) Tirms
 - c. the government
 - all of the above

200 CHAPTER 8 GDP: Measuring Total Production and Income

13. Co	mplete the following sentence: Total income in the economy equals the sum of wages, interest,
	and
a.	dividends; transfer payments
	rent; profit
	taxes; transfer payments
d.	disposable income; net exports
14. Fill	in the blank. The flow of funds from into the financial system makes it possible for
gov	vernment and firms to borrow.
a.	government and firms
(b)	households
c.	investment banks
d.	exports
15. An	important conclusion to draw from the circular-flow diagram is that
a.	personal consumption expenditures are equal to the value of GDP.
b.	only the value of total income equals the value of GDP, not the value of expenditures.
	only the total value of expenditures equals the value of GDP, not the value of income.
c.	we can measure GDP by calculating the total value of expenditures on final goods and services
(4)	or we can measure GDP by calculating the value of total income.
16. Wh	nich of the following goods and services would be excluded from personal consumption
exp	penditures in the Bureau of Economic Analysis (BEA) statistics?
a.	medical care
b.	education
	a haircut
_	a new house
17 W/F	nich of the following is counted in the gross private-domestic investment category used by the
	reau of Economic Analysis when measuring GDP?
	business fixed investment
a.	residential investment
C.	
9	all of the above
18. Wh	nich of the following is included in the economist's definition of investment?
(a)	the purchase of new machines, factories, or houses
Ъ.	the purchase of a share of stock
c.	the purchase of a rare coin or a deposit in a savings account
596	all of the above
19. In a	calculating GDP, which levels of government spending are included in government purchases?
a.	spending by the federal government only
	spending by federal, state, and local governments
c.	spending by the federal government and some state governments, but not local governments
d.	spending by governments only as they relate to national security, social welfare, and other
u.	national programs

20. When accounting for exports and imports in GDP, which of the following is correct? Exports are added to the other categories of expenditures. Exports are added to the other categories of expenditures. Imports are added to the other categories of expenditures. c. Both exports and imports are added to the other categories of expenditures. d. Both exports and imports are subtracted from the other categories of expenditures. 21. Which of the following is *not* a component of GDP from the expenditure point of view? a. consumption b. investment CD government taxes d. net exports 22. Which of the following is true about the consumption component of U.S. GDP in 2010? Consumer spending on durable and nondurable goods was greater than consumption of services. Consumer spending on durable goods was greater than the sum of spending on nondurable goods and on services. Consumer spending on nondurable goods was greater than the sum of spending on nondurable goods and on services. Consumer spending on services was greater than the sum of spending on durable and nondurable goods. 23. Which of the following is true about the government purchases component of U.S. GDP in 2012? The entire amount was composed of federal government purchases because state and local governments are not included. Most of the spending on education and law enforcement occurs at the federal level. Purchases by the federal government are greater than purchases by state and local governments. Purchases by state and local governments are greater than purchases by the federal government. 24. The difference between the price the firm sells a good for and the price it paid other firms for intermediate goods is called producer surplus. b. fixed investment. value added. d. profit. 25. Household production and the underground economy a. are fully accounted for in GDP figures gathered by the Commerce Department. b. are not considered formal production of goods and services and, therefore, are not included when calculating GDP. are important but unaccounted for in the Commerce Department's estimate of GDP. d. are irrelevant because they constitute only a very small fraction of GDP for most countries. 26. Which of the following is *not* a shortcoming of GDP as a measure of welfare? 2. It does not include the value of leisure. It is not adjusted for the effects of pollution caused by the production of goods and services. (c) It only counts final goods and services and not intermediate goods. d. It is not adjusted for crime and other social problems.

27. According to most economists, is not counting household production or production in the underground economy a serious shortcoming of GDP? (A) Most economists would answer "no" because these types of production do not affect the	e most
important use of the GDP measure, which is to see how the economy is performing over	short
periods of time. b. Most economists would answer "yes" because these types of production are likely to significantly from one year to the next.	grow
c. Most economists would answer "no" because the purpose of measuring GDP is to see he economy performs over fairly long periods of a decade or more.	w the
d. Most economists would answer "yes" because these types of production are likely to be a component of the economy (or large percentage of measured GDP), especially in countrie the United States.	large es like
28. In many developing countries, the informal sector is because taxes are and government regulations are	
large; low; minimal	
b. large; high; extensive	
c. small; low; minimal d. small; low; extensive	
d. Shan, low, extensive	
29. If Americans still worked 60 hour weeks, as they did in 1890, both GDP and the well-being of the typical person would be much higher than they are. both GDP and the well-being of the typical person would be lower than they are.	
b. both GDP and the well-being of the typical person would be lower than they are. GDP would be much higher than it is, but the well-being of the typical person wou necessarily be higher.	ld not
d. GDP would be lower than it is, but the well-being of the typical person would be higher.	
30. As the value of a country's GDP increases, the country is likely to	
devote more resources to pollution reduction.	
b. devote fewer resources to pollution reduction.	
c. include the value of pollution in calculating GDP.d. exclude the value of pollution in calculating GDP.	
d. exclude the value of pollution in calculating opti-	
31. Real GDP is	
the value of goods and services evaluated at current year prices.	
the value of goods and services evaluated at base year prices.equal to the value of nominal GDP in every year except for the base year.	
d. a measure of output that was replaced by nominal GDP some time ago.	
32. Which measure of GDP represents changes in the quantity of goods and services produced in the economy, holding prices constant?	e
a. nominal GDP	
net national product	
d. None of the above. All GDP measures represent changes in both prices and quantities.	

203

Multiply the quantities in 2000 by the prices in 2013, and add up the results.

Multiply the quantities in 2013 by the prices in 2013, and add up the results.

Multiply the quantities in 2013 by the prices in 2000, and add up the results.

d. Multiply the quantities in 2013 by the prices in 2013, and subtract them from nominal GDP in 2000.

34. In an economy with rising prices, compared to the base year,

a) nominal GDP is larger than real GDP in years after the base year.

- b. nominal GDP is equal to real GDP in years after the base year.
- c. nominal GDP is larger than real GDP in years before the base year.
- d. nominal GDP is equal to real GDP in years before the base year.
- 35. Growth in the economy is almost always measured as
 - a. growth in nominal GDP.
 - (b) growth in real GDP.
 - c. growth in net national product.
 - d. the growth of personal disposable income.
- 36. Using the year 2013 as the base year, and assuming that prices during 2000 were lower on average than prices in 2010, we can conclude that

a nominal GDP was lower than real GDP in 2000.

- b. nominal GDP was higher than real GDP in 2000.
- c. nominal GDP was equal to real GDP during 2000.
- d. neither nominal GDP nor real GDP were good measures of GDP.
- 37. Over time, prices may change relative to each other. To allow for this, the BEA calculates
 - a. nominal GDP using chain weights.
 - (6.) real GDP and the price deflator using chain weights.
 - real GDP and nominal GDP using only base-year prices.
 - d. real GDP using the prices in the current year.
- 38. If the GDP deflator in 2013 has a value of 110, then

the inflation rate in 2013 is 10 percent.

b. the inflation rate in 2013 is -10 percent.

- Q. prices have increased 10 percent between the base year and 2013.
- d. prices have increased 110 percent between the base year and 2013.
- 39. When a significant fraction of domestic production takes place in foreign-owned facilities, a country's difference between GDP and GNP is as follows:
 - a. GNP will be a more accurate measure of the level of production within the country's borders.
 - 60 GDP will be much larger than GNP.
 - c. GNP will be almost identical to GDP.
 - d. GNP will be closer to zero.
- 40. Which of the following do we subtract from GNP to obtain NNP?
 - a. the production of fixed capital
 - b. consumption
 - c. investment
 - d.) depreciation

a. (b) c.	
d.	government revenue.
B c.	e total national income actually received by a country's residents is larger than the value of GDP. smaller than the value of GDP. exactly equal to the value of GDP. smaller or larger than the value of GDP depending on the year.
BE a. b.	calculate personal income from national income, which of the following must be done by the A? add corporate retained earnings add profits add government transfer payments all of the above
44. Dis b. c. d.	personal income is equal to personal income minus personal tax payments plus government transfer payments. personal income minus government transfer payments plus personal tax payments. personal income minus Social Security payments. the income households have to consume, save, and pay taxes.
а 6 с.	e best measure of the income households actually have available to spend is national income. disposable personal income. net national product. gross domestic product.
Short	Answer Questions
1.	GDP is a measurement of the market value of final goods and services produced in an economy in one year. What is the difference between a final good and an intermediate good? Why do we only count final goods in GDP and not intermediate goods?

2. Suppose that an economy produces only baseballs and footballs. The prices and quantities of these goods for years 2000 and 2013 are given below.

Year	Basel	balls	Footb	Footballs	
	P	Q	Р	Q	
2000	\$4.00	75	\$6.00	45	
2013	\$6.00	105	\$8.00	65	

<u> </u>	
es are rising (as they have in the U.S. economy du the base year, real GDP will be larger than nomin al GDP will be larger than real GDP. Explain why	al GDP. In years after the base year,
ast bought a 10-year-old house. How does that transed with the assistance of a real estate agent, is the local contractor to re-do the wiring. You paid the new wire. How does the purchase of wire by the one the wiring yourself? In this case, you bought \$ this influence GDP? Why do the two methods of ations for calculating GDP when the actual productions	is payment included in GDP? You the contractor \$10,000. The contractor I contractor influence GDP? What if you 2,000 in wire to complete the task. However, the house have different

6. For the years 2011 and 2012, Nominal GDP and Real GDP are given in the table below:

Year	Nominal GDP	Real GDP
2011	\$15,533.8 billion	\$11,800.5 billion
2012	16,244.6 billion	12,128.5 billion

What is the inflation rate for 2012?	

True/False Questions

- T F 1. Macroeconomics is the study of the economy as a whole.
- T F 2. GDP measures total production in an economy by adding together the quantities of every good and service in that economy.
- T F 3. GDP measures the value of all goods and services produced in an economy for a specific time period.
- T F 4. Consumption spending includes households' expenditures for building new houses.
- T F 5. The purchase of 100 shares of Apple Inc. stock is an example of investment spending.
- T F 6. Net exports (NX) are defined as imports minus exports.
- T F 7. The value added of a firm equals the firm's profit from selling its goods and services.
- T F 8. The circular flow diagram indicates that GDP can be measured either by adding the values of expenditures on final goods and services or by adding the values of different types of income.
- T F 9. In the United States, household production and the underground economy are included in the calculation of GDP.
- T F 10. The value of GDP is reduced to reflect the impact of pollution generated by production.
- T F 11. Real GDP provides a more meaningful measure of output than nominal GDP.
- T F 12. For every year, nominal GDP is always greater than real GDP.
- T F 13. GNP is the value of final goods and services produced by labor and capital supplied by U.S. residents, even if the production occurs outside the United States.
- T F 14. NNP is GNP plus the amount of depreciation in that time period.
- T F 15. Personal income is the best measure of the income households have available for spending.

Answers to the Self-Test

Multiple-Choice Questions

Question	Answer	Comment
1.	d	Macroeconomics looks at what determines the total level of production of goods and services and the total levels of employment and unemployment. It also looks at what determines the inflation rate, or how fast prices in general are increasing.
2.	c	GDP measures the market value of all final goods and services produced in a country, and so it excludes the production of a country's citizens living overseas.
3.	b	When we measure total production in the economy, we can't just add together the quantities of every good and service because the result would be a meaningless jumble. Instead, we measure production by taking the value in dollar terms of all the goods and services produced, since this approach allows for the use of a common unit of measure: dollars.
4.	a	Consumption is about 70 percent of GDP.
5.	d	A distinction is made between final goods and services, which are purchased by final users and are not included in the production of any other goods or services, and intermediate goods and services, which are used as inputs into the production of other goods and services.
6.	b	GDP includes only the market value of final goods. If we included the value of the inputs used in making the computer, we would be double counting!
7.	c	GDP only counts final goods and services, but not intermediate goods and services.
8.	a	GDP includes only production that takes place during the indicated time period. GDP does not include the value of used goods. If you buy a smartphone and six months later you resell that smartphone, the resale is not included in GDP.
9.	c	Adding up the value of every good and service would include the values of many intermediate goods that are not counted in GDP. This is called double counting.
10.	d	When we measure the value of total production in the economy by calculating GDP, we are simultaneously measuring the value of total income.
11.	d	Firms use the factors of production—entrepreneurship, labor, capital, and raw materials—to produce goods and services. (For brief definitions of entrepreneur and capital, see the glossary at the end of Chapter 1.)
12.	a	Firms use the factors of production to produce goods and services. Households supply the factors of production to firms in exchange for income.
13.	b	The sum of wages, interest, rent, and profit is total income in the economy.
14.	b	According to the circular flow model used in the chapter, households provide funds to the financial system which makes it possible for governments and firms to borrow.
15.	d	Because all money earned by a business must be paid out to someone, workers, owners, or suppliers, production must equal income.

Question	Answer	Comment
16.	d	Personal consumption expenditures are made by households and are divided into expenditures on services, such as medical care, education, and haircuts; expenditures on nondurable goods, such as food and clothing; and expenditures on durable goods, such as automobiles and furniture. The spending by households that is not included in consumption is spending on new houses. Spending on new
1.7		houses is included in investment expenditures. Gross private domestic investment (or simply "investment") is divided into three
17.	d	categories: Business fixed investment is spending by firms on new factories, office buildings, and machinery, which are used by firms in producing other goods. Residential investment is spending by households on new housing. Changes in business inventories are also included in investment.
18.	a	Economists reserve the word investment for purchases of machinery, factories, and houses. Why don't economists include purchases of stock or rare coins or deposits in savings accounts in the definition of investment? The reason is that these other activities don't result in the production of new goods.
19.	b	That is the definition of government purchases.
20.	a	Exports are goods and services produced in the United States but purchased by foreign businesses, households, and governments. We need to add exports to our other categories of expenditures because otherwise we would not be including all new goods and services produced in the United States. Imports are goods and services produced in foreign countries but purchased by U.S. businesses, households, and governments. We need to subtract imports from total expenditures because otherwise we would be including spending that does not result in production of new goods and services in the United States.
21.	c '	From the expenditure point of view, GDP is made up of consumption, investment, government purchases, and net exports. Government taxes are pure transfer payments, and so they are excluded from the calculation of GDP.
22.	d	Consumer spending on services is greater than the sum of spending on durable and nondurable goods. In the United States and other industrial countries, there has been a continuing trend away from the production of goods and toward the production of services.
23.	· d	Purchases by state and local governments are greater than purchases by the federal government. In the United States, state and local government purchases are greater than federal government purchases because basic government activities, such as education and law enforcement, occur largely at the state and local levels. The fact that the federal government collects most of the taxes may lead someone to surmise that the government also spends more. However, the federal government makes many transfer payments that are not part of government purchases or are not included in GDP.
24.	С	Value added refers to the additional market value a firm gives to a product and is equal to the difference between the price the firm sells a good for and the price it paid other firms for intermediate goods.
25.	c	The Commerce Department does not attempt to estimate the value of goods and services that are not bought and sold in markets. Individuals and firms sometimes conceal the buying and selling of goods and services, so they will not have to pay taxes on the income received.

Question	Answer	Comment
26.	С	The omission of intermediate goods in the calculation of GDP is to avoid counting goods and services twice—or double counting. This is a strength, not a weakness, of GDP.
27.	a	The most important use of GDP is to measure how the economy is performing over short periods of time, such as from one year to the next. For this purpose, omitting household production and production in the underground economy won't have much effect because these types of production are not likely to be significantly larger or smaller fractions of total production from one year to the
28.	b	The informal sector is large in developing countries because taxes are high and government regulations are extensive. Many economists believe taxes in developing countries are so high because these countries are attempting to pay for government sectors that are as large relative to their economies as the government sectors of industrial economies.
29.	c	GDP does not include the value of leisure, but we may value leisure as much as the income we sacrifice in order to obtain it. Output growth also comes with social problems attached, as described in the section of this chapter titled "GDP Is Not Adjusted for Pollution or Other Negative Effects of Production."
30.	a	Increasing GDP often leads countries to devote more resources to pollution reduction. While poor countries are concerned about providing basic needs such as food, clothing, and shelter, wealthier countries with higher incomes are able to focus on other concerns, such as consuming luxury goods and protecting the environment.
31.	b	Real GDP is the value of goods and services evaluated at base year prices. Real GDP is calculated by designating a particular year as the base year. The prices of goods and services in the base year are used to calculate the value of goods and services in all other years in order to have a more consistent measure of production over time unaffected by price increases.
32.	b	By keeping prices constant, we know that changes in real GDP represent changes in the quantity of goods and services produced in the economy. Holding prices constant means that the purchasing power of a dollar remains the same from one year to the next.
33.	С	Real GDP is the value of all final goods and services, evaluated at base-year prices.
34.	a	Because nominal GDP uses current prices and real GDP uses base-year prices, in an economy with rising prices, current prices will be more than base-year prices, and nominal GDP will be larger than real GDP.
35.	b	Growth in the economy is almost always measured as growth in real GDP.
36.	a	As prices rise, nominal GDP rises above real GDP. In the 2000, prices were on average lower than in 2013, so nominal GDP was lower than real GDP.
37.	b	Because changes in relative prices are not reflected in the fixed prices from the base year, the estimate of real GDP is somewhat distorted. In order to make the calculation of real GDP more accurate, in 1996, the BEA switched to a method that uses "chain-weighted" prices.
38.	c	A GDP deflator of 110 (or 1.10 before multiplying by 100) indicates that the current level of prices is 1.10 times the base year, not the last year, or prices have increased 10 percent from the base year.

Question	Answer	Comment
39.	b	The difference between GDP and GNP is domestic production that takes place in foreign-owned facilities and foreign production that takes place in U.Sowned facilities. Foreign owned domestic production is in GDP but not GNP. If this is large then GDP will be much larger than GNP.
40.	d	If we subtract this value from GNP, we are left with net national product or NNP. In the NIPA tables, depreciation is referred to as the consumption of fixed capital, or the capital consumption allowance.
41.	С	In order to calculate the total income actually received by a country's residents, the BEA has to subtract the value of sales taxes from net national product. In the NIPA tables, sales taxes are referred to as indirect business taxes.
42.	b	The BEA has to subtract the value of sales taxes (indirect business taxes) and depreciation from gross domestic product in order to arrive at national income. A country's residents do not receive either depreciation or the taxes paid on purchases, so neither should be included in a measure of total income received.
43.	c	Personal income is income received by households. To calculate personal income, we need to subtract the earnings that corporations retain rather than pay to shareholders in the form of dividends. We also need to add in the payments received by households from the government in the form of transfer payments or interest on government bonds. Transfer payments, such as Social Security payments or payments to retired government workers, are payments the government makes for which it does not receive a good or service in return.
44.	a	Disposable personal income is equal to personal income minus personal tax payments, such as the federal personal income tax.
45.	b	Because disposable personal income includes the income that households actually receive after taxes it is the best measure of the income households actually have available to spend.

Short Answer Responses

- A final good is one that is sold to the ultimate user of the product. It is not being purchased with the
 plan to transform the good and resell it. The alternative to a final good, an intermediate good, is
 purchased with the intent of using that good as a component in another good or service that is sold.
 Intermediate goods are inputs in a production process. Intermediate goods are excluded because the
 value of the final goods includes the value of the intermediate goods which are a component of the
 final good.
- 2. Nominal GDP and Real GDP for 2000 and 2013 are:

Year	Nominal GDP	Real GDP	GDP Deflator
2000	\$570	\$570	100.0
2013	\$11 <i>5</i> 0	\$810	142.0

Nominal GDP has increased for two reasons: Output has increased, and the prices of baseballs and footballs have increased.

- 3. Real GDP uses base year prices. Rising prices imply that in the years prior to the base year, the price used to calculate nominal GDP would be less than the price used to calculate real GDP (which is the price in the base year). So in the earlier years, real GDP is greater than nominal GDP. In time periods after the base year, with rising prices, the price level used to calculate nominal GDP would be larger than the base-year price level used to calculate real GDP, so nominal GDP is larger than real GDP. See Figure 8.3 in Chapter 8.
- 4. Because the house is 10 years old, its purchase will not be included in GDP. It was counted in GDP 10 years ago when it was built. If a real estate agent is employed, the agent's fee should be counted in GDP. The agent produced a service in the current time period, bringing together the buyer and the seller of the house. All of the contractor's wiring fee is included in GDP. The contractor's purchase of wire does not count in GDP because the wire is included in the contractor's fee. The wire in this case is an intermediate good. If the new homeowner did the wiring, then only the purchase of the wire would count in GDP. In this case, the wire is a final good. The difference in the two approaches to wiring the house is that household production does not enter a market so it is not counted in GDP.
- 5. Gross domestic product is the value of final goods and services produced by labor and capital within the United States. The gross national product, or GNP, is the value of final goods and services produced by labor and capital supplied by residents of the United States, even if the production takes place outside of the United States. U.S. firms have facilities in foreign countries, and foreign firms have facilities in the United States. GNP includes foreign production by U.S. companies, but excludes U.S. production by foreign companies. For the United States, they are about the same. One is not necessarily larger than the other.
- The GDP deflator in 2012 was 133.9 (remember that the GDP deflator is the ratio of Nominal GDP to Real GDP multiplied by 100 or (Nominal GDP/Real GDP) × 100). The GDP deflator in 2011 was 131.6. As measured by the percentage change in the GDP deflator, the inflation rate in 2012 (which is equal to: $100 \times [(GDP \text{ deflator in } 2012 - GDP \text{ deflator in } 2011)/GDP \text{ deflator in } 2011])$ was 1.7 percent (= $100 \times [(133.9 - 131.6)/131.6]$).

True/False Answers

Question	Answer	Comment
1.	T	See page 238 in the textbook for the definition of macroeconomics.
2.	F	GDP is measured using the market values of all final goods and services, not their quantities. See page 239 in the textbook.
3.	F	To avoid double counting, GDP includes only final goods and services but not intermediate goods or services. See page 239 in the textbook.
4.	F	Households' expenditures for building new houses are part of investment, not consumption.
5.	F	The purchase of stock shares is a financial transaction, not investment.
6.	F	Net exports equal exports minus imports.
7.	F *	Value added is the price at which a firm sells its output minus the outlay paid to obtain the inputs to produce its output, including profits for entrepreneurs. See page 245 in the textbook.
8.	Τ	The circular flow diagram indicates the total value of expenditures on final goods and services equals the total value of different types of income. See page 241 of the textbook.

212 CHAPTER 8 GDP: Measuring Total Production and Income

Question	Answer	Comment
9.	F	In the United States, household production and the underground economy are estimated to be about 10 percent of GDP, but these activities are not officially included in the calculation of U.S. GDP.
10.	F	GDP does not subtract "bads" generated by production.
11.	T	See pages 249–250 in the textbook about the comparison between real GDP and nominal GDP.
12.	F	This is true only for years where prices are greater than base year prices.
13.	T	See page 253 in the textbook for the definition of GNP.
14.	F	NNP equals GNP minus depreciation
15.	F	Disposable personal income is better because it subtracts taxes.

CHAPTER 9 | Unemployment and Inflation

Chapter Summary and Learning Objectives

9.1 Measuring the Unemployment Rate, the Labor Force Participation Rate, and the Employment-Population Ratio (pages 264–273)

Define the unemployment rate, the labor force participation rate, and the employment-population ratio and understand how they are computed. The U.S. Bureau of Labor Statistics uses the results of the monthly household survey to calculate the unemployment rate and the labor force participation rate. The labor force is the total number of people who have jobs plus the number of people who do not have jobs but are actively looking for them. The unemployment rate is the percentage of the labor force that is unemployed. Discouraged workers are people who are available for work but who are not actively looking for a job. Discouraged workers are not counted as unemployed. The labor force participation rate is the percentage of the working-age population in the labor force. Since 1950, the labor force participation rate of women has been rising, while the labor force participation rate of men has been falling. White men and women have below-average unemployment rates. Teenagers and black men and women have above-average unemployment rates. Except during severe recessions, the typical unemployed person finds a new job or returns to his or her previous job within a few months. Each year, millions of jobs are created and destroyed in the United States.

9.2 Types of Unemployment (pages 273–276)

Identify the three types of unemployment. There are three types of unemployment: frictional, structural, and cyclical. Frictional unemployment is short-term unemployment that arises from the process of matching workers with jobs. One type of frictional unemployment is seasonal unemployment, which refers to unemployment due to factors such as weather, variations in tourism, and other calendar-related events. Structural unemployment arises from a persistent mismatch between the job skills or attributes of workers and the requirements of jobs. Cyclical unemployment is caused by a business cycle recession. The natural rate of unemployment is the normal rate of unemployment, consisting of structural unemployment and frictional unemployment. The natural rate of unemployment is also sometimes called the full-employment rate of unemployment.

9.3 Explaining Unemployment (pages 276–278)

Explain what factors determine the unemployment rate. Government policies can reduce the level of frictional and structural unemployment by aiding the search for jobs and the retraining of workers. Some government policies, however, can add to the level of frictional and structural unemployment. Unemployment insurance payments can raise the unemployment rate by extending the time that unemployed workers search for jobs. Government policies have caused the unemployment rates in most other industrial countries to be higher than in the United States. Wages above market levels can also increase unemployment. Wages may be above market levels because of the minimum wage, labor unions, and efficiency wages. An efficiency wage is a higher-than market wage that a firm pays to increase worker productivity.

9.4 Measuring Inflation (pages 278–282)

Define price level and inflation rate and understand how they are computed. The price level measures the average prices of goods and services. The inflation rate is equal to the percentage change in the price level from one year to the next. The federal government compiles statistics on three different measures of the price level: the consumer price index (CPI), the GDP price deflator, and the producer price index (PPI). The consumer price index (CPI) is an average of the prices of goods and services purchased by the typical urban family of four. Changes in the CPI are the best measure of changes in the cost of living as experienced by the typical household. Biases in the construction of the CPI cause changes in it to overstate the true inflation rate by 0.5 percentage point to 1 percentage point. The producer price index (PPI) is an average of prices received by producers of goods and services at all stages of production.

9.5 Using Price Indexes to Adjust for the Effects of Inflation (pages 282–283)

Use price indexes to adjust for the effects of inflation. Price indexes are designed to measure changes in the price level over time, not the absolute level of prices. To correct for the effects of inflation, we can divide a nominal variable by a price index and multiply by 100 to obtain a real variable. The real variable will be measured in dollars of the base year for the price index.

9.6 Nominal Interest Rates versus Real Interest Rates (pages 284–285)

Distinguish between the nominal interest rate and the real interest rate. The stated interest rate on a loan is the **nominal interest rate.** The **real interest rate** is the nominal interest rate minus the inflation rate. Because it is corrected for the effects of inflation, the real interest rate provides a better measure of the true cost of borrowing and the true return from lending than does the nominal interest rate. The nominal interest rate is always greater than the real interest rate unless the economy experiences deflation. **Deflation** is a decline in the price level.

9.7 Does Inflation Impose Costs on the Economy? (pages 285–289)

Discuss the problems that inflation causes. Inflation does not reduce the affordability of goods and services to the average consumer, but it does impose costs on the economy. When inflation is anticipated, its main costs are that paper money loses some of its value and firms incur menu costs. Menu costs include the costs of changing prices on products and printing new catalogs. When inflation is unanticipated, the actual inflation rate can turn out to be different from the expected inflation rate. As a result, income is redistributed as some people gain and some people lose.

Chapter Review

Chapter Opener: Caterpillar Announces Plans to Lay Off Workers (page 263)

Caterpillar is the world's largest manufacturer of construction and mining equipment. During the 2007–2009 recession, the company fared relatively well because developing countries, such as China, continued to experience economic growth. In 2013, however, Caterpillar announced that it would lay off 260 employees from its South Milwaukee plant as a result of a decline in the demand for its equipment. At the time of the layoff, U.S. unemployment was over 7 percent, well above what economists consider the normal level of about 5.5 percent. Some economists speculated that unemployment would not reach that normal level for a few more years.

9.1

Measuring the Unemployment Rate, the Labor Force Participation Rate, and the Employment-Population Ratio (pages 264-273)

Learning Objective: Define the unemployment rate, the labor force participation rate, and employment-population ratio and understand how they are computed.

Our measures of unemployment come from a survey conducted each month by the U.S. Bureau of the Census. The Current Population Survey, often referred to as the household survey, collects the data needed to compute the unemployment rate. The survey asks questions about the employment status of people in the household and attempts to determine if a worker is employed, out of the work force (neither employed nor looking for a job), or unemployed. The sum of employed and unemployed persons in the economy is known as the labor force. The unemployment rate is the percentage of the labor force that cannot find work. People who are not actively looking for a job are not considered to be a part of the labor force. This includes discouraged workers as well as retirees, homemakers, full-time students, and people on active military service, in prison, or in mental hospitals. The labor force participation rate is the percentage of the working age population that is in the labor force. Working age is defined as 16 years or older.

Study Hint

Figure 9.1 shows various segments of the population and labor force. In which category do you fall at this stage of your life?

- If you are a traditional college student who does not work, you are not in the labor force and not available for work.
- If you attend college and also work part time, you are in the labor force.
- If you attend college and want to work but can't find a job and have stopped looking, you are not in the labor force, and you are considered a discouraged worker.

The results of the Current Population Survey provide the data to calculate unemployment rates and labor force participation rates. These two statistics are more precisely defined as:

Unemployment rate =
$$\frac{\text{Number of Unemployed}}{\text{Labor Force}} \times 100$$

Labor Force Participation Rate = $\frac{\text{Labor Force}}{\text{Working Age Population}} \times 100$

The unemployment and labor force data provide a useful picture of employment, but the measures are not perfect due to sampling and reporting errors in the survey. For instance, there some people who are not counted in the labor force who might still be considered unemployed. Discouraged workers, for example, are workers who have dropped out of the labor force because they believe no jobs are available for them. These workers are not included in the measured unemployment rate and, if included, would raise the measured unemployment rate.

The labor force participation rate of men and women and other demographic groups has varied over time in the United States. The participation rate of women increased rapidly in the 1960s and 1970s before leveling off in recent years. The participation rate of men has steadily declined over the years. A gap still exists between male and female labor force participation rates, although it is much smaller today than it was 60 years ago. There are wide differences in the unemployment rates of different demographic groups. The average unemployment rate was 7.6 percent in August 2013. Unemployment rates among white

adults fell slightly below that rate, while teenagers, regardless of race or ethnic group, had much higher rates. Today, a typical unemployed person in the United States stays unemployed for a brief period of time. The experience during and after the 2007–2009 recession was a sharp break from the normal experience. The average period of unemployment in late 2011 was 10 months, compared to about four months in early 2007. Read *Making the Connection* feature in this section to learn more about the unusual unemployment situation following the 2007–2009 recession.

In addition to the *Current Population Survey*, the establishment survey, or the payroll survey, is another way for the Department of Labor to measure total employment in the economy. The establishment survey provides information on the total number of people who are employed and on a company payroll by surveying about 300,000 business establishments. The establishment survey has the following drawbacks:

- 1. Does not provide information on the number of self-employed persons.
- 2. Fails to count people employed at newly opened businesses.
- 3. Does not provide information on the unemployed.

Types of Unemployment (pages 273–276)

Learning Objective: Identify the three types of unemployment.

It is useful to divide unemployment into three types: frictional, structural, and cyclical. **Frictional unemployment** includes unemployed workers who have left one job and are looking for another job or are out of a job due to seasonal factors. Frictionally unemployed people usually find new jobs quickly. **Structural unemployment** includes workers who have lost their jobs because their skills do not match those employers want. Structurally unemployed workers are usually out of work longer than those who are frictionally unemployed because they must learn new job skills, which takes time. **Cyclical unemployment** occurs when workers lose jobs due to a recession. As the economy begins to recover, these workers are sometimes rehired by the same firms that laid them off.

When the only types of unemployment are structural and frictional, the economy is said to be at full employment. Sometimes this is also referred to as the **natural rate of unemployment**.

M Study Hint

9.2

Making the Connection "How Should We Categorize Unemployment at Caterpillar?" explains that it is often difficult to categorize unemployment in a particular case of unemployment like the layoffs at Caterpillar. If the layoffs were due to the business cycle of some economies, then the unemployment at Caterpillar was cyclical. If instead the layoffs were resulted from mining firms preferring machinery produced by Caterpillar's competitors, then the unemployment would be frictional.

Extra Solved Problem 9.2

The Reason for Unemployment

Supports Learning Objective 9.2: Identify the three types of unemployment.

The BLS collects data about the reasons people are unemployed. Some of this data is in the table below (the numbers are in thousands).

				Reason for unemployment		
Unemployment						
Year	Rate	Number	Job losers	Job leavers	Reentrants	New entrants
2002	5.8	8,377	4,607	866	2,368	536
2003	6.0	8 , 774	4,838	818	2,477	641
2004	5.5	8,149	4,197	858	2,408	686
2005	5.1	<i>7,</i> 591	3,667	872	2,386	666
2006	4.6	<i>7,</i> 001	3,321	827	2,237	616
2007	4.7	7,078	3,515	793	2,142	627
2008	5.8	8,924	4,789	896	2,472	766
2009	9.3	14,265	9,160	882	3,187	1,035
2010	9.6	14,825	9,250	889	3,466	1,220
2011	8.5	13,075	7,487	943	3,359	1286
2012	7.8	12,269	6,408	983	3 , 587	1291

- a. Calculate the percentage of the unemployed who have just lost their jobs and the percentage of those who have left their jobs.
- b. Calculate the percentage of the unemployed who are unemployed as the result of entering the labor force, either for the first time or as a reentrant.

Solving the Problem

Step 1: Review the chapter material.

This problem is about definitions of unemployment, so you may want to review the section "Types of Unemployment," which begins on page 273 in the textbook.

Step 2: Answer question (a) by calculating the percentages of unemployed.

For example, the percentage of job losers in 2002 can be calculated as: $(4,607/8,377) \times 100 = 55.0$ percent. The percentage of reentrants and new entrants in 2002 is: $[(2,368 + 536)/8,377] \times 100 = 34.7$ percent. The percentages for the three categories in each year are:

	Percen	Percentages of those unemployed due to			
Year	Job losers	Job leavers	Reentrants and new entrants		
2002	55.0%	10.3%	34.7%		
2003	55.1	9.3	35.5		
2004	51.5	10.5	38.0		
2005	48.3	11.5	40.2		
2006	47.4	11.8	40.8		
2007	49.7	11.2	39.1		
2008	53.7	10.0	36.3		
2009	64.2	6.2	29.6		
2010	62.4	6.0	31.6		
2011	57.3	7.2	35.5		
2012	52.2	8.0	39.8		

Step 3: Answer part (b) by comparing the different sources of unemployment.

Notice that the major source of unemployment is job losers, followed by reentrants and new entrants. The majority of the reentrants and new entrants group is reentrants, which are people who lost or quit jobs in the past, dropped out of the labor force for some reason, and are now looking for jobs.

9.3

Explaining Unemployment (pages 276–278)

Learning Objective: Explain what factors determine the unemployment rate.

The business cycle is the cause of cyclical unemployment. Frictional and structural unemployment are influenced by government policies, such as unemployment insurance. This insurance program provides payments of about half the average wage to provide unemployed workers with some income while they search for a new job. Unemployment insurance helps workers take sufficient time to find a job that is a good match for their skills. Unfortunately, as workers spend more time searching, they are also unemployed longer, increasing the unemployment rate. Unemployment insurance also helps the unemployed maintain their income and lessens the severity of a recession. The minimum wage also has an impact on the unemployment rate, particularly for teenage workers. By forcing employers to pay some workers a wage above the market equilibrium wage, the minimum wage contributes to increased unemployment among those with few job skills. Firms may also pay a wage above the market level, called an efficiency wage, which is designed to increase worker productivity. This higher wage may result in the quantity demanded of labor being less than the quantity supplied. The result can be unemployment, even when cyclical employment is zero. Labor unions can also temporarily increase unemployment by bargaining for wages that are higher than the equilibrium level. Workers who are unable to find employment in the unionized sector can generally find employment—possibly for lower wages—in the nonunionized sector. Unions have a relatively small impact on labor markets in the United States because only about 9 percent of nongovernment workers are members of unions.

Extra Solved Problem 9.3

Unemployment Insurance

Supports Learning Objective 9.3: Explain what factors determine the unemployment rate.

Suppose the U.S. government increases the length of time that an unemployed worker can receive unemployment insurance benefits. Predict how this will influence the unemployment rate.

Solving the Problem

Step 1: Review the chapter material.

This problem is about the effects of government policy on unemployment rates, so you may want to review the section "Government Policies and the Unemployment Rate," which begins on page 276 in the textbook.

Step 2. Predict the effects.

If the government extends the period for receiving unemployment insurance payments, the extension will reduce the opportunity cost of unemployment. This may cause some workers to continue their search for employment, increasing the duration of unemployment, the level of unemployment, and the unemployment rate.

Measuring Inflation (pages 278–282)

Learning Objective: Define price level and inflation rate and understand how they are computed.

The price level measures the average prices of goods and services in the economy, while the inflation rate is the percentage increase in the price level from one year to the next. There are several price indexes. The GDP deflator measures the average price of all goods and services included in GDP. The consumer price index (CPI) measures the average price of the goods and services purchased by a typical urban household. The producer price index (PPI) measures the average price paid by firms for intermediate goods. Any price index is the average price of a set of goods and services. These price indexes differ in terms of which goods are included in them and in terms of how the index is calculated. The GDP deflator is the ratio of nominal GDP to real GDP multiplied by 100:

GDP Deflator =
$$\frac{\text{Nominal GDP}}{\text{Real GDP}} \times 100$$

The GDP deflator is an average of the prices of all final goods and services produced during a year. The CPI includes goods and services purchased by consumers. Every two years, the BLS does a large-scale survey to determine the goods and services a typical urban household purchases. The CPI is the ratio of the current value of that market basket of goods and services to the value of that basket in the base year multiplied by 100:

$$CPI = \frac{Expenditures in the current year}{Expenditures in the base year} \times 100$$

Study Hint

Remember that a value of the CPI of 138 in the year 2012 means that in that year, the average price of the market basket has increased 38 percent from the base year (1999). What additional information would you need to calculate the inflation rate for that year compared to the previous year? (Answer: You would need the value of the CPI for 2011.) Suppose the CPI was 78 in 1990. What does that number tell us about the price level relative to the base year? (Answer: It tells us that the price level in 1990 was 22 percent lower than in the base year.)

The PPI is a measure of the average prices received by producers at all stages of production. The PPI includes intermediate goods and may sometimes give an early warning of possible future movements in the CPI.

Regardless of which price index you use, the inflation rate is the rate of change in the index from one year to the next. In the following formula, t refers to the current year and t-1 refers to the previous year:

Inflation Rate, =
$$\frac{\text{Price Index}_{t} - \text{Price Index}_{t-1}}{\text{Price Index}_{t-1}} \times 100$$

Study Hint

Remember that if the inflation rate falls between two years, (for example, if it is 5 percent one year and 4 percent the next year), then prices are still rising, but at a smaller rate of increase. Economists call a decline in the inflation rate disinflation.

Because the CPI is the most widely used measure of inflation, it is important that the CPI be as accurate as possible. There are, however, four reasons why the CPI inflation rate overstates the true inflation rate.

- The CPI has a substitution bias because it is constructed with the assumption that people buy the same goods and services and do not substitute for lower priced goods and services as relative prices change.
- 2. The CPI does not fully take into account increases in the quality of products over time. For example, the price of a particular car model might increase from one year to the next, but part of that increase may be due to improvements in the car's safety and gas mileage. Because of increases in quality, increases in prices overstate the true rate of inflation.
- 3. Sometimes older products are replaced with new, less-expensive products. If these newer products, such as LCD TV sets, are not properly included in the CPI market basket, then decreases in their prices will be reflected in the inflation rate.
- 4. The CPI collects data from traditional stores and does not sample prices at less expensive outlet stores, such as Sam's Club, creating an outlet bias.

Extra Solved Problem 9.4

Calculating the CPI

Supports Learning Objective 9.4: Define price level and inflation rate and understand how they are computed.

The CPI compares the cost of a market basket of goods with the cost of the same quantities of goods and services in the base year. Suppose that the basket includes (1) admission for two to the local theater for a Friday evening movie, (2) a large popcorn at the theatre, (3) a large pepperoni pizza (carry-out from the local pizza place), and (4) a two-liter bottle of diet Coke.

Year	Theatre admission for one person	Popcorn	Pizza	Diet Coke
1	\$5.00	\$2.00	\$12.00	\$1.25
2	6.00	2.50	12.50	1.40
3	6.50	3.00	13.00	1.50

Calculate the value of the market basket in each year.

Solving the Problem

Step 1: Review the chapter material.

This problem is about using a price index to measure inflation, so you may want to review the section "Measuring Inflation," which begins on page 278 in the textbook.

Step 2: Determine the value of the market basket.

The value of the market basket is the sum of the prices of each good or service multiplied by the quantity of that good or service in the basket. (The basket above has two theater admissions but one of each of the other goods.) The value of the market basket in Year 2 will be $(2 \times \$6.00) + (1 \times \$2.50) + (1 \times \$1.40) = \28.40 . The table below also gives the value of the market basket for Years 1 and 3.

Step 3: Calculate the CPI and CPI inflation rates for each year.

The CPI is the ratio of the value of the market basket in a given year to the value of the market basket in the base year. Once we have calculated the CPI, we can also calculate the CPI inflation rate. These values are in the table below.

Year	Value of the basket	СРІ	Inflation
1	\$25.25	100.0	
2	28.40	112.5	12.5%
3	30.50	120.8	7.4

Extra Solved Problem 9.4

Comparing Inflation Rates

Supports Learning Objective 9.4: Define price level and inflation rate and understand how they are computed.

Below are price level data for the GDP deflator, the consumer price index (CPI), and the producer price index (PPI) for the period 2000-2012. Calculate the inflation rates for each of these price indexes for each time period. Do the different price indexes give the same inflation rate? The data are from the Economic Report of the President, found online at www.gpoaccess.gov/eop/.

Year	GDP deflator	CPI	PPI
2000	100.0	103.4	138.0
2001	102.4	106.3	140.7
2002	104.1	108.0	138.9
2003	106.4	110.5	143.3
2004	109.4	113.4	148.5
2005	112.7	117.2	155.7
2006	116.0	121.0	160.3
2007	119.8	124.5	166.6
2008	122.4	129.2	177.2
2009	123.7	128.8	172.7
2010	125.1	130.9	180.0
2011	127.6	135.0	190.8
2012	129.8	137.8	194.5

Solving the Problem

Step 1: Review the chapter material.

This problem is about using a price index to measure inflation, so you may want to review the section "Measuring Inflation," which begins on page 278 in the textbook.

Step 2: Use the inflation formula.

Inflation Rate_t =
$$\frac{\text{Price Index}_{t} - \text{Price Index}_{t-1}}{\text{Price Index}_{t-1}} \times 100$$

GDP deflator CPI i Year inflation rate	nflation PPI inflation rate rate
2001 2.4% 2	2.8% 2.0%
2002 1.7 1	.6 –1.3
2003 2.2 2	2.3 3.2
2004 2.8 2	2.7 3.6
2005 3.0	3.4 4.8
2006 2.9	3.2 3.0
2007 3.3 2	2.9 3.9
2008 2.2	3.8 6.4
2009 1.1 –0).3 – 2.5
2010 1.1	1.6 4.2
2011 2.0	3.1 6.0
2012 1.7	2.1 1.9

Notice that while the numbers are different, because each price index measures the price level differently, they show a similar pattern. So which is the correct inflation rate? The answer is all are the correct inflation rate. The inflation rate measures a rate of change in prices. There are many ways to measure prices. Each measurement implies a different inflation rate.

9.5 Using Price Indexes to Adjust for the Effects of Inflation (pages 282–283) Learning Objective: Use price indexes to adjust for the effects of inflation.

Price indexes, such as the CPI, give us a way of adjusting for the effects of inflation so that we can compare the purchasing power of dollar values in different years. The formula we would use to calculate the value in 2012 dollars of a good or service in the year 2000 would be:

Value in 2012 dollars = Value in
$$2000 \times \frac{\text{CPI in } 2012}{\text{CPI in } 2000}$$

For example, suppose a pizza and two drinks from the local pizza place cost \$6.99 in 2000. If the CPI in 2012 is 138 and the CPI in 2000 is 103, then the value of the pizza and two drinks in 2010 dollars is

Value in 2012 dollars =
$$\$6.99 \times \frac{138}{103} = \$9.37$$

Nominal Interest Rates versus Real Interest Rates (pages 284–285)

Learning Objective: Distinguish between the nominal interest rate and the real interest rate.

The interest rate is the return to lending or the cost of borrowing. If you lend \$100 at a 2 percent interest rate, you will receive \$2.00 in interest one year from now. If there is inflation during that year, the \$2.00 will not buy the same amount of goods and services at the end of the year as at the beginning of the year. The nominal interest rate is the stated interest rate on a loan. The real interest rate adjusts the nominal interest rate for inflation. The real interest rate is defined as:

Real Interest Rate = Nominal Interest Rate - Inflation Rate

The real interest rate provides a better measure of the true cost of borrowing and the true rate of return to lending than does the nominal interest rate. In a period of **deflation**, where the inflation rate is negative (the price level is falling), the real interest rate will be larger than the nominal interest rate.

Extra Solved Problem 9.6

Nominal and Real Interest Rates

Supports Learning Objective 9.6: Distinguish between the nominal interest rate and the real interest rate.

The table below contains interest rate data on bonds issued by large corporations. In this case, the bonds have received a "AAA" rating, which means that the corporations that issued the bonds are not likely to go out of business. The table also shows the inflation rate calculated using the CPI. Calculate the real interest rate and compare changes in the nominal and real interest rates.

2001 7. 2002 6.	.1% 2.9% .5 1.6
2002 6.	.5 1.6
2003 5.	7 2.3
2004 5.	.6 2.7
2005 5.	.2 3.4
2006 5.	.6 3.2
2007 5.	6 2.9
2008 5.	6 3.8
2009 5.	.3 –0.3
2010 4.	9 1.6
2011 4.	.6 3.1
2012 3.	7 2.1

Solving the Problem

Step 1: Review the chapter material.

This problem is about calculating the real interest rate, so you may want to review the section "Nominal Interest Rates versus Real Interest Rates," which begins on page 284 in the textbook.

Step 2: Use the real interest rate formula.

Real Interest Rate = Nominal Interest Rate - Inflation Rate

The resulting real interest rates are:

AAA bond interest rate (nominal rate)	CPI inflation rate	AAA bond interest rate (real rate)
7.1%	2.9%	4.2%
6.5	1.6	4.9
5.7	2.3	3.4
5.6	2.7	2.9
5.2	3.4	1.8
5.6	3.2	2.4
5.6	2.9	2.7
5.6	3.8	1.8
5.3	-0.3	5.6
4.9	1.6	3.3
4.6	3.1	1.5
3.7	2.1	1.6
	interest rate (nominal rate) 7.1% 6.5 5.7 5.6 5.2 5.6 5.6 5.6 5.3 4.9 4.6	interest rate (nominal rate) CPI inflation rate 7.1% 2.9% 6.5 1.6 5.7 2.3 5.6 2.7 5.2 3.4 5.6 3.2 5.6 2.9 5.6 3.8 5.3 -0.3 4.9 1.6 4.6 3.1

Notice that because the inflation rate is positive during most years except 2009, the real interest rate was smaller than the nominal interest rate. In 2009, the real interest rate was greater than the nominal interest rate as a result of a negative inflation rate, or deflation. Also notice that the patterns of the real interest rate are sometimes different than the patterns of nominal interest rates. For instance, from 2001 to 2002, the nominal interest rate fell from 7.1 percent to 6.5 percent, while the real interest rate increased from 4.2 percent to 4.9 percent. But, if we examine 2007–2008 changes, the nominal interest rate did not change, while the real interest rate decreased.

Does Inflation Impose Costs on the Economy? (pages 285–289)

Learning Objective: Discuss the problems that inflation causes.

Inflation affects the distribution of income and can, in turn, hurt some people. For example, people on fixed nominal incomes—such as retired people who rely on company pensions that pay them a fixed amount each month—are hurt by inflation. As prices rise, their incomes do not rise, so they are able to buy fewer goods and services. Inflation can be characterized as anticipated or unanticipated. Anticipated

inflation imposes costs by reducing the purchasing power of assets, such as money in a checking account. Anticipated inflation can also create additional costs to firms from raising prices—these costs are called **menu costs.** Unanticipated inflation can affect the distribution of income, causing some people to gain and some people to lose.

Key Terms

Consumer price index (CPI) An average of the prices of the goods and services purchased by the typical urban family of four.

Cyclical unemployment Unemployment caused by a business cycle recession.

Deflation A decline in the price level.

Discouraged workers People who are available for work but have not looked for a job during the previous four weeks because they believe no jobs are available for them.

Efficiency wage A higher-than market wage that a firm pays to increase worker productivity.

Frictional unemployment Short-term unemployment that arises from the process of matching workers with jobs.

Inflation rate The percentage increase in the price level from one year to the next.

Labor force The sum of employed and unemployed workers in the economy.

Labor force participation rate The percentage of the working-age population in the labor force.

Menu costs The costs to firms of changing prices.

Natural rate of unemployment The normal rate of unemployment, consisting of frictional unemployment plus structural unemployment.

Nominal interest rate The stated interest rate on a loan.

Price level A measure of the average prices of goods and services in the economy.

Producer price index (PPI) An average of the prices received by producers of goods and services at all stages of the production process.

Real interest rate The nominal interest rate minus the inflation rate.

Structural unemployment Unemployment that arises from a persistent mismatch between the skills and attributes of workers and the requirements of jobs.

Unemployed In the government statistics, someone who is not currently at work but who is available for work and who has actively looked for work during the previous month.

Unemployment rate The percentage of the labor force that is unemployed.

Self-Test

(Answers are provided at the end of the Self-Test.)

Multiple-Choice Questions

1.	The "misery index" gives a rough measure of the state of the a. establishing the success or failure of government spending b. determining why the economy is unable to generate a high adding together the inflation and unemployment rates. d. monitoring changes in the number of people on the welfar	g on social programs. her level of real GDP per person.
2.	1	•
	often referred to as the household survey, is a sample of	households and asks about the
	employment status of everyone in the household	and older.
	a. 1,000; 18 years of age	
	b. 5,000; 21 years of age	
	(E) 60,000; 16 years of age	
	d. 80,000; 19 years of age	
3.	Which of the following groups is included in the labor force?	
	a. the unemployed	
	k retirees, homemakers, and full-time students	
	retirees, homemakers, and full-time students people who could have a civilian job but are on active	military service, in prison, or in mental
	hospitals	μ
	d. none of the above	
	di lione oi die doore	
4	With respect to statistics on the labor market, we can say that	
	the labor force is the sum of the ampleyed and unampleyed	

- - the labor force is the sum of the employed and unemployed.

The unemployment rate is calculated as: (number of unemployed/number of employed) × 100.

the number of unemployed includes discouraged workers.
the number of unemployed includes people who are not employed and not actively looking for jobs.

- 5. If you are available for work and have looked for a job at some point during the previous 12 months but have not actively looked during the previous four weeks, you are considered
 - a. in the labor force but structurally unemployed.
 - not in the labor force.
 - in the labor force but frictionally unemployed.
 - d. none of the above.
- 6. Suppose that you are available for work but have not looked for a job for at least the last four weeks because you believe that no jobs are available. You would then be counted as
 - a. part of the labor force.
 - b. unemployed.
 - a discouraged worker.
 - underemployed.

7. At full employment, a. cyclical unemployment is zero. b. frictional unemployment is zero. (c). structural unemployment is zero. d no one is unemployed. 8. In August 2013, the working-age population of the United States was about a. 79 million. b. 156 million. c. 218 million. 246 million. 9. In August 2013, which of the following groups was smallest? a. the unemployed b. people who were not in the labor force and not available for work discouraged workers and those who were not working for other reasons d. the number of people in the labor force 10. Which of the following is the correct formula for calculating the unemployment rate? Number of unemployed $\times 100$ Labor force Labor force Working-age population Both of the formulas above are used to calculate the unemployment rate. Neither of the formulas above is used to calculate the unemployment rate. 11. How would employment statistics be affected if they included people in the military? The unemployment rate would decrease. The working-age population would remain the same. c. The labor force participation rate would remain the same. all of the above d. 12. Among the following, who is counted by the BLS as unemployed? a. a person working part-time but prefers to have a full-time job b. a person has stopped actively looking for a job after have trouble finding one c. a worker who believes she is underpaid none of the above

13. What would be the impact of counting as unemployed both discouraged workers and those who work part time but would prefer to work full time?

a. The unemployment rate would remain the same because those people are already counted as unemployed.

b.) The unemployment rate would increase.

The unemployment rate would decrease.

d. The annual unemployment rate would have been close to 100 percent.

14. Fill in the blanks. Two important trends in the labor force participation rates of adults aged 20 a over in the United States since 1950 are the labor force participation rate of adult wom and the labor force participation rate of adult men. a. falling; rising b. falling; falling rising; falling d. rising; rising	nd
 15. In August 2013, which of the following demographic groups had a higher rate of unemployment the unemployment rate for the total population? a. white adults black adults c. Hispanic adults d. None of the above. The unemployment rates for these groups were all lower than the over unemployment rate. 	
 16. In mid-2013, how long was the average period of unemployment in the United States? a. less than two weeks b. one month c. four months d. nine months 	
 17. Relative to the household survey, which of the following is a strength of the establishment survey? a. It provides better information on the number of persons self-employed than the household surve does. b. It provides information on unemployment, which the household survey does not provide. It is determined by actual payrolls rather than by the unverified answers of the household survey does not provide. All of the above are strengths of the establishment survey. 	
 18. The extent of job creation and job destruction is a. a serious shortcoming of our economic system. b. what we would expect in a vibrant market system. c. an ideal feature of our economy because very few jobs are ever destroyed while many new or are created all the time. d. the main reason why the U.S. unemployment rate is persistently high. 	nes
 19. From 1950 until 2013, the behavior of the annual unemployment rate in the United State demonstrated that the unemployment rate a. rises during both recessions and expansions. b. falls during both recessions and expansions. c. falls during recessions and rises during expansions. Trises during recessions and falls during expansions. 	tes
 20. The short-term unemployment that arises from the process of matching workers with jobs is called frictional unemployment. c. cyclical unemployment. d. seasonal unemployment. 	

an a. b c.	nemployment arising from a persistent mismatch between the skills and characteristics of worker d the requirements of jobs is called frictional unemployment. structural unemployment. cyclical unemployment. cyclical unemployment. seasonal unemployment.
(a. b.	frictional and structural
d.	frictional and cyclical None of the above. Full employment means that there is no unemployment, so the unemployment rate would be zero.
b. c.	the sum of structural unemployment and frictional unemployment. the full-employment rate of unemployment. the natural rate of unemployment. all of the above.
ca fri a. b.	overnment policies can help to reduce the levels of frictional and structural unemployment, but they also help to increase them. Which of the following policies can cause an increase in the levels of ctional or structural unemployment? increasing the length of time that the unemployed can receive payments from the government passing legislation that makes it more difficult for firms to fire workers increasing the minimum wage all of the above
25. Inda a/ b c.	creases in the minimum wage will increase unemployment among workers whose market wage is higher than the new minimum wage. increase teenage unemployment. increase the level of unemployment for all groups of workers. have a large effect on the unemployment rate in the United States.
probable b.	hich of the following is the prevailing view of economists about the unemployment insurance ogram in the United States? Unemployment insurance is a bad idea because the unemployed spend more time searching for jobs after they receive these payments. Unemployment insurance is a bad idea because it promotes laziness among the unemployed. Unemployment insurance is a good idea because it helps the unemployed maintain their income and spending, which helps reduce the severity of recessions. Most economists are against unemployment insurance, but they don't explain why.
a. b. c.	Il in the blanks. The unemployment rate in the United States is usually than the employment rates in most other high-income countries, partly because the United States has requirements for the unemployed to receive government payments. higher; less stringent lower; less stringent lower; more stringent lower; more stringent

	the minimum wage generates a shortage of unskilled workers.	
a. b.	wage higher than the market wage paid by a firm in order to increase worker productivity is the idea behind the minimum wage. a burden on production costs and profits. an efficiency wage.	
	a compensating differential.	de
L	ill in the blanks. To obtain prices of a representative group of goods and services, the Burabor Statistics (BLS) conducts a monthly survey of households nationwide opending habits. The results of this survey are used to construct a market basket of	eau of n their goods
ai a.	nd services purchased by the typical urban family of four. 1,000; 80,000	goods
	10,000; 525 2 30,000; 211 5,000; 75	
a. b	the largest group of items in the market basket is food and beverages. the BLS varies the quantity of a good in the market basket in response to changes in currer of the good. the market basket of goods and services is updated monthly.	t sales
	the market basket does not include large equipment purchased by business firms.	
	of the eight categories in the CPI market basket, which three categories make up more thercent of the basket?	nan 75
	medical care, recreation, and education food and beverages, apparel, and other goods and services	*
	housing, transportation, and food	
ď	None of the above. Each category in the basket comprises the same percentage of the bathe others.	sket as
	the prices of the products purchased in the current year the quantities of the products purchased in the base year	s each
	uppose the CPI in 2013 was 215.3 and the CPI in 2014 was 214.6, what was the inflation etween 2013 and 2014? 3.0 percent	on rate
b d	. 0.7 percent	
u		

35. Changes in the CPI overstate the true inflation rate due to four "biases." If apple prices rise rapidly during the month while orange prices fall, consumers will reduce their apple purchases and increase their orange purchases. Which of the four biases is concerned with this tendency?

(a) the substitution bias

- b. the increase in quality bias
- c. the new product bias
- d. the outlet bias
- 36. Which of the following is a better measure of the average prices of all goods and services included in GDP?
 - a. the consumer price index
 - b, the producer price index
 - d.) the GDP deflator
 - d. the inflation rate
- 37. If nominal GDP in a given year is \$11,000 billion and real GDP is \$10,000 billion, then the GDP price deflator in that year equals
 - a. 1.1 percent.
 - **(b)** 110.
 - c. 10 percent.
 - d. 90.
- 38. If the inflation rate is 6 percent and the nominal interest rate is 4 percent, then the real interest rate is
 - a. 16 percent, which is the sum of the nominal interest rate and the inflation rate.
 - b. 2 percent, which is the inflation rate minus the nominal interest rate.
 - ©.) –2 percent, which is the nominal interest rate minus the inflation rate.
 - d. 1.5 percent, which is the ratio of the nominal interest rate to the inflation rate.
- 39. The inflation rate is the percentage
 - a. change in nominal GDP from one year to the next.
 - b. change in real GDP from one year to the next.
 - c. difference between nominal GDP and real GDP in any given year.
 - (d) change in the GDP deflator from one year to the next.
- 40. Which market basket below specifically targets intermediate goods?
 - a. the basket used by the consumer price index
 - b. the basket used by the GDP deflator
 - the basket used by the producer price index
 - d. all of the above
- 41. If the consumer price index was 73 in 1979 and 225 in 2014, then prices in 2014 were on average
 - a. half of what they were in 1979.
 - three times as high as in 1979.
 - c. 150 percent higher than in 1979.
 - d. the same as they were in 1979.

232 CHAPTER 9 Unemployment and Inflation

	the CPI was 207 in 2010 and 223 in 2014, what pay raise would someone w	
inc	come in 2007 have to earn in order to keep her purchasing power constant in 201	4?
a.	\$1,252	
b.	\$4,000	
©	\$4,348	
d.	none of the above	
are	Il in the blanks. Economic variables that are calculated in current year prices variables, while variables that have been corrected to account for the variables. nominal; real	
\sim	real; nominal	
b.		
c.	updated; deflated	
d.	deflated; updated	
_	e stated interest rate on a loan is	
_	the nominal interest rate.	
6	the real interest rate.	
c.		
d.	the credit rate.	
45. Th	ne real interest rate equals	
a.	the inflation rate minus the nominal interest rate.	
(6)	the nominal interest rate minus the inflation rate.	
c.	the nominal interest rate plus the inflation rate.	
d.	the nominal interest rate divided by the CPI for a given year.	
Short	Answer Questions	
1.	Suppose that the working-age population of a country is 1,000. Currently 600 a force. In addition, 550 people are currently employed. For this country, what a participation rate and the unemployment rate?	
	participants in the and the anompleyment takes	
		<u> </u>
2.	Suppose that because of improvements in health care, people postpone their re continue working until they are 68 instead of 63. How would this influence the participation rate?	
		8

consumer		nds of coffee,	three boxes o			ola. A typical cola. Prices of the
Year	Price of coffee	Price of tea	Price of	Value of market basket	СРІ	CPI inflation rate
1	\$3.25	\$2.00	\$1.10			
2	\$3.75	\$2.22	\$1.20			
3	\$4.05	\$2.50	\$1.25			
	-					
						ed to pay Emma a
percent int percent inf on the loar rate Jacob	erest rate to conflation in the part of th	ompensate he ast. That nom t during the y d expected. W	r for not using ninal interest rear the inflati Who gains, and	g her \$500 for pate would impon rate was 4 pd who loses? H	that year and ly a 1 percont, rat	ed to pay Emma a nd to adjust for the ent real interest in her than the 3 per your answer diff
percent int percent inf on the loar rate Jacob	erest rate to co flation in the p n. Suppose that and Emma had	ompensate he ast. That nom t during the y d expected. W	r for not using ninal interest rear the inflati Who gains, and	g her \$500 for pate would impon rate was 4 pd who loses? H	that year and ly a 1 percont, rat	nd to adjust for the ent real interest in the than the 3 pe
percent int percent inf on the loar rate Jacob the actual	erest rate to co flation in the p n. Suppose that and Emma had inflation rate d	ompensate he ast. That nom t during the y d expected. When the year the yea	r for not using hinal interest rear the inflati Who gains, and Ir was 1 perce	g her \$500 for rate would imp on rate was 4 pd who loses? H	that year and a ly a 1 percent, rate ow would	nd to adjust for the ent real interest in the than the 3 pe

True/False Questions

- T F 1. The unemployment rate is the percentage of the population that is unemployed.
- T F 2. A discouraged worker is someone who is still working but is underemployed or paid less than she prefers.
- T F 3. Over the last 50 years, the labor force participation rate tended to decline for men but rise for women.
- T F 4. Teenage unemployment rates are about the same as adult unemployment rates.
- T F 5. The household survey gives a higher total for people employed than the establishment survey because the household survey includes self-employment.
- T F 6. Frictional unemployment includes people who quit their jobs to look for different jobs.
- T F 7. Structural unemployment includes people who lost jobs because their job skills were no longer needed by their employer.
- T F 8. Cyclical unemployment is caused by firms reducing employment due to decreased demand for their products during a recession.
- T F 9. At full employment, the unemployment rate is zero.
- T F 10. The CPI is the average price of all goods and services in the economy.
- T F 11. The market basket for the CPI changes every month.
- T F 12. The CPI in 2012 is 138. This indicates that prices have increased 138 percent from the base year.
- T F 13. The GDP deflator is defined as the ratio of real GDP to nominal GDP multiplied by 100.
- T F 14. The real interest rate is the nominal interest rate plus the inflation rate.
- T F 15. If inflation is unexpectedly high, this will benefit lenders and harm borrowers.

Answers to the Self-Test

Multiple-Choice Questions

Question	Answer	Comment
1.	c	In the 1960s, Arthur Okun, who was chairman of the Council of Economic Advisers during Lyndon Johnson's administration, coined the term "misery index," which adds together the inflation rate and the unemployment rate to give a rough measure of the state of the economy.
2.	С	The Current Population Survey, often referred to as the household survey, is a sample of 60,000 households, chosen to represent the U.S. population, and asks about the employment status of everyone in the household 16 years of age or older.
3.	a	The labor force is the sum of the employed and the unemployed.
4.	a	The unemployment rate is the ratio of the number of people unemployed to the labor force, where the labor force is the sum of the employed and the unemployed. People are counted as unemployed if they are without a job, but are actively seeking a new job.

Question	Answer	Comment
5.	b	People who are available for work and who have actively looked for a job at some point during the previous 12 months, but who have not looked during the previous four weeks, are not in the labor force.
6.	С	The definition of a discouraged worker is someone who is available for work but has not looked for a job during the previous four weeks because he or she believes no jobs are available.
7.	a	Frictional and structural unemployment will exist at full employment. At full employment there is no unemployment due to the business cycle, or in other words, no cyclical unemployment.
8.	d	In August 2013, the working-age population of the United States was 246 million. The working-age population is divided into those in the labor force (156 million) and those not in the labor force (90 million).
9.	c	The smallest group consisted of people who could possibly work but were not in the labor force, such as discouraged workers (1 million) and those not working for other reasons (1.6 million).
10.	a	The unemployment rate measures the percentage of the labor force that is unemployed.
11.	a	Including people in the military would increase the number of people counted as being in the labor force but would leave unchanged the number of people counted as unemployed. Therefore, the unemployment rate would decrease.
12.	d	The BLS counts a person as employed even if he or she prefers to work more hours or wishes to earn more. A person who is not actively looking for a job after having trouble finding one is considered as a discouraged worker. Discouraged workers are not considered as unemployed either.
13.	b	For example, in August 2013, if the BLS counted as unemployed all the people who were available for work but not actively looking for a job, and all the people who had part-time jobs but wanted full-time jobs, the unemployment rate would have increased from 7.6 percent to more than 15 percent.
14.	c	Textbook Figure 9.3 highlights two important trends in labor force participation rates of adults aged 20 and over in the United States since 1948: the rising labor force participation rate of adult women and the falling labor force participation rate of adult men.
15.	b	Textbook Figure 9.4 shows that different groups in the population can have very different unemployment rates.
16.	d	In mid-2013, the average period of unemployment was 9 months, which was substantially higher than the average period before the 2007–2009 recession.
17.	c	The establishment survey has the strength of being determined by actual payrolls rather than by unverified answers, as is the case with the household survey. In recent years, some economists have come to rely more on establishment survey data than on household survey data in analyzing current labor market conditions.
18.	b	In 2010, for example, about 26.6 million jobs were created and about 25.5 million jobs were also destroyed. This degree of job creation and destruction is what we would expect in a vibrant market system where new firms are constantly being started, some existing firms are expanding, some existing firms are contracting, and some firms are going out of business.

Question	Answer	Comment
19.	d	Figure 9.6 illustrates that the unemployment rate follows the business cycle, rising during recessions and falling during expansions.
20.	a	The definition of frictional unemployment is the short-term unemployment that arises from the process of matching workers with jobs.
21.	b	The definition of structural unemployment is unemployment that arises from a persistent mismatch between the job skills or attributes of workers and the requirements of jobs.
22.	b	When the only remaining unemployment is structural and frictional unemployment, the economy is said to be at full employment.
23.	d	Economists often think of frictional and structural unemployment as being the "normal" underlying level of unemployment in the economy. This normal level of unemployment, which is the sum of frictional and structural unemployment, is referred to as the natural rate of unemployment. The natural rate of unemployment is also sometimes called the full-employment rate of unemployment.
24.	d	Some government policies can add to the level of frictional and structural unemployment by either increasing the time workers devote to searching for jobs, by providing disincentives to firms to hire workers, or by keeping wages above their market level.
25.	b	Increases in the minimum wage mostly affect teenage unemployment rates.
26.	c	The unemployed spend more time searching for jobs because they receive these payments. This additional time spent searching raises the unemployment rate. Does this mean that the unemployment insurance program is a bad idea? Most economists would say no. Reduced spending contributes to the severity of recessions. Unemployment insurance helps the unemployed maintain their income and spending, which helps reduce the severity of recessions.
27.	d	The unemployment rate in the United States is usually lower than the unemployment rates in most other high-income countries, partly because the United States has tougher requirements for the unemployed to receive government payments. This raises the costs of searching for a better job and lowers the unemployment rate.
28.	b	If the minimum wage is set above the market wage determined by the demand and supply of labor, then the quantity of labor supplied will be greater than the quantity of labor demanded. As a result, the unemployment rate will be higher than it would be without a minimum wage.
29.	С	An efficiency wage is a wage higher than the market wage paid by a firm in order to increase worker productivity. An efficiency wage also helps to retain and motivate workers.
30.	c	To obtain prices of a representative group of goods and services, the Bureau of Labor Statistics (BLS) surveys 30,000 households nationwide on their spending habits. They use the results of this survey to construct a market basket of 211 goods and services purchased by the typical urban family of four.
31.	d	In calculating the CPI, the market basket includes only consumer purchases, not business purchases. Further, the market basket is updated only every few years.

Question	Answer	Comment
32.	c	Almost three-quarters of the market basket is made up of housing, transportation, and food.
33.	d	The quantities of the products purchased in the current year are irrelevant in calculating the CPI because we are assuming that households buy the same market basket of products each month.
34.	c	The inflation rate is computed as follows: $[(214.6 - 215.3)/215.3] \times 100 = -0.3\%$.
35	a	In constructing the CPI, the Bureau of Labor Statistics assumes that each month consumers purchase the same amount of each product in the market basket. In fact, consumers are likely to buy fewer of those products that increase most in price and more of those products that increase least in price.
36.	c	The GDP deflator provides the broadest measure we have of the price level because it includes the price of every final good and service. It is an average of the prices of all goods and services included in GDP.
37.	b	We can calculate the value of the GDP deflator for any year by dividing the value of nominal GDP for that year by the value of real GDP and multiplying by 100. In this case, $(11,000/10,000) \times 100 = 110$.
38.	c	The real interest rate is the nominal interest rate minus the inflation rate, or $4\% - 6\% = -2\%$. When the inflation rate is greater than the nominal interest rate, the real interest rate is negative.
39.	d	We can calculate the inflation rate as the percentage change of any price measure including GDP deflator from one year to the next.
40.	c	Like the consumer price index, the producer price index tracks the prices of a market basket of goods. But whereas the consumer price index tracks the prices of goods and services purchased by the typical household, the producer price index tracks the prices firms receive for goods and services at all stages of production.
41.	b	On average, prices were about three times as high in 2014 as in 1979, because $225/73 = 3.1$.
42.	c	Value in 2014 dollars = Value in 2007 dollars \times (CPI in 2014/CPI in 2010). Then, \$50,000 \times (225/207) = \$50,000 \times 1.09 = \$54,348. The pay raise required is \$54,348 - \$50,000 = \$4,348.
43.	a	Economic variables that are calculated in current year prices are referred to as nominal variables. When we are interested in tracking changes in an economic variable over time, rather than in seeing what its value would be in today's dollars, or to correct for the effects of inflation, we can divide the nominal variable by a price index and multiply by 100 to obtain a real variable.
44.	a	The stated interest rate on a loan is the nominal interest rate. The real interest rate corrects the nominal interest rate for the impact of inflation.
45.	b	The real interest rate corrects the nominal interest rate for the impact of inflation and is equal to the nominal interest rate minus the inflation rate.

Short Answer Responses

1. Using the equations:

Labor force participation rate =
$$\frac{\text{Labor force}}{\text{Working-age population}} \times 100 = \left(\frac{600}{1000}\right) \times 100 = 60.0\%$$
Unemployment rate = $\frac{\text{Number of unemployed}}{\text{Labor force}} \times 100$

$$= \left(\frac{600 - 550}{600}\right) \times 100 = 8.3\%$$

- 2. If workers stayed in the labor force longer, we would expect to see labor force levels increase. Given levels of the population, we would expect to see the labor force participation rate increase.
- 3. At full employment the economy cannot be in a recession. Therefore by definition there can be no cyclical unemployment. Frictional and structural unemployment are not due to the business cycle and can exist at any time, including at full employment.
- 4. With Year 1 as the base year, the results are:

Year	Price of coffee	Price of tea	Price of diet coke	Value of market basket	СРІ	CPI inflation rate
1	\$3.25	\$2.00	\$1.10	\$13.60	100.0	
2	3.75	2.22	1.20	15.36	112.9	12.9%
3	4.05	2.50	1.25	16.85	123.9	9. <i>7</i>

With Year 3 as the base year, the results are:

Year	Price of coffee Price of tea		Price of diet coke	Value of market basket	СРІ	CPI inflation rate
1	\$3.25	\$2.00	\$1.10	\$13.60	80.7	_
2	3.75	2.22	1.20	15.36	91.2	12.9%
3	4.05	2.50	1.25	16.85	100.0	9.7

Notice that the values for the CPI in each year are different, but the inflation rates are the same.

5. Jacob and Emma agreed on a 4 percent nominal interest rate and expected a 3 percent inflation rate. They implicitly agreed on a 1 percent real interest rate on the loan. If the actual inflation rate rose to 5 percent, the real interest rate on the loan would have been -1 percent. Emma's real return would be lower than she wanted, and in fact, it would be negative. Emma loses. Jacob, on the other hand, only pays a real interest rate of -1 percent instead of 1 percent. Jacob gains from the higher inflation.

6. The labor force participation rate is the ratio of the number in the labor force to the working-age population multiplied by 100. In this economy, the working age population is 7,500, and because 3,000 people are not in the labor force, the labor force will be 4,500 (= 7,500 - 3,000 = 4,500), so the labor force participation rate is 60 percent = $[100 \times (4,500/7,500) = 60 \text{ percent}]$. The unemployment rate is 100 multiplied by the percentage of the labor force that is unemployed, or 100 × (number unemployed/number in the labor force), so the unemployment rate is 6 percent $[= 100 \times (270/4,500) =$ 6.0 percent].

True/False Answers

Question	Answer	Comment
1.	F	The unemployment rate is the percentage of the labor force that is unemployed.
2.	F	See page 264 in the textbook for the definition of discouraged workers.
3.	F	Female participation rates have risen while male rates have fallen.
4.	F	Teenage unemployment rates are much higher than adult rates.
5.	T	See page 264 in the textbook for the household survey.
6.	T	See page 274 in the textbook for the definition of frictional unemployment.
7.	T	See page 275 in the textbook for the definition of structural unemployment.
8.	T	See page 275 in the textbook for the definition of cyclical unemployment.
9.	F	There will always be some structural and frictional unemployment. The natural rate of unemployment is always positive.
10.	F	The CPI includes only those goods that are in the BLS market basket.
11.	F	The market basket is updated every two years.
12.	F	Because the CPI in the base year is 100. When the CPI is 225, prices increase by $(225 - 100)/100 = 125$ percent.
13.	F	The GDP deflator is defined as the ratio of nominal GDP to real GDP multiplied by 100
14.	F	The real interest rate equals the nominal interest rate minus the inflation rate.
15.	F	Unexpectedly high inflation benefits borrowers and harms lenders. See page 287 in the textbook for the effects of unexpected inflation.

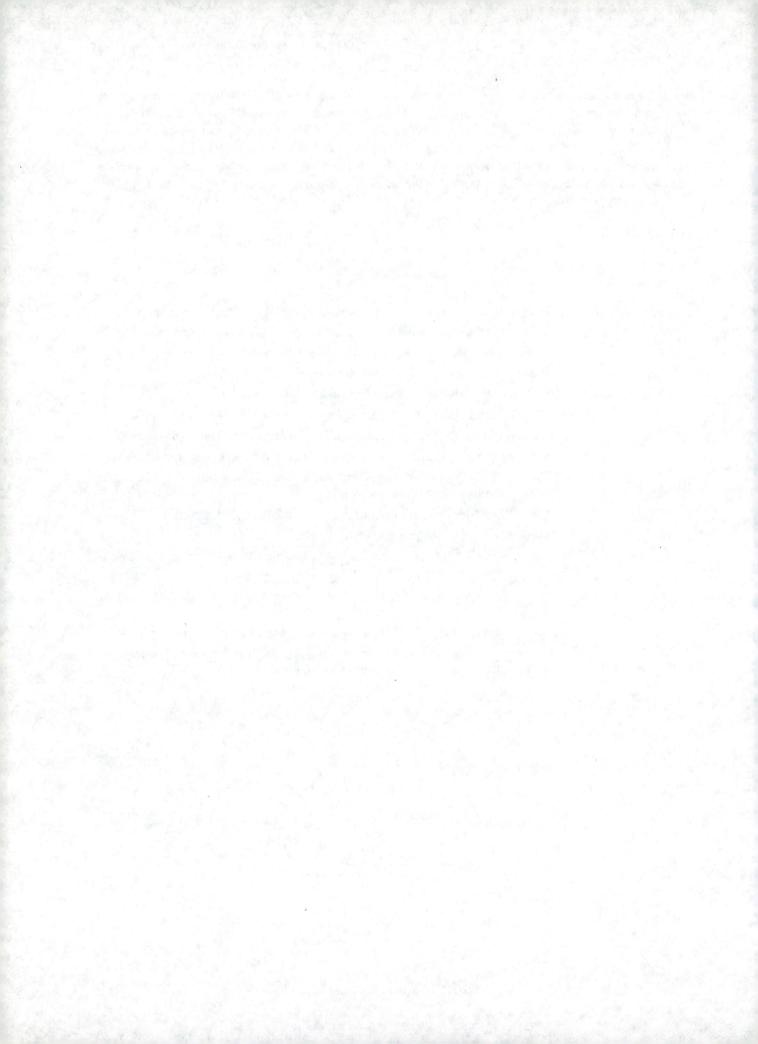

CHAPTER 10 | Economic Growth, the Financial System, and **Business Cycles**

Chapter Summary and Learning Objectives

10.1 Long-Run Economic Growth (pages 300-308)

Discuss the importance of long-run economic growth. The U.S. economy has experienced both long-run economic growth and the business cycle. The **business cycle** refers to alternating periods of economic expansion and economic recession. Long-run economic growth is the process by which rising productivity increases the standard of living of the typical person. Because of economic growth, the typical American today can buy almost eight times as much as the typical American of 1900. Long-run growth is measured by increases in real GDP per capita. Increases in real GDP per capita depend on increases in labor productivity. Labor productivity is the quantity of goods and services that can be produced by one worker or by one hour of work. Economists believe two key factors determine labor productivity—the quantity of capital per hour worked and the level of technology. Capital refers to manufactured goods that are used to produce other goods and services. Human capital is the accumulated knowledge and skills workers acquire from education, training, or their life experiences. Economic growth occurs if the quantity of capital per hour worked increases and if technological change occurs. Economists often discuss economic growth in terms of growth in potential GDP, which is the level of GDP attained when all firms are producing at capacity.

10.2 Saving, Investment, and the Financial System (pages 308–316)

Discuss the role of the financial system in facilitating long-run economic growth. Financial markets and financial intermediaries together compose the **financial system**. A well-functioning financial system is an important determinant of economic growth. Firms acquire funds from households, either directly through financial markets—such as the stock and bond markets—or indirectly through financial intermediaries—such as banks. The funds available to firms come from saving. There are two categories of saving in the economy: private saving by households and public saving by the government. The value of total saving in the economy is always equal to the value of total investment spending. In the model of the market for loanable funds, the interaction of borrowers and lenders determines the market interest rate and the quantity of loanable funds exchanged.

10.3 The Business Cycle (pages 316–325)

Explain what happens during the business cycle. During the expansion phase of the business cycle, production, employment, and income are increasing. The period of expansion ends with a business cycle peak. Following a business cycle peak, production, employment, and income all decline during the recession phase of the cycle. The recession comes to an end with a business cycle trough, after which another period of expansion begins. The inflation rate usually rises near the end of a business cycle expansion and then falls during a recession. The unemployment rate declines during the later part of an expansion and increases during a recession. The unemployment rate often continues to increase even after an expansion has begun. Economists have not found a method to predict when recessions will begin and end. Recessions are difficult to predict because they are due to more than one cause. Until the severe recession of 2007–2009, recessions had been milder and the economy had been more stable in the period since 1950.

10.1

Chapter Review

Chapter Opener: Economic Growth and the Business Cycle at Whirlpool (page 299)

Whirlpool is the world's leading manufacturer of home appliances. In 2012, Whirlpool had more than 68,000 employees and \$18 billion in revenue. Whirlpool's experiences have mirrored two key macroeconomic facts: In the long run, the U.S. economy has experienced economic growth, and in the short run, the economy has experienced a series of business cycles. Whirlpool has also experienced growth over the long run, while being affected by the business cycle. In 1900, only 3 percent of families lived in homes with electric lights, and no families had electric washing machines, dishwashers, or refrigerators. Today, nearly all families have electric washing machines and refrigerators. The housing market collapse that led to the recession of 2007-2009 caused a sharp decline in the demand for durable goods, including household appliances. As the economy recovered from the recession, spending on durable goods rose again.

Long-Run Economic Growth (pages 300–308)

Learning Objective: Discuss the importance of long-run economic growth.

Long-run economic growth increases living standards. It is the reason why the standard of living for the average American today is so different from that of the 1900s. The best measure for the standard of living is real GDP per person or real GDP per capita. Real per capita GDP (in 2005 dollars) has grown from \$5,600 in 1900 to \$43,642 in 2012. Today, the average American can purchase about eight times as many goods and services compared to 1900. Economists use growth in real GDP per capita over time as a key measure of the long-term performance of the economy.

In the following formula for calculating the growth rate in real GDP (or real GDP per capita), t refers to the current year and t-1 refers to the previous year:

Real GDP growth rate, =
$$\frac{\text{Real GDP}_{t} - \text{Real GDP}_{t-1}}{\text{Real GDP}_{t-1}} \times 100$$

Real GDP was \$15,052 billion in 2011 and \$15,471 billion in 2012. So the growth rate in real GDP for 2012 was:

Real GDP growth rate
$$2012 = \frac{\text{Real GDP } 2012 - \text{Real GDP } 2011}{\text{Real GDP } 2011} \times 100$$

$$= \frac{\$15,471 \text{ billion} - \$15,052 \text{ billion}}{\$15,052 \text{ billion}} \times 100$$

$$= 2.8\%$$

To find real GDP growth rates over longer periods of time, such as 10 years, we can average the growth rates for each year.

Increases in real GDP and real GDP per capita are caused by increases in **labor productivity** (output per hours worked). Economists believe that there are two key factors that determine labor productivity: the quantity of the capital per hour worked and the level of technology. Recall that **capital** refers to manufactured goods that are used to produce other goods or services. As the capital stock per hour increases, so does worker productivity.

Technological change has similar effects on labor productivity. Technological change refers to an increase in the quantity of output that firms can produce using the same level of inputs. This means an economy can produce more output (real GDP) with the same quantities of workers and capital. However, it is important to point out that accumulating more workers and capital does not ensure that an economy will experience economic growth unless technological change also occurs. Most technological change is embodied in new machinery, equipment, or software.

The concept of **potential GDP** is very useful to economists when discussing long-run economic growth. Potential GDP refers to the level of output that could be produced if all firms are producing at capacity using normal working hours and their normal work force. Potential GDP grows over time as the labor force increases, as new machinery is installed, and as technological change takes place. In the United States, potential GDP increases about 3.3 percent per year.

Study Hint

Note the distinction between long-run economic growth and the business cycle. Economic growth is a long-term phenomenon, whereas the business cycle is captured by short-run economic fluctuations. As shown in textbook Figure 10.2, economic growth is typically measured as a smooth trend in real GDP over a long period of time, and business cycles are periodic deviations from that smooth trend.

Making the Connection "The Connection between Economic Prosperity and Health" discusses the impact of long-run economic growth on different measures of health, such as life expectancy. Making the Connection "Can India Sustain Its Rapid Growth?" explains that for India to continue its rapid growth of the past 10 years, its government will need to upgrade infrastructure, improve the provision of educational and health services, and renew its commitment to the rule of law and to market-based reforms.

10.2

Saving, Investment, and the Financial System (pages 308–316)

Learning Objective: Discuss the role of the financial system in facilitating long-run economic growth.

Economic growth depends on firms purchasing capital goods. However, before a firm can acquire new buildings and machines, it must find financing. This requires access to the **financial system**. The U.S. financial system includes **financial markets** (like the stock and bond markets) and **financial intermediaries** (like banks, credit unions, pension funds, and insurance companies). The financial system channels funds from savers (lenders) to borrowers, who pay savers interest for use of the funds. Financial intermediaries pool the savings of many small savers and make large loans from the pooled funds.

A fundamental macroeconomic identity is that the total value of saving should equal the total value of investment. We can show why this identity holds: First, remember that the relationship between GDP (Y) and its components, consumption (C), investment (I), government purchases (G), and net exports (NX) can be expressed in terms of the following equation:

$$Y = C + I + G + NX$$
.

In a closed economy where exports and imports (and therefore, net exports) are zero, we know that:

$$Y = C + I + G$$

or

$$I = Y - C - G$$
.

Private saving $(S_{private})$ is equal to what households retain of their income after purchasing goods and services (C) and paying taxes (T). In addition to receiving income for supplying factors of production to firms (Y), households also receive income from the government in the form of transfer payments (TR). Private saving can be expressed in the following equation:

$$S_{\text{private}} = Y + TR - C - T.$$

Public saving occurs when the government engages in saving (S_{public}). It is the difference between the government's revenue and the government's spending and can be expressed in the following equation:

$$S_{\text{public}} = T - G - TR$$
.

Total saving in the economy (S) is $S_{private} + S_{public}$. It can also be expressed through the following equations:

$$S = S_{\text{private}} + S_{\text{public}} = (Y + TR - C - T) + (T - G - TR),$$

or

$$S = Y - C - G$$

or

$$S = I$$

The above equations have demonstrated that total saving must equal total investment. The financial system brings about the equality of total saving and total investment through the market for loanable funds. Borrowers and savers interact in the market for loanable funds, which determines the quantity of loanable funds and the interest rate on these funds. The demand for loanable funds is determined by the willingness of firms to borrow funds to finance new investment projects. These projects can range from building new factories to engaging in research and development. When determining whether to borrow funds, firms compare the return they expect to receive on an investment with the interest rate they must pay to borrow the necessary funds. The demand for loanable funds is downward sloping because the lower the interest rate, the larger the number of profitable investment projects there are and the larger the quantity of loanable funds firms want to borrow. The supply of loanable funds is determined by the willingness of households to save and by the extent of government saving or dissaving. The government saves when it runs a budget surplus and dissaves when it runs a deficit. The supply curve for loanable funds is upward sloping because the higher the interest rate, the greater the quantity of loanable funds supplied by savers. Because both borrowers and lenders are interested in the real interest rate they will receive or pay, equilibrium in the market for loanable funds determines the real interest rate, not the nominal interest rate.

Equilibrium in the market for loanable funds determines the quantity of loanable funds that will flow from lenders to borrowers each period and determines the real interest rate that lenders will receive and that borrowers must pay. The demand for loanable funds is determined by the willingness of firms to borrow money and engage in new investment projects, while the supply of loanable funds is determined by the

willingness of households to save. Textbook Figure 10.3 shows equilibrium in the market for loanable funds.

Study Hint

Draw a loanable funds market graph and show what will happen to the equilibrium real interest rate and equilibrium quantity of loanable funds if demand increases. What will happen if supply increases?

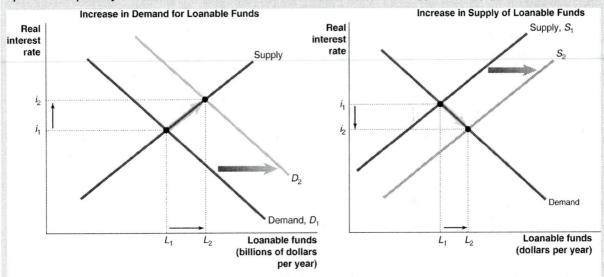

An increase in demand will increase both the real interest rate and the quantity of loanable funds.

An increase in supply will reduce the real interest rate and increase the quantity of loanable funds.

Don't forget the difference between a movement along a curve and a shift in the curve. A shift is caused by a change in a variable that is held constant when we draw a particular curve. For instance, a budget deficit causes a shift in the supply of loanable funds, and an increase in income causes an increase in demand for loanable funds. A change in the real interest rate will cause a movement along both the supply curve of loanable funds and the demand curve for loanable funds.

Making the Connection "Ebenezer Scrooge: Accidental Promoter of Economic Growth?" explains that in Charles Dickens's A Christmas Carol, Scrooge the saver was in fact better for economic growth than Scrooge the spender because savings raise the supply of loanable funds.

When the government runs a budget deficit, it causes the supply curve for loanable funds to shift to the left. This is shown in textbook Figure 10.5. When the supply curve for loanable funds shifts to the left, the real interest rate will rise, and private investment spending will fall because there will be fewer profitable private investment projects at the new, higher interest rate. This reduction in investment is referred to as **crowding out.** A budget surplus would have the opposite effects: increasing the total amount of saving in the economy, which would shift the supply of loanable funds to the right. As a result, a government budget surplus will lead to a lower real interest rate, a larger quantity of loanable funds, and higher saving and investment.

The Business Cycle (pages 316–325)

Learning Objective: Explain what happens during the business cycle.

The **business cycle** is a period of economic expansion followed by a period of economic recession. The expansion phase of a business cycle ends with a business cycle peak, followed by a period of contraction or recession. The recession phase of a business cycle ends with a business cycle trough, which is followed by another expansion. Textbook Figure 10.6 (a) shows the four phases of the business cycle.

Recessions tend to reduce inflation. On average, inflation is about 2.5 percentage points lower in the year after a recession than in the year before a recession. Recessions almost always increase unemployment. The unemployment rate tends to be about 1.2 percentage points higher in the year after a recession than in the year before a recession. Since the end of World War II, expansions have gotten progressively longer, and recessions have become shorter. Until 2007, recessions had become milder.

The federal government does not officially decide when a recession begins and when it ends. Economists turn to the Business Cycle Dating Committee of the National Bureau of Economics Research (NBER). The NBER defines a recession as "a significant decline in activity across the economy, lasting more than a few months, visible in industrial production, employment, real income, and wholesale retail trade." The NBER is slow in announcing when the country is in a recession because its staff need time to gather and analyze economic statistics and normally are not able to do so until the recession has already begun.

Until 2007, the business cycle had become milder, and the economy had been more stable. Economists believe that there are three reasons behind the reduced severity of recessions and a generally more stable economy in the period of 1950–2007:

- 1. Services have been an increasing fraction of GDP over the last 50 years. Because goods are a smaller fraction of GDP, problems caused by uneven movements in business inventories have been reduced. A shift in the economy from producing durable goods, whose demand is more responsive to income changes, to services has had a damping effect on recessions in the United States. (Almost by definition, services cannot be held as inventories.)
- 2. Unemployment insurance provides some income for families to continue to buy goods and services during a recession.
- 3. Many economists believe that active government policies to combat recessions have had the effect of reducing the severity of recessions.
- 4. Many economists believe the increased stability of the financial system contributed to the stability of the overall economy in the period after the Great Depression and before the 2007–2009 economic recession.

M Study Hint

Read the feature **Don't Let This Happen to You**, which reinforces the difference between the price level and the inflation rate. Economic growth is measured by the growth rate in real GDP, not the level of real GDP. Notice that it is possible for the growth rate in real GDP to decline while the level of real GDP is still increasing. Likewise, the price level and inflation are different. Inflation is a rate of change. Inflation can be falling while prices are still rising.

Making the Connection "Can a Recession Be a Good Time for a Business to Expand?" discusses the outcomes of different companies that expanded their factories and facilities during the 2007–2009 recession. Betting on the future seemed to have paid off for VF Corporation, the largest apparel maker in the world, but not for Intel, a major computer chip manufacturer, or Caterpillar, a major heavy equipment manufacturer.

Extra Solved Problem 10.3

Interest Rates and Recession

Supports Learning Objective 10.3: Explain what happens during the business cycle.

Using a graph of the market for loanable funds, predict what will happen to real interest rates as the economy enters a recession.

Solving the Problem

Step 1: Review the chapter material.

This problem is about using the market for loanable funds model, so you may want to review the section "The Market for Loanable Funds," which begins on page 311 in the textbook.

Draw a graph illustrating the effect of a reduction in saving. Step 2:

The equilibrium real interest rate depends on the demand and supply of loanable funds. As the economy enters a recession, we would expect income to fall, reducing both consumption (and, therefore, investment) and saving. This reduction in saving should reduce the supply of loanable funds, shifting the supply curve to the left. The reduction in the supply of loanable funds is shown in the following graph:

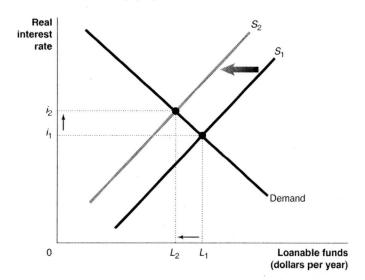

As a result of this reduction in supply, we would expect the equilibrium real interest rate to increase from i_1 to i_2 .

Step 3: Draw a graph illustrating the reduction in the demand for loanable funds.

At the same time that the supply of loanable funds is falling, we would expect the recession to reduce business investment opportunities. If firms do not expect output to grow, they may be unwilling to commit to new investment purchases. Firms will not need to expand their capital if they are laying off employees due to reduced demand. This should have the effect of reducing the demand for loanable funds, shifting the demand curve to the left. This is seen in the graph below:

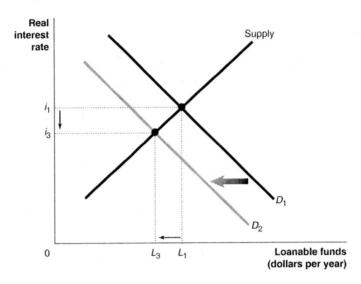

Step 4: Predict what will happen to real interest rates.

As a result of this reduction in demand, we would expect the equilibrium real interest rate to decrease from i_1 to i_2 . As the economy enters the recession, both the demand curve and the supply curve shift. Because both curves are shifting, the effect of the recession on the equilibrium real interest rate is uncertain. This is because the shift in the supply curve causes the real interest rate to increase at the same time the shift in the demand curve causes the real interest rate to decrease.

If the effect of the shift in demand is greater than the effect of the shift in supply, then we would expect to see the equilibrium real interest rate fall to i_4 as a result of the recession. This is seen in the graph below:

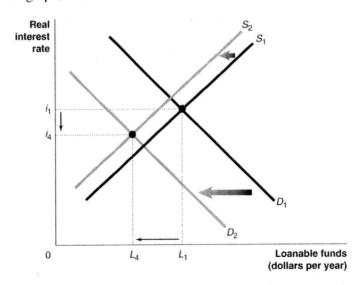

©2015 Pearson Education, Inc.

If the effect of the shift in supply is greater than the effect of the shift in demand, then we would expect to see the equilibrium real interest rate rise to i_5 as a result of the recession. This is seen in the graph below:

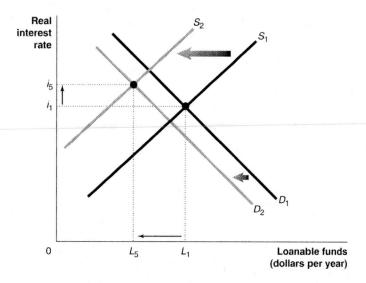

Our conclusion is that, based upon the market for loanable funds, we cannot predict what will happen to the equilibrium real interest rate as the economy enters a recession. The rate could either rise or fall. It is possible that the rate will not change. If this happens, the effect of the shift in supply on the interest rate offsets the effect of the shift in demand and the real interest rate remains at i_1 . The graph below shows this situation. In practice, we normally see the real interest rate fall during a recession, which means that the shift in the demand for loanable funds must typically be greater than the shift in supply.

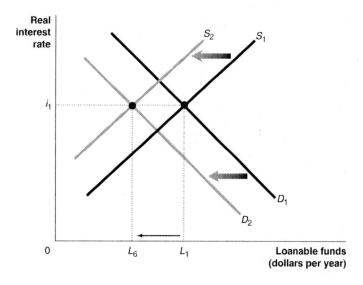

Key Terms

Business cycle Alternating periods of economic expansion and economic recession.

Capital Manufactured goods that are used to produce other goods and services.

Crowding out A decline in private expenditures as a result of an increase in government purchases.

Financial intermediaries Firms, such as banks, mutual funds, pension funds, and insurance companies, that borrow funds from savers and lend them to borrowers.

Financial markets Markets where financial securities, such as stocks and bonds, are bought and sold.

Financial system The system of financial markets and financial intermediaries through which firms acquire funds from households.

Labor productivity The quantity of goods and services that can be produced by one worker or by one hour of work.

Long-run economic growth The process by which rising productivity increases the average standard of living.

Market for loanable funds The interaction of borrowers and lenders that determines the market interest rate and the quantity of loanable funds exchanged.

Potential GDP The level of real GDP attained when all firms are producing at capacity.

Self-Test

(Answers are provided at the end of the Self-Test.)

Multiple-Choice Questions

- 1. The only way that the standard of living of the average person in a country can increase is by
 - a. increasing population growth so output can increase. Ib. increasing production faster than population growth.
 - c. ensuring that the country's economic growth is faster than economic growth in other countries.
 - d. producing the amount of output necessary for subsistence.
- 2. A defining characteristic of the business cycle is
 - a. periods of extremely slow growth followed by periods of very fast growth.
 - b. frequent economic recessions followed by severe depressions.
 - (c.) alternating periods of expansion and recession.
 - d. periods of stable growth but with frequent downturns.
- 3. The defining characteristic of long-run economic growth is
 - a. the business cycle.b rising productivity.
 - steady increases in living standards for everyone each year.
 - d. high rates of inflation.

- 4. Because the focus of long-run economic growth is on the standard of living of the average person, we measure the standard of living in terms of
 - a. real GDP.
 - b. nominal GDP.
 - c. nominal GDP per capita.
 - d.) real GDP per capita.
- 5. In measuring changes in the standard of living in a country, economists rely heavily on comparisons over time of real GDP per capita because
 - a. it is a very precise, almost perfect measure of well-being.
 - b. it is an effective means of accounting for things like the level of pollution, the level of crime, spiritual well-being, and many factors that other measures can't count.
 - it includes the value of all production in the economy.
 - despite its well-known flaws, it is the best means we have of comparing the performance of an economy over time.
- 6. The computation of the average annual growth rate of real GDP
 - a. is the same for shorter periods of time as for longer periods of time.
 - b. is computed by simply averaging the growth rate for each year but only if we use a lot of years.
 - c. is more complex when a long period of time is involved than when only a few years are included.
 - d. involves computing the percentage change in real GDP between the first year and the last year for the period we are interested in.
- 7. What is the best use of the rule of 70 among those listed below?
 - a. to forecast the duration of recessions
 - b. to find the average annual growth rate of real GDP
 - (c.) to judge how rapidly real GDP per capita is growing over long time periods
 - d. to calculate the difference between the growth rate in real GDP and the growth rate in real GDP per capita
- 8. When it comes to raising the standard of living in a country, how important is the growth rate of real GDP?
 - (a. Growth rates in real GDP are very important. Small differences in growth rates can have large effects over long time periods.
 - The difference in growth rates must be substantial before we notice any rise in living standards.
 - The standard of living can increase in the long run without any growth in real GDP.
 - d. When explaining changes in the standard of living, economists focus more on social factors than on growth rates of GDP.
- 9. Which of the following *does not* cause the quantity of goods and services that can be produced by one worker, or in one hour of work, to increase?
 - a. an increase in the quantity of capital per hour worked
 - b-technological change
 - C. an increase in the number of workers
 - d. an increase in the literacy rate

- 10. Which of the following terms refers to the accumulated knowledge and skills that workers acquire from education and training or from their life experiences?
 - a. capital
 - b. financial capital
 - c. human capital
 - d. physical capital
- 11. Which of the following will ensure that an economy experiences sustained economic growth?
 - a. increasing the amount of labor
 - b. increasing the amount of capital
 - c. increasing the amount of raw materials
 - (d. technological change
- 12. Which of the following government policies can help economic growth?
 - a. ensuring relative political stability and relatively little corruption
 - b. promoting the existence of an efficient financial system
 - c. protecting private property rights, allowing for freedom of the press, and having a democratic form of government
 - d. all of the above
- 13. Which of the following will not cause an economy to grow in the long run?
 - a. a more productive labor force
 - b. increases in capital per hour worked
 - c. a low minimum-wage rate
 - d. technological change
- 14. Potential GDP is
 - always greater than actual real GDP.
 - b. always less than actual real GDP.
 - sometimes greater, sometimes less, and sometimes equal to actual real GDP.
 - d. the level of GDP that would be produced when firms are operating at maximum capacity.
- How do firms acquire funds by using indirect finance rather than direct finance?
 - by issuing stocks or bonds
 - by borrowing from households
 - ©.) by borrowing from a bank
 - d. by borrowing from other firms
- 16. Which of the following are financial securities that represent promises to repay a fixed amount of funds?
 - a. stocks
 - (b.) bonds
 - c. both stocks and bonds
 - d. neither stocks nor bonds
- 17. Which of the following is a financial intermediary?
 - (a.) a bank
 - b. the White House
 - c. a company that develops an Internet search engine
 - d. a real estate brokerage

- 18. Which of the following is *not* a service that the financial system provides for savers and borrowers? a. risk sharing among savers b. increased liquidity for savers c. matching savers with borrowers d. protecting information or facts about borrowers from savers. 19. A government that collects more in taxes than it spends experiences a. a budget surplus. b. a budget deficit. c. a budget balance. d. an increase in the national debt. 20. What happens when government spending is greater than government tax revenues? a. There is negative public saving. b. There is dissaving by government, and the national debt rises. c. The government issues more new bonds than the old bonds it pays off. d. All of the above occur. 21. In determining whether or not to borrow funds, firms compare the rate of return they expect to make on an investment with a. the revenue expected from the investment. b. the interest rate they must pay to borrow the necessary funds. c. the initial cost of the investment. d. the total amount of profit they expect to make from the investment. 22. Fill in the blanks. The the interest rate, the more investment projects firms can profitably undertake, and the the quantity of loanable funds they will demand. a. lower; greater b. lower; smaller c. higher; greater d. higher; smaller 23. An increase in the real interest rate will a. shift the demand curve for loanable funds to the left. b. shift the supply curve of loanable funds to the right. c. cause a movement along the demand curve for loanable funds. d. result from the supply curve for loanable funds shifting to the right. 24. Which of the following determines the supply of loanable funds? a. the willingness of households and governments to save b. the number of financial intermediaries available c. changes in the interest rate, which cause business firms to undertake more or less profitable investment projects
- 25. If technological change increases the profitability of new investment to firms, which of the following will occur?
 - a. The demand for loanable funds will increase.

d. the quantity of stocks and bonds issued by business firms

- b. The supply of loanable funds will increase.
- c. The demand for loanable funds will decrease.
- d. The supply of loanable funds will decrease.

- 26. A federal government budget deficit will
 - a. increase the demand for loanable funds and increase the equilibrium real interest rate.
 - b. increase the supply of loanable funds and decrease the equilibrium real interest rate.
 - c. decrease the supply of loanable funds and increase the equilibrium real interest rate.
 - d. decrease the supply of loanable funds and decrease the equilibrium real interest rate.
- 27. If the government begins running a budget deficit, what impact will the deficit have on the loanable funds market?
 - a. The demand for loanable funds will increase.
 - b. The supply of loanable funds will increase.
 - c. The demand for loanable funds will decrease.
 - d. The supply of loanable funds will decrease.
- 28. Which of the following equals the amount of public saving?
 - a. the government's tax revenue minus the sum of government purchases and transfer payments to households
 - b. the sum of the government's tax revenue, government purchases, and government transfer payments to households
 - c. the sum of government purchases and transfer payments to household, minus transfer payments to households
 - d. the government's transfer payments to household minus the sum of the government's tax revenue and government purchases.
- 29. How would replacing an income tax by a tax on consumption affect the loanable funds market?
 - a. The demand for loanable funds would increase.
 - b. The supply of loanable funds would increase.
 - c. The demand for loanable funds would decrease.
 - d. The supply of loanable funds would decrease.
- 30. From a trough to a peak, the economy goes through
 - a. the recessionary phase of the business cycle.
 - b. the expansionary phase of the business cycle.
 - c. falling real GDP.
 - d. rising real GDP, but falling real GDP per capita.
- 31. Typically, when will the National Bureau of Economic Research (NBER) announce that the economy is in a recession?
 - a. about six months prior to the recession
 - b. on the precise date that the recession starts
 - c. only well after the recession has begun
 - d. exactly one year after the recession starts
- 32. As the economy nears the end of an expansion, which of the following occurs?
 - a. Interest rates are usually rising.
 - b. Wages are usually rising faster than prices.
 - c. The profits of firms will be falling.
 - d. All of the above occur.

- 33. When do households and firms typically increase their debts substantially?
 - a. toward the end of a recession
 - b. toward the end of an expansion
 - c. at the beginning of both recessions and expansions
 - d. in the middle of a recession
- 34. In business cycles.
 - a. expansions are usually the same length as recessions.
 - b. the peak is the end of the expansion.
 - c. the trough is always six months after the previous peak.
 - d. the dates of the peak and trough are determined by Congress.
- 35. Which types of goods are most likely to be affected by the business cycle?
 - a. durable goods
 - b. nondurable goods
 - c. services
 - d. goods purchased by the government
- 36. How does the inflation rate behave during the business cycle?
 - a. During expansions, the inflation rate usually increases.
 - b. During recessions, the inflation rate usually increases.
 - c. The inflation rate is unpredictable; it may increase or decrease during recessions or expansions.
 - d. The inflation rate usually decreases during both recessions and expansions.
- 37. Fill in the blanks. Recessions cause the inflation rate to , and they cause the unemployment
 - a. increase; increase
 - b. increase; decrease
 - c. decrease; decrease
 - d. decrease: increase
- 38. During the early stages of a recovery,
 - a. firms usually rush to hire new employees before other firms employ them.
 - b. firms are usually reluctant to hire new employees.
 - c. the rate of unemployment increases dramatically.
 - d. the rate of unemployment decreases dramatically.
- 39. Comparing the 1950–2007 period with other periods, how would you describe the business cycle?
 - a. Recessions were milder, and the economy was more stable.
 - b. Recessions were deeper and longer lasting, and the economy was more unstable.
 - c. There were no periods of recession in the 1950–2007 period, and the economy was very stable.
 - d. There were expansions and recessions in the 1950–2007 period, but the recessions were longer than the expansions.
- 40. Which of the following is *not* a reason that the economy is considered to be more stable in the 1950– 2007 period than in other periods?
 - a. the increasing importance of services and the declining importance of goods
 - b. the establishment of unemployment insurance programs
 - c. the use of active government policies to stabilize the economy
 - d. the introduction of a minimum-wage rate

- 41. During the last half of the twentieth century, the U.S. economy experienced
 - a. long expansions, interrupted by relatively short recessions.
 - b. long recessions, interrupted by relatively short expansions.
 - c. much more severe swings in real GDP than in the first half of the twentieth century.
 - d. an inflation rate that increased during both recessions and expansions.
- 42. Changes in the stability of the economy during the 1950-2007 period were attributed to
 - a. the steady rise of manufacturing production as a percentage of GDP.
 - b. the fact that the production of services fluctuates more than the production of durable goods such as automobiles.
 - c. the increasing importance of services and the declining importance of goods.
 - d. the increased instability in financial markets that partially offset the instability in other markets.
- 43. How have the establishment of unemployment insurance and the creation of other transfer programs that provide funds to the unemployed contributed to business cycle stability?
 - a. They have not contributed; in fact, they have worsened the stability of the economy.
 - b. They have made it possible for workers who lose their jobs to have higher incomes and, therefore, to spend more than they would otherwise.
 - c. They have limited the ability of the government to spend on other, more effective programs to bring about stability.
 - d. It is difficult to establish the impact of these programs on economic stability.
- 44. The period between the mid-1980s and the recession that began in late 2007 is commonly known as
 - a. the Great Depression.
 - b. the Great Recession.
 - c. the Great Moderation.
 - d. the Great Divide.
- 45. Which of the following statements best characterizes the views of economists with respect to government stabilization policies?
 - a. All economists are in favor of government policies intended to stabilize the economy.
 - b. Hardly any economists are in favor of government policies intended to stabilize the economy.
 - c. Some economists believe that government policies have played a key role in stabilizing the economy, but other economists disagree.
 - d. Most economists agree that government policies intended to stabilize the economy policies have been very effective, while only a few disagree.

Short Answer Questions

١.	If real GDP grows more slowly than the rate at which population is growing, what will happen to
	real GDP per capita? What will happen to the standard of living?

Suppose that households decide to save a greater fraction of their income even though the current interest rate has not changed. Use the loanable funds model to predict how the equilibrium real interest rate will change.
What effect does the business cycle typically have on the unemployment rate and the inflation rate? On average, how much difference is there between each rate in the year before a recession begins and the year after a recession ends?
Explain how unemployment insurance may cause a recession to be shorter and milder, while at the same time keeping unemployment higher for a longer time.

6. The table below gives real GDP for Canada for the period 2005–2012:

Year	Real GDP (millions of 2010 Canadian dollars)
2005	\$1,529,968
2006	1,573,159
2007	1,607,768
2008	1,618,846
2009	1,574,004
2010	1,624,608
2011	1,662,535
2012	1,699,111

Using this data, calculate the growth rate in real GDP for each year from 2005 to 2012, and the average growth rate in real GDP for this period. If Canadian real GDP grew at this average rate, how many years would it take for real GDP to double?

True/False Questions

- T F 1. Adjusted for inflation, GDP per capita in the United States today is about the same as it was in 1900.
- T F 2. If real GDP grows at a rate of 10 percent per year, it will take more than nine years for real GDP to double.
- T F 3. Labor productivity is the quantity of goods and services that can be produced by one hour of work.
- T F 4. Labor productivity is now about the same as it was in 1900.
- T F 5. Actual real GDP can never be higher than potential GDP because potential GDP is the upper limit of real GDP.
- T F 6. In an economy with no imports or exports, total savings equal investment.
- T F 7. Private saving in the economy equals total savings plus public saving.
- T F 8. An increase in the real interest rate caused by a decrease in the supply of loanable funds will reduce the demand for loanable funds and shift the loanable funds demand curve to the left.
- T F 9. In the market for loanable funds, savers demand loanable funds.
- T F 10. An increase in the equilibrium quantity of loanable funds will result in an increase in both saving and investment.
- T F 11. The dates for business cycle peaks and troughs are determined by the Business Cycle Committee of Congress (BCCC).
- T F 12. A business cycle is (in this order) an expansion, a peak, a recession, a trough, and then another expansion.
- T F 13. Recessions in the period between 1950 and 2013 typically lasted more than three years.

- T F 14. Inflation is usually lower and unemployment is usually higher after a recession than before a recession.
- 15. Unemployment insurance is one of the reasons that recessions have become shorter and less T F severe.

Answers to the Self-Test

Multiple-Choice Questions

Question	Answer	Comment
1.	b	Increasing production faster than population growth is the only way that the standard of living of the average person in a country can increase.
2.	c	Dating back to at least the early nineteenth century, the U.S. economy has experienced periods of expanding production and employment followed by periods of recession, during which production and employment decline. These alternating periods of expansion and recession are called the business cycle.
3.	b	Long-run economic growth is the process by which rising productivity increases the standard of living of the typical person.
4.	d	Because the focus of long-run economic growth is on the standard of living of the average person, we measure it by real GDP per capita. We use real GDP rather than nominal GDP to eliminate the effect of price changes.
5.	d	The quantity of goods and services that a person can buy, as measured by real GDP, is not a perfect measure of how happy or contented that person may be. The level of pollution, the level of crime, spiritual well-being, and many other factors are ignored in calculating GDP but contribute to a person's happiness. Nevertheless, economists rely heavily on comparisons of real GDP per capita because—flawed though the measure is—it is the best means we have of comparing the performance of an economy over time or the performance of different economies at any particular time. (Economists who have studied the issue of happiness have found a high correlation between per capita real GDP and per capita happiness.)
6.	c	For example, real GDP in the United States was \$2,004 billion in 1950 and \$13,088 billion in 2010. To find the average annual growth rate during this 60-year period, we need to compute the growth rate that would result in \$2,004 billion growing to \$13,088 billion over 60 years. In this case, the growth rate is 3.2 percent. That is, if \$2,004 billion grows at an average rate of 3.2 percent per year, then after 60 years it will have grown to \$13,088 billion. For shorter
		periods of time, we get approximately the same answer by averaging the growth rate for each year.
7.	c ·	One way to judge how rapidly real GDP per capita is growing is to calculate the number of years it would take to double. If real GDP per capita in a country doubles, say every 20 years, then most people in the country will experience significant increases in their standard of living over the course of their lives. If real GDP per capita doubles only every 100 years, then increases
		in the standard of living will be too slow to notice.

Question	Answer	Comment
8.	a	Small differences in growth rates can have large effects on how rapidly the standard of living in a country increases. For example, in 50 years, a \$1 trillion economy would grow to a \$4.4 trillion economy at a 3 percent growth rate. The same economy would grow to \$7.1 trillion at a growth rate of 4 percent.
9.	С	Increasing the number of hours of work is not sufficient to increase productivity. Economists believe two key factors determine labor productivity: the quantity of capital per hour worked and the level of technology.
10.	c	Human capital is defined as the accumulated knowledge and skills that workers acquire from education and training, or from their life experiences.
11.	d	A very important point is that just accumulating more inputs—such as labor, capital, and raw materials—will allow growth for a period of time. To sustain the growth, however, technological change must also occur.
12.	d	Protecting private property, avoiding political instability and corruption, and allowing press freedom and democracy are a straightforward recipe for providing an environment in which economic growth can occur.
13.	c	A low minimum wage may increase teenage employment but would not influence economic growth.
14.	c	Potential real GDP increases every year as the labor force and the capital stock grow and technological change occurs. Actual real GDP has sometimes been greater than potential real GDP and sometimes less, because of the effects of the business cycle. Note that potential real GDP results from firms producing at normal capacity, rather than at maximum capacity.
15.	С	Firms acquire funds from households, either directly through financial markets—such as the stock and bond markets—or indirectly through financial intermediaries, such as banks. In financial markets, firms raise funds by selling financial securities directly to savers.
16.	b	Stocks are financial securities that represent partial ownership of a firm. If you buy one share of stock in General Electric, then you become one of millions of owners of that firm who are entitled to a share of the firm's profits. Bonds are financial securities that represent promises to repay a fixed amount of funds.
17.	a	Financial intermediaries, such as banks, mutual funds and insurance companies, channel funds from savers to borrowers.
18.	d	The financial system provides savers with information or facts about borrowers and expectations about returns on financial securities.
19.	a	A government that collects more in taxes than it spends experiences a budget surplus. A government that spends more than it collects in taxes experiences a budget deficit.
20.	d	When government spending is greater than government tax revenues, there is negative public saving. Negative saving is also referred to as <i>dissaving</i> . Only when the government runs a budget surplus does it provide funds to financial markets by paying off more old bonds than it issues new bonds.
21.	b	In determining whether or not to borrow funds, firms compare the return they expect to make on an investment with the interest rate they must pay to borrow the necessary funds.

Question	Answer	Comment
22.	a	The demand for loanable funds is downward sloping because the lower the interest rate is, the more investment projects firms can profitably undertake, and the greater the quantity of loanable funds they will demand.
23.	c	Because the real interest rate is plotted on the vertical axis, a change in that rate will cause a movement along the graph, not a shift.
24.	a	The supply of loanable funds is determined by the willingness of households to save, and by the extent of government saving or dissaving. Financial intermediaries are not a source of funds but merely a conduit for channeling funds from savers to borrowers. Changes in the interest rate are caused by a change in the supply of loanable funds, not the other way around. Stocks and bonds are a source of acquiring funds (borrowing) and represent demand for funds, not a supply of loanable funds.
25.	a	The demand for loanable funds is determined by the willingness of firms to borrow money to engage in new investment projects. A technological change that increases profitability will increase that willingness for every level of the real interest rate.
26.	С	A federal budget deficit takes funds out of the economy, which will shift the supply of loanable funds to the left, resulting in a higher equilibrium real interest rate.
27.	d	When the government runs a budget surplus it provides funds to financial markets by paying off more old bonds than it issues new bonds—there is positive public saving. When government spending is greater than government tax revenues, there is negative public saving. Negative saving is also referred to as dissaving. Therefore, the deficit reduces the total amount of savings in the economy.
28.	a	Public saving equals tax revenue minus the sum of government purchases and transfer payments to households.
29.	b	For example, consider someone who puts her savings in a certificate of deposit at an interest rate of 2 percent and whose tax rate is 25 percent. Under an income tax, this person's after-tax return to saving is 1.5 percent $[2 \times (1-0.25)]$. Under a consumption tax where savings are not taxed, the return rises to 2 percent. We can conclude that moving from an income tax to a consumption tax would increase the return to saving, causing the supply of loanable funds to increase.
30.	b	The period of contraction ends with a business cycle trough. Following the business cycle trough, production, employment, and income rise as the economy enters the expansion phase of the cycle.
31.	c	The NBER is fairly slow in announcing business cycle dates because it takes time to gather and analyze economic statistics. Typically, the NBER will announce that the economy is in a recession only well after the recession has begun. Sometimes the NBER Business Cycles Committee continues to debate the exact dates on which a recession began and ended for several years after the recession is over. For example, the debate about when the 2001 recession ended continued well into 2004. The starting period (December 2007) of the 2007–2009 recession was not announced until late 2008.

Question	Answer	Comment
32.	d	As the economy nears the end of an expansion, interest rates are usually rising, and the wages of workers are usually rising faster than prices. As a result of rising interest rates and rising wages, the profits of firms will be falling. Typically, toward the end of an expansion, both households and firms will have substantially increased their debts.
33.	b	Typically, toward the end of an expansion, both households and firms will have substantially increased their debts.
34.	b	The phases of the business cycle are the trough, followed by the expansion, the peak, and then the contraction followed by a trough and another cycle.
35.	a	Consumer durables are affected more by the business cycle than are nondurables—such as food and clothing—or services—such haircuts or medical care. Because people can often continue to use their existing furniture, appliances, or automobiles, they are more likely to postpone spending on durables than on other goods.
36.	a	During economic expansions, the inflation rate usually increases, particularly near the end of the expansion, and during recessions, the inflation rate usually decreases. In every recession since 1950, the inflation rate has been lower during the 12 months after the recession ended than it was during the 12 months before the recession began.
37.	d	Recessions cause the inflation rate to fall, but they cause the unemployment rate to increase.
38.	b	The reluctance of firms to hire new employees during the early stages of a recovery means that the unemployment rate usually continues to rise even after the recession has ended.
39.	a	Before 1950 and after 2007, real GDP went through much greater year-to-year fluctuations than other periods. During the time period from 1950–2007, the American economy did not experience anything similar to the sharp fluctuations in real GDP that occurred during the early 1930s or after 2007.
40.	d	The minimum wage has nothing to do with the stability of the economy.
41.	a	During the last half of the twentieth century, the U.S. economy experienced long expansions, interrupted by relatively short recessions.
42.	c	As services, such as medical care or investment advice, have become a much larger fraction of GDP, there has been a corresponding decline in the production of goods.
43.	b	These and other government programs make it possible for workers who lose their jobs during recessions to have higher incomes and, therefore, to spend more than they would otherwise. This additional spending may have helped to make recessions shorter and shallower.
44.	С	Because the mild economic fluctuations during the period between the mid- 1980s and the recession that began in late 2007, that period is commonly known as the "Great Moderation."
45.	С	Many economists believe that these government policies have played a key role in stabilizing the economy in the years during the 1950–2007 period, but other economists disagree. These economists argue that far from helping to stabilize the economy, active policy has kept the economy from becoming even more stable.

Short Answer Responses

- 1. If the rate of growth of population is greater than the rate of growth of real GDP, then real GDP per capita will decrease and the standard of living is likely to decline.
- Investment spending includes (1) the purchase of capital goods by firms, including new factories, office buildings, and machinery used to produce other goods; (2) changes in business inventories; and (3) new residential construction. If the purchase of new capital goods exceeds the level of depreciation (the amount of capital worn out by current production), then the capital stock will increase.

3.

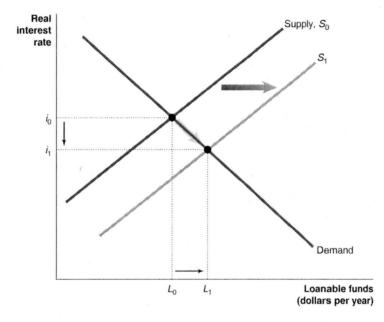

The increased desire to save by the public will shift the supply of loanable funds to the right, from S_0 to S_1 . This will cause the real interest rate to fall from i_0 to i_1 . The equilibrium quantity of loanable funds will increase from L_0 to L_1 .

- 4. During expansion, the unemployment rate usually falls and the inflation rate usually rises. During recession, the unemployment rate usually rises and the inflation rate usually falls. On average, inflation is about 2.5 percentage points lower in the year after a recession than for the year before the recession. Also, on average, unemployment is about 1.2 percentage points higher the year after a recession than the year before a recession.
- Unemployment insurance is an economic cushion. When the economy slips into a recession, some individuals will lose jobs. Unemployment insurance replaces some of the lost income and allows families to continue to buy goods and services. This makes the recession milder because spending does not fall as much as it would have if these families had no funds to spend. At the same time, unemployment insurance payments may reduce the incentive for those unemployed to take a new job quickly.

6. Based on the given information, the growth rates for the years are as given in the table (for example, the growth rate in 2006 is calculated as $100 \times [(1,573,159 - 1,529,968)/1,529,968] = 2.8$ percent). Note that because data for 2004 are not given, we cannot calculate the growth rate for 2005.

- 2.8%
2 8%
2.0 /0
2.2
0.7
-2.8
3.2
2.3
2.2

The average growth rate for this period was 1.5% (=2.8 + 2.2 + 0.7 - 2.8 + 3.2 + 2.3 + 2.2)/5). According to the Rule of 70, the number of years for the economy to double is 46.7 = 70/1.5).

True/False Answers

Question	Answer	Comment
1.	F	Textbook Figure 10.1 shows that real GDP per capita in the United States was about eight times today as it was in 1900.
2.	F	According to the rule of 70, if real GDP growth is 10 percent, then it will take seven years $(70/10 = 7 \text{ years})$ to double real GDP.
3.	T	See page 304 in the textbook.
4.	F	Growing labor productivity is the major source of economic growth.
5.	F	Potential GDP is the level of real GDP when all firms are producing at capacity, but actual real GDP can still be higher than potential GDP. See textbook Figure 10.2.
6.	T	See page 311 in the textbook.
7.	F	Total savings equal private saving plus public saving.
8.	F	An increase in the real interest rate caused by a decrease in the supply of loanable funds will cause a movement along the demand curve and reduce quantity demanded.
9.	F	In the market for loanable funds, borrowers demand loanable funds and savers supply loanable funds.
10.	T	See textbook Figure 10.4.
11.	F	The dates are determined by the NBER (which is not a government agency).
12.	T	See page 317 in the textbook.
13.	F	Recessions have gotten shorter after 1950. Until 2013, a typical recession lasted less than a year.
14.	T	See pages 321 to 323 in the textbook.
15.	T	See page 324 in the textbook.

CHAPTER 11 Long-Run Economic **Growth: Sources and Policies**

Chapter Summary and Learning Objectives

Economic Growth over Time and around the World (pages 334–339) 11.1

Define economic growth, calculate economic growth rates, and describe global trends in economic growth. Until around 1300 A.D., most people survived with barely enough food. Living standards began to rise significantly only after the **Industrial Revolution** began in England in the 1700s, with the application of mechanical power to the production of goods. The best measure of a country's standard of living is its level of real GDP per capita. Economic growth occurs when real GDP per capita increases, thereby increasing the country's standard of living.

11.2 What Determines How Fast Economies Grow? (pages 339–345)

Use the economic growth model to explain why growth rates differ across countries. An economic growth model explains changes in real GDP per capita in the long run. Labor productivity is the quantity of goods and services that can be produced by one worker or by one hour of work. Economic growth depends on increases in labor productivity. Labor productivity will increase if there is an increase in the amount of capital available to each worker or if there is an improvement in technology. **Technological change** is a change in the ability of a firm to produce a given level of output with a given quantity of inputs. There are three main sources of technological change: better machinery and equipment, increases in human capital, and better means of organizing and managing production. **Human** capital is the accumulated knowledge and skills that workers acquire from education and training or from their life experiences. We can say that an economy will have a higher standard of living the more capital it has per hour worked, the more human capital its workers have, the better its capital, and the better job its business managers do in organizing production. The per-worker production function shows the relationship between capital per hour worked and real GDP per hour worked, holding technology constant. Diminishing returns to capital mean that increases in the quantity of capital per hour worked will result in diminishing increases in output per hour worked. Technological change shifts up the perworker production function, resulting in more output per hour worked at every level of capital per hour worked. The economic growth model stresses the importance of changes in capital per hour worked and technological change in explaining growth in output per hour worked. New growth theory is a model of long-run economic growth that emphasizes that technological change is influenced by how individuals and firms respond to economic incentives. One way governments can promote technological change is by granting patents, which are exclusive rights to a product for a period of 20 years from the date the product is invented. To Joseph Schumpeter, the entrepreneur is central to the "creative destruction" by which the standard of living increases as qualitatively better products replace existing products.

11.3 Economic Growth in the United States (pages 345–348)

Discuss fluctuations in productivity growth in the United States. Productivity in the United States grew rapidly from the end of World War II until the mid-1970s. Growth then slowed down for 20 years before increasing again after 1995. Economists continue to debate the reasons for the growth slowdown of the mid-1970s to mid-1990s. Leading explanations for the productivity slowdown are measurement problems, high oil prices, and a decline in labor quality. Because Western Europe and Japan experienced a productivity slowdown at the same time as the United States, explanations that focus on factors affecting only the United States are unlikely to be correct. Some economists argue that the development of a "new economy" based on information technology caused the higher productivity growth that began in the mid-1990s.

11.4 Why Isn't the Whole World Rich? (pages 348–357)

Explain economic catch-up and discuss why many poor countries have not experienced rapid economic growth. The economic growth model predicts that poor countries will grow faster than rich countries, resulting in **catch-up.** In recent decades, some poor countries have grown faster than rich countries, but many have not. Some poor countries do not experience rapid growth for four main reasons: wars and revolutions, poor public education and health, failure to enforce the rule of law, and low rates of saving and investment. The **rule of law** refers to the ability of a government to enforce the laws of the country, particularly with respect to protecting private property and enforcing contracts. **Globalization** has aided countries that have opened their economies to foreign trade and investment. **Foreign direct investment (FDI)** is the purchase or building by a corporation of a facility in a foreign country. **Foreign portfolio investment** is the purchase by an individual or firm of stocks or bonds issued in another country.

11.5 Growth Policies (pages 357–360)

Discuss government policies that foster economic growth. Governments can attempt to increase economic growth through policies that enhance property rights and the rule of law, improve health and education, subsidize research and development, and provide incentives for savings and investment. Whether continued economic growth is desirable is a normative question that cannot be settled by economic analysis.

Chapter Review

Chapter Opener: Can China Save General Motors? (page 333)

Founded in 1908 under the leadership of Alfred P. Sloan, the General Motors Company (GM) is one of the largest sellers of automobiles in the world. By 2013, the company was selling more cars in China than in the United States. Beginning in 1978, China experienced rapid growth after moving away from a centrally planned economy. China's rapid economic growth has presented GM and other firms with the opportunity to profit from its rapidly expanding consumer market. But until today, the Chinese government has failed to fully establish the rule of law, particularly the enforcement of property rights. The absence of the rule of law is a problem for the long-term prospects of the Chinese economy. Without property rights, entrepreneurs cannot fulfill their role in the market system by bringing the factors of production together to produce goods and services.

11.1

Economic Growth Over Time and around the World (pages 334–339)

Learning Objective: Define economic growth, calculate growth rates, and describe global trends in economic growth.

There was not any significant economic growth in the world until the Industrial Revolution, which started in England around the year 1750. Estimates suggest that growth averaged about 0.2 percent per year in the 500 years before the Industrial Revolution and averaged about 1.3 percent per year in the 100 years after the Industrial Revolution. The Industrial Revolution probably started in England because of political

changes that gave entrepreneurs the incentive to invest in the important technological inventions of the time, such as the steam engine.

The rate of economic growth is important because increasing growth rates allow for higher standards of living, which bring not only larger selections of goods but also health and education. Over long periods of time, small differences in economic growth rates have large effects because compounding magnifies the effects of even slightly higher economic growth rates.

We can divide the world's countries into two groups, higher income countries, sometimes called industrial countries, and poorer countries, sometimes called developing countries. In 2010, GDP per capita ranged from \$82,600 in Luxembourg to only \$300 in Congo.

Study Hint

When economists talk about growth rates over periods of more than one year, they are talking about average annual growth rates, not total percentage changes. Read **Don't Let This Happen To You** "Don't Confuse the Average Annual Percentage Change with the Total Percentage Change." Between 1950 and 2012, real GDP per capita in the United States increased by a total of 242 percent, but the average increase per year was 2.0 percent.

Making the Connection "Why Did the Industrial Revolution Begin in England?" explains an argument that the Industrial Revolution was triggered by the institutional changes in the British government that encouraged investments and technological developments by upholding property rights, protecting wealth, and eliminating arbitrary increases in taxes. Another Making the Connection "Is Income All That Matters?" explains that some increases in living standards do not require increases in income but instead increases in technology and knowledge that are inexpensive enough to be widely available.

Extra Solved Problem 11.1

Economic Growth Rates

Supports Learning Objective 11.1: Define economic growth, calculate economic growth rates, and describe global trends in economic growth.

The table below has data on per capita real GDP for three Western European countries (in U.S. dollars):

Year	Germany	Italy	United Kingdom
2000	\$33,002	\$27,710	\$25,660
2001	33,839	29,031	26,753
2002	34,252	30,096	28,056
2003	34,457	30,852	29,620
2004	35,233	31,835	31,126
2005	35 , 707	32,382	32,253
2006	37,172	33,482	33,976
2007	39,071	34,629	35,682
2008	39,847	34,825	36,495
2009	38,348	33,513	34,974
2010	40,138	33,959	36,280

For each of these countries, calculate the average growth rate over this time period.

Solving the Problem

Step 1: Review the chapter material.

This problem is about computing economic growth rates, so you may want to review the section "Economic Growth over Time and around the World," which begins on page 334 in the textbook.

Step 2: Calculate average growth rate.

The total growth rates for the whole period from 2000 to 2010 would be computed as:

Growth rate =
$$\frac{\text{Per capita GDP in 2010} - \text{Per capita GDP in 2000}}{\text{Per capita GDP in 2000}} \times 100$$

But we are interested in the average annual growth rate, which means we have to compute the growth each year and then average the values we obtain. For instance, to compute the average growth rate for the year 2001, we need to compute the percentage change in per capita GDP from 2000 to 2001:

Growth rate in 2001 =
$$\frac{\text{Per capita GDP in 2001} - \text{Per capita GDP in 2000}}{\text{Per capita GDP in 2000}} \times 100$$

For Italy, this value is:

Growth rate in 2001 =
$$\left(\frac{\$29,031 - \$27,710}{\$27,710}\right) \times 100 = 4.8\%$$
.

The values for each country and each year are in the table below. The average annual growth rates are the averages of the growth rates for these years. For instance, for Italy the average annual growth rate is:

$$\frac{4.8\% + 3.7\% + 2.5\% + 3.2\% + 1.7\% + 3.4\% + 3.4\% + 0.6\% - 3.8\% + 1.3\%}{10} = 2.1\%.$$

	Gern	nany	Ita	ly	United K	(ingdom
Year	GDP per capita	Growth rate	GDP per capita	Growth rate	GDP per capita	Growth rate
2000	\$33,002	-	\$27,710	2 2 <u>2</u> 2	\$25,660	-
2001	33,839	2.5%	29,031	4.8%	26,753	4.3%
2002	34,252	1.2%	30,096	3.7%	28,056	4.9%
2003	34,457	0.6%	30,852	2.5%	29,620	5.6%
2004	35,233	2.3%	31,835	3.2%	31,126	5.1%
2005	35,707	1.3%	32,382	1.7%	32,253	3.6%
2006	37,172	4.1%	33,482	3.4%	33,976	5.3%
2007	39,071	5.1%	34,629	3.4%	35,682	5.0%
2008	39,847	2.0%	34,825	0.6%	36,495	2.3%
2009	38,348	-3.8%	33,513	-3.8%	34,974	-4.2%
2010	40,138	4.7%	33,959	1.3%	36,280	3.7%
Average of growth ra		2.0%		2.1%		3.6%

11.2 What Determines How Fast Economies Grow? (pages 339–345)

Learning Objective: Use the economic growth model to explain why growth rates differ across countries.

An economic growth model explains growth rates in real GDP per capita. Growth requires that the average worker produce more goods per time period. By definition, this means labor productivity increases over time. Labor productivity grows with increases in the quantity of capital per worker and with technological change. Technological change occurs through better machinery and equipment, increases in human capital, and better means of organizing production. The per-worker production function exhibits diminishing returns to capital as long as technology does not change. Diminishing returns to capital are illustrated in textbook Figure 11.3.

Increases in the capital-labor ratio, given the level of technology, will result in increases in output per worker. However, because of diminishing returns to capital, as the capital-labor ratio grows, the size of the increases in output per worker will get smaller. Long-term economic growth requires more than just growth in capital. It also needs technological change. Technological change shifts up the per-worker production function, resulting in more output with the same level of resources. Shifts in the per-worker production function are due to technological changes, as shown in textbook Figure 11.4.

Study Hint

Changes in capita per worker cause movements along a single per-worker production function, while changes in technology cause shifts in the per-worker production function. An upward shift in the production function means that the economy can produce more with the same level of capital per worker. Making the Connection "What Explains the Economic Failure of the Soviet Union?" explains how the new growth model can explain the economic collapse of the Soviet Union.

Over time, living standards can increase only if a country experiences continuing technological change. Paul Romer, an economist at Stanford University, argues that technological change is influenced by economic incentives. Romer's approach is referred to as the new growth theory. In this theory, the accumulation of knowledge capital is a key determinant of economic growth because knowledge capital is subject to increasing returns. This is true because knowledge is nonrival and nonexcludable, so that once it is discovered, it becomes available to everyone. Knowledge is nonrival because one person's using it does not prevent another person from using it. Knowledge is nonexcludable because once something is known, it becomes widely available for anyone to use. As a result of the nonrival and nonexcludable nature of knowledge capital, firms have little incentive to invest in research and development because they can free ride on other firms' knowledge capital. Government policy can help increase the accumulation of knowledge capital by protecting intellectual property rights with patents and copyrights, subsidizing research and development, and subsidizing education.

11.3

Economic Growth in the United States (pages 345–348)

Learning Objective: Discuss fluctuations in productivity growth in the United States.

Economic growth rates in the United States have varied over time. From 1950 to 1972, real GDP per hour worked grew at an annual rate of 2.6 percent. Growth then slowed to 1.3 percent per year during the period from 1974 until 1995. This slowdown in productivity growth is usually linked to measurement problems caused by the increase in the service sector of the economy and difficulties measuring increases in safety and environmental improvements, the rapid increase in oil prices, and the mismatch of worker skills with the increase in the number of jobs requiring greater technical training. Growth rates since 1996 have increased, partly due to the use of computers and information technology in the workplace. From 2006 to 2012, productivity growth, measured by changes in real GDP per hour worked, fell back to the level as during the period of slow growth from the mid-1970s to the mid-1990s. However, some economists believe that developments in information technology have resulted in unmeasured benefits to the economy, so that measured growth rates in recent years have understated the actual growth of the economy.

Study Hint

Remember, as we saw in Chapter 10, the financial system is where the funds of savers are loaned to borrowers. This process allows loanable funds to flow from households to firms that use the funds for new investment projects.

Extra Solved Problem 11.3

Output and Productivity Growth Rates

Supports Learning Objective 11.3: Discuss fluctuations in productivity growth in the United States.

The Bureau of Labor Statistics collects data on U.S. productivity. The table below lists an index of total manufacturing output and an index of nonfarm business output per hour worked, which is a measure of productivity in the business sector. The base year for both indexes is 2009, meaning that the level of business output and business output per hour worked for 2009 are both set equal to 100. A value of 106.3 (as in business output for 2010) indicates that the value of output in 2010 was 6.3 percent higher than the value of output in 2009. Calculate the average annual growth rate in output and in output per hour worked for this period from 2003 to 2012. Are the growth rates for the two indexes the same? If they are different, what are the implications of the difference?

Year	Index of business output	Index of business output per hour worked	
2003	109.9	89.3	
2004	111.9	92.1	
2005	115.9	94.0	
2006	117.8	94.6	
2007	120.3	96.0	
2008	114.8	96.9	
2009	100.0	100.0	
2010	106.3	103.3	
2011	109.5	103.8	
2012	114.1	105.3	

Solving the Problem

Step 1: Review the chapter material.

This problem is about growth in productivity, so you may want to review the section "Economic Growth in the United States," which begins on page 345 in the textbook.

Step 2: Calculate the growth rates.

You can calculate the growth rates using the following equation:

Growth rate in 2010=
$$\frac{\text{Value in } 2012 - \text{Value in } 2009}{\text{Value in } 2009} \times 100$$

Using this formula for both columns of data gives us:

Year	Index of business output	Growth rate of business output	Index of business output per hour worked	Growth rate of business output per hour worked
2003	109.9	- ,	89.3	-
2004	111.9	1.7%	92.1	3.1%
2005	115.9	3.6%	94.0	2.0%
2006	11 <i>7.</i> 8	1.6%	94.6	0.7%
2007	120.3	2.1%	96.0	1.4%
2008	114.8	-4.5%	96.9	1.0%
2009	100.0	-12.9%	100.0	3.2%
2010	106.3	6.3%	103.3	3.3%
2011	109.5	3.1%	103.8	0.5%
2012	114.1	4.1%	105.3	1.5%
Average annual growth rate, 2003–2012		0.6%		1.9%

Step 3: Discuss why the growth rates are different.

The average annual growth rate in business output is 0.6 percent, while the average annual growth in business output per worker is 1.9 percent. How is it possible for output growth to be much lower than growth in output per hour? This can happen if the number of hours worked in the business sector decreased while total output increased during this period.

11.4

Why Isn't the Whole World Rich? (pages 348–357)

Learning Objective: Explain economic catch-up and discuss why many poor countries have not experienced rapid economic growth.

The economic growth model tells us that economies grow when the quantity of capital per hour worked increases and when technological change takes place. Growth in capital and technology will have their biggest payoffs in poorer economies. This suggests that poorer countries should grow faster than rich countries. The prediction that poorer countries should grow faster than rich countries is called **catch-up** or convergence. The growth data suggests that convergence applies to some, but not all, countries. Economists have suggested several reasons why a number of low-income countries have not experienced rapid growth.

- a legal system that does not enforce contracts and protect property rights or country has not established the "rule of law"
- wars and revolutions
- poor public education and health
- low levels of saving and investment

Globalization, the process of countries becoming more open to foreign trade and investment, can help poorer countries that have low levels of domestic saving and investment and that lack access to the latest technologies. Foreign direct investment (FDI) occurs when firms build or purchase facilities in foreign countries. This inflow of capital can help speed development. Foreign portfolio investment occurs when individuals buy stock or bonds issued in other countries. This access to new capital can also speed growth. The process of globalization can help countries deal with the problem of low saving and investment.

Study Hint

While the catch-up effect has occurred among high-income countries, much of the world hasn't been catching up. *Making the Connection* "What Do Parking Tickets in New York City Tell Us about Poverty in the Developing World?" explains that poor countries tend have a more corrupt government, and the level of corruption is reflected in the number of parking violations per official delegate in New York City.

11.5

Growth Policies (pages 357-360)

Learning Objective: Discuss government policies that foster economic growth.

Governments can do many things to help promote long-run economic growth. Policies that help enforce property rights and reduce corruption will encourage investment and contribute to economic growth. Policies that support health and education lead to increases in productivity and higher levels of growth. Policies that encourage technological innovation, such as subsidizing research and development or encouraging direct foreign investment, will also increase growth. Policies that encourage saving generate more funds for financing investment and will also encourage growth.

Study Hint

It is much easier to talk about the government policies that aid economic growth than actually implementing them. *Making the Connection* "Will China's Standard of Living Ever Exceed That of the United States?" explains that GDP per capita in the United States was more than six times higher than GDP per capita in China, but if the recent growth rates of these countries were to continue, then China's standard of living would exceed the U.S. in the year 2037. However, there are several reasons that China would not maintain high rates of productivity growth in the future.

Extra Solved Problem 11.5

Investment Tax Credits

Supports Learning Objective 11.5: Discuss government policies that foster economic growth.

The government can increase the incentive for firms to acquire physical capital through investment tax credits. An investment tax credit allows firms to deduct from their taxes some fraction of the funds they have spent on investment goods. The reduction in the taxes that firms pay increases their after-tax profits, and thereby increases their incentive to invest in new factories, offices, and machines. There are two ways that an investment tax credit can affect growth in the economy. Use separate per-worker production function graphs to illustrate each way the investment tax credit can affect economic growth.

Solving the Problem

Step 1: Review the chapter material.

This problem is about government policies to foster economic growth, so you may want to review the section "Policies that Promote Saving and Investment," which begins on page 359 in the textbook.

Step 2: Draw two per-worker production function graphs to illustrate the effects of the investment tax credit.

As firms increase investment spending as a result of the investment tax credit, the capital stock will also increase. If the new capital has the same technology as the existing capital stock, then the level of technology will not change. In this case, the new capital will increase the ratio of capital to labor and cause a movement along the per-worker production function. You can illustrate this with the graph below as a movement from point A to point B.

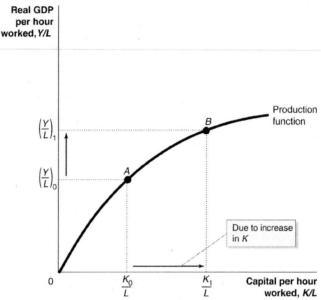

Notice that at point B, the increases in capital as a result of the new investment will result in more production as real GDP per hour worked increases.

If the new capital causes a change in the level of technology, then the new capital will also cause the production function to shift upward. So, the investment tax credit will cause both a movement along the per-worker production function and an upward shift as the level of technology changes. This is shown in the graph below as a movement from point A to point B:

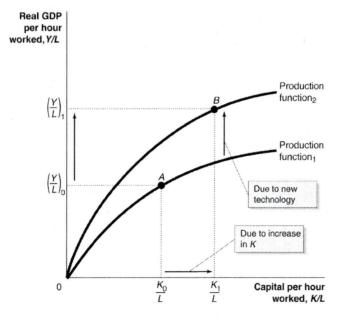

©2015 Pearson Education, Inc.

Key Terms

Catch-up The prediction that the level of GDP per capita (or income per capita) in poor countries will grow faster than in rich countries.

Economic growth model A model that explains growth rates in real GDP per capita over the long run.

Foreign direct investment (FDI) The purchase or building by a corporation of a facility in a foreign country.

Foreign portfolio investment The purchase by an individual or a firm of stocks or bonds issued in another country.

Globalization The process of countries becoming more open to foreign trade and investment.

Human capital The accumulated knowledge and skills that workers acquire from education and training or from their life experiences.

Industrial Revolution The application of mechanical power to the production of goods, beginning in England around 1750.

Labor productivity The quantity of goods and services that can be produced by one worker or by one hour of work.

New growth theory A model of long-run economic growth that emphasizes that technological change is influenced by economic incentives and so is determined by the working of the market system.

Patent The exclusive right to produce a product for a period of 20 years from the date the patent is applied for.

Per-worker production function The relationship between real GDP per hour worked and capital per hour worked, holding the level of technology constant.

Property rights The rights individuals or firms have to the exclusive use of their property, including the right to buy or sell it.

Rule of law The ability of a government to enforce the laws of the country, particularly with respect to protecting private property and enforcing contracts.

Technological change A change in the quantity of output a firm can produce using a given quantity of inputs.

Self-Test

(Answers are provided at the end of the Self-Test.)

Multiple-Choice Questions

- 1. What is the best measure we have of a country's standard of living?
 - a. the unemployment rate
 - b. nominal GDP per capita
 - c. real GDP per capita
 - d. the consumer price index

- 2. Which of the following marks the beginning of significant economic growth in the world economy?
 - a. the economic reform in China beginning in 1978
 - b. the American Revolution of 1776
 - c. the Industrial Revolution in England
 - d. the Bolshevik Revolution
- 3. Which of these institutional changes gave entrepreneurs the incentive to make the investments necessary for technological development in the second half of the eighteenth century in England?
 - a. upholding private property rights
 - b. protecting wealth
 - c. eliminating arbitrary increases in taxes
 - d. all of the above
- 4. The process known as compounding does which of the following?
 - a. It minimizes the differences in interest rates or growth rates over short periods of time.
 - b. It magnifies even small differences in interest rates or growth rates over long periods of time.
 - c. It highlights the social characteristics necessary for economic growth to occur.
 - d. It magnifies the importance of the effect of inflation on increases in the standard of living of the typical person.
- 5. In the 1980s and 1990s, a small group of countries experienced high rates of growth. These countries are sometimes referred to as the newly industrializing countries. Where are they located?
 - a. in East Asia
 - b. in Africa
 - c. in Latin America
 - d. in Western Europe
- 6. What does the economic growth model explain?
 - a. trends in labor productivity
 - b. changes in real GDP per capita in the long run
 - c. how the interaction of inflation and unemployment accounts for most economic growth
 - d. why economic fluctuations and the business cycle occur
- 7. Which of the following are the two key factors that determine labor productivity?
 - a. economic growth and real GDP per capita
 - b. the amount of land and capital available in a country
 - c. government policies that promote household consumption
 - d. the quantity of capital per hour worked and the level of technology
- 8. Better machinery and equipment, increases in human capital, and better means of organizing and managing production are the three main sources of
 - a. rising unemployment.
 - b. increases in capital per hour worked.
 - c. technological change.
 - d. increases in inflation.

- 9. The accumulated knowledge and skills that workers acquire from education, training, and their life experiences are called
 - a. labor productivity.
 - b. technical knowledge.
 - c. physical capital.
 - d. human capital.
- 10. What is the name given to the relationship between real GDP per hour worked and capital per hour worked, holding the level of technology constant?
 - a. the output growth function
 - b. the capital-labor function
 - c. the per-worker production function
 - d. the production possibilities frontier
- 11. Along the per-worker production function, what happens to real GDP per hour worked as capital per hour worked increases?
 - a. Real GDP per hour worked increases at an increasing rate.
 - b. Real GDP per hour worked increases at a decreasing rate.
 - c. Real GDP per hour worked decreases at an increasing rate.
 - d. Real GDP per hour worked decreases at a decreasing rate.
- 12. The law of diminishing returns states that as we add more of one input to a fixed quantity of another input, output increases by smaller additional amounts. In the case of the per-worker production function, which input is the fixed input, and which one is the variable input?
 - a. Capital is the fixed input, and labor is the variable input.
 - b. Capital is the variable input, and labor is the fixed input.
 - c. Capital is the variable input, and real GDP is the fixed input.
 - d. Real GDP is the variable input, and capital is the fixed input.
- 13. The per-worker production function exhibits
 - a. diminishing returns to labor.
 - b. diminishing returns to capital.
 - c. diminishing returns to real GDP per capita.
 - d. all of the above.
- 14. The per-worker production function
 - a. shows that equal increases in capital per worker cause equal increases in output per hour worked.
 - b. shifts up with increases in labor hours worked.
 - c. shifts up with increases in technology.
 - d. shifts up with increases in capital at a given level of technology.
- 15. A movement along the per-worker production function is not caused by an increase in
 - a. technology.
 - b. capital at a given level of technology.
 - c. hours worked per worker.
 - d. the number of workers.

- 16. What is the impact of technological change on the per-worker production function?
 - a. As technological change occurs, the economy moves from one point to another along the perworker production function.
 - b. Technological change shifts the per-worker production function up.
 - c. Technological change does not affect the per-worker production function.
 - d. Technological change may or may not affect the per worker production function depending on how it affects the quantity of capital per worker.
- 17. In the long run, a country will experience an increasing standard of living only if
 - a. the country's labor force increases.
 - b. the country's capital stock increases.
 - c. the country experiences continuing technological change.
 - d. all of the above occur.
- 18. In which economies is there a greater incentive for technological change?
 - a. in centrally planned economies
 - b. in market economies
 - c. in countries with high inflation rates
 - d. in countries that lack patent laws
- 19. Which of the following is known as the new growth theory?
 - a. a growth model that focuses on growth in the ratio of capital to labor as the key factor in explaining long-run growth in real GDP per capita
 - b. the economic growth model that was first developed in the 1950s by Robert Solow, an economist at MIT and winner of the Nobel Prize in Economics
 - c. a model of long-run economic growth that emphasizes that technological change is influenced by economic incentives
 - d. a model of long-run economic growth that emphasizes that increases in technology are difficult to explain
- 20. When are additions of knowledge capital subject to diminishing returns?
 - a. when they are made at the firm level
 - b. when they apply to the economy as a whole
 - c. when those additions don't contribute to economic growth
 - d. when the additions are due to improved education for workers
- 21. Which of the following is not a government policy that will increase the accumulation of knowledge capital?
 - a. encouraging the growth of labor unions
 - b. subsidizing research and development
 - c. protecting intellectual property with patents and copyrights
 - d. subsidizing education
- 22. Which of the following is nonrival and nonexcludable?
 - a. labor hired by a firm
 - b. a prescription drug purchased by a consumer
 - c. the use of physical capital
 - d. the use of knowledge capital that is not protected by a patent or copyright

- 23. In which case are firms more likely to try to be free riders?
 - a. in using physical capital owned by other firms
 - b. in using labor hired by other firms
 - c. in using the research and development of other firms
 - d. in paying taxes
- 24. How can government policy help increase the accumulation of knowledge capital and bring it closer to the optimal level?
 - a. by protecting intellectual property with patents and copyrights
 - b. by subsidizing research and development
 - c. by subsidizing education
 - d. all of the above
- 25. According to Joseph Schumpeter, which of the following provides the most important incentive for bringing the factors of production together to start new firms and to introduce new goods and services?
 - a. the accumulation of knowledge capital
 - b. government policies that help to increase the accumulation of physical capital
 - c. the profits entrepreneurs hope to earn
 - d. the existence of export markets
- 26. Which of the following periods in U.S. economic history had the slowest growth rate, as measured by the average annual increase in real GDP per hour worked?
 - a. 1900-1950
 - b. 1950-1973
 - c. 1974-1995
 - d. 1996-2012
- 27. Which of the following are explanations that have been offered for the productivity slowdown of the mid-1970s to mid-1990s?
 - a. measurement problems
 - b. high oil prices
 - c. a decline in labor quality
 - d. all of the above
- 28. According to economists, a major factor in the faster growth in productivity beginning in the mid-1990s was
 - a. the fact that services, such as haircuts and financial advice, became a larger fraction of GDP and goods.
 - b. oil price increases.
 - c. the increasing skill and training of workers.
 - d. the development of a "new economy" based on information technology.
- 29. Some economists argue that that the "new economy" has led to an increase in U.S. productivity growth since 1996. What caused the development of the "new economy"?
 - a. advances in information technology
 - b. increases in foreign direct investment
 - c. globalization of the world economy
 - d. rapid growth among developing countries

- a. richer countries will grow faster than poorer countries.
- b. poorer countries will grow faster than richer countries.
- c. richer and poorer countries will have the same growth rates.
- d. there is no consistent relationship between the level of per capita GDP and economic growth.
- 31. In the United States, what is a key source of funds for start-up firms bringing new technologies to market?
 - a. loans from commercial banks and other financial institutions
 - b. the sale of stock
 - c. the sale of bonds
 - d. funding from venture capital firms
- 32. Catch-up, or convergence, is the prediction that the level of GDP per capita (or income per person) in poor countries will grow
 - a. faster than in rich countries.
 - b. slower than in rich countries.
 - c. at the same pace as the growth in rich countries.
 - d. at the same rate as the growth rate of capital per hour worked.
- 33. Which of the following statements about catch-up is correct?
 - a. The lower-income industrial countries have been catching up to the higher-income industrial countries.
 - b. The developing countries as a group have been catching up to the industrial countries as a group.
 - c. both a. and b.
 - d. neither a. nor b.
- 34. Along the downward-sloping catch-up line, a country near the top of the line is
 - a. a rich country growing slowly.
 - b. a rich country growing rapidly.
 - c. a poor country growing rapidly.
 - d. a poor country growing slowly.
- 35. Why do many low-income countries have low growth rates?
 - a. because of the failure of governments to enforce the rule of law
 - b. because of wars and revolutions
 - c. because of poor public education and health
 - d. All of the above are reasons why some low-income countries have low growth rates.
- 36. Which countries grow faster?
 - a. countries that have a strong rule of law, such as the Czech Republic, Tunisia, and Israel
 - b. countries that have a weak rule of law, such as Haiti and Albania
 - c. countries that rely on a common law system rather than on a civil law system
 - d. None of the above. There is no relationship between the rule of law and economic growth.
- 37. In the vicious cycle of poverty,
 - a. households have low incomes.
 - b. households save very little.
 - c. few funds are available for businesses to borrow.
 - d. all of the above are true.

- 38. What is the name given to the purchase or building of a facility by a corporation in a foreign country?
 - a. foreign portfolio investment
 - b. foreign diversification investment
 - c. foreign financial investment
 - d. foreign direct investment
- 39. What is the name given to the purchase of stocks or bonds issued in a foreign country?
 - a. foreign portfolio investment
 - b. foreign diversification investment
 - c. foreign physical investment
 - d. foreign direct investment
- 40. Which countries have experienced faster economic growth?
 - a. countries that have been generally more open to foreign trade and investment
 - b. countries that have relied less on foreign trade and more on their own internal sources of saving and investment
 - c. countries that focused on job preservation
 - d. countries that avoided globalization
- 41. The migration of highly educated and successful individuals from developing countries to high-income countries is called
 - a. the human portfolio drain.
 - b. the brain drain.
 - c. the intelligent exodus.
 - d. intellectual outsourcing.
- 42. One of the lessons from the economic growth model presented in this chapter is that
 - a. technological change is more important than increases in physical capital in explaining long-run growth.
 - b. technological change is less important than increases in physical capital in explaining long-run growth.
 - c. technological change is equally important to increases in physical capital in explaining long-run growth.
 - d. technological change is only possible in countries that have already attained a high level of real GDP per capita.
- 43. Investment tax credits allow
 - a. firms to deduct from their taxes some fraction of the funds they have spent on investment.
 - b. households to save for retirement by placing funds in 401(k) or 403(b) plans or in Individual Retirement Accounts (IRAs).
 - c. firms to deduct from their taxes part of the wages they pay workers.
 - d. the government to raise a larger amount of revenue from households.
- 44. As a generalization, who is opposed to economic growth?
 - a. very few people, because economic growth is good for everyone, regardless of income
 - b. some people who think that, at least in the high-income countries, further economic growth is not desirable
 - c. many people who think that economic growth in low-income countries is undesirable
 - d. most politicians in developing countries

- 45. Which of the following are assertions made by opponents of globalization?
 - a. Globalization has undermined the distinctive cultures of many countries.
 - b. Globalization has contributed to multinational firms moving production to low-income countries to avoid safety and environmental regulations that such firms would be required to follow in high-income countries.
 - c. Economic growth and globalization may be contributing to global warming, deforestation, and other environmental problems.
 - d. All of the above are assertions made by opponents of globalization.

01	A	<u> </u>
Short	Ancwar	Questions
SHOLL	WII2 MEI	CACCOLOLIS

	Explain the effect on the per-worker production function of an increase in capital per hour worked. Now explain the effect of technological change.				
	What happened to the economy of the former Soviet Union? What does the experience of the Soviet economy teach us about the nature of long-run economic growth?				
What is "catch-up"? Why would we expect catch-up to occur? Has it occurred?					

282 CHAPTER 11 Long-Run Economic Growth: Sources and Policies

5.	The "brain drain" refers to highly educated and successful individuals leaving developing countries for high-income countries, such as the United States. How does the brain drain affect growth rates in the developing countries that experience it?				

True/False Questions

- T F 1. Over time, economic growth rates have not significantly changed.
- T F 2. The Industrial Revolution began in Japan during the seventeenth century.
- T F 3. Small differences in growth rates cause significant differences in living standards in the long
- T F 4. Over the past 20 years, most other high-income countries have caught up to the United States in GDP per capita, and some of them have even surpassed the United States.
- T F 5. Real GDP per capita for the United States grew from \$35,495 in 2003 to \$38,636 in 2012. This is an average annual growth rate of approximately 9 percent.
- T F 6. The new growth theory explains long-run economic growth through increases in the amounts of labor growth and capital accumulation.
- T F 7. An increase in capital per hour worked will shift up the per-worker production function.
- T F 8. Diminishing returns to capital mean that as we add more capital to a fixed amount of labor, increases in output will become smaller and smaller.
- T F 9. In the long run, a country will experience rising living standards only if it experiences continuing technological change.
- T F 10. Paul Romer argues that knowledge capital is subject to increasing returns, unlike physical capital.
- T F 11. A patent gives its owner the exclusive right to produce a good for two years.
- T F 12. During the years 2006 to 2012, labor productivity increased at a much faster rate than during the previous 20 years.
- T F 13. The catch-up hypothesis suggests that countries with lower levels of real GDP per capita will grow more slowly than countries with higher levels of real GDP per capita.
- T F 14. Countries that fail to protect property rights grow at slower rates than countries that succeed in protecting property rights.
- T F 15. In the 1990s, there was no difference between the growth rates of more globalized and less globalized countries.

Answers to the Self-Test

Multiple-Choice Questions

Question	Answer	Comment
1.	С	Real GDP per capita is the best measure we have of a country's standard of living because GDP measures a country's total income. Economic growth occurs when real GDP per capita increases.
2.	c	Significant economic growth did not begin until the Industrial Revolution, which started in England around the year 1750.
3.	d	Upholding private property rights, protecting wealth, and eliminating arbitrary increases in taxes were the institutional changes that gave entrepreneurs the incentive to make the investments necessary to use the important technological developments of the second half of the eighteenth century. Most economists accept the idea that economic growth is not likely to occur unless a country's government provides the right type of institutional framework.
4.	b	Compounding magnifies even small differences in interest rates or growth rates over long periods of time. The important point to keep in mind is that in the long run, small differences in economic growth rates result in big differences in living standards.
5.	a	In the 1980s and 1990s, a small group of countries, mostly East Asian countries such as South Korea, Taiwan, and Singapore, experienced high rates of growth and are sometimes referred to as the newly industrializing countries.
6.	Ь	An economic growth model is a model that explains changes in real GDP per capita in the long run.
7.	d	Economists believe two key factors determine labor productivity: the quantity of capital per hour worked and the level of technology. Therefore, the economic growth model will focus on technological change and changes over time in the quantity of capital per hour worked in explaining changes in real GDP per capita.
8.	С	Among the sources of technological change are: better machinery and equipment, increases in human capital, and better means of organizing and managing production.
9.	d	Human capital is defined as the accumulated knowledge and skills that workers acquire from education, training, and their life experiences. As workers increase their human capital through education or on-the-job training, their productivity also increases. The more educated workers are, the greater their human capital.
10.	c ,	The per-worker production function is the relationship between real GDP (output) per hour worked and capital per hour worked, holding the level of technology constant. Using the per-worker production function, we explored the effects of increases in the amount of capital per hour worked and technological change on economic growth.
11.	b	Holding technology constant, equal increases in the amount of capital per hour worked lead to diminishing increases in output per hour worked.
12.	b	As it applies to the per-worker production function, the law of diminishing returns states that as we add more of one input—in this case, capital—to a fixed quantity of another input—in this case, labor—output increases by smaller additional amounts.

Question	Answer	Comment
13.	b	An increase in capital per hour worked increases real GDP per hour worked, but each additional increase in capital per hour worked results in progressively smaller increases in output per hour worked.
14.	c	In a per worker production function, changes in capital and labor cause movements along the curve, while changes in technology cause the curve to shift.
15.	a	In a per worker production function, changes in capital and labor cause movements along the curve, while changes in technology cause the curve to shift.
16.	b	Technological change shifts the per-worker production function up and allows an economy to produce more real GDP per hour worked with the same quantity of capital per hour worked.
17.	c	Because of diminishing returns to capital, continuing increases in real GDP per hour worked cannot occur by simply increasing capital. It can only occur if there is technological change. Remember that a country will experience increases in its standard of living only if it experiences increases in real GDP per hour worked. If the labor force increases the country will be able to produce more, but it will have more mouths to feed. Unless the new workers can be more productive than existing workers, they will not increase the standard of living.
18.	b	The drive for profit provides an incentive for technological change that centrally planned economies are unable to duplicate. In market economies, decisions on which investments to make and which technologies to adopt are made by entrepreneurs and managers with their own money on the line.
19.	С	The new growth theory is a model of long-run economic growth that emphasizes that technological change is influenced by economic incentives and so is determined by the working of the market system.
20.	а	We have seen that accumulation of physical capital is subject to diminishing returns: increases in capital per hour worked lead to increases in real GDP per hour worked, but at a decreasing rate. Paul Romer argues that the same is true of knowledge capital at the firm level. As firms add to their stock of knowledge capital, they will increase their output but at a decreasing rate. At the level of the economy, however, Romer argues that knowledge capital is subject to increasing returns. This is true because, once discovered, knowledge becomes available to everyone.
21.	a	Labor unions do not have a role in the accumulation of knowledge capital and government policy.
22.	d	The use of physical capital is rival because if one firm uses it, other firms can't, and excludable because the firm that owns the capital can keep other firms from using it. The use of knowledge capital is nonrival because one firm's use of this knowledge does not interfere with another firm's use of it. Knowledge capital is also nonexcludable because once something like a chemical formula becomes known, it becomes widely available for other firms to use.
23.	С	Because knowledge capital is nonrival and nonexcludable, firms will attempt to free ride on the research and development of other firms. Firms take a free ride when they benefit from the results of research and development they did not pay for. (Patent law and other legal restrictions on the use of intellectual property can discourage this free riding.)

Question	Answer	Comment
37.	d	The low savings rates in developing countries contribute to a <i>vicious cycle</i> of poverty. Because households have low incomes, they save very little. Because households save very little, few funds are available for businesses to borrow. Lacking funds, businesses do not invest in the new factories, machinery, and equipment needed for economic growth. Because the economy does not grow, household incomes remain low, as do their savings, and so on.
38.	d	Foreign direct investment (FDI) is defined as corporations building or purchasing facilities in foreign countries. When an individual or firm buys stock or bonds issued in another country, they are engaging in foreign portfolio investment.
39.	a	Foreign portfolio investment is defined as an individual or firm purchasing stocks or bonds issued in a foreign country. When a firm builds or purchases facilities in a foreign country, it is engaging in foreign direct investment.
40.	a	Countries that were more open to foreign trade and investment grew much faster during the 1990s than countries that were less open.
41.	b	The rising incomes that result from economic growth can help developing countries deal with the brain drain. The brain drain refers to highly educated and successful individuals leaving developing countries for high-income countries.
42.	a	Technological change is more important than increases in capital in explaining long-run growth because increases in capital hit diminishing marginal returns, whereas technological progress is unlimited. For low-income countries, access to existing technologies is of paramount importance.
43.	a	Investment tax credits allow firms to deduct from their taxes some fraction of the funds they have spent on investment.
44.	b	It seems undeniable that increasing the growth rates of very low-income countries would help relieve the daily suffering that many people in these countries must endure. But some people are convinced that, at least in the high-income countries, further economic growth is not desirable.
45.	d	Some people believe that globalization has undermined the distinctive cultures of many countries, as imports of food, clothing, movies, and other goods displace domestically produced goods. We have seen that allowing foreign direct investment is an important way in which low-income countries can gain access to the latest technology. Some people, however, see multinational firms that locate in low-income countries as paying very low wages and as failing to follow the same safety and environmental regulations they are required to follow in the high-income countries. Also, some people blame economic growth for deforestation, global warming, and other environmental problems.

Short Answer Responses

Due to the effects of compounding, small differences in growth rates when maintained for many years
can lead to very large differences in real GDP per capita. The standard of living in the United States
and other high-income countries is much higher than the standard of living in developing countries
because the high-income countries have experienced higher growth rates than the developing
countries.

2. Using the graph below, an increase in the capital stock will cause a movement along the per-worker production function. This is a movement from point A to point B. Technological change will allow the economy to produce more with the same amount of inputs (same amount of capital per hour worked). This is a shift in the per-worker production function and a movement from point B to point C.

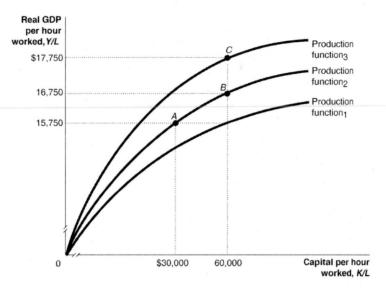

- 3. The Soviet economy eventually experienced very low growth rates. Although the Soviet Union was successful in increasing levels of capital per hour worked, it was unsuccessful in implementing continuing technological change. The experience of the Soviet economy shows that because of diminishing returns to capital, economic growth will persist in the long run only if an economy experiences technological change.
- 4. Catch-up—also known as convergence—is the prediction of the economic growth model that poor countries will grow faster than rich countries. The profitability of using additional capital or better technology is generally greater in a developing country than in a high-income country. Therefore, we would expect that developing countries would experience more rapid growth in capital per hour worked and would adopt the best technology, which would cause them to experience rapid rates of economic growth and to catch-up with the high-income countries. Among the countries that currently have high incomes, catch-up has occurred. But the developing countries as a group are not catching up with the high-income countries as a group.
- The brain drain will cause a country to lose those individuals who can help implement and create technological change. Slower technological change means smaller upward shifts in the per-worker production function and slower rates of economic growth.

True/False Answers

Question	Answer	Comment
1.	F	See textbook Figure 11.1.
2.	F	The Industrial Revolution began in England during the eighteenth century.
3.	T	Because of compounding, small differences in growth rates cause significant differences in living standards over time.
4.	F	See textbook Figure 11.9.

Question	Answer	Comment
5.	F	Nine percent is the total percentage change rather than the average annual growth rate.
6.	F	The new growth theory emphasizes economic incentives that drive technological change.
7.	F	An increase in capital per hour worked results in a movement along the per- worker production function.
8.	T	See page 344 in the textbook for the meaning of diminishing returns.
9.	T	See page 342 in the textbook for the role of technological change on living standards.
10.	T	See page 344 in the textbook the nature of knowledge capital.
11.	F	The life of a patent is 20 years.
12.	F	Between 2006 and 2012, productivity growth fell to an average of 1.2 percent, which was near the level during the period of slow growth between the mid-1970s and mid-1990s.
13.	F	Catch-up holds that countries with lower levels of real GDP per capita will have faster growth rates.
14.	T	See pages 357 and 358 in the textbook about the importance of property rights on economic growth.
15.	F	More globalized countries grew much faster than less globalized countries.

CHAPTER 12 | Aggregate Expenditure and Output in the **Short Run**

Chapter Summary and Learning Objectives

The Aggregate Expenditure Model (pages 372-375) 12.1

Understand how macroeconomic equilibrium is determined in the aggregate expenditure model. Aggregate expenditure (AE) is the total amount of spending in the economy. The aggregate expenditure model focuses on the relationship between total spending and real GDP in the short run, assuming that the price level is constant. In any particular year, the level of GDP is determined by the level of total spending, or aggregate expenditure, in the economy. The four components of aggregate expenditure are consumption (C), planned investment (I), government purchases (G), and net exports (NX). When aggregate expenditure is greater than GDP, there is an unplanned decrease in inventories. which are goods that have been produced but not yet sold, and GDP and total employment will increase. When aggregate expenditure is less than GDP, there is an unplanned increase in inventories, and GDP and total employment will decline. When aggregate expenditure is equal to GDP, firms will sell what they expected to sell, production and employment will be unchanged, and the economy will be in macroeconomic equilibrium.

Determining the Level of Aggregate Expenditure in the Economy (pages 375–387) 12.2

Discuss the determinants of the four components of aggregate expenditure and define marginal propensity to consume and marginal propensity to save. The five determinants of consumption are current disposable income, household wealth, expected future income, the price level, and the interest rate. The consumption function is the relationship between consumption and disposable income. The marginal propensity to consume (MPC) is the change in consumption divided by the change in disposable income. The marginal propensity to save (MPS) is the change in saving divided by the change in disposable income. The determinants of planned investment are expectations of future profitability, real interest rate, taxes, and cash flow, which is the difference between the cash revenues received by a firm and the cash spent by the firm. Government purchases include spending by the federal government and by local and state governments for goods and services. Government purchases do not include transfer payments, such as Social Security payments by the federal government or pension payments by local governments to retired police officers and firefighters. The three determinants of net exports are the price level in the United States relative to the price levels in other countries, the growth rate of GDP in the United States relative to the growth rates of GDP in other countries, and the exchange rate between the dollar and other currencies.

Graphing Macroeconomic Equilibrium (pages 387–394) 12.3

Use a 45°-line diagram to illustrate macroeconomic equilibrium. The 45°-line diagram shows all the points where aggregate expenditure equals real GDP. On the 45°-line diagram, macroeconomic equilibrium occurs where the line representing the aggregate expenditure function crosses the 45° line. The economy is in recession when the aggregate expenditure line intersects the 45° line at a level of GDP that is below potential GDP. Numerically, macroeconomic equilibrium occurs when:

Consumption + Planned Investment + Government Purchases + Net Exports = GDP.

12.4 The Multiplier Effect (pages 394–401)

Describe the multiplier effect and use the multiplier formula to calculate changes in equilibrium GDP. Autonomous expenditure is expenditure that does not depend on the level of GDP. An autonomous change is a change in expenditure not caused by a change in income. An induced change is a change in aggregate expenditure caused by a change in income. An autonomous change in expenditure will cause rounds of induced changes in expenditure. Therefore, an autonomous change in expenditure will have a multiplier effect on equilibrium GDP. The **multiplier effect** is the process by which an increase in autonomous expenditure leads to a larger increase in real GDP. The **multiplier** is the ratio of the change in equilibrium GDP to the change in autonomous expenditure. The formula for the multiplier is: 1/(1 - MPC).

Because of the paradox of thrift, an attempt by many individuals to increase their saving may lead to a reduction in aggregate expenditure and a recession.

12.5 The Aggregate Demand Curve (pages 401–403)

Understand the relationship between the aggregate demand curve and aggregate expenditure. Increases in the price level cause a reduction in consumption, investment, and net exports. This causes the aggregate expenditure function to shift down on the 45°-line diagram, leading to a lower equilibrium real GDP. A decrease in the price level leads to a higher equilibrium real GDP. The aggregate demand curve shows the relationship between the price level and the level of aggregate expenditure, holding constant all factors other than the price level that affect aggregate expenditure.

Appendix: The Algebra of Macroeconomic Equilibrium (pages 410-411)

Apply the algebra of macroeconomic equilibrium. The chapter relies on graphs and tables to illustrate the aggregate expenditure model of short-run real GDP. The appendix uses equations to represent the aggregate expenditure model. Your instructor may cover or assign this appendix.

Chapter Review

Chapter Opener: Fluctuating Demand Helps—and Hurts—Intel and Other Firms (page 371)

Intel is the world's largest semiconductor manufacturer and a major supplier of the microprocessors and memory chips found in most personal computers. But because of its dependence on computer sales, Intel is vulnerable to the swings of the business cycle. Intel was hurt by the 2007–2009 recession. During the last quarter of 2008, its revenues fell 90 percent, and it made plans to lay off 6,000 workers. Many other firms in the United States were also cutting production and employment as a result of a decline in the total amount of spending, or *aggregate expenditure*, in the economy. As the U.S. economy recovered from the recession, Intel bounced back with increased demand for computers and technology-based parts.

12.1

The Aggregate Expenditure Model (pages 372–375)

Learning Objective: Understand how macroeconomic equilibrium is determined in the aggregate expenditure model.

The **aggregate expenditure model** explains many aspects of business cycles. This model looks at the relationship in the short run between total planned spending and real GDP. An important assumption of the model is that the price level is constant. The main idea behind the aggregate expenditure model is that real GDP is determined mostly by aggregate expenditure. We define **aggregate expenditure** (AE) as:

Aggregate expenditure = Consumption + Planned Investment + Government Purchases + Net Exports

where:

- Consumption (C): Spending by households on goods and services, such as automobiles and haircuts.
- Planned Investment (I): Spending by businesses on capital goods, such as factories, office buildings, and machine tools, and spending by households on new homes.

Study Hint

Remember that investment expenditure includes the purchase of plant and equipment by firms, residential construction, and any changes in business inventories. Planned investment includes only planned inventory changes. Unanticipated or unplanned changes in business inventories are called unplanned investment.

- Government Purchases (G): Spending by local, state, and federal governments on goods and services. such as aircraft carriers, bridges, and the salaries of FBI agents.
- Net Exports (NX): Spending by foreign businesses and households on goods and services produced in the United States minus spending by U.S. businesses and households on goods and services produced in all other countries.

In equation form:

$$AE = C + I + G + NX$$

Planned investment in the AE function may differ from the actual level of investment. Actual investment will include any unplanned changes in inventories caused by differences between production and sales. If a firm produces \$100 of output and only sells \$80 of that output, the \$20 of output produced but not sold ends up in inventories. This \$20 is included in actual investment but not in planned investment.

For the economy as a whole, equilibrium occurs when aggregate expenditure equals total production or

$$AE = \text{real GDP}.$$

In this model, equilibrium real GDP will not change unless aggregate expenditure changes.

If AE is less than real GDP, firms are producing more output than is being purchased, and there will be an unplanned increase in inventories. Firms will respond to the increase in inventories by reducing production and employment. If AE is more than production, firms are producing less output than is being purchased. The only way a firm can sell more than it produces is by selling part of its inventory. Firms will respond to this unplanned decrease in inventories by increasing production and employment. In either case, the economy moves toward an equilibrium in which AE = real GDP. The following table—similar to Table 12.1 in the textbook—summarizes the relationship between AE and GDP:

If	Then	And
Aggregate expenditure is Equal to GDP	There is no unplanned inventory change	The economy is in macroeconomic equilibrium.
Aggregate expenditure is Less than GDP	There is an unplanned inventory increase	GDP and employment decrease.
Aggregate expenditure is Greater than GDP	There is an unplanned inventory decrease	GDP and employment increase.

Extra Solved Problem 12.1

Unplanned Investment

Supports Learning Objective 12.1: Understand how macroeconomic equilibrium is determined in the aggregate expenditure model.

To meet any unexpected increases in demand, Whirlpool would like to keep an inventory of 5,000 refrigerators. Whirlpool expects to sell 50,000 refrigerators this month, and so to keep its inventories constant, it manufactured 50,000 refrigerators this month. What will happen to Whirlpool's inventories if it sells only 49,000 refrigerators? What if it sells 52,000 refrigerators?

Solving the Problem

Step 1: Review the chapter material.

This problem is about inventories and unplanned investment, so you may want to review the section "The Difference between Planned Investment and Actual Investment" on page 373 in the textbook.

Step 2: Calculate inventory changes.

Inventories are the goods that firms have produced but have not sold. This could be intentional. For example, Whirlpool wants to keep 5,000 refrigerators on hand to meet unexpected increases in demand. A change in inventories can be planned or unplanned. For example, a firm may not have accurately forecast its sales. Unexpectedly high sales will cause an unplanned decrease in inventories, and unexpectedly low sales will cause an unplanned increase in inventories. The change in inventories is calculated as production minus sales. If this difference is positive, inventories will rise. If the difference is negative, inventories will fall. Given the numbers above,

If production is 50,000 and sales are 49,000, then the change in inventories is 1,000 refrigerators, and the level of inventories will rise to 6,000.

If production is 50,000 and sales are 52,000, the change in inventories is -2,000, and the level of inventories will fall to 3,000.

Determining the Level of Aggregate Expenditure in the Economy (pages 375-387)

Learning Objective: Discuss the determinants of the four components of aggregate expenditure and define the marginal propensity to consume and the marginal propensity to save.

Different variables influence each of the four major parts of aggregate expenditure.

Consumption spending is determined by:

- 1. Current disposable income. Consumption will increase with increases in current disposable
- 2. Household wealth. Consumption will increase with increases in wealth.
- 3. Expected future income. If you expect your income to rise in the future, your consumption will be higher than if you do not expect your income to rise.
- 4. The price level. Consumption will fall with increases in the price level as a higher price level lowers the purchasing power of wealth.
- 5. The interest rate. Consumption will fall with increases in the real interest rate.

Planned investment is determined by:

- 1. Expectations of future profitability. Planned investment spending will increase if firms expect profits to rise in future years.
- 2. The interest rate. Planned investment will fall with increases in the real interest rate.
- 3. Taxes. Planned investment spending will fall with higher taxes.
- 4. Cash flow. Planned investment will increase with higher levels of cash flow caused by increased profits.

Government purchases are determined by:

The president, Congress, and state and local government decision makers.

Net exports are determined by:

- 1. The price level in the United States relative to the price levels in other countries. Net exports will increase if U.S. inflation is less than inflation in other countries. If U.S. prices are rising less than prices in other countries, the foreign currency price of U.S. produced goods will fall compared to the prices of similar goods made in foreign countries. Foreigners will shift their purchases away from domestic production and toward U.S. production, causing exports to rise. Similar logic explains why U.S. imports will fall. An increase in exports and a decrease in imports cause net exports to rise.
- 2. Growth in real GDP relative to other countries. Net exports will fall if U.S. growth rates in real GDP are greater than growth rates in real GDP in other countries. Real GDP is equivalent to real income, so higher real income means greater spending on everything, including imports. If U.S. GDP grows faster than foreign GDP, then U.S. spending will also grow faster than foreign spending. This will increase U.S. imports. U.S. exports will also rise, but our exports are determined by foreign income. Therefore, U.S. imports will rise by more than exports and net exports will fall.
- 3. The exchange rate. Net exports will fall as the value of the U.S. dollar increases relative to other currencies (a dollar appreciation). A dollar appreciation raises the foreign currency price of goods produced in the United States and lowers the domestic price of goods produced in other countries. The impact on net exports is the same as a change in domestic prices compared to foreign prices (but in the opposite direction).

The relationship between current real disposable income (YD) and real consumption spending (C) is called the **consumption function**. An increase in YD causes an increase in C. The change in consumption caused by a change in YD is called the marginal propensity to consume (MPC). Using the Greek letter delta, Δ , to represent "change in":

$$MPC = \frac{\Delta C}{\Delta YD}$$

or.

$$\Delta C = MPC \times \Delta YD$$
.

Real GDP is the same as national income. National income minus net taxes equals disposable income (YD):

$$YD$$
 = National income – Net taxes = Real GDP – Net taxes.

The following table and graph show these relationships. The assumption is that the MPC = 0.75 and net taxes = \$1,000.

National Income or Real GDP (billions of dollars)	Net Taxes (billions of dollars)	Disposable Income (billions of dollars)	Consumption (billions of dollars)	Change in National Income (billions of dollars)	Change in Disposable Income (billions of dollars)
\$1,000	\$1,000	\$0	\$750	\$2,000	\$2,000
3,000	1,000	2,000	2,250	2,000	2,000
5,000	1,000	4,000	3,750	2,000	2,000
7,000	1,000	6,000	5,250	2,000	2,000
9,000	1,000	8,000	6,750	2,000	2,000
11,000	1,000	10,000	8,250	2,000	2,000
13,000	1,000	12,000	9,750	2,000	2,000

If we draw a graph with real consumption spending on the vertical axis and real national income on the horizontal axis, it looks like textbook Figure 12.3.

Consumers can either spend their income, save it, or use it to pay taxes. For the economy as a whole, we can write the following equation relating income (Y), consumption (C), saving (S), and taxes (T):

$$Y = C + S + T$$
.

This equation implies that any change in total income must be equal to the sum of changes in consumption, saving, and taxes:

$$\Delta Y = \Delta C + \Delta S + \Delta T$$
.

If we assume for simplicity that taxes are a constant amount, then $\Delta T = 0$ and

$$\Delta Y = \Delta C + \Delta S$$
.

The marginal propensity to save (MPS) is the amount by which saving increases when disposable income increases. If we divide both sides of the last equation by ΔY , we get an equation that shows the relationship between the marginal propensity to consume and the marginal propensity to save (MPS):

$$\frac{\Delta Y}{\Delta Y} = \frac{\Delta C}{\Delta Y} + \frac{\Delta S}{\Delta Y}$$

or

$$1 = MPC + MPS$$
.

This last equation tells us that when taxes are constant, the marginal propensity to consume plus the marginal propensity to save must always equal 1. They must add up to 1 because part of any increase in income is consumed, and whatever remains must be saved.

Study Hint

The different components of real aggregate expenditure do not fluctuate in the same way over time. Textbook Figure 12.1 shows that consumption follows a smooth upward trend with infrequent interruptions during recessions. Making the Connection "Intel Moves into Tablets and Perceptual Computing" explains that Intel tried to deal with its vulnerability to large fluctuations in sales over the business cycle by developing memory chips for portable consumer electronic devices, such as tablets and smartphones, instead of microprocessors for companies like Apple and Dell. Making the Connection "The iPhone Is Made in China...Or Is It?" explains how trade statistics have become misleading as a result of the reliance of global supply chains in making the iPhone.

Extra Solved Problem 12.2

Calculating the MPC and MPS

Supports Learning Objective 12.2: Discuss the determinants of the four components of aggregate expenditure and define marginal propensity to consume and the marginal propensity to save.

Using the data in the table below, calculate disposable income, the MPC, and the MPS.

Solving the Problem

Step 1: Review the chapter material.

This problem is about calculating the MPC and MPS, so you may want to read the section "Determining the Level of Aggregate Expenditure in the Economy," which begins on page 375 in the textbook.

Real GDP (Y)	Net Taxes	Disposable Income	Consumption	Saving	MPC	MPS
\$10,000	\$1,000		\$8,000			- i - i -
10,500	1,000		8,350			
11,000	1,000		8 , 700			
11,500	1,000		9,050			
12,000	1,000		9,400			
12,500	1,000		9,750			

Solve the problem by filling in the values in the table. Step 2:

Disposable income is defined as real GDP less net taxes, so, for example, at a level of real GDP of \$10,000 with net taxes of \$1,000, disposable income is \$9,000 (= \$10,000 - \$1,000 =\$9,000). The table should then look like:

Real GDP (Y)	Net Taxes	Disposable Income	Consumption	Saving	MPC	MPS
\$10,000	\$1,000	\$9,000	\$8,000			
10,500	1,000	9,500	8,350			
11,000	1,000	10,000	8,700			
11,500	1,000	10,500	9,050			
12,000	1,000	11,000	9,400			
12,500	1,000	11,500	9,750			

Saving is the difference between disposable income and consumption (or the part of disposable income that is not consumed). At real GDP = \$10,000, with net taxes of \$1,000, disposable income is \$9,000. If consumption is \$8,000, then saving will be \$1,000 (= \$9,000 - \$8,000 = \$1,000). Using this calculation, the table will look like:

Real GDP (Y)	Net Taxes	Disposable Income	Consumption	Saving	MPC	MPS
\$10,000	\$1,000	\$9,000	\$8,000	\$1,000		
10,500	1,000	9,500	8,350	1,150		
11,000	1,000	10,000	8,700	1,300		
11,500	1,000	10,500	9,050	1,450		
12,000	1,000	11,000	9,400	1,600		
12,500	1,000	11,500	9,750	1,750		

The MPC is defined as the change in consumption for a dollar change in disposable income. so between real GDP of \$10,000 and \$10,500, disposable income increased \$500 (= \$9,500 -\$9,000 = \$500). For the same change in income, consumption spending increased by \$350 (= \$8.350 - \$8.000 = \$350), which means that the MPC equals \$350/\$500 = 0.7.

The MPS is defined as the change in saving for a dollar change in disposable income, so between real GDP of \$10,000 and \$10,500, disposable income increased \$500 (= \$9,500 -\$9,000 = \$500). Saving increased by \$150 (= \$1,150 - \$1000 = \$150), so the MPS equals 150/500 = 0.3.

Using these calculations, the table will look like:

Real GDP (Y)	Net Taxes	Disposable Income	Consumption	Saving	MPC	MPS
\$10,000	\$1,000	\$9,000	\$8,000	\$1,000		
10,500	1,000	9,500	8,350	1,150	0.7	0.3
11,000	1,000	10,000	8,700	1,300	0.7	0.3
11,500	1,000	10,500	9,050	1,450	0.7	0.3
12,000	1,000	11,000	9,400	1,600	0.7	0.3
12,500	1,000	11,500	9,750	1 <i>,</i> 750	0.7	0.3

Notice that at all levels of real GDP, the MPC + MPS = 1.

Graphing Macroeconomic Equilibrium (pages 387–394)

Learning Objective: Use a 45°-line diagram to illustrate macroeconomic equilibrium.

The graphical view of macroeconomic equilibrium starts with a line defining all possible points of equilibrium. Because equilibrium is AE = Y, the line will intersect the origin at an angle of 45 degrees. This is shown in textbook Figure 12.8. At points below the line, AE is less than Y, and at points above the line, AE is greater than Y.

In textbook Figure 12.8, the 45° line shows all possible points of macroeconomic equilibrium, where Y = AE. During any particular year, only one of these points will represent the actual level of equilibrium real GDP, given the actual level of planned expenditure. To find the macroeconomic equilibrium, we need to add a line representing the aggregate expenditure function to the graph. This is done in textbook Figure 12.9. Equilibrium will occur at the level of real GDP where the AE line (which is equal to C + I + G + NX) intersects the 45° line.

Study Hint

We've assumed that net exports (NX) are positive. For more than 30 years, U.S. net exports have been negative. See Figure 12.6 on page 386 in the textbook, which graphs real net exports from 1979 through the second quarter of 2010.

Equilibrium occurs at the level of real GDP that makes AE = Y. At production levels less than this level of real GDP, inventories will decline and firms will respond by increasing production. At production levels above the equilibrium level of real GDP, inventories will increase and firms will reduce production. This adjustment is shown in textbook Figure 12.10.

Extra Solved Problem 12.3

Calculating Equilibrium Real GDP

Supports Learning Objective 12.3: Use a 45°-line diagram to illustrate macroeconomic equilibrium.

The table below has several values of real GDP. The goal is to determine the level of equilibrium real GDP where Y = AE. To do this, assume that net taxes are \$1,000 at every level of real GDP. Calculate disposable income (YD). You are also given consumption for one level of YD. If the MPC is 0.6, determine consumption at all levels of real GDP. Suppose that planned investment, government purchases, and net exports are \$2,000, \$2,000, and \$900, respectively, at all levels of real GDP. Using these values, calculate AE. Based upon these levels of AE, determine unplanned changes in inventories. From these levels of unplanned changes in inventories, determine if Y will rise or fall, or remain unchanged at each level of real GDP. Fill in values in the table below.

Real GDP (Y)	Taxes (T)	Disposable Income (YD)	Consumption (C)		Government Purchases (G)	Net Exports (NX)	AE = C+I+G+NX	Unplanned Changes in Inventories	Y will:
\$8,000	\$1,000		\$4,700	\$2,000	\$2,000	\$900			
9,000									
10,000									
11,000									
12,000									
13,000									
14,000									

Solving the Problem

Step 1: Review the chapter material.

This problem is about determining macroeconomic equilibrium, so you may want to review the section "Graphing Macroeconomic Equilibrium," which begins on page 387 of the textbook.

Step 2: Calculate the level of disposable income.

For this economy, net taxes are \$1,000 at each level of real GDP. The level of disposable income is calculated as real GDP – net taxes. With this information you complete the net taxes and disposable income columns.

Real GDP (Y)	Taxes (T)	Disposable Income (YD)	Consumption (C)	Planned Investment (I)	Government Purchases (G)	Net Exports (NX)	AF = C + I + G + NX	Unplanned Changes in Inventories	Y will:
\$8,000	\$1,000	\$7,000	\$4,700	\$2,000	\$2,000	\$900			
9,000	1,000	8,000							
10,000	1,000	9,000							
11,000	1,000	10,000							
12,000	1,000	11,000							
13,000	1,000	12,000							
14,000	1,000	13,000							

Step 3: Calculate consumption.

The MPC is 0.6. This means that for each \$1,000 increase in disposable income, consumption will increase by \$600. For example, as YD increases from \$7,000 to \$8,000, consumption will increase by \$600 from \$4,700 to \$5,300. After calculating consumption for the remaining levels of disposable income, the table should look like:

Real GDP (Y)	Taxes (T)	Disposable Income (YD)	Consumption (C)	Planned Investment (I)	Government Purchases (G)	Net Exports (NX)	AE = C + I + G + NX	Unplanned Changes in Inventories	Y will:
\$8,000	\$1,000	\$7,000	\$4,700	\$2,000	\$2,000	\$900			
9,000	1,000	8,000	5,300		***************************************				
10,000	1,000	9,000	5,900						
11,000	1,000	10,000	6,500						
12,000	1,000	11,000	7,100						
13,000	1,000	12,000	7,700						
14,000	1,000	13,000	8,300						

Step 4: Fill in the values for planned investment, government purchases, and net exports. Planned investment, government purchases, and net exports are autonomous expenditures and are assumed to have constant values of \$2,000, \$2,000, and \$900. Using these values, the table should look like:

Real GDP (Y)	Taxes	Disposable Income (YD)	Consumption (C)	Planned Investment (I)	Government Purchases (G)	Net Exports (NX)	AE = C + I + G + NX	Unplanned Changes in Inventories	Y will:
\$8,000	\$1,000	\$7,000	\$4,700	\$2,000	\$2,000	\$900			
9,000	1,000	8,000	5,300	2,000	2,000	900			
10,000	1,000	9,000	5,900	2,000	2,000	900			
11,000	1,000	10,000	6,500	2,000	2,000	900			
12,000	1,000	11,000	7,100	2,000	2,000	900			
13,000	1,000	12,000	7,700	2,000	2,000	900			
14,000	1,000	13,000	8,300	2,000	2,000	900			

Step 5: Calculate the values of AE.

AE is defined as C + I + G + NX, so when real GDP = \$8,000, the value of AE will be \$4,700 + \$2,000 + \$9,000 + \$900 = \$9,600. Filling in the values for AE at every level of real GDP results in the table looking like this:

Real GDP (Y)	Taxes (T)	Disposable income (YD)	Consumption (C)	Planned investment (I)	Government purchases (G)	Net exports (NX)	AE = C + I + G + NX	Unplanned Changes in Inventories	Y will:
\$8,000	\$1,000	\$7,000	\$4,700	\$2,000	\$2,000	\$900	\$9,600		
9,000	1,000	8,000	5,300	2,000	2,000	900	10,200		
10,000	1,000	9,000	5,900	2,000	2,000	900	10,800		
11,000	1,000	10,000	6,500	2,000	2,000	900	11,400		
12,000	1,000	11,000	7,100	2,000	2,000	900	12,000		
13,000	1,000	12,000	7,700	2,000	2,000	900	12,600		
14,000	1,000	13,000	8,300	2,000	2,000	900	13,200		

Step 6: Calculate unplanned changes to inventories.

At real GDP = \$8,000 and AE = \$9,600, total demand for output is \$9,600, but firms are only producing \$8,000. For firms to meet demand, they must sell \$1,600 of products held as inventories. This \$1,600, when added to real GDP, will allow firms to meet the total level of demand (\$8,000 + \$1,600 = \$9,600). Thus at real GDP = \$8,000, unplanned changes in inventories are -\$1,600. In general, unplanned changes in inventories equal Y - AE. A negative value for unplanned changes in inventories means there is an unplanned decrease in

inventories. If Y - AE is positive, there is an unplanned increase in inventories. Using these calculations, the table should look like:

Real GDP (Y)	Taxes (T)	Disposable Income (YD)	Consumption (C)	Planned Investment (I)	Government Purchases (G)	Net Exports (NX)	AE = C + I + G + NX	Unplanned Changes in Inventories	Y will:
\$8,000	\$1,000	\$7,000	\$4,700	\$2,000	\$2,000	\$900	\$9,600	-\$1,600	
9,000	1,000	8,000	5,300	2,000	2,000	900	10,200	-1,200	
10,000	1,000	9,000	5,900	2,000	2,000	900	10,800	-800	
11,000	1,000	10,000	6,500	2,000	2,000	900	11,400	-400	
12,000	1,000	11,000	7,100	2,000	2,000	900	12,000	0	
13,000	1,000	12,000	7,700	2,000	2,000	900	12,600	400	
14,000	1,000	13,000	8,300	2,000	2,000	900	13,200	800	

Step 7: Determine if Y will rise, fall, or remain unchanged at each level of real GDP.

If inventories are falling, then firms will increase production (real GDP). If inventories are rising, then firms will decrease production (real GDP). Knowing this, we can fill in the last column of the table:

Real GDP (Y)	Taxes (T)	Disposable Income (YD)	Consumption (C)	Planned Investment (I)	Government Purchases (G)	Net Exports (NX)	AE = C+I+G+NX	Unplanned Changes in Inventories	Y will:
\$8,000	\$1,000	\$7,000	\$4,700	\$2,000	\$2,000	\$900	\$9,600	-\$1,600	increase
9,000	1,000	8,000	5,300	2,000	2,000	900	10,200	-1,200	increase
10,000	1,000	9,000	5,900	2,000	2,000	900	10,800	-800	increase
11,000	1,000	10,000	6,500	2,000	2,000	900	11,400	-400	increase
12,000	1,000	11,000	7,100	2,000	2,000	900	12,000	0	not change
13,000	1,000	12,000	7,700	2,000	2,000	900	12,600	400	decrease
14,000	1,000	13,000	8,300	2,000	2,000	900	13,200	800	decrease

Equilibrium real GDP will be \$12,000. At this level of real GDP, AE also equals \$12,000, so AE = Y and unplanned changes in inventories are zero, so production (real GDP) will not change.

M Study Hint

Read the feature **Don't Let This Happen to You** in this section to keep clear the difference between aggregate expenditure and consumption spending: Aggregate expenditure (AE) includes more than just consumption expenditures (which is the largest component of AE). Also included in aggregate expenditure are planned investment, government purchases, and net exports.

12.4

The Multiplier Effect (pages 394–401)

Learning Objective: Define the multiplier effect and use the multiplier formula to calculate changes in equilibrium GDP.

The aggregate expenditure model predicts that, in the short run, the level of real GDP is determined by the level of aggregate expenditure (C + I + G + NX). Changes in aggregate expenditure cause real GDP to change. This is shown in textbook Figure 12.12.

Suppose the economy is in equilibrium at point A in the figure. If AE increases to AE_2 , at point A, the new level of spending, AE_2 , will be greater than output (AE > Y). There will be an unplanned decrease in inventories. In response, firms will increase output and employment. Real GDP will therefore rise. The new equilibrium will be at point B, where AE = Y again.

What can cause AE to increase? Increases in **autonomous expenditure**, which is spending that does not depend on the level of real GDP, cause AE to increase. In the simple model developed in this chapter, planned investment, government purchases, and net exports are autonomous.

Any rise in autonomous expenditure will cause real GDP to increase by more than the increase in autonomous expenditure. This is true because increases in expenditure lead to increases in production and income, which in turn cause increases in consumption spending as household disposable income rises. The series of induced increases in consumption spending that result from an initial increase in autonomous expenditure is called the **multiplier effect**. The multiplier effect is the process by which an increase in autonomous expenditure leads to an increase in real GDP. The size of the multiplier depends upon the size of the *MPC*. The formula for the simple **multiplier** is:

$$\frac{1}{1 - MPC}$$

There are several important points you should know about the multiplier effect:

- The multiplier works for both increases and decreases in autonomous expenditure.
- The multiplier effect implies that the economy is more sensitive to changes in autonomous spending than it would otherwise be.
- The larger the MPC (or smaller the MPS), the larger the multiplier.
- The multiplier derived in this chapter is based on a very simple model of the economy. There are several real world complications caused by rising real GDP and its effect on (for example) interest rates and inflation. Also, we've assumed some variables are autonomous that are not constant in the real world. For example, we expect net exports to actually fall as income rises. But our model assumes net exports are constant. Our simple multiplier formula overstates the true value of the multiplier.

12.5

The Aggregate Demand Curve (pages 401–403)

Learning Objective: Understand the relationship between the aggregate demand curve and aggregate expenditure.

As the price level increases, the level of autonomous expenditure will fall, and through the multiplier process, the level of aggregate expenditure and equilibrium real GDP will also fall. An increase in the price level will reduce autonomous expenditure for three reasons:

1. A higher price level will reduce the purchasing power of household wealth, reducing consumption spending.

- 2. A higher price level will make products produced in the United States more expensive than products produced in the rest of the world. This will reduce exports and increase imports, reducing net exports.
- 3. An increase in the price level will increase real interest rates, causing consumption and planned investment to fall.

In the aggregate expenditure model, a higher price level shifts the AE line down. In panel (a) of textbook Figure 12.13, a higher price will shift AE from AE_1 to AE_2 , causing equilibrium real GDP to fall. In panel (b), a lower price level will shift AE from AE_1 to AE_2 , causing equilibrium real GDP to rise.

The relationship between the price level and the resulting level of real GDP is shown in an **aggregate demand curve**. The aggregate demand curve is illustrated in textbook Figure 12.14.

Study Hint

The aggregate demand curve is different from the demand curve for a single product, like a smartphone. The demand curve for smartphones shows what happens to the quantity of smartphones that will be purchased at different prices for smartphones, holding other prices, income, and other factors affecting demand for smartphones constant. On the AD curve, the price level changes, not just the price of one product, so that all prices are changing at the same time. But like the microeconomic demand curves we encountered in Chapter 3, a change in the price level will cause a movement along the AD curve rather than a shift of the AD curve.

Extra Solved Problem 12.5

The Aggregate Demand Relationship

Supports Learning Objective 12.5: Understand the relationship between the aggregate demand curve and aggregate expenditure.

Using the table below, determine the equilibrium level or real GDP. What is the value of the multiplier for the economy? Then suppose that because of a price level increase, net exports fall to -\$1,650. What will be the new equilibrium real GDP at the new higher price level?

Real GDP (Y)	Consumption (C)	Planned Investment (I)	Government Purchases (G)	Net Exports (NX)
\$8,000	\$6,050	\$2,500	\$2,000	-\$1,350
9,000	6,750	2,500	2,000	-1,350
10,000	7,450	2,500	2,000	-1,350
11,000	8,150	2,500	2,000	-1,350
12,000	8,850	2,500	2,000	-1,350
13,000	9,550	2,500	2,000	-1,350
14,000	10,250	2,500	2,000	-1,350

Solving the Problem

Step 1: Review the chapter material.

This problem is about aggregate demand and aggregate expenditure, so you may want to review the section "The Aggregate Demand Curve," which begins on page 401 of the textbook.

Step 2: Calculate equilibrium real GDP.

Equilibrium income is where AE = Y. To find this level of Real GDP, calculate AE as C + I + G + NX. The results of this calculation are shown in the column labeled AE:

Real GDP (Y)	Consumption (C)	Planned Investment (I)	Government Purchases (G)	Net Exports (NX)	AE = C + I + G + NX
\$8,000	\$6,050	\$2,500	\$2,000	- \$1 , 350	\$9,200
9,000	6,750	2,500	2,000	-1,350	9,900
10,000	7,450	2,500	2,000	-1,350	10,600
11,000	8,150	2,500	2,000	-1,350	11,300
12,000	8,850	2,500	2,000	-1,350	12,000
13,000	9,550	2,500	2,000	-1,350	12,700
14,000	10,250	2,500	2,000	-1,350	13,400

AE is equal to Y at a level of real GDP of \$12,000.

Step 3: Calculate the multiplier.

The multiplier is defined as 1/MPS or 1/(1 - MPC). For this economy, a \$1,000 increase in real GDP increases consumption by \$700. Therefore, the MPC = 0.7, and the MPS = 0.3, because the MPC + MPS = 1. The multiplier is 1/(1 - MPC) = 1/(1 - 0.7) = 1/0.3 = 3.33.

Step 4: Calculate the new equilibrium real GDP at the new level of net exports.

With the new level of net exports, AE = Y at a level of real GDP = \$11,000.

Real GDP (Y)	Consumption (C)	Planned Investment (1)	Government Purchases (G)	Net Exports (NX)	AE = C + I + G + NX	New Net Exports	AE = C + I + G + NX
\$8,000	\$6,050	\$2,500	\$2,000	-\$1,350	\$9,200	-\$1,650	\$8,900
9,000	6,750	2,500	2,000	-1,350	9,900	-1,650	9,600
10,000	<i>7,</i> 450	2,500	2,000	-1,350	10,600	-1,650	10,300
11,000	8,150	2,500	2,000	-1,350	11,300	-1,650	11,000
12,000	8,850	2,500	2,000	-1,350	12,000	-1,650	11,700
13,000	9,550	2,500	2,000	-1,350	12,700	-1,650	12,400
14,000	10,250	2,500	2,000	-1,350	13,400	-1,650	13,100

An increase in the price level will reduce net exports and cause real GDP to fall. Notice that the fall in real GDP is the multiplier (1/0.3) times the change in net exports (-\$300), or $-\$1,000 = (1/0.3) \times (-\$300)$.

Appendix

The Algebra of Macroeconomic Equilibrium (pages 410-411)

Learning Objective: Apply the algebra of macroeconomic equilibrium.

It is possible to view the determination of equilibrium using basic algebra. In equations, the aggregate expenditure model is:

1. $C = \overline{C} + MPC(Y)$

Consumption function

2. $I = \overline{I}$

Planned investment function

3. $G = \overline{G}$

Government spending function

4. $NX = \overline{NX}$

Net export function

5. Y = C + I + G + NX

Equilibrium condition

The letters with "bars" represent fixed or autonomous values. Solving for equilibrium we get

$$Y = \overline{C} + MPC(Y) + \overline{I} + \overline{G} + \overline{NX}$$
,

or,

$$Y - MPC(Y) = \overline{C} + \overline{I} + \overline{G} + \overline{NX}$$
,

or,

$$Y(1-MPC) = \overline{C} + \overline{I} + \overline{G} + \overline{NX}$$
,

or,

$$Y = \frac{\overline{C} + \overline{I} + \overline{G} + \overline{NX}}{1 - MPC}.$$

Remember that 1/(1 - MPC) is the multiplier, and all four variables in the numerator of the last equation represent autonomous expenditure. Therefore, an alternative expression for equilibrium GDP is:

Equilibrium real GDP = Autonomous Expenditure × Multiplier.

Key Terms

Aggregate demand (AD) curve A curve that shows the relationship between the price level and the level of planned aggregate expenditure in the economy, holding constant all other factors that affect aggregate expenditure.

Aggregate expenditure (AE) The total amount of spending in the economy: the sum of consumption, planned investment, government purchases, and net exports.

Aggregate expenditure model A macroeconomic model that focuses on the short-run relationship between total spending and real GDP, assuming that the price level is constant.

Autonomous expenditure An expenditure that does not depend on the level of GDP.

Cash flow The difference between the cash revenues received by a firm and the cash spending by the firm.

Consumption function The relationship between consumption spending and disposable income.

Inventories Goods that have been produced but not vet sold.

Marginal propensity to consume (MPC) The slope of the consumption function: The amount by which consumption spending changes when disposable income changes.

Marginal propensity to save (MPS) The amount by which saving changes when disposable income changes.

Multiplier The increase in equilibrium real GDP divided by the increase in autonomous expenditure.

Multiplier effect The process by which an increase in autonomous expenditure leads to a larger increase in real GDP.

Self-Test

(Answers are provided at the end of the Self-Test.)

Multiple-Choice Questions

- 1. Aggregate expenditure, or the total amount of spending in the economy, equals
 - a. household spending on durable goods plus household spending on nondurable goods.
 - b. household spending on durable goods plus business investment spending.
 - c. consumption spending plus planned investment spending plus government purchases plus net exports.
 - d. total spending by households plus total spending by businesses.
- 2. Fluctuations in total spending in the economy may affect
 - a. the level of employment in the short run.
 - b. the level of production in the short run.
 - c. both employment and production in the short run.
 - d. neither the level of employment nor the level of production in the short run.

- 3. The aggregate expenditure model focuses on the relationship between total spending and
 - a. nominal GDP in the short run.
 - b. nominal GDP in the long run.
 - c. real GDP in the short run.
 - d. real GDP in the long run.
- 4. The key idea of the aggregate expenditure model is that in any particular year, the level of GDP is determined mainly by
 - a. the economy's endowment of economic resources and the current state of technology.
 - b. the level of the interest rate for the economy as a whole.
 - c. the level of aggregate expenditure.
 - d. the level of government expenditures.
- 5. Economists and business analysts usually explain fluctuations in GDP in terms of fluctuations in these four categories:
 - a. interest rates, exchange rates, inflation rates, and government purchases.
 - b. inflation rates, unemployment rates, interest rates, and consumer spending.
 - c. investment spending, unplanned inventory changes, government transfer spending, and government purchases.
 - d. consumption, planned investment, government purchases, and net exports.
- 6. Which of the following statements is correct?
 - a. Actual investment and planned investment are always the same thing.
 - b. Actual investment will equal planned investment only when inventories rise.
 - c. Actual investment will equal planned investment only when there is no unplanned change in inventories.
 - d. Actual investment equals planned investment only when inventories decline.
- 7. Macroeconomic equilibrium occurs where
 - a. the unemployment rate is zero.
 - b. total spending, or aggregate expenditure, equals total production, or GDP.
 - c. consumption equals investment, and investment equals government expenditure.
 - d. total production, or GDP, equals total planned investment.
- 8. What happens when there is an unplanned decrease in inventories?
 - a. Actual investment equals planned investment.
 - b. Actual investment is greater than planned investment.
 - c. Actual investment is less than planned investment.
 - d. None of the above: actual investment can always be greater or less than planned investment.
- 9. When aggregate expenditure is less than GDP,
 - a. inventories will rise.
 - b. inventories will fall.
 - c. unplanned inventory adjustment will remain the same.
 - d. the total amount of production in the economy is greater than the total amount of spending.
- 10. If aggregate expenditure is equal to GDP, then
 - a. inventories are rising.
 - b. GDP and employment will fall.
 - c. the economy is in macroeconomic equilibrium.
 - d. inventories are falling.

11.	Fill in the blanks. When aggregate expenditure is greater than GDP, inventories will and
	GDP and total employment will
	a. rise; increaseb. rise; decrease
	c. fall; increase
	d. fall; decrease
	d. Tall, decrease
12.	The most important determinant of consumption is
	a. current disposable income.
	b. household wealth.
	c. the price level.
	d. the interest rate.
13.	An increase in household wealth will
	a. increase the consumption component of aggregate expenditure.
	b. decrease the investment component of aggregate expenditure.
	c. increase the government purchases component of aggregate expenditure.
	d. not cause any change in the components of aggregate expenditure.
14	Which of the following causes saving to increase?
	a. an increase in consumption
	b. an increase in the interest rate
	c. an increase in unemployment
	d. an increase in the price level
15	If the marginal propensity to consume (MPC) is 0.9, how much additional consumption will result
13.	from an increase of \$100 billion of disposable income?
	a. \$90 billion
	b. \$80 billion
	c. \$10 billion
	d. \$9 billion
16.	If the MPC is 0.8, then a \$100 million increase in government expenditures will increase equilibrium
	GDP by
	a. \$100 million.
	b. \$80 million. c. \$400 million.
	c. \$400 million. d. \$500 million.
	d. \$500 illillion.
17.	Which of the following equalities is correct?
	a. Disposable income is equal to national income plus government transfer payments plus taxes.
	b. Government transfer payments minus taxes equals net taxes.
	c. Disposable income is equal to national income minus net taxes.
	d. Disposable income equals national income.
1 2	When national income increases, there must be some combination of an increase in household
10.	a. consumption and saving.
	b. consumption, saving, and taxes.

c. consumption and investment.d. saving and investment.

- 19. The amount by which consumption spending increases when disposable income increases is called
 - a. marginal consumption.
 - b. autonomous consumption.
 - c. the marginal propensity to consume.
 - d. disposable national consumption.
- 20. The sum of the marginal propensity to consume (MPC) and the marginal propensity to save (MPS) equals
 - a. disposable income.
 - b. zero.
 - c. one.
 - d. national income.
- 21. Which of the following is *not* correct?
 - a. MPS + MPC = 1
 - b. 0 < MPS < 1
 - c. $MPS = 1 (\Delta C/\Delta YD)$
 - d. MPS = 1 (C/YD)
- 22. The behavior of consumption and investment over time can be described as follows:
 - a. investment follows a smooth, upward trend, but consumption is highly volatile.
 - b. consumption follows a smooth, upward trend, but investment is subject to significant fluctuations.
 - c. both consumption and investment fluctuate significantly over time.
 - d. neither consumption nor investment fluctuates significantly over time.
- 23. Which of the following statements about investment spending is correct?
 - a. The optimism or pessimism of business firms is an important determinant of investment spending.
 - b. A higher real interest rate results in less investment spending.
 - c. When the economy moves into a recession, many firms will postpone buying investment goods even if the demand for their own product is strong.
 - d. All of the above are correct.
- 24. Which of the following statements is correct?
 - a. An increase in the corporate income tax decreases the after-tax profitability of investment spending.
 - b. Changes in tax laws have no effect on investment spending.
 - During periods of recession, the ability of firms to finance spending on new factories or machinery and equipment increases.
 - d. All of the above are correct.
- 25. For most of the 1979–2013 period, real government purchases
 - a. rose steadily.
 - b. fell steadily.
 - c. rose and fell sharply from time to time.
 - d. remained constant.

26.	exports have usually when the U.S. economy is in recession and when the U.S. economy is expanding. a. positive; increased; decreased b. positive; decreased; increased c. negative; increased; decreased d. negative; decreased; increased
27.	Which of the following is among the most important determinants of the level of net exports? a. the price level in the United States relative to the price levels in other countries
	 b. the unemployment rate in the United States relative to the unemployment rate in other countries c. the level of investment spending in the United States relative to the level of investment spending in other countries d. all of the above
28.	Fill in the blanks. If inflation in the United States is lower than inflation in other countries, then U.S. exports and U.S. imports, which net exports. a. increase; increase; decreases b. increase; decrease; increases c. decrease; increases d. decrease; increase; decreases
29.	 When incomes rise faster in the United States than in other countries, a. U.S. net exports will rise. b. U.S. net exports will fall. c. foreign consumers' purchases of U.S. goods and services will increase faster than U.S. consumers' purchases of foreign goods and services. d. exports usually rise faster than imports.
30.	Fill in the blanks. An increase in the value of the dollar (the dollar appreciates against other currencies) will exports and imports, so net exports will a. increase; decrease; rise b. decrease; increase; fall c. increase; decrease; fall d. increase; increase; rise
31.	At points above the 45° line, aggregate expenditure is a. greater than GDP. b. less than GDP. c. equal to GDP. d. in equilibrium.
32.	As long as the AE line is above the 45° line, inventories will a. rise, and firms will expand production. b. decline, and firms will expand production. c. rise, and firms will reduce production. d. decline, and firms will reduce production.

33. Macroeconomic equilibrium in the short run

- a. must be consistent with macroeconomic equilibrium in the long run.
- b. results in a zero unemployment rate.
- c. will occur at a point on the 45° line.
- d. All of the above are true.

34. When is the economy in a recession?

- a. when the aggregate expenditure line does not intersect the 45° line anywhere
- b. when the aggregate expenditure line intersects the 45° line at a level of GDP below potential real GDP
- c. when the aggregate expenditure line intersects the 45° line at a level of GDP above potential real GDP
- d. when the aggregate expenditure line intersects the 45° line at a level of GDP equal to potential real GDP

35. When the economy is in a recession, the shortfall in aggregate expenditure is exactly equal to

- a. the value of GDP.
- b. the shortfall in aggregate production.
- c. the unplanned increase in inventories that would occur if the economy were initially at potential GDP.
- d. all of the above.

36. Which of the following statements is correct?

- a. Autonomous expenditure depends on the level of GDP.
- b. Autonomous expenditure does not depend on the level of GDP.
- c. No part of consumption spending is autonomous.
- d. No part of government purchases is autonomous.

37. What is the multiplier?

- a. The multiplier is the amount by which investment spending increases following an initial increase in consumption spending.
- b. The multiplier is the ratio of the unemployment rate to the inflation rate.
- c. The multiplier is the ratio of the increase in equilibrium real GDP to the increase in autonomous expenditure.
- d. The multiplier is the ratio of the increase in autonomous expenditure to the increase in equilibrium real GDP.

38. The value of the multiplier is larger when

- a. the value of the MPC is smaller.
- b. the value of the MPC is larger.
- c. the value of the MPC equals zero.
- d. the value of the MPC is equal to the value of autonomous expenditure.

39. If we account for the impact of increasing GDP on imports, inflation, and interest rates, the simple multiplier formula would

- a. reflect accurately the true value of the multiplier.
- b. understate the true value of the multiplier.
- c. overstate the true value of the multiplier.
- d. change to MPC/(1 MPC).

- 40. According to the paradox of thrift, a simultaneous increase in saving without any change in income
 - a. higher real GDP in the short run but lower real GDP in the long run.
 - b. lower real GDP in the short run but higher real GDP in the long run.
 - c. higher real GDP in both the short run and the long run.
 - d. lower real GDP in both the short run and the long run.
- 41. Which of the following happens if the price level rises?
 - a. Investment will rise, while consumption and net exports will fall.
 - b. Investment and consumption will fall, but net exports will rise.
 - c. Investment, consumption and net exports will all rise.
 - d. Investment, consumption and net exports will all fall.
- 42. A curve showing the relationship between the price level and the level of aggregate expenditure in the economy, holding constant all other factors that affect aggregate expenditure, is called
 - a. the inflation curve.
 - b. the autonomous expenditure function.
 - c. aggregate demand.
 - d. the price-expenditure curve.
- 43. What is the value of autonomous expenditure in the following macroeconomic model?

$$C = 1.000 + 0.8Y$$

$$I = 500$$

$$G = 600$$

$$NX = -100$$

$$Y = C + I + G + NX$$

- a. 2,000
- b. 8,000
- c. 10,000
- d. 20,000
- 44. Find equilibrium GDP using the following macroeconomic model:

$$C = 1.000 + 0.8Y$$

$$I = 500$$

$$G = 600$$

$$NX = -100$$

$$Y = C + I + G + NX$$

a.
$$2.000$$

- c. 10,000
- d. 20,000
- 45. Which of the following is correct concerning shifts in the aggregate demand (AD) curve?
 - a. An increase in the price level will decrease real household wealth, which will decrease consumption and shift the AD curve to the left.
 - b. A larger MPS will cause the AD curve to shift further to the right when there is an increase in autonomous expenditures.
 - c. An increase in taxes will shift the AD curve to the left because the tax multiplier is negative.
 - d. An increase in the price level will increase interest rates, which will reduce investment expenditures and shift the AD curve to the left.

Short Answer Questions

1.	The AE curve is built up using the expenditure components as shown in Figure 12.9. How would the AE line and resulting macroeconomic equilibrium change if NX was negative?

2. The table below has several values of real GDP. The goal is to determine the level of equilibrium real GDP. To do this, assume that net taxes are \$500 at every level of real GDP. Calculate disposable income (YD). Consumption is given for real GDP of \$8,000. If the MPC is 0.7, determine consumption at the other levels of real GDP. In addition, suppose that planned investment, government purchases, and net exports are \$2,000, \$2,000, and -\$1,150 respectively at all levels of real GDP. Using these values, calculate AE. Based on these levels of AE, determine the unplanned changes in inventories. From the unplanned changes in inventories, determine if Y will rise or fall, or remain unchanged. What will be the equilibrium level of real GDP?

Real GDP (Y)	Taxes (T)	Disposable Income (YD)	Consumption (C)	Planned Investment (I)	Government Purchases (G)	Net Exports (NX)	AE = C + I + G + NX	Unplanned Changes in Inventories	Y will:
\$8,000	\$500		\$6,050	\$2,000	\$2,000	-\$1,150			
9,000									
10,000									
11,000									
12,000									
13,000									
14,000									

3. Suppose that planned investment increases to a value of \$2,300. Determine the new level of equilibrium real GDP. Use the table below.

(Y)	Taxes (T)	Disposable Income (YD)	Consumption (C)	Planned Investment (I)	Government Purchases (G)	Net Exports (NX)	AE = C + I + G + NX	Unplanned Changes in Inventories	Y will
\$8,000	\$500		\$6,050	\$2,300	\$2,000	-\$1,150			
9,000									
10,000									
11,000									
12,000									
13,000									
14,000									
_									
			terest rate fal ium real GD				level of aggi	regate expe	nditure
and	the level	of equilibr		P? Show or	n a 45°-line	graph.		regate expe	nditure

True/False Questions

- T F 1. In the aggregate expenditure model, the price level is constant.
- T F 2. Planned investment and actual investment are equal when there are no unplanned changes in inventories.
- T F 3. If aggregate expenditure is greater than real GDP, then inventories will be rising.
- T F 4. If aggregate expenditure is less than real GDP, then real GDP will decrease.
- T F 5. The paradox of thrift explains why an increase in saving can raise real GDP in both the short run and the long run.
- T F 6. An increase in the real interest rate will increase consumption spending.
- T F 7. The marginal propensity to consume (MPC) is the ratio of consumption to disposable income.
- T F 8. If the marginal propensity to consume (MPC) is 0.5, then the marginal propensity to save (MPS) is also 0.5.
- T F 9. At points above the 45° line, AE > Y.
- T F 10. Macroeconomic equilibrium will occur when unplanned investment equals zero.
- T F 11. If the MPC = 0.8, then the multiplier is 4.
- T F 12. If the MPS is 0.4, then a \$1,000 increase in autonomous expenditure will increase real GDP by \$2,000.
- T F 13. An increase in government purchases will result in an increase in autonomous expenditure.
- T F 14. A decrease in the price level will increase autonomous expenditure, which will result in an increase in equilibrium real GDP.
- T F 15. An increase in the price level will reduce equilibrium real GDP, shifting the AD curve to the right.

Answers to the Self-Test

Multiple-Choice Questions

Question	Answer	Comment
1.	С	Aggregate expenditure (AE) is the total amount of spending in the economy: the sum of consumption, planned investment, government purchases, and net exports.
2.	c	During some years, total spending in the economy, or aggregate expenditure, increases about as much as does the production of goods and services. If this happens, most firms will sell about what they expected to sell, and they will probably not increase or decrease production or the number of workers hired. During other years, total spending in the economy increases more than the production of goods and services. In these years, firms will increase production and hire more workers.
3.	C	The aggregate expenditure model states that the economy is in short-run equilibrium when total spending equals real GDP.
4.	С	The key idea of the aggregate expenditure model is that in any particular year, the level of gross domestic product (GDP) is determined mainly by the level of aggregate expenditure.

Question	Answer	Comment
5.	d	In 1936, the English economist John Maynard Keynes published <i>The General Theory of Employment, Interest, and Money</i> . In this book, he systematically analyzed the relationship between fluctuations in aggregate expenditure and fluctuations in GDP. Keynes identified four categories of aggregate expenditure that together equal GDP.
6.	c	For the economy as a whole, we can say that actual investment spending will be greater than planned investment spending when there is an unplanned increase in inventories. Actual investment spending will be less than planned investment spending when there is an unplanned decrease in inventories.
		Therefore, actual investment will only equal planned investment when there is no unplanned change in inventories.
7.	b	For the economy as a whole, macroeconomic equilibrium occurs where total spending, or aggregate expenditure, equals total production, or GDP.
8.	c	See page 373 in the textbook.
9.	a	When aggregate expenditure is less than GDP, the total amount of spending in the economy is less than the total amount of production. That causes an unplanned increase in inventories.
10.	c	If aggregate expenditure is equal to real GDP, there is no reason for output to rise or fall. Therefore, the economy is in macroeconomic equilibrium.
11.	c	When aggregate expenditure is greater than GDP, the total amount of spending in the economy is greater than the total amount of production. The only way firms can sell more goods than they produce is to fill the excess orders from their inventories. That causes an unplanned decrease in inventories. GDP and total employment will increase in order to replenish the inventories.
12.	a	Because most spending is financed through income rather than savings, the most important determinant of consumption is the current disposable income of households. For most households, the higher their disposable income, the more they spend, and the lower their disposable income, the less they spend.
13.	a	When household wealth increases, consumption increases, and when household wealth decreases, consumption decreases.
14.	b	When the interest rate is high, the reward for saving is increased, and households are likely to save more and spend less.
15.	a	We can use the MPC to tell us how much consumption will change as income changes. Change in consumption = change in disposable income \times MPC . In this case: \$100 billion \times 0.9 = \$80 billion.
16.	d	The multiplier is $1/(1 - MPC)$, so with an MPC of 0.8 (and a multiplier of 5), a \$100 million increase in government purchases will increase real GDP by \$500 million (= \$100 million × 4).
17.	c	Disposable income is equal to national income plus government transfer payments minus taxes. Government transfer payments minus taxes are referred to as net taxes. So, we can write: Disposable income = National income – Net taxes.

Overtion	A	Comment
Question	Answer	Comment
18.	b	Households either spend their income, save it, or use it to pay taxes. For the economy as a whole, we can write: National income = Consumption + Saving + Taxes.
		When national income increases, there must be some combination of an increase in consumption, an increase in saving, or an increase in taxes. Therefore: Change in national income = Change in consumption + Change in saving + Change in taxes.
19.	С	The marginal propensity to consume is also the slope of the consumption function.
20.	С	Assuming that net taxes do not change, the relationship between the marginal propensity to consume and the marginal propensity to save is: $1 = MPC + MPS$. In other words, for each additional dollar of income, some will go to savings; the rest will go to consumption.
21.	d	Assuming that net taxes do not change, for each additional dollar of income, some will go to savings, and the rest will go to consumption. Therefore, $MPC + MPS = 1$, so choice (a) is correct. Because the MPS is the fraction of each new dollar of income that will be saved, MPS cannot be less than 0 or greater than 1, so choice (b) is correct. Starting with the function $MPC + MPS = 1$ and rearranging, we get $MPS = 1 - MPC$. MPC is the change in consumption that results from a change is income (or $\Delta C/\Delta YD$) so $MPS = 1 - (\Delta C/\Delta YD)$, so choice (c) is correct. Due to the presence of autonomous consumption, MPC does not equal C/YD , so option (d) is incorrect.
22.	b	Investment is subject to more changes than is consumption. Investment declined significantly during the recessions of 1980, 1981–1982, 1990–1991, 2001, and 2007–2009.
23.	d	The higher the interest rate, the more expensive it becomes for firms and households to borrow. Because households and firms are interested in the cost of borrowing after taking into account the effects of inflation, investment spending will depend on the real interest rate. Therefore, holding the other factors that affect investment spending constant, there is an inverse relationship between the real interest rate and investment spending. Also, it is true that when the economy moves into a recession, many firms will postpone buying investment goods even if the demand for their own product is strong. If
		businesses are optimistic about the future of the economy and thus they feel that investment will pay as consumers have the ability to buy their expanded output, then they will be more likely to invest in the capacity to produce higher output.
24.	a	A reduction in the corporate income tax increases the after-tax profitability of investment spending. An increase in the corporate income tax decreases the after-tax profitability of investment spending.
25.	a	Government purchases grew steadily for most of the 1979–2013 period, with the exception of the mid-1990s, when concern about the federal budget deficit caused real government purchases to fall for three years, beginning in 1992.
26.	С	Net exports have been negative in most years between 1979 and 2013. Net exports rise when the U.S. economy is in recession because domestic spending falls and imports fall. Net exports decrease when the U.S. economy is expanding because domestic spending rises and imports rise.

autonomous expenditure are called the multiplier effect.

37.

c

The ratio of the increase in equilibrium real GDP to the increase in

autonomous expenditure is called the multiplier. The series of induced increases in consumption spending that result from an initial increase in

Question	Answer	Comment
38.	b	The larger the MPC , the larger the value of the multiplier. With an MPC of 0.75, the multiplier is 4, but with an MPC of 0.50, the multiplier is only 2. This is because the larger the MPC , the greater the amount of additional consumption spending that takes place after each rise in income during the multiplier process.
39.	c	Increasing GDP has an impact on imports, inflation, and interest rates, which in turn decrease consumption. Thus, the <i>MPC</i> would be lower. Excluding these effect therefore, cause our simple formula to overstate the true value of the multiplier.
40.	b	As John Maynard Keynes argued, the paradox of thrift occurs because a simultaneous increase in saving and decrease in spending result in lower aggregate expenditure and GDP in the short run, even though more saving increases the rate of economic growth in the long run by providing funds for investment.
41.	d	If the price level rises, investment, consumption and net exports will all fall, causing the AE line to shift down on the 45° line diagram. The AE line shifts down because with higher prices there will be less spending in the economy at every level of GDP or national income. Textbook Figure 12.13 (a) shows that
		the downward shift of the AE line results in a lower level of equilibrium real GDP.
42.	c	The relationship shown in textbook Figure 12.14 between the price level and the level of aggregate expenditure is known as the aggregate demand curve (AD) : a curve showing the relationship between the price level and the level of aggregate expenditure in the economy, holding constant all other factors that affect aggregate expenditure.
43.	a	Autonomous expenditure equals $1000 + 500 + 600 - 100 = 2000$.
44.	С	Equilibrium GDP = Autonomous spending \times multiplier, or $2000 \times [1/(1-0.8)] = 2000 \times 5 = 10000$.
45.	c	A negative tax multiplier implies that an increase in taxes will reduce real GDP. It follows that an increase in taxes will shift the AD curve to the left.

Short Answer Responses

1. If net exports are negative, then C + I + G + NX will be less than C + I + G. In the 45° line graph, AE will be below C + I + G. Macroeconomic equilibrium still occurs at the level of Y that makes AE = Y.

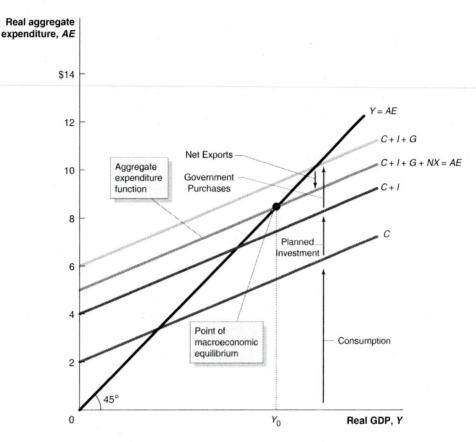

2. Filling in values for the table gives:

Real GDP (Y)	Taxes (T)	Disposable Income (YD)	Consumption (C)	Planned Investment (I)	Government Purchases (G)	Net Exports (NX)	AE = C + I + G + NX	Unplanned Changes in Inventories	Y will:
\$8,000	\$500	\$7,500	\$6,050	\$2,000	\$2,000	-\$1,150	\$8,900	-\$900	increase
9,000	500	8,500	6,750	2,000	2,000	-1,150	9,600	-600	increase
10,000	500	9,500	7,450	2,000	2,000	-1,150	10,300	-300	increase
11,000	500	10,500	8,150	2,000	2,000	-1,150	11,000	0	no change
12,000	500	11,500	8,850	2,000	2,000	-1,150	11,700	300	decrease
13,000	500	12,500	9,550	2,000	2,000	-1,150	12,400	600	decrease
14,000	500	13,500	10,250	2,000	2,000	-1,150	13,100	900	decrease

The equilibrium level of real GDP will be at the level of real GDP where AE = Y (or unplanned changes in inventories = 0). This is where real GDP = \$11,000.

3. If planned investment increased to \$2300, then the table would change to:

Real GDP (Y)	Taxes	Disposable Income (YD)	Consumption (C)	Planned Investment (I)	Government Purchases (G)	Net Exports (NX)	AE = C + I + G + NX	Unplanned Changes in Inventories	Y will:
\$8,000	\$500	\$7,500	\$6,050	\$2,300	\$2,000	-\$1,150	\$9,200	-\$1,200	increase
9,000	500	8,500	6,750	2,300	2,000	-1,150	9,900	-900	increase
10,000	500	9,500	7,450	2,300	2,000	-1,150	10,600	-600	increase
11,000	500	10,500	8,150	2,300	2,000	-1,150	11,300	-300	increase
12,000	500	11,500	8,850	2,300	2,000	-1,150	12,000	0	no change
13,000	500	12,500	9,550	2,300	2,000	-1,150	12,700	300	decrease
14,000	500	13,500	10,250	2,300	2,000	-1,150	13,400	600	decrease

The new level of equilibrium real GDP equals \$12,000. An increase in autonomous expenditure of \$300 leads to an increase in real GDP of \$1,000. This is the multiplier effect. Because MPC = 0.7, the multiplier = 1/(1 - 0.7) = 3.33, so a \$300 increase in autonomous expenditure (in this case planned investment) will lead to an increase in real GDP of \$1,000 (\$1,000 = $3.33 \times 300). You could also calculate the multiplier as

$$\Delta Y/\Delta I = (\$12,000 - \$11,000)/(\$2,300 - \$2,000) = \$1,000/\$300 = 3.33$$

4. The fall in the real interest rate will increase the level of consumption and the level of planned investment. The increase in C and I will increase AE. In the 45° line graph below, the AE curve shifts upward from AE_1 to AE_2 .

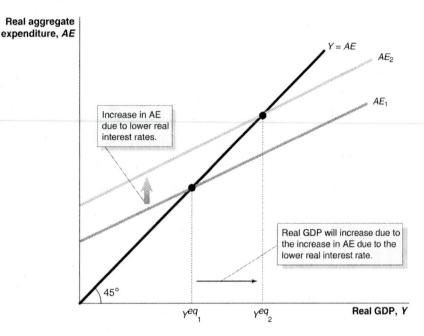

5. An increase in government spending will increase equilibrium real GDP. Because of the multiplier effect, the increase in equilibrium real GDP will be larger than the change in government purchases. This increase in equilibrium real GDP will be independent of the price level and is a shift to the right of the AD curve (from AD_0 to AD_1 in the graph below).

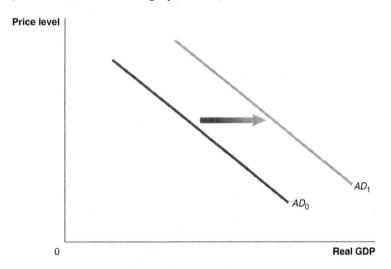

6. To increase real GDP from \$11,000 to \$12,000, real GDP must increase by \$1,000. The simple multiplier for this economy is equal to 5 = 1/(1 - MPC) = 1/(1 - 0.8) = 1/0.2 = 5. For every \$1 increase in autonomous expenditure, real GDP will rise by 5. The change in real GDP divided by the change in autonomous expenditure equals the multiplier, or (\$1,000/Change in autonomous expenditure) = 5. Therefore, the necessary change in autonomous expenditure is \$1,000/5 or \$200.

True/False Answers

Question	Answer	Comment
1.	T	One key assumption of the aggregate expenditure model is that the price level is constant. See page 376 in the textbook.
2.	T	See page 373 in the textbook.
3.	F	If aggregate expenditure is greater than real GDP, then inventories will be falling.
4.	T	See page 374 in the textbook.
5.	F	The paradox of thrift explains that an increase in the saving rate will reduce aggregate expenditure and real GDP in the short run, even though a higher saving rate is favorable to higher economic growth in the long run.
6.	F	An increase in the real interest rate will reduce consumption spending.
7.	F	The MPC is the ratio of the change in consumption to the change in disposable income, or MPC = $\Delta C/\Delta YD$.
8.	F	The $MPC + MPS = 1$, so if the $MPC = 0.5$, then the $MPS = 0.5$.
9.	T	See textbook Figure 12.8.
10.	T	See page 374 in the textbook.
11.	F	The multiplier is $1/(1-0.8) = 5$.
12.	F	If the $MPS = 0.4$, then the multiplier $[1/(1 - MPC)]$ or $1/MPS$ is 2.5. With a multiplier of 2.5, an increase in autonomous expenditure of \$1,000 will increase real GDP by \$2,500 [$(1/0.4) \times $1,000 = $2,500$].
13.	T	Autonomous expenditure is expenditure not related to the level of GDP or income, such as government purchases.
14.	T	See page 395 in the textbook.
15.	F	A change in the price level will cause a movement along the AD curve.

CHAPTER 13

13 | Aggregate Demand and Aggregate Supply Analysis

Chapter Summary and Learning Objectives

13.1 Aggregate Demand (pages 414–421)

Identify the determinants of aggregate demand and distinguish between a movement along the aggregate demand curve and a shift of the curve. The aggregate demand and aggregate supply model enables us to explain short-run fluctuations in real GDP and price level. The aggregate demand curve shows the relationship between the price level and the level of planned aggregate expenditures by households, firms, and the government. The short-run aggregate supply curve shows the relationship in the short run between the price level and the quantity of real GDP supplied by firms. The long-run aggregate supply curve shows the relationship in the long run between the price level and the quantity of real GDP supplied. The four components of aggregate demand are consumption (C), investment (I), government purchases (G), and net exports (NX). The aggregate demand curve is downward sloping because a decline in the price level causes consumption, investment, and net exports to increase. If the price level changes but all else remains constant, then the economy will move up or down a stationary aggregate demand curve. If any variable other than the price level changes, then the aggregate demand curve will shift. The variables that cause the aggregate demand curve to shift are divided into three categories: changes in government policies, changes in the expectations of households and firms, and changes in foreign variables. For example, monetary policy involves the actions the Federal Reserve takes to manage the money supply and interest rates to pursue macroeconomic policy objectives. When the Federal Reserve takes actions to change interest rates, then consumption and investment spending will change, shifting the aggregate demand curve. Fiscal policy involves changes in federal taxes and purchases that are intended to achieve macroeconomic policy objectives. Changes in federal taxes and purchases shift the aggregate demand curve.

13.2 Aggregate Supply (pages 421–426)

Identify the determinants of aggregate supply and distinguish between a movement along the short-run aggregate supply curve and a shift of the curve. The long-run aggregate supply curve is a vertical line because in the long run, real GDP is always at its potential level and is unaffected by the price level. The short-run aggregate supply curve slopes upward because workers and firms fail to accurately predict the future price level. The three main explanations of why this failure results in an upward-sloping aggregate supply curve are that (1) contracts make wages and prices "sticky," (2) businesses often adjust wages slowly, and (3) menu costs make some prices sticky. Menu costs are the costs to firms of changing prices on menus or catalogs. If the price level changes but all else remains constant, then the economy will move up or down a stationary aggregate supply curve. If any variable other than the price level changes, then the aggregate supply curve will shift. The aggregate supply curve shifts as a result of increases in the labor force and capital stock, technological change, expected increases or decreases in the future price level, adjustments of workers and firms to errors in past expectations about the price level, and unexpected increases or decreases in the price of an important raw material. A supply shock is an unexpected event that causes the short-run aggregate supply curve to shift.

13.3 Macroeconomic Equilibrium in the Long Run and the Short Run (pages 426–433)

Use the aggregate demand and aggregate supply model to illustrate the difference between short-run and long-run macroeconomic equilibrium. In long-run macroeconomic equilibrium, the aggregate demand and short-run aggregate supply curves intersect at a point on the long-run aggregate supply curve. In short-run macroeconomic equilibrium, the aggregate demand and short-run aggregate supply curves often intersect at a point off the long-run aggregate supply curve. An automatic mechanism drives the economy to long-run equilibrium. If short-run equilibrium occurs at a point below potential real GDP, then wages and prices will fall, and the short-run aggregate supply curve will shift to the right until potential GDP is restored. If short-run equilibrium occurs at a point beyond potential real GDP, then wages and prices will rise, and the short-run aggregate supply curve will shift to the left until potential GDP is restored. Real GDP can be temporarily above or below its potential level, either because of shifts in the aggregate demand curve or because supply shocks lead to shifts in the aggregate supply curve. Stagflation is a combination of inflation and recession, usually resulting from a supply shock.

13.4 A Dynamic Aggregate Demand and Aggregate Supply Model (pages 434–439)

Use the dynamic aggregate demand and aggregate supply model to analyze macroeconomic conditions. To make the aggregate demand and aggregate supply model more realistic, we need to make it dynamic by incorporating three facts that were left out of the basic model: (1) Potential real GDP increases continually, shifting the long-run aggregate supply curve to the right; (2) during most years, aggregate demand shifts to the right; and (3) except during periods when workers and firms expect high rates of inflation, the aggregate supply curve shifts to the right. The dynamic aggregate demand and aggregate supply model allows us to analyze macroeconomic conditions, including the beginning of the 2007–2009 recession.

Appendix: Macroeconomic Schools of Thought (pages 447-450)

Understand macroeconomic schools of thought. There are three major alternative models to the aggregate demand and aggregate supply model. Monetarism emphasizes that the quantity of money should be increased at a constant rate. New classical macroeconomics emphasizes that workers and firms have rational expectations. The real business cycle model focuses on real, rather than monetary, causes of the business cycle.

Chapter Review

Chapter Opener: The Fortunes of FedEx Follow the Business Cycle (page 413)

Many economists believe that changes in the quantity of packages shipped by FedEx are a good indicator of the overall state of the economy. FedEx was founded by Fred Smith, who in the 1960s proposed a new method of sending packages that moved away from using passenger airlines. FedEx's profits rise and fall with the quantity of packages they ship, and that quantity changes with the changing level of overall economic activity, referred to as the business cycle. During the 2007–2009 recession, FedEx announced layoffs for some employees and pay cuts for most other employees. In July 2013, its chief economist was predicting continued slow growth in U.S. and world GDP through the end of the year, which would also affect FedEx's sales growth and profitability.

13.1

Aggregate Demand (pages 414-421)

Learning Objective: Identify the determinants of aggregate demand and distinguish between a movement along the aggregate demand curve and a shift of the curve.

This chapter uses the aggregate demand and aggregate supply model to explain fluctuations in real GDP and the price level. Real GDP and the price level are determined in the short run by the intersections of the aggregate demand curve and the aggregate supply curve. This is seen in textbook Figure 13.1. Changes in real GDP and changes in the price level are caused by shifts in these two curves.

The aggregate demand curve (AD) shows the relationship between the price level and the level of real GDP demanded by households, firms and the government. The four components of real GDP are:

- Consumption (C)
- Investment (I)
- Government purchases (G)
- Net exports (NX)

Using Y for real GDP, then we can write the following:

$$Y = C + I + G + NX$$

The aggregate demand curve is downward sloping because a decrease in the price level increases the quantity of real GDP demanded. We assume that government purchases do not change as the price level changes. There are three reasons why the other components of real GDP change as the price level

- The wealth effect. As the price level increases, the real value of household wealth falls and so will consumption. In contrast, if the price level declines, real household wealth rises and so does consumption.
- The interest rate effect. A higher price level will tend to increase interest rates. Higher interest rates will reduce investment spending by firms as borrowing costs rise. In addition, higher interest rates will also reduce consumption spending.
- The international effect. A higher price level will make U.S. goods relatively more expensive compared to other countries' goods. This will reduce exports, increase imports, and therefore, reduce net exports.

Price level changes cause movements along the AD curve. A change in any other variable that affects the willingness of households, firms, and the government to spend will cause a shift in the AD curve. The variables that cause AD to shift fall into three categories:

- Changes in government policies. Monetary policy refers to the actions the Federal Reserve takes to manage the money supply and interest rates to pursue macroeconomic policy objectives. Fiscal policy refers to changes in federal taxes and purchases that are intended to achieve macroeconomic policy objectives, such as high unemployment, price stability, and high rates of economic growth.
- Changes in expectations of households and firms. If consumers or firms are more optimistic about the future, they may purchase more goods and services, increasing consumption and investment expenditures.
- Changes in foreign variables. As income changes in other countries, consumers in those countries may buy more U.S. goods, causing exports to increase. Changes in exchange rates can also shift the AD curve; for example, if the U.S. dollar appreciates relative to other currencies, it makes imported goods less expensive and exports more expensive to foreign consumers, shifting the AD curve to the left.

The variables that shift the AD curve are summarized in Table 13.1.

Study Hint

It is important to understand why the *AD* curve slopes downward. Read the feature *Don't Let This Happen to You*. Remember in Chapter 12 that the aggregate demand curve is different from the demand curve for a single product (like a smartphone). Unlike the demand curve for an individual good where the prices of other goods are held constant, on the aggregate demand curve as the price level increases, all prices in the economy are increasing. Because of this distinction, the reason why the aggregate demand curve is downward sloping is not the same as the reason why the demand curve is downward sloping for a single product. The aggregate demand curve has a downward slope because of the wealth effect, the interest rate effect, and the international trade effect. Read *Solved Problem 13.1* to understand the distinction between movements along the aggregate demand curve and shifts of the aggregate demand curve. *Making the Connection* "Which Components of Aggregate Demand Changed the Most during the 2007–2009 Recession?" describes how the components of aggregate demand changed during the most recent recession.

13.2

Aggregate Supply (pages 421–426)

Learning Objective: Identify the determinants of aggregate supply and distinguish between a movement along the short-run aggregate supply curve and a shift of the curve.

The aggregate supply curve shows the effects of price level changes on the quantity of goods and services firms are willing to supply. Because price level changes have different effects in the short run and in the long run, there is an aggregate supply curve for the long run and an aggregate supply curve for the short run.

The **long-run aggregate supply curve** (*LRAS*) is a curve showing the relationship in the long run between the price level and the level of real GDP supplied. As we saw in Chapter 11, in the long run the level of real GDP is determined by:

- the number of workers,
- the capital stock, and
- the available technology.

Because price level changes do not affect these factors, price level changes do not affect the level of real GDP in the long run. The long-run aggregate supply curve is therefore a vertical line. Increases in the number of workers, the capital stock, and the available technology will increase real GDP and shift the *LRAS* to the right. This is seen in textbook Figure 13.2.

Although the *LRAS* curve is vertical, the short-run aggregate supply curve (*SRAS*) is upward sloping. In the short run, as the price level increases, the quantity of goods and services that firms are willing to supply increases. This short-run relationship between the price level and the quantity of goods and services supplied occurs because as prices of final goods and services rise, the prices of inputs, such as wages and natural resource, rise more slowly and may even remain constant. A consequence of this is that as the prices of final goods and services rise, profits increase and firms are willing to supply more goods and services in the short run. In addition, as the overall price level rises, some firms are slower to adjust their prices. These firms may find their sales increasing and produce more output. Economists believe that some firms adjust prices more slowly than others and wages adjust more slowly than the price level because firms and workers fail to perfectly forecast changes in the price level. If firms and workers could accurately forecast prices, the short-run and long-run aggregate supply curves would both be vertical.

The three most common explanations for the upward-sloping short run supply curve are:

- Contracts make some wages and prices sticky. For example, the labor contract between General Motors and the United Automobile Workers fixes wages by contract.
- Firms are often slow to adjust wages. Firms tend to adjust wages once or twice a year, making wages slow to change. In addition, firms are often also reluctant to cut wages.
- Menu costs make some prices sticky. Some firms are slow to change prices because of expenses associated with the price changes. These are called menu costs.

Study Hint

Making the Connection "How Sticky Are Wages?" discusses that firms are less likely to cut the nominal wages they pay current workers. Even if a worker's nominal wage does not change, the real wage will decrease gradually over time because of inflation.

The short-run aggregate supply curve will shift to the right when something happens that makes firms willing to supply more goods and services at the same prices. The short-run aggregate supply curve will shift with:

- Changes in the labor force or capital stock.
- Technological change.
- Expected changes in the future price level.
- Adjustment of workers and firms to errors in past expectations about the price level.
- Unexpected changes in the price of natural resources that are important inputs to many industries (this is often referred to as a **supply shock**).

Study Hint

Natural resource prices can rise or fall. An adverse supply shock usually refers to an increase in resource prices.

Oil is a natural resource. When hurricane Katrina hit New Orleans in 2005, it disrupted one-quarter of U.S. oil and natural gas output. This unexpected fall in oil production caused oil prices to soar. This made it more costly for firms to operate and produce and transport their goods.

The factors that shift the SRAS curve are summarized in textbook Table 13.2.

Extra Solved Problem 13.2

Shifts and Movements along the Short-Run Aggregate Supply Curve

Supports Learning Objective 13.2: Identify the determinants of aggregate supply and distinguish between a movement along the short-run aggregate supply curve and a shift of the curve.

Show how an increase in wages has a different effect on the SRAS curve than does an increase in prices.

Solving the Problem

Step 1: Review the chapter material.

This question is about the difference in shifts and movements along the *SRAS* curve, so you may want to review the section "The Short-Run Aggregate Supply Curve," which begins on page 422 of the textbook.

Step 2: Use a graph to show the effect on the SRAS curve of a change in the price level.

Changes in the price level cause movements along the SRAS curve. This is shown in the movement from point A to point B in the graph below. The higher price level leads firms to produce more goods and services, resulting in a higher level of real GDP in the short run.

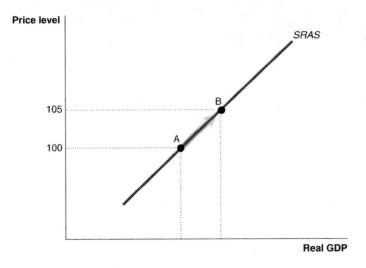

Step 3: Use a second graph to show the effect on the SRAS curve of a change in wages.

Wages are one of the economic variables that are held constant along a given SRAS curve. An increase in the overall wage rate will shift the SRAS curve to the left. This is seen in the movement from point A to point B in the graph below. If wages rise, the production costs of firms increase, and in the short run, at any given price level firms are willing to supply a lower level of real GDP.

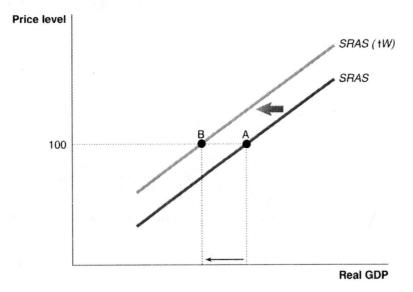

13.3

Macroeconomic Equilibrium in the Long Run and the Short Run (pages 426–433)

Learning Objective: Use the aggregate demand and aggregate supply model to illustrate the difference between short-run and long-run macroeconomic equilibrium.

In long-run macroeconomic equilibrium, the AD curve and the SRAS curve intersect at a point on the LRAS curve. This is shown in textbook Figure 13.4.

Because that point—price level of 100 and real GDP of \$14.0 trillion—is on the *LRAS* curve, firms will be operating at normal levels of capacity, and everyone that wants a job at the prevailing wage rate will have one (although there will still be frictional and structural unemployment).

Study Hint

Remember that although in long-run macroeconomic equilibrium there is no cyclical unemployment, there will still be frictional and structural unemployment. The *LRAS* curve represents the level of real GDP that will be produced when firms are operating at their normal capacity; it does *not* represent the level of real GDP that could be produced if firms operated at their maximum capacity.

The aggregate demand and aggregate supply model can be used to examine events that move the economy away from long-run equilibrium. As a starting point, assume:

- The economy has not been experiencing inflation.
- The economy has not been experiencing long-run growth.

Recession

A decline in AD will cause a short-run decline in real GDP. As the AD curve shifts to the left, the economy will move to a new short-run equilibrium where AD intersects the SRAS curve at a level of real GDP below potential GDP. The economy will be in a recession. Because firms need fewer workers to produce the lower level of output, wages will begin to fall. As wages fall, firms' costs will decline. Over time, as costs fall, the SRAS curve will shift to the right and the economy will move back to long-run equilibrium at potential GDP. This is shown in textbook Figure 13.5.

This adjustment back to long-run equilibrium will occur automatically without any form of government intervention. But it may take several years to complete this adjustment. This is usually referred to as an *automatic mechanism*.

Expansion

An increase in AD will cause a short-run expansion in the economy. An increase in AD will shift the AD curve to the right as spending by households, firms, or government increases. This increased spending will cause a short-run expansion as firms meet increased demand by increasing production. In expanding production, firms may hire workers who would normally be structurally or frictionally unemployed. The lower level of unemployment will eventually result in higher wages, which will raise costs to firms. These higher costs will shift the SRAS curve to the left and eventually return output to potential GDP. This is shown in textbook Figure 13.6.

As with a recession, the return to long-run equilibrium is an automatic adjustment in the long run. The inflation caused by an expansion beyond potential GDP usually occurs fairly quickly.

Supply Shock

An adverse supply shock (such as an oil price increase) is a shift to the left of the *SRAS* curve not caused by the automatic adjustment mechanism of the economy. In the short run, this adverse supply shock will reduce real GDP and increase the price level. The higher price level and recession is often referred to as **stagflation.** The recession caused by the supply shock will result in lower wages, which will shift the *SRAS* curve to the right, returning the economy to the initial long-run equilibrium. This is shown in textbook Figure 13.7.

Study Hint

It is important to understand what causes a change in aggregate demand or aggregate supply. Read *Making the Connection* "Does It Matter What Causes a Decline in Aggregate Demand?" to understand the importance of residential construction in determining the business cycle since 1955.

Making accurate macroeconomic forecasts is difficult because many factors can cause aggregate demand and aggregate supply to shift. This difficulty is illustrated by the diverse official forecasts in *Making the Connection* "How Long Does It Take to Return to Potential GDP? Economic Forecasts Following the Recession of 2007–2009."

Extra Solved Problem 13.3

Determining Growth and Inflation Rates

Supports Learning Objective 13.3: Use the aggregate demand and aggregate supply model to illustrate the difference between short-run and long-run macroeconomic equilibrium.

Draw graphs showing how, as the AD and LRAS curves shift over time, real GDP and the price level are affected.

Solving the Problem

Step 1: Review the chapter material.

This problem is about analyzing the effects of shifts in aggregate demand and aggregate supply on the price level and real GDP, so you may want to review the section "Recessions, Expansions, and Supply Shocks," which begins on page 428 of the textbook.

Step 2: Discuss how the price level and level of real GDP are determined in the long run.

The price level and the level of real GDP are determined in the long run by the levels of aggregate demand and LRAS. Over time, LRAS changes due to growth in the capital stock, growth in the number of workers, and technological change. These cause the LRAS curve to shift to the right from $LRAS_0$ to $LRAS_1$ in the graph:

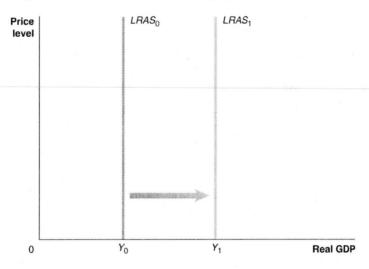

At the same time, the AD curve will also shift to the right as consumption, investment, and government purchases all increase. Combining the shifts of the LRAS and AD curves on one graph gives the following:

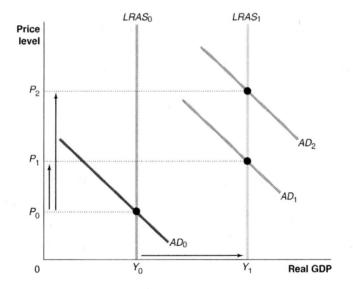

Step 3: Determine the amount of real GDP growth.

The amount of real GDP growth depends on the change in LRAS. In the case above, real GDP will grow from Y_0 to Y_1 . The shift in AD will not affect that long-run result. How much the price level rises—in other words, how high the inflation rate is—will be affected by the shift in AD. The larger the change in AD is, the higher the inflation rate. In the long run, output growth is determined by shifts in the LRAS curve, and inflation is determined by shifts in the AD curve.

A Dynamic Aggregate Demand and Aggregate Supply Model (pages 434-439)

Learning Objective: Use the dynamic aggregate demand and aggregate supply model to analyze macroeconomic conditions.

The dynamic model of aggregate demand and aggregate supply builds on the basic aggregate demand and aggregate supply model to account for two key macroeconomic facts: the economy experiences long-term growth as potential real GDP increases every year, and the economy experiences at least some inflation every year. Three changes are made to the basic model:

- Potential real GDP increases continually, shifting the *LRAS* curve to the right.
- During most years, the AD curve will also shift to the right.
- Except during periods when workers expect very high rates of inflation, the SRAS curve will also shift to the right.

Study Hint

Spend time reviewing the acetate of Figure 13.8 on page 435 of the textbook. This acetate builds the dynamic aggregate demand and aggregate supply model step by step.

The dynamic aggregate demand and aggregate supply model assumes that the LRAS curve shifts to the right each year, which represents normal long-run growth in the economy. The AD curve also typically shifts to the right each year as the components of AD change.

An example of including these changes is shown in textbook Figure 13.9. If we start at point A, the increase in LRAS and SRAS along with the shift in the AD curve will move the equilibrium to point B where the price level and the level of real GDP are both higher. If the AD curve shifts to the right more than the LRAS curve, the economy will experience both growth and inflation. If the AD and LRAS curves had shifted to the right by the same amount, the economy would have experienced growth without inflation. If the economy had suffered an adverse supply shock during the same period (with the SRAS curve shifting to the left), the price level would have increased more and real GDP would have increased less.

The dynamic aggregate demand and supply model suggests that inflation is caused by increases in total spending that are larger than increases in real GDP and by the SRAS curve shifting to the left due to higher costs. The model can shed light on the recession of 2007-2009. This recession, which began in December 2007, was due to the bursting of the housing bubble of 2002–2005. A housing bubble occurs when people become less concerned with the underlying value of a house and focus instead on expectations of the house price rising. Spending on residential construction dropped as a result of the deflating of the housing bubble, leading to a slow down in the growth of aggregate demand. Falling housing prices led to an increase in borrowers' defaults on their mortgage loans. These defaults caused banks and some major financial institutions to suffer heavy losses. The resulting financial crisis in turn led to a "credit crunch" that made it difficult for many households and firms to obtain loans they needed to finance their spending. Consumer spending and investment spending declined as a result. The severity of the 2007-2009 recession was also attributable to the rapid increase in oil prices during 2008, which resulted in a supply shock that causes the short-run aggregate supply curve to shift to the left. These changes are shown in textbook Figure 13.10, which shows the beginning of the economic recession in late 2007.

Appendix

Macroeconomic Schools of Thought (pages 447-450)

Learning Objective: Understand macroeconomic schools of thought.

There are three major alternative models to the aggregate demand and aggregate supply model. **Monetarism** emphasizes that the quantity of money should be increased at a constant rate. **New classical macroeconomics** emphasizes that workers and firms have rational expectations. The **real business cycle model** focuses on real, rather than monetary, causes of the business cycle.

Key Terms

Aggregate demand and aggregate supply model A model that explains short-run fluctuations in real GDP and the price level.

Aggregate demand (*AD***) curve** A curve that shows the relationship between the price level and the quantity of real GDP demanded by households, firms, and the government.

Fiscal policy Changes in federal taxes and purchases that are intended to achieve macroeconomic policy objectives.

Long-run aggregate supply (*LRAS*) **curve** A curve that shows the relationship in the long run between the price level and the quantity of real GDP supplied.

Menu costs The costs to firms of changing prices.

Monetary policy The actions the Federal Reserve takes to manage the money supply and interest rates to pursue macroeconomic policy objectives.

Short-run aggregate supply (*SRAS***) curve** A curve that shows the relationship in the short run between the price level and the quantity of real GDP supplied by firms.

Stagflation A combination of inflation and recession, usually resulting from a supply shock.

Supply shock An unexpected event that causes the short-run aggregate supply curve to shift.

Key Terms—Appendix

Keynesian revolution The name given to the widespread acceptance during the 1930s and 1940s of John Maynard Keynes's macroeconomic model.

Monetarism The macroeconomic theories of Milton Friedman and his followers, particularly the idea that the quantity of money should be increased at a constant rate.

Monetary growth rule A plan for increasing the quantity of money at a fixed rate that does not respond to changes in economic conditions.

New classical macroeconomics The macroeconomic theories of Robert Lucas and others, particularly the idea that workers and firms have rational expectations.

Real business cycle model A macroeconomic model that focuses on real, rather than monetary, causes of the business cycle.

Self-Test

(Answers are provided at the end of the Self-Test.)

Multiple-Choice Questions

- 1. The aggregate demand and aggregate supply model explains
 - a. the effect of changes in the inflation rate on the nominal interest rate.
 - b. short-run fluctuations in real GDP and the price level.
 - c. the effect of long-run economic growth on the standard of living.
 - d. the effect of changes in the interest rate on investment spending.
- 2. The aggregate demand curve shows the relationship between
 - a. the interest rate and the quantity of real GDP demanded.
 - b. the interest rate and the quantity of real GDP supplied.
 - c. the price level and the interest rate.
 - d. the price level and the quantity of real GDP demanded.
- 3. The wealth effect refers to the fact that
 - a. when the price level falls, the real value of household wealth rises, and so will consumption.
 - b. when income rises, consumption rises.
 - c. when the price level falls, the nominal value of assets rises, while the real value of assets remains the same.
 - d. all of the above
- 4. The interest rate effect refers to the fact that a higher price level results in
 - a. higher interest rates and higher investment.
 - b. higher interest rates and lower investment.
 - c. lower interest rates and lower investment.
 - d. lower interest rates and higher investment.
- 5. The international-trade effect refers to the fact that an increase in the price level will result in
 - a. an increase in exports and a decrease in imports.
 - b. a decrease in exports and an increase in imports.
 - c. an increase in exports and an increase in imports.
 - d. a decrease in exports and a decrease in imports.
- 6. If the price level increases, then
 - a. the economy will move up and to the left along a stationary aggregate demand curve.
 - b. the aggregate demand curve will shift to the right.
 - c. the aggregate demand curve will shift to the left.
 - d. none of the above would occur.
- 7. Which of the following factors *does not* cause the aggregate demand curve to shift?
 - a. a change in the price level
 - b. a change in government policies
 - c. a change in the expectations of households and firms
 - d. a change in foreign variables

8.	 Which of the following shifts the aggregate demand curve to the right? a. a fall in the price level b. lower interest rates c. households expecting lower future income d. falling exports
9.	Which of the following policies affects the economy through intended changes in the money supply and interest rates? a. fiscal policy b. monetary policy
	c. both fiscal and monetary policiesd. neither fiscal nor monetary policies
10.	How can government policies shift the aggregate demand curve to the right? a. by increasing personal income taxes b. by increasing business taxes c. by increasing government purchases d. all of the above
11.	If households become more optimistic about their future incomes, then a. the short-run aggregate supply curve will shift to the right. b. the short-run aggregate supply curve will shift to the left. c. the aggregate demand curve will shift to the left. d. the aggregate demand curve will shift to the right.
12.	Fill in the blanks. If real GDP in the United States increases faster than real GDP in other countries, U.S. imports will faster than U.S. exports, and net exports will a. increase; rise b. increase; fall c. decrease; rise d. decrease; fall
13.	If the exchange rate between the dollar and foreign currencies rises (the dollar rises in value versus foreign currencies), the price in foreign currency of U.S. products will and the U.S. aggregate demand curve will shift to the a. rise; right b. rise; left c. fall; right d. fall; left
14.	If net exports decrease as a result of a change in the price level in the United States, then a. the aggregate demand curve will shift to the right. b. the aggregate demand curve will shift to the left. c. both the aggregate demand curve and the short-run aggregate supply curve will shift to the right. d. neither the aggregate demand curve nor the short-run aggregate supply curve will shift.
15.	 Which of the following statements is true? a. In the long run, increases in the price level result in an increase in real GDP. b. In the long run, increases in the price level result in a decrease in real GDP. c. In the long run, changes in the price level do not affect the level of real GDP. d. In the long run, changes in the price level may either increase or decrease real GDP.

- 16. The long-run aggregate supply curve
 - a. is positively sloped.
 - b. shifts to the right as technological change occurs.
 - c. is negatively sloped.
 - d. shifts to the left as the capital stock of the country grows.
- 17. Which of the following factors will cause the long-run aggregate supply curve to shift to the right?
 - a. an increase in the number of workers in the economy
 - b. the accumulation of more machinery and equipment
 - c. technological change
 - d. all of the above
- 18. Which of the following factors will shift the short-run aggregate supply to the left?
 - a. a decrease in the price level
 - b. a decrease in the wage rate
 - c. a decrease in the cost of production
 - d. a decrease in the size of the labor force
- 19. Why does the short-run aggregate supply curve slope upward?
 - a. Profits rise when the prices of the goods and services firms sell rise more rapidly than the prices they pay for inputs.
 - b. An increase in market price results in an increase in quantity supplied, as stated by the law of supply.
 - c. As the number of workers, machinery, equipment, and technological changes increase, quantity supplied increases.
 - d. All of the above are reasons the short-run aggregate supply curve slopes upward.
- 20. If firms and workers could predict the future price level exactly, the short-run aggregate supply curve would be
 - a. downward sloping.
 - b. upward sloping.
 - c. horizontal.
 - d. the same as the long-run aggregate supply curve.
- 21. Why does the failure of workers and firms to accurately predict the price level result in an upward-sloping aggregate supply curve?
 - a. because contracts make some wages and prices "sticky"
 - b. because firms are often slow to adjust wages
 - c. because menu costs make some prices "sticky"
 - d. all of the above
- 22. Assume that cotton is the only good produced in the economy. Which of the following would explain why the short-run aggregate supply curve for cotton would be upward sloping?
 - a. Cotton demand and cotton prices begin to rise rapidly, and the wages of cotton workers rise as the demand for cotton workers increases.
 - b. Cotton demand and cotton prices begin to rise rapidly, but the price of fertilizer—an input into the production of cotton—remains fixed by contract.
 - c. Cotton demand and cotton prices begin to rise rapidly, but foreign cotton producers increase production faster than domestic cotton producers increase production.
 - d. All of the above explain why the short-run aggregate supply curve for cotton would be upward sloping.

- 23. What are menu costs?
 - a. the costs of searching for profitable opportunities
 - b. the costs associated with guarding against the effects of inflation
 - c. the costs to firms of changing prices
 - d. the costs of a fixed list of inputs
- 24. What is the impact of an increase in the price level on the short-run aggregate supply curve?
 - a. a shift of the curve to the right
 - b. a shift of the curve to the left
 - c. a movement up and to the right along a stationary curve
 - d. a combination of a movement along the curve and a shift of the curve
- 25. Which of the following causes the short-run aggregate supply curve to shift to the right?
 - a. a higher expected future price level
 - b. an increase in the actual (or current) price level
 - c. a technological change
 - d. all of the above
- 26. If all workers and firms adjust to the fact that the price level is higher than they had expected it to be,
 - a. there will be a movement up and to the right along a stationary aggregate supply curve.
 - b. there will be a movement down and to the left along a stationary aggregate supply curve.
 - c. the short-run aggregate supply curve will shift to the left.
 - d. the short-run aggregate supply curve will shift to the right.
- 27. If oil prices rise unexpectedly,
 - a. there will be a movement up and to the right along a stationary aggregate supply curve.
 - b. there will be a movement down and to the left along a stationary aggregate supply curve.
 - c. the short-run aggregate supply curve will shift to the left.
 - d. the short-run aggregate supply curve will shift to the right.
- 28. An unexpected change in the price of oil would be called by economists.
 - a. a demand shock
 - b. a supply shock
 - c. disinflation
 - d. stagflation
- 29. In the short run, a supply shock as a result of an unexpected decrease in oil prices will
 - a. increase the price level but decrease real GDP.
 - b. decrease the price level but increase real GDP.
 - c. increase both the price level and real GDP.
 - d. decrease both the price level and real GDP.
- 30. The economy is in long-run equilibrium when
 - a. the short-run aggregate supply curve and the aggregate demand curve intersect at a point to the right of the long-run aggregate supply curve.
 - b. the short-run aggregate supply curve and the aggregate demand curve intersect at a point to the left of the long-run aggregate supply curve.
 - c. the short-run aggregate supply curve and the aggregate demand curve intersect at a point on the long-run aggregate supply curve.
 - d. None of the above is true of an economy in long-run equilibrium.

- 31. If firms reduce investment spending and the economy enters a recession, which of the following contributes to the adjustment that causes the economy to return to its long-run equilibrium?
 - a. the eventual agreement by workers to accept lower wages
 - b. the decision by firms to charge higher prices
 - c. both of the above
 - d. none of the above
- 32. If the economy adjusts through the automatic mechanism, then a decline in aggregate demand causes
 - a. a recession in the short run and an increase in the price level in the long run.
 - b. a recession in the short run and a decline in the price level in the long run.
 - c. an expansion in the short run and a decline in the price level in the long run.
 - d. an expansion in the short run and an increase in the price level in the long run.
- 33. Fill in the blanks. If the economy is initially at full-employment equilibrium, then an increase in aggregate demand causes _____ in real GDP in the short run and _____ in the price level in the long run.
 - a. an increase; an increase
 - b. a decrease; a decrease
 - c. an increase; a decrease
 - d. a decrease; an increase
- 34. Stagflation is
 - a. a combination of inflation and recession.
 - b. a combination of recession and deflation.
 - c. a situation of low inflation and low unemployment.
 - d. stagnant employment during periods of expansion.
- 35. Which of the following is usually the cause of stagflation?
 - a. a reduction in government purchases
 - b. an increase in investment as a result of a reduction in interest rates
 - c. a decline in net exports as a result of a change in the exchange rate
 - d. a supply shock as a result of an unexpected increase in the price of a natural resource
- 36. After a supply shock that shifts the short-run aggregate supply (*SRAS*) curve to the left, what causes the *SRAS* to shift to the right until the long-run level of equilibrium output is reached once again?
 - a. an increase in the wages that workers earn and the prices that firms charge
 - b. workers' willingness to accept lower wages and firms' willingness to accept lower prices
 - c. an increase in government spending
 - d. a decrease in government spending
- 37. Which of the following is true about the basic or static aggregate demand and aggregate supply model?
 - a. The economy experiences continuing inflation.
 - b. The economy does not experience long-run growth.
 - c. The price level is constant and so the short-run aggregate supply is horizontal.
 - d. All of the above are true.

- 38. To turn the basic model of aggregate demand and aggregate supply into a dynamic model, which of the following assumptions must be made?
 - a. Potential real GDP increases continually, shifting the long-run aggregate supply (LRAS) curve to the right.
 - b. During most years, the aggregate demand (AD) curve will be shifting to the right.
 - c. Except during periods when workers and firms expect high rates of inflation, the short-run aggregate supply (SRAS) curve will be shifting to the right.
 - d. All of the above assumption must be made.
- 39. If no other factors that affect the SRAS curve have changed, what impact will increases in the labor force, increases in the capital stock, and technological change have on both the short-run and the long-run aggregate supply?
 - a. Over time, both the long-run aggregate supply and the short-run aggregate supply will shift to the right by the same amount.
 - b. Over time, the long-run aggregate supply will shift to the right, and the short-run aggregate supply will remain stationary.
 - c. Over time, the long-run aggregate supply will remain stationary, and the short-run aggregate supply will shift to the right.
 - d. Both the long-run aggregate supply and the short-run aggregate supply will shift to the left by the same amount.
- 40. How does the dynamic model of aggregate supply and aggregate demand explain inflation?
 - a. by showing that if total production in the economy grows faster than total spending, prices will rise
 - b. by showing that increases in labor productivity usually lead to increases in prices
 - c. by showing that if total spending in the economy grows faster than total production, prices will rise
 - d. none of the above
- 41. In the dynamic aggregate demand and supply model, which of the following is correct?
 - a. If aggregate demand increases more than aggregate supply increases, the price level will rise.
 - b. If aggregate demand and aggregate supply both increase the same amount, the price level will
 - c. If aggregate supply increases more than aggregate demand increases, the price level will rise.
 - d. If aggregate supply increases more than aggregate demand increases, the price level will not change.
- 42. The recession of 2007–2009 was caused by a decline in aggregate demand. Which factors contributed to this decline?
 - a. unexpected increases in oil prices
 - b. a "credit crunch" as a result of the collapse of major banks and other financial institutions
 - c. the corporate accounting scandals
 - d. all of the above
- 43. The increases of oil prices in 2008 are best described as shifts of the
 - a. short-run aggregate supply curve to the right.
 - b. short-run aggregate supply curve to the left.
 - c. aggregate demand curve to the right.
 - d. aggregate demand curve to the left.

- 44. The 2007–2009 recession was a clear example of
 - a. the impact that a decrease in aggregate demand can have on the economy.
 - b. the impact of a shift to the left in the long-run aggregate supply on the economy.
 - c. the impact of a positive supply shock on the economy.
 - d. all of the above.
- 45. The 1974-1975 recession was a result of
 - a. a supply shock that caused a leftward shift of the short-run aggregate supply curve.
 - b. a supply shock that caused a leftward shift of the long-run aggregate supply curve.
 - c. a housing bubble collapse that caused a leftward shift of the aggregate demand curve.
 - d. a financial crisis that caused a leftward shift of both the short-run aggregate supply curve and the aggregate demand curve.

Short Answer Questions

1.	Explain the difference between the aggregate demand curve and the demand curve for an individual product.
2.	Explain the difference between a shift of the AD curve and a movement along the AD curve.
3.	Over time, as the capital stock increases, the number of workers increases, and technology chang occurs, what happens to the <i>LRAS</i> and <i>SRAS</i> curves?
4.	Suppose the <i>AD</i> and <i>SRAS</i> curves intersect at a level of real GDP to the right of the <i>LRAS</i> curve. Show this graphically. Explain how real GDP will adjust toward potential real GDP. Show the resulting long-run equilibrium graphically.

	al e		
			10
ential real GDP, ex			
ential real GDP, ex put is different fro			

True/False Questions

- T F 1. The wealth effect suggests that a fall in the price level will increase consumption spending by households.
- T F 2. As the price level in the United States increases, exports from the United States will also increase.
- T F 3. An increase in taxes will reduce consumption and shift the AD curve to the right.
- T F 4. Because prices do not influence the level of the capital stock, the number of workers, or the level of technology in the long run, changes in the price level will not change the level of real GDP in the long run.
- T F 5. Better technology that raises labor productivity will shift the *LRAS* curve to the right.
- T F 6. When real GDP is equal to potential real GDP, there is no unemployment.
- T F 7. The *LRAS* curve is upward sloping because wages of workers rise as prices of final goods and service rise.
- T F 8. If workers expect prices to rise, the SRAS curve will shift to the left.
- T F 9. An unexpected increase in the price of an important natural resource causes a movement up a stationary *SRAS* curve.
- T F 10. Long-run macroeconomic equilibrium occurs where the AD and SRAS curves intersect at a point on the LRAS curve.
- T F 11. A decrease in AD will reduce real GDP in the short run and in the long run.
- T F 12. If real GDP is to the left of the *LRAS* curve, there will be no cyclical unemployment.
- T F 13. The adjustment from short-run to long-run equilibrium is due to government policy actions.
- T F 14. When real GDP is at the potential GDP level, then a supply shock will affect the level of real GDP in both the short run and the long run.
- T F 15. If AD grows faster than LRAS, prices will decrease.

Answers to the Self-Test

Multiple-Choice Questions

Que	estion	Answer	Comment
	1.	b	The aggregate demand and aggregate supply model explains short-run fluctuations in real GDP and the price level. As textbook Figure 13.1 shows, in this model real GDP and the price level are determined in the short run by the intersection of the aggregate demand curve and the aggregate supply curve. Fluctuations in real GDP and the price level are caused by shifts in the aggregate demand curve or in the aggregate supply curve.
	2.	d	The aggregate demand curve shows the relationship between the price level and the quantity of GDP demanded by households, firms and the government. This is shown in textbook Figure 13.1.
	3.	a	When the price level falls, the real value of household wealth rises and so will consumption. Economists refer to this impact of the price level on consumption as the wealth effect.
	4.	b	When prices rise, businesses and households need more money to finance buying and selling. A higher interest rate raises the cost of borrowing to business firms and households. As a result, firms will borrow less to build new factories or to install new machinery and equipment, and households will borrow less to buy new houses. A lower price level will have the reverse effect, leading to an increase in investment.
	5.	b	If the price level in the United States rises relative to the price levels in other countries, U.S. exports will become relatively more expensive and foreign imports will become relatively less expensive. Some consumers in foreign countries will shift from buying U.S. products to buying domestic products, and some U.S. consumers will also shift from buying U.S. products to buying imported products. U.S. exports will fall and U.S. imports will rise, causing net exports to fall. A lower price level in the United States has the reverse effect, causing net exports to rise.
	6.	a	If the price level rises but other factors that affect the willingness of households, firms, and the government to spend are unchanged, then the economy will move up a stationary aggregate demand curve.
	7.	a	The factors that cause the aggregate demand curve to shift fall into three categories: changes in government policies, changes in the expectations of households and firms, and changes in foreign factors. Changes in the price level causes a movement along the aggregate demand curve, not a shift.
	8.	b	Lower interest rates reduce the cost of borrowing so that consumption and investment spending increase, resulting in a shift of the AD curve to the right. A price level change causes a movement along the AD curve rather than a shift in the curve.
	9.	b	The federal government uses monetary policy and fiscal policy to shift the aggregate demand curve. Monetary policy involves changes in interest rates, and fiscal policy involves changes in government purchases and taxes.

Question	Answer	Comment
10.	c	Because government purchases are one component of aggregate demand, an increase in government purchases shifts the aggregate demand curve to the right. An increase in personal income taxes reduces disposable income available to households. This reduces consumption spending and shifts the aggregate demand curve to the left. Lower personal income taxes shift the aggregate demand curve to the right. Increases in business taxes reduce the profitability of investment spending and shift the aggregate demand curve to the left. Decreases in business taxes shift the aggregate demand curve to the right.
11.	d	If households become more optimistic about their future incomes, they are likely to increase their current consumption. This will shift the aggregate demand curve to the right.
12.	b	When real GDP increases, so does the income available for consumers and businesses to spend. If real GDP in the United States increases faster than real GDP in other countries, U.S. imports will increase faster than U.S. exports, and net exports will fall. This happened in the late 1990s and early 2000s.
13.	b	Net exports will fall if the exchange rate between the dollar and foreign currencies rises because the price in foreign currency of U.S. products sold in other countries will rise, thereby lowing exports, and the dollar price of foreign products sold in the United States will fall, which increases U.S. imports. Consequently, net exports will fall. A decrease in net exports at every price level will shift the <i>AD</i> curve to the left.
14.	d	A change in the U.S. domestic price level causes a movement along the U.S. aggregate demand curve, not a shift. Therefore, a change in net exports caused by a change in the price level in the United States will <i>not</i> cause the aggregate demand curve to shift. Neither will it cause the short-run aggregate supply curve to shift.
15.	С	In the long run, changes in the price level do not affect the level of real GDP. Textbook Figure 13.2 illustrates the fact that in the long run, changes in the price level do not affect real GDP by showing the long-run aggregate supply curve (<i>LRAS</i>) as a vertical line.
16.	b	The long-run aggregate supply curve is vertical and shifts to the right with increases in capital, labor, and technology.
17.	d	The long-run aggregate supply curve and potential real GDP increase each year as the number of workers in the economy increases, the economy accumulates more machinery and equipment, and technological improvement occurs.
18.	d	A price level change will cause a movement along the short-run aggregate supply curve, while decreasing costs of production and lower wages will cause the curve to shift to the right. A decrease in the size of the labor force will cause the curve to shift to the left.

Question	Answer	Comment
19.	a	The short-run aggregate supply curve (<i>SRAS</i>) slopes upward because, as prices of final goods and services rise, prices of inputs—such as the wages of workers—rise more slowly. Profits rise when the prices of the goods and services firms sell rise more rapidly than the prices they pay for inputs. Therefore, a higher price level leads firms to supply more goods and services. A secondary reason the <i>SRAS</i> curve slopes upward is that as the price level rises or falls, some firms are slow to adjust their prices. A firm that is slow to raise its prices when the price level is increasing may find its sales increasing and will increase production.
20.	d	It is impossible for each firm and every individual to correctly predict the future price level. If they could, the short-run aggregate supply curve would be the same as the long-run aggregate supply curve. Most economists agree that the short-run aggregate supply curve slopes upward because workers and firms cannot accurately predict the future price level.
21.	d	Most economists agree that the short-run aggregate supply curve slopes upward because workers and firms fail to accurately predict the future price level. Economists are not in complete agreement on why this is true, but the three most common explanations are: contracts make some wages and prices "sticky," businesses are often slow to adjust wages, and menu costs make some prices sticky.
22.	b	If steel demand and steel prices begin to rise rapidly, producing additional steel will be profitable because coal prices will remain fixed by contract. In both of these cases, rising prices lead to higher output. If these examples are representative of enough firms in the economy, then a rising price level should lead to a greater quantity of goods and services supplied. In other words, the short-run aggregate supply curve will be upward sloping. If the workers of the coal companies had accurately predicted what would happen to prices, this would have been reflected in the contracts, and the steel mill would not have earned greater profits when prices rose. In that case, rising prices would not have led to higher output.
23.	c	If demand for their products is higher or lower than they had expected, firms may want to charge prices different from the ones printed in their menus or catalogs. Changing prices would be costly, however, because it would involve printing new menus or catalogs. The costs to firms of changing prices are called menu costs.
24.	С	If the price level changes, but other factors are unchanged, then the economy will move up or down a stationary aggregate supply curve. If any factor other than the price level changes, the aggregate supply curve will shift.
25.	с	As technology improves, the productivity of workers and machinery increases, which means that firms can produce more goods and services with the same quantities of labor and capital. This reduces their costs of production and allows them to produce more output at every price level. As a result, the short-run aggregate supply curve shifts to the right.
26.	С	If workers and firms across the economy are adjusting to the price level being higher than expected, they will require higher wages for the same work. This puts upward pressure on prices and the short-run aggregate supply curve will shift to the left. If they are adjusting to the price level being lower than expected, the short-run aggregate supply curve will shift to the right.

Question	Answer	Comment
27.	c	If oil prices rise unexpectedly, the costs of production will rise for many firms. Some utilities also burn oil to generate electricity, so electricity prices will rise. Rising oil prices lead to rising gasoline prices, which raises transportation costs for many firms. Oil is a key input to manufacturing plastics and artificial fibers, so costs will rise for many other products. Because many firms face rising marginal production costs, they will supply the same level of output only at higher prices, and the short-run aggregate supply curve will shift to the left.
28.	b	Economists refer to an unexpected increase or decrease in the price of an important raw material as a supply shock.
29.	b	An unexpected decrease in oil prices shifts the short-run aggregate supply curve to the right, resulting in a lower price level and higher real GDP.
30.	c	When the short-run aggregate supply curve and the aggregate demand curve intersect at a level of real GDP that is above or below the level of potential GDP represented by the long-run aggregate supply curve (<i>LRAS</i>), the economy will adjust back toward the <i>LRAS</i> . Only when the short-run aggregate supply curve intersects the aggregate demand curve at a point on the <i>LRAS</i> is the economy in long-run equilibrium. Long-run equilibrium is shown in textbook Figure 13.4.
31.	a	The decrease in aggregate demand initially leads to a short-run equilibrium with a lower price level and GDP below potential. Workers and firms will begin to adjust to the price level being lower than they had expected it to be. Workers will be willing to accept lower wages—because each dollar of wages is able to buy more goods and services—and firms will be willing to accept lower prices. In addition, the unemployment resulting from the recession will make workers more willing to accept lower wages, and the decline in demand will make firms more willing to accept lower prices. This causes the short-run aggregate supply curve to shift to the right.
32.	b	An important point to notice is that a decline in aggregate demand causes a recession in the short run, but in the long run, it causes only a decline in the price level. Economists refer to the process of adjustment back to full employment just described as an automatic mechanism because it occurs without any actions by the government.
33.	a	In the short run, an increase in aggregate demand causes an increase in real GDP as a result of a rightward shift of the AD curve. In the long run, it causes only an increase in the price level as the SRAS curve shifts to the left.
34.	a	Stagflation is defined as a combination of inflation and recession.
35.	d	Stagflation, a combination of inflation (higher prices) and recession, occurs when the short-run aggregate supply curve shifts left. This type of shift usually results from an adverse supply shock.
36.	b	The recession caused by the supply shock increases unemployment and reduces output. This eventually results in workers being forced to accept lower wages and firms being forced to accept lower prices. Lower wages cause the short-run aggregate supply curve to shift back to the long-run equilibrium output at full employment.

Question	Answer	Comment
37.	b	The basic aggregate demand and aggregate supply model gives us important insights into how short-run macroeconomic equilibrium is determined. Unfortunately, the model relies on two assumptions: (1) The economy does not experience continuing inflation, and (2) the economy does not experience long-run growth.
38.	d	The economy is not static, with an unchanging level of full-employment real GDP and no continuing inflation. Real economies are dynamic, with growing potential GDP and ongoing inflation. We can create a dynamic aggregate demand and aggregate supply model by making three changes to the basic model: (1) The full-employment level of real GDP increases continually, shifting the long-run aggregate supply ($LRAS$) curve to the right; (2) during most years, the aggregate demand (AD) curve will be shifting to the right; and (3) except during periods when workers and firms expect high rates of inflation, the short-run aggregate supply ($SRAS$) curve will be shifting to the right.
39.	a	Increases in the labor force and the capital stock and technological change cause both the long-run aggregate supply curve and the short-run aggregate supply curve to shift. If no other factors that affect the <i>SRAS</i> curve have changed, the <i>LRAS</i> and <i>SRAS</i> curves will shift to the right by the same amount.
40.	c	The dynamic aggregate demand and aggregate supply model provides a more accurate explanation than the basic model of the source of most inflation. Figure 13.9 shows that if total spending in the economy grows faster than total production, prices rise. If the <i>AD</i> curve shifts to the right by more than the <i>LRAS</i> curve, inflation will result because equilibrium will occur at a higher price level.
41.	a	In a growing economy, prices rise when aggregate demand grows more than aggregate supply.
42.	ь	A "credit crunch" among major banks and other financial institutions made it difficult for consumers to finance their spending, leading to declines in consumption and investment spending. Other factors that led to a decline in aggregate demand include the ending of the housing bubble of 2002–2005, leading to a decline in spending on residential construction, which is part of investment spending.
43.	b	Increases in oil prices, such as those in 2008, are considered as adverse supply shocks. An adverse supply shock causes a shift of the short-run aggregate supply curve to the left. This contributed to the severity of the 2007–2009 recession.
44.	a	The 2007–2009 recession provides a clear example of the impact of a decline in aggregate demand on the economy. Following the end of the housing bubble, spending on residential construction declined sharply. The collapse of the housing market also caused a crisis in the financial sector, which in turn led to a "credit crunch" that led to declines in consumption and investment spending.
45.	a	The 1974–1975 recession was a result of an oil shock that shifted the short-run supply curve to the left. See <i>Solved Problem 13.4</i> in the textbook.

Short Answer Responses

- 1. Though the demand curve for an individual product and the AD curve look alike, they are very different. On the individual product demand curve, as the price changes, all other prices are held constant. On the AD curve, all prices are changing together.
- 2. A change in the price level (the GDP deflator) will cause a movement along the AD curve. As the price level increases, the quantity demand of real GDP falls because of the wealth effect, the interest-rate effect, and the international-trade effect. The AD curve shifts when something happens that changes demand for real GDP at each price level, such as a change in government purchases, investment spending, or net exports.
- 3. Over time as the capital stock increases, the number of workers increases, and technology changes, firms can produce more output. This is seen as a shift in the *LRAS* curve to the right. As this happens the *SRAS* curve also shifts out, reflecting the notion that firms can produce more with fewer resources. This is shown in the graph below.

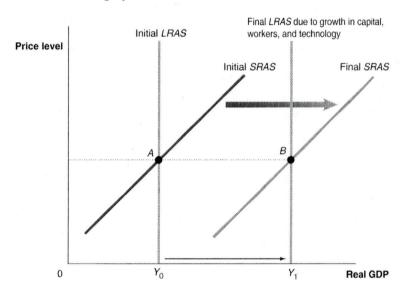

As this growth occurs, other economic variables may also change, so the shift in the *SRAS* curve could be larger or smaller than that shown above. For example, if a supply shock occurred, the new *SRAS* curve would not shift as far to the right as shown above.

4. The initial equilibrium, with the AD and SRAS curves together at an output level to the right of the LRAS curve, would look like:

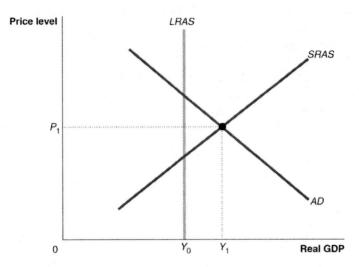

With the SRAS and AD curves above, the short-run equilibrium would be at P_1 and Y_1 . Because this level of real GDP is above potential real GDP, eventually wages will start to rise. This increase in wages will shift the SRAS curve to the left. The SRAS curve will continue to shift to the left until real GDP returns to the level of potential real GDP, Y_0 . This is the automatic adjustments mechanism. The final equilibrium is shown in the graph below.

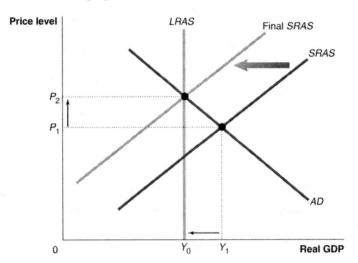

5. Over time, both the AD curve and the LRAS curve will shift to the right. What happens to the price level depends on the increase in demand relative to the increase in supply. Shown below are three possibilities. If the AD curve shifts to the right more than the LRAS curve $(AD_0 \rightarrow AD_1)$, the price level will rise from P_0 to P_1 , so there will be inflation. If the AD curve shifts the same as the LRAS curve $(AD_0 \rightarrow AD_2)$, prices will not change. If the AD curve shifts to the right less than the LRAS curve $(AD_0 \rightarrow AD_3)$, then the price level will fall from P_0 to P_2 , so there will be deflation.

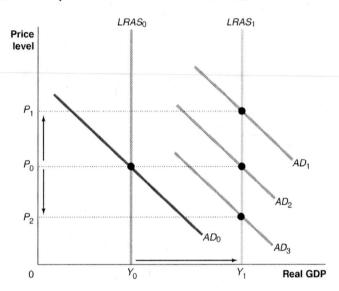

Because we observe over time that both the price level and real GDP generally increase, we can conclude that AD usually increases more that LRAS.

6. In the short run, the increase in AD will result in a higher price level and a higher level of output. This extra production pushes the economy above potential real GDP. At this higher level of production above potential, costs of producing will begin to rise. These higher costs will in the long run cause the SRAS curve to shift to the left, eventually returning the economy to potential real GDP. In the short run, with costs fixed, output can rise from an increase in aggregate demand. In the long run, as costs adjust upward, the level of real GDP returns to potential GDP.

True/False Answers

Question	Answer	Comment
1.	T	See page 415 in the textbook for the definition of the wealth effect.
2.	F	As U.S. prices rise, all other things (prices in other countries) equal, U.S. goods get more expensive, causing exports to fall.
3.	F	Higher taxes will reduce consumption but shift AD to the left.
4.	T	See page 422 in the textbook for the concept of the short-run aggregate supply (SRAS) curve.
5.	T	Better technology that raises labor productivity will increase potential real GDP, and so the <i>LRAS</i> curve shifts to the right.
6.	F	At potential real GDP there is both structural and frictional unemployment.
7.	F	The <i>LRAS</i> curve is vertical because changes in the price level do not affect the level of real GDP in the long run.

350 CHAPTER 13 | Aggregate Demand and Aggregate Supply Analysis

Question	Answer	Comment
8.	T	If workers expect prices to rise, they will bargain for higher wages, which will push costs upward.
9.	F	A supply shock causes the SRAS curve to shift.
10.	T	See textbook Figure 13.4.
11.	F	A change in AD will only change real GDP in the short run.
12.	F	At output to the left of the LRAS curve, there will be cyclical unemployment.
13.	F	The automatic adjustment from short-run to long-run equilibrium is due to the adjustment of input prices.
14.	F .	A supply shock affects real GDP only in the short run. In the long run, the economy returns to potential GDP.
15.	F	If AD grows faster than LRAS, prices will rise.

CHAPTER 14 | Money, Banks, and the Federal Reserve System

Chapter Summary and Learning Objectives

14.1 What Is Money, and Why Do We Need It? (pages 454–457)

Define money and discuss the four functions of money. A barter economy is an economy that does not use money and in which people trade goods and services directly for other goods and services. Barter trade occurs only if there is a double coincidence of wants, where both parties to the trade want what the other one has. Because barter is inefficient, there is strong incentive to use money, which is any asset that people are generally willing to accept in exchange for goods or services or in payment of debts. An asset is anything of value owned by a person or a firm. Commodity money is a good used as money that also has value independent of its use as money. Money has four functions: It is a medium of exchange, a unit of account, a store of value, and a standard of deferred payment. The gold standard was a monetary system under which the government produced gold coins and paper currency that were convertible into gold. The gold standard collapsed in the early 1930s. Today, no government in the world issues paper currency that can be redeemed for gold. Instead, paper currency is fiat money, which has no value except as money.

14.2 How Is Money Measured in the United States Today? (pages 457–461)

Discuss the definitions of the money supply used in the United States today. The narrowest definition of the money supply in the United States today is M1, which includes currency, checking account balances, and traveler's checks. A broader definition of the money supply is M2, which includes everything that is in M1, plus savings accounts, small-denomination time deposits (such as certificates of deposit [CDs]), money market deposit accounts in banks, and noninstitutional money market fund shares.

14.3 How Do Banks Create Money? (pages 461–469)

Explain how banks create money. On a bank's balance sheet, reserves and loans are assets, and deposits are liabilities. **Reserves** are deposits that the bank has retained rather than loaned out or invested. **Required reserves** are reserves that banks are legally required to hold. The fraction of deposits that banks are required to keep as reserves is called the **required reserve ratio**. Any reserves that banks hold over and above the legal requirement are called **excess reserves**. When a bank accepts a deposit, it keeps only a fraction of the funds as reserves and loans out the remainder. In making a loan, a bank increases the checking account balance of the borrower. When the borrower uses a check to buy something with the funds the bank has loaned, the seller deposits the check in his bank. The seller's bank keeps part of the deposit as reserves and loans out the remainder. This process continues until no banks have excess reserves. In this way, the process of banks making new loans increases the volume of checking account balances and the money supply. This money creation process can be illustrated with T-accounts, which are stripped-down versions of balance sheets that show only how a transaction changes a bank's balance sheet. The **simple deposit multiplier** is the ratio of the amount of deposits created by banks to the amount of new reserves. An expression for the simple deposit multiplier is 1/RR.

14.4 The Federal Reserve System (pages 469–475)

Discuss the three policy tools the Federal Reserve uses to manage the money supply. The United States has a fractional reserve banking system in which banks keep less than 100 percent of deposits as reserves. In a bank run, many depositors decide simultaneously to withdraw money from a bank. In a bank panic, many banks experience runs at the same time. The Federal Reserve System ("the Fed") is the central bank of the United States. It was originally established in 1913 to stop bank panics, but today its main role is to carry out monetary policy. Monetary policy refers to the actions the Federal Reserve takes to manage the money supply and interest rates to pursue macroeconomic policy objectives. The Fed's three monetary policy tools are open market operations, discount policy, and reserve requirements. Open market operations are the buying and selling of Treasury securities by the Federal Reserve. The loans the Fed makes to banks are called discount loans, and the interest rate the Fed charges on discount loans is the discount rate. The Federal Open Market Committee (FOMC) meets in Washington, D.C., eight times per year to discuss monetary policy. In the past 20 years, a "shadow banking system" has developed. During the financial panic of 2008, the existence of the shadow banking system complicated the Fed's policy response. A security is a financial asset—such as a stock or a bond—that can be bought and sold in a financial market. The process of securitization involves creating a secondary market in which loans that have been bundled together can be bought and sold in financial markets just as corporate or government bonds are.

14.5 The Quantity Theory of Money (pages 475–478)

Explain the quantity theory of money and use it to explain how high rates of inflation occur. The quantity equation that relates the money supply to the price level is: $M \times V = P \times Y$, where M is the money supply, V is the velocity of money, P is the price level, and Y is real output. The velocity of money is the average number of times each dollar in the money supply is spent during the year. Economist Irving Fisher developed the quantity theory of money, which assumes that the velocity of money is constant. If the quantity theory of money is correct, the inflation rate should equal the rate of growth of the money supply minus the rate of growth of real output. Although the quantity theory of money is not literally correct because the velocity of money is not constant, it is true that in the long run, inflation results from the money supply growing faster than real GDP. When governments attempt to raise revenue by selling large quantities of bonds to the central bank, the money supply will increase rapidly, resulting in a high rate of inflation.

Chapter Review

Chapter Opener: Washing Dollar Bills to Save the Economy of Zimbabwe (page 453)

Today our money has value not because of the materials used to make it, but because people have confidence that if they accept it, they will be able to use it to purchase other goods and services. When people lack confidence in their money, there are serious macroeconomic consequences. One of those consequences is inflation, which can be so high that is called a *hyperinflation*. Recently in Zimbabwe, the public lost confidence in its official currency, the Zimbabwean dollar, as a result of hyperinflation. The OK Mart supermarket was one of the Zimbabwean businesses that could not obtain the U.S. dollars it needed to import goods from foreign suppliers who refused to accept Zimbabwean dollars. Hyperinflation ended after the government eventually made the U.S. dollar the country's official currency.

14.1

What Is Money and Why Do We Need It? (pages 454–457)

Learning Objective: Define money and discuss the four functions of money.

Money is an asset that people are generally willing to accept in exchange for goods and services or payments of debts. Economies where goods and services are traded for other goods and services are called barter economies. Societies evolve from barter economies to economies that use money for transactions. Money serves several functions.

- Medium of exchange. Money is the asset that we use to buy goods and services. In the United States, we buy and sell goods and services using dollars.
- Unit of account. All goods and services are priced in terms of money. In the United States, goods and services are priced in dollars.
- Store of value. Dollars not spent on goods and services in one time period can be held for use in the future.
- Standard for deferred payments. In the United States, contracts involving future payments are usually written specifying payment in dollars.

For an asset to serve as a medium of exchange, it must be generally acceptable, of standardized quality, durable, valuable relative to its weight, and divisible. At one time, all money was commodity money. Commodity money has usefulness as money or as a commodity (such as a gold coin, which can be used as a coin or as jewelry). **Commodity money** can be awkward to use and inefficient, so all countries have replaced commodity money with fiat money. **Fiat money**, such as dollar bills in the United States, has no value as a commodity and is money because it has been declared money by the government and because people have confidence in it.

Study Hint

Read *Making the Connection* "Apple Didn't Want My Cash!" to learn about the fact although Federal Reserve Notes are legal tender of the United States, businesses like Apple do not have to accept them as payment for goods and services.

Extra Solved Problem 14.1

Unit of Account and the Number of Unique Prices

Supports Learning Objective 14.1: Define money and discuss the four functions of money.

One of the functions of money is to serve as a unit of account. The prices of goods are expressed in terms of the thing we call money. This makes comparisons easier. Suppose music CDs cost \$10, and DVDs cost \$20. So, we can say DVDs cost twice as much as CDs. Without money, each good would have to be priced in terms of all other goods. If an economy has 100 different goods, how many prices will there be in this system?

Solving the Problem

Step 1: Review the chapter material.

This problem is about the function of money called unit of account, so you may want to review the section "The Functions of Money," which begins on page 455 in the textbook.

Step 2: Calculate the number of prices.

If the economy had three goods, A, B, and C, then there would be a price between A and B, between A and C, and between B and C, or three unique prices. For more than three goods, the formula we would use is $n \times [(n-1)/2]$, where n is the number of goods, so in an economy with 100 goods, the number of unique prices is $100 \times (99/2) = 4,950$ prices. Each good would have a price tag with 99 different prices written on it.

14.2

How Is Money Measured in the United States Today? (pages 457–461) Learning Objective: Discuss the definitions of the money supply used in the United States today.

In the United States, the Federal Reserve System uses two definitions of the money supply. The two definitions of money are based on the different functions of money. The current definitions of money are:

M1, which includes:

- currency—all the paper money and coins in circulation (in circulation means not held by banks or the government),
- checking account balances at banks, and
- the value of outstanding traveler's checks.

M2, which includes:

- M1.
- savings accounts and small (less than \$100,000) time deposits accounts, such as certificates of deposit (CDs).
- money market deposit accounts at banks, and
- noninstitutional money market share funds.

The M1 definition of money is more closely related to the function of money as a medium of exchange, while the M2 definition of money adds assets that are thought of as stores of value. We can write checks against M1 checking account deposits, but we can't write checks against savings accounts and CDs. Because checking accounts are a part of M1, banks play an important role in determining the supply of money and how the supply of money changes.

Even though many people use credit cards for transactions today, credit cards are not included in definitions of money supply. The reason is that when you charge a credit card, you are in effect taking a loan from the bank that issued that credit card. Only when you pay your credit card is the transaction complete.

M Study Hint

Read the feature *Don't Let this Happen to You* in this section for tips on how to distinguish income from wealth. Remember that we use money to measure income and wealth. Someone who has wealth of \$10 million may not have \$10 million of the medium of exchange but has assets that when valued in money terms (for instance, they may own a house worth \$500,000) add up to \$10 million.

Making the Connection "Are Bitcoins Money?" explains that policymakers are concerned about Bitcoin and other forms of e-money, like PayPal. Policymakers are concerned that those forms of e-money can be used by criminals to disguise movements of cash.

How Do Banks Create Money? (pages 461–469) Learning Objective: Explain how banks create money.

In the United States, checking account deposit balances are about half of M1. Checking accounts at banks are owned by households, business firms, and the government. One way to look at bank operations is to look at a bank's balance sheet. The balance sheet lists what the bank owns (assets), what the bank owes (liabilities), and its stockholders' equity. The bank's net worth is the difference between the values of the bank's assets and the value of its liabilities. By definition, then:

Assets = Liabilities + Stockholders' equity.

A sample balance sheet for a bank, Andover Bank, might look as follows with assets listed on the left-hand side and liabilities and stockholders' equity on the right-hand side (values are in thousands of dollars):

Assets		Liabilities and Stockholders' Equity					
Reserves	\$2,737	Deposits	\$69,380				
Loans and Securities	87,908	Short-Term Borrowing	3,217				
Buildings	2,142	Long-Term Borrowing	12,558				
Other Assets	7,882	Other Liabilities	5,492				
		Total Liabilities	90,647				
		Stockholders' Equity	10,022				
		Total Liabilities and					
Total Assets	\$100,669	Stockholders' Equity	\$100,669				

Banks do not keep all their deposits as cash. Most banks are required by law to keep 10 percent of their deposits either physically in the bank, as vault cash, or on deposit at their regional Federal Reserve Bank. Vault cash plus deposits at the Fed are called the bank's **reserves**. Reserves are deposits that have not been loaned out or used to purchase securities. The amount of reserves a bank must keep, called **required reserves**, is determined by the **required reserve ratio** (*RR*). If a bank has more reserves than required, these reserves are called **excess reserves**.

Excess reserves = Reserves – Required reserves

We can use a T-account to look at changes in a bank's balance sheet. A T-account is a stripped down version of a balance sheet that shows only how a transaction changes a bank's balance sheet. Suppose that someone deposits \$5,000 in currency in her checking account. The bank now has additional deposits and additional reserves, both equal to \$5,000. The balance sheet's changes are shown in the T-account below:

	Andove	er Bank	
Assets		Liab	ilities
Reserves	+\$5,000	Deposits	+\$5,000

Banks are required to keep only 10 percent of their deposits as reserves. In this case, required reserves will increase by \$500 ($$500 = 0.1 \times $5,000$). This bank now has \$4,500 in excess reserves; that is, reserves over and above the level of required reserves. The bank can use these funds to grant loans or purchase securities. If the bank loans \$4,500 to an individual, the bank will deposit \$4,500 in the borrower's checking account. After this loan, the changes in the bank's balance sheet look like this:

Andov	ver Bank	
sets	Lial	oilities
+\$5,000	Deposits	+\$5,000
+\$4,500	Deposits	+\$4,500
	sets +\$5,000	+\$5,000 Deposits

When the person who received the loan purchases goods and services using a check written against the deposits created by the loan, then Andover Bank loses reserves to another bank. Andover Bank loses these reserves because the check written by the borrower will be presented to Andover Bank for payment by the bank that receives the check. The changes in Andover Bank's balance sheet will then look like this:

	Andov	er Bank	
Ass	sets	Liab	ilities
Reserves	+ \$500	Deposits	+\$5,000
Loans	+\$4,500		

If we assume the bank that receives the check is Bank of America, then Bank of America's balance sheet will also change:

	Bank of	America	
Ass	ets	Liab	ilities
Reserves	+\$4,500	Deposits	+\$4,500

Bank of America now has excess reserves of \$4,050, because it needs to keep only 10 percent of its new deposit of \$4,500 as reserves ($$4,500 - (0.01 \times $4,500) = $4,050$). Suppose Bank of America grants a loan for the amount of their excess reserves. Then the changes in Bank of America's balance sheet will look like this:

	Bank of	America	
Ass	ets	Liab	ilities
Reserves Loans	+\$4,500 +\$4,050	Deposits Deposits	+\$4,500 +\$4,050

This loan created new deposits and new money of \$4,050. After the funds for that loan are used and a check in that amount is presented to Bank of America for payment, the changes in that bank's balance sheet will look like this:

	Bank of	America		
Assets		Liabilities		
Reserves	+ \$450	Deposits	+\$4,500	
Loans	+\$4,050			

The \$4,050 of reserves that are lost by Bank of America are gained by another bank. This bank will be able to loan (and create new money of) \$3,645. This process of loans being made and new checking account deposits being created continues through many banks in the economy. We can summarize the results in the following table:

Bank	Increase in Checking Account Deposits
Andover Bank	\$5,000.00
Bank of America	\$4,500.00 (= 0.9 x \$5,000)
The Third Bank	\$4,050.00 (= 0.9 x \$4,050)
The Fourth Bank	\$3,645.00 (= 0.9 x \$4050)
The Fifth Bank	\$3,280.50 (= 0.9 x \$3,645)
- 17 ·	
•	•
•	
Total Change in Checking Accounts	\$50,000

The end result can be computed with the formula:

$$\Delta D = \frac{1}{RR} \times \Delta R,$$

where ΔD is the total change in checking account deposits, ΔR is the change in reserves, and (1/RR) is the **simple deposit multiplier.** In this example, the change in reserves was \$5,000, and with a required reserve ratio (RR) of 10 percent, which implies a simple deposit multiplier of 10 (10 = 1/0.10), the change in deposits is:

$$\Delta D = \frac{1}{0.1} \times \$5,000 = \$50,000.$$

The real world increase in the money supply as a result of an increase in bank reserves is much smaller than the increase shown by the simple deposit multiplier. This is because some reserves leave the banking system when the public takes currency from their checking accounts and because banks sometimes hold excess reserves.

The important point is that whenever banks gain reserves, they make new loans, and the money supply expands. Whenever banks lose reserves, they reduce loans, and the money supply contracts.

Study Hint

The discussion of money creation involves looking at a bank's T-account, in which assets are listed on the left and liabilities are listed on the left. Read the feature *Don't Let this Happen to You* in this section for tips on how to distinguish between assets and liabilities. In particular, checking account deposits are a bank's liability, and a bank loan is the bank's asset.

Extra Solved Problem 14.3

Determining Actual, Excess, and Required Reserves

Supports Learning Objective 14.3: Explain how banks create money.

Suppose that Lehigh Bank has \$500,000 in deposits and \$60,000 in reserves. If the required reserve ratio for the bank is 10 percent, determine the level of actual, required, and excess reserves.

Solving the Problem

Step 1: Review the chapter material.

This problem is about bank reserves, so you may want to review the section "How Do Banks Create Money?" which begins on page 461 of the textbook.

Step 2: Determine the level of actual and required reserves.

Actual reserves represent the amount of vault cash and deposits that the bank has at the Federal Reserve. Actual reserves are determined from the bank's balance sheet. For Lehigh Bank, actual reserves are \$60,000. Required reserves are calculated from the level of deposits and the required reserve ratio. The formula for required reserves is:

Required reserves = Required reserve ratio \times deposits.

Given that Lehigh Bank has \$500,000 in deposits:

Required reserves = $0.10 \times \$500,000 = \$50,000$.

Step 3: Determine the level of excess reserves.

To meet the Fed's requirements, Lehigh Bank must keep \$50,000 as reserves. Any reserves that the bank has above the level of required reserves are called excess reserves. Excess reserves are calculated with the formula:

Excess reserves = Actual reserves – required reserves.

So for Lehigh Bank,

Excess reserves = \$60,000 - \$50,000 = \$10,000.

Lehigh Bank has \$10,000 in reserves above the required level. The bank can use these reserves to make loans or buy securities, allowing the bank to earn interest and increase its revenues.

14.4

The Federal Reserve System (pages 469–475)

Learning Objective: Discuss the three policy tools the Federal Reserve uses to manage the money supply.

The **Federal Reserve System** (or the Fed) is the central bank for the United States. Congress created the Federal Reserve System in 1913. Congress divided the country into 12 Federal Reserve districts, each with a Federal Reserve Bank that provides services to banks in that district. The Board of Governors was created to oversee the system. The Board of Governors has seven members, who are appointed by the

President to 14-year, nonrenewable terms. Look at Figure 14.3 on page 470 in the textbook for a map showing the 12 Federal Reserve districts.

As part of **monetary policy**, the Fed has the task of managing the U.S. money supply. The Fed has three monetary policy tools: open market operations, discount policy, and reserve requirements.

Open market operations is the buying and selling of Treasury securities, such as Treasury bills. Eight times per year the **Federal Open Market Committee (FOMC)** meets in Washington, D.C., to discuss monetary policy. When the FOMC orders an open market purchase, the payment it makes for the securities puts more reserves in the banking system. When banks make new loans with these new reserves, the level of deposits and the money supply will increase. When the Fed sells securities, the payment for the securities by the public takes reserves out of the banking system and causes the money supply to fall.

Study Hint

When the Fed carries out an open market purchase by buying securities from the public, the amount of bank reserves and the amount of money supply will increase. Pay attention to the changes in the T-account of the banking system and the changes in the T-account of the Fed in this section as a result of an open market purchase of \$10 million. When the Fed carries out an open market sale by selling securities to the public, the amount of bank reserves and the amount of money supply will decrease.

Banks can borrow from the Fed. Loans from the Fed to banks are called **discount loans** and occur at an interest rate called the **discount rate.** The Fed sets the discount rate at the FOMC meetings. The Fed serves as a lender of last resort for banks and is willing to lend to banks when banks cannot borrow elsewhere. Making **discount loans** can help stop **bank runs** and **bank panics**, which occur when many depositors decide simultaneously to withdraw their deposits.

Most banking systems (including the U.S. banking system) are **fractional reserve banking systems** in which banks keep less than 100 percent of their deposits as reserves. U.S. banks keep only about 10 percent of their deposits as reserves. The Fed's reserve policy determines the fraction of deposits banks must keep. These reserves are kept in the bank as vault cash or as deposits at the Fed. The Fed changes the required reserve ratio infrequently.

The Fed, in combination with the U.S. Treasury, responded aggressively to the financial panic of 2008. As a housing bubble burst in 2007 and house prices began to fall, a large number of borrowers began to default on their mortgages. Many commercial banks had securitized their mortgage loans to firms in the shadow banking system rather than keeping the loans until they were paid off. Securitization is a process of transforming loans or other financial assets into securities. The shadow banking system includes nonbank financial firms like investment banks, money market mutual funds, and hedge funds that purchase mortgage-backed securities from commercial banks. As houses' prices began to fall, a large number of borrowers began to default on their mortgages, which in turn caused the values of mortgagebacked securities to fall. Commercial firms and many firms in the shadow banking system suffered heavy losses as a result. The Fed or other government agencies did not regulate those firms in the shadow banking system, which relied more heavily on borrowed money to finance their operations than did commercial banks. In early 2008, the Fed saved the investment bank Bear Stearns by making arrangements for it to be acquired by JP Morgan Chase. Another major investment bank, Lehman Brothers, failed later but the Fed and the U.S. Treasury decided not to take any action. The failure of Lehman Brothers set off a panic in the financial system. In the fall of 2008, under the Troubled Asset Relief Program (TARP), the Fed and Treasury began attempting to stabilize the commercial banking

Extra Solved Problem 14.4

Open Market Operations and Changes in the Supply of Money

Supports Learning Objective 14.4: Discuss the three policy tools the Federal Reserve uses to manage the money supply.

Suppose that the Federal Reserve would like to increase the money supply by \$500,000. How can the Fed use open market operations to bring about a \$500,000 increase in the money supply? Assume the required reserve ratio is 10 percent.

Solving the Problem

Step 1: Review the chapter material.

This problem is about the Fed using open market operations, so you may want to review the section "The Federal Reserve System," which begins on page 469 in the textbook.

Step 2: Determine the level of deposits that can be created from an increase in reserves.

When the Federal Reserve uses open market operations to increase the supply of money, it buys Treasury bills from the public. When the public deposits the proceeds from these Treasury bill sales into their banks, the level of deposits and the level of reserves increase in the banking system. The level of deposits that can be created from a given amount of reserves is determined by the formula:

$$\Delta D = \frac{1}{RR} \times \Delta R,$$

where ΔD is the change in deposits, ΔR is the change in reserves, and RR is the required reserve ratio.

Step 3: Calculate the change in reserves needed.

Using the 10 percent required reserve ratio (RR = 0.10), if the Fed would like to increase the money supply by \$500,000, then the desired change in deposits is \$500,000. We can use the formula in Step 2:

\$500,000 =
$$\frac{1}{RR} \times \Delta R = \frac{1}{0.10} \times \Delta R$$
.

Solving this formula for ΔR gives a value of $\Delta R = \$50,000$. Therefore, if the Fed buys \$50,000 of Treasury bills from the public, reserves will increase by \$50,000. As banks create new loans based upon these new reserves, the quantity of bank loans and deposits will increase.

Step 4: Determine the money supply change.

The money supply change will be:

$$\Delta D = \frac{1}{RR} \times \Delta R = \frac{1}{0.10} \times \$50,000 = \$500,000.$$

A \$50,000 Fed open market purchase will lead to a \$500,000 money supply change. If the Fed wants to increase the money supply by \$500,000, they must buy \$50,000 of Treasury bills from the public.

14.5

The Quantity Theory of Money (pages 475–478)

Learning Objective: Explain the quantity theory of money and use it to explain how high rates of inflation occur.

The quantity of money in an economy plays a role in determining the inflation rate. One way of analyzing the relationship between money and prices is called the quantity theory of money, which can be illustrated using the quantity equation:

$$M \times V = P \times Y$$
.

where M is the supply of money, P is the price level (GDP Deflator), and Y is real GDP. V is defined as the velocity of money, which measures the average number of times a dollar is used to purchase a final good or service, and is calculated as $V = (P \times Y)/M$. From the quantity equation, it follows that:

Growth rate in M + Growth rate in V =

Growth rate in P (or the inflation rate) + Growth rate in Y (real GDP growth rate).

Study Hint

The general rule is that the growth rate of two variables multiplied together equals the sum of the growth rates of each variable. So, for example, the growth rate of $M \times V =$ Growth rate of M + Growth rate of V.

Rearranging terms gives:

Inflation rate = (Growth rate in M – Growth rate in Y) + Growth rate in V.

The equation implies that if velocity is constant (which means that the growth rate in velocity = 0), then the economy will experience inflation if the growth rate in the money supply is greater than the growth rate in output. This equation suggests that in the long run, inflation results from growth in the money supply being greater than growth in output. Empirical studies show that velocity is not a constant.

Extra Solved Problem 14.5

Calculating Velocity

Supports Learning Objective 14.5: Explain the quantity theory of money and use it to explain how high rates of inflation occur.

Because there are two measures of the money supply—M1 and M2—there are two measures of velocity, one based on each measure of the money supply. The table below has data on Money (M1 and M2), the GDP deflator, and real GDP. (The values for real GDP, M1, and M2 are in billions.) Compute velocity measures using each money supply measure and also compute the growth rates in velocity with each money supply measure for each year from 2001 to 2012. Are the growth rates the same? (Remember that in the quantity equation, real GDP = Y and GDP deflator = P.)

Real GDP	GDP Deflator	M1	M2
\$ 9,81 <i>7</i>	100	\$1,087.7	\$4,917.2
9,891	102	1,182.3	5,431.2
10,049	104	1,220.4	5,784.7
10,301	106	1,306.8	6,071.7
10,676	109	1,376.4	6,412.2
10,990	113	1,374.2	6,674.1
11,295	117	1,365.6	7,033.6
11,524	120	1,373.0	7,438.4
11,652	122	1,604.9	8,183.8
11,246	124	1,695.8	8,487.4
11,587	125	1,836.7	8,782.4
11,801	127	2,160.9	9,638.3
12,129	129	2,445.6	10,409.1
	\$ 9,817 9,891 10,049 10,301 10,676 10,990 11,295 11,524 11,652 11,246 11,587 11,801	\$ 9,817 100 9,891 102 10,049 104 10,301 106 10,676 109 10,990 113 11,295 117 11,524 120 11,652 122 11,246 124 11,587 125 11,801 127	GDP Deflator M1 \$ 9,817 100 \$1,087.7 9,891 102 1,182.3 10,049 104 1,220.4 10,301 106 1,306.8 10,676 109 1,376.4 10,990 113 1,374.2 11,295 117 1,365.6 11,524 120 1,373.0 11,652 122 1,604.9 11,246 124 1,695.8 11,587 125 1,836.7 11,801 127 2,160.9

Step 1: Review the chapter material.

This problem is about velocity, so you may want to review the section "The Quantity Theory of Money," which begins on page 475 in the textbook.

Step 2: Calculate velocity.

Velocity is defined as $V = (P \times Y)/M$. (Note that in this calculation we need to divide the GDP deflator by 100.) The values of velocity are:

Year	Real GDP	GDP Deflator	M1	M2	V(M1)	V(M2)
2000	\$ 9,817	100	\$1,087.7	\$4,917.2	9.03	2.00
2001	9,891	102	1,182.3	5,431.2	8.53	1.86
2002	10,049	104	1,220.4	5,784.7	8.56	1.81
2003	10,301	106	1,306.8	6,071.7	8.36	1.81
2004	10,676	109	1,376.4	6,412.2	8.45	1.81
2005	10,990	113	1,374.2	6,674.1	9.04	1.86
2006	11,295	11 <i>7</i>	1,365.6	7,033.6	9.68	1.88
2007	11,524	120	1,373.0	7,438.4	8.86	1.74
2008	11,652	122	1,604.9	8,183.8	8.22	1.64
2009	11,246	124	1,695.8	8,487.4	7.89	1.65
2010	11,587	125	1 , 836.7	8,782.4	6.94	1.55
2011	11,801	127	2,160.9	9,638.3	6.40	1.50
2012	12,129	129	2,445.6	10,409.1	8.86	1.74

Step 3: Calculate growth rates.

Calculate the growth rate in velocity for the velocity values based upon the different measures of the money supply.

Year	Real GDP	GDP Deflator	M1	M2	V(M1)	Growth Rate in V(M1)	V(M2)	Growth Rate in V(M2)
2000	\$ 9,817	100	\$1,087.7	\$4,917.2	9.03		2.00	
2001	9,891	102	1,182.3	5,431.2	8.53	-5.45%	1.86	-6.96%
2002	10,049	104	1,220.4	5,784.7	8.56	0.36	1.81	-2.74
2003	10,301	106	1,306.8	6,071.7	8.36	-2.40	1.81	-0.46
2004	10,676	109	1,376.4	6,412.2	8.45	1.15	1.81	0.91
2005	10,990	113	1,374.2	6,674.1	9.04	6.89	1.86	2.53
2006	11,295	11 <i>7</i>	1,365.6	7,033.6	9.68	7.04	1.88	0.97
2007	11,524	120	1,373.0	7,438.4	8.86	4.08	1.74	-1.05
2008	11,652	122	1,604.9	8,183.8	8.22	-12.06	1.64	-6.57
2009	11,246	124	1,695.8	8,487.4	7.89	-7.16	1.65	-5.41
2010	11,587	125	1,836.7	8,782.4	6.94	-4.10	1.55	0.37
2011	11,801	127	2,160.9	9,638.3	6.40	-12.05	1.50	-5.71
2012	12,129	129	2,445.6	10,409.1	8.86	-7.76	1.74	-3.33

While the growth rates of M1 velocity and M2 velocity are different in every year, they generally move in the same direction. The exceptions are the values in 2002 and 2007, when the growth rate in M1 velocity rose while the growth rate in M2 velocity fell, and the value in 2010, when the growth rate in M1 velocity fell while the growth rate in M2 velocity rose.

Key Terms

Asset Anything of value owned by a person or a firm.

Bank panic A situation in which many banks experience runs at the same time.

Bank run A situation in which many depositors simultaneously decide to withdraw money from a bank.

Commodity money A good used as money that also has value independent of its use as money.

Discount loans Loans the Federal Reserve makes to banks.

Discount rate The interest rate the Federal Reserve charges on discount loans.

Excess reserves Reserves that banks hold over and above the legal requirement.

Federal Open Market Committee (FOMC)The Federal Reserve committee responsible for

open market operations and managing the money supply in the United States.

Federal Reserve The central bank of the United States.

Fiat money Money, such as paper currency, that is authorized by a central bank or governmental body and that does not have to be exchanged by the central bank for gold or some other commodity money.

Fractional reserve banking system A banking system in which banks keep less than 100 percent of deposits as reserves.

M1 The narrowest definition of the money supply: The sum of currency in circulation, checking account deposits in banks, and holdings of traveler's checks.

M2 A broader definition of the money supply: It includes M1 plus savings account balances, small-denomination time deposits, balances in money market deposit accounts in banks, and noninstitutional money market fund shares.

Monetary policy The actions the Federal Reserve takes to manage the money supply and interest rates to pursue macroeconomic policy objectives.

Money Assets that people are generally willing to accept in exchange for goods and services or for payment of debts.

Open market operations The buying and selling of Treasury securities by the Federal Reserve in order to control the money supply.

Quantity theory of money A theory about the connection between money and prices that assumes that the velocity of money is constant.

Required reserve ratio The minimum fraction of deposits banks are required by law to keep as reserves.

Required reserves Reserves that a bank is legally required to hold, based on its checking account deposits.

Reserves Deposits that a bank keeps as cash in its vault or on deposit with the Federal Reserve.

Securitization The process of transforming loans or other financial assets into securities.

Security A financial asset—such as a stock or a bond—that can be bought and sold in a financial market.

Simple deposit multiplier The ratio of the amount of deposits created by banks to the amount of new reserves.

Velocity of money The average number of times each dollar in the money supply is used to purchase goods and services included in GDP.

Self-Test

(Answers are provided at the end of the Self-Test.)

Multiple-Choice Questions

- 1. Assets that are generally accepted in exchange for goods and services or for payment of debts are specifically called
 - a. wealth.
 - b. net worth.
 - c. money.

- 2. A double coincidence of wants refers to
 - a. the situation in which a good that is used as money also has value independent of its use as money.
 - (b) the fact that for a barter trade to take place between two people, each person must want what the other one has.
 - c. the idea that a barter economy is more efficient than an economy that uses money.
 - d. the situation where two parties are involved in a transaction where money is the medium of exchange.
- 3. By making exchange easier, money allows for
 - a. a double coincidence of wants.
 - b. the possible risk of inflation.
 - .\ specialization and higher productivity.

all of the above.

- 4. If prisoners of war use cigarettes as money, then cigarettes are
 - a. token money.
 - b. fiduciary money.
 - c. fiat money.
 - d commodity money.
- 5. Money serves as a unit of account when
 - a. sellers are willing to accept it in exchange for goods or services.
 - b. it can be easily stored and used for transactions in the future.
 - prices of goods and services are stated in the monetary unit.
 - All of the above are examples of money serving as a unit of account.
- 6. Money serves as a standard of deferred payment when
 - a. it can be easily stored today and used for transactions in the future.
 - repayment of debts is made using money units.
 - c. sellers are willing to accept it in exchange for goods or services.
- All of the above are examples of money serving as a standard of deferred payment.
- 7. Which of the following conditions make a good suitable for use as a medium of exchange?
 - a. The good must be acceptable to (that is, usable by) most buyers and sellers.
 - The good should be of standardized quality, so that any two units are identical.
 - The good should be durable, valuable relative to its weight, and divisible.
 - All of the above conditions must be met.
- 8. Which of the following statements is correct?
 - Today, most governments in the world issue paper currency that is backed by gold and can be redeemed for gold.
 - Paper currency has no value unless it is used as money.
 - c. Paper money is commodity money.
 - d. All of the above are true.

- 9. What is fiat money?
 - a. money that has value independent of its use as money
 - b. an asset that has the ability to be easily converted into the medium of exchange
 - money that is authorized by a central bank and that does not have to be exchanged for gold or some other commodity money
 - d. money issued by financial intermediaries, such as banks and thrift institutions, not the central bank
- 10. What of the following statements is true about money?
 - a. Money is only those assets that serve as a medium of exchange.
 - b. Money is only currency, checking account deposits, or traveler's checks.
- Money can be narrowly or broadly defined, depending on the types of assets included.
 - d. None of the above. There is no official definition or measurement of the money supply today.
- 11. The sum of currency in circulation, checking account balances in banks, and holdings of traveler's checks equals
 - (a. M1.
 - b. M2.
 - c. M1 + M2.
 - d. none of the above.
- 12. Savings account balances, small-denomination time deposits, and noninstitutional money market fund shares are
 - a. included only in M1.
 - (b) included only in M2.
 - c. included in both M1 and M2.
 - d. financial assets that are not included in the money supply.
- 13. Jamie makes a deposit into her savings account at the local bank with \$500 in cash. As a result of this transaction.
 - a. both M1 and M2 will increase by \$500.
 - b. M2 will increase by \$500.
 - c.)M1 will decrease by \$500.
 - d. Both b. and c. are correct.
- 14. Which of the following statements is correct about currency in the United States?
 - Currency is used much more often than checking account balances to make payments.
 - (b.) More than 80 percent of all goods and services are purchased with checking account balances rather than with currency.
 - c. Most of the U.S. currency is held within the United States, but a small amount is actually outside the borders of the United States.
 - d. All of the above are true.
- 15. Which of the following statements is true?
 - Today U.S. law prohibits banks from paying interest on checking account deposits.
 - (b.) Today, people are not allowed to write checks against their savings account balances.
 - c. Today, the difference between checking accounts and savings accounts is greater than it was before the banking reform in 1980.
 - d. All of the above are true.

- a. the quantity equation
- b. the simple deposit multiplier

(c.) the required reserve ratio

The cash to deposit ratio

- 23. Which of the following is the largest liability of a typical bank?
 - a. deposits
 - b.) loans
 - reserves
 - d. treasury bills

0	incr a. b.	the required reserve ratio is 10 percent, then using the simple deposit multiplier, what is the rease in checking account deposits caused by an initial deposit of \$1,000? \$100 \$10,000 \$100,000	total
	a. b. c.	the inverse, or reciprocal, of the required reserve ratio. the ratio of the amount of deposits created by banks to the amount of new reserves. the formula used to calculate the total increase in checking account deposits from an increase bank reserves. all of the above.	ase in
,	a. 6. c.	leaves unchanged	
	dep a. d. c.	increase in the amount of excess reserves that banks keep the value of the real- posit multiplier. increases decreases leaves unchanged nullifies	world
28. (pero a. b	American Bank has \$500 in deposits and \$200 in reserves and the required reserve ratio cent, then American Bank has \$200 in excess reserves. \$50 in required reserves. \$50 in excess reserves. \$200 in required reserves.	is 10
29.	Fill a. b. c. d.	in the blanks. Whenever banks gain reserves and make new loans, the money s ; and whenever banks lose reserves, they reduce their loans and the money s expands; expands expands; contracts contracts; contracts contracts; expands	
30.	A b. a. b. c. d.	banking system in which banks keep less than 100 percent of deposits as reserves is called the Federal Reserve System. a fractional reserve banking system. a fully funded reserve system. wildcat banking.	

a. b.	en many depositors decide simultaneously to withdraw their money from a bank, there is an increase in bank lending. usually a decline in discount lending by the Fed. a bank run. inflation.
a. b.	there is an increase in bank lending. the central bank carries out open market purchases. many banks experience runs at the same time. many banks fail to attract depositors so their reserves increase significantly.
b. c.	Federal Reserve System is the central bank of the United States. the institution that regulates all state banks. the institution solely responsible for regulating the stock and bond markets. the institution also known as the Treasury of the United States.
pre app a. b.	in the blanks. There are members of the Board of Governors, who are appointed by the sident of the United States to, nonrenewable terms. One of the Board members is sointed Chairman for a(n), renewable term. nine; seven-year; eight-year twelve; four-year; four-year seven; fourteen-year; four-year fourteen; four-year
GP GE	e actions the Federal Reserve takes to manage the money supply and interest rates to pursue nomic objectives is called fiscal policy. open market operations. monetary policy. financial management.
a. b.	e Fed uses three monetary policy tools. Which of the following is <i>not</i> one of those tools? open market operations discount policy
	increase the money supply, the FOMC directs the trading desk, located at the Federal Reservence of New York, to buy U.S. Treasury securities from the public. sell U.S. Treasury securities to the public. print U.S. Treasury securities and put them out in circulation. buy U.S. dollars in the foreign exchange market.
(a.)	e Fed conducts monetary policy primarily through open market operations. discount policy. reserve requirements. none of the above.

h a	fill in the blanks. By raising the discount rate, the Fed encourages banks to make loans to ouseholds and firms, which will checking account deposits and the money supply. . more; increase . more; decrease . fewer; increase . fewer; decrease
6	Which of the following is <i>not</i> a factor that helped lead to the financial panic of 2008? deposit insurance for all commercial banks falling housing prices high leverages of financial firms that purchased mortgage-backed securities none of the above
a C	The theory concerning the link between the money supply and the price level that assumes the elocity of money is constant is called the quantity equation. the quantity theory of money. the constant velocity theory of money. the purchasing power parity theory of money.
a b	Velocity is defined as: $V = M/(P \times Y)$. $V = M \times P \times Y$. $V = M + P + Y$. $V = (P \times Y)/M$.
a a c	Suppose that velocity is 4 and the money supply is \$100 million. According to the quantity theory of noney, nominal output equals \$25 million. \$400 million. \$400 billion.
a	f Irving Fisher was correct in his prediction about the value of velocity, then the quantity equation can be written to solve for the inflation rate as follows: Inflation rate = Growth rate of the money supply + Growth rate of real output. Inflation rate = Growth rate of the money supply - Growth rate of real output. Inflation rate = Growth rate of the money supply - Growth rate of velocity. Inflation rate = Growth rate of the money supply + Growth rate of velocity.
4	Which of the following predictions can be made using the growth rates associated with the quantity equation? If the money supply grows at a faster rate than real GDP, there will be inflation. If the money supply grows at a slower rate than real GDP, there will be inflation. If the money supply grows at the same rate as real GDP, the price level will fall. In none of the above.

Short Answer Questions

		Victoria de la composição			
***************************************					All relative species and area to the control of the
Relow are the	changes in the balanc	e sheet for	Andover Bank as	a result of a \$1	0.000 denos
	pose the required reser				
	Assets	2000	Liabilities		
		10000		\$10,000	
	Keserves T	10,000 De	posits +	\$10,000	
	ank makes a loan for t nanges in the bank's ba	he amount	ou have just calcafter the bank gra	culated; use the	T-account be
	ank makes a loan for t	he amount	ou have just calo	culated; use the	T-account be
	ank makes a loan for t nanges in the bank's ba	he amount	ou have just calcafter the bank gra	culated; use the	T-account be
	ank makes a loan for t nanges in the bank's ba	he amount	ou have just calcafter the bank gra	culated; use the	T-account be
to show the ch	ank makes a loan for to the langes in the bank's ba	he amount plance sheet	ou have just calcafter the bank gra	culated; use the ants the loan.	
to show the ch	ank makes a loan for to the langes in the bank's ba	he amount plance sheet	ou have just calcafter the bank gra	culated; use the ants the loan.	
to show the ch	ank makes a loan for the bank's bath Assets Ount below to show the oses reserves.	he amount plance sheet	you have just calcafter the bank gra Liabilities the bank's balanc	culated; use the ants the loan.	
to show the ch	ank makes a loan for the bank's bath Assets Ount below to show the oses reserves.	he amount plance sheet	you have just calcafter the bank gra Liabilities the bank's balanc	culated; use the ants the loan.	
to show the ch	ank makes a loan for the bank's bath Assets Ount below to show the oses reserves.	he amount plance sheet	you have just calcafter the bank gra Liabilities the bank's balanc	culated; use the ants the loan.	
to show the ch	ank makes a loan for the bank's bath Assets Ount below to show the oses reserves.	he amount plance sheet	you have just calcafter the bank gra Liabilities the bank's balanc	culated; use the ants the loan.	
to show the ch	ank makes a loan for the bank's bath Assets Ount below to show the oses reserves.	he amount plance sheet	you have just calcafter the bank gra Liabilities the bank's balanc	culated; use the ants the loan.	

372 CHAPTER 14 | Money, Banks, and the Federal Reserve System

of reserves at the public, re	MC buys Treasury bills from the public as part of open market operations, the lend the level of deposits will increase. If the Fed buys \$2 million of securities for serves and deposits in the banking system will both increase by \$2 million. This is T-account below:
	Assets Liabilities Reserves +\$2 million Deposits +\$2 million
Assuming a	
change in the	10 percent required reserve ratio, determine the potential change in deposits money supply as a result of this open market purchase by the Fed. If the Fed wis e money supply by \$5 million, how many dollars of securities would the Fed nee
change in the to increase th	money supply as a result of this open market purchase by the Fed. If the Fed wis

6. Suppose that the required reserve ratio is 10 percent. By what amount must reserves grow for the level of deposits to rise by \$500?

True/False Questions

- T F 1. Economies that trade goods and services for other goods and services are barter economies.
- T F 2. Money that has value different from its use as money is called fiat money.
- T F 3. Goods and services in the United States are priced in dollars. This is an example of the store of value function of money.
- T F 4. The U.S. government backs Federal Reserve Notes with an equal amount of gold.
- T F 5. The M1 measure of money includes the currency in banks, called vault cash.
- T F 6. M2 includes savings accounts but not checking accounts.
- T F 7. A household checking account is an asset to the household and a liability to its bank.
- T F 8. As households deposit paychecks in their banks, M1 will immediately increase.
- T F 9. Excess reserves are actual reserves plus required reserves.
- T F 10. If a bank has no excess reserves, the required reserve ratio is 20 percent, then that bank can lend \$4,000 when a household deposits \$5,000 in currency.
- T F 11. A bank with \$1,000 of excess reserves cannot safely lend more than \$1,000.
- T F 12. The simple deposit multiplier is 1/(1 RR).
- T F 13. Congress makes decisions on open market operations.
- T F 14. To expand the money supply, the Fed will sell government securities to the public.
- T F 15. According to the quantity theory of money, an economy will experience inflation if the money supply grows more than 5 percent per year.

Answers to the Self-Test

Multiple-Choice Questions

Question	Answer	Comment		
1.	c	The economic definition of money is any asset that is generally accepted in exchange for goods and services or for payment of debts.		
2.	b	Economies that do not use money, but instead trade goods and services direct for other goods and services, are called barter economies. For a barter trade take place between two people, each person must want what the other one has Economists refer to this requirement as a double coincidence of wants.		
3.	c	Most people in modern economies are highly specialized. The high income levels in modern economies are based on the specialization that money makes possible. By making exchange easier, money allows for specialization and higher productivity.		

Question	Answer	Comment
4.	d	The usual inefficiencies of barter led the prisoners to begin using cigarettes as money. Cigarettes have a value independent of their use as money, so they are commodity money.
5.	c	Instead of having to quote the price of a single good in terms of many other goods, each good has a single price quoted in terms of the medium of exchange. This function of money gives buyers and sellers a unit of account, a way of measuring value in the economy in terms of money. When the U.S. economy uses dollars as money, then each good has a price in terms of dollars.
6.	b	Money is useful because of its ability to serve as a standard of deferred payment in borrowing and lending. Money can facilitate exchange at a given point in time by providing a medium of exchange and unit of account. It can facilitate exchange over time by providing a store of value and a standard of deferred payment.
7.	d	What makes a good suitable to use as a medium of exchange? There are five criteria: (1) The good must be acceptable to (that is, usable by) most traders; (2) it should be of standardized quality so that any two units are identical; (3) it should be durable so that value is not lost by spoilage; (4) it should be valuable relative to its weight so that amounts large enough to be useful in trade can be easily transported; and (5) because different goods are valued differently, the medium of exchange should be divisible.
8.	b	In modern economies, paper currency is generally issued by a central bank, which is a special governmental or quasi-governmental institution in the financial system (like the Federal Reserve in the United States) that regulates the money supply. Today, no government in the world issues paper currency that can be redeemed for gold. Paper currency has no value unless it is used as money and is therefore not commodity money.
9.	С	Fiat money: Money, such as paper currency, that is authorized by a central bank or governmental body and that does not have to be exchanged by the central bank for gold or some other commodity money.
10.	c	Economists have developed several different definitions of the money supply. Each definition includes a different group of assets. The definitions range from narrow to broad. The narrowest definition of money includes cash, checkable deposits, and traveler's checks. Broader definitions include other assets that can be easily converted to cash—savings account deposits or certificates of deposit, for example.
11.	a	M1 is the narrowest definition of the money supply: the sum of currency in circulation, checking account balances in banks, and holdings of traveler's checks. (Technically, M1 includes all checkable deposits, funds in commercial banks, S&Ls and credit unions that can be transferred using a check-like instrument. If the account is in an S&L, the instrument is called a negotiated order of withdrawal or NOW. If the account is in a credit union, the instrument is called a share draft.)
12.	b	M2 includes M1, savings account balances, small-denomination time deposits, money market deposit accounts, and noninstitutional money market fund shares.

Question	Answer	Comment
13.	c	Because the cash is in M1 but the savings account is not, the reduction of checking will reduce M1 by \$500, but the transfer to savings will not change M2. Only the composition of M2 changes.
14.	b	Although currency and checking account balances are roughly equal in value, checking account balances are used much more often to make payments than currency. More than 80 percent of all goods and services are purchased with checking account balances rather than with currency.
15.	b	Before 1980, U.S. law prohibited banks from paying interest on checking
		account deposits. In 1980, the law was changed to allow banks to pay interest on certain types of checking accounts. This change reduced the difference between checking accounts and savings accounts, although people are still not allowed to write checks against their savings account balances. (But some people have checking accounts that will automatically transfer funds from their savings account if their checking account balance is not large enough to cover a specific check. However, the bank usually charges a fee for this service, meaning the savings account balance is still not as liquid as the checking account balance.)
16.	d	M2 includes M1 plus savings account balances, small-denomination time deposits, balances in money market deposit accounts in banks, and noninstitutional money market fund shares.
17.	d	Many people buy goods and services with credit cards, yet credit cards are not included in definitions of the money supply. The reason is that when you buy something with a credit card, you are in effect taking out a loan from the bank that issued the credit card. Only when you pay your credit card bill at the end of the month—usually with a check—is the transaction complete.
18.	С	Warren Buffett's wealth made him one of the richest people in the world in 2010. He also has a very large income, but how much money does he have? A person's wealth is equal to the value of his assets minus the value of any debts he has. A person's income is equal to his earnings during the year. But his money is just equal to what he has in currency and in checking accounts.
19.	С	The key role that banks play in the economy is to accept deposits and make loans. By doing this, they create checking account deposits.
20.	a	The key assets on a bank's balance sheet are its reserves, its loans, and its holdings of securities, such as U.S. Treasury bills.
21.	a	Loans are the largest asset of a typical bank.
22.	c	Banks are required by law to keep 10 percent of their checking account deposits above a certain level as reserves. These reserves are called required reserves. The minimum fraction of deposits that banks are required to keep as reserves (currently 10 percent) is called the required reserve ratio. Any reserves banks hold over and above the legal requirement are called excess reserves.
23.	a	Deposits include checking accounts, savings accounts, and certificates of deposit. Loans, reserves, and treasuries are not liabilities to a bank; they are assets.
24.	c	The change in deposits equals $$1,000 \times (1/0.1) = $10,000$.

Question	Answer	Comment
25.	d	The simple deposit multiplier is the ratio of the amount of deposits created by banks to the amount of new reserves. It is the formula used to calculate the total increase in checking account deposits from an increase in bank reserves. It is also the inverse of the required reserve ratio.
26.	b	The simple deposit multiplier formula $(1/RR)$ makes it clear that the higher the required reserve ratio, the smaller the multiplier.
27.	b	The more excess reserves banks keep, the smaller the real-world deposit multiplier.
28.	b	With \$500 in deposits and a 10 percent required reserve ratio, required reserves are $$50 = 0.10 \times 500 . Excess reserves are actual reserves (\$200) minus required reserves (\$50) or $$150 = $200 - 50 .
29.	b	The most important part of the money supply is checking account balances. When banks make loans, they increase checking account balances, expanding the money supply. Banks make new loans whenever they gain reserves. The whole process can also work in reverse. If banks lose reserves, they reduce their outstanding loans and deposits, and the money supply contracts.
30.	b	The United States, like nearly all other countries, has a fractional reserve banking system. In a fractional reserve banking system, banks keep less than 100 percent of deposits as reserves.
31.	c	Sometimes depositors lose confidence in a bank when they question the value of the bank's underlying assets, particularly its loans. Often, the reason for a loss of confidence is bad news, whether true or false. When many depositors decide simultaneously to withdraw their money from a bank, there is a bank run.
32.	c	When many depositors decide simultaneously to withdraw their money from a bank, there is a bank run. If many banks experience runs at the same time, the result is a bank panic. It is possible for one bank to handle a run by borrowing from other banks, but if many banks simultaneously experience runs, the banking system may be in trouble. In that case, the central bank should act as lender of last resort.
33.	a	With the intention of putting an end to banking panics, Congress in 1913 passed the Federal Reserve Act, setting up the Federal Reserve System. The system began operation in 1914. The Federal Reserve—usually referred to as the "Fed"—is the central bank of the United States. The Fed's main job is controlling the money supply. The Fed also acts as a lender of last resort to banks and as a bankers' bank, providing services such as check clearing to banks.
34.	c	There are seven members of the Board of Governors, who are appointed by the President of the United States to fourteen-year, nonrenewable terms. Board members come from banking, business, and academic backgrounds. One of the seven Board members is appointed Chairman for a four-year, renewable term. No more than one Board member can be selected from any Federal Reserve district.
35.	С	Monetary policy refers to the actions the Federal Reserve takes to manage the money supply and interest rates to pursue economic objectives.

Question	Answer	Comment
36.	d	Setting a target for the federal funds rate is not a tool of monetary policy. To manage the money supply, the Fed uses three monetary policy tools: (1) open market operations, (2) discount policy, and (3) reserve requirements. Remember that the most important component of the money supply is checking account balances. (The federal funds rate is, however, the main operating target of U.S. monetary policy.)
37.	a	To increase the money supply, the FOMC directs the trading desk, located at the Federal Reserve Bank of New York, to buy U.S. Treasury securities—most frequently bills, but sometimes notes or bonds—from the public. When the
		sellers of the Treasury securities deposit the funds in their banks, the reserves of banks will rise. This increase in reserves will start the process of increasing loans and checking account deposits, increasing the money supply.
38.	a	The Fed conducts monetary policy principally through open market operations for three reasons. First, because the Fed initiates open market operations, it completely controls their volume. Second, the Fed can make both large and small open market operations. Third, the Fed can implement its open market operations quickly, with no administrative delay or required changes in regulations. Many other central banks, including the European Central Bank and the Bank of Japan, use open market operations in conducting monetary policy.
39.	d	By lowering the discount rate, the Fed can encourage banks to increase the volume of their borrowing from the Fed. When banks borrow from the Fed, they are borrowing reserves. With more reserves, banks will make more loans to households and firms, which will increase checking account deposits and the money supply. Raising the discount rate will have the opposite effect.
40.	a	The financial panic of 2008 was caused largely by the bursting of the housing market bubble, which lead to falling house prices. Many commercial banks had securitized their mortgage loans by selling them to nonbank financial firms as securities. Those firms, including investment banks like Goldman Sachs and Lehman Brothers, suffered heavy losses as a result of the falling values of mortgage-backed securities. Many of them began to fail because they were
		more highly leveraged than were commercial banks. The bankruptcy of Lehman Brothers in the fall of 2008 caused a panic in the financial system.
41.	b	Irving Fisher turned the quantity equation into the quantity theory of money, by asserting that velocity was constant. He asserted that the average number of times a dollar is spent depends on how often people get paid, how often they do their grocery shopping, how often businesses mail bills, and other factors that do not change very often. Because this assertion may be true or false, the quantity theory of money is, in fact, a theory.
42.	d	$M \times V = P \times Y$, so $V = (P \times Y)/M$.
43.	b	According to the quantity theory of money, $M \times V = P \times Y$. Because $P \times Y$ (the price level times real output) equals nominal output, if $V = 4$ and $M = \$100$ million, nominal output = $\$100$ million $\times 4 = \$400$ million.

Question	Answer	Comment
44.	b	If Irving Fisher was correct that velocity is constant, then the growth rate of velocity will be zero. That is, if velocity is, say, always 6.4, then its percentage change from one year to the next will always be zero. This allows us to rewrite the equation as: Inflation rate = Growth rate of the money supply – Growth rate of real output.
45.	a	The growth rate version of the quantity equation leads to the following predictions (recall that deflation is a decline in the price level): (1) If the money supply grows at a faster rate than real GDP, there will be inflation; (2) if the money supply grows at a slower rate than real GDP, there will be
		deflation, and (3) if the money supply grows at the same rate as real GDP, the price level will be stable. There will be neither inflation nor deflation.

Short Answer Responses

- 1. Because M1 includes both currency and checking accounts, the deposit of \$500 currency in her checking account will change the composition of M1 (less currency and more checking deposits), not the level of M1. Because M2 includes M1 plus savings accounts, then the deposits of \$500 in her checking account will also not change M2. If she had deposited the \$500 currency in her savings account, then M1 would decrease by \$500 (less currency), and M2 would not change (less currency and more savings accounts).
- 2. As a result of the currency deposit, Andover Bank's required reserves will increase by \$1,000 (10 percent of the increase in deposits, or $0.10 \times $10,000$). The bank can now create a loan for \$9,000, the amount of excess reserves (\$10,000 \$1,000). After that loan the balance sheet will be:

As	ssets	Liabilities	
Reserves	+\$10,000	Deposits	+\$10,000
Loans	+\$9,000		+\$9,000

When the person that receives the loan uses it to write checks, the level of deposits at the bank will fall, and the bank will lose reserves to other banks. The bank balance sheet will then look like:

Assets		Liabilities		
Reserves Loans	+\$1,000 +\$9,000	Deposits	+\$10,000	

3. If Alice deposits \$100 in her checking account, the supply of money will not change, but the level of bank deposits and the level of excess reserves in the bank will change. This is shown in the T-account below:

Assets		Liabilities and Net Worth	
Reserves	+\$100	Deposits	+\$100

With RR = 0.10 (or 10 percent), Alice's bank has \$90 of excess reserves that it can use to make a new loan, which will create \$90 of new deposits and \$90 of new money. The banking system can create deposits according to the formula:

$$\Delta D = \frac{1}{RR} \times \Delta Reserves = \frac{1}{0.1} \times \$100 = \$1,000$$

The level of deposits will increase by \$1,000, and the money supply will increase by \$900. If RR = 0.20 (or 20 percent), then the same \$100 deposit by Alice will increase the level of deposits by \$500 [(1/0.20) × \$100], and the money supply will increase \$400.

4. If the Fed buys \$2 million of securities from the public as part of open market operations, the level of bank reserves will increase by \$2 million. Assuming a 10 percent required reserve ratio, the new level of deposits is determined with the formula:

$$\Delta D = \frac{1}{RR} \times \Delta Reserves = \frac{1}{0.1} \times \$2 \text{ million} = \$20 \text{ million}.$$

In this case, since the deposit did not start with a deposit of currency by the public, the supply of money will also increase \$20 million.

If the Fed wanted to increase the money supply by \$5 million, then using the formula:

$$\Delta D = \frac{1}{RR} \times \Delta Reserves$$
 or \$5 million = $\frac{1}{0.1} \times \Delta Reserves$, or $\Delta Reserves$ = \$0.5 million.

Because the simple deposit = 10, a \$0.5 million security purchase will result in a \$5 million deposit and money supply change.

5. If velocity was constant (which means the growth rate in velocity is zero) then using the equation:

Inflation rate = (Growth rate in
$$M$$
 – Growth rate in Y) + Growth rate in V

we would predict an inflation rate of 0.3 percent (3.3% - 3.0% = 0.3%). However, if we observe that inflation was 1.5 percent, then that would imply from the equation that the velocity growth rate was 1.2 percent, meaning velocity increased in 2010.

6. The simple deposit expansion formula is:

$$\Delta \text{Deposits} = \frac{1}{RR} \times \Delta \text{Reserves} = \frac{1}{0.1} \times \Delta \text{Reserves} = 10 \times \Delta \text{Reserves}.$$

So if we want deposits to increase by \$500, then reserves must grow by \$50 (\$500 = $10 \times \Delta Reserves$, or $\Delta Reserves = 50).

True/False Answers

Question Answer Comment

- 1. T See page 454 in the textbook.
- 2. F Money that has value other than as money is called a commodity money.

380 CHAPTER 14 Money, Banks, and the Federal Reserve System

F This is the unit of the account function of money. 3. F Federal Reserve Notes are not backed by any commodity. They are an example 4. of fiat money. 5. F M1 only counts currency outside banks or the government. F 6. M2 includes both savings accounts and checking accounts. 7. T See the **Don't Let This Happen to You** feature on page 466 in the textbook. F When the household's checking account increases from the deposit, the firm's 8. checking account decreases by the same amount so that M1 will not change. 9. F Excess reserves are actual reserves minus required reserves. T The bank will increase its required reserves by \$1,000 (\$5,000 \times 0.2), and it can 10. lend out \$4,000. 11. T The bank can safely lend up to its current holding of excess reserves. 12. F The simple deposit multiplier is 1/RR. 13. F The Federal Open Market Committee makes decisions on open market operations. To expand the money supply, the Fed will buy government securities from the 14. F public to increase the amount of bank reserves. According to the quantity theory, an economy will experience inflation if money 15. F growth exceeds output growth.

CHAPTER 15 | Monetary Policy

Chapter Summary and Learning Objectives

15.1 What Is Monetary Policy? (pages 488–490)

Define monetary policy and describe the Federal Reserve's monetary policy goals. Monetary policy is the actions the Fed takes to manage the money supply and interest rates to pursue its macroeconomic policy goals. The Fed has four monetary policy goals that are intended to promote a well-functioning economy: price stability, high employment, stability of financial markets and institutions, and economic growth.

15.2 The Money Market and the Fed's Choice of Monetary Policy Targets (pages 490–495)

Describe the Federal Reserve's monetary policy targets and explain how expansionary and contractionary monetary policies affect the interest rate. The Fed's monetary policy targets are economic variables that it can affect directly and that in turn affect variables such as real GDP and the price level that are closely related to the Fed's policy goals. The two main monetary policy targets are the money supply and the interest rate. The Fed has most often chosen to use the interest rate as its monetary policy target. The Federal Open Market Committee announces a target for the federal funds rate after each meeting. The federal funds rate is the interest rate banks charge each other for overnight loans. To fight a recession, the Fed uses an expansionary policy of increasing the money supply to lower the interest rate. To reduce the inflation rate, the Fed uses a contractionary monetary policy of adjusting the money supply to increase the interest rate. In a graphical analysis of the money market, an expansionary monetary policy shifts the money supply curve to the right, causing a movement down the money demand curve and a new equilibrium at a lower interest rate. A contractionary policy shifts the money supply curve to the left, causing a movement up the money demand curve and a new equilibrium at a higher interest rate.

15.3 Monetary Policy and Economic Activity (pages 495–503)

Use aggregate demand and aggregate supply graphs to show the effects of monetary policy on real GDP and the price level. An expansionary monetary policy lowers interest rates to increase consumption, investment, and net exports. This increased spending causes the aggregate demand curve (AD) to shift out more than it otherwise would, raising the level of real GDP and the price level. An expansionary monetary policy can help the Fed achieve its goal of high employment. A contractionary monetary policy raises interest rates to decrease consumption, investment, and net exports. This decreased spending causes the aggregate demand curve to shift out less than it otherwise would, reducing both the level of real GDP and the inflation rate below what they would be in the absence of policy. A contractionary monetary policy can help the Fed achieve its goal of price stability.

15.4 Monetary Policy in the Dynamic Aggregate Demand and Aggregate Supply Model (pages 503–507)

Use the dynamic aggregate demand and aggregate supply model to analyze monetary policy. We can use the dynamic aggregate demand and aggregate supply model introduced in Chapter 13 to look more closely at expansionary and contractionary monetary policies. The dynamic aggregate demand and aggregate supply model takes into account that (1) the economy experiences continuing inflation, with the

price level rising every year, and (2) the economy experiences long-run growth, with the *LRAS* curve shifting to the right every year. In the dynamic model, an expansionary monetary policy tries to ensure that the aggregate demand curve will shift far enough to the right to bring about macroeconomic equilibrium with real GDP equal to potential GDP. A contractionary monetary policy attempts to offset movements in aggregate demand that would cause macroeconomic equilibrium to occur at a level of real GDP that is greater than potential real GDP.

15.5 A Closer Look at the Fed's Setting of Monetary Policy Targets (pages 507–511)

Discuss the Fed's setting of monetary policy targets. Some economists have argued that the Fed should use the money supply, rather than an interest rate, as its monetary policy target. Milton Friedman and other monetarists argued that the Fed should adopt a monetary growth rule of increasing the money supply every year at a fixed rate. Support for this proposal declined after 1980 because the relationship between movements in the money supply and movements in real GDP and the price level weakened. John Taylor analyzed the factors involved in Fed decision making and developed the **Taylor rule** for federal funds targeting. The Taylor rule links the Fed's target for the federal funds rate to economic variables. Over the past decade, many economists and central bankers have expressed significant interest in using **inflation targeting**, under which monetary policy is conducted to commit the central bank to achieving a publicly announced inflation target. A number of foreign central banks have adopted inflation targeting, but the Fed has not. The Fed's performance in the 1980s, 1990s, and early 2000s generally received high marks from economists, even without formal inflation targeting.

15.6 Fed Policies during the 2007–2009 Recession (pages 512–517)

Discuss the policies the Federal Reserve used during the 2007–2009 recession. A housing bubble that began to deflate in 2006 led to the 2007–2009 recession and an accompanying financial crisis. In response, the Federal Reserve instituted a variety of policy actions. In a series of steps, it cut the target for the federal funds rate from 5.25 percent in September 2007 to effectively zero in December 2008. The decline in the housing market caused wider problems in the financial system, as defaults on home mortgages rose and the value of mortgage-backed securities declined. The Fed and the U.S. Treasury Department implemented a series of new policies to provide liquidity and restore confidence. The Fed expanded the types of firms eligible for discount loans and began lending directly to corporations by purchasing commercial paper. Under the *Troubled Asset Relief Program*, the Treasury provided financial support to banks and other financial firms in exchange for part ownership. The Treasury also moved to have the federal government take control of Fannie Mae and Freddie Mac, government-sponsored firms that play a central role in the mortgage market. The failure of the investment bank Lehman Brothers in September 2008 led to a deepening of the financial crisis and provided the motivation for some of the new policies. Ultimately, the new policies stabilized the financial system, but their long-term effects remain the subject of debate.

Chapter Review

Chapter Opener: Why Do Business Care What the Federal Reserve Does? (page 487)

Most economists believe the chair of the Federal Reserve is more important to the U.S. economy than the president of the United States. They also believe that monetary policy matters for businesses. Many businesses also pay attention to the Fed's actions because the Fed can affect interest rates that in turn affect many businesses directly or indirectly. Most homebuilders, like Hovnanian Enterprises headquartered in New Jersey, benefited from the Fed's policy of low interest rates during the mid-2000s, but suffered losses during the 2007–2009 recession.

15,1

What Is Monetary Policy? (pages 488–490)

Learning Objective: Define monetary policy and describe the Federal Reserve's monetary policy goals.

Monetary policy refers to actions taken by the Federal Reserve System (the Fed, which is the central bank of the United States) to manage the money supply and interest rates in order to influence the level of economic activity. The Fed's conduct of monetary policy is driven by four goals.

- **Price stability.** Low inflation is one of the Fed's important goals. Low inflation over the long run gives the Fed the flexibility to lessen the impact of recessions.
- *High employment*. Low employment (or high unemployment) causes the level of real GDP to be below potential.
- *Economic growth*. Growth is important to the economy to increase standards of living.
- Stability of financial markets and institutions. A stable economy, without wide swings in prices and employment rates, will grow faster than an unstable economy.

Extra Solved Problem 15.1

Monetary Policy and Economic Growth

Supports Learning Objective 15.1: Define monetary policy and describe the Federal Reserve's monetary policy goals.

Monetary policy refers to the Federal Reserve System's actions to control the money supply and interest rates in order to pursue its economic objectives. The textbook lists the Federal Reserve's four monetary policy goals: (1) price stability, (2) high employment, (3) economic growth, and (4) stability of financial markets and institutions. The control the Fed has over the supply of money and interest rates is the source of its influence over goals (1) and (4), but how much control does the Fed have over real variables such as employment and economic growth? In Chapter 10, the textbook argues that increases in per-capita real GDP are the result of the growth of labor productivity. In turn, increases in labor productivity are caused by increases in the quantity of capital per hour worked and the level of technology, not changes in the money supply. Laurence H. Meyer made the following comments in a speech while he served as a member of the Federal Reserve's Board of Governors.

"... monetary policy cannot influence real variables—such as output and employment.... This is often referred to as the principle of the neutrality of money. One of the most important disciplines for policymakers is understanding what they can and what they cannot accomplish. The Fed, for example, cannot raise the long-run rate of economic growth. It should not try."

Source: Lawrence H. Meyer. "Come with Me to the FOMC." The Federal Reserve Board. April 2, 1998. www.federalreserve.gov/boarddocs/Speeches/1998/199804022.htm

Is Lawrence Meyer correct in stating that the Federal Reserve cannot affect output (or economic growth) and employment?

Solving the Problem

Step 1: Review the chapter material.

This problem concerns monetary policy, so you may want to review the section "What Is Monetary Policy?" which begins on page 488 in the textbook.

Step 2: Is Lawrence Meyer correct in stating that the Federal Reserve cannot affect output (or economic growth) and employment?

An important phrase was left out of Meyer's comments. The full quotation is "... monetary policy cannot influence real variables—such as output and employment—in the long run (except via the contribution of price stability to living standards)." Meyer also states "... because prices in many markets are slow to react to changes in supply and demand, shocks to the economy can lead to persistent departures of the economy from full employment.... This ... offers at least the potential for monetary policy to play a role in smoothing out business cycles." In other words, monetary policy can affect output and employment but only in the short run. In the long run, a nation's economic growth is determined by real factors such as investment in capital and the level of technology, not by monetary policy. We saw that this was true in Chapter 12, where we indicated that potential real GDP was not affected by the level of aggregate demand.

15.2

The Money Market and the Fed's Choice of Monetary Policy Targets (pages 490–495)

Learning Objective: Describe the Federal Reserve's monetary policy targets and explain how expansionary and contractionary monetary policies affect the interest rate.

The Fed tries to keep both the unemployment rate and the inflation rate low, but it cannot affect either of these economic variables directly. Using its tools of open market operations, changing the required reserve ratio, and changing the discount rate, the Fed can directly affect only interest rates or the money supply. The Fed uses monetary policy targets that it can affect directly. These targets then affect the goal variables. The Fed chooses between money supply targets and interest rate targets. In practice, the Fed has typically chosen interest rate targets.

Money supply and interest rate targets are linked by the money market and the demand and supply of money. The demand for money curve is shown in a graph by a downward-sloping line, with the interest rate on the vertical axis and the quantity of money on the horizontal axis. As the interest rate rises, the opportunity cost of holding money increases. With high interest rates, financial assets such as bonds earn more interest income, and the public chooses to hold less money and hold more bonds. This is shown in textbook Figure 15.2.

A change in the interest rate causes a movement up or down a stationary money demand curve. If other factors that affect the willingness of households and firms to hold money change, then the money demand curve will shift. A shift to the right in the demand for money curve is caused by:

- An increase in real GDP
- An increase in the price level (the GDP deflator)

A shift in the money demand curve is shown in textbook Figure 15.3.

The supply of money is determined by the Fed. The Fed can use open market operations (buying and selling Treasury bills) to change the supply of money.

M Study Hint

Recall from the last chapter, when the Fed buys Treasury bills from the public, the supply of money will increase, and interest rates will fall. When the Fed sells Treasury bills to the public, the money supply will decrease, and interest rates will rise.

Money market equilibrium occurs when the quantity of money supplied is equal to the quantity of money demanded. This equilibrium is shown in textbook Figure 15.4. The figure shows that the Fed can change both the money supply and the interest rate. Equilibrium occurs where the money supply curve and the money demand curve intersect. As the Fed increases the supply of money, the public will use these new dollars to buy financial assets. This purchase of financial assets, such as Treasury bills or other short-term bonds, will increase bond prices and lower interest rates. So, the result of the Fed increasing the money supply will be a new equilibrium with a lower interest rate. Thus, the Fed can change both the money supply and the interest rate.

When the Fed chooses an interest rate target, it must change the money supply to keep the interest rate at the target level as money demand changes. If the Fed chooses a money supply target, the interest rate will change with changes in money demand.

The Fed's primary monetary policy target is the interest rate known as the federal funds rate. The **federal funds rate** is the interest rate banks charge each other for overnight loans of bank reserves. Changes in the federal funds rate usually cause changes in other interest rates, such as the interest rate on Treasury bills, corporate bond rates, and home mortgage rates.

The Federal Open Market Committee (FOMC) picks a target federal funds interest rate and announces that rate at the end of the FOMC meeting. The actual federal funds rate is usually very close to the target rate. Because the Fed can control the supply of bank reserves, it has a great deal of control over the fed funds rate.

15.3

Monetary Policy and Economic Activity (pages 495-503)

Learning Objective: Use aggregate demand and aggregate supply graphs to show the effects of monetary policy on real GDP and the price level.

As the Fed changes the target federal funds rate, other interest rates change, which will influence the level of aggregate demand. Other being things equal, increases in the interest rate will tend to:

- Decrease consumption spending as the financing costs of consumer durables increase.
- Decrease investment as the financing costs of new capital goods purchased by firms increase and as
 mortgage interest rates rise (recall that spending on residential construction is included as part of
 investment spending).
- Decrease exports as the value of the dollar increases. Higher interest rates in the United States increase the demand for dollars as foreign investors increase their purchases of U.S. financial assets. A higher value for the dollar makes U.S. goods more expensive in foreign markets.

If the current level of real GDP is below potential real GDP, to reach the goal of high employment the Fed needs to carry out an **expansionary monetary policy** by increasing the money supply and decreasing interest rates. This is shown in panel (a) of textbook Figure 15.7. If the short-run equilibrium is at a level of real GDP to the right of the *LRAS* supply curve, to reach the goal of price stability, the Fed needs to carry out a **contractionary monetary policy** by decreasing the money supply and increasing interest rates. This is shown in panel (b) of textbook Figure 15.7.

The Fed can use monetary policy to affect the price level, and the level of real GDP in the short run. The effect of monetary policy on short-run real GDP and the price level allows the Fed to attain the goals of price stability and high employment.

386

In a growing economy, expansionary monetary policy is used if increases in aggregate demand are not great enough to bring the economy to equilibrium at potential GDP. This slow growth in aggregate demand could be due to weak consumption or investment growth, a cut back in government purchases, or a fall in exports. The Fed can use monetary policy to increase aggregate demand to the desired level.

The Fed's ability to recognize the need for a change in policy is very important. If the Fed is late in recognizing that a recession has begun or that inflation is increasing, its policy response may be too late to correct the problem, and potentially may actually make the problem worse. This is shown in textbook Figure 15.8, which shows what happens if the Fed moves too late to implement monetary policy to bring the economy out of a recession and increases aggregate demand too much, thereby increasing the inflation rate. In this case, the delay in the response to the recession has a procyclical effect, which means that it increases the fluctuations of the business cycle, as opposed to a countercyclical policy, which is meant to reduce the severity of the business cycle, and which is what the Fed intends to use.

Because it can take a long time for a change in monetary policy to affect real GDP, the Fed sets its policy according to its forecasts about the state of the economy in the future. But economic forecasts can be unreliable because the factors determining real GDP can change over time. This difficulty is illustrated by Table 15.1, which shows the differences between the Fed's forecasts of real GDP growth for 2007 and 2008 and the actual growth rates.

Table 15.2 in the textbook summarizes how expansionary and contractionary monetary policy work, relative to what would have happened without the policy. Note that sometimes expansionary monetary policy is called *loose* or *easy policy*, and contractionary monetary policy is called *tight policy*.

Study Hint

Read the *Don't Let this Happen to You* feature, which explains how monetary policy works. It is only when the interest rate falls due to a money supply increase that spending changes. It is the lower interest rate that stimulates the economy, not the extra dollars in circulation. *Making the Connection* "Too Low for Zero: The Fed Tries Quantitative Easing and Operation Twist" describes the Fed's actions that aimed at reducing interest rates on long-term Treasury securities when the target for the federal funds rate was nearly zero. Such actions involved buying securities beyond the short-term Treasury securities. Another *Making the Connection* feature "Trying to Hit a Moving Target: Making Policy with 'Real-Time Data'" discusses a challenge to the conduct of monetary policy as a result of the fact that macroeconomic data such as GDP estimates are subject to substantial revisions over time.

Extra Solved Problem 15.3

Monetary Policy Effects

Supports Learning Objective 15.3: Use aggregate demand and aggregate supply graphs to show the effects of monetary policy on real GDP and the price level.

Suppose that the economy is at a level of real GDP above potential real GDP. Show this graphically, and show how contractionary monetary policy can be used to reduce inflation.

Solving the Problem

Step 1: Review the chapter material.

This problem refers to expansionary monetary policy, so you may want to review the section "The Effects of Monetary Policy on Real GDP and the Price Level," which begins on page 496 of the textbook.

387

If output $(Y_0 = \$10,000)$ is above potential real GDP $(Y_{Potential} = \$9,000)$, AD will intersect the SRAS above the LRAS. This is shown in the following graph.

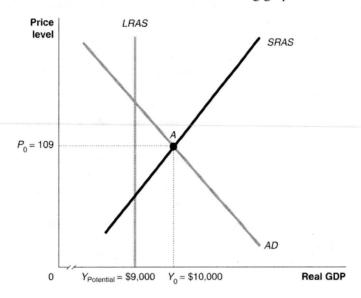

Step 3: Draw the equilibrium with the contractionary monetary policy.

If output is above potential real GDP, contractionary monetary policy can reduce the existing level of aggregate demand. This will shift AD to the left, resulting in equilibrium at a lower level of real GDP. This is shown in the graph below. Monetary policy causes a movement from point A to point B, and the price level falls from 109 to 100. This implies that monetary policy can be used to lower the price level or inflation, though contractionary policy will also lower the output level (from \$10,000 to \$9,000 in the graph).

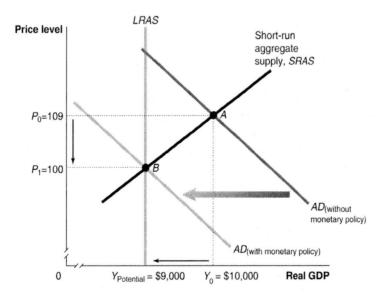

Monetary Policy in the Dynamic Aggregate Demand and Aggregate Supply Model (pages 503-507)

Learning Objective: Use the dynamic aggregate demand and aggregate supply model to analyze monetary policy.

The discussion of monetary policy effects illustrated by textbook Figure 15.7 ignores two important facts about the economy: (1) The economy experiences continuing inflation, with the price level rising every year, and (2) the economy experiences long-run growth, with the LRAS curve shifting to the right every year. In Chapter 13, we developed a dynamic aggregate demand and aggregate supply model that took these two facts into account. Figure 15.9 in the textbook illustrates an expansionary monetary policy using the dynamic aggregate demand and aggregate supply model. In this example, the Fed uses monetary policy to eliminate a recession by bringing the economy to equilibrium at potential GDP of \$14.3 trillion.

The Fed can also use a contractionary monetary policy if aggregate demand is increasing too rapidly and causing inflation to increase. This is shown in textbook Figure 15.10, where the contractionary monetary policy reduces the size of the aggregate demand growth, resulting in a lower inflation rate. In 2006, the FOMC raised the target for the federal funds rate to slow the growth in aggregate demand and reduce the inflation rate. The Fed was able to slow but not stop inflation during this period.

Study Hint

Review Solved Problem 15.4, which provides a detailed discussion of the effects of monetary policy with the aid of the dynamic aggregate demand and aggregate supply model. An expansionary monetary policy, which increases the money supply and lower the interest rate, shifts the AD curve to the right, so that the short-run macroeconomic equilibrium will move up the short-run aggregate supply (SRAS) curve. As a result, real GDP will increase, and the price level will also be higher.

15.5

A Closer Look at the Fed's Setting of Monetary Policy Targets (pages 507-511)

Learning Objective: Discuss the Fed's setting of monetary policy targets.

Monetarist economists have argued that the Fed should adopt a money supply growth rule that would set the growth rate of the money supply at about 3.5 percent per year. These economists argue that a money supply growth rule would reduce fluctuations in real GDP and keep the inflation rate low. Most economists, however, believe that using an interest rate target is better than adopting a money supply growth rule.

The Fed cannot have a money supply target and an interest rate target at the same time. To see why, suppose money demand increases because of rising real GDP. If the Fed targets the money supply by keeping the current level of the money supply constant, the increase in money demand will cause the interest rate to rise. If the Fed targets the interest rate by keeping it constant, the increase in money demand will force the Fed to increase the money supply in order to keep the interest rate at the target level. This is shown in textbook Figure 15.11.

John Taylor, an economist at Stanford University, has developed an equation to predict the target federal funds rate. His equation, known as the **Taylor Rule**, is as follows:

Federal funds target rate = Current inflation rate + Real equilibrium federal funds rate $+(1/2) \times Inflation gap + (1/2) \times Output gap$

The inflation gap is the difference between current inflation and the target inflation rate (about 2 percent), and the output gap is the percentage difference between actual and potential real GDP. The equilibrium real federal funds rate (about 2 percent) is the federal funds rate—adjusted for inflation—that would be consistent with real GDP being equal to potential real GDP in the long run. The Taylor Rule equation predicts that

- as inflation increases, the Fed will raise the target for the federal funds rate, and
- as real GDP rises above potential real GDP, the Fed will also raise the target for the federal funds rate.

An alternative way of conducting monetary policy is for the Fed to have an explicit target for the inflation rate. This is called **inflation targeting** and is the framework that many countries use to conduct monetary policy. The reasons to move to an inflation-targeting approach to monetary policy are:

- In the long run, real GDP returns to potential, and potential real GDP is not influenced by monetary policy.
- An announced target makes it easier to form accurate expectations about inflation.
- Monetary policy would not change as policymakers change.
- An announced target will promote accountability for the Fed, giving a measure of its performance.

Study Hint

The inflation rate is one of the variables that affect the conduct of monetary policy. As we learned in Chapter 9, the consumer price index (CPI) is the most popular measure of inflation in the world, but it suffers from biases that cause it to overstate the true underlying rate of inflation. The GDP deflator is another broad measure of the price level, but it is not a good measure of inflation experienced by the typical consumer, worker or firm. *Making the Connection* "How Does the Fed Measure Inflation?" describes that the Fed announced in 2000 that it would rely more on an alternative of inflation called the personal expenditure price index (PCE) than on the CPI. The PCE is a measure of the price level that is similar to the GDP deflator, except it includes only the prices of goods from the consumption category of GDP.

Extra Solved Problem 15.5

Targeting Inflation

Supports Learning Objective 15.5: Discuss the Fed's setting of monetary policy targets.

On February 1, 2006, Ben S. Bernanke was sworn in as chairman of the Federal Reserve Board. Although Bernanke is a respected macroeconomist, he succeeded a chairman, Alan Greenspan, who was given high marks for his leadership of the Fed during a period (1987–2006) of remarkable prosperity and low inflation. In the months leading up to the end of Greenspan's tenure, much speculation surrounded how the Reserve Board would operate under its new chairman. Long before his appointment as chairman, Bernanke proposed that the Fed engage in "inflation targeting." In a 2004 interview, Bernanke was asked if the Fed's prior commitment to price stability was not a de facto inflation targeting policy. Bernanke gave the following response.

"It's true that the Federal Reserve is already practicing something close to de facto inflation targeting, and I think we've seen many benefits from that. My main suggestion is to take the natural next step and give an explicit objective ... to provide the public with a working definition of price stability in the form of a number or a numerical range for inflation First, such a step would increase the coherence of policy ... I think the ... [Federal Reserve's] decision-making process would be improved if members shared a collective view of where we want the inflation rate to be once the economy is on a steady expansion path.

Second, there's ... evidence now that tightly anchored public expectations of inflation are very beneficial not only for stabilizing inflation but also in reducing the volatility of output Third, from a communications viewpoint, financial markets would be well served by knowing the ... inflation objective of the Fed ... [it] would help market participants accurately price long-term assets..."

Source: Interview with Ben S. Bernanke. *The Region*. Federal Reserve Bank of Minneapolis. June 2004. www.minneapolisfed.org/publications_papers/pub_display.cfm?id=3326

Given that rates of inflation were low during the tenure of Alan Greenspan, what purpose would be served by setting a target for inflation?

Solving the Problem

Step 1: Review the chapter material.

This problem concerns the monetary policy targets of the Federal Reserve System, so you may want to review the section "A Closer Look at the Fed's Setting of Monetary Policy Targets," which begins on page 507 of the textbook.

Step 2: Explain why setting a target for inflation might still be a good idea even though rates of inflation were low during the tenure of Alan Greenspan.

The main reason for establishing an inflation rate target is that it strengthens the commitment of the Federal Reserve to price stability. In the article cited above, Bernanke stated, "I think that announcing a target would strengthen our commitment to ...price stability ... and ... give more emphasis to long-run considerations. ... Having a medium- to long-term objective would force us to keep in view where we want the economy to be in the longer run." Central banks can come under political pressure to engage in expansionary monetary policy in order to increase output and employment in the short run, even though the result of the policy may also be an increase in inflation. An explicit target for inflation can help a central bank to resist this political pressure. An explicit inflation target also makes it easier for the public to evaluate a central bank's performance.

15.6

Fed Policies During the 2007–2009 Recession (pages 512–517)

Learning Objective: Discuss the policies the Federal Reserve used during the 2007–2009 Recession.

As we have learned in this chapter, the Fed's traditional response to a recession is to lower the target for the federal funds rate. By December 2008, the Fed had lowered the target for the federal funds rate to zero without having much expansionary effect on the economy. The severity of the 2007–2009 recession and the problems in financial markets during that period, however, complicated the Fed's job. The recession was caused largely by the bursting of the housing market bubble in 2006. The decline in the housing market first affected consumption and investment spending.

Falling housing prices also led to an increasing number of defaults in the mortgage market. Because many commercial banks had securitized their mortgage loans by selling them as securities to other financial firms, particularly investment banks, increasing defaults led to significant losses for commercial banks and those financial firms holding those mortgage-backed securities. The bankruptcy of the investment bank Lehman Brothers on September 15, 2008, significantly worsened the financial crisis.

The recession along with the accompanying financial crisis had led the Fed and the Treasury to implement new approaches to policy. In October, Congress passed the Troubled Asset Relief Program

391

(TARP), under which the Treasury attempted to stabilize the commercial banking system by providing funds to banks in exchange for stock. The Fed also announced that it would lend directly to corporations through the Commercial Paper Funding Facility by purchasing three-month commercial paper issued by nonfinancial corporations. Many of these new approaches were controversial, particularly because they involved partial government ownership of financial firms, implicit guarantees to large financial firms that they would not be allowed to go bankrupt, and unprecedented intervention in financial markets.

Study Hint

Changes in the housing market after the 2001 recession were important for understanding the financial crisis and the 2007–2009 recession. *Making the Connection* "The Wonderful World of Leverage" explains that one of the reasons for the housing bubble to deflate in 2006 was the fact that many home owners were highly leveraged, meaning that their investment in their houses was made mostly with borrowed money.

Key Terms

Contractionary monetary policy The Federal Reserve's increasing interest rates to reduce inflation.

Expansionary monetary policy The Federal Reserve's decreasing interest rates to increase real GDP.

Federal funds rate The interest rate banks charge each other for overnight loans.

Inflation targeting Conducting monetary policy so as to commit the central bank to achieving a publicly announced level of inflation.

Monetary policy The actions the Federal Reserve takes to manage the money supply and interest rates to pursue macroeconomic policy goals.

Taylor rule A rule developed by John Taylor that links the Fed's target for the federal funds rate to economic variables.

Self-Test

(Answers are provided at the end of the Self-Test.)

Multiple-Choice Questions

- 1. As a result of the Great Depression of the 1930s, Congress amended the Federal Reserve Act to give the Fed the responsibility to
 - a. promote high employment, stabilize prices, and moderate interest rates.
 - b. keep interest rates high in order to benefit savers and banks.
 - c. finance the federal government's spending by buying Treasury securities.
 - d. None of the above is a Fed responsibility.
- 2. Which of the following is *not* one of the monetary policy goals of the Federal Reserve?
 - a. price stability
 - b. high employment and economic growth
 - c. stability of financial markets
 - d. a high foreign exchange rate of the U.S. dollar relative to other currencies

- 3. Monetary policy refers to the actions the Fed takes to
 - a. regulate business activity.
 - b. manage the money supply and interest rates.
 - c. manage government spending and taxation.
 - d. all of the above
- 4. Which of the following periods had the highest inflation rate?
 - a. the 1950s and 1960s
 - b. the 1970s
 - c. the 1990s
 - d. the 2000s.
- 5. Attempts to ensure that there will be an efficient flow of funds from savers to borrowers is the objective of which monetary policy goal?
 - a. price stability
 - b. high employment
 - c. economic growth
 - d. stability of financial markets
- 6. Which two policy goals can be pursued simultaneously without being at odds with each other?
 - a. high employment and inflation reduction
 - b. economic growth and inflation reduction
 - c. high employment and economic growth
 - d. Any of the combinations above can be pursued simultaneously without being at odds with each other.
- 7. Which of these two variables are the main monetary policy targets of the Fed?
 - a. real GDP and the price level
 - b. the money supply and the interest rate
 - c. the inflation rate and the unemployment rate
 - d. economic growth and productivity
- 8. Which of the following is *not* a goal of monetary policy?
 - a. price stability
 - b. high employment
 - c. economic growth
 - d. low interest rates
- 9. When is the opportunity cost of holding money higher?
 - a. when interest rates are high
 - b. when interest rates are low
 - c. when the inflation rate is lower
 - d. when the money supply increases
- 10. When the interest rate decreases,
 - a. the money demand curve shifts to the right.
 - b. the money demand curve shifts to the left.
 - c. there is a movement down along a stationary money demand curve.
 - d. there is a movement up along a stationary money demand curve.

393

- 11. Fill in the blanks. When interest rates on Treasury bills and other financial assets are low, the opportunity cost of holding money is ______, so the quantity of money demanded will be
 - a. low; low
 - b. high; high
 - c. low; high
 - d. high; low
- 12. If real GDP increases,
 - a. the money demand curve shifts to the right.
 - b. the money demand curve shifts to the left.
 - c. there is a movement down along a stationary money demand curve.
 - d. there is a movement up along a stationary money demand curve.
- 13. If the price level increases,
 - a. the money demand curve shifts to the right.
 - b. the money demand curve shifts to the left.
 - c. there is a movement down along a stationary money demand curve.
 - d. there is a movement up along a stationary money demand curve.
- 14. If the FOMC decides to increase the money supply, it orders the trading desk at the Federal Reserve Bank of New York to
 - a. buy stocks.
 - b. sell stocks.
 - c. buy U.S. Treasury securities.
 - d. sell U.S. Treasury securities.
- 15. If the FOMC orders the trading desk to sell Treasury securities,
 - a. the money supply curve will shift to the left, and the equilibrium interest rate will fall.
 - b. the money supply curve will shift to the left, and the equilibrium interest rate will rise.
 - c. the money supply curve will shift to the right, and the equilibrium interest rate will rise.
 - d. the money supply curve will shift to the right, and the equilibrium interest rate will fall.
- 16. The prices of financial assets and the interest rates on these assets
 - a. move in the same direction.
 - b. move in opposite directions.
 - c. are identical.
 - d. are unrelated.
- 17. Suppose for \$980 you buy a U.S. Treasury bill that matures in one year, at which time the Treasury will pay you \$1,000. How much interest will you earn on your investment of \$980?
 - a. 80 percent
 - b. 20 percent
 - c. 8 percent
 - d. 2 percent

18.	Fill in the blanks. Suppose that when the Fed decreases the money supply, households and firms initially hold less money than they want to, relative to other financial assets. As a result, households and firms will Treasury bills and other financial assets, thereby their prices, and their interest rates. a. buy; increasing; decreasing b. sell; increasing; decreasing c. buy; decreasing; decreasing d. sell; decreasing; increasing
19.	Which of the following will shift the money demand curve to the right? a. an increase in the interest rate b. an increase in real GDP c. a decrease in the interest rate d. an increase in the money supply
20.	The interest rate that banks charge each other for overnight loans is called the a. Treasury bill rate. b. prime lending rate. c. discount rate. d. federal funds rate.
21.	 Which of the following statements is correct? a. Changes in the federal funds rate usually will result in changes in both short-term and long-term interest rates on financial assets. b. The effect of a change in the federal funds rate on long-term interest rates is usually smaller than it is on short-term interest rates. c. A majority of economists support the Fed's choice of the interest rate as its monetary policy target, but some economists believe the Fed should concentrate on the money supply instead. d. All of the above are true.
22.	Fill in the blanks. As interest rates decline, stocks become a attractive investment relative to bonds, and this causes the demand for stocks and their prices to a. more; rise b. more; fall c. less; rise d. less; fall
23.	Fill in the blanks. If interest rates in the United States rise relative to interest rates in other countries, the demand for dollars will, which will the value of the dollar and cause net exports to a. fall; lower; fall b. rise; increase; rise c. fall; lower; rise d. rise; increase; fall
24.	An increase in the money supply will shift a. the money demand curve to the right and reduce the interest rate. b. the money supply curve to the right and increase the interest rate. c. the money demand curve to the left and increase the interest rate. d. the money supply curve to the right and reduce the interest rate.

- 25. The Fed's strategy of increasing the money supply and lowering interest rates in order to increase real GDP is called
 - a. expansionary fiscal policy.
 - b. contractionary monetary policy.
 - c. expansionary monetary policy.
 - d. contractionary fiscal policy.
- 26. Suppose that the FOMC meets and learns that real GDP will fall short of potential real GDP by \$200 billion. If the FOMC tries to correct this situation, it will enact which type of policy?
 - a. expansionary monetary policy to decrease short-run aggregate supply
 - b. expansionary monetary policy to increase aggregate demand
 - c. expansionary monetary policy to increase short-run aggregate supply
 - d. contractionary monetary policy to decrease long-run aggregate supply
- 27. How did the FOMC react to the 2007–2009 recession?
 - a. The FOMC increased the target for the federal funds rate steadily in 2008.
 - b. The FOMC reduced the target for the federal funds rate steadily in 2008.
 - c. The FOMC decided to leave interest rates unchanged in 2008.
 - d. The FOMC did not react because it failed to recognize that a recession was taking place.
- 28. The actions of the Fed during the 2007–2009 recession demonstrated that
 - a. the ability of the Fed to head off a severe recession is almost nonexistent.
 - b. the Fed is able to "fine tune" the economy, practically eliminating the business cycle, and achieving absolute price stability.
 - c. the Fed may reduce the severity of a recession but is unable to eliminate it entirely.
 - d. the Fed prefers to allow the economy to correct its problems on its own, without active monetary policy.
- 29. Which of the following is a consequence of deflation?
 - a. an increase in real interest rates
 - b. an increase in the real value of debts
 - c. consumers may postpone their purchases in the hope of facing even lower prices in the future
 - d. all of the above
- 30. If the Fed decreases the money supply and increases interest rates in order to reduce inflation, it is engaging in
 - a. contractionary fiscal policy.
 - b. expansionary monetary policy.
 - c. contractionary monetary policy.
 - d. discretionary fiscal policy.
- 31. All of the following will most likely increase as a result of expansionary monetary policy except
 - a. consumption.
 - b. government purchases.
 - c. investment.
 - d. net exports.

- 32. Why would the Fed intentionally use contractionary monetary policy to reduce real GDP?
 - a. The Fed intends to reduce inflation, which occurs if real GDP is above potential GDP.
 - b. The Fed intends to reduce unemployment, which occurs if real GDP is above potential GDP.
 - c. The Fed intends to reduce real GDP so that real GDP will grow again but at a faster pace.
 - d. The Fed intends to raise interest rates to make investment more attractive.
- 33. If the Fed is too slow to react to a recession and applies an expansionary monetary policy only after the economy begins to recover, then
 - a. inflation will be higher than if the Fed had not acted.
 - b. the unemployment rate will be higher than if the Fed had not acted.
 - c. the real GDP will be lower than if the Fed had not acted.
 - d. the economy will be more stable than if the Fed had not acted.
- 34. A procyclical policy is one that
 - a. is used to stabilize the economy.
 - b. inadvertently increases the severity of the business cycle.
 - c. minimizes the cost of economic recessions.
 - d. enhances the benefits of economic expansions.
- 35. A countercyclical policy is one that
 - a. is used to attempt to stabilize the economy.
 - b. inadvertently increases the severity of the business cycle.
 - c. follows the fluctuations in the business cycle.
 - d. enhances the benefits of economic expansions.
- 36. Monetarism is a school of economic thought that favors
 - a. a plan for increasing the money supply at a constant rate that does not change in response to economic conditions.
 - b. a monetary growth rule.
 - c. increasing the money supply every year at a rate equal to the long-run growth rate of real GDP.
 - d. all of the above.
- 37. If the economy moves into recession, monetarists argue that the Fed should
 - a. increase the money supply.
 - b. decrease the money supply.
 - c. keep the money supply growing at a constant rate.
 - d. keep the money supply fixed.
- 38. Which of the following statements is true about the Fed's monetary policy targets?
 - a. The only monetary policy target the Fed can choose is the money supply.
 - b. The only monetary policy target the Fed can choose is the interest rate.
 - c. The Fed could simultaneously choose the interest rate and the money supply as its monetary policy targets.
 - d. The Fed is forced to choose between the interest rate and the money supply as its monetary policy target.

- 39. The Taylor rule for federal funds rate targeting does which of the following?
 - a. It links the Fed's target for the federal funds rate to economic variables.
 - b. It sets the target for the federal funds rate so that it is equal to the sum of the inflation rate and the unemployment rate.
 - c. It multiplies the inflation gap by the output gap to obtain a target of the federal funds rate.
 - d. The Taylor rule does all of the above.
- 40. Fill in the blanks. The federal funds rate target predicted by the Taylor Rule is ______ than the actual target used by the Fed during the period of the late 1970s and early 1980s when Paul Volcker was Federal Reserve Chairman, and _____ than the actual federal funds target used by the Fed when Arthur Burns was chairman from 1970 to 1978.
 - a. higher; higher
 - b. lower; lower
 - c. higher; lower
 - d. lower; higher
- 41. According to the Taylor Rule, if the Fed reduces its target for the inflation rate, this will result in
 - a. a higher target federal funds rate.
 - b. no change in the target federal funds rate.
 - c. a lower target federal funds rate.
 - d. a higher target output growth rate.
- 42. When the central bank commits to conducting policy in a manner that achieves the goal of holding inflation to a publicly announced level, it is using
 - a. inflation targeting.
 - b. the Taylor rule.
 - c. contractionary monetary policy.
 - d. monetary policy independence.
- 43. Which of the following countries has *not* officially adopted an inflation target?
 - a. United States
 - b. Canada
 - c. New Zealand
 - d. the United Kingdom
- 44. Which of the following was a likely cause of the 2007–2009 recession?
 - a. monetary policy that was too tight
 - b. the collapse of a housing bubble
 - c. a federal budget crisis
 - d. a financial crisis in Europe
- 45. Which of the following is a monetary policy response to the 2007–2009 recession and the accompanying financial crisis?
 - a. The Fed expanded the types of firms eligible for discount loans beyond commercial banks.
 - b. The Fed provided loans directly to corporations by purchasing commercial paper.
 - c. The Fed purchased large amounts of mortgage-backed securities.
 - d. All of the above were responses.

Short Answer Questions

Using a money demand and money supply graph, show the effect on the interest rate of ar increase in real GDP.
A U.S. Treasury bond that matures in one year has a face value of \$1,000 and a current price o \$900. What will be the interest rate on the bond? What if the current price is \$910?
Using a money demand and money supply graph, show how the Fed can keep the interest rate at predetermined rate (i_0) as money demand increases.
Suppose that the economy experiences weak AD growth and a supply shock at the same time Discuss the monetary policy options using the dynamic AD - AS model.
,

399

True/False Questions

- T F 1. The Fed has a dual mandate to attain high employment and price stability.
- T F 2. The Fed's goal to maintain stability of financial markets is to ensure high profits for banks and other financial institutions.
- T F 3. The opportunity cost of holding money is measured by the nominal interest rate.
- T F 4. As bond prices increase, the interest rates on the bonds also increase.
- T F 5. An increase in the price level will cause the money demand curve to shift to the right, resulting in a lower interest rate.
- T F 6. The federal funds rate is the interest rate banks charge each other for overnight loans.
- T F 7. Increases in interest rates tend to increase the level of investment spending.
- T F 8. A reduction in the Fed's interest rate target tends to increase the level of aggregate demand.
- T F 9. An expansionary monetary policy tends to generate higher real GDP growth and higher inflation.
- T F 10. Other things being equal, the short-term interest rate falls when the Fed increases the money supply.
- T F 11. Interest rate targets are chosen by the Monetary Policy Committee of Congress.
- T F 12. If the Fed implements a countercyclical monetary policy too late in the business cycle, more economic fluctuations will occur than otherwise.
- T F 13. If the Fed targets the interest rate, it automatically targets the money supply.
- T F 14. According to the Taylor rule, an increase in the inflation rate will lead to a higher federal funds target rate.
- T F 15. A change in the federal funds rate has a smaller effect on short-term interest rates than on long-term interest rates.

Answers to the Self-Test

Multiple-Choice Questions

Question	Answer	Comment
1.	a	Congress amended the Federal Reserve Act to give the Fed the responsibility to act "so as to promote effectively the goals of maximum employment, stable prices, and moderate long-term interest rates."
2.	d	The Fed has four policy goals: (1) price stability, (2) high employment, (3) economic growth, and (4) stability of financial markets.
3.	b	Any action the Fed takes to manage the money supply and interest rates is referred to as monetary policy.
4.	b	For most of the 1950s and 1960s the inflation rate in the United States was 4 percent or less. During the 1970s, the inflation rate increased, peaking during 1979–1981, when it averaged more than 11 percent. Since 1992, the inflation rate has mostly been less than 4 percent. See textbook Figure 15.1.
5.	d	The Fed has four policy goals: (1) price stability, (2) high employment, (3) economic growth, and (4) stability of financial markets. The Fed attempts to promote the stability of financial markets and institutions so that there will be an efficient flow of funds from savers to borrowers.
6.	c	The Fed can sometimes be successful in pursuing multiple goals at the same time. For example, it can spur both high employment and economic growth because steady economic growth contributes to high employment. At other times, however, the Fed encounters conflicts between its policy goals. For example, to reduce the inflation rate, the Fed may have to raise interest rates which would increase unemployment and dampen growth.
7.	b	The Fed uses variables, called monetary policy targets, that it can affect directly and that in turn affect variables such as real GDP and the price level that are closely related to the Fed's policy goals. The two main monetary policy targets are the money supply and the interest rate. The Fed typically uses an interest rate as its policy target.
8.	d	Low interest rates are not a Fed goal, although in certain circumstances low interest rates may help the Fed achieve its goals.
9.	а	Remember that opportunity cost is what you have to forgo in order to engage in an activity. When interest rates on financial assets such as U.S. Treasury bills are high, the amount of interest that households and firms lose by holding money is also high. When interest rates are low, the amount of interest households and businesses lose by holding money is low. Therefore, the interest rate is the opportunity cost of holding money.
10.	c	The money demand curve slopes downward because lower interest rates cause households and firms to switch from financial assets such as Treasury bills to money. An increase in the interest rate will decrease the quantity of money demanded. A decrease in the interest rate will increase the quantity of money demanded.

Question	Answer	Comment
11.	c	When interest rates on Treasury bills and other financial assets are low, the opportunity cost of holding money is low, so the quantity of money demanded will be high; when interest rates are high, the opportunity cost of holding money will be high, so the quantity of money demanded will be low. This explains why the money demand curve slopes downward.
12.	a	An increase in real GDP means that the amount of buying and selling of goods and services will increase. To carry out these new transactions, households and firms will need more money, which increases the demand for money as a medium of exchange. So the quantity of money households and firms want to hold increases at each interest rate.
13.	a	An increase in the price level increases the quantity of money demanded at each interest rate, shifting the money demand curve to the right. A decrease in the price level decreases the quantity of money demanded at each interest rate, shifting the money demand curve to the left.
14.	С	If the FOMC decides to increase the money supply, it orders the trading desk at the Federal Reserve Bank of New York to purchase U.S. Treasury securities. The sellers of these Treasury securities deposit the funds they receive from the Fed in banks, which increases the banks' reserves. The banks loan out most of these reserves, which creates new checking account deposits and expands the money supply. If the FOMC decides to decrease the money supply, it orders the trading desk to sell Treasury securities, which decreases banks' reserves, and contracts the money supply.
15.	b	If the Fed sells Treasury securities, the money supply will decrease, the money supply curve will shift to the left, and the equilibrium interest rate will rise. This is the opposite case to the one shown in textbook Figure 15.4.
16.	b	Price = Face Value / (1 + interest rate). Therefore the prices of financial assets and their interest rates move in opposite directions.
17.	b	The interest rate on the Treasury bill is: $(\$20/\$980) \times 100 = 2.0\%$.
18.	a	Suppose the Fed decreases the money supply. If households and firms initially hold less money than they want to relative to other financial assets, then they will buy Treasury bills and other financial assets in exchange for money. An increase in the demand for Treasury bills and other financial assets raises their prices. The interest rates of Treasury bills and other financial assets will therefore decrease because the interest rates and prices of those assets are inversely related.
19.	b	Interest rate changes cause movements along the money demand curve. Increases in real GDP cause the money demand curve to shift to the right as consumers need more money to carry out the additional transactions.
20.	d	The interest rate banks charge each other for overnight loans is called the federal funds rate.

Question	Answer	Comment
21.	d	Changes in the federal funds rate usually will result in changes in both interest rates on other short-term financial assets, such as Treasury bills, and interest rates on long-term financial assets, such as corporate bonds and mortgages. The effect of a change in the federal funds rate on long-term interest rates is usually smaller than it is on short-term interest rates. Although a majority of economists support the Fed's choice of the interest rate as its monetary policy target, some economists believe the Fed should concentrate on the money supply instead.
22.	a	As interest rates decline, stocks become a more attractive investment relative to bonds. The increase in demand for stocks raises their prices. An increase in stock prices signals firms that the future profitability of investment projects has increased. Firms often issue new shares of stocks and use the proceeds to buy new plants and equipment, thereby increasing investment.
23.	d	If interest rates in the United States rise relative to interest rates in other countries, the desirability of investing in U.S. financial assets will increase, causing foreign investors to increase their demand for dollars, and this will increase the value of the dollar. As the value of the dollar increases, net exports will fall.
24.	d	An increase in the money supply will shift the money supply curve to the right, causing it to intersect the money demand curve at a lower interest rate. So, the equilibrium interest rate will be lower.
25.	с	When the Fed increases the money supply and decreases interest rates to increase real GDP, it is engaging in expansionary monetary policy.
26.	b	The FOMC may then decide to take action to lower interest rates in order to stimulate aggregate demand.
27.	b	Throughout 2008, the FOMC lowered its target for the federal funds rate as actions of expansionary monetary policy. The target for the federal funds rate was effectively zero by the end of 2008 in order to boost aggregate demand.
28.	c	The Fed has no realistic hope of "fine tuning" the economy to eliminate the business cycle and achieve absolute price stability. The Fed is usually unable to entirely eliminate a recession, but keeping it shorter and milder than it would otherwise be is usually the best the Fed can do.
29.	d	Deflation can contribute to slow growth by raising real interest rates, increasing the real value of debts, and causing consumers to postpone purchases in the hope of experiencing even lower prices in the future.
30.	С	If Fed acts to decrease the money supply and increase interest rates in order to reduce inflation, it is engaging in a practice called contractionary monetary policy.
31.	b	An expansionary monetary policy lowers interest rates, which in turn raises aggregate demand. First, lower interest rates reduce the cost of payments on loans so that consumers spend more, especially on durable goods. Lower interest rates also reduce the return to saving, leading households to save less and spend more. Second, lower interest rates reduce the cost of financing investment projects so that investment spending increases. Third, if interest rates in one country decline relative to interest rates in other countries, the value of the dollar will fall, and net exports will rise.

Question	Answer	Comment
32.	a	When real GDP is higher than potential GDP, inflation increases. The Fed intends to reduce inflation by using contractionary monetary policy. However, contractionary monetary policy not only brings inflation down, but it also reduces real GDP.
33.	a	Despite Fed chair Ben Bernanke proposing using inflation targeting as a monetary policy framework, the Fed has yet to officially adopt a fixed inflation target rate.
34.	b	A procyclical policy is one that inadvertently increases the severity of the
		business cycle, while a countercyclical policy—which is what the Fed intends to use—would stabilize the economy.
35.	a	A countercyclical policy involves the Fed attempting to stabilize the economy.
36.	d	Monetarists favor replacing current monetary policy with a monetary growth rule. Ordinarily we expect monetary policy to respond to changing economic conditions: When the economy is in recession, the Fed reduces interest rates, and when inflation is increasing, the Fed raises interest rates. A monetary growth rule, in contrast, is a plan for increasing the money supply at a constant rate that does not change in response to economic conditions. Monetarists have
		proposed a monetary growth rule of increasing the money supply every year at a rate equal to the long-run growth rate of real GDP, which has been 3.5 percent.
37.	С	The Fed should stick to the monetary growth rule even during recessions. Monetarists believe active monetary policy destabilizes the economy, increasing the number of recessions and their severity. By keeping the money supply growing at a constant rate, Friedman argued, the Fed would greatly increase economic stability.
38.	d	If money demand shifts right, the interest rate will rise. The Fed can then either keep the money supply at its old rate and accept the higher interest rate, or it can increase the money supply to restore the old level of interest rates. Thus, the Fed is forced to choose between using either an interest rate or the money supply as its monetary policy target.
39.	a	According to the Taylor rule, the federal funds target rate = Current inflation rate + Real equilibrium federal funds rate + $(1/2) \times Inflation gap + (1/2) \times Output gap$.
40.	d	The Taylor rule predicted a federal funds rate target lower than the actual target used by the Fed during the period when Paul Volcker was chairman. This indicates that Chairman Volcker kept the federal funds rate at an unusually high level in order to rapidly bring down the very high inflation rates plaguing the economy in the late 1970s and early 1980s. In contrast, using data from the chairmanship of Arthur Burns from 1970 to 1978, the Taylor rule predicted a federal funds rate target higher than the actual target. This indicates that Chairman Burns kept the federal funds rate at an unusually low level
41	2	during these years, which can help explain why the inflation rate grew worse.
41.	a	A reduction in the target inflation rate requires the Fed to carry out a contractionary monetary policy. This will be done by raising the target for the federal funds rate.
42.	a	With inflation targeting, the central bank commits to conducting policy so as to achieve a publicly announced inflation target of, for example, 2 percent.

Question	Answer	Comment
43.	b	In the long run, real GDP returns to its potential level, and potential real GDP is not affected by monetary policy. Therefore, in the long run, the Fed can have an impact on inflation but not on real GDP.
44.	Ь	A housing bubble that began to deflate in 2006 led to a financial crisis and the 2007–2009 recession.
45.	d	In response to the 2007–2009 recession and the accompanying financial crisis, the Fed took several new policy actions, including expanding the types of firms eligible for discount loans, lending directly to corporations, and buying mortgage-backed securities.

Short Answer Responses

1. Beginning in equilibrium, the increase in the real GDP will increase money demand and shift the MD curve to the right. With the money supply unchanged, the increased demand for money will result in the public selling bonds to try to increase the quantity of money they hold. The sale of the bonds will lower bond prices and increase the interest rate. Graphically, we have:

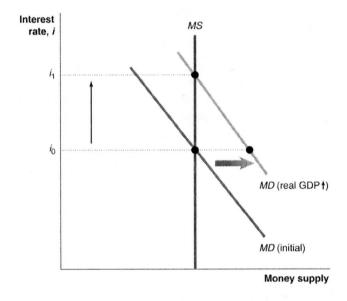

2. If the current price of a \$1,000 face value U.S. Treasury bond is \$900, then the interest rate on the bond will be:

$$(\$1,000 - \$900)/\$900 = 11.11\%$$

If the price of the bond rises to \$910, then the interest rate will fall to:

$$(\$1,000 - \$910)/\$910 = 9.89\%$$

Notice that the rise in the price of a bond reduces the interest rate on the security.

3. As money demand grows from MD (initial) to MD (end), the money demand curve shifts out. If the Fed had kept the money supply constant (targeted the money supply), the interest rate would have increased from i_0 to i_1 . If the Fed targets the interest rate, then the Fed must increase the money supply from MS (initial) to MS (end) to keep the interest rate constant at i_0 .

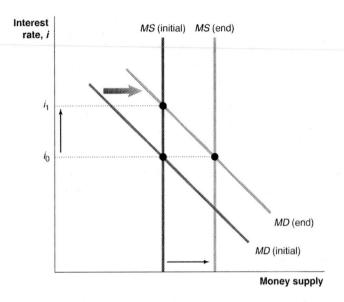

4. Weak AD growth and a supply shock can be seen in the following graph. The adverse supply shock will cause the ultimate shift in SRAS to be smaller than the shift in SRAS without the supply shock. Because of the weak growth, the Fed decides to follow an expansionary monetary policy and reduce target interest rates.

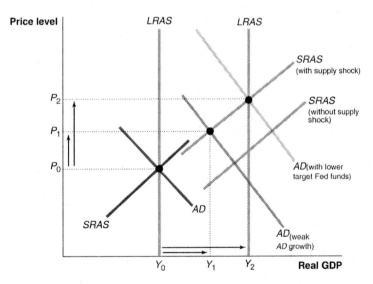

As a result of the initial changes, prices increase from P_0 to P_1 and real GDP increases from Y_0 to Y_1 . Because of the low growth, the Fed reduces the target fed funds rate and begins a more expansionary monetary policy. This is done to increase real GDP, and as a result of the policy, real GDP increases to Y_2 . Notice that as a result of this policy decision, inflation will be higher because price rises to P_2 .

Alternatively, the Fed might decide to follow a contractionary monetary policy and fight the inflation caused by the supply shock. In this case, the Fed would increase target fed funds rates in order to restrict aggregate demand growth. This is seen in the following graph.

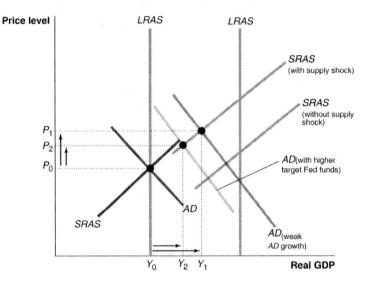

Again, as a result of the initial changes, prices increase from P_0 to P_1 and real GDP increases from Y_0 to Y_1 . This time the Fed follows a contractionary monetary policy to fight the inflation effects of the supply shock. As a result of this, AD declines (or does not grow as much), and inflation will be lower as prices only rise to P_2 instead of P_1 . However, the consequence of the policy is that real GDP will grow even less than before $Y_0 \rightarrow Y_1$.

5. The output gap is calculated as $100 \times (Actual - Potential)/Potential = -2.6\%$, so the predicted target federal fund rate is:

Target federal funds rate = $2.4\% + 2\% + (1/2) \times (0.4) + (1/2) \times (-2.6) = 3.3\%$.

The actual target was between 0 percent and 0.25 percent at the end of third quarter of 2011.

True/False Answers

Question	Answer	Comment
1.	T	High employment and stable prices are the Fed's dual mandate.
2.	F	The goal of maintaining financial stability is to ensure an efficient transfer of funds between savers and borrowers.
3.	T	See pages 490 and 491 in the textbook the measure of the opportunity cost of holding money.
4.	F	Bond prices and interest rates move in opposite directions.
5.	F	The shift to the right in money demand will result in increases in the interest rate.
6.	T	See page 494 in the textbook for the definition of the federal funds rate.
7.	F	Interest rate increases tend to reduce investment purchases.
8.	T	See page 496 in the textbook for the effect of a reduction of the interest rate target.
9.	T	See pages 496 and 497 in the textbook for the effects of an expansionary monetary policy.

Question	Answer	Comment
10.	T	See page 492 in the textbook for the effect of an increase in the money supply on interest rates.
11.	F	Target interest rate decisions are made by the FOMC.
12.	T	If the Fed implements a policy too late, it can destabilize the economy.
13.	F	The Fed can't target both the money supply and the interest rate simultaneously.
14.	T	According to the Taylor rule, the federal funds rate increases when the inflation gap—the difference between current inflation and a target inflation rate—or the output gap—the percentage difference between real GDP and potential real
		GDP—increases.
15.	F	A change in the federal funds rate has a greater effect on short-term interest rates than on long-term interest rates, and its effect on long-term interest rates occur only after a lag in time.

나는 살이 가장 살아가 있는 것이 없는 것이 하나 하는 것이 되는 것이 없는 것이 없는 것이 없는 것이 없는 것이 없는 것이다.	

CHAPTER 16 | Fiscal Policy

Chapter Summary and Learning Objectives

16.1 What is Fiscal Policy? (pages 528–532)

Define fiscal policy. Fiscal policy involves changes in federal taxes and purchases that are intended to achieve macroeconomic policy objectives. Automatic stabilizers are government spending and taxes that automatically increase or decrease along with the business cycle. Since World War II, the federal government's share of total government expenditures has been between two-thirds and three-quarters. Federal government expenditures as a percentage of GDP rose from 1950 to the early 1990s and fell between 1992 and 2001, before rising again. Federal government purchases have declined as a percentage of GDP since the end of the Korean War in the early 1950s. The largest component of federal expenditures is transfer payments. The largest sources of federal government revenue are individual income taxes, followed by social insurance taxes, which are used to fund the Social Security and Medicare systems.

16.2 The Effects of Fiscal Policy on Real GDP and the Price Level (pages 532–535)

Explain how fiscal policy affects aggregate demand and how the government can use fiscal policy to stabilize the economy. To fight recessions, Congress and the president can increase government purchases or cut taxes. This expansionary policy causes the aggregate demand curve to shift out more than it otherwise would, raising the level of real GDP and the price level. To fight rising inflation, Congress and the president can decrease government purchases or raise taxes. This contractionary policy causes the aggregate demand curve to shift out less than it otherwise would, reducing the increase in real GDP and the price level.

16.3 Fiscal Policy in the Dynamic Aggregate Demand and Aggregate Supply Model (pages 535–536)

Use the dynamic aggregate demand and aggregate supply model to analyze fiscal policy. We can use the dynamic aggregate demand and aggregate supply model introduced in Chapter 12 to look more closely at expansionary and contractionary fiscal policies. The dynamic aggregate demand and aggregate supply model takes into account that (1) the economy experiences continuing inflation, with the price level rising every year, and (2) the economy experiences long-run growth, with the LRAS curve shifting to the right every year. In the dynamic model, an expansionary fiscal policy tries to ensure that the aggregate demand curve will shift far enough to the right to bring about macroeconomic equilibrium, with real GDP equal to potential GDP. A contractionary fiscal policy attempts to offset movements in aggregate demand that would cause macroeconomic equilibrium to occur at a level of real GDP that is greater than potential real GDP.

16.4 The Government Purchases and Tax Multipliers (pages 536–541)

Explain how the government purchases and tax multipliers work. Because of the multiplier effect, an increase in government purchases or a cut in taxes will have a multiplied effect on equilibrium real GDP. The government purchases multiplier is equal to the change in equilibrium real GDP divided by the change in government purchases. The tax multiplier is equal to the change in equilibrium real GDP divided by the change in taxes. Increases in government purchases and cuts in taxes have a positive

multiplier effect on equilibrium real GDP. Decreases in government purchases and increases in taxes have a negative multiplier effect on equilibrium real GDP.

16.5 The Limits of Using Fiscal Policy to Stabilize the Economy (pages 541–548)

Discuss the difficulties that can arise in implementing fiscal policy. Poorly timed fiscal policy can do more harm than good. Getting the timing right with fiscal policy can be difficult because obtaining approval from Congress for a new fiscal policy can be a very long process and because it can take months for an increase in authorized spending to actually take place. Because an increase in government purchases may lead to a higher interest rate, it may result in a decline in consumption, investment, and net exports. A decline in private expenditures as a result of an increase in government purchases is called **crowding out.** Crowding out may cause an expansionary fiscal policy to fail to meet its goal of keeping the economy at potential GDP.

16.6 Deficits, Surpluses, and Federal Government Debt (pages 548–554)

Define federal budget deficit and federal government debt and explain how the federal budget can serve as an automatic stabilizer. A budget deficit occurs when the federal government's expenditures are greater than its tax revenues. A budget surplus occurs when the federal government's expenditures are less than its tax revenues. A budget deficit automatically increases during recessions and decreases during expansions. The automatic movements in the federal budget help to stabilize the economy by cushioning the fall in spending during recessions and restraining the increase in spending during expansions. The cyclically adjusted budget deficit or surplus measures what the deficit or surplus would be if the economy were at potential GDP. The federal government debt is the value of outstanding bonds issued by the U.S. Treasury. The national debt is a problem if its interest payments require taxes to be raised substantially or require other federal expenditures to be cut.

16.7 The Effects of Fiscal Policy in the Long Run (pages 554–557)

Discuss the effects of fiscal policy in the long run. Some fiscal policy actions are intended to have long-run effects by expanding the productive capacity of the economy and increasing the rate of economic growth. Because these policy actions primarily affect aggregate supply rather than aggregate demand, they are sometimes referred to as supply-side economics. The difference between the pretax and posttax return to an economic activity is known as the tax wedge. Economists believe that the smaller the tax wedge for any economic activity—such as working, saving, investing, or starting a business—the more that economic activity will occur. Economists debate the size of the supply-side effects of tax changes.

Appendix: A Closer Look at the Multiplier (pages 564–568)

Apply the multiplier formula. In the chapter, you will see that changes in government purchases and changes in taxes have a multiplied effect on equilibrium real GDP. In the appendix, you will build a simple economic model of the multiplier effect. Your instructor may cover the appendix in class or assign it for reading.

Chapter Review

Chapter Opener: Does Government Spending Create Jobs? (page 527)

The American Recovery and Reinvestment Act (ARRA) of 2009, often referred to as the "stimulus bill," is an example of *discretionary fiscal policy* aimed at increasing aggregate demand, real GDP, and employment. The construction project to widen the Caldecott Tunnel in north California is an example of increasing government spending in an attempt to raise aggregate demand during the 2007–2009 recession.

Tutor-Saliba of Southern California is one of the construction firms involved in the Caldecott Tunnel project. Whether increases in government spending actually raise employment is, however, controversial. Some economists argue that employment simply shifts from one activity to another activity or from one place to another place, and government spending increases will reduce private spending. Following the recession, the federal government ran the largest peacetime deficits in history. At the end of 2012, Congress enacted cuts in federal spending and increases in taxes to try to reduce the budget deficits.

16.1

What Is Fiscal Policy? (pages 528-532)

Learning Objective: Define fiscal policy.

Fiscal policy refers to changes in federal taxes and spending that are intended to achieve macroeconomic policy objectives, such as high levels of employment, price stability, and economic growth. Fiscal policy is restricted to tax and spending decisions by the federal government and does not include spending decisions not intended to achieve macroeconomic policy goals, such as military spending or spending to aid people with low incomes.

Some types of government spending and taxes are automatic stabilizers, while other types are discretionary fiscal policy. Automatic stabilizers are spending and tax changes that increase or decrease over the business cycle without actions by the government. An example is unemployment insurance payments, which rise because of layoffs in a recession and fall as employment increases in the expansion phase of the business cycle. Discretionary fiscal policy requires the government to take action to change spending or taxes.

Federal government purchases include all purchases of goods, as well as the wage costs of providing services. Federal government expenditures include purchases plus:

- interest on the national debt
- grants to state and local governments
- transfer payments

In 2012, transfer payments were about 46 percent of federal government expenditures, as compared to only about 25 percent in the 1960s. The increasing share of transfer payments in federal expenditures is a result of the aging U.S. population, which has caused medical costs and spending on the Social Security and Medicare programs to increase rapidly.

Today about 43 percent of federal government revenue comes from individual income taxes and about 35 percent from social insurance taxes. Corporate profit taxes contribute about 14 percent of tax revenues, and the remainder comes from sales taxes and import fees.

L Study Hint

Read Making the Connection "Is Spending on Social Security and Medicare a Fiscal Time Bomb?" for details about the current problems with the Social Security and Medicare programs. Social Security was established in 1935 to provide payments to retired workers with taxes collected from current workers. Medicare was established in 1965 to provide health care coverage to people 65 and older. Both programs have been successful in reducing poverty among elderly Americans, but as the number of workers per retiree has declined and retirees has tended to live longer, it has become difficult for the federal government to continue to make payments and to provide health care coverage to retirees using taxes collected from current workers.

Extra Solved Problem 16.1

Growth in Government Purchases and Taxes

Supports Learning Objective 16.1: Define fiscal policy.

Generally, over time, federal government purchases and taxes have risen. Below are data on federal government tax receipts and expenditures from 2003 to 2012 (all values are in billions of dollars). Calculate receipts and expenditures as a percentage of GDP. While the level of receipts and expenditures is generally rising, are receipts and expenditures also rising as a percentage of GDP?

Year	Nominal GDP	Federal Government Tax Receipts	Federal Government Expenditures
2003	\$11,142	\$1,796	\$2,192
2004	11,853	1,926	2,325
2005	12,623	2,196	2,518
2006	13,377	2,450	2,659
2007	14,029	2,600	2,788
2008	14,292	2,465	3,145
2009	14,418	2,045	3,516
2010	14,958	2,206	3,481
2011	15,534	2,326	3,576
2012	16,245	2,509	3,569

Solving the Problem

Step 1: Review the chapter material.

This problem refers to the definition of fiscal policy, so you may want to review the section "What Fiscal Policy Is and What It Isn't" on page 528 of the textbook.

Step 2: Calculate receipts and expenditures as a percentage of GDP.

Receipts and expenditures as a percentage of GDP are calculated as the value of the year's receipts divided by GDP. Notice that since receipts and expenditures are nominal, we are also using nominal GDP. These percentages are shown in the table below.

Year	Nominal GDP	Federal Government Tax Receipts	Federal Government Expenditures	Federal Government Tax Receipts as a Percentage of GDP	Federal Government Expenditures as a Percentage of GDP
2003	\$11,142	\$1,796	\$2,192	16.1%	19.7%
2004	11,853	1,926	2,325	16.3	19.6
2005	12,623	2,196	2,518	17.4	19.9
2006	13,377	2,450	2,659	18.3	19.9
2007	14,029	2,600	2,788	18.5	19.9
2008	14,292	2,465	3,145	17.2	22.0
2009	14,418	2,045	3,516	14.2	24.4
2010	14,958	2,206	3,481	14.7	23.3
2011	15,534	2,326	3,576	15.0	23.0
2012	16,245	2,509	3,569	15.4	22.0

Notice that while the dollar value of tax receipts has increased over this period, tax receipts as a percentage of GDP were lower in 2012 than in 2003. On the other hand, federal government expenditures as a percentage of GDP have increased remarkably. Because federal expenditures as a percentage of GDP have been larger than receipts for each year since 2003, the federal budget has been in deficit. To eliminate the deficit, receipts would have to rise or expenditures would have to be cut.

16.2

The Effects of Fiscal Policy on Real GDP and the Price Level (pages 532-535)

Learning Objective: Explain how fiscal policy affects aggregate demand and how the government can use fiscal policy to stabilize the economy.

Like monetary policy, fiscal policy can be used by the president and Congress to influence the level of aggregate demand and, consequently, influence the level of real GDP and the inflation rate. Expansionary fiscal policy is shown in panel (a) of Figure 16.5 in the textbook. Expansionary fiscal policy involves increases in government purchases or decreases in taxes. Increases in government purchases directly increase aggregate demand, while decreases in taxes have indirect effects on aggregate demand. Tax cuts increase household disposable income and bring about higher levels of consumption spending and, therefore, higher levels of aggregate demand. Expansionary fiscal policy can reduce the impact of weak aggregate demand growth. Increasing government purchases or decreasing taxes will shift the aggregate demand curve to the right. Contractionary fiscal policy involves decreases in government purchases or increases in taxes. Contractionary fiscal policy will cause aggregate demand to increase less than it otherwise would. The AD will be to the left of where it would have been without the contractionary policy. Contractionary fiscal policy is generally used when aggregate demand is growing too rapidly, which may worsen the inflation rate. This is shown in panel (b) of Figure 16.5 in the textbook.

The table below summarizes the use of fiscal policy:

PROBLEM	TYPE OF POLICY	ACTIONS BY CONGRESS AND THE PRESIDENT	RESULT
Recession	Expansionary	Increase government spending or cut taxes	Real GDP and the price level rise
Rising inflation	Contractionary	Decrease government spending or raise taxes	Real GDP and the price level fall

Extra Solved Problem 16.2

Expansionary Fiscal Policy

Supports Learning Objective 16.2: Explain how fiscal policy affects aggregate demand and how the government can use fiscal policy to stabilize the economy.

Suppose that the economy is at a level of real GDP below potential real GDP. Show this graphically, and show how expansionary fiscal policy can be used to move the economy to the potential real GDP level.

Solving the Problem

Step 1: Review the chapter material.

This problem refers to expansionary fiscal policy, so you may want to review the section "Expansionary and Contractionary Fiscal Policy," which begins on page 533 of the textbook.

Step 2: Draw the initial equilibrium with output below potential real GDP.

If output $(Y_0 = \$10,000)$ is below potential real GDP $(Y_{Potential} = \$11,000)$, AD will intersect the SRAS below the LRAS. This is shown in the following graph.

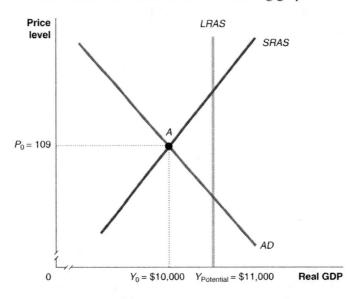

Step 3: Draw the equilibrium with the expansionary fiscal policy.

If output is below potential real GDP, expansionary fiscal policy can add to the existing level of aggregate demand. This will shift AD to the right, resulting in equilibrium at a higher level of real GDP. This is shown in the graph below. Fiscal policy causes a movement from point A to point B, and output grows from \$10,000 to \$11,000. This implies that fiscal policy can be used to push the economy to potential GDP, though expansionary fiscal policy will also cause an increase in the price level (from 109 to 112 in the graph).

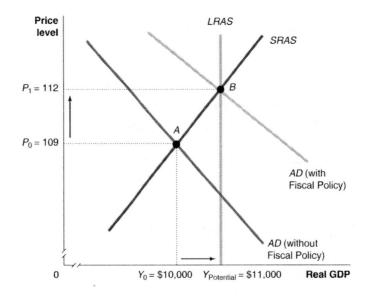

Study Hint

Read the feature **Don't Let This Happen to You** "Don't Confuse Fiscal Policy and Monetary Policy." The purpose of expansionary monetary policy is to lower interest rates, which will increase aggregate demand. The purpose of expansionary fiscal policy is to increase aggregate demand by adding to the level of government purchases or to induce consumers to spend more by lowering taxes. Fiscal and monetary policies have the same goals but have different ways of reaching the goals.

16.3

Fiscal Policy in the Dynamic Aggregate Demand and Aggregate Supply Model (pages 535-536)

Learning Objective: Use the dynamic aggregate demand and aggregate supply model to analyze fiscal policy.

The discussion of fiscal policy effects illustrated by Figure 16.5 in the textbook ignores two important facts about the economy: (1) The economy experiences continuing inflation, with the price level rising every year, and (2) the economy experiences long-run growth, with the LRAS curve shifting to the right every year. In Chapter 13, we developed a dynamic aggregate demand and aggregate supply model that took these two facts into account.

In the dynamic aggregate demand and supply model, expansionary fiscal policy adds to the growth in aggregate demand. In textbook Figure 16.6, the growth in aggregate demand without fiscal policy results in equilibrium at less than potential GDP (point A to B). Fiscal policy adds to aggregate demand and pushes the economy to potential GDP at point C.

Contractionary fiscal policy involves fiscal policy changes to reduce the growth in aggregate demand. This is shown in textbook Figure 16.7. The expansion in aggregate demand without contractionary policy (from point A to B) will result in inflation. With the contractionary fiscal policy, demand will not increase as much, and the economy will move instead to point C with less inflation.

Extra Solved Problem 16.3

Fiscal Policy Effect on Real GDP and Inflation

Supports Learning Objective 16.3: Use the dynamic aggregate demand and aggregate supply model to analyze fiscal policy.

Suppose that consumer spending grows at a rapid pace so that inflation increases to a high rate. Explain what type of fiscal policy the government should carry out to reduce inflation and discuss what will happen to real GDP using the dynamic aggregate demand and aggregate supply model.

Solving the Problem

Step 1: Review the chapter material.

This problem refers to the analysis of fiscal policy in a dynamic aggregate demand and aggregate supply model, so you may want to review the section "Fiscal Policy in the Dynamic Aggregate Demand and Aggregate Supply Model," which begins on page 535 of the textbook.

Step 2: Analyze the type of fiscal policy response.

To respond to a relatively high inflation rate as a result of high growth in consumer spending, the government should carry out a contractionary fiscal policy, which involves a reduction in government spending or an increase in taxes.

Analyze the fiscal policy effects using the dynamic aggregate demand and Step 3: aggregate supply model.

A contractionary fiscal policy lowers the growth of aggregate demand. According to the dynamic aggregate demand and aggregate supply model, a smaller growth in aggregate demand as a result of the contractionary fiscal policy will result in a lower real GDP and a lower inflation rate than there would have been without the policy. The effect of a contractionary fiscal policy on real GDP and the price level is shown in textbook Figure 16.7.

The Government Purchases and Tax Multipliers (pages 536-541) 16.4

Learning Objective: Explain how the government purchases and tax multipliers work.

Fiscal policy changes have a multiplier effect on the level of aggregate demand. Increases in government purchases lead to further increases in spending. The initial increase in government spending will lead to increases in income, which will generate additional spending by households and firms, which will lead to additional increases in aggregate demand. It may take several time periods for the multiplier process to complete itself. Economists refer to the initial change as autonomous because it does not depend on the level of real GDP. The changes in real GDP in other rounds are referred to as induced because they are changes caused by the initial change in autonomous spending. An increase in government spending causes the aggregate demand curve to shift to the right because the level of equilibrium real GDP will be higher at each price level. There are then two outward shifts in AD due to an expansionary fiscal policy, one for the autonomous change and one for the induced changes. This is shown by Figure 16.8 in the textbook.

The ratio of the change in equilibrium real GDP to the change in government purchases is known as the government purchases multiplier:

Government purchases multiplier =
$$\frac{\text{Change in equilibrium real GDP}}{\text{Change in government purchases}}$$

Economists have estimated that the government purchases multiplier is about 2, so that a \$100 billion increase in autonomous government purchases will increase AD by about \$200 billion, other things being equal. Figure 16.9 shows the cumulative increase of \$200 billion in real GDP as a result of an initial increase in government purchases by \$100 billion.

Taxes also have a multiplier effect. The tax multiplier is:

Tax multiplier =
$$\frac{\text{Change in equilibrium real GDP}}{\text{Change in taxes}}$$

The tax multiplier will be negative because an increase in taxes will result in a reduction in spending. These spending reductions will cause decreases in income, which will cause further decreases in spending, resulting in additional decreases in aggregate demand. If the tax multiplier is -1.6, then a \$100 million increase in taxes will result in a \$160 million decrease in AD, other things being equal. The tax multiplier is negative because an increase in taxes lowers spending, causing real GDP to fall.

Study Hint

In absolute value, the tax multiplier should be smaller than the government purchases multiplier. A \$1 increase in government purchases will increase autonomous spending by \$1. A \$1 decrease in taxes will increase disposable income by \$1, but consumption spending will fall by less than \$1 because some of the increase in income will be saved.

The multiplier effect results in an additional shift of the *AD* curve. Because the *SRAS* curve is upward sloping, an expansionary fiscal policy results in a higher price level as well as a higher level of real GDP. Figure 16.10 in the textbook illustrates the multiplier effect.

It is important to note that the multiplier works in both directions. A decrease in government purchases will cause a fall in AD greater than the fall in government purchases. An increase in taxes will cause a fall in AD greater than the increase in taxes.

Extra Solved Problem 16.4

The Multiplier and Shifts in the Aggregate Demand Curve
Supports Learning Objective 16.4: Explain how the government purchases and tax multipliers
work.

Using the basic aggregate demand-aggregate supply model with potential real GDP constant, show that the short-run effect of an increase in government purchases on real GDP depends upon the size of the multiplier, but the long-run effects are independent of the size of the multiplier.

Solving the Problem

Step 1: Review the chapter material.

This problem is about understanding the multiplier effect, so you may want to review the section "The Government Purchases and Tax Multipliers," which begins on page 536 of the textbook.

Step 2: Illustrate the shift in aggregate demand with a larger and smaller multiplier.

The change in equilibrium real GDP will depend on the size of the multiplier, as we can see from the following formula:

Change in equilibrium real GDP = multiplier \times change in government purchases.

It makes sense that the larger the multiplier, the larger the change in real GDP. In the aggregate demand-aggregate supply model, the larger the multiplier is, the larger the shift in AD from a given change in government purchases. Consider an increase in government purchases with a larger multiplier and a smaller multiplier. These shifts are shown in the graph on the next page:

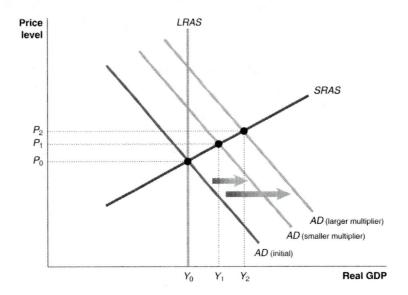

Step 3: Analyze the results in the short run.

In the short run, the increase in government purchases will increase real GDP from Y_0 to Y_1 with the smaller multiplier and from Y_0 to Y_2 with the larger multiplier. A larger multiplier will cause a larger short-run change in real GDP.

Step 4: Analyze the results in the long run.

In the long run, the increase in aggregate demand will eventually cause wages and other costs to increase. This will cause the SRAS curve to shift to the left. The SRAS curve will continue to shift until real GDP returns to potential real GDP at Y_0 . The long run is shown in the graph below:

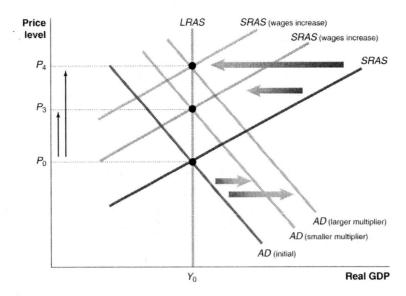

In the long run, real GDP will return to potential real GDP at Y_0 . Consequently, the smaller and larger multiplier both have the same long-run effect on real GDP: zero. In the long run, AD changes do not change the level of real GDP. However, in the long run, multipliers of different sizes do have different effects on the price level. The larger the multiplier is, the greater the increase in the price level.

The Limits of Using Fiscal Policy to Stabilize the Economy (pages 541–548) Learning Objective: Discuss the difficulties that can arise in implementing fiscal policy.

Proper timing is an important part of a stabilization policy. Implementing a policy too late may not help the economy and may destabilize it instead. Fiscal policy decisions are made by Congress and the president. Because it generally takes considerable time for Congress and the president to agree on a change in policy, fiscal policy changes will generally not be quickly implemented. The Federal Open Market Committee, which meets eight times per year, can change monetary policy quickly.

In addition to problems with timing, **crowding out** also limits the effectiveness of fiscal policy. In the short run, expansionary fiscal policy will increase real GDP and the price level. Increases in real GDP and the price level will increase money demand, which will result in a higher interest rate. This is shown in Figure 16.11 in the textbook.

This higher interest rate will reduce the level of aggregate demand by reducing investment and consumption spending. So, crowding out will slow the growth in aggregate demand. The effects of crowding out in the short run are illustrated in Figure 16.12 in the textbook.

Most economists believe that, in the short run, increases in government purchases cause partial but not complete crowding out. Most economists also believe that, in the long run, there is complete crowding out. This is true because in the long run, the economy returns to potential real GDP. Therefore, in the long run, an increase in government purchases must cause some other component of GDP—consumption, investment, or net exports—to fall by an equal amount. In the short run, if the economy is below potential real GDP, it is possible for both government purchases and private purchases to increase.

The 2007–2009 recession occurred during the end of the presidency of George W. Bush and the beginning of the presidency of Barack Obama. Both presidents used expansionary fiscal policy to fight the recession. In 2008, the Bush administration applied a tax cut in the form of rebates of taxes already paid. Rebate checks totaling \$95 billion were sent to taxpayers between April and July of 2008. Many economists believe that consumers base their spending on their permanent income rather than just on their current income. This means that the one-time tax rebate that increased consumers' current income, but not their permanent income, would have little effect on consumption spending.

Although the tax rebates helped to some extent in increasing aggregate demand, the recession worsened in September 2008 following the bankruptcy of Lehman Brothers investment bank and the deepening of the financial crisis. In February 2009, Congress passed the American Recovery and Reinvestment Act, a \$787 billion package of spending increases and tax cuts that President Obama proposed soon after he took office in January 2009. Figure 16.13 in the textbook shows details of this stimulus package.

Economists differ in their views about the effectiveness of the Obama stimulus package. One of the reasons for their different views is the difficulty in isolating the effects of the stimulus package from the effects of other factors, such as the Federal Reserve's monetary policy, other fiscal policy actions, and the typical changes in real GDP and employments during a business cycle. Table 16.2 in the textbook shows the Congressional Budget Office's (CBO) estimates of the effectiveness of the stimulus package between 2009 and 2013. According to the CBO estimates, the stimulus package had significantly reduced the severity of the recession of 2007–2009 and its aftermath.

Another reason for the different views about the effectiveness of fiscal policy is the different estimates of the government purchases and tax cut multipliers. When British economist John Maynard Keynes and his followers first developed the idea of spending and tax multipliers in the 1930s, they argued that the government purchases multiplier might be as large as 10. In preparing their estimates of the effect of the

stimulus package on GDP, Obama administration economists used an estimate of 1.57 for the government purchases multiplier. Some economists argued that this estimate of the size of the multiplier was too high, while others argued that it was too low. Table 16.3 in the textbook lists the various estimates of the size of the multiplier.

Study Hint

The CBO estimates of the effects of the stimulus package indicate that even a massive government spending increase and tax cut left the economy with real GDP far below potential GDP and the unemployment rate above 9 percent. Why was the 2007–2009 recession so severe? Read the *Making the Connection* feature in this section for a possible answer to this question. Looking at the historical economic data of a number of countries, some economists have found that recessions following a financial crisis were more severe than recessions without it.

16.6

Deficits, Surpluses, and Federal Government Debt (pages 548-554)

Learning Objective: Define federal budget deficit and federal government debt and explain how the federal budget can serve as an automatic stabilizer.

If the federal government spends less than its revenues, there is a **budget surplus**. If the federal government spends more than its revenues, there is a **budget deficit**. Deficits tend to increase during recessions. Deficits also increase during wars and other periods when extra government purchases are not offset by additional taxes.

The United States had four years of budget surpluses from 1998–2001. The recession of 2001, along with tax cuts and additional spending on homeland security and the wars in Afghanistan and Iraq, converted the budget surpluses back into budget deficits after 2001.

The federal budget serves as an automatic stabilizer for the economy. During a recession, deficits occur automatically for two reasons: Lower tax revenues and higher levels of transfer payments (such as unemployment insurance payments). During an expansion, the budget moves toward a surplus as tax revenues increase and transfer payments fall as more workers are employed. The **cyclically adjusted budget deficit or surplus** removes the effect of the business cycle on the budget by evaluating the budget at potential GDP, not the current level of GDP.

Although many economists believe it is a good idea for the federal government to have a balanced budget, few economists think the budget needs to be balanced each year. In certain circumstances, the changes in government spending or taxes necessary to achieve a balanced budget may push the economy away from potential GDP.

When the federal government runs a budget deficit, the Treasury borrows from the public by selling Treasury bonds. In years of budget surpluses, the Treasury pays off some of the existing bonds. Because the federal budget has been in deficit during many more years than it has been in surplus, the stock of outstanding Treasury bonds has grown over time. The value of these bonds is known as the federal government debt. In the long run, this debt can create a problem due to the crowding out of investment spending as the government borrows funds that would otherwise have been borrowed by firms.

Study Hint

During the debate over President Obama's stimulus package, fiscal policy during the Great Depression was called in question again. Increases in federal government expenditures were part of President Franklin D. Roosevelt's New Deal program. *Making the Connection* "Did Fiscal Policy Fail during the Great Depression?" explains that although government spending increased during the 1930s, the cyclically adjusted government budget was in surplus most years. This suggests that fiscal policy did not fail, but it was simply not used.

Extra Solved Problem 16.6

The Ownership of the U.S. Government Debt

Supports Learning Objective 16.6: Define federal budget deficit and federal government debt and explain how the federal budget can serve as an automatic stabilizer.

The federal government debt (also referred to as the "national debt" or the "public debt") grows as a result of budget deficits. Determine the percentages of the debt owned by:

- a. U.S. government agencies (including the Federal Reserve)
- b. U.S. citizens (individuals and firms)
- c. Individuals, firms, and governments outside the United States

Use data for the fiscal years 2003–2013, which are shown below (in billions of dollars):

Year	Total Public Debt	Held by Federal Reserve and Government Accounts	Held by Foreign and International Investors	Held by Domestic Investors
2003	\$6,783.2	\$3,515.3	\$1,454.2	\$1,813.7
2004	7,379.1	3,772.0	1,836.6	1,770.5
2005	7,932.7	4,067.8	2,069.0	1,795.9
2006	8,507.0	4,432.8	2,133.6	1,940.6
2007	9,007.6	4,611.9	2,352.9	2,042.8
2008	10,024.7	4,131.3	3,078.7	2,814.7
2009	11,723.4	4,378.6	3,495.6	3,849.2
2010	13,390.4	4,552.2	4,177.5	4,660.8
2011	14,566.7	1,642.1	4,801.4	8,123.3
2012	15,960.6	1 , 655.7	5,394.5	8,910.5

Solving the Problem

Step 1: Review the chapter material.

This problem is about the federal government debt, so you may want to review the section "Deficits, Surpluses, and Federal Government Debt," which begins on page 548 in the textbook.

Step 2: Calculate the percentages of the debt owned by the different groups.

The percentages owned by the different groups are calculated as the group value divided by the total public debt. These numbers are in the table below:

Year	Total Public Debt	Held by Federal Reserve and Government Accounts	Held by Foreign and International Investors	Held by Domestic Investors
2003	\$6,783.2	51.8%	21.4%	26.7%
2004	7,379.1	51.1	24.9	24.0
2005	7,932.7	51.3	26.1	22.6
2006	8,507.0	52.1	25.1	22.8
2007	9,007.6	51.2	26.1	22.7
2008	10,024.7	41.2	30.7	28.1
2009	11,723.4	37.3	29.8	32.8
2010	13,390.4	34.0	31.2	34.8
2011	14,566.7	11.3	33.0	55.8
2012	15,960.6	10.4	33.8	55.8

Step 3: Determine the percentage owned within the United States and the percentage owned outside of the United States.

The percentages indicate that about half of the U.S. debt was owned internally by the U.S. government until 2007. Between 2004 and 2008, the portion owned by investors outside the United States was larger than the domestic investors. This implies that the interest payments on the debt owned externally became income to residents of countries other than the United States. Economists debate the significance of a large percentage of federal government debt being held by foreign investors.

16.7

The Effects of Fiscal Policy in the Long Run (pages 554–557)

Learning Objective: Discuss the effects of fiscal policy in the long run.

Some fiscal policy changes are designed to have long-run effects by expanding the productive capacity of the economy and encouraging economic growth. These fiscal policy changes are usually done through taxes and have their effect by changing aggregate supply. Because these policy changes primarily affect aggregate supply rather than aggregate demand, they are sometimes referred to as supply-side economics.

Tax changes influence the **tax wedge**. The tax wedge is the difference between pretax and posttax returns to economic activity. Cutting tax rates can affect aggregate supply in several ways:

- A lower individual tax rate will increase posttax wages and increase the quantity of labor supplied. In
 addition, lower individual tax rates will increase the return to saving, increasing the level of saving in
 the economy.
- Reducing the corporate tax rate will encourage investment spending and can increase the rate of technological innovation.
- Lowering the tax rate on dividends and capital gains can increase the supply of loanable funds, which lowers real interest rates. The lower interest rates cause increases in investment spending by firms, which will increase the growth rate of the capital stock.

In addition to gains from cutting taxes, there are gains from tax simplification. A simpler tax code means that resources that are currently being used to comply with the tax laws can be used more productively.

The economic effects of tax simplification and tax reduction can increase the growth rate of long-run aggregate supply. This is shown in Figure 16.17 in the textbook. Tax reduction and simplification can result in more economic growth and lower inflation.

While economists agree that the effects of tax reduction and simplification exist, there is not agreement on the size of the effects. There is also disagreement on the magnitude of the effects of tax changes on aggregated supply compared to the effects on aggregate demand.

Extra Solved Problem 16.7

Long-Run Effects of a Tax Increase

Supports Learning Objective 16.7: Discuss the effects of fiscal policy in the long run.

Show what will happen to the long-run aggregate supply curve when there is an increase in the individual income tax rate.

Solving the Problem

Step 1: Review the chapter material.

This problem is about the effects on the long run aggregate supply curve of an increase in the tax rate, so you may want to review the section "The Economic Effect of Tax Reform," which begins on page 555 in the textbook.

Step 2: Show the change in the long-run aggregate supply curve in the absence of a tax increase.

Potential real GDP grows each year as the labor force and the capital stock increase and technological change occurs. This growth is seen in the graph below as LRAS shifts out from $LRAS_1$ to $LRAS_2$. This growth will move the economy from point A to point B and real GDP will increase from Y_0 (= \$10,000) to Y_1 (= \$11,000).

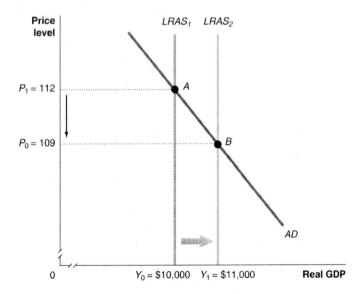

Step 3: Now show the effects on the long-run aggregate supply curve of the tax increase.

An increase in the individual income tax rate will reduce the posttax wage and reduce the increase that would otherwise occur in the labor supply. Fewer workers result in a lower level of potential real GDP. This can be shown as a reduction in the shift of the $LRAS_1$ to $LRAS_3$ instead of $LRAS_2$ as in the graph below.

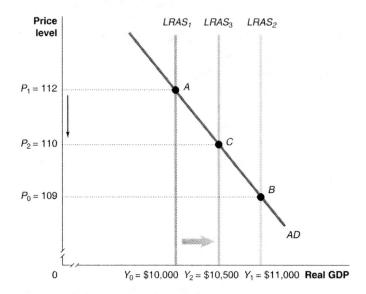

So, as a result of the tax increase, real GDP only increases to Y_2 (= \$10,500) and the price level only falls to P_2 (= 110). The tax increase will consequently slow growth in real GDP (from \$10,000 to \$10,500, instead of from \$10,000 to \$11,000) and reduce the decline in the price level (the price level falls from 112 to 110, instead of 112 to 109).

Appendix

A Closer Look at the Multiplier (pages 564–568)

Learning Objective: Apply the multiplier formula.

In this chapter, you have learned that a change in government purchases and a change in taxes have a multiplied effect on equilibrium real GDP. We can express the formulas of the multiplier effects using the mathematical model we built in the appendix to Chapter 12.

An Expression for Equilibrium Real GDP

In equations, the aggregate expenditure model for a closed economy is:

1. $C = \overline{C} + MPC(Y - T)$ Consumption function

2. $I = \overline{I}$ Planned investment function

3. $G = \overline{G}$ Government purchases function

4. $T = \overline{T}$ Tax function

5. Y = C + I + G Equilibrium condition

The letters with "bars" represent fixed or autonomous values. MPC stands for the marginal propensity to consume. Solving for equilibrium, we get

$$Y = \frac{\overline{C} - (MPC \times \overline{T}) + \overline{I} + \overline{G}}{1 - MPC}.$$

From the above equation for equilibrium, we can derive the following formulas for the multiplier effects of government policies.

A Formula for the Government Purchases Multiplier (page 565)

Government purchases multiplier =
$$\frac{\Delta Y}{\Delta G} = \frac{1}{1 - MPC}$$
.

A Formula for the Tax Multiplier (page 566)

Tax multiplier =
$$\frac{\Delta Y}{\Delta T} = \frac{-MPC}{1-MPC}$$
.

The "Balanced Budget" Multiplier (pages 566)

"Balanced Budget" multiplier =
$$\frac{\Delta Y}{\Delta G} + \frac{\Delta Y}{\Delta T} = \frac{1}{1 - MPC} + \frac{-MPC}{1 - MPC} = 1$$
.

The Effects of Changes in Tax Rates on the Multiplier

We can also derive the formula for the effect of a change in the tax rate as opposed to a change in a fixed amount of taxes. Suppose the tax rate is t, the consumption function now becomes:

$$C = \overline{C} + MPC(1-t)Y,$$

so that the government purchases multiplier becomes:

$$\frac{1}{1-MPC(1-t)}.$$

The Multiplier in an Open Economy

Instead of a closed economy, we can also consider the case of an open economy by including net exports. If imports increase as a result of higher real GDP so that:

Imports =
$$MPI \times Y$$

where MPI is the marginal propensity to import. The government purchases multiplier in the case of an open economy becomes:

$$\frac{1}{1-[MPC(1-t)-MPI]}.$$

Key Terms

Automatic stabilizers Government spending and taxes that automatically increase or decrease along with the business cycle.

Budget deficit The situation in which the government's expenditures are greater than its tax revenue.

Budget surplus The situation in which the government's expenditures are less than its tax revenue.

Crowding out A decline in private expenditures as a result of an increase in government purchases.

Cyclically adjusted budget deficit or surplus The deficit or surplus in the federal government's budget if the economy were at potential GDP. **Fiscal policy** Changes in federal taxes and purchases that are intended to achieve macroeconomic policy objectives.

Multiplier effect The series of induced increases in consumption spending that results from an initial increase in autonomous expenditures.

Tax wedge The difference between the pretax and posttax return to an economic activity.

Self-Test

(Answers are provided at the end of the Self-Test.)

Multiple-Choice Questions

- 1. Fiscal policy refers to
 - a. changes in the money supply and interest rates to pursue macroeconomic policy goals, including price stability and high employment.
 - b. changes in federal taxes and spending that are intended to achieve macroeconomic policy objectives.
 - c. the manipulation of the price level, the level of real GDP, and total employment by the Federal Reserve.
 - d. the use of economic policies to improve the functioning of the public sector.
- 2. Economists use the term fiscal policy to refer to changes in taxing and spending policies by
 - a. only state and local governments.
 - b. only the federal government.
 - c. all levels of government, federal, state, and local.
 - d. none of the above.

- 3. The U.S. government increased spending for defense and homeland security after 2001 to fund the war on terrorism and the invasion of Iraq. These spending increases are considered
 - a. strictly monetary policy.
 - b. strictly fiscal policy.
 - c. part of defense and homeland security policy, but not fiscal policy.
 - d. both fiscal and monetary policy.
- 4. Changes in taxes and spending that happen without actions by the government are called
 - a. discretionary fiscal policy changes.
 - b. automatic stabilizers.
 - c. transfer payments.
 - d. autonomous fiscal expenditures.
- 5. Which of the following is an example of an automatic stabilizer?
 - a. an unemployment benefit program
 - b. an increase in tax rates to reduce inflation
 - c. an increase in government spending to fight a recession
 - d. All of the above are automatic stabilizers.
- 6. If the government cuts taxes in order to raise aggregate demand in the economy, the action is called
 - a. an automatic stabilizer.
 - b. a discretionary monetary policy.
 - c. a discretionary fiscal policy.
 - d. a procyclical policy.
- 7. Which of the following fiscal policy actions will increase real GDP in the short run?
 - a. an increase in government expenditures
 - b. an increase in the individual income tax
 - c. an increase in the money supply
 - d. an increase in the Social Security tax
- 8. When the government takes actions to change taxes and spending, the type of policy involved is called
 - a. discretionary fiscal policy.
 - b. automatic stabilizers.
 - c. transfer payments.
 - d. autonomous fiscal expenditures.
- 9. What is the relationship between government purchases and government expenditures?
 - a. Government purchases include government expenditures.
 - b. Government expenditures include government purchases.
 - c. Government purchases and government expenditures are the same thing.
 - d. Government purchases include all government spending, while government expenditures do not.
- 10. Which of the following is the largest category of federal government expenditures, excluding transfer payments?
 - a. interest on the national debt
 - b. defense spending
 - c. grants to state and local governments
 - d. spending on running the federal government's day-to-day activities

d. all of the above.

a. expansionary; rise; rise b. expansionary; rise; fall c. contractionary; rise; fall d. contractionary; fall; fall

428	CHAPTER 16 Fiscal Policy
11.	The largest and fastest growing category of federal expenditures is a. interest on the national debt. b. grants to state and local governments. c. transfer payments. d. defense spending.
12.	Spending on most of the federal government's day-to-day activities—including running federal agencies like the Environmental Protection Agency, the FBI, the National Park Service, and the Immigration and Customs Enforcement—make up a. about 85 percent of federal government expenditures. b. about 50 percent of federal government expenditures. c. less than 10 percent of federal government expenditures. d. less than 1 percent of federal government expenditures.
13.	 Which of the following is the main reason for the long-run funding problems of Social Security? a. The health of the typical American is declining. b. Too many workers are delaying their retirement until after age 65. c. The number of workers per retiree continues to decline. d. Increasing levels of immigration will eventually lead to larger numbers of retirees.
14.	Which of the following are the largest sources of federal government revenues? a. corporate income taxes and sales taxes b. revenue from tariffs on imports and other fees c. individual income taxes and social insurance taxes d. property taxes and excise taxes
15.	When the economy is in a recession, the government can a. reduce expenditures and leave taxes constant in order to stimulate aggregate demand. b. increase government purchases or decrease taxes in order to increase aggregate demand. c. decrease government purchases or increase taxes in order to decrease aggregate supply. d. change spending and taxation but not aggregate demand or aggregate supply.
16.	Which of the following will reduce the inflation rate? a. increasing the money supply b. increasing government purchases c. reducing government purchases or increasing taxes d. none of the above
17.	The goal of expansionary fiscal policy is a. to decrease short-run aggregate supply. b. to decrease long-run aggregate supply. c. to increase aggregate demand

18. Fill in the blanks. An attempt to reduce inflation requires ______ fiscal policy, which causes

real GDP to _____ and the price level to _____.

- 19. Which of the following statements is *incorrect*?
 - a. Just as increasing or decreasing the money supply does not have any direct effect on government spending or taxes, increasing or decreasing government spending or taxes will not have any direct effect on the money supply.
 - b. Fiscal policy and monetary policy may have the same goals, but they have different effects on the economy.
 - c. The only difference between fiscal policy and monetary policy in fighting recessions and stimulating spending is where the money comes from.
 - d. All of the above statements are correct.
- 20. By how much will equilibrium real GDP change as a result of a \$50 billion decrease in government purchases?
 - a. increase by more than \$50 billion
 - b. increase by less than \$50 billion
 - c. decrease by more than \$50 billion
 - d. decrease by less than \$50 billion
- 21. The multiplier effect consists of
 - a. a series of autonomous expenditures that result from an initial increase in government expenditures.
 - b. a series of autonomous expenditure increases that result from an initial increase in induced expenditures.
 - c. a series of induced increases in consumption spending that result from an initial increase in autonomous expenditures.
 - d. a change in government spending resulting from a change in equilibrium income.
- 22. How would you decompose the total effect of an increase in government purchases on the aggregate demand curve? (Note: the magnitudes of the shifts do not have to be the same.)
 - a. The aggregate demand curve shifts once to the right and then back to the left.
 - b. The aggregate demand curve shifts as a result of two distinct effects, twice to the right.
 - c. The aggregate demand curve shifts as a result of two distinct effects, twice to the left.
 - d. The aggregate demand curve does not shift, but there are two movements, one downward and one upward, along the curve.
- 23. The tax multiplier equals the change in
 - a. taxes divided by the change in equilibrium GDP.
 - b. equilibrium GDP multiplied by the change in taxes.
 - c. equilibrium GDP divided by the change in taxes.
 - d. taxes multiplied by the resulting change in consumption.
- 24. We would expect the tax multiplier to be _____ in absolute value than the government purchases multiplier.
 - a. smaller
 - b. larger
 - c. the same
 - d. either smaller or larger, depending on the current tax rate

430 CHAPTER 16 Fiscal Policy

25.	When the tax rate increases, the size of the multiplier effect a. increases
	b. decreases
	c. remains the same
	d. increases for small increases in the tax rate and decreases for large increases in the tax rate
26.	Fill in the blanks. Increases in government purchases and decreases in taxes have a multiplier effect on equilibrium real GDP, and decreases in government purchases and increases in taxes have a multiplier effect on equilibrium real GDP.
	a. positive; negativeb. negative; positive
	c. positive; positive
	d. negative; negative
27.	Assume that the absolute size of the government purchases multiplier is larger than the absolute size of the tax multiplier. What happens to equilibrium real GDP if the government increases both government purchases and taxes by the same amount?
	a. Real GDP will increase.
	b. Real GDP will decrease.
	c. Real GDP will remain unchanged.
	d. Real GDP will increase or decrease, depending on the size of the difference between the government purchases multiplier and the tax multiplier in absolute terms.
28.	Which of the following statements is true about using fiscal policy to stabilize the economy? a. It is easier to get the timing right for implementing fiscal policy than monetary policy. b. The delay caused by the legislative process is typically longer for fiscal policy than for monetary
	policy.c. Fiscal policy is used more often than monetary policy when the economy experiences high inflation.
	d. Fiscal policy is used more often than monetary policy when the economy is in a recession.
29.	Crowding out refers to
	a. the problem arising from having to consult with a large number of people in order to get fiscal policy approved in time to help the economy.
	b. the decline in private expenditures that result from an increase in government purchases.
	c. the ever-decreasing amount of induced expenditures that eventually stop the government purchases multiplier.
	d. the reduction in government expenditures following an increase in consumption or investment expenditures.
30.	Fill in the blanks. According to the crowding-out effect, if the federal government increases spending, the demand for money and the equilibrium interest rate will, which will cause some consumption, investment, and net exports to
	a. increase; increase
	b. increase; decrease
	c. decrease; decrease
	d. decrease; increase

- 31. The American Recovery and Reinvestment Act of 2009 is a clear example of
 - a. expansionary fiscal policy.
 - b. contractionary fiscal policy.
 - c. an automatic stabilizer.
 - d. policy aimed at balancing the government budget.
- 32. What is the long-run effect of a permanent increase in government spending?
 - a. Investment, consumption, and net exports decline but less than the increase in government purchases; therefore, aggregate demand increases.
 - b. Investment, consumption, and net exports decline but more than the increase in government purchases; therefore, aggregate demand decreases.
 - c. The decline in investment, consumption, and net exports exactly offsets the increase in government purchases; therefore, aggregate demand remains unchanged.
 - d. Investment, consumption, and net exports remain unchanged; therefore, there is no change in aggregate demand.
- 33. Which of the following is true of any permanent increase in government purchases in the long run?
 - a. Any permanent increase in government purchases can be accommodated by the economy in the long run so as to maintain a steady level of private expenditures.
 - b. In the long run, any permanent increase in government purchases must come at the expense of private expenditures.
 - c. In the long run, a permanent increase in government purchases does not affect private expenditures in any way.
 - d. In the long run, any permanent increase in government purchases is usually accompanied by an increase in private expenditures of the same amount.
- 34. If the federal government's expenditures are greater than its revenue, there is a
 - a. budget deficit.
 - b. budget surplus.
 - c. balanced budget.
 - d. declining federal government debt.
- 35. Which of the following was a period of federal budget surpluses?
 - a. from 1970 through 1997
 - b. from 1998 through 2001
 - c. from 2002 through 2012
 - d. None of the above: the federal government has experienced budget deficits every year since 1970.
- 36. Budget deficits automatically during recessions and during expansions.
 - a. increase: increase
 - b. increase: decrease
 - c. decrease: increase
 - d. decrease: decrease
- 37. The cyclically adjusted budget deficit,
 - a. is never negative.
 - b. is measured as if the economy were at potential real GDP.
 - c. moves up and down as the economy moves around potential real GDP.
 - d. is always in balance.

- 38. To obtain a more accurate measure of the effects of the government's spending and tax policies on the economy, economists prefer to look at
 - a. the actual budget deficit or surplus.
 - b. the cyclically adjusted budget deficit or surplus.
 - c. changes in the federal government debt.
 - d. changes in the money supply.
- 39. Every time the federal government runs a budget deficit, the Treasury must
 - a. buy securities from the Fed in order to increase its reserves.
 - b. print money in order to finance the excess expenditures.
 - c. borrow funds from savers by selling Treasury securities.
 - d. supply funds in the federal funds market.
- 40. The national debt is best measured as the
 - a. value of all debts of private citizens and businesses.
 - b. difference between federal government spending and federal taxes.
 - c. total value of U.S. Treasury securities outstanding.
 - d. total value of stocks issued in a country.
- 41. Which of the following statements about the federal debt is correct?
 - a. The federal government is in danger of defaulting on its debt.
 - b. Given the current interest payments as a percentage of total federal expenditures, there is a great need for tax increases or significant cutbacks in other types of federal spending.
 - c. If the debt becomes very large relative to the economy, then the government may have to raise taxes to high levels, or cut back on other types of spending to make the interest payments on the debt.
 - d. Interest payments are currently about 60 percent of total federal expenditures.
- 42. If a tax cut has supply-side effects, then it will
 - a. affect only aggregate demand.
 - b. affect only aggregate supply.
 - c. affect both aggregate demand and aggregate supply.
 - d. definitely not increase the federal budget deficit.
- 43. Economists believe that the smaller the *tax wedge* for any economic activity, such as working, saving, investing, or starting a business,
 - a. the lower the equilibrium interest rate.
 - b. the greater the difference between the pretax and posttax return to those activities.
 - c. the more of that economic activity that will occur.
 - d. the greater the marginal tax rate.
- 44. The effect on the economy of tax reduction and simplification is
 - a. a change in the costs and expectations of producers, as shown by an upward shift in the short-run aggregate supply curve.
 - b. an increase in consumption and investment spending, and a rightward shift of the aggregate demand curve.
 - c. an increase in the quantity of real GDP supplied at every price level, or a shift in the long-run aggregate supply curve.
 - d. higher employment and real GDP but also a higher price level.

- 45. Tax simplification and reductions in tax rates will result in additional shifts to the right in LRAS leading to a
 - a. higher price level and lower real GDP.
 - b. lower price level and lower real GDP.
 - c. lower price level and higher real GDP.
 - d. higher price level and higher real GDP.

Short Answer Questions

1.	Give an example of government spending that is not fiscal policy and an example of government
	spending that is fiscal policy.
2.	Show how expansionary fiscal policy can be used to lessen the impact of weak aggregate demand (AD) growth on the economy.
3.	Determine the government purchases multiplier if an increase in government purchases of \$100 billion increases equilibrium real GDP by \$250 billion. Suppose the tax multiplier is -2.5. How much must taxes change to change equilibrium real GDP by \$100 billion?

434 CHAPTER 16 Fiscal Policy

ir	n the short run?
-	
-	
-	
Е	xplain how the federal government debt grows over time.
-	
-	
tł tł	uppose at the beginning of the current year, the federal government debt is at \$13 trillion, and nat during the year federal expenditures are \$5.3 trillion and receipts are \$4.3 trillion. Determine value of the surplus or deficit during the year and the value of the federal government debt ne end of the year.
-	
-	
-	

True/False Questions

- T F 1. Fiscal policy refers to the level of spending by the states and the federal government.
- T F 2. The only difference between fiscal policy and monetary policy is the source of money because fiscal policy is about spending money while monetary policy is about supplying money.
- T F 3. Falling federal government tax collections as the level of economic activity slows down is an example of an automatic stabilizer.
- T F 4. Defense spending is the difference between federal government purchases and federal government expenditures.
- T F 5. Increases in government spending will tend to shift the aggregate demand curve to the right.
- T F 6. The larger the government purchases multiplier, the further the aggregate demand curve will shift to the right.
- T F 7. A reduction in taxes will tend to, in the short run, increase the level of real GDP and reduce the price level.

- T F 8. The tax multiplier can be either positive or negative.
- T F 9. The larger the change in equilibrium real GDP from a given change in government spending, the larger the government purchases multiplier.
- T F 10. Fiscal policy changes in spending can be quickly implemented by Congress.
- T F 11. Other things being equal, an increase in government spending will not change the interest rate.
- T F 12. In the long run, an increase in government purchases will reduce private spending by the same amount.
- T F 13. If federal government spending is larger than tax revenues, there will be a budget deficit and the federal government debt will fall.
- T F 14. When there is a budget deficit, the Treasury will borrow from the public by selling bonds.
- T F 15. A lower individual income tax rate will increase labor supply and shift the *LRAS* to the right.

Answers to the Self-Test

Multiple-Choice Questions

Question	Answer	Comment								
1.	b	Changes in federal taxes and spending that are intended to achieve macroeconomic policy objectives are called fiscal policy.								
2.	b	Economists restrict the term fiscal policy only to the actions of the federal government. State and local governments will sometimes change their taxing and spending policies to aid their local economies, but these are not fiscal policy actions because they are not intended to affect the national economy.								
3.	c	The defense and homeland security spending increases in the years after 2001 to fund the war on terrorism and the invasion of Iraq were part of defense and homeland security policy, not fiscal policy. These decisions are not part of fiscal policy actions because they are not intended to achieve macroeconomic policy goals. Nevertheless, the increased spending had an impact on the								
4.	b	economy. Automatic stabilizers are government spending and taxes that automatically increase or decrease along with the business cycle. The word "automatic" refers to the fact that changes in these types of spending and taxes happen without actions by the government.								
5.	a	An unemployment benefit program is an example of automatic stabilizers because unemployment benefit payments tend to rise when real GDP falls so that the program helps stabilize the economy without deliberate actions of the government. Increasing tax rates and government spending require Congress to take action and thus is not automatic stabilizers.								
6.	c	If the government cuts taxes in order to raise aggregate demand in the economy, then the action is called an expansionary fiscal policy. The policy is also a discretionary policy instead of an automatic stabilizer because the policy requires a deliberate action of the government.								

Question	Answer	Comment
7.	a	An increase in government expenditures will shift AD to the right, and increase real GDP in the short run. An increase in the money supply is monetary policy, not fiscal policy. Increasing taxes shift the aggregate demand curve to the left.
8.	a	With discretionary fiscal policy, the government takes actions to change spending or taxes. For example, the tax cuts passed by Congress in 2001 are an example of a discretionary fiscal policy action.
9.	b	There is a difference between federal government purchases and federal government expenditures. When the federal government purchases an aircraft carrier or the services of an FBI agent, it receives a good or service in return. Federal government expenditures include purchases plus all other federal government spending. One large expenditure not included in purchases is transfer payments such as Social Security.
10.	b	Excluding transfer payments, the largest category of federal government expenditures is defense spending, which makes up about 22 percent of the federal budget today.
11.	С	The largest and fastest growing category of federal expenditures is transfer payments. Some of these programs, such as Social Security and unemployment insurance, began in the 1930s. Others, such as Medicare, which provides health care to the elderly, or the Food Stamps and Temporary Assistance for Needy Families programs that are intended to aid the poor, began in the 1960s or later.
12.	c	Spending on most of the federal government's day-to-day activities—including running federal agencies like the Environmental Protection Agency, the FBI, the National Park Service, and the Immigration and Customs Enforcement—make up less than 10 percent of federal government expenditures.
13.	С	Falling birth rates after 1965 will mean long-run problems for the Social Security system, as the number of workers per retiree will continue to decline. Currently there are only about three workers per retiree and that ratio will decline to two workers per retiree in the coming decades.
14.	c	In 2012, the individual income tax raised about 43 percent of the federal government's revenues. The corporate income tax raised about 14 percent of the revenue. Payroll taxes to fund the Social Security and Medicare programs have risen from less than 10 percent of federal government revenues in 1950 to about 35 percent in 2012. The remaining 7 percent of revenues were raised from sales taxes, tariffs on imports, and other fees.
15.	b	Because changes in government purchases and taxes lead to changes in aggregate demand, they can affect the level of real GDP, employment, and the price level. When the economy is in a recession, increases in government purchases or decreases in taxes will increase aggregate demand.
16.	С	The inflation rate may increase when aggregate demand is increasing faster than aggregate supply. Decreasing government purchases or raising taxes can slow the growth of aggregate demand, and reduce the inflation rate.
17.	С	The goal of both expansionary monetary policy and expansionary fiscal policy is to increase aggregate demand relative to what it would have been without the policy.

Question	Answer	Comment
18.	d	Reducing inflation requires contractionary fiscal policy, or a decrease in government spending and/or higher taxes, which causes real GDP and the price level to fall.
19.	c	If the government wants to spend more than its tax revenue, it must issue bonds. Only the Federal Reserve can issue money. Just as increasing or decreasing the money supply does not have any direct effect on government spending or taxes, increasing or decreasing government spending or taxes will not have any direct effect on the money supply. Fiscal policy and monetary policy have the same goals, but they have different effects on the economy.
20.	c	A decrease in government spending by \$50 billion will reduce real GDP by more than \$50 billion because the initial decrease in aggregate demand will lead to additional decreases in income and spending through the multiplier effect.
21.	С	Economists refer to the series of induced increases in consumption spending that result from an initial increase in autonomous expenditures as the multiplier effect.
22.	b	An initial increase in government purchases causes the aggregate demand to shift to the right from the impact of the initial increase in government purchases. Because this initial increase raises incomes and leads to further increases in consumption spending, the aggregate demand curve will shift further to the right.
23.	c	The tax multiplier equals the change in equilibrium GDP divided by the change in taxes.
24.	a	We would expect the tax multiplier to be smaller in absolute value than the government purchases multiplier. The entire amount of an increase in government purchases results in an increase in aggregate demand. But some portion of a decrease in taxes will be saved by households and not spent, and some portion will be spent on imported goods. The fractions of the tax cut that are saved or spent on imports will not increase aggregate demand.
25.	Ь	The higher the tax rate, the smaller the amount of any increase in income households have available to spend, which reduces the size of the multiplier effect.
26.	a	Increases in government purchases and cuts in taxes have a positive multiplier effect on equilibrium real GDP. Decreases in government purchases and increases in taxes also have a multiplier effect on equilibrium real GDP, only in this case the effect is negative.
27.	a	If the absolute size of the government purchases multiplier is greater than the absolute size of the tax multiplier, then the positive effect of the increase in government spending on real GDP will be greater than the negative effect of the increase in taxes on real GDP.
28.	Ь	Getting the timing right can be more difficult with fiscal policy than with monetary policy because fewer people are involved in making decisions about monetary policy, while the president and a majority of the 535 members of Congress have to agree on changes in fiscal policy. The delays caused by the legislative process in Congress can be very long while the Federal Open Market Committee can change monetary policy at any of its meetings.
		Market Committee can change monetary policy at any of its meetings.

Question	Answer	Comment
29.	b	A decline in private expenditures as a result of an increase in government purchases is called crowding out.
30.	b	If the federal government increases spending, the demand for money will increase as real GDP and income rise. With the supply of money constant, the result is an increase in the equilibrium interest rate, which crowds out some consumption, investment, and net exports.
31.	a	The American Recovery and Reinvestment Act of 2009 involved increases in government purchases and cut taxes to increase aggregate demand, and so it is an example of an expansionary fiscal policy.
32.	c	Most economists agree that the long-run effect of a permanent increase in government spending is complete crowding out. In the long run, the decline in investment, consumption, and net exports exactly offsets the increase in government purchases and aggregate demand remains unchanged.
33.	b	An expansionary fiscal policy does not have to cause complete crowding out in the short run. If the economy is below potential real GDP, it is possible for both government purchases and private expenditures to increase. But in the long run, any permanent increase in government purchases must come at the expense of private expenditures.
34.	a	The federal government's budget shows the relationship between its expenditures and its tax revenue. If the federal government's expenditures are greater than its revenue, there is a budget deficit. If the federal government's expenditures are less than its revenue, there is a budget surplus.
35.	b	The federal government entered into a long period of continuous budget deficits in 1970. From 1970 through 1997, the federal government's budget was in deficit every year. From 1998 through 2001, there were four years of budget surpluses. The recession of 2001, tax cuts, and increased government spending on homeland security and the war in Iraq kept the budget in deficit in the years after 2001.
36.	b	Deficits occur automatically during recessions for two reasons: First, during a recession, wages and profits fall, which cause government tax revenues to fall. Second, the government automatically increases its spending on transfer payments when the economy moves into recession.
37.	b	By definition, the cyclically adjusted budget deficit or surplus is measured at potential GDP.
38.	b	Because budget deficits automatically increase during recessions and fall during expansions, economists often look at the cyclically adjusted budget deficit or surplus, which can provide a more accurate measure of the effects on the economy of the government's spending and tax policies than does the actual budget deficit or surplus.
39.	c	Every time the federal government runs a budget deficit, the Treasury must borrow funds from savers by selling Treasury securities. These securities are bills, notes, and bonds. When the federal government runs a budget surplus, the Treasury pays off some existing bonds. The total value of U.S. Treasury bonds outstanding is referred to as the federal government debt (or, sometimes, as the national debt). Each year the federal budget is in deficit, the federal government debt grows. Each year the federal budget is in surplus, the debt shrinks.

Question	Answer	Comment
40.	c	The national debt refers to the federal government debt, which is the accumulation of federal budget deficits over time. The federal government finances its deficits through issuing U.S. Treasury securities so that the total value of U.S. Treasury securities is the best measure of the national debt.
41.	С	The federal government is in no danger of defaulting on its debt. Ultimately, the government can raise the funds it needs through taxes to make the interest payments on the debt. But if the debt becomes very large relative to the economy, then the government may have to raise taxes to high levels, or cut back on other types of spending to make the interest payments on the debt.
		Interest payments are currently about 10 percent of total federal expenditures. At this level, tax increases or significant cutbacks in other types of federal spending are not required.
42.	c	Proponents of supply side theory argue that a tax cut can increase aggregate supply by increasing the quantity of labor supplied, and the quantities of saving and investment. It is also true that a tax cut can affect aggregate demand by increasing disposable income and, therefore, consumption spending.
43.	c	In general, economists believe that the smaller the tax wedge for any economic activity—such as working, saving, investing, or starting a business—the more of that economic activity that will occur.
44.	c	If tax reduction and simplification is effective, it should result in a larger quantity of labor supplied, an increase in saving, investment, the formation of new firms, and an increase in economic efficiency. The result would be an increase in the quantity of real GDP supplied at every price level. We show the effects of the tax changes by a shift in long-run aggregate supply. In effect, this is a beneficial supply shock.
45.	С	Tax simplifications and reductions can increase employment, which will increase <i>LRAS</i> . The shift to the right in <i>LRAS</i> will result in a lower price level and higher real GDP.

Short Answer Responses

1. Suppose that because of a cold winter, it is necessary for the federal government to spend more to heat government offices in Washington, D.C. This change in government purchases is not fiscal policy because it was not undertaken to influence the level of economic activity. Fiscal policy changes are done to achieve macroeconomic policy objectives. A reduction in taxes designed to increase consumer spending to help pull the economy out of (or prevent) a recession is an example of fiscal policy.

2. In the graph below, the weak AD growth, along with growth in aggregate supply $(LRAS_0 \rightarrow LRAS_1)$ and $SRAS_0 \rightarrow SRAS_1$) has moved the economy from P_0 , Y_0 to P_1 , Y_1 so that real GDP (Y_1) is now below the new potential real GDP (Y_2) .

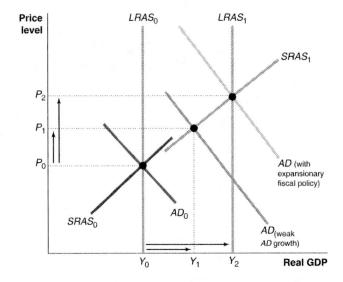

Expansionary fiscal policy can shift the AD curve out by increasing government purchases or by reducing taxes. As AD shifts to the right, real GDP will increase to its potential level at Y_2 . This increase in aggregate demand also increases the price level to P_2 .

3. Using the government purchases multiplier equation, the government purchases multiplier implied by a \$100 billion increase in government purchases is:

Government purchases multiplier =
$$\frac{\text{Change in equilibrium real GDP}}{\text{Change in government purchases}} = \frac{\$250 \, \text{billion}}{\$100 \, \text{billion}} = 2.5.$$

Using the tax multiplier equation,

Then to increase real GDP by \$100 billion, the needed change in taxes is:

$$-2.5 = \frac{\$100 \text{ billion}}{\text{Change in taxes}}.$$

Solving this equation for the change in taxes yields the needed tax change of -\$40 billion. The negative sign implies that taxes must fall by \$40 billion. In other words, cutting taxes by \$40 billion will increase disposable personal income by \$40 billion, causing equilibrium real GDP to rise by \$100 billion.

5. The federal budget deficit is the difference between government expenditures and federal tax receipts, or:

component of GDP increases, one or more of the other components must decrease.

Federal budget deficit = Federal government expenditures – Federal tax receipts.

When the deficit is positive, the government borrows, increasing the federal government debt. When there is a federal budget surplus the government can repay some debt, lowering the federal government debt. It follows that:

Federal government debt (end of year) = federal budget deficit (during year) + federal government debt (beginning of year).

Therefore, the federal government debt will increase when there is a budget deficit, and fall when there is a federal budget surplus.

6. In any year, the value of the federal government's budget surplus or deficit is the difference between government receipts and expenditures. If this is negative, there is a budget surplus. If the difference is negative, there is a budget deficit. For this year, the difference is -\$1 trillion (= \$5.2 - \$4.3 = -\$1). The federal government debt at the end of the year is the federal government debt at the beginning of the year plus the value of the deficit. So, in this case, the end of year federal government debt is \$14 trillion (= \$13 + \$1).

True/False Answers

Question	Answer	Comment				
1.	F	Fiscal policy refers to spending only at the federal government level.				
2.	F	As explained in the <i>Don't Let This Happen to You</i> feature on page 534 of the textbook, it is a common mistake to think of fiscal policy as spending more money and monetary policy as increasing the money supply. Fiscal policy does not have a direct effect on the money supply.				
3.	T	See page 528 in the textbook for the meaning of automatic stabilizers.				
		The differences between expenditures and purchases are interest on the national debt, grants to state and local governments, and transfer payments.				
5.	T	See page 537 in the textbook.				
6. T		See textbook Figure 16.8 for the effect of the government purchases multiplier on the change in the aggregate demand curve.				
7.	F	It will increase equilibrium real GDP and increase the price level.				
8.	F	The tax multiplier is always negative. Higher taxes reduce AD.				
9.	T	See page 538 in the textbook for the meaning of the government purchases multiplier.				
10.	F	Fiscal policy changes are generally very slow to implement.				
11.	F	An increase in government spending will tend to increase real GDP and the price index. Both of these changes will increase money demand and tend to increase interest rates.				

442 CHAPTER 16 Fiscal Policy

12.	T	See the section "Crowding Out in the Long Run," which begins on page 543 in the textbook.
13.	F	During periods of budget deficits, the federal government debt will increase.
14.	T	See page 553 in the textbook for how to finance a budget deficit.
15.	T	See textbook Figure 16.17.

CHAPTER 17 Inflation, Unemployment, and Federal Reserve Policy

Chapter Summary and Learning Objectives

The Discovery of the Short-Run Trade-off between Unemployment and Inflation 17.1 (pages 572-577)

Describe the Phillips curve and the nature of the short-run trade-off between unemployment and inflation. The Phillips curve illustrates the short-run trade-off between the unemployment rate and the inflation rate. The inverse relationship between unemployment and inflation shown by the Phillips curve is consistent with the aggregate demand and aggregate supply analysis developed in Chapter 11. The aggregate demand and aggregate supply (AD-AS) model indicates that slow growth in aggregate demand leads to both higher unemployment and lower inflation, and rapid growth in aggregate demand leads to both lower unemployment and higher inflation. This relationship explains why there is a short-run tradeoff between unemployment and inflation. Many economists initially believed that the Phillips curve was a structural relationship that depended on the basic behavior of consumers and firms and that remained unchanged over time. If the Phillips curve were a stable relationship, it would present policymakers with a menu of combinations of unemployment and inflation from which they could choose. Nobel Laureate Milton Friedman argued that there is a natural rate of unemployment, which is the unemployment rate that exists when the economy is at potential GDP and to which the economy always returns. As a result, there is no trade-off between unemployment and inflation in the long run, and the long-run Phillips curve is a vertical line at the natural rate of unemployment.

17.2 The Short-Run and Long-Run Phillips Curves (pages 577–581)

Explain the relationship between the short-run and long-run Phillips curves. There is a short-run tradeoff between unemployment and inflation only if the actual inflation rate differs from the inflation rate that workers and firms had expected. There is a different short-run Phillips curve for every expected inflation rate. Each short-run Phillips curve intersects the long-run Phillips curve at the expected inflation rate. With a vertical long-run Phillips curve, it is not possible to buy a permanently lower unemployment rate at the cost of a permanently higher inflation rate. If the Federal Reserve attempts to keep the economy below the natural rate of unemployment, the inflation rate will increase. Eventually, the expected inflation rate will also increase, which causes the short-run Phillips curve to shift up and pushes the economy back to the natural rate of unemployment. The reverse happens if the Fed attempts to keep the economy above the natural rate of unemployment. In the long run, the Federal Reserve can affect the inflation rate but not the unemployment rate.

17.3 Expectations of the Inflation Rate and Monetary Policy (pages 581–584)

Discuss how expectations of the inflation rate affect monetary policy. When the inflation rate is moderate and stable, workers and firms tend to have adaptive expectations. That is, they form their expectations under the assumption that future inflation rates will follow the pattern of inflation rates in the recent past. During the high and unstable inflation rates of the mid to late 1970s, Robert Lucas and Thomas Sargent argued that workers and firms would have rational expectations. Rational expectations are formed by using all the available information about an economic variable, including the effect of the policy being used by the Federal Reserve. Lucas and Sargent argued that if people have rational expectations, expansionary monetary policy will not work. If workers and firms know that an expansionary monetary policy is going to raise the inflation rate, the actual inflation rate will be the same as the expected inflation rate. Therefore, the unemployment rate won't fall. Many economists remain skeptical of Lucas and Sargent's argument in its strictest form. **Real business cycle models** focus on "real" factors—technology shocks—rather than changes in the money supply to explain fluctuations in real GDP.

17.4 Federal Reserve Policy from the 1970s to the Present (pages 584–593)

Use a Phillips curve graph to show how the Federal Reserve can permanently lower the inflation rate. Inflation worsened through the 1970s. Paul Volcker became Fed chairman in 1979, and under his leadership, the Fed used contractionary monetary policy to reduce inflation. A significant reduction in the inflation rate is called **disinflation**. This contractionary monetary policy pushed the economy down the short-run Phillips curve. As workers and firms lowered their expectations of future inflation, the short-run Phillips curve shifted down, improving the short-run trade-off between unemployment and inflation. This change in expectations allowed the Fed to switch to an expansionary monetary policy to bring the economy back to the natural rate of unemployment. During Alan Greenspan's terms as Fed chairman, inflation remained low, and the credibility of the Fed increased. In recent years, some economists believe that actions taken during Greenspan's term may have contributed to the problems the financial system experienced during the 2007–2009 recession. Some economists and policymakers fear that actions taken by the Fed during the 2007–2009 recession may have reduced its independence.

Chapter Review

Chapter Opener: Why Does Parker Hannifin Worry about Monetary Policy? (page 571)

In conducting monetary policy, the Federal Reserve has to balance the risks of inflation against the risks of unemployment. In June 2013, the Federal Reserve Chairman announced that the Fed might soon curtail its quantitative easing (QE) policy of purchasing \$85 billion of Treasury bonds and mortgage-backed securities per month. Many businesses believed that the Fed's cutting back on QE would result in higher interest rates, which in turn would lower their business sales. One of those businesses was Cleveland-based Parker Hannifin Corporation, which sells components to firms that make machinery. If higher interest rates reduce demand for products that those firms sell, Parker Hannifin will suffer as well.

17.1

The Discovery of the Short-Run Trade-off between Unemployment and Inflation (pages 572–577)

Learning Objective: Describe the Phillips curve and the nature of the short-run trade-off between unemployment and inflation.

Inflation and unemployment are two important macroeconomic problems that the Fed must deal with in the short run. Increases in aggregate demand often lead to higher inflation and lower unemployment, while decreases in aggregate demand often lead to lower inflation and higher unemployment. The inverse relationship between unemployment and inflation is often shown as a negatively sloped graph known as the **Phillips curve**.

A Phillips curve is shown in Figure 17.1 in the textbook. During years when inflation is relatively high, unemployment tends to be relatively low (point A). During years when inflation is relatively low, unemployment tends to be relatively high (point B).

We can use the AD-AS model to explain the Phillips curve. Figure 17.2 in the textbook shows the economy in 2015 is in macroeconomic equilibrium with real GDP of \$17.0 trillion and a price level of 110.0. If there is weak growth in aggregate demand in 2016, the new short-term equilibrium is at point B, with real GDP of \$17.3 trillion and a price level of 112.2. This corresponds to point B on the Phillips curve in panel (b), which shows the inflation rate of 2 percent and the unemployment rate of 6 percent. If instead there is strong growth in aggregate demand, short-run equilibrium is at point C, which results in a higher inflation rate of 4 percent but a lower unemployment rate of 5 percent.

A structural relationship depends on the basic behavior of consumers and firms and remains unchanged over long periods. In the 1960s, many economists and policymakers believed the Phillips curve was a structural relationship and represented a permanent trade-off between unemployment and inflation. Today, most economists believe the Phillips curve is not a structural relationship, and they view the tradeoff between inflation and unemployment as temporary rather than permanent. A short-run trade-off exists only because workers and firms sometimes expect the inflation rate to be either higher or lower than it turns out to be. For example, if workers and firms both expect an inflation rate of 5 percent, and the actual inflation rate is 5 percent, wages will rise by 5 percent, so that the real cost of hiring workers will not change. Because the real cost of hiring workers is the same, the unemployment rate will not change. If, however, workers and firms believe that inflation will be 3 percent, and wages adjust based upon that belief, but actual inflation is 5 percent, then real wages will fall (for more on this point, see Short Answer Ouestion 3 in the "Self-Test" section). Lower real wages will cause firms to hire more workers, and the unemployment rate will decrease. The short-run trade-off between inflation and unemployment comes from unanticipated inflation, not inflation itself. Because there is no trade-off between unemployment and inflation in the long run, economists believe that the long-run Phillips curve is vertical at the natural rate of unemployment. We saw in Chapter 13 that because the LRAS curve is vertical at potential GDP, in the long run, higher prices will not affect the level of real GDP or the level of employment. Similarly, the vertical long-run Phillips curve tells us that higher inflation rates will not lower unemployment in the long run. The level of unemployment that corresponds with potential real GDP is known as the natural rate of unemployment. The long-run Phillips curve is shown in the graph on the right from Figure 17.3 in the textbook along with the LRAS curve in the graph on the left.

Study Hint

Remember that when the economy at potential real GDP, although there will be no cyclical unemployment, there will be frictional and structural unemployment. As a result of friction and structural unemployment, the natural rate of unemployment will not be zero.

A long-run vertical Phillips curve indicates that there is no trade-off between inflation and unemployment in the long run. This conclusion is different from the experience of the 1950s and 1960s.

There is a trade-off between unemployment and inflation in the short run because workers often expect inflation to be higher or lower than it turns out to be. Differences between the actual inflation rate and the expected inflation rate can cause the unemployment rate to be higher or lower than the natural rate (and real GDP to be higher or lower than potential real GDP). Table 17.1 in the textbook shows how differences between actual and expected inflation cause differences between actual and expected real wages.

Milton Friedman argued that inflation will increase employment only if inflation is unexpected; that is, if the actual inflation rate is greater than the expected inflation rate. These higher levels of employment are temporary and will disappear when the inaccurate expectations are changed. This short-run trade-off is shown in Table 17.2 in the textbook.

Study Hint

The short-run Phillips curve trade-off occurs when a higher inflation brings about lower unemployment if inflation is unexpected. The *Making the Connection* feature "Do Workers Understand Inflation?" shows survey evidence to support that workers expect their wages to catch up only slowly with rising inflation. This means that the short-run Phillips curve is downward sloping as firms can raise wages by less than the inflation rate without workers quitting or their morale falling.

Extra Solved Problem 17.1

The Short-Run Trade-off between Unemployment and Inflation

Supports Learning Objective 17.1: Describe the Phillips curve and the nature of the short-run trade-off between unemployment and inflation.

The United States entered a recession in late 2007 as a result of falling aggregate demand. By mid-2009, the U.S. unemployment rate had risen to nearly 10 percent from 4.5 percent in 2007. In 2007, the U.S. inflation rate was 3 percent. Given the nature of the short-run Phillips curve, what would you predict about the change in the inflation rate between 2007 and 2009? Explain how you make your prediction using the aggregate demand and aggregate supply model.

Solving the Problem

Step 1: Review the chapter material.

This problem is about the nature of the short-run trade-off between unemployment and inflation, so you may want to review the section "The Discovery of the Short-Run Trade-off between Inflation and Unemployment," which begins on page 572 in the textbook.

Step 2: Illustrate the effect of a decrease in aggregate demand using an AD-AS model.

In the aggregate demand and aggregate supply model below, a decrease in aggregate demand causes a shift of the aggregate demand curve from AD_{2007} to AD_{2009} . The shift of the AD curve results in a decrease in both real GDP and the price level.

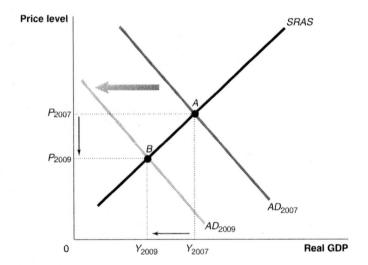

Step 3: Illustrate the effect of short-run trade-off between inflation and unemployment.

The short-run Phillips curve shows the short-run trade-off between inflation and unemployment. Along any short-run Phillips curve, an increase in unemployment as a result

of falling aggregate demand will be accompanied by a decrease in inflation. The graph below illustrates this point by showing that a movement from point A to point B results in an increase in unemployment from 5 percent in 2007 to 10 percent in 2009 while inflation decreases from 3 percent to a level of inflation that is negative, or deflation.

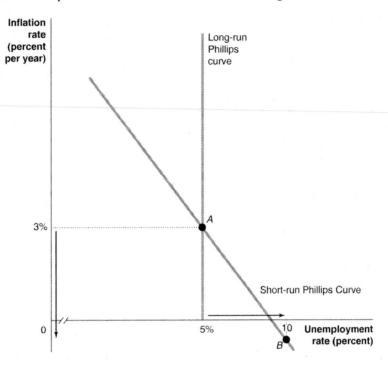

Step 4: Analyze the prediction from the short-run Phillips curve.

As shown in the graph above, a decrease in aggregate demand causes a movement along the short-run Phillips curve from point A to point B. At point B, the unemployment rate is higher, but the inflation rate is lower than at point A. Therefore, the prediction from the short-run Phillips curve is a decrease in the inflation rate from 2007 to 2009. In fact, the inflation rate decreased over that period and even turned negative during 2009.

17.2

The Short-Run and Long-Run Phillips Curves (pages 577–581)

Learning Objective: Explain the relationship between the short-run and long-run Phillips curves.

The short-run Phillips curve is drawn with the expected rate of inflation held constant. When the expected inflation rate and the actual inflation rate are equal, unemployment will be at the natural rate of unemployment. Figure 17.4 in the textbook provides an example of a short-run and a long-run Phillips curve. In this graph, the short-run and long-run Phillips curves intersect at an inflation rate of 1.5 percent. At the point where the short-run and long-run Phillips curves intersect, we know that the expected inflation rate is equal to the actual inflation rate. Changes in expectations cause shifts in the short-run Phillips curve. Increases in expected inflation cause upward shifts in the short-run Phillips curve, as seen in Figure 17.5, which illustrates the impact of the expected inflation rate rising from 1.5 percent to 4.5 percent.

Increases in inflation cause unemployment to fall, as long as expected inflation does not change. This is a movement along the short-run Phillips curve. When workers and firms begin to adjust their expectations to the actual inflation rate being higher than they had expected, the short-run Phillips curve will shift up to

reflect the higher expected inflation rate. Therefore, there is a short-run Phillips curve for every expected inflation rate. Each short-run Phillips curve intersects the long-run Phillips curve at the expected inflation rate. This is shown in Figure 17.6 in the textbook.

Study Hint

The expected inflation rate is held constant along any single short-run Phillips curve. When expected inflation changes, the short-run Phillips curve shifts.

The short-run and long-run Phillips curves have important implications for the conduct of monetary policy. If the Fed tries to use an expansionary monetary policy to lower unemployment by increasing inflation, this can be successful only in the short run. As workers and firms begin to expect higher inflation, the short-run Phillips curve will shift and unemployment will eventually return to the natural rate of unemployment. Thus to keep unemployment below the natural rate of unemployment, the actual inflation rate must constantly increase to stay higher than the upward adjustment of the expected inflation rate. This acceleration of inflation is seen in Figure 17.7 in the textbook.

At point C, the current inflation rate will not change because expected inflation equals actual inflation. At point A, the inflation rate will increase because actual inflation is greater than expected inflation and the short-run Phillips curve shifts up. At point B, the inflation rate will decrease because actual inflation is less than expected inflation and the short-run Phillips curve shifts down. The unchanging unemployment rate along the long-run Phillips curve is called the **nonaccelerating inflation rate of unemployment (NAIRU)**.

Study Hint

In the long run, expansionary and contractionary monetary policies will only change the inflation rate. Monetary policy cannot affect the level of real GDP or the unemployment rate in the long run. However, this unemployment rate in the long run is not constant over time. The *Making the Connection* feature "Does the Natural Rate of Unemployment Ever Change?" explains that the nature rate of unemployment changes over time as a result of changes in demographics, changes in labor market institutions, and the effects of high past levels of unemployment.

Expectations of the Inflation Rate and Monetary Policy (pages 581–584) Learning Objective: Discuss how expectations of the inflation rate affect monetary policy.

How long the economy can remain at a point that is not on the long-run Phillips curve depends on how long it takes workers and firms to adjust their expectations of inflation to the actual inflation rate. People are said to have adaptive expectations if they assume that future rates of inflation will follow the pattern of rates of inflation in the recent past. Experience indicates that how fast workers adjust their expectations depends upon how high the inflation rate is. There are three possibilities:

- Low inflation. When inflation is low, workers and firms tend to ignore it.
- Moderate but stable inflation. With stable inflation, individuals and firms tend to expect inflation to be what it was last period. This is called adaptive expectations.
- *High and unstable inflation*. With higher inflation rates and less stable inflation rates, workers attempt to estimate inflation rates more accurately. The hypothesis of **rational expectations** states that workers use all available information to try to accurately forecast the inflation rate.

Lucas and Sargent argued that if workers and firms have rational expectations and if they expect an expansionary monetary policy will raise the inflation rate, they will use this information in their forecasts of the inflation rate. Consequently, the increase in the inflation rate would *not* be unanticipated, and the expansionary policy would not cause a decline in unemployment, even in the short run. If Lucas and Sargent are correct, an expansionary policy will cause only a movement along the long-run Phillips curve. This is shown in Figure 17.8. In the graph, if workers and firms have adaptive expectations, expansionary monetary policy will move the economy up the short-run Phillips curve, and the unemployment rate will fall. But if workers and firms have rational expectations, the inflation rate will increase, while the unemployment rate will not change.

The logic of Lucas and Sargent's argument is that the Phillips curve is vertical, even in the short run. With a vertical short-run Phillips curve, expansionary monetary policy cannot reduce the unemployment rate below the natural rate of unemployment. Many economists do not agree that the Phillips curve is vertical in the short run either because they do not believe that workers and firms have rational expectations or because they believe that wages and prices adjust only slowly to changes in aggregate demand.

Other economists believe that workers and firms have rational expectations, but argue that fluctuations in unemployment are due to changes in real factors rather than mistakes about the actual inflation rate. These real factors are often referred to as technology shocks, which make it possible to produce more or less output with the same level of employment. Models that focus on real rather than monetary explanations of fluctuations in real GDP and employment are referred to as **real business cycle models**. Some economists are skeptical of these models because they explain recessions as caused by negative technology shocks, which are uncommon (apart from oil price shocks).

Study Hint

Read this section's **Don't Let This Happen to You** feature, which draws the distinction between disinflation and deflation: Disinflation refers to a decline in the inflation rate, whereas deflation refers to a decline in the price level. Textbook Figure 17.10 illustrates a decline in the inflation rate between 1979 and 1983, but there was no deflation.

Extra Solved Problem 17.3

Expectation Errors and Unemployment

Supports Learning Objective 17.3: Discuss how expectations of the inflation rate affect monetary policy.

Suppose that workers and firms expect that the inflation rate is going to increase from 3 percent to 5 percent. Suppose, though, the inflation rate actually rises only to 4 percent. What would you predict about the effect on the unemployment rate of the actual inflation rate being less than the expected inflation rate?

Solving the Problem

Step 1: Review the chapter material.

This problem is about expectations of inflation and monetary policy, so you may want to review the section "Expectations of the Inflation Rate and Monetary Policy," which begins on page 581 in the textbook.

Step 2: Use a graph to show the effect of workers and firms expecting the inflation rate to increase from 3 percent to 5 percent.

The increase in the expected inflation rate will shift the short-run Phillips curve upward.

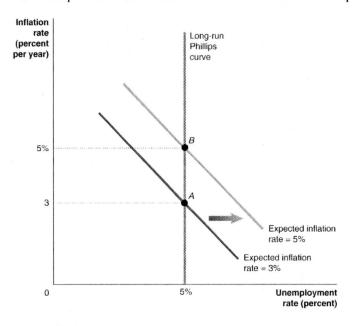

If the inflation rate had increased as workers and firms expected, macroeconomic equilibrium would move from point A to point B and the unemployment rate would not change.

Step 3: Draw a second graph showing the effect of the actual inflation rate being less than the expected inflation rate.

If, however, inflation did not increase as much as workers and firms expected, the real wage is likely to have increased as nominal wages increased faster than the price level. Higher real wages will result in a higher unemployment rate. So, the new short-run macroeconomic equilibrium will be at point C on the graph, rather than point B. In the short-run macroeconomic equilibrium at point C the inflation rate is lower, but the unemployment rate is higher than at point C.

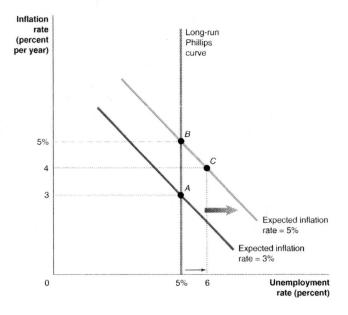

17.4

Federal Reserve Policy from the 1970s to the Present (pages 584-593)

Learning Objective: Use a Phillips curve graph to show how the Federal Reserve can permanently lower the inflation rate.

The high inflation rates of the late 1960s and early 1970s was in part due to the Fed's attempts to keep the unemployment rate below the natural rate. A supply shock in the 1970s due to higher oil prices made inflation worse.

A supply shock will cause the short-run Phillips curve to shift. A supply shock will shift the SRAS to the left. This shift will lower real GDP and increase the price level. On a Phillips curve graph, the Phillips curve will shift up to indicate that both inflation and unemployment have increased. The effect of a supply shock on short-run aggregate supply and the Phillips curve is shown in Figure 17.9 in the textbook.

If the Fed uses contractionary monetary policy to fight the inflation resulting from a supply shock, it can lower the inflation rate but only at the cost of higher unemployment in the short run. If the Fed decides to use expansionary monetary policy to fight the unemployment increases, this will cause more inflation as the economy moves up the short-run Phillips curve. When confronted with this situation in the 1970s, the Fed chose to fight high unemployment with an expansionary monetary policy, even though this decision worsened the inflation rate.

Paul Volcker was appointed Fed chairman in August 1979. Under Volcker, the Fed was able to reduce inflation from 10 percent to 5 percent. This disinflation—or significant reduction in the inflation rate—is shown in Figure 17.10, where each dot represents the inflation and unemployment rates in a 10-year period beginning with 1979.

Alan Greenspan, who followed Volcker as Fed Chairman in 1987, was able to keep the inflation rate low. Greenspan deemphasized the money supply as a policy target in favor of the federal funds rate. The Federal Open Market Committee has continued to target the federal funds rate in the years since. The Fed has also been successful at increasing its credibility by publicly announcing its target for the federal funds rate and by demonstrating a strong commitment to fighting inflation.

Typically, the chairman of the Fed formulates policy independently of other government agencies. The recession of 2007-2009 and the financial crisis in that period led the Fed to move well beyond the target for the federal funds rate as the focus of monetary policy. Close collaboration between the Fed and the Treasury Department has raised the question of whether the Fed will be able to pursue policies independent of the rest of the government. The main reason for central bank independence is to avoid inflation. Beginning in November 2008, the FOMC engaged in a policy of quantitative easing (QE). Under the QE policy, the Fed purchased long-term Treasury securities and mortgage-backed securities to reduce long-term interest rates, which could increase investment spending and aggregate demand.

Study Hint

Most economists believe that the Fed's quantitative easing policy contributed to declining long-term interest rates beginning in 2008. Read this section's Making the Connection feature to also understand some economists' views about the drawbacks of quantitative easing.

Internationally, countries with more independent central banks tend to have lower inflation rates. The United States, Switzerland, and Germany are among those countries with highly independent central banks and relatively lower inflation rates.

Key Terms

Disinflation A significant reduction in the inflation rate.

Natural rate of unemployment The unemployment rate that exists when the economy is at potential GDP.

Nonaccelerating inflation rate of unemployment (NAIRU) The unemployment rate at which the inflation rate has no tendency to increase or decrease.

Phillips curve A curve showing the short-run relationship between the unemployment rate and the inflation rate.

Rational expectations Expectations formed by using all available information about an economic variable.

Real business cycle models Models that focus on real rather than monetary explanations of fluctuations in real GDP.

Structural relationship A relationship that depends on the basic behavior of consumers and firms and that remains unchanged over long periods.

Self-Test

(Answers are provided at the end of the Self-Test.)

Multiple-Choice Questions

- 1. A trade-off between inflation and unemployment exists
 - a. only in the short run.
 - b. only in the long run.
 - c. in both the short run and the long run.
 - d. in neither the short run nor the long run.

2.	Fill in the blanks	. When aggregate	demand	increases,	unemployment	will	usually	 and
	inflation will	·						
	a. rise; rise							
	h missy fall							

- b. rise; fall
- c. fall; fall
- d. fall; rise
- 3. A Phillips curve is a curve showing the
 - a. relationship between the inflation rate and the money supply.
 - b. short-run relationship between the unemployment rate and the inflation rate.
 - c. relationship between the inflation rate and the exchange rate.
 - d. relationship between the size of the federal budget deficit and the size of the federal debt.
- 4. The long-run Phillips curve
 - a. has a negative slope.
 - b. is vertical at the natural rate of unemployment.
 - c. shifts to the right with an increase in inflation.
 - d. shifts to the right as cyclical unemployment decreases.

- 5. A point near the top left segment of the short-run Phillips curve represents a combination of
 - a. high unemployment and high inflation.
 - b. high unemployment and low inflation.
 - c. low unemployment and low inflation.
 - d. low unemployment and high inflation.
- 6. Slow growth in aggregate demand leads to
 - a. higher unemployment and higher inflation.
 - b. higher unemployment and lower inflation.
 - c. lower unemployment and lower inflation.
 - d. lower unemployment and higher inflation.
- 7. Which of the following statements concerning the Phillips curve is correct?
 - a. Most economists in the 1960s and 1970s believed the Phillips curve was vertical in the long run.
 - b. Many economists and policymakers in the 1960s and 1970s viewed the Phillips curve as a structural relationship.
 - c. Economists have always recognized that there is a permanent trade-off between inflation and unemployment.
 - d. The only economist who ever viewed the Phillips curve as a structural relationship was A.W. Phillips.
- 8. If the long-run aggregate supply curve is vertical, then the Phillips curve
 - a. must be horizontal in the short run.
 - b. must be vertical in the short run.
 - c. cannot be downward sloping in the long run.
 - d. must be downward sloping in the long run.
- 9. Which of the following statements is *correct?*
 - a. In the long run, a higher or lower price level has no effect on real GDP.
 - b. In the long run, a higher or lower inflation rate has no effect on the unemployment rate.
 - c. In the long run, the Phillips curve is a vertical line at the natural rate of unemployment.
 - d. all of the above
- 10. The natural rate of unemployment is
 - a. the prevailing rate of unemployment in the economy in the short run.
 - b. the unemployment rate that results when the economy produces the potential level of real GDP.
 - c. the rate of unemployment when the inflation rate equals zero.
 - d. the lowest unemployment rate on the short-run Phillips curve.
- 11. According to Milton Friedman, differences between the actual and expected inflation rates could lead the actual unemployment rate to
 - a. rise above or fall below the natural rate.
 - b. rise above the natural rate, but not fall below it.
 - c. fall below the natural rate, but not rise above it.
 - d. remain equal to the natural rate for a long time.

- 12. Fill in the blanks. If expected inflation is higher than actual inflation, actual real wages in the economy will turn out to be ______ than expected real wages; consequently, firms will hire _____ workers than they had planned.
 - a. higher; more
 - b. higher; fewer
 - c. lower; more
 - d. lower: fewer
- 13. An increase in expected inflation will shift the
 - a. short-run Phillips curve up.
 - b. long-run Phillips curve to the right.
 - c. short-run Phillips curve down.
 - d. short-run Phillips curve up and the long-run Phillips curve to the right.
- 14. Which change in the inflation rate is more likely to affect the levels of both inflation and unemployment?
 - a. a change in the inflation rate that is expected
 - b. a change in the inflation rate that is unexpected
 - c. a change in the inflation rate that is exactly equal to the percentage change in the unemployment rate
 - d. a change in the inflation rate when the unemployment rate equals the natural rate of unemployment
- 15. If the annual inflation rate is 2 percent, which of the following will increase real wages?
 - a. an increase in nominal wages of less than 2 percent
 - b. an increase in nominal wages of more than 2 percent
 - c. an increase in nominal wages equal to 2 percent
 - d. a decrease in nominal wages of more than 2 percent
- 16. If the wage rate is \$10.00 and the price level is 125, then the real wage rate is
 - a. \$15.00.
 - b. \$12.50.
 - c. \$8.
 - d. \$1.25.
- 17. If banks need to receive a 2.0 percent real interest rate on home mortgage loans, what nominal interest rate must they charge if they expect the inflation rate to be 1.5 percent?
 - a. -3.5 percent
 - b. -0.5 percent
 - c. 3.5 percent
 - d. 0.5 percent
- 18. If workers and firms revise their expectations of inflation upward,
 - a. there will be a movement downward along the short-run Phillips curve.
 - b. there will be a movement upward along the short-run Phillips curve.
 - c. the short-run Phillips curve will shift up.
 - d. the short-run Phillips curve will shift down.

	19.	Fill in the blanks. There is a different short-run Phillips curve for every level of the
		inflation rate. The inflation rate at which the short-run Phillips curve intersects the long-run Phillips
		curve equals the inflation rate.
		a. actual; expectedb. expected; actual
		b. expected; actualc. actual; actual
		d. expected; expected
	20.	Fill in the blanks. If the unemployment rate is below the natural rate, the inflation rate tends to, and eventually, the short-run Phillips curve will shift
		a. increase; up
		b. increase; down
		c. decrease; up
		d. decrease; down
	0.1	NII
	21.	What is the nonaccelerating inflation rate of unemployment (NAIRU)?
		a. the inflation rate at which the unemployment rate has no tendency to change
		b. the inflation rate at which the unemployment rate only has the tendency to decrease
		c. the unemployment rate at which the inflation rate has no tendency to change
		d. the unemployment rate at which the inflation rate only has the tendency to decrease
	22	The concept of a nonaccelerating inflation rate of unemployment (NAIRU) helps us to understand
	44.	why in the long run, the Federal Reserve
		a. can affect both the inflation rate and the unemployment rate.
		b. cannot affect either the inflation rate or the unemployment rate.
		c. can affect the unemployment rate but not the inflation rate.
		d. can affect the inflation rate but not the unemployment rate.
		d. Can affect the inflation rate out not the unemployment late.
	23.	What determines how long the economy remains at a point that is on the short-run Phillips curve but not on the long-run Phillips curve?
		a. how quickly the public's expectations of future inflation adjust to changes in current inflation
		b. how demographic changes affect the natural rate of unemployment
		c. how much the Federal Reserve changes interest rates
		d. the slope of the trade-off between inflation and unemployment
		uic stope of the data of control manner and acceptance
	24.	If people assume that future rates of inflation will be about the same as past rates of inflation, they are
		said to have
		a. naïve expectations.
		b. adaptive expectations.
		c. rational expectations.
		d. consistent expectations.
	25.	Expectations formed by using all available information about an economic variable are called
		a. naïve expectations.
		b. adaptive expectations.
		c. rational expectations.
		d. consistent expectations.

- 26. If workers and firms have rational expectations and wages and prices adjust quickly, an expansionary monetary policy will
 - a. increase the inflation rate, but lower the unemployment rate.
 - b. increase the inflation rate, but not change the unemployment rate.
 - c. increase both the inflation and unemployment rates.
 - d. change neither the inflation nor the unemployment rates.
- 27. If workers ignore inflation in calculating the real wage rate, what is the effect of an expansionary monetary policy?
 - a. a move downward along the short-run Phillips curve
 - b. a move upward along the short-run Phillips curve
 - c. a move upward along the long-run Phillips curve
 - d. a move downward along the long-run Phillips curve
- 28. In a real business cycle model, which of the following best explains an increase in real GDP above the full-employment level?
 - a. rational expectations
 - b. an increase in the money supply
 - c. a positive technology shock
 - d. all of the above
- 29. The monetary explanations of Lucas and Sargent and the real business cycle models are sometimes grouped together under the label of
 - a. monetarism.
 - b. the new classical macroeconomics.
 - c. the new Keynesian macroeconomics.
 - d. the new growth theory.
- 30. Like the classical economists, the new classical macroeconomists believe that
 - a. the economy cannot correct itself, but requires government intervention in order to remain stable.
 - b. the short-run Phillips curve is horizontal.
 - c. the economy will normally be at its potential level.
 - d. All of the above are true of new classical macroeconomists.
- 31. A negative supply shock will shift the
 - a. short-run Phillips curve up.
 - b. long-run Phillips curve to the right.
 - c. long-run Phillips curve down.
 - d. short-run Phillips curve up and the long-run Phillips curve to the right.

32.	Fill	in t	he blanks. <i>A</i>	A negative suppl	y shock, such	as tl	ne O	PEC oil p	rice increas	es of the	e early	1970	s,
	can	be	illustrated	by a	shif	of	the	short-run	aggregate	supply	curve	and	a
				shift of the sh	ort-run Phillip	s cur	ve.						
	_	1 - 0			-								

- a. leftward; upward
- b. leftward; downward
- c. rightward; upward
- d. rightward; downward

	 How can the Fed fight a combination of rising unemployment and rising inflation? a. By applying expansionary monetary policy, the Fed can solve both problems simultaneously. b. By applying contractionary monetary policy, the Fed can solve both problems simultaneously. c. Not easily. Neither expansionary nor contractionary monetary policy can solve both problems simultaneously. d. By resorting to the use of fiscal policy instead of monetary policy.
	 How did the Federal Reserve respond to the effects of the oil supply shock in the mid-1970s that led to rising unemployment and rising inflation? a. The Fed used a contractionary monetary policy to fight the high inflation rate. b. The Fed used an expansionary monetary policy to fight the high unemployment rate. c. The Fed used a combination of expansionary monetary policy and contractionary monetary policy to fight both the high unemployment rate and the high inflation rate. d. The Fed did not take any action in response to the oil supply shock.
35.	After Fed Chairman Paul Volcker decided to fight inflation in 1979, the Fed's monetary policy resulted in a. lower interest rates. b. a lower unemployment rate. c. lower expectations of future inflation by firms and workers. d. all of the above.
36.	Fill in the blanks. After Fed Chairman Paul Volcker began fighting inflation in 1979, workers and firms eventually their expectations of future inflation; consequently, the short-run Phillips curve shifted a. raised; up b. raised; down c. lowered; up d. lowered; down
37.	A significant reduction in the inflation rate is called a. deflation. b. disinflation. c. stagflation. d. cost-push inflation.
38.	 Paul Volcker's monetary policy caused the Phillips curve to shift down, but only after several years of high unemployment. This suggests that workers and firms had a. rational expectations; that is, they used all available information to form their expectations of future inflation. b. adaptive expectations; that is, they changed their expectations of future inflation after the current inflation rate had fallen. c. naïve expectations; that is, they expected inflation today to be exactly what it was yesterday. d. no expectations at all of future inflation.
39.	Fill in the blanks. Disinflation refers to a decline in the, while deflation refers to a decline in the a. inflation rate; price level b. price level; inflation rate c. market prices; economy-wide prices

d. money supply; price level

- 40. In order to drive down the inflation rate, the unemployment rate will have to rise more if the short-run Phillips curve is
 - a. flatter.
 - b. steeper.
 - c. vertical.
 - d. upward sloping.
- 41. During the 1980s and 1990s, the relationship between growth in M2 and inflation
 - a. broke down, and the Fed announced that it would no longer set targets for M2.
 - b. strengthened significantly, renewing the Fed's confidence in using monetary targets for M2.
 - c. involved higher inflation rates leading to higher rates of growth of M2.
 - d. caused inflation to soar to its highest levels since World War II.
- 42. Which of the following is identified in the textbook as an action by the Fed during Greenspan's term that possibly contributed to the financial crisis of 2007–2009?
 - a. The Fed's decision not to save the failing hedge fund Long-Term Capital Management in 1998
 - b. The Fed's decision to keep the target for the federal funds rate at 1 percent for more than 18 months after the end of the 2001 recession
 - c. The Fed's decision to announce at the end of each FOMC meeting about its future economic outlook
 - d. The Fed's decision to disclose any change to its target for the federal funds rate immediately each FOMC meeting
- 43. Which of the following is true about the Fed under the leadership of Alan Greenspan between 1987 and 2006?
 - a. The Fed relied on setting targets for M1 in the conduct of monetary policy.
 - b. The Fed attempted to fight inflation by keeping interest rates high over the entire period between 1987 and 2006.
 - c. The Fed attempted to enhance its credibility by announcing its monetary policy action at the conclusion of the FOMC meeting.
 - d. none of the above
- 44. Beginning in 2008, the Fed implemented quantitative easing policy in order to
 - a. keep the stock market from developing a bubble.
 - b. lower long-term interest rates on corporate bonds and mortgages.
 - c. close the gap between long-term interest rates and short-term interest rates.
 - d. reduce speculative investment.
- 45. Cross-country evidence supports that the more independent a country's central bank,
 - a. the higher its inflation rate.
 - b. the lower its inflation rate.
 - c. the higher its national debt.
 - d. the lower its national debt.

Short Answer Questions

1.	Why does the short-run Phillips curve have a negative slope?
2.	In 2012, average hourly earning in manufacturing was \$23 and the price level (measured by the GDP deflator) was 122. Suppose that in 2013, the inflation rate was 3 percent. How much would average hourly earnings needed to have changed to keep the real wage constant?
3.	Suppose that workers and firms both expect prices to increase by 3 percent. The current average wage rate is \$23. The price level is 122. Show what will happen to the real wage if the actual inflation rate is 2 percent but expected inflation remains at 3 percent.
4.	Why does a vertical long-run aggregate supply curve imply a vertical long-run Phillips curve?

460 CHAPTER 17 Inflation, Unemployment, and Federal Reserve Policy

	•		
		Ferent effects expansionary monetary policy values ations compared to rational expectations.	Ferent effects expansionary monetary policy will have on u ations compared to rational expectations.

True/False Questions

- T F 1. A Phillips curve trade-off means that a higher unemployment rate is associated with a lower inflation rate in the short run.
- T F 2. In the long run, there is no trade-off between unemployment and inflation.
- T F 3. The short-run Phillips curve has a positive slope.
- T F 4. The long-run Phillips curve has a negative slope.
- T F 5. Milton Friedman argued that the Phillips curve represents a permanent structural relationship between unemployment and inflation.
- T F 6. If the nominal wage increases at a rate higher than the inflation rate, then the real wage will increase.
- T F 7. If prices rise more than expected, the real wage rate will also rise.
- T F 8. Milton Friedman and Edmund Phelps argued that an increase in the inflation rate can reduce unemployment only if the increase in inflation rate is expected.
- T F 9. An increase in the expected inflation rate will shift the short-run Phillips curve up.
- T F 10. At the point where the short-run Phillips curve crosses the long-run Phillips curve, the public's expectations of inflation are the same as the actual inflation rate.
- T F 11. In the long run, the Federal Reserve can affect the inflation rate but not the unemployment rate.
- T F 12. The natural rate of unemployment is fixed and does not change.
- T F 13. If expectations of inflation are rational, then they are based only on past inflation rates.
- T F 14. A negative supply shock shifts the *SRAS* curve to the left and the short-run Phillips curve up.

T F 15. There is strong evidence to support that the Fed has increasingly emphasized the use of the money supply as a monetary policy target since Alan Greenspan became Fed chair.

Answers to the Self-Test

Multiple-Choice Question	Multi	ple-Ch	oice (Questions
--------------------------	-------	--------	--------	-----------

Question	Answer	Comment
1.	a	An important consideration for the Fed is that in the short run, there can be a
		trade-off between unemployment and inflation: Lower unemployment rates can result in higher inflation rates. In the long run, however, this trade-off disappears and the unemployment rate is independent of the inflation rate.
2.	d	When aggregate demand increases, unemployment will usually fall, and inflation will rise. When aggregate demand decreases, unemployment will usually rise, and inflation will fall. As a result, there is a short-run trade-off between unemployment and inflation.
3.	b	The Phillips curve is a curve showing the short-run relationship between the unemployment rate and the inflation rate.
4.	b	The long-run Phillips curve shows the unemployment rate at different inflation rates assuming people's expectations of inflation are accurate. If expectations are correct, there will be no adjustment in unemployment, and the curve is vertical at the natural rate of unemployment.
5.	d	Figure 17.1 shows a typical short-run Phillips curve.
6.	b	The <i>AD-AS</i> model indicates that slow growth in aggregate demand leads to both higher unemployment and lower inflation. This relationship explains why there is a short-run trade-off between unemployment and inflation, as shown by the downward-sloping Phillips curve.
7.	b	Because many economists and policymakers in the 1960s and 1970s viewed the Phillips curve as a structural relationship, they believed it represented a permanent trade-off between unemployment and inflation. As long as policymakers were willing to accept a permanently higher inflation rate, they would be able to keep the unemployment rate permanently lower.
8.	c	Friedman and Phelps noted that economists had come to agree that the long- run aggregate supply curve was vertical. If this was true, then the Phillips curve could not be downward sloping in the long run. There was a critical inconsistency between a vertical long-run aggregate supply curve and a long- run Phillips curve that is downward sloping. Friedman and Phelps argued, in essence, that there is no trade-off between unemployment and inflation in the long run.
9.	d	In the long run, a higher or lower price level has no effect on real GDP, because real GDP is always at its potential level in the long run. In the same way, in the long run, a higher or lower inflation rate will have no effect on the unemployment rate, because the unemployment rate is always equal to the natural rate in the long run. Figure 17.3 illustrates Friedman's conclusion that the long-run aggregate supply curve is a vertical line at the potential real GDP and the long-run Phillips curve is a vertical line at the natural rate of unemployment.

Question	Answer	Comment
10.	b	At potential real GDP, firms will operate at their normal level of capacity and everyone who wants a job will have one, except the structurally and frictionally unemployed. Milton Friedman defined the natural rate of unemployment as the unemployment rate that exists when the economy is at potential GDP.
11.	a	Friedman argued that the short-run trade-off between unemployment and inflation exists only because workers and firms sometimes expect the inflation rate to be either higher or lower than it turned out to be. Differences between the expected inflation rate and the actual inflation rate could lead the unemployment rate to rise above or dip below the natural rate.
12.	b	If expected inflation is higher than actual inflation, then that nominal wage (which is set based on expected inflation) will increase more than is necessary to keep purchasing power level. Thus actual real wages in the economy will turn out to be higher than expected. Because of the higher real wage firms will hire fewer workers than they had planned.
13.	a	If the public expects higher inflation, it will be necessary for the inflation rate to rise to keep unemployment at the same level. This is an upward shift in the short-run curve.
14.	b	Milton Friedman and Edmund Phelps concluded that an increase in the inflation rate increases employment (and decreases unemployment) only if it is unexpected: There is always a temporary trade-off between inflation and unemployment; there is no permanent trade-off. The temporary trade-off comes not from inflation as such, but from unanticipated inflation.
15.	b	Firms know that only nominal wage increases of more than 2 percent will increase real wages. Workers realize that unless they receive a nominal wage increase of at least 2 percent, they will not be able to purchase the same selection of goods as before.
16.	b	The real wage rate is defined as the nominal wage divided by the price level and multiplied by 100, or $(\$10/125) \times 100 = \8.00 .
17.	c	The nominal interest rate is the real interest rate plus the expected inflation rate. If banks need to receive a 2.0 percent real interest rate on home mortgage loans, they will charge a nominal interest rate of 3.5 percent if they expect the inflation rate to be 1.5 percent.
18.	c	The point where the short-run Phillips curve intersects the long-run Phillips curve is the expected inflation rate. If workers and firms revise their expectations of inflation upward, the short-run Phillips curve will need to shift up, which will make the short-run trade-off between unemployment and inflation worse.
19.	d	There is a different short-run Phillips curve for every expected inflation rate. Each short-run Phillips curve intersects the long-run Phillips curve at the expected inflation rate.
20.	a	As shown in textbook Figure 17.7, the inflation rate is only stable if the unemployment rate equals the natural rate. If the unemployment rate is below the natural rate, the inflation rate increases and, eventually, the short-run Phillips curve shifts up. If the unemployment rate is above the natural rate, the inflation rate decreases, and, eventually, the short-run Phillips curve shifts down.

Question	Answer	Comment
21.	, c	The nonaccelerating inflation rate of unemployment is the unemployment rate at which the inflation has no tendency to either increase or decrease. See page 579 in the textbook.
22.	d	As discussed in the chapter, in the long run the economy always returns to the natural rate of unemployment, which is sometimes called the nonaccelerating inflation rate of unemployment, or NAIRU. Thus, the Fed cannot control the unemployment rate in the long run. We can conclude that: In the long run, the Federal Reserve can affect the inflation rate but not the unemployment rate.
23.	a	How long the economy remains at a point that is on the short-run Phillips curve but not on the long-run Phillips curve depends on how quickly workers and firms adjust their expectations of future inflation to changes in current inflation. If workers and firms have rational expectations, the expected inflation rate will adjust immediately to the actual inflation rate, so that the unemployment rate will not deviate from the natural rate.
24.	b	People are said to have adaptive expectations of inflation if they assume that future rates of inflation will be about the same as past rates of inflation.
25.	С	Expectations formed by using all available information about an economic variable are called rational expectations.
26.	b	If workers have rational expectations, they will adjust their expectations about inflation following an expansionary monetary policy. As a result, the inflation rate will increase, but the unemployment rate will not change.
27.	Ь	If workers ignore inflation, an expansionary monetary policy will not cause them to adjust their expectations of inflation, so the short-run Phillips curve does not shift. Rather, the short-run equilibrium moves upward along the short-run Phillips curve; inflation will rise and unemployment will fall. If workers have rational expectations, an expansionary monetary policy will cause them to adjust their inflation expectations so the short-run equilibrium moves up the long-run Phillips curve. Inflation will still rise, but there will be no change in unemployment.
28.	c	Real GDP will be above its previous potential level following a positive technology shock and below its previous potential level following a negative technology shock. Real business cycle models focus on real factors, rather than changes in the money supply, to explain fluctuations in real GDP. This is why they are known as real business cycle models.
29.	Ь	The approach of Lucas and Sargent and the real business cycle models are sometimes grouped together under the label of new classical macroeconomics, because these approaches share the assumptions that people have rational expectations and that wages and prices adjust rapidly. These assumptions are similar to those held by "classical economists."
30.	c	John Maynard Keynes, in his book <i>The General Theory of Employment, Interest, and Money</i> , published in 1936, referred to economists before the Great Depression as "classical economists." Like the classical economists, the new classical macroeconomists believe that the economy will normally be at its potential level.
31.	a	An adverse supply shock increases the cost of production. At a given expected inflation rate, increased production costs will reduce real GDP, increasing unemployment and shifting the short-run Phillips curve up.

Question	Answer	Comment
32.	a	As shown in textbook Figure 17.9, when OPEC increased the price of a barrel of oil from less than \$3 to more than \$10, the <i>SRAS</i> curve shifted to the left. Between 1973 and 1975, real GDP declined from \$4,917 billion to \$4,880 billion and the price level rose from 28.1 to 33.6. Also, the supply shock shifted the Phillips curve up. In 1973, the U.S. economy had an inflation rate of about 5.5 percent and an unemployment rate of about 5 percent. By 1975, the inflation rate had risen to about 9.5 percent and the unemployment rate to about 8.5 percent.
33.	c	A combination of rising unemployment and rising inflation places the Federal Reserve in a difficult position. If the Fed uses an expansionary monetary policy to fight the high unemployment rate, the <i>AD</i> curve would shift to the right. Real GDP would increase and the unemployment rate would fall, but at the cost of higher inflation. Thus the economy's equilibrium would move up the short-run Phillips curve. If the Fed used a contractionary monetary policy to fight the high inflation rate, the <i>AD</i> curve would shift to the left. This would cause real GDP to fall and reduce the inflation rate, but at the cost of higher unemployment. Thus the economy would move down the short-run Phillips
34.	b	curve. In response to the supply shock in the mid-1970s, the Fed chose to fight the
34.	U	high unemployment with an expansionary monetary policy.
35.	С	As it became clear the Fed was determined to lower the inflation rate, workers and firms lowered their expectations of future inflation.
36.	d	Fed Chairman Paul Volcker began fighting inflation in 1979 by reducing the growth of the money supply, thereby raising interest rates. By 1982, the unemployment rate had risen to almost 10 percent and the inflation rate had fallen to 6 percent. As workers and firms lowered their expectations of future inflation, the short-run Phillips curve shifted down, improving the short-run trade-off between unemployment and inflation.
37.	b	Under Paul Volcker's leadership, the Fed had reduced the inflation rate from more than 10 percent to less than 5 percent. The inflation rate has generally remained below 5 percent ever since. A significant reduction in the inflation rate is called disinflation. Prices are still rising, but at a slower rate than before. When the economy experiences deflation, then prices are falling.
38.	b	Volcker's announcement in October 1979 that he planned to use a contractionary monetary policy to bring down the inflation rate was widely publicized. If workers and firms had rational expectations, we might have expected them to quickly reduce their expectations of future inflation. The economy should have moved smoothly down the long-run Phillips curve. However, the economy moved down the existing short-run Phillips curve and only after several years of high unemployment did the Phillips curve shift down. Apparently, workers and firms had adaptive expectations, only changing their expectations of future inflation after the current inflation rate had fallen.
39.	a	Disinflation refers to a decline in the inflation rate. Deflation refers to a decline in the price level.

Question	Answer	Comment
40.	a	How much the unemployment rate would need to rise in order to drive down the inflation rate depends on the steepness of the short-run Phillips curve. The flatter the Phillips curve, the more the unemployment rate will need to rise in order to reduce the inflation rate.
41.	a	During the 1980s and 1990s, there was a breakdown in the close relationship between growth in M2 and inflation. Before 1987, the Fed would announce annual targets for how much M1 and M2 would increase during the year. In February 1987, near the end of Paul Volcker's term, the Fed announced that it would no longer set targets for M1. In July 1993, Alan Greenspan announced
		that the Fed would also no longer set targets for M2. Instead, the Federal Open Market Committee (FOMC) has relied on setting targets for the federal funds rate to meet its goals of price stability and high employment.
42.	b	In addition to the Fed's decision to keep the target for the federal funds rate at 1 percent for more than 18 months after the end of the 2001 recession, the decision to intervene in the failure of Long-Term Capital Management (LTCM) is considered to have possibly contributed to the financial crisis of 2007–2009. Some economists see the Fed's actions in the case of LTCM as encouraging the excessive risk taking that helped cause the financial crisis of 2007–2009.
43.	С	Under the leadership of Alan Greenspan between 1987 and 2006, the Fed deemphasized the money supply as a monetary policy target and instead relied on setting targets for the federal funds rate. The Fed also took steps to raise its monetary policy credibility, including the announcement of any change in the target interest rate soon after each FOMC meeting.
44.	b	The Fed's quantitative policy aimed at lowering long-term interest rates on corporate bonds and mortgages in order to increase investment spending and aggregate demand. See <i>Making the Connection</i> "The Debate over Quantitative Easing."
45.	b	The main reason to keep a country's central bank independent of the rest of the government is to avoid inflation. Figure 17.11 in the textbook shows evidence to support the idea that countries with more independent central banks tend to have lower inflation.

Short Answer Responses

1. Increases in inflation, if unanticipated, will cause reductions in real wages. Because wages usually keep pace with expected inflation, an unexpected increase in inflation will cause the real wage rate to fall. As the real wage rate falls, firms will try to hire more workers to take advantage of the lower cost of resources. This will result in output above potential real GDP and increases in employment, and consequently, a reduction in unemployment. Higher inflation (if unanticipated) will result in lower unemployment, so the short-run Phillips curve has a negative slope.

2. If the nominal wage is \$23 and the price level is 122, then the real wage is:

Real Wage =
$$\frac{$23}{122} \times 100 = $18.85$$
.

If inflation is 3 percent, the price level will increase to 125.66 ($122 \times 1.03 = 125.66$), so to keep the real wage the same, the new nominal wage will need to increase to \$23.69, or

$$$18.85 = \frac{\text{New Wage}}{125.66} \times 100 = \frac{$23.69}{125.66} \times 100.$$

Notice that the percentage increase in the wage rate is 3 percent $[100 \times (\$23.69 - \$23)/ \$23 = 3.0]$, which is the same as the inflation rate.

3. If wages rise as much as workers and firms expect prices to rise, wages will also increase 3 percent, so that wages will rise to \$23.69 ($$23 \times 1.03 = 23.69). If prices rise 2 percent, then the new price level will be 124.44 ($122 \times 1.02 = 124.44$). The real wage will then be:

Real Wage =
$$\frac{$23.69}{124.44} \times 100 = $19.04$$
.

Because the real wage in 2012 was \$18.85 (see Question 2), the unexpected inflation increases the real wage rate by 1 percent.

- 4. The vertical long-run aggregate supply curve implies that, regardless of the level of aggregate demand and the resulting price level, the level of output will in the long-run move toward potential real GDP. Consequently, whatever the inflation rate (the rate of change in the price level), in the long run, output will be at potential real GDP. If output is always at potential real GDP, unemployment will always be at the natural rate of unemployment. Therefore, in the long run at each inflation rate, the resulting unemployment rate will be the natural rate, which means the long-run Phillips curve will be vertical.
- 5. If the Fed is successful in using a contractionary monetary policy to reduce inflation, the impact this will have on the unemployment rate will depend on how expectations are formed. If expectations are formed adaptively, then inflation expectations are based on past inflation. In this case, the lower inflation will cause a movement along a short-run Phillips curve, so that the lower inflation will be accompanied by higher unemployment. This is shown in a movement from point A to point B in the graph below. If expectations of inflation are formed rationally, then because the public is able to predict the reduction in inflation, expected inflation will fall as the inflation rate falls. This implies that the short-run Phillips curve will shift to the left as the inflation rate falls. In this case, the reduction in inflation will not be accompanied by higher unemployment. This is shown in the movement from point A to point C in the graph on the next page.

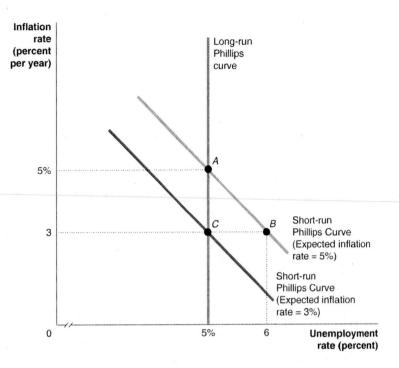

6. If expectations of inflation are formed adaptively, then an expansionary monetary policy will not be anticipated by workers or firms, and the inflation caused by the policy will be a surprise. In this case, the higher inflation rate will result in a decrease in the unemployment rate. This is the movement from point A to point B in the graph below. If however, the expansionary monetary policy is anticipated by workers and firms—as would be the case with rational expectations—the resulting inflation will be anticipated and workers and firms will not be surprised by the price increases. In this case, the unemployment rate will not change, and the economy will move from point A to point C as in the following graph.

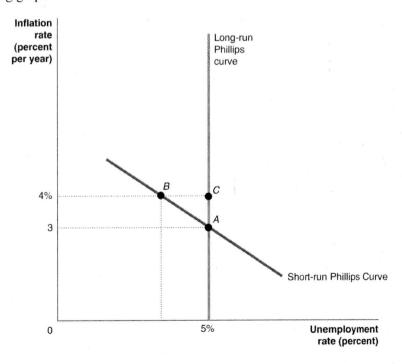

True/False Answers

Question	Answer	Comment
1.	T	See page 574 in the textbook for the meaning of the Phillips curve trade-off.
2.	T	See page 578 in the textbook for the Phillips curve trade-off in the long run.
3.	F	The short-run Phillips curve has a negative slope, indicating the trade-off between inflation and unemployment.
4.,	F	The long-run Phillips curve is vertical.
5.	F	Friedman argued that there is no trade-off between unemployment and inflation in the long run, even though the trade-off exists in the short run.
6.	T	The real wage is the nominal wage divided by the price level. So if the nominal wage rises at a rate higher than inflation, the real wage will also rise.
7.	F	If prices rise more than expected, the real wage will fall.
8.	F	Milton Friedman and Edmund Phelps argued that the trade-off between inflation and unemployment occurs only if there is unexpected inflation.
9.	T	See textbook Figure 17.5.
10.	T	See page 579 in the textbook.
11.	T	See page 579 in the textbook.
12.	F	The natural rate of unemployment may change if there are demographic changes, changes in labor market institutions, or if the unemployment rate remains high for an extended period.
13.	F	Rational expectations of inflation are based on all available information about inflation, including expected monetary policy changes.
14.	T	See textbook Figure 17.9.
15.	F	Since the late 1980s, the Fed has moved away from using the money supply as a monetary policy target. In 1993, Alan Greenspan announced that the Fed would no longer set targets for M2 in addition to M1. See pages 589 and 590 in the textbook.

CHAPTER 18 | Macroeconomics in an **Open Economy**

Chapter Summary and Learning Objectives

The Balance of Payments: Linking the United States to the International Economy 18.1 (pages 602-606)

Explain how the balance of payments is calculated. Nearly all economies are open economies that trade with and invest in other economies. A closed economy has no transactions in trade or finance with other economies. The balance of payments is the record of a country's trade with other countries in goods, services, and assets. The current account records a country's net exports, net investment income, and net transfers. The financial account shows investments a country has made abroad and foreign investments received by the country. The balance of trade is the difference between the value of the goods a country exports and the value of the goods a country imports. Net foreign investment is the difference between capital outflows from a country and capital inflows. The capital account is a part of the balance of payments that records relatively minor transactions. Apart from measurement errors, the sum of the current account and the financial account must equal zero. Therefore, the balance of payments must also equal zero.

The Foreign Exchange Market and Exchange Rates (pages 607-614) 18.2

Explain how exchange rates are determined and how changes in exchange rates affect the prices of imports and exports. The nominal exchange rate is the value of one country's currency in terms of another country's currency. The exchange rate is determined in the foreign exchange market by the demand and supply of a country's currency. Changes in the exchange rate are caused by shifts in demand or supply. The three main sets of factors that cause the supply and demand curves in the foreign exchange market to shift are changes in the demand for U.S.-produced goods and services and changes in the demand for foreign-produced goods and services; changes in the desire to invest in the United States and changes in the desire to invest in foreign countries; and changes in the expectations of currency traders particularly speculators—concerning the likely future values of the dollar and the likely future values of foreign currencies. Currency appreciation occurs when a currency's market value increases relative to another currency. Currency depreciation occurs when a currency's market value decreases relative to another currency. The real exchange rate is the price of domestic goods in terms of foreign goods. The real exchange rate is calculated by multiplying the nominal exchange rate by the ratio of the domestic price level to the foreign price level.

The International Sector and National Saving and Investment (pages 614-617) 18.3

Explain the saving and investment equation. A current account deficit must be exactly offset by a financial account surplus. The financial account is equal to net capital flows, which is equal to net foreign investment but with the opposite sign. Because the current account balance is roughly equal to net exports, we can conclude that net exports will equal net foreign investment. National saving is equal to private saving plus government saving. Private saving is equal to national income minus consumption and minus taxes. Government saving is the difference between taxes and government spending. As we saw in previous chapters, GDP (or national income) is equal to the sum of investment, consumption, government spending, and net exports. We can use this fact, our definitions of private and government saving, and the fact that net exports equal net foreign investment to arrive at an important relationship known as the saving and investment equation: S = I + NFI.

18.4 The Effect of a Government Budget Deficit on Investment (pages 617–619)

Explain the effect of a government budget deficit on investment in an open economy. When the government runs a budget deficit, national saving will decline unless private saving increases by the full amount of the budget deficit, which is unlikely. As the saving and investment equation shows, the result of a decline in national saving must be a decline in either domestic investment or net foreign investment.

18.5 Monetary Policy and Fiscal Policy in an Open Economy (pages 620–621)

Compare the effectiveness of monetary and fiscal policy in an open economy and in a closed economy. When the Federal Reserve engages in an expansionary monetary policy, it buys government bonds to lower interest rates and increase aggregate demand. In a closed economy, the main effect of lower interest rates is on domestic investment spending and purchases of consumer durables. In an open economy, lower interest rates will also cause an increase in net exports. When the Fed wants to slow the rate of economic growth to reduce inflation, it engages in a contractionary monetary policy. With a contractionary policy, the Fed sells government bonds to increase interest rates and reduce aggregate demand. In a closed economy, the main effect is once again on domestic investment and purchases of consumer durables. In an open economy, higher interest rates will also reduce net exports. We can conclude that monetary policy has a greater impact on aggregate demand in an open economy than in a closed economy. To engage in an expansionary fiscal policy, the government increases government spending or cuts taxes. An expansionary fiscal policy can lead to higher interest rates. In a closed economy, the main effect of higher interest rates is on domestic investment spending and spending on consumer durables. In an open economy, higher interest rates will also reduce net exports. A contractionary fiscal policy will reduce the budget deficit and may lower interest rates. In a closed economy, lower interest rates increase domestic investment and spending on consumer durables. In an open economy, lower interest rates also increase net exports. We can conclude that fiscal policy has a smaller impact on aggregate demand in an open economy than in a closed economy.

Chapter Review

Chapter Opener: A Strong Dollar Hurts McDonald's Profits (page 601)

McDonald's is a global company, with about two-thirds of its sales coming from outside the United States. McDonald's has 32,000 outlets in 118 countries, serving 60 million customers per day. Its Big Mac is one of the most widely available products in the world. In 2012, McDonald's global profits increased by 6.3 percent from the previous year when measured in local currency—pounds in Great Britain, euros in France, and yen in Japan. But when measured in dollars terms, McDonald's profits *fell* by 0.7 percent. Why the discrepancy? The value of the dollar had increased relative to most other currencies. So, converting pounds, euros, and yen into dollars yielded fewer dollars for McDonald's.

18.1

The Balance of Payments: Linking the United States to the International Economy (pages 602–606)

Learning Objective: Explain how the balance of payments is calculated.

Most economies in the world today are open economies. An **open economy** has interactions with other economies through the trading of goods and services and financial assets. A **closed economy** has no interactions or trade with other countries. The best way to look at a country's financial interactions with other countries is to look at its balance of payments. The **balance of payments** is the record of a country's trade with other countries in goods, services and assets. The balance of payments includes three accounts: the current account, the financial account, and the capital account.

The current account measures current flows of funds into and out of a country. The current account includes:

- Net exports (Exports Imports)
- Net investment income (the difference between investment income earned by U.S. residents in other countries and investment income on U.S. investments paid to residents in all other countries)
- Net transfers (the difference between transfers received by U.S. residents and transfers made to individuals in other countries by U.S. residents)

Note that these terms are defined from the perspective of the United States. We could also calculate net investment income or net transfers for France or any other country.

The balance of trade, which is the difference between goods exported and imported, is the largest component of the current account. If exports are greater than imports, there is a balance of trade surplus. If exports are less than imports, there is a balance of trade deficit.

The financial account records the purchases of assets a country has made abroad and foreign purchases of assets in the country. A capital outflow occurs when an individual or firm in the United States buys a financial asset issued by a foreign company or government or builds a factory in another country. A capital inflow occurs when a foreign individual or firm buys a bond issued by a U.S. firm or the U.S. government or builds a factory in the United States. The financial account is a measure of net capital flows, or the difference between capital inflows and capital outflows. Net foreign investment is the opposite of net capital flows and is capital outflows minus capital inflows.

The capital account is less important than the financial account or the current account. It measures the net flow of funds for things like migrants' transfers and the purchase and sale of nonproduced, nonfinancial assets (such as trademarks, patents, or copyrights). In the discussion that follows, we will not focus on the capital account because it is very small.

The sum of the current account, the financial account, and the capital account is the balance of payments. The balance of payments must always be zero because if the current account is negative (the typical situation for the United States), more dollars flowed out of the United States as a result of U.S. households and firms buying foreign goods and services than flowed back into the United States as a result of the United States selling goods and services to foreign households and firms. These extra dollars were either used to buy U.S. financial assets or to buy physical assets, such as office buildings or factories, in the United States, or were added to foreign dollar holdings. Changes in foreign holding of U.S. dollars are called official reserve transactions. Foreign investment in the United States and additions to foreign holdings of dollars are positive entries in the financial account. The positive entries in the financial account exactly equal the negative entries in the current account. As a result, the current account plus the financial account will sum to zero.

Study Hint

Remember, we are ignoring the capital account. If the current account and the financial account do not sum to zero, as they should, there has been some form of measurement error. An entry in the balance of payments called the "statistical discrepancy" accounts for the measurement error.

Spend some time reviewing Table 18.1, "The Balance of Payments, 2012 (billions of dollars)," on

page 603 of the textbook. The table shows the current account, financial account, and balance on the capital account for the United States in 2012. The balance of payments is zero.

Read Don't Let This Happen to You "Don't Confuse the Balance of Trade, the Current Account Balance, and the Balance of Payments." Remember, the balance of trade includes the flow of goods between countries—but it does not include services.

The current account balance includes:

- 1. the balance of trade.
- 2. the balance of services.
- 3. net investment income, and
- 4. net transfers.

The balance of payments is the sum of the current account and the financial account balances and must always equal zero. When the phrase "balance of payments surplus" or "balance of payments deficit" is used, it usually is a mistaken reference to the balance of trade, or the phrase is addressing the balance of payments without including changes in currency holdings, or official reserve transactions in the financial account.

Net exports are the sum of the balance of trade and the balance of services. The balance of trade is the difference between goods exported and imports, meaning that the balance of trade ignores the balance of services.

18.2

The Foreign Exchange Market and Exchange Rates (pages 607–614)

Learning Objective: Explain how exchange rates are determined and how changes in exchange rates affect the prices of imports and exports.

The exchange rate is the price of one currency in terms of another currency. For example, the **nominal** exchange rate between the dollar and the yen ($\frac{1}{4}$) can be expressed as $\frac{100}{4}$ = \$1. (This exchange rate means that the price of 1 U.S. dollar in the market for foreign exchange is 100 yen.) Instead of stating the exchange rate as the number of yen per dollar, we could state it as number of dollars per yen: $\frac{1}{4}$ = \$0.01 (which we can calculate as \$1/\frac{1}{4}100). The exchange rate is determined by the demand for and supply of dollars in the foreign exchange market. In a graph with the exchange rate plotted on the vertical axis, the demand curve for dollars is downward sloping. The demand for dollars comes from three sources:

- Consumers and firms in other countries that would like to buy goods and services made in the United States.
- Consumers and firms in other countries that would like to buy U.S. assets, such as buildings, bonds, and stocks.
- Currency traders that believe the value of the dollar will increase over time.

The supply of dollars in exchange for yen is upward sloping. When the value of the dollar is high, the demand for Japanese goods is high, and U.S. households and firms supply a larger quantity of dollars in exchange for the yen necessary to buy these Japanese goods. When the value of the dollar is low, Japanese goods are expensive, so U.S. households and firms want to buy a smaller quantity of Japanese goods and consequently need a smaller quantity of yen. This results in an upward-sloping supply curve for dollars in international exchange markets. Figure 18.2 in the textbook shows the demand for and supply of U.S. dollars in exchange for Japanese yen.

M Study Hint

The supply of dollars is the result of U.S. households and firms buying Japanese goods, services, and assets. To obtain the yen necessary to buy Japanese goods, services, and assets, U.S. residents supply dollars. Read *Making the Connection* feature "Exchange Rate Listings" for sources of current exchange rate data available online or in newspapers.

In Figure 18.2, as the exchange rate increases (from $\frac{100}{100} = 1$, to $\frac{120}{100} = 1$, to $\frac{150}{100} = 1$), U.S. goods, services, and financial assets are more expensive to households and firms in Japan. As U.S. goods become

more expensive, Japanese households and firms will buy fewer U.S. goods and need fewer dollars. This explains why the demand curve for dollars is downward sloping. As the exchange rate increases, Japanese goods, services, and assets become cheaper to households and firms in the United States. As Japanese goods get cheaper, U.S. consumers and firms will want to buy more Japanese goods. To buy more, they will need more yen, and to get those yen they will supply more dollars. This explains why the supply curve for dollars is upward sloping.

Equilibrium occurs where the quantity of dollars supplied equals the quantity of dollars demanded in the foreign exchange market. In the graph, equilibrium occurs at an exchange rate of $\frac{120}{120} = 1$. A currency appreciates when it rises in value compared to other currencies, and a currency depreciates when its value falls compared to other currencies.

The equilibrium exchange rate changes due to changes in the demand for and supply of dollars. The three main factors that cause the demand and supply curves in the foreign exchange market to shift are:

- Changes in the demand for U.S. produced goods and services and changes in the demand for foreign produced goods and services;
- Changes in foreigners' desire to buy assets in the United States and changes in U.S. residents' desire to buy assets in foreign countries;
- Changes in currency traders' expectations about the future value of the dollar and the future value of other currencies.

The demand curve for dollars will shift to the right when households and firms in Japan want to buy more U.S. goods and services or more U.S. assets. This will happen as incomes rise in Japan, or U.S. interest rates rise. The demand curve for dollars will also shift to the right when speculators decide that the value of the dollar will rise relative to the yen. The supply of dollars will shift to the right when U.S. consumers and firms want to buy more Japanese goods and services or more Japanese assets. This will happen as U.S. incomes rise, or interest rates rise in Japan, or **speculators** believe the yen will rise in value relative to the dollar.

The change in the exchange rate over time depends on changes in the supply of and demand for a currency. Figure 18.3 in the textbook shows the exchange rate increasing when the demand curve shifts out more than the supply curve.

While this model works well for major currencies, such as the dollar, euro, pound, and yen, not all exchange rates are determined by demand and supply. For example, the Chinese yuan-dollar exchange rate is set by the Chinese government.

Exchange rate changes will affect the quantities of exports and imports. As a country's currency appreciates, other countries' goods and services become cheaper, and its goods and services become more expensive when sold in other countries. Consequently, as a country's currency appreciates, its exports should fall, and its imports should rise, causing net exports to decline. Similarly, as a country's currency depreciates, its net exports should increase.

The **real exchange rate** measures the price of domestic goods in terms of foreign goods. The relative prices between two countries' goods and services are based on two variables, the relative price levels and the nominal exchange rate. The real exchange rate is calculated as:

Real exchange rate
$$=$$
 Nominal exchange rate \times $\frac{\text{Domestic price level}}{\text{Foreign price level}}$.

Changes in nominal exchange rates or changes in relative prices cause the real exchange rate to change. Real exchange rates are reported as index numbers, with one year chosen as the base year. The main value of real exchange rates is to track changes over time.

Extra Solved Problem 18.2

Using Exchange Rates

Supports Learning Objective 18.2: Explain how exchange rates are determined and how changes in exchange rates affect the prices of imports and exports.

Suppose that the exchange rate between the euro and the dollar is now \$1.37 = €1. How much will a \$20.00 bottle of California wine cost in the euro area (ignoring transportation costs)? How much will a €30 bottle of French wine cost in the United States (ignoring transportation costs)?

Solving the Problem

Step 1: Review the chapter material.

This problem is about understanding exchange rates, so you may want to review the section "The Foreign Exchange Market and Exchange Rates," which on page 607 of the textbook.

Step 2: Calculate the price of the bottle of California wine in the euro area using the current exchange rate.

At the current exchange rate of \$1.37 = \$1, we can calculate the price using the formula:

Price in the United States = Exchange rate ($\$/\mbox{\ensuremath{\ensuremath{\&lhe}E}}$) × Price in the euro area.

 $$20.00 = $1.37/\text{€} \times \text{Price in the euro area.}$

Price in the euro area = 20.00/1.37/ = 14.60.

Step 3: Calculate the price of the bottle of French wine in the United States using the current exchange rate.

At the current exchange rate of 1.37 = 1, we can calculate the price using the formula:

Price in the United States = Exchange rate ($\$/\epsilon$) × Price in the euro area.

Price in the United States = $\$1.37/€ \times €30 = \41.10 .

Study Hint

18.3

The *Making the Connection* feature in the section explains the factors that led to changes in the value of the dollar against the yen since 1990 and how such changes have affected Japanese firms that have relied heavily on sales in the United States, such as Bridgestone, Toyota and Sony. Also read the *Don't Let This Happen to You* feature "Don't Confuse What Happens When a Currency Appreciates with What Happens When It Depreciates." Exchange rates can be expressed in two ways: dollars per yen and yen per dollar. If the yen per dollar number increases (from \$100/dollar to \$120/dollar), we say that the dollar has appreciated and the yen has depreciated. Dollars are more expensive when purchased in exchange for yen. If the dollar per yen number increases (from \$0.01/yen to \$0.105/yen), then the dollar has depreciated and the yen has appreciated. In this case, yen are more expensive when purchased in exchange for dollars.

The International Sector and National Saving and Investment (pages 614–617)

Learning Objective: Explain the saving and investment equation.

When a household spends more than it earns, it must sell assets—such as stocks or bonds—or borrow. The same is true for a country. When a country has an excess of imports over exports, it must sell assets or borrow. In balance of payment terms, a country's current account deficit must be offset by a financial account surplus (or net foreign investment). In equation form, this is:

Current Account Balance + Financial Account Balance = 0

or

Current Account Balance = - Financial Account Balance

or

Net Exports = Net Foreign Investment.

Study Hint

The relationship between net exports and net foreign investment given in this equation tells us that countries such as the United States that import more than they export must borrow more from abroad than they lend abroad. If net exports are negative—as they usually are for the United States—then net foreign investment will also be negative.

In Chapter 10, we saw the following

National Saving = Private saving + Public saving, or

$$S = S_{\text{private}} + S_{\text{public}}$$

And by definition:

 $S_{\text{private}} = \text{National Income} - \text{Consumption} - \text{Taxes, or}$

$$S_{\text{private}} = Y - C - T.$$

And

 $S_{\text{public}} = \text{Taxes} - \text{Government Spending, or}$

$$S_{\text{public}} = T - G$$
.

And since Y = C + I + G + NX, then

$$S = I + NX$$
.

Because net exports equal net foreign investment, we can now state the saving and investment equation:

National Saving = Domestic Investment + Net Foreign Investment

or

$$S = I + NFI$$

or

$$S - I = NFI$$
.

For the United States, where *NX* is typically negative and *NFI* is typically positive, the amount of domestic investment is greater than the level of national saving. The level of investment over and above the level of national saving is financed by borrowing from abroad (which means *NFI* is negative).

In countries like Japan, where saving is typically greater than domestic investment, net foreign investment is positive and has taken the form, to give one example, of building automobile factories in the United States.

The Effect of a Government Budget Deficit on Investment (pages 617–619)

Learning Objective: Explain the effect of a government budget deficit on investment in an open economy.

The saving and investment equation also helps us understand the role of government budget deficits. When the government runs a budget deficit ($T \le G$, or $S_{\text{public}} \le 0$), national saving will decline unless private saving increases by the amount of the budget deficit, which is unlikely. This decrease in national saving will lead to a decrease in domestic investment or net foreign investment. The bonds the U.S. Treasury sells to finance the deficit may increase interest rates, which will discourage domestic investment. In addition, the higher interest rates will also increase the demand for U.S. financial assets, which will increase the demand for dollars foreigners need to buy these assets. This will increase the exchange rate, which will lead to lower exports from the United States and higher imports to the United States. Net exports, and therefore net foreign investment, will fall. When a budget deficit leads to a decline in net exports, the result is sometimes referred to as the twin deficits. The experience of the United States and other countries shows, however, that a budget deficit is not always accompanied by a current account deficit as indicated by the twin deficits idea.

Extra Solved Problem 18.4

U.S. Budget Deficits and Investment

Supports Learning Objective 18.4: Explain the effect of a government budget deficit on investment in an open economy.

Figure 18.4 on page 618 in the textbook shows that the United States had large federal budget deficits and large current account deficits in the early 1980s, but not in the 1990s. Former Federal Reserve chairman Ben Bernanke offered an explanation for these changes in the federal budget and current account.

"... over the past decade a combination of diverse forces has created a significant increase in the global supply of saving ... which helps to explain both the increase in the U.S. current account deficit and the relatively low level of long-term interest rates in the world today. ... All investment in new capital goods must be financed in some manner. In a closed economy . . . the funding for investment would be provided entirely by the country's national saving ... but ... virtually all economies today are open economies, and well-developed international capital markets allow savers to lend to those who wish to make capital investments in any country. . . . In the United States, national saving . . . falls considerably short of U.S. capital investment . . . this shortfall is made up by net foreign borrowing . . . [one reason for] the emergence of a global saving glut ... is the strong saving motive of rich countries with aging populations. ... With slowly growing ... workforces, as well as high capital-labor ratios, many advanced economies outside the United States also face an apparent dearth of domestic opportunities . . . a possibly more important source of the rise in the global supply of saving is the recent metamorphosis of the developing world from a net user to a net supplier of funds to international capital markets."

Global Account Balances (billions of U.S. dollars)

Countries	1996	2000	2004
Industrial	\$41.5	-\$331.5	-\$400.3
United States	-120.2	-413.4	-665.9
Japan	65.7	119.6	171.8
Euro Area	78.5	-71.7	53.0
Developing	−90.4	131.2	326.4

"The increase in the U.S. current account deficit from 1996 to 2004 was matched by a shift toward surplus of equal magnitude in other countries. Most of this swing did not occur in industrial countries as a whole, but in developing countries. A key reason for this was a series of financial crises those countries experienced in the past decade. These crises caused rapid capital outflows, currency depreciation, declines in asset prices, weakened banking systems and recession. Some of these countries built up their foreign-exchange reserves as a buffer against potential future capital outflows. These countries issued debt to their citizens and used the proceeds to buy U.S. securities and other assets. . . . The development . . . of new technologies and rising productivity . . . with the country's long-standing advantages such as lower political risk . . . made the U.S. economy exceptionally attractive to international investors . . . capital flowed rapidly into the United States, helping to fuel large appreciations in stock prices and the value of the dollar. . . . Thus the rapid increase in the U.S. current account deficit between 1996 and 2000 was fueled to a significant extent both by increased global saving and the greater interest on the part of foreigners in investing in the United States."

Source: Ben S. Bernanke. "The Global Savings Glut and the U.S. Current Account Deficit." The Federal Reserve Board. April 14, 2005. http://www.federalreserve.gov/boarddocs/speeches/2005/20050414/default.htm

Bernanke argues that the pattern of international capital flows he describes—the developing world lending large amounts of saving to developed countries—has some benefits but could prove counterproductive if it persists. Briefly explain why it might be better for the United States and developing countries if the pattern of capital flows Bernanke describes is eventually reversed.

Solving the Problem

Step 1: Review the chapter material.

This problem is about the impact of a government budget deficit, so you may want to review the section "The Effect of a Government Budget Deficit on Investment," which begins on page 617 in the textbook.

Step 2: Explain whether it would be better for the United States and developing countries if the pattern of capital flows Bernanke describes is eventually reversed.

In the United States and other developed countries, workers have large quantities of capital to work with. Population is growing slowly and workforces are aging. These countries have very good reasons to save to support their future retirees. In contrast, developing countries have younger and more rapidly growing populations and offer relatively high returns to capital. Therefore, in the long run it would probably be better for developed countries to run current account surpluses and lend some of their savings to the developing world.

18.5

Monetary Policy and Fiscal Policy in an Open Economy (pages 620–621) Learning Objective: Compare the effectiveness of monetary and fiscal policy in an open

economy and in a closed economy.

In a closed economy, an expansionary monetary policy lowers interest rates, which will increase aggregate demand by increasing demand for investment goods and consumer durables. In an open economy, the lower interest rates from the expansionary monetary policy will also affect the exchange rate. Lower U.S. interest rates will increase the demand by U.S. and foreign investors for foreign assets. This will lower the demand for the dollar relative to other currencies and cause the value of the dollar to fall, which will result in an increase in U.S. net exports. We can conclude that monetary policy has a greater impact on aggregate demand in an open economy than in a closed economy.

An expansionary fiscal policy will result in higher interest rates. In an open economy, these higher interest rates will lead to an increase in the foreign exchange value of the dollar, which will reduce net exports. So, in an open economy an expansionary fiscal policy may crowd out both investment spending and net exports. We can conclude that fiscal policy has a smaller impact on aggregate demand in an open economy than in a closed economy.

Extra Solved Problem 18.5

Monetary and Fiscal Policy in a Recession

Supports Learning Objective 18.5: Discuss the difference between the effectiveness of monetary and fiscal policy in an open economy and a closed economy.

Assume that the United States, an open economy, has slipped into a recession. Policymakers consider two different strategies for increasing aggregate demand. First, the Federal Reserve can use open market operations to lower the federal funds rate by one percentage point. Second, Congress and the president can pass legislation to cut income taxes.

- a. If the United States were a closed economy, would the Federal Reserve have to lower the federal funds rate by more or less than one percentage point to have the same impact on aggregate demand as in an open economy? Briefly explain your answer.
- b. In an open economy, as national income or GDP increases, so will spending on imports. Let's define the marginal propensity to import (*MPI*) as the increase in imports divided by the increase in GDP. Assume two different values for the MPI for the United States: *MPI* = 0.10 and *MPI* = 0.20. For which value of the *MPI* would an income tax cut have a greater impact on aggregate demand? Explain your answer.

Solving the Problem

Step 1: Review the chapter material.

This problem concerns the impact of fiscal policy and monetary policy, so you may want to review the section "Monetary Policy and Fiscal Policy in an Open Economy," which begins on page 620 of the textbook.

Step 2: Answer question (a) by explaining whether an expansionary monetary policy has a greater impact in a closed economy or in an open economy.

Because the United States has an open economy, open market operations that reduce the federal funds rate will cause some investors to switch from investing in U.S. financial assets to investing in foreign assets that have higher yields. As investors sell dollars to buy foreign currencies, the value of the dollar will fall relative to other currencies. The depreciation of the dollar will eventually cause U.S. exports to rise. If the United States was a closed economy, lowering the federal funds rate would have no effect on the exchange rate or exports. Therefore, the Federal Reserve would have to lower the federal funds rate by more than one percentage point to have the same impact on aggregate demand.

Step 3: Answer question (b) by explaining for which value of the MPI an income tax cut would have the greater impact on aggregate demand.

The multiplier effect of a given change in taxes or government spending would be greater in a closed economy than in an open economy. The *MPI* in a closed economy would equal zero because there would no increase in imports as GDP increases. In an open economy, the larger the value of the *MPI*, the larger the increase in imports as GDP increases and, therefore, the larger the decline in net exports and aggregate demand. We can conclude that a given size tax cut will have a larger impact on aggregate demand when the *MPI* equals 0.10 than when the *MPI* equals 0.20 because, with the smaller *MPI*, there will be a smaller decrease in net exports.

Key Terms

Balance of payments The record of a country's trade with other countries in goods, services, and assets.

Balance of trade The difference between the value of the goods a country exports and the value of the goods a country imports.

Capital account The part of the balance of payments that records relatively minor transactions, such as migrants' transfers and sales and purchases of nonproduced, nonfinancial assets.

Closed economy An economy that has no interactions in trade or finance with other countries.

Currency appreciation An increase in the market value of one currency relative to another currency.

Currency depreciation A decrease in the market value of one currency relative to another currency.

Current account The part of the balance of payments that records a country's net exports, net income on investments, and net transfers.

Financial account The part of the balance of payments that records purchases of assets a country has made abroad and foreign purchases of assets in the country.

Net foreign investment The difference between capital outflows from a country and capital inflows, also equal to net foreign direct investment plus net foreign portfolio investment.

Nominal exchange rate The value of one country's currency in terms of another country's currency.

Open economy An economy that has interactions in trade or finance with other countries.

Real exchange rate The price of domestic goods in terms of foreign goods.

Saving and investment equation An equation that shows that national saving is equal to domestic investment plus net foreign investment.

Speculators Currency traders who buy and sell foreign exchange in an attempt to profit from changes in exchange rates.

Self-Test

(Answers are provided at the end of the Self-Test.)

Multiple-Choice Questions

- 1. Nearly all economies in the world are
 - a. open economies.
 - b. closed economies.
 - c. able to trade in goods, but not services.
 - d. open to trade, but closed to investment and financial interactions with other economies.

- 2. The balance of payments is
 - a. a record of the assets and liabilities of one country relative to the assets and liabilities of other countries.
 - b. a record of a country's trade with other countries in goods, services, and assets.
 - c. a record of the payments made to other countries when a country engages in trade.
 - d. the difference between a country's exports and its imports.
- 3. The part of the balance of payments that records a country's exports and imports of goods and services is
 - a. the financial account.
 - b. the capital account.
 - c. the current account.
 - d. the international account.
- 4. In the balance of payments, the current account records
 - a. imports and exports of goods and services.
 - b. income received and income paid for investments between U.S. residents and foreigners.
 - c. the difference between transfers made to residents of other countries and transfers received by U.S. residents from other countries.
 - d. All of the above are true of the current account.
- 5. In the balance of payments, the difference between the value of the goods a country exports and the value of the goods a country imports is called
 - a. the current account balance.
 - b. the balance of trade.
 - c. the balance of net exports.
 - d. the net export position.
- 6. The balance of trade
 - a. is equal to net exports.
 - b. is equal to the difference between exports of goods and imports of goods.
 - c. is always zero.
 - d. can never be negative.
- 7. In 2012, the United States ran a _____ with all of its major trading partners and with every region of the world.
 - a. trade surplus
 - b. trade deficit
 - c. trade balance
 - d. payment balance
- 8. In the balance of payments, the net exports component of aggregate expenditures can be obtained by
 - a. subtracting the balance of trade from the balance of services.
 - b. adding together exports and imports.
 - c. subtracting exports from imports.
 - d. adding together the balance of trade and the balance of services.

- 9. From a balance of payments point of view, the net exports component of aggregate expenditures equals
 - a. the capital account balance.
 - b. net income on investments.
 - c. net transfers.
 - d. the balance of trade and services.
- 10. Purchases of assets a country has made abroad and foreign purchases of assets in the country are recorded in
 - a. the current account.
 - b. the financial account.
 - c. the capital account.
 - d. all of the above.
- 11. In the financial account,
 - a. there is a capital outflow from the United States when an investor in the United States buys a foreign bond.
 - b. there is a capital inflow into the United States when a U.S. firm builds a factory abroad.
 - c. foreign direct investment is always equal to the government budget deficit.
 - d. capital inflows and outflows are always equal.
- 12. When a foreign investor buys a bond issued by either a U.S. firm or the federal government, or when a foreign firm builds a factory in the United States, the transaction is recorded in the balance of payments as
 - a. only a capital inflow.
 - b. only a capital outflow.
 - c. both a capital outflow and a capital inflow.
 - d. neither a capital outflow nor a capital inflow.
- 13. Fill in the blanks. When firms build or buy facilities in foreign countries, they are engaging in foreign

 When investors buy stocks or bonds issued in foreign countries, they are engaging in foreign

 engaging in foreign
 - a. venture capital; venture investment
 - b. direct finance; indirect finance
 - c. direct investment; portfolio investment
 - d. capital investment; financial investment
- 14. Which of the following measures are closely associated with the concept of net foreign investment?
 - a. net capital flows
 - b. capital outflows and capital inflows
 - c. net foreign direct investment and net foreign portfolio investment
 - d. all of the above
- 15. Suppose the net capital flows of the China equaled –\$10 billion in one year, what do you know about the net foreign investment of the United States in that year?
 - a. -\$10 billion
 - b. \$10 billion
 - c. more than \$10 billion
 - d. None of the above. We cannot calculate net foreign investment from net capital flows.

- 16. Which of the following statements about the balance of payments is correct?
 - a. Foreign investment in the United States shows up as a positive entry in the U.S. financial account.
 - b. Additions to foreign holdings of dollars show up as positive entries in the U.S. financial account.
 - c. Ignoring the capital account, a current account deficit must be exactly offset by a financial account surplus, leaving the balance of payments equal to zero.
 - d. All of the above statements are correct.
- 17. Which of the following statements about the accounts in the balance of payment is correct?
 - a. A country that runs a current account surplus must also run a financial account surplus.
 - b. A country that runs a current account surplus must run a financial account deficit.
 - c. A country that runs a current account surplus may run a financial account surplus or deficit.
 - d. None of the above statements are correct.
- 18. If a country has a deficit in its balance of trade, it means that this country
 - a. imports more goods than it exports.
 - b. imports more services than it exports.
 - c. imports more goods and services together than it exports.
 - d. has a negative net exports.
- 19. Which of the following determines how many units of a foreign currency you can purchase with one dollar?
 - a. the real exchange rate
 - b. the nominal exchange rate
 - c. the inflation rate
 - d. the purchasing power parity of one dollar
- 20. Which of the following are sources of foreign demand for U.S. dollars?
 - a. foreign firms and consumers who want to buy goods and services produced in the United States
 - b. foreign firms and consumers who want to invest in the United States
 - c. currency traders who believe that the value of the dollar in the future will be greater than its value today
 - d. all of the above

21.	Fill in the blanks. When the exchange rate (measured as foreign currency per dollar) is above the
	equilibrium exchange rate, there is a of dollars and, consequently,
	pressure on the exchange rate.
	a. surplus; upward
	h aumlus dayayand

- b. surplus; downward
- c. shortage; upward
- d. shortage; downward

22.	Fill in the blanks. Currency	occurs when the	market value of a countr	y's currency rises
	relative to the value of another country's	currency, while	currency	occurs when the
	market value of a country's currency decli	nes relative to val	ue of another country's	currency.

- a. appreciation; depreciation
- b. depreciation; appreciation
- c. valuation; devaluation
- d. devaluation; valuation

- 23. Fill in the blanks. If the exchange rate changes from \(\frac{1}{2}\)100 = \(\frac{1}{2}\)1 to \(\frac{1}{2}\)85 = \(\frac{1}{2}\)1, the dollar has , and the yen has appreciated; depreciated b. depreciated; appreciated
 - c. revalued; devalued

 - d. devalued: revalued
- 24. Which of the following factors cause both the demand curve and the supply curve for dollars in the foreign exchange market to shift?
 - changes in the demand for U.S.-produced goods and services and changes in the demand for foreign produced goods and services
 - b. changes in the desire to invest in the United States and changes in the desire to invest in foreign countries
 - c. changes in the expectations of currency traders concerning the likely future value of the dollar and the likely future value of foreign currencies
 - d. all of the above
- 25. Currency traders who buy and sell foreign exchange in an attempt to profit from changes in exchange rates are
 - a. hedgers.
 - b. speculators.
 - c. arbitrageurs.
 - d. risk takers.
- 26. When will the demand curve for dollars shift to the right?
 - a. when incomes in Japan fall
 - b. when interest rates in the United States fall
 - c. when speculators decide that the value of the dollar will rise relative to the value of the yen
 - d. all of the above
- 27. An increase in interest rates in Japan will
 - a. leave the supply curve of dollars unchanged.
 - b. shift the supply curve of dollars to the right.
 - c. shift the supply curve of dollars to the left.
 - d. shift the demand curve for dollars to the right.
- 28. A recession in the United States will
 - a. leave the supply curve of dollars unchanged.
 - b. shift the supply curve of dollars to the right.
 - c. shift the supply curve of dollars to the left.
 - d. shift the demand curve for dollars to the right.
- 29. In the foreign exchange market for dollars, which of the following will cause the equilibrium exchange rate to rise?
 - a. a shift right in supply that is greater than an increase in demand
 - b. a decrease in demand that is greater than a shift right in supply
 - c. a shift left in supply that is greater than a decrease in demand
 - d. a decrease in demand accompanied by a shift right in supply

- 30. A depreciation in the domestic currency will
 - a. increase exports and decrease imports, thereby increasing net exports.
 - b. increase exports and imports, thereby increasing net exports.
 - c. decrease exports and increase imports, thereby decreasing net exports.
 - d. decrease exports and imports, thereby decreasing net exports.
- 31. Which two factors do economists combine to establish the real exchange rate between two countries?
 - a. the balance of payments and whether or not the currency of either country faces a shortage or surplus in the foreign exchange market
 - b. the money supply in each country and the fixed exchange rate between the two countries
 - c. the relative price levels and the nominal exchange rate between the two countries' currencies
 - d. net exports and whether there is currency appreciation or depreciation between the two countries
- 32. If the exchange rate between the U.S. dollar and the yen is 1 = 100, the price level in the United States is 110 and the price level in Japan is 100, what is the real exchange rate?
 - a. 90
 - b. 110
 - c. 0.9
 - d. 1.10
- 33. If the dollar price of a euro is \$1.35, then the euro price of a dollar is
 - a. €0.74.
 - b. €0.80.
 - c. €1.25.
 - d. €1.35.
- 34. In which of the following situations does a country experience a net capital inflow and a financial account surplus?
 - a. when the country sells more assets to foreigners than it buys from foreigners
 - b. when the country borrows more from foreigners than it lends to foreigners
 - c. when the country runs a current account deficit
 - d. all of the above
- 35. Which of the following statements is correct?
 - a. Net exports is roughly equal to the current account balance.
 - b. The financial account balance is roughly equal to net capital flows.
 - c. Net capital flows are roughly equal to net foreign investment but with the opposite sign.
 - d. All of the above are correct.
- 36. When imports are greater than exports, as is usually the case for the United States, which of the following must be true?
 - a. There will be a net capital inflow as people in the United States sell assets and borrow to pay for the surplus of imports over exports.
 - b. The United States must be a net borrower from abroad.
 - c. U.S. net foreign investment must be negative.
 - d. All of the above are true.

- 37. An increase in income in both the United States and the United Kingdom income will increase
 - a. both the demand and supply for pounds and cause the dollar to appreciate.
 - b. the demand for pounds and cause the dollar to appreciate.
 - c. the supply of pounds and cause the dollar to appreciate.
 - d. the supply and demand for pounds and have an uncertain effect on the exchange rate.
- 38. Which of the following is the saving-investment equation?
 - a. Private Saving = National Income Consumption Taxes
 - b. National Saving = Domestic Investment + Net Foreign Investment
 - c. Public Saving = Taxes Government Spending
 - d. Domestic Investment = Private Saving + Public Saving
- 39. The savings and investment equation shows that
 - a. the government budget's must always be balanced.
 - b. S = I at all times.
 - c. S = I + NFI.
 - d. net exports are always positive.
- 40. Given the definition of net foreign investment, a country such as the United States that has negative net foreign investment must be
 - a. investing less than it is saving domestically.
 - b. saving less than it is investing domestically.
 - c. experiencing positive net exports.
 - d. a net lender, not a borrower.
- 41. Budget deficits may reduce
 - a. domestic investment but not net foreign investment.
 - b. net foreign investment but not domestic investment.
 - c. both domestic investment and net foreign investment.
 - d. neither domestic investment nor net foreign investment.
- 42. A country experiences twin deficits when a government budget deficit causes a
 - a. capital account deficit.
 - b. service exports deficit.
 - c. current account deficit.
 - d. financial account deficit.
- 43. What impact does the additional policy channel available in an open economy have?
 - a. It increases the ability of an expansionary monetary policy to affect aggregate demand.
 - b. It decreases the ability of an expansionary monetary policy to affect aggregate demand.
 - c. It does not have any impact on the ability of an expansionary monetary policy to affect aggregate demand.
 - d. It has an indeterminate effect, sometimes increasing and sometimes decreasing the ability of an expansionary monetary policy to affect aggregate demand.

44.	Fill in th	e blanks.	In an	open	economy,	an	expansionary	fiscal	policy	may	be	 effective
	because t	he crowdi	ng out	effec	t could be		·					

- a. more; larger
- b. more; smaller
- c. less; larger
- d. less; smaller

486 CHAPTER 18 | Macroeconomics in an Open Economy 45. Fill in the blanks. In an open economy, a contractionary fiscal policy will have a _____ impact on aggregate demand and, therefore, will be ______ effective in slowing down an economy. a. larger; more b. larger; less c. smaller; more d. smaller; less **Short Answer Questions** 1. Explain why a current account deficit implies a financial account surplus. 2. Suppose that the exchange rate between the dollar and the British pound is £0.65 = \$1. In dollars. what will be the price of a £40 West End London theater ticket? How much will a \$75 Broadway play ticket cost in pounds? 3. Suppose that real GDP is rising in both the United States and Japan. Using a graph showing the demand for and supply of dollars in the foreign exchange market, predict what will happen to the exchange rate.

Why is the open econo	ability of monetary and fiscal policy to influence aggregate demand different in a my than in a closed economy?
-	
\	
and the De exchange r (ignoring to	the Appeal by John Grisham has a price of \$19.97 at a U.S. bookstore, and Harry and Hallows by J. K. Rowling has a price of £9.95 at a U.K. bookstore. If the late is $$1.62 = £1$, then what will be the price of Harry Potter in the United States ransportation charges), and what will be the price of The Appeal in the United Eignoring transportation costs)?

True/False Questions

- T F 1. If a country's imports of goods exceed its exports of goods, there will be a balance of trade deficit.
- T F 2. Net investment income measures the difference between income received by U.S. residents from investments abroad and income paid on investments in the United States to residents of other countries.
- T F 3. The purchase of a bond issued by a German corporation by a U.S. resident represents a capital outflow.
- T F 4. Net capital flows is the same as net foreign investment.
- T F 5. The balance of payments will have the same value as the balance of trade.
- T F 6. Suppose the dollar/euro exchange rate is \$1.30 = \$1.00. The price of a dollar, in terms of euros, is \$0.77 = \$1.00.

- T F 7. If the price of a euro decreases from \$1.40 to \$1.30, then the dollar has depreciated.
- T F 8. An increase in the U.S. interest rate will increase the demand for dollars in the foreign exchange market and shift the demand curve for dollars to the right.
- T F 9. An increase in the supply of dollars lowers the exchange rate and causes the value of the dollar to appreciate.
- T F 10. As the dollar appreciates, net exports will rise, increasing aggregate demand.
- T F 11. Public saving is always positive.
- T F 12. If domestic investment is larger than national saving, then net foreign investment must be positive.
- T F 13. An increase in the federal budget deficit always causes an increase in the current account deficit.
- T F 14. A contractionary monetary policy tends to cause the domestic currency to appreciate.
- T F 15. Fiscal policy will cause smaller changes in aggregate demand in an open economy than in a closed economy.

Answers to the Self-Test

Multiple-Choice Questions

Question	Answer	Comment
1.	a	Nearly all economies are open economies and have extensive interactions in trade or finance with other countries.
2.	b	The best way to understand the interactions between one economy and other economies is through the balance of payments. The balance of payments provides a record of a country's trade with other countries in goods, services, and assets.
3.	С	The current account records a country's exports and imports of goods and services. The current account represents current, or short-term, flows of funds into and out of a country.
4.	d	The current account for the United States includes imports and exports of goods and services, income received by U.S. residents from investments in other countries, income paid on investments in the United States owned by residents of other countries, and the difference between transfers made to residents of other countries and transfers received by U.S. residents from other countries.
5.	b	The difference between the value of the goods a country exports and the value of the goods a country imports is called the balance of trade.
6.	b	The balance of trade is defined as exports of goods minus imports of goods.
7.	b	As textbook Figure 18.1 shows, in 2012, the United States ran a trade deficit with all of its major trading partners and with every region of the world.
8.	d	Net exports are a component of aggregate expenditures. Net exports can be calculated by adding together the balance of trade and the balance of services. Subtracting exports from imports (Imports – Exports) give you the negative of net exports (–NX).
9.	d	Net exports are a component of aggregate expenditures. Net exports can be calculated by adding together the balance of trade and the balance of services.

Question	Answer	Comment
10.	b «	The financial account records purchases of assets a country has made abroad and foreign purchases of assets in the country. The financial account records long-term flows of funds into and out of a country.
11.	a	When a U.S. investor buys a foreign bond, dollars flow out of the United States to the other country. This is a capital outflow.
12.	a	When an investor in the United States buys a bond issued by a foreign company or government, or when a U.S. firm builds a factory in another country, there is a capital outflow from the United States. There is a capital inflow into the United States when a foreign investor buys a bond issued by a
		U.S. firm or by the federal government or when a foreign firm builds a factory in the United States.
13.	С	When firms build or buy facilities in foreign countries, they are engaging in foreign direct investment. When investors buy stocks or bonds issued in another country, they are engaging in foreign portfolio investment.
14.	d	A closely related concept to net capital flows is net foreign investment, which is equal to capital outflows minus capital inflows. Net foreign investment is the difference between capital outflows from a country and capital inflows, and also equal to net foreign direct investment plus net foreign portfolio investment. Net capital flows and net foreign investment are always equal, but have opposite signs: When net capital flows are positive, net foreign investment is negative, and when net capital flows are negative, net foreign investment is positive.
15.	b	Net capital flows and net foreign investment are always equal but have opposite signs: When net capital flows are positive, net foreign investment is negative.
16.	d	Changes in foreign holdings of dollars are known as official reserve transactions. Foreign investment in the United States or additions to foreign holdings of dollars both show up as positive entries in the U.S. financial account. Therefore, a current account deficit must be exactly offset by a financial account surplus, leaving the balance of payments equal to zero. Similarly, a country such as China or Japan, that runs a current account surplus, must run a financial account deficit of exactly the same size.
17.	b	It is impossible to run a current surplus and a financial account surplus simultaneously. A country that runs a current account surplus must run a financial account deficit, and vice versa.
18.	a	The balance of trade includes only trade in goods; it does not include services. Net exports are the sum of the balance of trade and the balance of services. A trade deficit means that a country's exports of goods are less than its imports of goods. Net exports will not be negative if the country runs a surplus in the balance of services that more than offsets the deficit in the balance of trade.
19.	b	The nominal exchange rate is how many units of a foreign currency you can purchase with one dollar and vice versa.

Question	Answer	Comment
20.	d	There are three sources of foreign currency demand for the U.S. dollar: (1) Foreign firms and consumers who want to buy goods and services produced in the United States; (2) foreign firms and consumers who want to invest in the United States either through foreign direct investment—buying or building factories or other facilities in the United States—or through foreign portfolio investment—buying stocks and bonds issued in the United States; and (3) currency speculators who believe that the value of the dollar in the future will be greater than its value today.
21.	b	As Figure 18.2 shows, at exchange rates above the equilibrium exchange rate, there will be a surplus of dollars and downward pressure on the exchange rate. The surplus and the downward pressure will not be eliminated until the exchange rate falls to equilibrium.
22.	a	Currency appreciation is defined as the market value of a country's currency rising relative to the value of another country's currency. Currency depreciation is defined as the market value of a country's currency declining relative to the value of another country's currency.
23.	b	When a currency appreciates, it increases in value relative to another currency. When it depreciates, it decreases in value relative to another currency. More precisely, currency A appreciates relative to currency B if, after a change in the exchange rate, one unit of currency A will buy more units of currency B. Currency X depreciates relative to currency Y if, after a change in the exchange rate, one unit of currency X will buy fewer units of currency Y. If the exchange rate changes from $\$100 = \1 to $\$80 = \1 , the dollar has depreciated, and the yen has appreciated because one dollar can now purchase fewer yen.
24.	d	The supply and demand curves for dollars in the foreign exchange market shift with changes in the demand for U.Sproduced goods and services and changes in the demand for foreign-produced goods and services, changes in the desire to invest in the United States and changes in the desire to invest in foreign countries, and changes in the expectations of currency traders concerning the likely future value of the dollar and the likely future value of foreign currencies.
25.	b	Speculators buy and sell foreign exchange in an attempt to profit from changes in exchange rates. If a speculator becomes convinced that the value of the dollar is going to rise in the future relative to the value of the yen, the speculator will sell yen and buy dollars now. A speculator is anyone who buys or sells a good today because they expect the price to change in the future.
26.	С	When incomes in Japan rise, when interest rates in the United States rise, or when speculators decide that the value of the dollar will rise relative to the value of the yen, the demand curve for dollars shifts to the right.
27.	b	An increase in interest rates in Japan will make financial instruments in Japan more attractive to U.S. savers. This will cause the supply of dollars to shift to the right, as U.S. savers use their dollars to purchase yen.

Question	Answer	Comment
28.	c	A recession in the United States will decrease the demand for Japanese products and cause the supply curve for dollars to shift to the left. Similarly, a decrease in interest rates in Japan will make financial instruments in Japan less attractive and cause the supply curve of dollars to shift to the left. And if traders become convinced that the future value of the yen will be lower relative to the dollar, the supply curve will also shift to the left.
29.	С	A decrease in the supply of dollars will increase the equilibrium exchange rate, holding other factors constant. A decrease in the demand for dollars will decrease the equilibrium exchange rate, holding other factors constant. In this case, the demand curve and the supply curve have both shifted, but because the
		supply curve has shifted to the left by more than the demand curve, the equilibrium exchange rate will increase.
30.	a	Depreciation in the domestic currency will make dollars cheaper to buy, thus making it easier for foreigners to buy dollars in order to buy our exports. The opposite effect is true for imports. Thus exports increase and imports decrease, thereby increasing net exports. An appreciation in the domestic currency should have the opposite effect: Exports should fall and imports should rise, which will reduce net exports, aggregate demand, and real GDP.
31.	c	An important factor in determining the level of a country's exports to and imports from another country is the relative prices of each country's goods. The relative prices of two countries' goods are determined by two factors: the relative price levels in the two countries and the nominal exchange rate between the two countries' currencies. Economists combine these two factors in the real exchange rate.
32.	b	The real exchange rate is computed as follows: real exchange rate = nominal exchange rate \times (domestic price level/foreign price level). In this case, $100 \times (110/100) = 100 \times 1.10 = 110$. This means that the prices of U.S. goods and services are 10 percent higher relative to the prices of Japanese goods and services.
33.	a	1/(\$1.35/€) = €0.74/\$.
34.	d	When a country sells more assets to foreigners than it buys from foreigners, or borrows more from foreigners than it lends to foreigners—as it must if it is running a current account deficit—the country experiences a net capital inflow and a financial account surplus.
35.	d	Net exports are roughly equal to the current account balance. Also, the financial account balance is roughly equal to net capital flows, which are in turn equal to net foreign investment but with the opposite sign.
36.	d	When imports are greater than exports, net exports are negative, and there will be a net capital inflow as people in the United States sell assets and borrow to pay for the surplus of imports over exports. Therefore, net capital flows will be equal to net exports (but with the opposite sign), and net foreign investment will also be equal to net exports (and with the same sign). Because net exports are usually negative for the United States, in most years, the United States must be a net borrower from abroad and U.S. net foreign investment will be negative.

Question	Answer	Comment
37.	d	The increase in income will increase purchases in the other country, increasing the demand for that country's currency. This will increase both the supply and demand for pounds. Because both curves are shifting to the right, and because we do not know the size of each shift, the impact on the exchange rate is uncertain.
38.	b	National Saving = Private Saving + Public Saving, and net exports equal net foreign investment. From these equalities we deduce the saving-investment equation, which can be written as: National Saving = Domestic Investment + Net Foreign Investment. The saving and investment equation tells us that a country's saving will be invested either domestically or overseas.
39.	c	By definition, $S = I + NFI$. This is true by definition.
40.	b	A country such as the United States, that has negative net foreign investment, must be saving less than it is investing domestically. To see this, rewrite the saving and investment equation by moving domestic investment to the left-hand side: $S - I = NFI$. If net foreign investment is negative—as it is for the United States nearly every year—domestic investment (I) must be greater than national saving (S).
41.	c	Higher interest rates will discourage some businesses from borrowing funds to build new factories or to buy new equipment or computers. Also, higher interest rates on financial assets in the United States will attract foreign investors. Investors in Great Britain, Canada, or Japan will have to buy U.S. dollars in order to purchase bonds in the United States. This greater demand for dollars will increase their value relative to foreign currencies. As the value of the dollar rises, exports from the United States will fall, and imports to the United States will rise. Net exports and, therefore, net foreign investment will fall.
42.	С	When a government budget deficit leads to a decline in net exports, the result is sometimes referred to as the twin deficits. The term twin deficits refers to the possibility that a government budget deficit will also lead to a current account deficit. The twin deficits first became widely discussed in the United States during the early 1980s when the federal government ran a large budget deficit that resulted in high interest rates, a high exchange value of the dollar, and a large current account deficit.
43.	a	In a closed economy, the main effect of lower interest rates is on domestic investment spending and purchases of consumer durables. In an open economy, lower interest rates will also affect the exchange rate between the dollar and other economies. Lower interest rates will cause some investors in the United States and abroad to switch from investing in U.S. financial assets to investing in foreign financial assets. This switch will lower the demand for
		the dollar relative to foreign currencies and cause its value to decline. A lower exchange rate will decrease the price of U.S. products in foreign markets and increase the price of foreign products in the United States. As a result, net exports will increase. This additional policy channel will increase the ability of an expansionary monetary policy to affect aggregate demand.

Question	Answer	Comment
44.	С	An expansionary fiscal policy may result in higher interest rates. In a closed economy, the main effect of higher interest rates is to reduce domestic investment spending and purchases of consumer durables. In an open economy, higher interest rates will also lead to an increase in the foreign exchange value of the dollar and a decrease in net exports. Therefore, in an open economy, an expansionary fiscal policy may be less effective because the crowding out effect may be larger. In a closed economy, only consumption and investment are crowded out by an expansionary fiscal policy. In an open economy, net exports may also be crowded out.
45.	d	A contractionary fiscal policy cuts government spending or raises taxes to reduce household disposable income and consumption spending. But a contractionary fiscal policy also reduces the federal budget deficit (or increases the budget surplus), which may lower interest rates. Lower interest rates will increase domestic investment and purchases of consumer durables, thereby offsetting some of the reduction in government spending and increases in taxes. In an open economy, lower interest rates will also reduce the foreign exchange value of the dollar and increase net exports. Therefore, in an open economy, a contractionary fiscal policy will have a smaller impact on aggregate demand and, therefore, will be less effective in slowing down an economy. In summary: Fiscal policy has a smaller impact on aggregate demand in an open economy than in a closed economy.

Short Answer Responses

- 1. When the current account is negative (net exports are negative), a country is selling fewer goods abroad than it is buying from abroad. This means that less of other currencies are coming into the country from the sale of goods and services than are leaving the country from the purchase of goods and services. These domestic currencies are used by foreign residents either to purchase domestic financial assets or physical assets or held as additional units of domestic currency. Both of those options are considered capital inflows and are positive entries in the balance of payments. The financial account balance should then be the same size as the current account balance but with the negative sign.
- 2. The exchange rate of £0.65/\$ is equivalent to \$1.54/£. The West End London theater ticket that costs £40 will cost \$61.60 (£40 \times \$1.54/£ = \$61.60). The Broadway theater ticket that costs \$75.00 will cost £48.75 (\$75.00 \times £0.65/\$ = £48.75).

3. An increase in U.S. real GDP will increase spending in the United States. Consumers and firms in the United States will buy more U.S. goods and also more Japanese goods. As U.S. consumers and firms buy more Japanese goods, they must buy more yen, which implies that they must supply more dollars in the foreign exchange market. Rising U.S. real GDP will increase the supply of dollars. This is shown in the graph below:

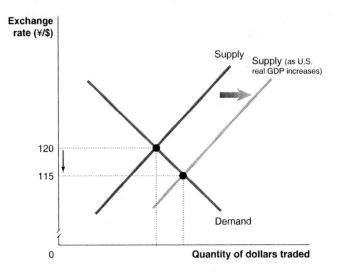

An increase in Japanese real GDP will increase spending in Japan. Consumers and firms in Japan will buy more Japanese goods and also more U.S. goods. As Japanese consumers and firms buy more U.S. goods, they must buy more dollars, which implies an increase in the demand for dollars in the foreign exchange market. Rising Japanese real GDP will increase the demand for dollars. This is shown in the graph below:

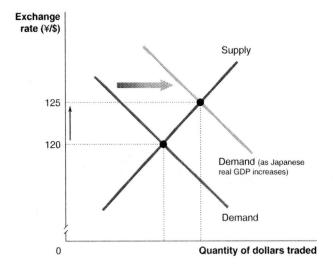

The increase in U.S. real GDP increases the supply of dollars. This lowers the $(\frac{4}{\$})$ exchange rate and causes the value of the dollar to depreciate. The increase in Japanese real GDP increases the demand for dollars. This increases the $(\frac{4}{\$})$ exchange rate and causes the value of the dollar to appreciate. If both of these events happen at the same time, then the impact on the exchange rate is uncertain. It is not possible to tell if the size of the increase in demand will be larger, smaller, or the same size as the size of the increase in supply.

4. According to the saving and investment equation,

$$S = S_{\text{private}} + S_{\text{public}} = I + NFI.$$

A budget deficit means that S_{public} is negative. A current account deficit (if we ignore the capital account) occurs when there is a financial account surplus, or when NFI is negative. If private savings equals investment ($S_{\text{private}} = I$), then public savings will have to equal NFI and a negative public savings will imply a negative NFI. In fact, as long as private savings is less than investment then NFI will have to be more negative than public savings, ensuring that a negative public savings implies a negative NFI.

- 5. Because monetary policy and fiscal policy affect the interest rate, these policies also affect the exchange rate in an open economy. Expansionary monetary policy tends to lower the interest rate; in an open economy, the lower U.S. interest rate makes foreign financial assets more attractive (and U.S. financial assets less attractive to investors outside the United States). This will result in an increase in the supply of dollars and a decrease in the demand for dollars in the foreign exchange market. This will cause the dollar to depreciate. The lower value of the dollar will increase exports and lower imports. This will increase net exports and provide additional increases in aggregate demand compared with the effects of monetary policy in a closed economy. The expansionary fiscal policy will lead to a higher interest rate. In an open economy, the higher interest rate will make U.S. financial assets more attractive to consumers and firms outside the United States (and make foreign assets less attractive to U.S. investors). This will increase the demand for dollars and reduce the supply of dollars in the foreign exchange market. This will cause the dollar to appreciate. The higher value of the dollar will cause exports to decrease and imports to increase. This will reduce net exports and reduce the level of aggregate demand (this is an added form of crowding out) compared with the effects of fiscal policy in a closed economy.
- 6. With the exchange rate of \$1.62 = £1, Harry Potter will have a price in the United States of \$16.12 (£9.95 × \$1.62/£ = \$16.12). The Appeal will have a price of £12.33 (\$19.97/\$1.62/£ = £12.33) in the United Kingdom.

True/False Answers

Question	Answer	Comment
1.	T	See page 602 in the textbook for the definition of a balance of trade deficit.
2.	T	See page 602 in the textbook for the definition of net investment income.
3.	T	The purchase of a bond of a corporation or government of another country by a U.S. resident represents a capital outflow.
4.	F	Net capital flows and net foreign investment (NFI) are equal but of opposite signs (if one is positive, the other is negative).
5.	F	The balance of payments is the sum of the current account balance (the sum of the balance of trade and balance of services), the financial account balance, and the capital account balance. The balance of trade can be positive, negative, or zero. The balance of payments will always be zero.
6.	T	The price of a dollar, in terms of the euro, will be
7.	F	If the price of a euro decreases from \$1.40 to \$1.30, then the euro has gotten less expensive to U.S. citizens, or the dollar has risen in value. So, the dollar has appreciated.

496 CHAPTER 18 Macroeconomics in an Open Economy

- 8. T Other things being equal, an increase in the U.S. interest rate causes some foreign investors to invest in U.S. financial assets instead of foreign financial assets. This will raise the demand for dollars in the foreign exchange market, thus shifting the demand curve for dollars to the right.
- 9. F An increase in the supply of dollars will lower the exchange rate and cause the value of the dollar to depreciate.
- 10. F As the dollar appreciates, net exports fall, which will cause a reduction in the level of aggregate demand.
- 11. F Public saving is equal to taxes minus government purchases. Public saving will be positive if there is a budget surplus, and negative if there is a budget deficit.
- 12. F Because S = I + NFI, if I > S, then NFI must be negative.
- 13. F An increase in the federal budget deficit will increase the current account deficit only if private saving and domestic investment do not change.
- 14. T If the Fed engages in a contractionary monetary policy, interest rates will increase. Higher interest rates will cause some foreign investors to invest in U.S. financial assets. This will raise the demand for the dollar relative to foreign currencies and thus the value of the dollar to rise.
- 15. T In a closed economy, only consumption and investment are crowded out by an expansionary fiscal policy. In an open economy, net exports may also be crowded out. This means that fiscal policy has a smaller impact on aggregate demand in an open economy than in a closed economy.

CHAPTER 19 | The International **Financial System**

Chapter Summary and Learning Objectives

19.1 Exchange Rate Systems (pages 630–631)

Understand how different exchange rate systems operate. When countries agree on how exchange rates should be determined, economists say that there is an exchange rate system. A floating currency is the outcome of a country allowing its currency's exchange rate to be determined by demand and supply. The current exchange rate system is a managed float exchange rate system, under which the value of most currencies is determined by demand and supply, with occasional government intervention. A fixed exchange rate system is a system under which countries agree to keep the exchange rates among their currencies fixed. Under the gold standard, the exchange rate between two currencies was automatically determined by the quantity of gold in each currency. By the end of the Great Depression of the 1930s, every country had abandoned the gold standard. Under the Bretton Woods system, which was in place between 1944 and the early 1970s, the United States agreed to exchange dollars for gold at a price of \$35 per ounce. The central banks of all other members of the system pledged to buy and sell their currencies at a fixed rate against the dollar.

19.2 The Current Exchange Rate System (pages 631–643)

Discuss the three key features of the current exchange rate system. The current exchange rate system has three key aspects: (1) The U.S. dollar floats against other major currencies; (2) most countries in Western Europe have adopted a common currency; and (3) some developing countries have fixed their currencies' exchange rates against the dollar or against another major currency. Since 1973, the value of the U.S. dollar has fluctuated widely against other major currencies. The theory of purchasing power parity states that in the long run, exchange rates move to equalize the purchasing power of different currencies. This theory helps to explain some of the long-run movements in the value of the U.S. dollar relative to other currencies. Purchasing power parity does not provide a complete explanation of movements in exchange rates for several reasons, including the existence of tariffs and quotas. A tariff is a tax imposed by a government on imports. A quota is a government-imposed limit on the quantity of a good that can be imported. Currently, 17 European Union member countries use a common currency, known as the euro. The experience of the countries using the euro will provide economists with information on the costs and benefits to countries of using the same currency. When a country keeps its currency's exchange rate fixed against another country's currency, it is pegging its currency. Pegging can result in problems similar to the problems countries encountered with fixed exchange rates under the Bretton Woods system. If investors become convinced that a country pegging its exchange rate will eventually allow the exchange rate to decline to a lower level, the demand curve for the currency will shift to the left. This illustrates the difficulty of maintaining a fixed exchange rate in the face of destabilizing speculation.

19.3 International Capital Markets (pages 643-645)

Discuss the growth of international capital markets. A key reason that exchange rates fluctuate is that investors seek out the best investments they can find anywhere in the world. Since 1980, the markets for stocks and bonds have become global. Foreign purchases of U.S. corporate bonds and stocks and U.S. government bonds have increased greatly in the period since 1995. As a result, firms around the world are no longer forced to rely only on the savings of domestic households for funds.

Appendix: The Gold Standard and the Bretton Woods System (pages 650-654)

Explain the gold standard and the Bretton Woods system. While the chapter covers the current exchange rate system, the appendix covers two earlier systems: the gold standard and the Bretton Woods system. Together, these systems lasted from the early nineteenth century through the early 1970s. Your instructor may assign this appendix.

Chapter Review

Chapter Opener: Volkswagen Deals with Fluctuating Exchange Rates (page 629)

Volkswagen is a German-based automobile company, which successfully entered the U.S. market in the 1960s. Like other German firms, Volkswagen benefited from the use of the euro, the common currency of 17 members of the European Union. Because of the euro, European firms do not have to deal with fluctuations in exchange rates within most of Europe. But Volkswagen and other German automobile companies still have to deal with fluctuations in the value of the euro against other currencies. In 2011, Volkswagen responded to the rising euro exchange rate relative to the dollar by opening an assembly plant in Tennessee.

19.1

Exchange Rate Systems (pages 630–631)

Learning Objective: Understand how different exchange rate systems operate.

An **exchange rate system** is the method that countries use to determine the exchange rates among their currencies. Some countries use a **floating currency system**, where the exchange rate is determined by the demand and supply of the currency in foreign exchange markets. Other countries, including the United States, occasionally intervene to buy and sell their currencies or other currencies to affect exchange rates. This is called a **managed float exchange rate system**. Until 1971, exchange rates were determined by a **fixed exchange rate system**, where the exchange rates remained constant for long periods of time. The gold standard was a fixed exchange rate system that lasted from the nineteenth century until the 1930s. The Bretton Woods system was also a fixed exchange rate system and lasted from 1944 to 1971.

Extra Solved Problem 19.1

A Tale of Two Currencies

Supports Learning Objective 19.1: Understand how different exchange rate systems operate.

From 1994 to July 2005, China maintained a fixed exchange rate between its currency—called the renminbi (which means "people's currency" in Chinese) or yuan—and the U.S. dollar. The exchange rate was 8.28 yuan per dollar. Pegging the yuan to the dollar reduced the risk of losses from changes in the exchange rate for anyone doing business in China. Assume that Apple, a firm with headquarters in the United States, establishes a manufacturing plant in Beijing. If Apple earns a profit of 1 million yuan in June 2005, this is equivalent to \$120,773. If the exchange rate had changed to 10 yuan per dollar, Apple's profit would only equal \$100,000. Unlike China, Canada has a floating exchange rate. A floating exchange rate increases the risk faced by those engaging in international trade and investment. A fixed exchange rate creates other problems when the exchange rate differs greatly from the fundamental value of the currency. One way to measure the fundamental value of a currency is by computing its purchasing power parity. In the long run, floating exchange rates should adjust to reflect equivalent purchasing power. (Other factors can keep purchasing power parity from completely explaining exchange rates. See the section "What Determines Exchange Rates in the Long Run?" beginning on page 632 of the

textbook). The World Bank compared the actual exchange rates of China and Canada to their purchasing power parity (PPP) conversion factors (the number of units of a country's currency required to buy the same amount of goods and services in the domestic market as a U.S. dollar would buy in the United States) for 2003.

	Actual	PPP
	Exchange Rate	Exchange Rate
China	8.28	1.8
Canada	1.4	1.2

Source: 2005 World Development Indicators. Table 5.7, Relative Prices and Exchange Rates. http://devdata.worldbank.org/wdi2005/Table5_7.htm

Critics of the Chinese exchange rate policy, including U.S. government officials, claimed that the yuan was undervalued. Assume that the purchasing power parity exchange rate accurately measures the relative purchasing power of the dollar and yuan in 2003.

- a. Explain how the undervalued yuan affected trade between the United States and China.
- b. Based on its purchasing power parity, was the Canadian dollar overvalued or undervalued relative to the U.S. dollar in 2003?
- c. On July 21, 2005 the Chinese government changed the exchange rate between the yuan and the dollar to a new fixed rate of 8.11 yuan to the dollar. Did this action cause the yuan to appreciate or depreciate relative to the U.S. dollar?

Solving the Problem

Step 1: Review the chapter material.

This problem concerns foreign exchange rates, so you may want to review the section "Exchange Rate Systems," which begins on page 630 of the textbook.

Step 2: Answer question (a) by explaining how the undervalued yuan affected trade between the United States and China.

If the purchasing power parity exchange rate is accurate, it implies that \$100 had the same purchasing power as 180 yuan in 2003. But if someone had exchanged dollars at the fixed exchange rate, she would have received 828 yuan (ignoring transactions costs). If similar goods could be purchased in both countries, it would be much cheaper to buy them in China—by first exchanging dollars for yuan—than it would be to buy them in the United States. The overvalued yuan resulted in greater U.S. imports from China and a lower level of U.S. exports to China than if the exchange rate equaled the purchasing power parity exchange rate.

Step 3: Answer question (b) by explaining whether, based on its purchasing power parity, the Canadian dollar was overvalued or undervalued relative to the U.S. dollar in 2003.

The actual exchange rate was 1.4. This means that 100 U.S. dollars would buy 140 Canadian dollars. Because the purchasing power parity exchange rate was 1.2, 100 U.S. dollars should have exchanged for only 120 Canadian dollars. So, the U.S. dollar was overvalued or the Canadian dollar was undervalued. But remember that the purchasing power parity is only an approximation of the fundamental value of the Canadian and U.S. dollars.

Step 4: Answer question (c) by explaining whether the yuan appreciated or depreciated relative to the U.S. dollar when on July 21, 2005 the Chinese government changed the fixed exchange rate to 8.11 yuan per dollar.

Because fewer yuan were required to buy one dollar, the dollar depreciated as the exchange rate fell. This meant that the yuan appreciated or increased in value relative to the dollar. Some U.S. government officials expressed their preference for an even larger appreciation.

M Study Hint

Read *Don't Let this Happen to You* "Remember That Modern Currencies Are Fiat Money." Even though the United States owns a large amount of gold, held in Fort Knox, Kentucky, and the basement of the Federal Reserve Bank of New York, this gold does not back U.S. currency. The U.S. dollar is an example of fiat money that does not have to be exchanged by the central bank for gold or some other commodity money. U.S. currency is money mainly because the government says it is money and people are willing to accept it in exchange for goods and services.

19.2

The Current Exchange Rate System (pages 631–643)

Learning Objective: Discuss the three key features of the current exchange rate system.

The current world exchange rate system has three important features:

- 1. The United States allows the dollar to float against other major currencies.
- 2. Most countries in Western Europe have adopted a single currency, the euro.
- 3. Some developing countries have tried to keep their currencies fixed against the dollar or other major currencies.

Over time, the value of the dollar fluctuates against other major currencies, increasing in value against some, and decreasing in value against others. In the short run, the two most important causes of exchange rate movements are interest rate changes and changes in investors' expectations about the future value of currencies.

In the long run, exchange rates move to the point where it is possible to buy the same amount of goods and services with an equivalent amount of currencies. This is the principle of **purchasing power parity**. If a good or service is cheaper in one country than in another country, consumers and firms will try to buy that good from the country with the lower price. That action will drive up the price of the cheaper country's currency, increasing the price of the good to the rest of the world. This will continue until there is no longer an advantage to buying the good in one country or another.

Study Hint

Purchasing power parity implies that the price of a good in Japan = exchange rate ($\frac{1}{2}$) × the price of the good in the United States. Put differently, the price of a good in the United States = ($\frac{1}{2}$) × the price of the good in Japan, where ($\frac{1}{2}$) = exchange rate ($\frac{1}{2}$). *Making the Connection* "The Big Mac Theory of Exchange Rates" uses the prices of Big Macs in a number of countries to compare the purchasing power parity exchange rates to the actual exchange rates. *Solved Problem* 19.2 further explains how to calculate the exchange rates implied by purchasing power parity and how to determine whether the actual exchange rates are overvalued or undervalued according to the purchasing power parity theory.

Several complications may keep purchasing power parity from exactly holding, even in the long run.

- Not all goods are traded internationally. If the services of a plumber are more expensive in the United States than in the United Kingdom, after adjusting for exchange rates, homeowners will not go to the United Kingdom to hire a plumber to fix a clogged drain.
- Consumer preferences for products are different across countries.
- Countries impose barriers to trade. Tariffs and quotas limit the price adjustments of some goods.
- Shipping, storage, and insurance costs will also affect the foreign price of domestic goods. Consider goods that must be handled carefully (wine) or that must be kept cold (frozen orange juice).

There are four main determinants of exchange rates in the long run.

- Relative price levels. Purchasing power parity is the most powerful long-run determinant of exchange
- Relative rates of productivity growth. If Japanese productivity grows faster than U.S. productivity, then Japan should have relatively lower prices, causing the value of the yen to rise relative to the
- Preference for domestic and foreign goods. If consumers and firms in Japan prefer U.S. products to Japanese products, the demand for U.S. products will increase, which will increase the value of the U.S. dollar.
- Tariffs and quotas. A tariff or quota forces domestic manufacturers to buy more expensive domestic goods. Tariffs and quotas lead toward higher exchange rates.

A second aspect of the current exchange rate system is the introduction of a common currency, the euro, in most Western European countries. See Figure 19.2 on page 636 of the textbook for a map showing the countries that have adopted the euro. The European Central Bank (ECB) controls the quantity of euros. The ECB operates very similarly to the Federal Reserve System. A common currency can make it easier for consumers and firms to buy and sell goods across country borders. The increased ease of cross-border trade can aid in growth of the countries using the common currency. Potential drawbacks of using a common currency are that:

- 1. The participating countries can no longer undertake independent monetary policies.
- 2. An individual country's currency cannot change in value during a recession to stimulate aggregate demand.

Study Hint

The euro zone is made up of countries that have adopted the euro as their official currency. Read Making the Connection "Can the Euro Survive?" to have a better understanding of the problems of the euro zone that were made worse by a sovereign debt crisis beginning 2010. Sovereign debt refers to bonds issued by a government. By the spring of 2010, many investors had come to doubt the ability of Greece to make payments on its government bonds. If Greece defaulted and stopped making interest payments on its bonds, investors would be likely to stop buying bonds issued by several other European governments, and the continuation of the euro would be called into question. The ultimate fate of the euro will help to answer the question of whether independent countries with diverse economies can successfully maintain a single currency.

A third important feature of the current exchange rate system is that some countries have attempted to keep their exchange rates fixed against the dollar or other major currencies. When a country keeps its exchange rate fixed compared to another country's currency, its currency is **pegged** to the other currency. With the exchange rate between countries fixed, business planning is much easier.

Because there is no guarantee that the market exchange rate will be the same as the pegged exchange rate, the government must be willing to buy its currency with dollars or buy dollars with its currency to maintain the exchange rate at the pegged rate. If a currency is pegged at a value above the market exchange rate, the currency is said to be overvalued. If the currency is pegged at a value below the exchange rate, the currency is said to be undervalued. The recent trend is for pegged exchange rate systems to be replaced with managed floating exchange rate systems. The textbook uses the case of Thai baht in the late 1990s to illustrate the problems that countries may encounter when they attempt to peg the value of their currencies. In textbook Figure 19.3, Thailand must buy their currency (the baht) to maintain the pegged exchange rate at \$0.04.

Pegging made it easier for Thai firms to export products to the United States and protected Thai firms that had taken out dollar loans. The Thai government ran into problems in 1997 when they had used up their dollar reserves buying their currency on the exchange market. The Thai government increased domestic interest rates in hopes of attracting dollars to increase the government's dollar reserves. The Thai government was afraid of the negative consequences of abandoning the peg even though it had led to the baht being overvalued.

The higher interest rates made it difficult for Thai firms and households to borrow, and domestic consumption and investment fell, pushing the economy into a recession. The high interest rates caused speculators to sell the baht in exchange for dollars in anticipation of a future lower exchange rate due to the Thai government's problems with maintaining the pegged rate. This destabilizing speculation is shown in Figure 19.4.

Foreign investors also began to sell off their investments and exchange baht for dollars. This capital flight forced the Bank of Thailand to run through its dollar reserves. In 1997 when the Thai government abandoned the peg and let the currency float, Thai firms that had to make loan payments in dollars discovered that the value of these payments in baht had increased. Many firms declared bankruptcy, which pushed the Thai economy deeper into recession. The fear that they might experience the same problems as Thailand caused other countries also to abandon their pegged currencies. As a result of these events, the number of pegged exchange rates has fallen dramatically. Most countries that have pegged exchange rates are small and trade only with one big country. Several Caribbean countries peg their currency to the dollar, and several African countries, because of their French background, peg their currency to the euro.

The Chinese yuan was pegged against the dollar in 1994 at 8.28 yuan to the dollar. The pegging against the dollar ensured Chinese exporters a stable dollar price for what they sell in the United States. For the Chinese government to maintain this pegged rate, it had to buy dollars with yuan. By 2005, the Chinese government had accumulated about \$700 billion in U.S. dollars which were used to purchase U.S. Treasury Bonds. The Chinese government began to allow the yuan to float in 2005. By late 2008, China had apparently returned to a "hard peg" of its currency. In 2010, the central bank of China announced that it would return to allowing the value of the yuan to rise against the dollar, which it did slowly through late 2013.

Study Hint

Read the *Making the Connection* feature "Why Did Iceland Recover So Quickly from the Financial Crisis?" to learn about how Iceland's recovery from the recent financial crisis was benefited from the falling value of its currency, the krona, thereby spurring the country's exports.

Extra Solved Problem 19.2

Purchasing Power Parity Exchange Rates

Supports Learning Objective 19.2: Discuss the three key features of the current exchange rate system.

At a leading U.S. Internet bookstore, *Harry Potter and the Deathly Hallows* by J.K. Rowling sells for \$14.99. The same book sells for £11.99 at a leading U.K. Internet bookstore. What is the implied purchasing power parity exchange rate? If the current exchange rate is £0.64 = \$1, is the dollar overvalued or undervalued?

Solving the Problem

19.3

Step 1: Review the chapter material.

This problem requires an understanding of exchange rates, so you may want to review the section "The Current Exchange Rate System," which begins on page 631 of the textbook.

Step 2: Calculate the purchasing power parity exchange rate.

The purchasing power parity exchange rate is the exchange rate such that the good sells for an equivalent price in each country. We can calculate it from the equation:

Price in the United States = Exchange Rate $(\$/\pounds) \times$ price in the United Kingdom.

Using the U.S. price of \$14.99 and the U.K. price of £11.99, the purchasing power parity exchange rate is calculated as:

Exchange rate $(\pounds/\$)$ = Price in the United Kingdom/Price in the United States

= £11.99/\$14.99 = £0.80/\$.

This implies that if the exchange rate were £0.80 = \$1, then the Harry Potter book would sell for an equivalent price in both countries.

Step 3: Determine if the dollar is overvalued or undervalued at the current exchange rate of £0.64 = \$1.

The dollar is overvalued if the actual exchange rate (£/\$) is greater than the implied purchasing power parity exchange rate. The dollar is undervalued if the actual exchange rate is less than the implied purchasing power parity exchange rate. Since the actual exchange rate of £0.64 = \$1 is less than the implied exchange rate of £0.80 = \$1, we would say the dollar is currently undervalued.

International Capital Markets (pages 643–645)

Learning Objective: Discuss the growth of international capital markets.

One important reason for exchange rate fluctuations is savers seeking the highest rate of return they can find anywhere in the world. To purchase foreign financial assets, savers must first purchase foreign currency, and when they sell foreign assets, they must purchase their home currency with the foreign currency in which the asset is denominated. Shares of stocks and long-term debt, both corporate and government, are bought and sold in capital markets. The largest capital markets are in the United States, Europe, and Japan. The three most important financial centers are in New York, London, and Tokyo. The use of world capital markets has helped increase growth in the world economy. Firms are no longer limited to domestic savings to help finance investment spending, and household savings can be used to purchase assets anywhere in the world.

In the 1990s, the flow of foreign funds into U.S. stocks and bonds—which is called portfolio investment—increased substantially. Investors in the United Kingdom accounted for more than 40 percent of all foreign purchases of U.S. stocks and bonds. Investors in China accounted for 10 percent, and investors in Japan accounted for 5 percent. Globalization of financial markets has helped increase growth and efficiency in the world economy. It is now possible for savings from around the world to move to the highest possible return anywhere.

Extra Solved Problem 19.3

Buying a Foreign Bond

Supports Learning Objective 19.3: Discuss the growth of international capital markets.

The globalization of capital markets means that for individuals and firms the opportunities for purchasing foreign financial assets have significantly increased. Not only can someone save by buying domestic government bonds or stocks, but he or she can save by buying bonds and stocks issued by foreign corporations or foreign governments.

In May 2010, the exchange rate between the dollar and the pound was \$1.42 = £1. In May 2011, the exchange rate between the dollar and the pound was \$1.62 = £1. Suppose that in May 2010, a U.K. resident paid \$1,000 for a bond paying 5 percent interest issued by a U.S. corporation. Assume that the bond will mature in one year, at which time the U.K. resident will be paid back the \$1,000 value of the bond. What would the rate of return on this investment be for this year, taking into account the change in the dollar-pound exchange rate between May 2010 and May 2011?

Solving the Problem

Step 1: Review the chapter material.

This problem requires an understanding of the current exchange rate system, so you may want to review the section "International Capital Markets," which begins on page 643 in the textbook.

Step 2: Determine the price of the bond in the U.S.

To buy the U.S. bond, the U.K. resident must first buy U.S. dollars. The cost of \$1,000 at the May 2010 exchange rate would be £704.23 (\$1,000/\$1.42/£ = £704.23).

Step 3: Determine the interest earned from holding the bond.

Because the bond was issued by a U.S. corporation, it will pay interest in dollars. With a 5 percent interest rate, the interest income will be $0.05 \times \$1,000 = \50 .

Step 4: Determine the rate of return earned on the investment by the U.K. resident.

After one year, the bondholder will receive the interest payment of \$50 and the value of the bond of \$1,000, or a total of \$1,050. The U.K. resident can then convert this back to pounds at the May 2011 exchange rate of \$1.62 = £1. This conversion will result in the investor receiving: \$1,050/\$1.62/£ = £648.15.

Thus, the rate of return the U.K. resident receives from investing in the bond is -7.9 percent:

(£648.15 - £704.23)/£704.23 = -0.079 or -7.9 percent.

While the U.K. resident earned interest income from investing in the bond, the net return is negative. The U.K. resident incurred a net loss because of the decreasing value of the dollar during that time period exceeded the interest income.

Appendix

The Gold Standard and the Bretton Woods System (pages 650–654)

Learning Objective: Explain the gold standard and the Bretton Woods system.

The Gold Standard

The gold standard was the basis of the exchange rate system from the early nineteenth century to the 1930s. Under the gold standard, each country's currency could be redeemed for a given quantity of gold. Therefore, exchange rates were determined by the relative amounts of gold in each country's currency. If there was one-fifth of an ounce of gold in a U.S. dollar and one ounce of gold in a British pound, the exchange rate would be \$5.00 = £1.00. Under the gold standard, the quantity of money depended on the quantity of gold a country owned.

The End of the Gold Standard

Many countries abandoned the gold standard during the 1930s because expansion was limited under that monetary system by the quantity of gold and countries could not follow independent monetary policies. During the Great Depression of the 1930s, countries on the gold standard experienced larger declines in real GDP than did countries not on the gold standard.

The Bretton Woods System

After the collapse of the gold standard, a conference held in Bretton Woods, New Hampshire, created an exchange rate system in which the United States agreed to buy and sell gold at a fixed price of \$35 per ounce. The central banks of other countries agreed to buy and sell their currencies at a fixed rate against the dollar. Under this system, central banks were required to sell dollar reserves in exchange for domestic currency. If a central bank ran out of dollar reserves, it could borrow dollars from the newly created **International Monetary Fund,** which was designed to oversee the operations of the exchange rate system and approve adjustments to the agreed-on exchange rates.

Under the **Bretton Woods system**, a fixed exchange rate was called the par exchange rate. If the market exchange rate was different from the par exchange rate, the central bank would intervene in the market and buy or sell its country's currency in exchange for dollars. A persistent surplus or shortage of domestic currency was evidence of a fundamental disequilibrium (the par exchange rate was not equal to the equilibrium exchange rate) and required an adjustment in the par exchange rate. A reduction in the fixed exchange rate was referred to as a **devaluation**, and an increase in the fixed exchange rate was a **revaluation**. A surplus of currency is shown in Figure 19A.1. The graph shows that the par exchange rate of the pound against the dollar is higher than the equilibrium exchange rate. As a result, the Bank of England has to purchase pounds in exchange for dollars to maintain the exchange rate at the agreed upon level.

Figure 19A.2 shows that the par exchange rate of the German deutsche mark against the dollar is lower than the equilibrium exchange, resulting in a surplus of U.S. dollars that the West German central bank must buy in exchange for marks to maintain the exchange rate.

The Collapse of the Bretton Woods System

The Bretton Woods system began to collapse in the late 1960s when the dollar value of reserves held in other countries exceeded the value of the U.S. stock of gold, so that the United States would not be able to redeem dollars at the agreed on \$35 per ounce price. In addition, some countries, particularly West Germany, were reluctant to devalue their currencies when faced with a fundamental disequilibrium. In August 1971, President Nixon decided to abandon the U.S. commitment to redeem dollars for gold. By 1973, the Bretton Woods system was effectively finished and was replaced by the current exchange rate system of floating rates.

Key Terms

Euro The common currency of many European countries.

Exchange rate system An agreement among countries about how exchange rates should be determined.

Fixed exchange rate system A system under which countries agree to keep the exchange rates among their currencies fixed for long periods.

Floating currency The outcome of a country allowing its currency's exchange rate to be determined by demand and supply.

Managed float exchange rate system The current exchange rate system, under which the value of most currencies is determined by demand and supply, with occasional government intervention.

Pegging The decision by a country to keep the exchange rate fixed between its currency and another currency.

Purchasing power parity The theory that in the long run, exchange rates move to equalize the purchasing powers of different currencies.

Quota A numerical limit that a government imposes on the quantity of a good that can be imported into the country.

Tariff A tax imposed by a government on imports.

Key Terms—Appendix

Bretton Woods system An exchange rate system that lasted from 1944 to 1973, under which countries pledged to buy and sell their currencies at a fixed rate against the dollar.

Capital controls Limits on the flow of foreign exchange and financial investment across countries.

Devaluation A reduction in a fixed exchange rate.

International Monetary Fund (IMF) An international organization that provides foreign currency loans to central banks and oversees the operation of the international monetary system.

Revaluation An increase in a fixed exchange rate.

Self-Test

(Answers are provided at the end of the Self-Test.)

Multiple-Choice Questions

- 1. A country that allows demand and supply to determine the value of its currency is said to have a
 - a. pegged exchange rate.
 - b. fixed exchange rate system.
 - c. managed float exchange rate system.
 - d. floating currency.
- 2. An agreement among countries on how exchange rates should be determined is called a(n)
 - a. exchange rate system.
 - b. fixed exchange rate mechanism.
 - c. integrated exchange rate approach.
 - d. Bretton Woods solution.
- 3. Which of the following happens in a managed float exchange rate system?
 - a. Countries agree to keep the value of their currencies constant.
 - b. Countries agree not to intervene in foreign exchange markets.
 - c. Countries will occasionally intervene to buy and sell their currency or other currencies in order to affect exchange rates.
 - d. Countries allow their currencies' exchange rates to be determined solely by demand and supply.
- 4. When countries agree to keep the value of their currencies constant, there is
 - a. a fixed exchange rate system.
 - b. a managed float exchange rate system.
 - c. no exchange rate system.
 - d. exchange rate integration.
- 5. The theory of purchasing power parity states that, in the long run,
 - a. exchange rates move to equalize the amount of goods that different currencies can buy.
 - b. exchange rates are determined by movements in interest rates.
 - c. exchange rates are determined by changes in investors' expectations about the future values of currencies.
 - d. All of the above are true.
- 6. According to purchasing power parity,
 - a. inflation rates should be the same in all countries.
 - b. exchange rates move to equalize the purchasing power of different currencies.
 - c. exchange rates will not change.
 - d. countries can gain from trading.
- 7. Which of the following is *not* a reason why purchasing power parity is not a complete explanation of exchange rates?
 - a. Not all products can be traded internationally.
 - b. Products and consumer preferences are different across countries.
 - c. Countries have different wage rates.
 - d. Countries impose barriers to trade.

- 8. Which of the following facts keeps purchasing power parity from being a complete explanation of exchange rates?
 - a. the fact that all products are traded internationally
 - b. the fact that products and consumer preferences are different across countries
 - c. the fact that most countries don't have any barriers to trade
 - d. All of the above keep purchasing power parity from being a complete explanation of exchange rates.
- 9. A quota is
 - a. a limit on the quantity of a good that can be imported.
 - b. an agreement to voluntarily restrain the quantity of goods that a country may import into another country.
 - c. a tax on imported goods.
 - d. a tax on exported goods.
- 10. Suppose in July 2013, a Big Mac sold for 37 pesos in Mexico and \$3.59 in the United States. The exchange rate at that time was 12.94 pesos per dollar. So based on Big Mac purchasing power parity, the peso of Mexico was
 - a. undervalued against the dollar.
 - b. overvalued against the dollar.
 - c. neither overvalued nor undervalued. Purchasing power parity between the peso and the dollar held.
 - d. devalued against the dollar.
- 11. Fill in the blanks. If prices in Mexico have risen faster on average than prices in the United States, while prices in Canada have risen more slowly, it must be true that in the long run the U.S. dollar has value against the Mexican peso and value against the Canadian dollar.
 - a. gained; lost
 - b. lost; gained
 - c. maintained; gained
 - d. gained; maintained
- 12. If the average productivity of Mexican firms increases faster than the average productivity of U.S. firms, then
 - a. Mexican products will become relatively more expensive than U.S. products.
 - b. the demand for Mexican products will fall relative to U.S. products.
 - c. the value of the Mexican peso should rise against the dollar.
 - d. all of the above will occur.
- 13. If consumers in the United States decrease their demand for Mexican roses, the result will be to
 - a. decrease the value of the Mexican peso relative to the dollar.
 - b. increase the value of the Mexican peso relative to the dollar.
 - c. have no effect on the value of the Mexican peso relative to the dollar.
 - d. increase the demand for dollars.
- 14. The euro is
 - a. the currency of all European countries.
 - b. used only in France, Italy, Spain, and Germany.
 - c. no longer used to any European country after the 2008 financial crisis.
 - d. controlled by the European Central bank (ECB).

a. 1 b. 2	The euro will help economic growth in the EU countries by making it easier for consumers and firms to buy and sell across borders. The euro will reduce costs and increase competition. The euro will increase the ability of participating countries to run independent monetary policies. The euro is used as currency in Germany, France, and Italy, among other countries.
a signi signi	In the blanks. When the value of a currency falls, the prices of imports If imports are gnificant fraction of the goods consumers buy, this fall in the value of the currency may ficantly the inflation rate.
b. 1 c. 1	rise; increase rise; decrease fall; increase fall; decrease
a. s b. a c. l	ency pegging refers to the decision by a country to share the same currency with another country, such as the decision of EU countries to adopt the euro. Allow two currencies to circulate simultaneously within the country. Keep the exchange rate fixed between its currency and another currency. Share the same fiscal policy with one or more countries.
rates some a. s b. a c. l	on currency traders become convinced that countries will have to abandon their pegged exchange as a wave of selling of these countries' currencies may occur. These waves of selling are estimes referred to as speculative attacks. Carbitrage. Checken desired to a selling are estimated by the selling are e
1997 a. t b. t c. t	ch of the following best describes the trend of the exchange rate systems in the world after the Asian currency crisis? Toward pegged exchange rates soward managed floating exchange rates soward fixed exchange rates soward the gold standard
the e a. t b. t c. 0	ha has pegged its exchange rate with the U.S. dollar at a rate (in terms of yuan per dollar) above equilibrium exchange rate. We can conclude that the Chinese Central bank must sell dollars to maintain this rate. The yuan is undervalued. Chinese exports to the United States and imports from the United States will be equal. The Chinese Central bank must buy yuan to maintain this rate.
atten sharp a. b. u c. l	in the blanks. Like other countries that underwent an exchange rate crisis, South Korea had a npted to maintain the value of the won by domestic interest rates. The result was a p in aggregate demand and a severe lowering; increase; inflation raising; decline; recession lowering; decrease; deflation raising; increase; recession

510 CHAPTER 19 | The International Financial System

22.	Fill in the blanks. If Chinese savers increase their demand for U.S. Treasury bonds, the demand for dollars will, and the value of the dollar will
	a. increase; rise
	b. increase; fall
	c. decrease; rise
	d. decrease; fall
23.	Shares of stock and long-term debt, including corporate and government bonds and bank loans, are
	bought and sold in
	a. capital markets.
	b. money markets.
	c. investment markets.
	d. foreign exchange markets.
24.	Fill in the blanks. In the 1980s and 1990s, European governments many restrictions on foreign investments in financial markets. Then, U.S. and other foreign investors investments in Europe, and European investors investments in foreign markets. a. removed; increased; increased b. imposed; decreased; decreased c. removed; increased; decreased d. imposed; decreased; increased
25.	 Today, the U.S. capital market is a. larger than all of the foreign capital markets combined. b. smaller than any of the capital markets operating in Europe and Japan. c. smaller than the markets operating in Europe and Japan but larger than the markets operating in Latin America and East Asia. d. large, but there are also large capital markets operating in Europe and Japan and somewhat smaller markets operating in Latin America and East Asia.
26.	The three most important international financial centers today are
	a. Zurich, Chicago, and Paris.
	b. New York, London, and Tokyo.
	c. Seoul, Moscow, and Buenos Aires.
	d. Los Angeles, Munich, and Shanghai.
27.	By 2012, corporations, banks, and governments had raised more than in funds on global financial markets. a. \$600 million b. \$600 billion c. \$600 billion d. \$6 trillion
28	During the 1990s, the flow of foreign funds into U.S. stocks and bonds
20.	a. increased dramatically.
	b. decreased substantially.
	c. remained fairly stable.
	d. was practically nonexistent.
	d. Has practically nonexistent.

- 29. Which of the following statements about foreign purchases of U.S. stocks and bonds is correct?
 - a. Growth in China, India, and some European countries caused a substantial increase in foreign ownerships of corporate bonds between 2007 and 2012.
 - b. Falling stock prices in the United States caused a fall in foreign ownership of corporate stocks between 2007 and 2012.
 - c. Foreign investment in U.S. government bonds was more than four times in 2012 as it was in 1995.
 - d. All of the above are correct.
- 30. Which of the following reflects the distribution of foreign purchases of U.S. stocks and bonds?
 - a. Investors in the United Kingdom accounted for about 20 percent of all foreign purchases of U.S. stocks and bonds.
 - b. Investors in Japan accounted for about 14 percent of all foreign purchases of U.S. stocks and bonds
 - c. Investors in China accounted for about 30 percent of all foreign purchases of U.S. stocks and bonds.
 - d. All of the above are true.
- 31. The globalization of financial markets has helped to
 - a. increase growth and efficiency in the world economy.
 - b. allow for the savings of investors around the world to be channeled to the best investments available.
 - c. allow firms in nearly every country to tap into the savings of investors around the world in order to find the funds needed for expansion.
 - d. All of the above are true.
- 32. Under the gold standard, the central bank
 - a. has substantial control over the money supply and a highly effective way of conducting monetary policy.
 - b. lacks the control of the money supply necessary to pursue an active monetary policy.
 - c. has control of monetary policy, but not of fiscal policy.
 - d. can manipulate the economy in precise ways by adjusting its supply of gold.
- 33. Which of the following periods marks the collapse of the gold standard?
 - a. the 1930s
 - b. the 1920s
 - c. the 1940s
 - d. the 1970s
- 34. A tariff is a(n)
 - a. limit on the quantity of goods that a country may import into another country.
 - b. agreement to voluntarily restrain the quantity of goods that a country may import into another country.
 - c. tax on imported goods.
 - d. tax on exported goods.

- 35. The Bretton Woods system was an agreement
 - a. between participating countries to reduce trade barriers.
 - b. in which central banks pledged to buy and sell their currencies at a fixed rate against the dollar.
 - c. in which the exchange rate between two currencies was automatically determined by the quantity of gold in each currency.
 - d. by countries to go off the gold standard to allow their central banks to expand the money supply and pay for war expenditures.
- 36. Under the Bretton Woods system, the International Monetary Fund (IMF) is an organization that
 - a. provides foreign currency loans to central banks.
 - b. oversees the operation of the international monetary system.
 - c. approves adjustments to agreements regarding fixed exchange rates.
 - d. All of the above are true.
- 37. Under the Bretton Woods System, if the par exchange rate was above equilibrium, the result would be
 - a. a shortage of domestic currency in the foreign exchange market.
 - b. a surplus of domestic currency in the foreign exchange market.
 - c. a shift to the left of the demand curve for domestic currency.
 - d. a shift to the right of the demand curve for domestic currency.
- 38. Which of the following is *not* a determinant of the exchange rate in the long run?
 - a. relative price levels
 - b. productivity growth rates
 - c. real GDP levels
 - d. tariffs and quotas
- 39. In a fixed exchange rate system, when the par exchange rate is below the equilibrium exchange rate, the central bank must
 - a. use its own currency to buy foreign currency.
 - b. use foreign currency to buy its own currency.
 - c. reduce the domestic money supply to drive up interest rates.
 - d. buy and sell its own currency simultaneously.

40.	Fill	in the blanks. A re	duction of a	fixed	exchange	rate is	a(n)	,	and	an	increase	in a
	fixe	ed exchange rate is a	(n)									
	a.	appreciation; deprec	ciation									
	1.	1										

- b. depreciation; appreciation
- c. revaluation; devaluation
- d. devaluation; revaluation
- 41. Which of the following factors contributed to the collapse of the Bretton Woods system?
 - a. After 1963, the total number of dollars held by foreign central banks was larger than the gold reserves of the United States.
 - b. The credibility of the U.S. promise to redeem dollars for gold was called into question.
 - c. Some countries with undervalued currencies, particularly West Germany, were unwilling to revalue their currencies.
 - d. All of the above contributed to the collapse of the Bretton Woods system.

	Fill in the blanks. Refer to the market for Deutsche marks in a fixed exchange rate system like the Bretton Wood system. Suppose that the par exchange rate is below the equilibrium exchange rate. In this situation, the quantity of Deutsche marks demanded is than the quantity of Deutsche marks supplied. To maintain the exchange rate at par, the Bundesbank would have to dollars and Deutsche marks. a. greater; buy; sell b. greater; sell; buy c. less; buy; sell d. less; sell; buy
43.	Capital controls are
	 a. requirements that force countries with undervalued currencies to revalue their currencies. b. limits on the flow of foreign exchange and financial wealth across countries.
	c. measures that allow countries to adjust their exchange rates when evidence of a fundamental
	disequilibrium in that country's exchange rate exists. d. all of the above.
44.	Actions by investors that make it more difficult for a central bank to maintain a fixed exchange rate
	are referred to as a. a fundamental disequilibrium.
	b. a panic run.
	c. an exchange rate market bubble.d. destabilizing speculation.
45.	Among the important aspects of the exchange rate system today is that a. the United States allows the dollar to float against other major currencies (with some intervention by central banks).
	b many countries in Western Europe have adopted a single currency, the euro.
	c. some developing countries have attempted to keep their currency's exchange rate fixed against
	the dollar, or against another major currency. d. All of the above are true of the current exchange rate system.
CL	
5h	ort Answer Questions
	1. What is the difference between a floating and a managed floating exchange rate system?

514 CHAPTER 19 The International Financial System

Question 2) action lead	asportation costs, so is £8.97. How is it p to the elimination of cortation costs? (Pri	possible to earn of the profits?	a profit buying a How would the a	and selling the CE answer be differe	? How will th
		-			
2.9 percent.	in 2014, the U.S. Based upon this, oth lative to the Canadi	ner things being			
-					
		22			
year. How v	payment of a busin ill the interest rate \$1?				
	ill the interest rate				

6.	When we buy bonds in other countries, it is necessary to think not only about the exchange rate now.
	because we need to buy foreign currency in order to purchase the bond, but also the exchange rate
	when the bond matures, when we would want to convert the end value back into our currency
	Suppose the current price of a U.K. bond is £950, and the bond has a face value of £1,000. Suppose
	that the exchange rate is $1.95 = £1$, and we expect the exchange rate to change to $2.05 = £1$ at the
	time the bond matures in one year. Based upon this, what would be the interest rate on the bond?
	time the bond matthes in one year. Based upon this, what would be the interest rate on the bond.

True/False Questions

- T F 1. A floating currency's exchange rate is determined by the demand and supply of the currency.
- T F 2. In a managed float exchange rate system, the exchange rate is determined by the demand and supply of the currency.
- T F 3. The gold standard is a fixed exchange rate system.
- T F 4. The value of the U.S. dollar is fixed against most other major currencies.
- T F 5. Purchasing power parity implies that a good that costs \$100 will cost \$100 in Japan.
- T F 6. Purchasing power parity implies that in the long run, exchange rates are determined by relative real GDP growth.
- T F 7. Because some goods are not traded internationally, purchasing power parity may not hold for those goods.
- T F 8. Tariffs and quotas may keep purchasing power parity from holding for all goods.
- T F 9. Suppose that based upon Big Mac prices, the implied exchange rate between the yen and the dollar is \frac{\pmathbf{1}}{105} = \frac{\pmathbf{1}}{1}, and the actual exchange rate is \frac{\pmathbf{1}}{10} = \frac{\pmathbf{1}}{1}. We can conclude that the yen is overvalued against the dollar.
- T F 10. If people in Japan increase their preferences for U.S. goods, this will increase the demand for dollars and cause the yen to increase in value.
- T F 11. The euro exchange rate is determined by the European Central Bank.
- T F 12. Speculative attacks, or waves of selling currencies, were a major cause for the currency crisis among East Asian countries in 1997.
- T F 13. A fixed exchange rate makes business planning more difficult.
- T F 14. To peg a country's exchange rate, the country's government must sell its own currency to keep its exchange rate at the pegged rate when the demand for its own currency increases.
- T F 15. In international capital markets, savers buy and sell bonds and stocks only from their own country.

Answers to the Self-Test

Multiple-Choice Questions

Question	Answer	Comment
1.	d	A country that allows demand and supply to determine the value of its currency is said to have a floating currency.
2.	a	When countries can agree on how exchange rates should be determined, economists say that there is an exchange rate system.
3.	С	In a managed float exchange rate system, countries will occasionally intervene to buy and sell their currencies or other currencies in order to affect exchange rates.
4.	a	When countries agree to keep the value of their currencies constant, they are using a fixed exchange rate system.
5.	a	It seems reasonable that, in the long run, exchange rates should be at a level that makes it possible to buy the same amount of goods and services with the equivalent amount of any country's currency. In other words, the purchasing power of every country's currency should be the same. The theory of purchasing power parity refers to the idea that, in the long run, exchange rates move to equalize the purchasing power of different currencies.
6.	b	Purchasing power parity says that exchange rates should adjust so that goods cost the same amount in different currencies. If this is not true, people will purchase the cheaper good, and that extra demand will drive the prices to similar levels.
7.	С	Exchange rates adjust for differences in wages, so differences in wages will not affect purchasing power parity.
8.	b	The three factors that keep purchasing power parity from being a complete explanation of exchange rates are: (1) the fact that most products are not traded internationally, (2) products and consumer preferences are different across countries, and (3) countries impose barriers to trade.
9.	a	A quota is a limit on the quantity of a good that can be imported. For example, the United States has a quota on imports of sugar. As a result, the price of sugar in the United States is much higher than the price of sugar in other countries. Economists have estimated that the price of sugar in the United States is about three times what it would be without the quota.
10.	a	If a Big Mac sold for 37 pesos in Mexico and \$3.59 in the United States, for purchasing power parity to hold, the exchange rate should have been 37 pesos/\$3.59, or 10.31 pesos = \$1. The actual exchange rate was 12.94 pesos = \$1. So according to Big Mac purchasing power parity, the Mexican peso was undervalued against the dollar by 20 percent $\{[(10.31 - 12.94)/12.94] \times 100 = 20 \text{ percent}\}$.
11.	a	If prices in Mexico have risen faster on average than prices in the United States, while prices in Canada have risen more slowly, this difference in inflation rates is a key reason why the U.S. dollar would have gained value against the Mexican peso, while losing value against the Canadian dollar.

517

Question	Answer	Comment
23.	a	Shares of stock and long-term debt, including corporate and government bonds and bank loans, are bought and sold in capital markets.
24.	a	In the 1980s and 1990s, European governments removed many restrictions on foreign investments in financial markets. It became possible for U.S. and other foreign investors to freely invest in Europe and for European investors to freely invest in foreign markets.
25.	d	At one time, the U.S. capital market was larger than all foreign capital markets combined, but this is no longer true. Today, there are large capital markets operating in Europe and Japan and somewhat smaller markets operating in Latin America and East Asia.
26.	b	The three most important international financial centers today are New York, London, and Tokyo. Each day the front page of the on-line version of the <i>Wall Street Journal</i> displays not just the Dow Jones Industrial Average and the Standard and Poor's 500 stock indexes of U.S. stocks, but also the Nikkei 225 average of Japanese stocks and the Euro STOXX 50 index of European stocks.
27.	С	By 2012, corporations, banks, and governments raised more than \$600 billion in funds on global financial markets. See Figure 19.6 in the textbook.
28.	a	During the 1990s, the flow of foreign funds into U.S. stocks and bonds—or portfolio investments—increased dramatically. As Figure 19.6 shows, since 1995 there has been a dramatic increase in foreign purchases of bonds issued by corporations and by the federal government.
29.	c	As shown in textbook Figure 19.6, there has been a large rise in foreign purchases of bonds issued by U.S. corporations and by the federal government since 1995. Some of the demand for U.S. government bonds was a result of the U.S. large current account deficits.
30.	b	As shown in textbook Figure 19.7, only the percentage for Japan is correct.
31.	d	The globalization of financial markets has helped increase growth and efficiency in the world economy. It is now possible for the savings of investors around the world to be channeled to the best investments available. It also possible for firms in nearly every country to tap the savings of investors around the world to gain the funds needed for expansion. Firms no longer are forced to rely only on the savings of domestic investors to finance investment.
32.	b	Under the gold standard, the central bank cannot determine how much gold will be discovered. It therefore lacks the control of the money supply necessary to pursue an active monetary policy. If the gold standard is adhered to in foreign exchange markets with a fixed exchange rate, the problem becomes
		worse as pressures on the exchange rate can cause gold inflows and outflows, further weakening the central bank's control of the money supply.
33.	a	In 1931, Great Britain became the first major country to abandon the gold standard. A number of other countries also went off the gold standard that
		year. The United States remained on the gold standard until 1933, and a few countries, including France, Italy, and Belgium, stayed on even longer. By the
		late 1930s, the gold standard had collapsed.

Question	Answer	Comment
34.	c	A tariff is a tax on imported goods. The United States started the tariff wars in June 1930 by enacting the Smoot-Hawley Tariff, which raised the average U.S. tariff rate to more than 50 percent. Many other countries raised tariffs during the next few years, leading to a collapse in world trade and contributing
		to the severity of the Great Depression.
35.	b	A conference held in Bretton Woods, New Hampshire, in 1944 set up a system in which the United States pledged to buy or sell gold at a fixed price of \$35 per ounce. The central banks of all other members of the new Bretton Woods system pledged to buy and sell their currencies at a fixed rate against the dollar.
36.	d	Under the Bretton Woods system, central banks were committed to selling dollars in exchange for their own currencies. This commitment required them to hold dollar reserves. If a central bank ran out of dollar reserves, it could borrow them from the newly created International Monetary Fund (IMF). The IMF is an international organization that provides foreign currency loans to central banks and oversees the operation of the international monetary system. In addition to providing loans to central banks that were short of dollar reserves, the IMF would oversee the operation of the system and approve
		adjustments to the agreed on fixed exchange rates.
37.	b	Under the Bretton Woods system, central banks were obligated to defend par exchange rates by buying and selling their countries' currencies at fixed rates against the dollar. If the par exchange rate was above equilibrium, the result would be a surplus of domestic currency in the foreign exchange market. If the par exchange rate was below equilibrium, the result would be a shortage of domestic currency.
38.	c	The real GDP level, which measures the size of an economy, will have no direct effect on exchange rates in the long run.
39.	a	Opposite to the example in textbook Figure 19A.1, when the par exchange rate is below the equilibrium exchange rate, the quantity of a currency demanded by people exceeds the quantity of that currency supplied. To keep the exchange rate fixed, the central bank must increase the supply of its own currency.
40.	d	In the early years of the Bretton Woods system, many countries found that their currencies were overvalued versus the dollar, meaning that their par exchange rates were too high. A reduction of a fixed exchange rate is a devaluation, and an increase in a fixed exchange rate is a revaluation. In 1949, there was a devaluation of several currencies, including the British pound, reflecting the fact that those currencies had been overvalued against the dollar.
41.	d	All of the factors above contributed to the collapse of the Bretton Woods system.

Question	Answer	Comment
42.	a	Under the Bretton Woods system, the Bundesbank, the German central bank, was required to buy and sell Deutsche marks for dollars at a rate of \$0.27 per Deutsche mark. The equilibrium that would have prevailed in the foreign exchange market if the Bundesbank did not intervene was about \$0.35 per Deutsche mark. Because the par exchange rate was below the equilibrium exchange rate, the quantity of Deutsche marks demanded by people wanting to buy German goods and services, or wanting to invest in German assets, was greater than the quantity of Deutsche marks supplied by people who wanted to exchange them for dollars. To maintain the exchange rate at a par of \$0.27 per Deutsche mark, the Bundesbank had to buy dollars and sell Deutsche marks. The amount of Deutsche marks supplied by the Bundesbank was equal to the shortage of Deutsche marks at the par exchange rate.
43.	b	During the 1960s, most European countries, including Germany, relaxed their capital controls. Capital controls are limits on the flow of foreign exchange and financial investment across countries. The loosening of capital controls made it easier for investors to speculate on changes in exchange rates.
44.	d	In the Bretton Woods system, an increased demand for a given currency by investors hoping to make a profit from an expected revaluation will increase demand for the currency. Because of this expectation, the central bank has to increase the quantity it supplies in exchange for dollars, raising the risk of inflation. Because these actions by investors make it more difficult to maintain a fixed exchange rate, they are referred to as destabilizing speculation.
45.	d	All of the above are important aspects of the exchange rate system today.

Short Answer Responses

- 1. A floating exchange rate is determined by the demand and supply of one currency compared to another currency. A change in supply and/or demand, caused by such events as interest rate changes or price changes, will change the exchange rate. In a managed floating exchange rate system, the government may decide that the exchange rate change is not in the country's best interests, and decide to offset the change in the exchange rate. To do this, the government must intervene in the foreign exchange market. For instance, if the \frac{1}{2} exchange rate rose from \frac{120}{3} to \frac{130}{3} and the Bank of Japan wanted to return the rate to the \frac{120}{3} level, they might do so by reducing the demand for dollars (by tariffs or quotas) or by increasing the supply of dollars by buying yen with U.S. dollars.
- 2. According to purchasing power parity, adjusted for exchange rates, traded goods should cost the same in all countries. Therefore, the Lady Gaga CD which costs \$18.99 in the U.S. should cost \$18.99 × £0.65/\$ = £12.34 in London.
- 3. You could take \$13.80 and exchange that dollar amount for £8.97, which is enough to buy the CD in London. You could then sell the CD in the United States for \$18.99, giving you a profit of \$5.19. If you exchanged enough dollars for pounds to buy one million CDs in London, you would make a profit of \$5.19 million. Unfortunately, as you continued to exchange dollars for pounds, you would drive up the value of the pound until the exchange rate reached the point where you would no longer make a profit. Transportation costs will also eat up part, or maybe all, of your profit. For instance, if it costs \$6.00 to ship one British CD to the United States, all of your potential profit would be eliminated.

- Prices of goods and services are rising relatively slower in Canada, which will increase the demand for Canadian goods relative to the (more expensive) U.S. goods. As a result, there will be an increase in the supply of U.S. dollars in exchange for Canadian dollars and a decrease in demand for U.S. dollars (by Canadians who will not be buying as many of the more expensive U.S. goods). This will cause the U.S. dollar to depreciate (the Canadian dollar will appreciate).
- Exchange rate changes can provide considerable uncertainty in day-to-day business operations. If a firm in Thailand borrows from a U.S. bank and has a \$100,000 per year interest payment, that payment is fixed in dollars. The price to the firm depends upon the exchange rate. If the exchange rate is 45 baht = \$1, then the interest payment will be 4,500,000 baht, but if the exchange rate were to rise to 35 baht = \$1, then the same fixed dollar interest payment would reduce to 3,500,000 baht. Note that if the Thai firm sells products in the United States, the exchange rate change will also change the firm's revenues. This will not happen if the firm sells products only in Thailand.
- 6. If the exchange rate is \$1.95 = £1, to purchase the U.K. bond, the U.S. price would be \$1,852.50 (= $\$1.95/£ \times £950 = \$1,852.50$). If the exchange rate were to remain at \$1.95 = £1 until the bond matured in one year, the £1,000 be worth \$1,950 (= £1,000 × \$1.95/£ = \$1,950). Based on this, the interest rate on the bond would be 5.26 percent (= $100 \times [\$1,950 - \$1,852.50]/\$1,852.50 = 5.26$ percent). Now if the exchange rate was 2.10 = £1 when the bond matured, the £1,000 would be worth \$2,050 (= $\$2.05/£ \times £1,000 = \$2,050$) and the interest rate would be 10.66 percent (= 100×10^{-10}) [\$2,050 - \$1,852.50]/\$1,852.50 = 10.66 percent).

True/False Answers

Question	Answer	Comment
1.	T	See page 630 in the textbook for the definition of a floating currency.
2.	F	The managed float exchange rate system's exchange rate is determined by demand and supply but with occasional government intervention.
3.	T	The gold standard and the Bretton Woods system were two fixed exchange rate systems in history.
4.	F	The dollar is a floating currency.
5.	F	The good will cost $100 \times [\text{exchange rate } (\frac{4}{\$})]$, so if the exchange rate were $\frac{490}{\$}$ = 1 , then the good should cost $\frac{49,000}{\$}$.
6.	F	Actually, purchasing power parity implies that in the long run, exchange rates are determined by inflation.
7.	T	Purchasing power party may not hold if (1) not all goods can be traded internationally, (2) goods and consumer preferences are different across countries, and (3) countries impose barriers to trade.
8.	T	As a result of a tariff or quota, the price of imported goods may be higher than the price of the same goods sold in foreign countries.
9.	F	If the exchange rate between the yen and the dollar is $\frac{110}{100} = 1$ as implied by purchasing power parity but the actual exchange rate is $\frac{120}{100} = 1$, the higher actual exchange rate implied that the yen is undervalued against the dollar.
10.	F	If people in Japan increase their preferences for U.S. goods, this will increase the demand for dollars and cause the yen to decrease in value (or the dollar to increase in value).
11.	F	The euro is a floating currency.

522 CHAPTER 19 The International Financial System

Question	Answer	Comment
12.	Т	After Thailand abandoned its pegged exchange rate, waves of currency selling, or speculative attacks, occurred in a number of East Asian countries, such as Korea, Indonesia, and Malaysia.
13.	F	A fixed exchange rate eliminates a source of uncertainty. See Short Answer Question 5.
14.	T	When the demand for its own currency increases, the country's government can keep its exchange rate at the pegged rate by increasing the supply of the own currency.
15.	F	In international capital markets, savers may buy and sell bonds and stocks from many different countries.